THE

CLASSIFIED

DIRECTORY

of

Artists' Signatures

Symbols & Monograms

THE
CLASSIFIED
DIRECTORY
of
Artists' Signatures
Symbols & Monograms

H.H. CAPLAN

GALE RESEARCH COMPANY
DETROIT – MICHIGAN – U.S.A.
1982

For Sheila

First published 1976 George Prior Publishers

This Enlarged and Revised Edition Published 1982 by
George Prior Publishers, London, England.

Distributed exclusively in the United States and Canada by
The Gale Research Company, Book Tower, Detroit, Michigan 48226. U.S.A.

Caplan, H.H.
 The classified directory of artists' signatures
 symbols and monograms.—2nd ed.
 1. Artists——Autographs—Dictionaries
 2. Artists' marks—Dictionaries
 I. Title
 760'.092'2 N45

ISBN 0 8103 0977 7

Printed in Great Britain by Hillman Printers, Frome, Somerset

CONTENTS

FOREWORD

When I was asked to write the Foreword for the first edition of this Directory, which was published in 1976, I talked of the fascination that all reference books, as a breed, hold for me; and I mused on the pleasure that any painter could gain from browsing through that particular volume. I emphasised, though, that its significance was really as a work of reference.

Obviously, my own reaction to it was echoed very widely — not only by other artists, but by museum directors, gallery owners, scholars, collectors and dealers — for orders were still being received for it in 1981, although the stocks were nearly exhausted by the early part of that year.

The first edition is now distributed across the world. In the author's Introduction to it, Hillier Caplan said that he intended to publish addenda from time to time, for he felt that inevitably there would be many omissions when undertaking a work of such wide-ranging scale. In fact, once the edition was sold out, the Directory could simply have been reprinted whilst work continued on gathering material for a first addendum: but, instead, Mr Caplan and the publishers decided on the larger undertaking of this revised edition. Since it is not a supplement, it repeats all the original entries as well as providing basic information in perhaps an additional fifteen hundred entries. Its purpose, of course, is still primarily to cross-index artists' symbols, monograms and illegible signatures: as before, standard reference books can normally be consulted if one wishes to fill in further details.

I feel complimented to have been asked to provide a Foreword again, for this revised edition. The author and publishers have undertaken a major task with the Directory, and I believe that this volume is a work that will stimulate yet more in the way of congratulations and gratitude.

Michael Noakes

Michael Noakes
Past President, The Royal Institute of Oil Painters
A Director, The Federation of British Artists

INTRODUCTION

Although some facsimile signatures, monograms and symbols of artists do exist in various reference works, the need for a comprehensive and classified directory dealing specifically with this subject has been apparent for some time. Whilst the comparison between two seemingly identical signatures does not obviate the possibility of forgery — and the reader must be warned against this — it is most useful to have some form of reference particularly where a signature is illegible or a monogram or symbol unidentifiable without such reference. In many instances artists have applied various forms of signature to their works and, wherever possible, examples of the different types of signature or monogram have been given.

Although it will no doubt be appreciated that the compilation and cross-indexing of a reference work of this magnitude has necessitated a great deal of research and labour there will unavoidably be many omissions, particularly relating to earlier periods where such signatures could not be found. Signatures of many contemporary artists have been included and research in both these fields is continuing in addition to information relating to artists of the late 18th. and 19th. centuries not included in this volume. It is the author's intention to publish addenda from time to time as other signatures and monograms etc. are recorded. It is to be hoped that this work will be of use and benefit to the many museums, dealers and collectors throughout the world who have an interest in paintings.

HISTORICAL INFORMATION

Biographical information on the artists concerned is in condensed form, as any comprehensive information relating to any particular artist is normally found in existing reference books. The data given herein is as follows:—

1. Surname
2. First names
3. Place of birth. Dates of birth and demise where known.
 Uncertainty in either case is indicated by a query.
4. Types of work executed or media employed.
5. Countries, towns or galleries etc. where works are known to exist or have been exhibited.

METHOD OF USE

Section 1. A - Z Classification

All names in this section are listed alphabetically. Information relating to the signature of any given artist should be referred to in this section.

Section 2. Monograms

Monograms have been classified alphabetically according to the letters contained within the monogram. In order that the user may locate any monogram with the minimum of difficulty the following procedure has been adopted in classification:—

1. Monograms have been classified by the first letter of the monogram where this is apparent.
2. Where this does not apply the uppermost letter has been taken as the classifying factor.
3. Where neither rule applies the most predominant or largest letter has been used
4. Should all letters be superimposed and of equal size the monogram will be cross-indexed under all the letters shown.
 Normal alphabetical procedure has been adopted in respect of subsequent letters, i.e. AA listed before AB etc.

In many early signatures the letter J appears as I, the letter T as J, letter G as C etc. In order to simplify classification all letters have been read as they appear and not necessarily the letters they are meant to represent.

Section 3. Illegible or misleading signatures

Signatures which, by their nature, are illegible or do not reveal the true surname of the artist are classified in this section, the first legible letter being used as the classifying factor. Any signature which cannot be listed in this manner has been included at the end of this section.

Section 4. Symbols

Symbols have been grouped, as far as possible, according to their form, i.e. square, circular, oval etc. Those with irregular form will be found at the end of this section.

ACKNOWLEDGEMENTS

The author wishes to extend his very sincere thanks to the many museums, galleries and other sources from whom much of the information contained within this book has been obtained and without whose help and assistance the preparation of this directory would not have been possible.

INTRODUCTION

Bien que l'on puisse trouver quelques fac-similés de signatures, monogrammes et symboles d'artistes dans plusieurs ouvrages de référence, la nécessite d'avoir un index simple spécialisé dans ce domaine s'est avérée de plus en plus indispensable depuis quelques temps. Alors que la comparaison entre deux signatures apparemment identiques n'exclue pas la possibilité de contre-facon, ce dont le lecteur doit être averti, il est très utile de pouvoir se référer a quelque chose là où une signature est illisible ou un monogramme ou symbole ne peut être identifié sans l'aide de cette référence. Dans de nombreux cas des artistes ont change de signature selon leurs oeuvres et, dans la mesure du possible, nous donnons des exemples des differentes signatures ou monogrammes utilisés.

Bien que le travail et les recherches nécessaires à l'élaboration d'un ouvrage de cette ampleur soient appréciables, les omissions sont inévitables, plus particulièrement en ce qui concerne les époques antérieures où de telles signatures font défaut. L'index comprend des sigantures de nombreux artistes contemporains et des recherches dans l'un et l'autre de ces domaines se poursuivent en plus de certains renseignements sur des artistes de la fin du 18eme et du 19eme siècle qui ne figurent pas dans ce volume. L'auteur a l'intention de publier des suppléments périodiques au fur et à mesure que de nouvelles signatures, monogrammes etc, sont homologués. Nous espérons que cet ouvrage sera utile et profitable aux nombreux musées, marchands et collectionneurs dans le monde entier, qui s'intéressent à la peinture.

BIBLIOGRAPHIE

Les renseignements sur l'artiste dont il est question sont réduits au minimum étant donné qu'il est toujours possible d'avoir accès aux ouvrages de référence existants déjà et qui traitent de ce sujet. Les renseignements donnés sont les suivants:

1. Nom
2. Prénoms
3. Lieu de naissance. Dates de naissance et de décès, là où ces dates nous sont connues. Toute incertitude est indiquée par une remarque.
4. Types d'oeuvres exécutées et média employé.
5. Pays, ville ou galerie etc, où la présence des oeuvres est connue ou où les oeuvres ont été exposées.

PRESENTATION

Section 1. Classification de A à Z

Tous les noms dans cette section apparaissent par ordre alphabétique. Les renseignements sur les signatures des artistes sont donnés dans cette section.

Section 2. Monogrammes

Les monogrammes se classent par ordre alphabétique selon les lettres qu'ils contiennent. Afin de permettre à l'utilisateur de localiser aisément n'importe quel monogramme, le système de classification suivant a été adopte.

1. Les monogrammes ont été classés d'après la première lettre là où elle est apparente.
2. Là où cela ne saurait être applicable, la classification se fait d'après la lettre située au-dessus des autres.
3. Là où aucune de ces règles ne peut être appliquée, nous utilisons la lettre la plus grande ou qui ressort le plus.
4. Dans le cas où toutes les lettres sont superposées et de même taille, le monogramme est classé sous chacune de ces lettres.

 L'ordre alphabétique normal a été adopté selon l'ordre des lettre, par ex. AA se situe avant AB, etc.

Dans de nombreux cas de signatures anciennes la lettre J s'écrit I, la lettre T, J, la lettre G, C, etc. Afin de simplifier la classification, il a été tenu compte des lettre telles qu'elles se présentent et non pas de ce qu'elles sont censées représenter.

Section 3. Signatures illisibles ou trompeuses

Les signatures illisibles ou qui ne donnent pas le nom véritable de l'artiste sont classées dans cette section, la première lettre lisible a été utilisée pour la classification. Toutes les signatures ne puvant être classées suivant ce procédé se trouvent à la fin de cette section.

Section 4. Symboles

Les symboles ont été classés, dans la mesure du possible, selon leur forme; carrée, ronde, ovale etc. Ceux de forme irrégulière se trouvent à la fin de cette section.

REMERCIEMENTS

L'auteur tient à remercier expressément les nombreux musées, galeries et autres sources qui ont fourni un bon nombre des renseignements contenus dans le présent ouvrage et sans l'aide et l'assistance desquels la préparation de cet ouvrage aurait été impossible.

EINFUHRUNG

Obwohl verschiedene Nachschlagewerke sich mit Faksimile-Signaturen, Monogrammen and Zeichen der Künstler befassen, ist der Mangel eines umfassenden und übersichtlichen Leitfadens, der sich speziell mit diesem Thema befaBt, seit einiger Zeit fühlbar geworden. Während der Vergleich zweier scheinbar identischer Signaturen nicht die Möglichkeit einer Fälschung ausschlieBt — und der Leser sollte sich dies ständig vor Augen halten — ist es in höchstem Grade zweckdienlich, eine Richtschnur zu haben, zumal, wenn eine Signatur unleserlich ist oder ein Monogramm oder Zeichen ohne ein solches Nachschlagewerk nicht identifiziert werden kann. In vielen Fällen haben die Künstler ihre Werke auf verschiedene Arten signiert, und nach Möglichkeit wurde diesen Signaturen und Monogrammen anhand von Beispielen Rechnung getragen.

Bei aller Sorgfalt und allem FleiB, die bei der Zusammenstellung und Alphabetisierung eines Nachschlagewerkes solchen AusmaBes Zweifellos erforderlich sind, kann der Autor doch keinen Anspruch auf Vollständigkeit erheben, besonders da die Signaturen der frühesten Perioden oft nicht vorhanden oder auffindbar sind. Dagegen wurden die Signaturen vieler zeitgenössischer Künstler in das Werk aufgenommen, und die Forschungsarbeit auf beiden Gebieten wird fortgesetzt, zuzüglich der Erkundung weiterer Einzelheiten bezüglich Künstlern des späten 18. und 19. Jahrhunderts, die in diesem Band nicht enthalten sind. Es ist die Absicht des Autors, von Zeit zu Zeit Nachträge zu veröffentlichen, so wie weitere Signaturen und Monogramme belegt werden. Es ist zu hoffen, daB dieses Werk den Museen, Kunsthändlern und Sammlern in der ganzen Welt nützlich und förderlich ist.

BIOGRAPHISCHE INFORMATION

Die biographischen Einzelheiten der Künstler wurden in geraffter Form gegeben, da sie in den schon vorhandenen Nachschlagewerken zumeist ausführlich behandelt werden. Sie wurden in den folgenden fünf Punkten erfaBt:

1. Nachname
2. Vornamen
3. Geburtsort. Geburts- und Todesdatum, soweit bekannt.
 Wo zweifelhaft, wird dies durch ein Fragezeichen gekennzeichnet.
4. Art der ausgeführten Arbeiten oder dabei verwandte Media.
5. Länder, Städte oder Galerien usw., wo die Werke des Künstlers aufbewahrt werden oder ausgestellt wurden.

HINWEISE ZUR BENUTZUNG
Abschnitt 1. Alphabetisches Namenregister

In diesem Abschnitt sind alle Namen de Künstler in alphabetischer Reihenfolge aufgeführt. Alles die Signatur betreffende ist in diesem Teil nachzuschlagen.

Abschnitt 2. Monogramme

Die Monogramme sind alphabetisch nach den Buchstaben des jeweiligen Monogramms aufgeführt. Um dem Benutzer die Ermittlung eines Monogramms weitgehend zu erleichtern, ist man nach der folgender Methode vorgegangen:

1. Die Monogramme sind nach dem ersten Buchstaben des Monogramms Alphabetisiert worden, wo dieser deutlich erkennbar ist.
2. Ist der erste Buchstabe nicht deutlich erkennbar, so wurde der oberste Buchstabe als bestimmender Faktor benutzt.
3. Trifft beides nicht zu, so wurde der auffallendste oder gröBte Buchstabe als bestimmender Faktor benutzt.
4. Sind alle Buchstaben übereinandergelagert und von gleicher GröBe, so wird das Monogramm unter jedem einzelnen Buchstaben in das Verzeichnis aufgenommen.
 Ansonsten ist nach der üblichen Alphabetisierungs methode vorgegangen worden, z.B. AA kommt vor AB usw.

In vielen frühen Signaturen erscheint der Buchstabe J wie I, T wie J, G wie C usw. Um die Einteilung zu vereinfachen, sind alle Buchstaben so eingereiht worden, wie sie äuBerlich erscheinen, und nicht unbedingt nach ihrer eigentlichen Bedeutung.

Abschnitt 3. Unleserlich oder irreführende Signaturen

Dieser Abschnitt enthält die Signaturen, die ihrer Natur nach unleserlich sind oder keinen AufschluB über den richtigen Nachnamen des Künstlers geben, wobei der erste leserliche Buchstabe als maBgeblich für die Alphabetisierung benutzt wurde.

Abschnitt 4. Zeichen

Zeichen wurden, so weit möglich, nach ihrer Form gruppiert, z.B. quadratisch, rund, oval. Zeichen, die sich nicht in eine dieser Gruppen einordnen lassen, sind am SchluB des Abschnitts zusammengefaBt.

ANERKENNUNG

Der Autor möchte seinen aufrichtigen Dank den vielen Museen, Galerien und anderen Quellen aussprechen, die ihm beim Zusammentragen des Materials wertvolle Hilfe galeistet haben, ohne die dieses Verzeichnis nicht hätte entstehen können.

INTRODUCCION

Si bien existen en facsímile algunas firmas, monogramas y símbolos de artistas en diversas obras de consulta, se ha venido manifestando desde hace algún tiempo la necesidad de un directorio completo y clasificado específicamente dedicado a este tema. Mientras la comparación entre dos firmas que parecen idénticas no elimina la posibilidad de una falsificación — debiéndose prevenir al lector de esta posibilidad — es sumamente ventajoso disponer de alguna forma de referencia, sobre todo cuando las firmas son ilegibles o los monogramas o símbolos no son identificables sin dicha referencia. En muchos casos los artistas han utilizado diversas formas de firma para sus obras, por lo que, siempre que resulta posible, se han presentado ejemplos de las diversas firmas y monogramas.

Aunque se reconocerá, sin duda alguna, que ha sido mucha la investigación y la labor que se ha necesitado para compilar esta obra de consulta y proveerla de las necesarias interreferencias, quedarán aun inevitablemente muchas omisiones, especialmente para los primeros períodos en que no resultó posible encontrar las firmas. Se han incluído las firmas de muchos artistas contemporáneos, y las investigaciones se prosiguen en los dos sectores además de la información relativa a artistas de fines del siglo 18 y del siglo 19 que no se han incluídos en este volumen. El autor tiene la intención de publicar adiciones de vez en cuando, a medida que se vayan registrando otras firmas, monogramas, etc. Se confía, pues, que esta obra será útil y beneficiosa para muchos museos, comerciantes y coleccionistas de todo el mundo que están interesados en el arte de la pintura.

INFORMACION HISTORICA

La información biográfica sobre los artistas se presenta en forma condensada, ya que la información detallada de todo artista se encuentra normalmente en libros de consulta existentes. Los datos que se incluyen aquí son los siguientes:

1. Apellido.
2. Prenombres.
3. Lugar de nacimiento. Fechas de nacimiento y de fallecimiento si se conocen. La incertidumbre en estos casos viene indicada por un interrogante.
4. Tipos de trabajo ejecutado o sectores utilizados.
5. Países, ciudades o galerías etc. donde se sabe que existen o han sido expuestas las obras.

COMO SE CONSULTA
Sección 1. Clasificación A - Z

En esta sección todos los nombres aparecen alfabéticamente. La información relativa a la firma de un artista se tiene que buscar en esta sección.

Sección 2. Monogramas

Los monogramas han sido clasificados alfabéticamente según las letras contenidas en el monograma. Para permitirle al usuario ubicar el monograma con la mínima dificultad, ha sido adoptado en la clasificación el siguiente procedimiento:

1. Los monogramas han sido clasificados por las primera letra del monograma donde la misma es visible.
2. De no ser así, la letra que se ha usado para la clasificación es la que está en posición más alta.
3. Si no es posible aplicar ninguna de estas dos reglas, se ha utilizado la letra mas evidente o la más grande.
4. Si todas las letras están superimpuestas y son del mismo tamaño, el monograma aparecerá por separado bajo todas las letras que aparecen en él.

 Con respecto a las latras subsiguientes, se ha adoptado el procedimiento alfabético normal, o sea que AA aparece antes de AB, etc.

En muchas firmas antiguas la letra J aparece en forma de I, y la T en forma de J, la G en forma de C, etc. Con el fin de simplificar la clasificación, se han interpretado todas las letras conforme aparecen, y no necesariamente conforme a lo que debían representar.

Sección 3. Firmas ilegibles o de falsa apariencia

Las firmas que, por su naturaleza, son ilegibles o no revelan el verdadero apellido del artista, están clasificadas en esta sección, usándose la primera letra legible como factor de clasificación. Las firmas que no se han podido ordenar de acuerdo con este principio se han puesto al final de esta sección.

Sección 4. Símbolos

Los símbolos han sido agrupados, en la medida de lo posible, según su forma, a saber, cuadrados, circulares, ovales, etc. Aquellos cuya forma es irregular se encuentran al final de esta sección.

AGRADECIMIENTO

El Autor desea expresar su más sincero agradecimiento a los numerosos museos, galerías y otras fuentes de las que ha sido recibida una buena parte de la información contenida en este volumen, y sin cuya ayuda y asistencia no hubiera sido posible compilar esta obra.

INTRODUZIONE

Anche se in vari libri di consultazione si possono trovare riproduzioni esatte di firme, monogrammi e simboli di artisti, da lungo tempo è ormai evidente la necessità di una guida classificata esauriente dedicata specificamente all'argomento. Mentre il confronto fra due firme apparentemente identiche non elimina la possibilità di una contraffazione — e il lettore ne deve essere avvertito — è molto utile poter disporre di qualche forma di riferimento, particolarmente per i casi di firme illeggibili oppure di monogrammi e simboli impossibili da individuare in mancanza di un riferimento quale menzionato qui sopra. Molti artisti hanno apposto al loro lavoro forme diverse di firma; quando possibile, abbiamo dato esempi dei tipi diversi di firma o monogramma.

E' facile vedere come la redazione di un'opera di consultazione di queste proporzioni e la compilazione del complesso indice hanno necessitato molto lavoro e profonde ricerche; malgrado ciò ci saranno inevitabilmente numerose omissioni, particolarmente per i periodi meno recenti per i quali tali firme sono risultate irreperibili. Abbiamo elencato firme di parecchi artisti contemporanei; continuano le ricerche in ambedue questi settori, oltre che sulle informazioni relative ad artisti della fine del 18° secolo e del 19°, che non appaiono nella presente guida. L'autore intende publicare di tanto in tanto supplementi contenenti altre firme, monogrammi ecc. Ci auguriamo che questa pubblicazione riesca utile e vantaggiosa a molti musei, commercianti e collezionisti d'arte di tutto il mondo.

NOTIZIE STORICHE

Le note biografiche relative agli artisti menzionati, sono in forma concisa, in quanto informazioni esaurienti su ogni particolare artista sono generalmente reperibili nei libri di consultazione già esistenti. I dati forniti nella presente guida sono:—

1. Cognome
2. Nomi di battesimo
3. Luogo di nascita. Date di nascita e di morte se conosciute.
 In caso di incertezza, si ha un punto interrogativo.
4. Tipi di lavoro eseguito o mezzi impiegati
5. Paesi, città o gallerie ecc nei quali si sa che esistono opere o che vi sono state esposte.

COME SERVIRSI DELLA GUIDA
Parte 1ª. Indice alfabetico

Tutti i nomi elencati in questa Prima Parte sono in ordine alfabetico.

Per le informazioni relative alla firma di un dato artista, si dovrà far riferimento a questa parte.

Parte 2ª. Monogrammi

I monogrammi sono stati elencati in ordine alfabetico in base alle lettere in esso contenute. Per aiutare il lettore a trovare il monogramma con la massima facilità, si è seguita la procedura qui soto:—

1. I monogrammi sono classificati in base alla prima lettera, quando questa è evidente.
2. Altrimenti la lettera più alta rappresenta il criterio di classificazione.
3. Quando non si può applicare né l'uno né l'altro di questi criteri, si è usata la lettera più grande o più in evidenza.
4. Se tutte le lettere sono sovrapposte e delle medesime dimensioni, il monogramma compare in tutti gli elenchi relativi alle lettere che lo compongono.

 Per le lettere successive si è applicato il normale ordine alfabetico. Per esempio AA prima di AB, e così via.

In molte firme antiche, J appare come I, T come J, G come C ecc. Per semplificare la classificazione tutte le lettere sono state elencate in base alla loro forma reale e non in base alla forma che dovrebbero avere.

Parte 3ª. Forme illeggibili o ingannevoli

Le firme che per loro natura sono illeggibili o non rivelano il vero cognome dell'artista, sono elencate in questa Terza Parte, in base alla prima lettera leggibile. Tutte le firme non classificabili in base a questo criterio, sono alla fine di questa Terza Parte.

Parte 4ª. Simboli

Per quanto possibile, i simboli sono stati raccolti in base alla loro forma, cioè quadrati, circolari, ovali ecc. Quelli di forma irregolare si trovano alla fine di questa Quarta Parte.

RINGRAZIAMENTO

L'autore desidera esprimere la propria sincera gratitudine ai numerosi musei, gallerie ed altre fonti alle quali ha attinto gran parte delle informazioni contenute nella presente guida, e senza l'aiuto e l'assistenza dei quali la presente opera non avrebbe potuto essere compilata.

QUALIFICATIONS & GENERAL ABBREVIATIONS

AAL	Academy of Art & Literature
AAS	Aberdeen Art Society
ACTC	Art Class Teacher's Certificate
AG's	Art Galleries, Museums and/or Individual or Group Exhibitions
AMC	Art Master's Certificate
AMTC	Art Master's Teaching Certificate
ARA	Associate of the Royal Academy
ARCA	Associate of the Royal Cambrian Academy
ARHA	Associate of the Royal Hibernian Academy
ARPE	Associate of the Royal Society of Painters & Etchers
ARSA	Associate of the Royal Scottish Academy
ARSW	Associate of the Royal Scottish Watercolour Society
ARWS	Associate of the Royal Watercolour Society
Ass.	Associate
ATD	Art Teacher's Diploma
b.	Place & Date of Birth. Date of Demise where known.
BA	Bachelor of Arts
BI	British Institute
BIIA	British Institute of Industrial Art
BM	British Museum
BPD	British Society of Poster Designers
BWS	British Watercolour Society
C	Century
CAS	Cathcart Art Society
CPS	Contemporary Portrait Society
DA	Diploma of Edinburgh College of Art
DIA	Design & Industries Association
Exh.	Where Exhibited or in Public Galleries, Museums, etc.
FAS	Fine Art Society
FBA	Fellow of the British Academy
FBSC	Fellow of the British Society of Commerce
FIC	Fellow of the Institute of Commerce
Fl.	Flourished
FOBA	Federation of British Artists
FRBS	Fellow of the Royal Society of British Sculptors
FRSA	Fellow of the Royal Society of Arts
FSA	Fellow of the Society of Artists (Before 1791)
FSIA	Fellow of the Society of Industrial Artists
GG	Grosvenor Gallery
GI	Royal Glasgow Institute of Fine Arts
Gov.	Governor
GS	Graphic Society
GSA	Glasgow School of Art
H	Honorary Member
HFRA	Honorary Foreign Royal Academician
HFRPE	Honorary Fellow of the Royal Society of Painter-Etchers
Hon.	Honorary
HRCA	Honorary Royal Cambrian Academician
HRI	Honorary Member of the Royal Institute of Watercolour Painters
HRSA	Honorary Royal Scottish Academician
HRSW	Honorary Member of Royal Scottish Watercolour Society
HRWS	Honorary Member of the Royal Watercolour Society
HSA	Hampstead Society of Artists
IAL	Imperial Arts League
IAS	Irish Art Society
IBIA	Institute of British Industrial Art
IFA	Incorporated Faculty of Arts
IS	International Society of Sculptors, Painters & Engravers
LAA	Liverpool Academy of Arts
LAS	London Art Society
LLA	Lady Literate in Arts
LRMS	Liverpool Royal Miniature Society
MA	Master of Arts
MAF	Member of the Academy of Florence
MAFA	Manchester Academy of Fine Arts
Mem.	Member
MSIA	Member of the Society of Industrial Artists
NA	National Academy of America
NBA	North British Academy
NDD	National Diploma in Design
NEAC	New English Art Club
NG	National Gallery

NMM	National Maritime Museum
NPG	National Portrait Gallery
NPS	National Portrait Society
NRD	National Registered Designer
NS	National Society
NSA	New Society of Artists
NSOA	Nottingham Society of Artists
NSPSP	National Society of Painters, Sculptors & Printmakers
NWS	New Watercolour Society
OWS	Old Watercolour Society
P	President
PAS	Pastel Society
Prov.	Provincial
PS	Paris Salon
RA	Royal Academician
RAAS	Royal Amateur Art Society
RBA	Royal Society of British Artists
RBC	Royal British Colonial Society of Artists
RBSA	Royal Birmingham Society of Artists
RCA	Royal College of Art
RCamA	Royal Cambrian Academician
RDS	Royal Drawing Society
RE	Royal Society of Painter-Etchers & Engravers
RGI	Royal Glasgow Institute
RHA	Royal Hibernian Academician
RI	Royal Institute of Painters in Watercolour
RIA	Royal Irish Academy
RIBA	Royal Institute of British Artists
RMS	Royal Society of Miniaturists
ROI	Royal Institute of Oil Painters
RP	Royal Society of Portrait Painters
RSA	Royal Scottish Academician
RSE	Royal Society of Edinburgh
RSMA	Royal Society of Marine Artists
RSW	Member of the Royal Scottish Watercolour Society
RWA (RWEA)	Royal West of England Academician
RWS	Member of the Royal Watercolour Society
SA	Society of Artists
SAF	Societe d'Artistes Des Francaise
SAI	Scottish Arts Institute
SAM	National Society of Art Masters
SAS	Southern Arts Association
SGA	Society of Graphic Art
SM	Society of Miniaturists
SOA	Society of Artists
SS	Suffolk Street
SSOA	Southern Society of Artists
SPDA	Society of Present Day Artists
SPS	Society of Portrait Sculptors
SSA	Society of Scottish Artists
SSSBA	Society of British Artists (Suffolk Street)
SSWA	Scottish Society of Women Artists
SWA	Society of Women Artists
SWLA	Society of Wildlife Artists
UA	United Artists
UK	United Kingdom
US	United States of America
USA	United Society of Artists
VA	Victoria & Albert Museum
VP	Vice-President
WAG	Walker Art Gallery
X	Works in Private and/or Public Collections
YC	Young Contemporaries

AACHEN (or Ach) **Johann von** b. Cologne. 1552–1616 Religious & mythological subjects Exh: London & European galleries	*ACH.*
AARTSEN (or Aertsen) **Pieter** b. Amsterdam. 1507–1575 Still life, genre, religious, architectural & historical subjects Exh: Holland, Germany, Belgium, Hungary, Russia, etc.	*AR AR AR AP AP*
ABBE **Hendrik** b. Anvers. 1639– Portrait artist	*A.delin. HA HA·F·*
ABBEY, RA **Edwin Austin** b. Philadelphia. 1852–1911 Historical subjects Exh: RA, France, etc.	*AA*
ABBOT, BA (Hon) **John** b. 1884–1956 Oil media Exh: RA, NEAC, ROI, PS, etc.	*J. Abbot*
ABDO **Alexander** b. Buckhurst Hill, Eng. 1865– Phantasies, landscapes & symbolical subjects Exh: RA, R.Cam.A., RWA, WAG	*∞ ∞*
ABELS **Jacobus Theodorus** b. Amsterdam. 1803–1866 Landscape artist Exh: Holland	*Abels. Af.*
ABRY **Leon Eugene Auguste** b. Anvers. 1857–1905 Military / historical subjects Exh: Anvers, Brussels, etc.	*LEON ABRY*
ACHENBACH **Andreas** b. Cassel. 1815–1910 Marine & landscape artist Exh: European AG's, US, etc.	*A. Achenbach*
ACHENBACH **Oswald** b. Dusseldorf. 1827–1905 Landscape artist	*Osw. Achenbach*

ACKLAND **Judith** b. Bideford, Devon Landscape watercolourist Exh: RA, Derby, Huddersfield & Huddersfield	
ACKROYD **Norman** b. Leeds. 1938— Exh: Switzerland, Holland, S.Africa, US, Austria, London & Prov. AG's	
ACQUA **Cesare Felix Georges** b. Trieste. 1821—1904 Historical & portrait artist Exh: Brussels, Paris, Rotterdam, Trieste, etc.	
ADAM **Albrecht** b. Bavaria. 1786—1862 Portraits, landscapes, battles & military subjects Exh: X French & German collections	
ADAM **Heindrich** b. Nordlingen. 1787—1862 Landscape artist Exh: Germany	
ADAM **Victor Jean** b. Paris. 1802—1867 Rustic genre, historical & battle scenes Exh: France	
ADAMS, NRD **Ernest D.** b. Margate. 1884— Etching, pastel, oil & watercolour media Exh: RBA, NS, PAS, SGA, RA, RI, RBSA	
ADAMS, RBA, R.Cam.A. **Harry William** b. Worcester. 1868— Winter scenes, landscapes, etc. Exh: RA, London & Prov. AG's, X	
ADAMS **James Frederick** b. 1914— Watercolour & black & white subjects Exh: RA, RBA, USA & Prov. AG's	
ADAMS **William Dacre** b. Oxford. 1864 - 1951 Portraits, genre & architectural subjects Exh: RA, NG, UKAG's, Paris	

ADAMSON, MSIA **George Worsley** b. New York. 1913— Graphics, illustration & humorous subjects Exh: RA, WAG, Liverpool, US Inst. of Graphic Arts (NY)	*a*　　*a*
ADAMSON **Sarah Gough** b. Manchester.　Fl. 1905-1950 Still life & floral subjects Exh: France, UK	SBA
ADAMSON **Sydney** b. Dundee. Fl. 1908 - 1920 Portraits & landscape artist Exh: RA, UK, AG's	[monogram]
ADAN **Louis Emile** b. Paris. 1839—1937 Watercolourist Exh: French AG's	L.Emile Adan
ADDERTON **Charles William** b. Nottingham. 1866—? Watercolourist Exh: RA, RI	C.W. Adderton
ADDISON **Byron Kent** b. St Louis, US. 1937 - Painter & sculptor Exh: US AG's, X	KA
ADLER **Jules** b. Luxeuil. 1865—? Street scenes & landscape artist Exh: Brussels, Spain, Germany, US, etc	JVLES ADLER
AELST (or AALST) **Willem van** b. Delft. 1626—1683 Fruit, flowers, game & still life subjects Exh: Holland, Belgium, Italy, Germany, UK, France, etc.	Guil.mo van Aelst 1677
AGNEESENS **Edouard Joseph Alexander** b. Brussels. 1842—1885 Genre & portrait artist Exh: France, Belgium, etc.	Ed Agneessens
d'AGNOLO **Andrea (called Andrea del Sarto)** b. Florence. 1487 - 1531 Portraits, biblical & historical subjects	AND. SAR. FLO FAC　　[monogram]

AHLERS-HESTERMANN **Frederich** b. Hamburg. 1883 - Pastel & oil media Exh: Berlin, Munich, Paris etc.	*[signature]*
AIGUIER **Louis Auguste Laurent** b. Toulon. 1819 - 1865 Landscape artist Exh: European AG's	*[signature]*
AIRD, FRSA, NS **Reginald James Mitchell** b. London. 1890 - Portraits & Decorative subjects Exh: RA, RP, IS, WAG, NPS, NS, ROI, RGI, etc.	*[signature]*
AIRY, RI, ROI; RE **Anna** b. 1882 - Etching, pen & pencil, pastel, oil & watercolour media Exh: RA, PS, INT EXH at Rome, Vienna, France, Canada etc.	*[signature]*
AITKEN, MLAA, MMAFA, RSW, **John Ernest** **ARBC, ARWA, R.Cam.A.** b. Liverpool. 1881 - 1957 Seashore & marine subjects Exh: RA, RI, RSA, R.Cam.A, RWA, GI, WAG	*[signature]*
AKEN **Jan van** b. Holland. 1614 - ? Landscape artist	*[monograms]*
AKEN **Leo van** b. Anvers. 1857 - 1904 Painter of genre & interiors Exh: Belgium, Holland	*[signature]*
ALAUX **Francois** b. Bordeaux. 1878 - ? Landscape & marine artist Exh: France, Italy, Spain etc	*[signatures]*
ALBANI (or ALBANO) **Francesco** b. Bologna. 1578 - 1660 Religious & mythological subjects Exh: Works in principal European collections	*[signatures]*
ALBANO **Francesco**	See ALBANI

ALBERTI (called BORGHEGIANO) **Cherubino** b. Borgo San Sepulcro. 1553 - 1615 Historical subjects, portraits etc Exh: France, Italy	
ALBERTINELLI **Mariotto** b. Florence. 1474 - 1515 Religious subjects Exh: France, Italy, UK, US, Austria	
ALBRACHT **Willem** b. Anvers. 1861 - ? Portraits, genre & landscape artist Exh: Belgium, France, Germany	Willem ALBRACHT
ALCORTA **Rodolfo** b. Buenos-Ayres. 1876 -? Landscapes, nudes & Portrait artist Exh: France	R.Alcorta
ALDEGREVER **Henry** b. Westphalia. 1502 - 1566? Portraits, biblical, historical & mythological subjects Exh: Germany, Hungary, France, UK, Ireland	
ALDIN **Cecil Charles Windsor** b. Slough. 1870 - ? Sporting & topographical subjects Exh: Paris, UK, AG's etc	Cecil ALDIN
ALDRIDGE **Frederick James** Fl. 19th - 20th C Landscape artist & watercolourist Exh: RA, RHA, UK AG's	F.J.ALDRIDGE.
ALDRIDGE **John Arthur Malcolm** b. London. 1905 - Portrait, still life & landscape artist Exh: RA, London & Prov. AG's	John Aldridge　　·JA·
ALENZA Y NIETO **Leonardo** b. Madrid. 1807 - 1845 Genre & Portrait artist Exh: Madrid	L.A.
ALEWYN **Abraham** b. Amsterdam. 1673 - 1735 Marine artist Exh: Holland	AALEWŸN:1701

ALEXANDER, RSA Edwin b. 1870 - 1926 Flower, bird & Animal subjects Exh: RSA, RNS.	
ALFANI Domenico di Paris b. Perugia. 1483 - 1555 ? Portraits & historical subjects Exh: Italy, France, Switzerland	ALFANI
ALIGNY Claude-Felix Theodore b. Chaumes. 1798 - 1871 Historical & landscape artist Exh: French AG's	
ALIX Yves b. France. 1890 - Figure, portrait & landscape artist Exh: European AG's	Yves ALIX
ALKEN Henry b. London. 1784 - 1851 Hunting & sporting subjects Exh: RA & Prov. AG's	H. Alken
ALLEGRAIN Etienne b. Paris. 1653 - 1736 Landscape artist Exh: France	G Allegrain AG
ALLEGRI (known as CORREGIO) Antonio DA	See CORREGGIO A.
ALLEMAND Hector b. Lyon. 1809 - 1886 Landscape artist Exh: PS & French AG's	H Allemand 65
ALLEN, RWS, RSW Robert Weir b. 1852 - 1942 Land & Seascape artist Exh: European & UK AG's	
ALLORI Alessandro (also called Alessandro Bronzino) b. Florence. 1535 - 1607 Portraits, biblical & historical subjects Exh: Germany, Italy, Spain, UK, France	Ales. Alori

ALLORI **Angiolo (called il Bronzino)** b. Montecelli 1502 - 1572 Portraits & historical subjects	*All Br*
ALLPORT Lily C. Fl. London. 1891 - 1900 Genre & landscape artist Exh: RA	*CLA 1899*
ALMA-TADEMA, OM, RA **Sir Lawrence** b. Westfriesland 1836 - 1912 Greek & Roman subjects Exh: RA, OWS, GG, NG, Germany France, Spain, Russia etc	*L Alma Tadema* *SAT*
ALSLOOT **Denis van** b. ?- 1628 Figure & landscape artist Exh: London, Belgium, Spain, Germany etc.	*DENIS ⊠ ALSLOOT*
ALTDORFER **Albrecht** b. Altdorff - Bavaria 1488 - 1538 Mythological, biblical & historical subjects Exh: Germany, France, Austria	*⫟* *Ⱥ 1517* *A*
ALTHAUS **Fritz B.** Fl. late 19th C Marine & landscape artist Exh: RA, SS, Prov. AG's	*A 97*
AMAURY-DUVAL **Eugene Emmanuel Pineu-Duval** b. Paris 1808 - 1885 Portrait & historical subjects Exh: French AG's	*AMAURY-DUVAL.*
AMEROM **Cornelius Hendrik** b. Arnheim 1804 - Portrait & landscape artist	*CM*
AMMAN **Justus** b. Zurich 1539 - 1591 Historical & mythological subjects	*XA* *AA* *AK* *AA* *CD* *A T* *WJ 1566* *XA*
AMOUR **George Denholm** b. 1864 - 1934 Sporting genre Exh: RA	*GDA*

ANASTASI **Auguste Paul Charles** b. Paris 1820 - 1889 Landscape artist Exh: European AG's	AUC.ANASTASI
ANDERSON **Stanley** b. Bristol. 1884 - Genre & architectural subjects Exh: RA, WG, Prov. AG's	SA SA
ANDERSON **William** Fl. London. 1856 - 1893 Landscape artist Exh: RA, SS, UK AG's	WA.
ANDRE **Albert** b. Lyon 1869 - 1954 Street scenes, still life & landscape artist Exh: France, US, S. America etc	Albert André
ANDRE **Jules** b. Paris 1807 - 1869 Landscape artist Exh: European AG's	Jules André 1854
ANDREWS **Lilian** b. 1878 - Watercolourist of birds & animals Exh: RA, RSA, & Prov. AG's	A
ANDRIESSEN **Anthony** b. Amsterdam 1746 - 1813 Still life & landscape artist Exh: Holland, France	AA
ANDRIESSEN **Christiaan** b. Amsterdam 1775 - ? Historical, genre & landscape artist	CA.
ANGEL **Philips** b. Middelbourg 1616 - 1684 Still life & genre subjects etc Exh: Germany	P Angel 1650 P Angel PR
ANGELICO **da Fiesole** b. Castello di Vicchio 1387 - 1455 Religious & historical subjects Exh: European AG's	A DA Fiesole

ANKER **Albert** b. Berne 1831 - 1910 Genre & portrait artist Exh: Switzerland, France, UK	*Anker*
ANNIGONI **Pietro** b. Milan 1910 - Portrait artist Exh: RA, Rome, Turin, Paris etc	*Otth.*
ANQUETIN **Louis** b. Etrepagny 1861 - 1932 Still life, genre & portrait artist Exh: France, UK AG's	*Anquetin*
ANRAEDT **Pieter van** b. Utrecht ?-1678 Historical subjects Exh: Holland, Germany, UK etc.	*Pieter Van Anraedt fA° 1674*
ANSDELL, RA **Richard** b. Liverpool. 1815 - 1885 Spanish genre, animals & sporting subjects Exh: RA, BI, UK AG's, Germany	*RA RA RA*
ANSIAUX **Antoine Jean Joseph** b. Liege 1764 - 1840 Portraits & historical & religious subjects Exh: French AG's	*ansiaux fat 1822*
ANSTED **William Alexander** Fl. London. Late 19th C. Landscape artist Exh: RA, VA, London & Prov. AG's	*AxA AxA*
ANTHONISSEN **Hendrick van** b. Anvers 1606 - 1660 Marine and landscape subjects Exh: Holland, Germany, UK etc	*HVANTHONISSEN H.V.ANT*
ANTIGNA **Alexandre** b. Orleans 1817 - 1878 Religious, genre & historical subjects Exh: French AG's	*Antigna*
ANTOLINEZ **Jose** b. Madrid 1635 - 1675 Portraits, historical & landscape artist Exh: Spain, Holland, Germany, UK etc	*IossF. ANTOLINES.F 1668.*

ANTONELLO da Messina b. Messina 1414 ? - 1493 ? Portraits, historical & religious subjects Exh: UK & principal European AG's	*AdM*
APPELBEE, ARCA Leonard b. London 1914 - Portraits, still life & landscape artist Exh: RA, London & Prov. AG's	*LA*
APPIANI Andrea b. Milan 1754 - 1817 Portraits, mythological & historical subjects Exh: Italy, Russia, France, Germany etc	*AA*
APPLEYARD Joseph b. 1908 Sporting subjects Exh: London & Prov. AG's	*Joseph Appleyard*
ARBO Peter Nicolai b. Norway 1831 - 1892 Historical subjects	*P.N Arbo*
ARCHER RSA James b. Edinburgh 1823 - 1904 Genre, portraits, landscapes & historical subjects Exh: RA, BI, SS, RSA	*⫲→*
ARDEN Blanche b. Leeds 1925 - Philosophical portrayals, portraits, landscapes etc Exh: PS, French AG's etc	*Blanche Arden .* *B·A.*
ARELLANO Juan de b. Santorcaz 1614 - 1676 Fruit & floral subjects etc. Exh: France, Spain	*Juan de Arellano.*
ARENTSZ Arent b. Amsterdam 1586 - 1635 Landscape artist Exh: Holland, Paris, London	*AA*
ARMFIELD George Fl. London. 1840 - 1875 Canine subjects Exh: RA, BI, SS, UK AG's	*GA*

ARMFIELD **Maxwell** b. Ringwood 1882 - Tempera & watercolourist Exh: RA, PS, & Prov. AG's etc	
ARMSTRONG **Thomas** b. Manchester 1835 - 1911 Figure artist etc. Exh: RA, GG, & Prov. AG's	
ARMYTAGE **Charles** Fl. London. 1863 - 1874 Domestic genre Exh: SS, London & Prov. AG's	
ARNOLD **Jonas** b. ? - 1669 Portraits, architectural, historical & floral subjects Exh: German AG's etc	
ARP **Jean Hans** b. Strasbourg 1887 - 1966 Painter & sculptor Exh: GB, US, France, Switzerland etc	
ARROBUS **Sydney** b. London 1901 - Watercolourist & commercial artist Exh: RBA, RI, NS, RWEA, SGA etc	
ART **Berthe** b. Brussels 1857 - ? Portrait, still life & landscape artist Exh: RA, PS, Belgium, Germany	
ARTAN **Louis** b. 1837 - 1890 Marine Artist Exh: Belgium, France	
ARTHOIS (or ARTOIS) **Jacques van** b. Brussels 1613 - 1686 ? Landscape artist Exh: France, Germany, Belgium, Spain, Austria etc	
ARTOIS **Jacques van**	See ARTHOIS (Jacques van)

ARTZ **David Adolf Constant** b. The Hague 1837 - 1890 Figure & genre artist Exh: Holland, Canada, France, UK etc	*ARTZ.*
ASCH **Pieter Jansz van** b. Delft 1603 - 1678 Landscape artist Exh: Holland, Hungary, Scandinavia, UK, etc	*PvANsh* *PA* *PA* *PA*
ASKEVOLD **Anders Monsen** b. 1834 - 1900 Painter of landscapes & animals Exh: Scandinavia, US, Austria, UK.	*A. Askevold.*
ASKEW **Felicity Katherine Sarah** b. London 1894 - Sporting subjects & sculpture Exh: PS, WAG, SSA, Berlin, Italy etc	*A* *1926*
ASKEW, ROI **Victor** Painter in oil media Exh: RA, PS, Canada etc.	**ASKEW**
ASPER **Hans John** b. Zurich 1499 - 1571 Portraits, game & still life & landscape subjects Exh: Germany	*Asper J.* *HA*
ASSELBERGS **Alphonse** b. Brussels 1839 - ? Landscape artist Exh: PS, Brussels, Holland	*Alp. Asselbergs*
ASSELIN **Maurice** b. Orleans 1882 - 1947 Portrait, still life, landscapes etc Exh: France, Germany, Japan, UK, US, Switzerland etc	**M. ASSELIN**
ASSELYN (or ASSELIN) **Jan** b. 1610 - 1652 ? Landscape artist Exh: Holland, Belgium, Germany, Hungary, France etc.	*Jean Asselin* *F. 1646* *A* *A* *A* *A* *A* *A* *JA.* *A*

ASSEN Jacob Walter van b. 1475 - 1555 Portraits & religious subjects Exh: Germany, Holland, UK.	
ASSEN Jan van b. Amsterdam 1635 ?- 1697 Portraits, landscapes & historical subjects Exh: Holland	
ATHAR Chiam b. Zlatapol, Russia 1902 - Painter in oil media Exh: Israel, PS, S. Africa etc.	
ATHERTON John Smith Oil & watercolourist Exh: RA, RSA, RI, RWA, GI, etc.	
ATKIN Ron b. Leicestershire 1938 - Acrylic, oil & watercolour media Exh: RA, London & Prov. AG's	
ATKINSON, BA, FRSA, Charles Gerrard b. 1879 - ? Portraits, architectural & landscape artist Exh: RWS, RBSA, R. Cam.A, & Prov. AG's etc	
ATKINSON Robert b. Leeds. 1863 - 1896 Landscape artist Exh: RA, UK AG's, Australia	
ATKINSON W.A. Fl. London. 1849 - 1867 Genre & historical subjects Exh: RA, BI, SS	
AUBRY Etienne b. Versailles 1745 - 1781 Genre & Portrait artist Exh: French AG's	
AUDENAERDE Robert van b. Ghent 1663 - 1743 Portraits & biblical subjects	

AUGUSTIN **Jean Baptiste jacques** b. France 1759 - 1832 Miniaturist Exh: European AG's	*augustin.*
AUMONT **Louis Auguste Francois** b. Copenhagen 1805 - 1879 Portrait artist Exh: France	*Aumont. 1898.*
AUSTEN, RI, RE **Winifred Marie Louise** b. Ramsgate. Fl. 19th-20th C. Bird & animal subjects Exh: RA, RI, RE, etc	
AUTREAU **Louis** b. Paris 1692 - 1760 Portrait artist Exh: France	*Autreau.*
AUZOU **Pauline** b. Paris 1775 - 1835 Interior & historical scenes Exh: France	*auzou.*
AVED **Jacques Andre Joseph** b. Douai 1702 - 1766 Portrait artist Exh: Holland, France	*Aved 1750* *AED*
AVELINE **Josephine Elizabeth** b. Surrey 1914 - Portraits & floral subjects Exh: RP, PAS, SWA etc London & Prov AG's	*Josephine Aveline*
AVERCAMP **Henri van** b. Amsterdam 1585 - 1663? Landscapes, marine & animal subjects Exh: Holland, Germany, Hungary, Italy, UK etc	
AVONT **Pieter van der** b. Antwerp 1600 - 1632 Religious subjects, landscapes etc Exh: European AG's Russia	
AYRTON, FRSA **Michael** b. London 1921 - Painter & sculptor Exh: London & Prov AG's. Italy, Germany, France & USA	*michael ayrton*

B

BAADE **Knud Andreassen** b. Norway 1808 - 1879 Marine & landscape artist Exh: Germany, Norway, UK.	*KBaade*
BACON **John Henry Frederick** b. London. 1868 - 1914 Genre & historical subjects Exh: London & Prov. AG's, France	*J.H.F.B* *B*
BACH **Alois** b. 1809 - 1893 Genre, historical, animal & landscape artist Exh: Germany	*SB*
BACH **Marcel** b. Bordeau 1879 - ? Still life & landscape artist Exh: French AG's	*BACH*
BACHELIER **Jean Jacques** b. Paris 1724 - 1806 Historical, animal & still life subjects Exh: France	*Bachelier 1769*
BACKER **Jacob Adriaensz** b. Holland 1608 - 1651 Historical & Portrait artist Exh: Holland, Germany	*Back d.* *A Backer* *Bac d.*
BACLER D'ALBE **Baron Louis Albert Guillain** b. France 1761 - 1848 Historical & landscape artist Exh: France	*Bacler-D'Albe.*
BADAROCCO **Giovanni Raffaello** b. Italy 1648 - 1726 Mythological & historical subjects Exh: Italy	*JRBadarocco.*
BADIALE **Alessandro** b. 1623 - 1668 Portraits & historical & biblical subjects	*AB* *AB* *AB* *AB* *AE*
BADILE **Antonio** b. Verona 1480 - 1560 Historical, biblical & portrait artist Exh: Spain, Italy, Austria, France	*1543 B*

BAERTSOEN **Albert** b. Belgium 1866 - 1922 Landscape artist Exh: Belgium	*aBaertsoen*
BAES **Emile** b. Brussels 1879 - ? Portraits, Historical & landscape artist Exh: France	*Emile Baes*
BAGDATOPOLOUS **William Spencer** b. Greece 1888 - Drawing & watercolourist Exh: RI, Holland, US, UK AG's etc	*W. S. Bylitipllis*
BAGER **Johann Daniel** b. Germany 1734 - 1815 Portrait, genre, still life & landscape artist Exh: Germany	*Johann. Daniel Bager.*
BAIL **Joseph** b. France 1862 - 1921 Genre, animals & interior subjects Exh: Canada, France	*Bail Joseph*
BAIN **Arthur Peter** b. London 1927 - Realist, abstract subjects Exh: London & Prov. AG's	*Bain 75*
BAINES, NDD, ATD, SGA, **FRSA, RDS, NS** **Richard John Mainwairing** b. Hastings. 1940 - Painter & etcher Exh: ROI, RBA, NS, SGA, Prov. AG's, X.	*RB.*
BAIRD, ROI **Nathaniel Hughes John** b. Roxburghshire 1865 - ? Portraits, landscapes & equestrian subjects	*NB (monogram)*
BAIRSTOW **Nancy** b. Wolstanton, Staffs. 19th - 20th C. Miniaturist Exh: PS, RA, RI.	*NB.*
BAJ **Enrico** b. Milan 1924 - Painter in collage Exh: USA, London, Holland, France etc	*baj enrico*

BAKER, SWA **Blanche** Fl. Bristol. 1869 - 1893 Landscape artist Exh: RA, SS, NWS	*BB* *BB*
BAKER **Ethelwyn** b. Belfast Sculptor, watercolourist etc Exh: RA, RBS, AIA, WAG, etc	*EB (monogram)*
BAKER **Thomas** b. 1809 - 1869 Landscape artist Exh: RA, BM, VA, Prov. AG's	*T.B.*
BAKHUIZEN (or BAKHUYZEN) **Ludolf** b. Emden 1631 - 1708 Portrait & marine artist Exh: Holland, Germany, Belgium, France, Russia, UK etc	*1683 L Bakhuizene* *LB* *LB*
BALE **C.T.** Fl 19th C. Still life subjects Exh: RA, SS & UK AG's	*CB (monogram)*
BALEN (The Elder) **Hendrik van** b. Antwerp 1575 ?- 1632 Religious, allegorical & mythological subjects Exh: Holland, France, Belgium, Germany, Italy, UK etc.	*H.V. BALEN* *HB (monogram)*
BALESTRA **Antonio** b. Verona 1666 - 1740 Historical subjects Exh: Italy, Denmark	*AB I P.R.* *ABf.* *ABf.*
BALL **Wilfred Williams** b. London 1853 - 1917 Landscape & Marine artist Exh: RA, SS, NWS, GG	*WB*
BALLANCE, RWA **Percy des Carrieres** b. Birmingham 1899 - Oil & watercolourist Exh: RA, RI, RBA, RWA, PS etc	*Percy-des C. Ballance.*

BALLANTINE, RSA **John** b. Kelso. 1815 - 1897 Historical, genre & portrait artist Exh: RA, UK AG's	
BALLENBERGER **Karl** b. Germany 1801 - 1860 Portraits & mythological subjects Exh: Germany	
BALTEN **Pieter** b. Anvers 1525 - 1598 Historical & landscape subjects Exh: Austria, Holland, France	PEETER BALTEN
BARBER **Charles Burton** b. Yarmouth. 1845 - 1894 Genre, portraits & animal subjects Exh: RA, UK AG's	G.B.B.
BARBER, RWS **Charles Vincent** b. Birmingham. 1784 - 1854 Landscape artist Exh: RA, RWS, Prov. AG's	C. VB 1844
BARBER **Reginald** Fl. L. 19th - 20th C. Genre & portrait artist Exh: RA, London & Prov. AG's, Paris	18 ⌀B 91
BARCLAY **Edgar** b. London 19th C. Landscape, figure & genre subjects Exh: RA, GG, NG	EB
BARDEN, ARIBA, ARCA, **Kenneth AFAS(Eng) MSIA, AIBD** b. Huddersfield 1924 - Landscapes, still life etc oil & watercolourist Exh: RA, RI, London & Prov. AG's Works in collections UK, Europe etc	K Barden K.B.
BARENTSEN (BARENDSEN or **Dirk BARENDSZ)** **(also known as Theodore Bernard)** b. Amsterdam 1534 - 1592 Portraits & historical subjects Exh: Holland, Austria	VBarentsen
BARILLOT **Leon** b. France 1844 - 1929 Still life, animals & landscape artist Exh: France, UK, Australia etc	L . Barillot

BARKER **Cicely Mary** b. Croydon 1895 - Figure painter & children's illustrator Exh: RI, PS, SWA, SGA	
BARKER **James Thomas** b. Rickmansworth 1884 - Figure & landscape painter Exh: RA	
BARKER, AMC, FRSA **John Edward** b. 1889 - 1953 Painter in oil media Exh: Prov. AG's	
BARLAND **Adam** Fl. London. 1843 - 1863 Landscape artist Exh: London & Prov. AG's	
BARLOW **Florence E.** Fl. London. 1873 - 1909 Figure & animal subjects Exh: RA, London & Prov. AG's	
BARLOW **Francis** b. Lincolnshire 1626 - 1702 Portraits, animals & wildlife subjects Exh: London & Prov. AG's	
BARLOW **Mary** b. Manchester 1901 - Landscapes & animal subjects Exh: R. Cam.A. WAG	
BARNARD **Frederick** b. London 1846 - 1896 Domestic & genre subjects Exh: RA, SS.	
BARNES **Alfred Richard Innott** B. London 1899 - Painter in oil media Exh: RA, ROI, USA, RI, etc	
BARNES **E.C.** b. London Fl. 19th C. Genre, Domestic & interior subjects Exh: RA, SS, BI, & Prov. AG's	

BARNES **Robert** Fl. 1873 - 1891 Genre subjects Exh: RA, Vienna	*AB*
BAROCCI (also called FIORI) **Frederigo** b. Urbino 1526 - 1612 Portraits, religious & historical subjects Exh: Belgium, Russia, Hungary, Germany, France etc	*F Fiori*
BARON **Henri Charles Antoine** b. France 1816 - 1885 Figure & genre subjects Exh: Switzerland, France, Australia etc	*H·BARON*
BARON **Theodore** b. Brussels 1840 - 1899 Landscape artist Exh: Belgium	*Baron 1872*
BARRATT **Krome** b. London 1924 - Abstract subjects Exh: RA, ROI, RBA, NS, London & Prov. AG's	*Krome* *KB*
BARROW **Edith** b. ? - 1930 Flowers & landscape artist Exh: RA, RI, SWA, WAG	*Edith Barrow*
BARTH **Carl Wilhelm Bockmann** b. Norway 1847 - ? Marine artist Exh: Scandinavia	*WBarth. 82.*
BARTLETT **William H.** b. 1858 - ? Genre landscapes & sporting subjects Exh: UK, AG's, France	*WHB*
BARTOLOZZI **Francesco** b. Florence 1725?- 1815 Portrait & figure artist Exh: UK & European AG's	*FBf*
BARTON, RWS **Rose** b. 1856 - 1929 Genre & landscape watercolourist Exh: OWS, RA, London & Prov. AG's, Ireland	*RB*

BASELEER **Richard** b. Belgium 1867 - ? Marine artist Exh: Belgium, Germany	*R Baseleer*
BASSANO **Jacopo** b. 1516? - 1592 Portraits, biblical & mythological subjects Exh: Many European AG's, US, Scandinavia etc	*JB*
BASSANO **Leandro da Ponte** b. 1557 - 1622 Portraits & biblical subjects Exh: Holland, Belgium, France, Italy, Germany etc.	*LEANDER BASSANENSIS*
BASSEN **Bartholomeus van** b. Holland. 1590? - 1652 Portraits, architectural interiors etc. Exh: UK & European AG's	*BvBASSEN* *vBASSEN* *B.van Bassen*
BASSINGTHWAITE **Lewin** b. Essex. 1928 - Painter Exh: US, London & Prov. AG's	*LB*
BASTIEN-LEPAGE **Jules** b. France 1848 - 1884 Genre & Portrait artist Exh: UK, France, US.	*j BASTIEN-LEPAGE.*
BASTIN **A.D.** Fl. 1871 - 1892 Figure artist Exh: SS, Prov. AG's	*A.D.BASTIN*
BATEMAN, RA, ARWS **James** b. Kendal. 1893 - 1959 Landscape artist Exh: RA, UK AG's	*JB* *JB*
BATES **Frederick Davenport** b. Manchester 1867 - ? Portraits, landscapes & religious subjects Exh: Brussels, Antwerp & UK AG's	*DAVENPORT BATES*
BATESON **Edith** b. Cambridge Fl. 19th - 20th C. Painter of varied subjects Exh: PS, RA, RBA, NEAC, IS, & Prov. AG's	*EB*

BATTEM Gerrit b. Holland 1636?- 1684 Landscape artist Exh: Holland	*Battem*
BATTEN John Dickson b. Plymouth 1860 - 1932 Figures & mythological subjects Exh: RA, GG, NG, Australia	JDB
BATTERSHILL, RBA, FRSA, MSIA Norman James b. London 1922 Landscape artist Exh: RBA, RI, USA, NS etc	*Norman Battershill* *Norman Battershill*
BAUDIT Amedee b. Geneva 1825 - 1890 Landscape artist Exh: French AG's	*a Baudit 1866*
BAUDOUIN Eugene b. France 1842 - 1893 Landscape artist Exh: France	*Eugene BAUDOUIN*
BAUDOUIN Pierre Antoine b. Paris 1723 - 1769 Painter & miniaturist Exh: Works in permanent & private collections	*Baudoin*
BAUDRY Paul b. France 1828 - 1886 Portraits, figure & mythological subjects Exh: France	*paul baudry*
BAUER Mari Alexander Jacques b. The Hague 1867 - 1932 Figure & decorative painter Exh: European AG's	*M BAUER* *MBauer* *MB*
BAUGIN Lubin b. France 1610 - 1663 Portraits, religious & historical subjects Exh: France	*Baugin.*

BAUR **John William** b. Strasburg 1600 - 1640 Landscape artist Exh: Germany, Switzerland	IWB
BAWDEN, RA **Edward** b. Braintree. 1903 - Military & landscape watercolourist Exh: London & Prov. AG's	EB EB
BAXAITI (or BASATI) **Marco** b. 1470? - 1532 ? Portraits, religious & historical subjects Exh: UK & European AG's	Marcus Baxaiti 1514 M·BAXE
BAXTER **Charles** b. London. 1809 - 1879 Portraits & miniaturist Exh: RA, VA, SS, Prov. AG's	CB
BAYARD **Emile** b. France 1837 - 1891 Portrait, genre & figure artist Exh: France	Emile Bayard
BAYER **August von** b. Germany 1803 - 1875 Interiors & architectural subjects Exh: German AG's	AB
BAYES, RMS **Jessie** b. London. Fl. 19th-20th C. Painter in oil media etc Exh: RA, Int. Ex. Paris, Rome, Canada, US, etc	JB
BAYES **Walter** b. London Fl. 19th-20th C. Landscape artist Exh: RA & UK AG's	WB
BAZILLE **Jean Frederic** b. France. 1841 - 1870 Portrait, genre & landscape artist Exh: France	F. Bazille
BEAMAN **Richard Bancroft** b. US. 1909 - Painter & sculptor Exh: US, X.	R B Beaman

BEAUFAUX **Polydore** b. Belgium. 1829 - ? Historical subjects Exh: Belgium AG's	*P Beaufaux*
BEAUFRERE **Adolphe Marie Timothee** b. 1876 - 1960 Landscape artist Exh: French AG's	*Beaufrere*
BEAUMONT **Charles Edouard de** b. France. 1812 - 1888 Genre & landscape artist Exh: France	*ⁿBeaumont*
BEAVIS, RWS **Richard** b. Exmouth. 1824 - 1896 Rustic genre, animals, coastal & landscape subjects Exh: RA, SS, BI, OWS, NWS, GG, NG, & European AG's	*RB RB RB (RB)*
BECCAFUMI (called MECARINO) **Domenico** b. Siena. 1486 - 1551 Religious & historical subjects Exh: Germany, Italy, Russia, Switzerland, UK	*B*
BECK **David** b. Delft. 1621 - 1656 Portrait artist Exh: Stockholm, Austria, Germany, Russia, France	*DBeck fecit· 1650*
BECKER **Philipp Jacob** b. Germany. 1759 - 1829 Landscape & town scenes Exh: Germany	*Be.*
BEDFORD **Celia Frances** b. London. 1904 - Oil & watercolourist Exh: NEAC, RBA, SWA etc	*Celia Bedford.*
BEDFORD **John Bates** b. Yorkshire. 1823 - ? Genre, historical & portrait artist Exh: RA, BI, UK AG's	*18⫶60 ⫶*
BEECHEY, RA **Sir William** b. Burford. 1753 - 1839 Portrait artist Exh: BI, NG, RA, UK AG's, Paris	*W Beechey 1820*

BEER **Arnould** b. Anvers. 1490 ? - 1542 Biblical & historical subjects	*Æ B.*　　*ÆB*
BEERBOHM **Max** b. London. 1872 - 1956 Painter & caricaturist Exh: London & Prov. AG's	*Max*
BEERNAERT **Euphrosine** B. Ostend. 1831 - 1901 Landscape artist Exh: Brussels, Holland	*E. Beernaert*
BEERS **Jan van** b. Lierre. 1852 - ? Portraits, genre & historical subjects Exh: Belgium, France, Spain	*JAN VAN BIER*
BEERSTRATEN **Jan Abraham** b. Amsterdam. 1622 - 1666 Marine & landscape artist Exh: European AG's, US	*I BEER-STRAATEN*　　*I BEERESTRATEN*
BEGA **Cornelis** b. Holland. 1620 - 1664 Interiors, genre & landscape artist Exh: Scandinavia, European & UK AG's	*C, bega*　　*Begaf*
BEGAS **Karl Joseph** b. 1794 - 1854 Portraits, genre & historical subjects Exh: German AG's	*cBF*　　*cBF.*
BEGEYN **Abraham Jansz** b. 1637 - 1697 Landscape artist Exh: Holland, Germany, France etc	*ABegein*　*AB*　*A. Begyn*　*BGf*
BEHAM **Barthel** b. Nuremberg. 1502 - 1540 Portraits & historical paintings Exh: France, Holland, Germany, US etc	*BB*　　*B*
BEICH **Joachim Franz** b. Ravensbourg. 1665 - 1748 Landscape artist Exh: France, Germany, Austria	*J*

BEJOT **Eugene** b. Paris. 1867 - 1931 Landscape subjects etc. Exh: London, Paris	
BELIN **Jean** b. Caen. 1653 - 1715 Still life subjects. Exh: France	
BELL **Alexander Carlyle** Fl. 1866 - 1891 Landscape artist Exh: RA, SS, NWS	
BELL, ARMS **Gladys Kathleen** Miniaturist Exh: RA, PS, LRMS	
BELL, RA **Robert Anning** b. 1863 - 1933 Figure artist Exh: RA, NEAC, RWS etc	
BELLEL **Jean Joseph Francois** b. Paris. 1816 - 1898 Landscape artist Exh: France	
BELLENGER **Georges** b. Rouen. 1847 - 1918 Still life & landscape artist Exh: PS, London AG's	
BELLEVOIS **Jacob Adriaensz** b. Rotterdam. 1621 - 1675 Marine artist Exh: Holland, Germany, Spain etc	
BELLINI **Gentile** b. Venice. 1429 - 1507 Portraits, religious & historical subjects Exh: Germany, Hungary, UK, France etc	
BELLINI **Giovanni** b. Venice. 1426 - 1516 Portrait, religious & historical subjects Exh: Most Principal European AG's & Collections	

BELLOTO (or BELLOTTO) **Bernado** b. Venice. 1720 - 1780 Architectural subjects Exh: European & UK AG's	*B Belloto*
BELLUCCI **Antonio** b. Italy. 1654 - 1726 Portraits, mythological subjects etc Exh: Germany, Italy	*A.B. A.B AB.*
BELLY **Leon Adolphe Auguste** b. France. 1827 - 1877 Portrait & landscape artist Exh: France	*L BELLY*
BELOT **Gabriel** b. Paris. 1882 - Portrait & genre subjects Exh: France, Japan	*Gabriel Belos GB*
BELTRAN - MASSES **Federico** b. Spain. 1885 - Portrait & figure artist Exh: Germany, Spain, France, UK, US	*F. Beltran Masses*
BEMMEL **Wilhelm von** b. Utrecht. 1630 - 1708 Landscape artist Exh: Holland, Germany, Austria	*VBemmel VB VBEml*
BENAZECH **Charles** b. London. 1767 - 1794 Portraits & genre subjects Exh: London, Italy, France	*Benazetch.*
BENDEMANN **Eduard Julius Friedrich** b. Berlin. 1811 - 1889 Portraits & historical subjects Exh: German AG's	*E Bendemann*
BENNETT **Newton** Fl. UK. ? - 1914 Landscape artist Exh: RA, SS, NWS	*NB NB*
BENGOUGH **R. W.** Fl. 1830 - 1836 Marine artist Exh: BI, SS, Prov. AG's	*RWB*

BENGTZ E. A. Ture b. US. 1907 - Exh: X, US	
BENNER Emmanuel b. France. 1836 - 1896 Portraits, still life, genre & landscape artist Exh: France, Holland, Switzerland	
BENNETT Frank Moss b. Liverpool. 1874 - 1953 Genre & historical subjects Exh: UK AG's, SAF	
BENNETT Harriet M. b. UK. Fl. 1877 - 1892 Genre subjects Exh: RA, RWS	
BENNETT Violet b. London. 1902 - Tempera & oil media Exh: RA, & Prov. AG's	
BENNETTER Johan Jakob b. Norway. 1822 - 1904 Marine artist Exh: PS	
BENOIT Camille b. France. 1820 - 1882 Animals & landscape artist Exh: France	
BENSO Giulio b. 1601 ? - 1668 Religious subjects	
BENSON, NA Frank Weston b. Salem. 1862 - 1951 Portrait & figure artist Exh: Various US AG's, Paris etc	
BENSUSAN-BUTT, RBA John Gordon b. Colchester. 1911 - Landscape watercolourist Exh: RA, NEAC, RBA & Prov. AG's	

BENT **Johannes van der** b. Amsterdam. 1651 - 1690 Landscape artist Exh: Russia, Hungary, France, Holland etc	
BERAUD **Jean** b. 1849 - 1936 Genre & portrait artist Exh: French AG's	*Jean Bèraud*
BERCHEM (or BERGHEM) **Nicolas (or Claes)** b. Amsterdam. 1620 - 1683 Hunting & coastal scenes, landscapes etc Exh: S. Africa, UK & European AG's	
BERCHER **Henri Edouard** b. Vevey. 1877 - ? Landscape artist Exh: France, Switzerland	
BERCK-HEYDE **Gerard** b. Haarlem. 1638 - 1698 Landscapes & architectural subjects Exh: France, Italy, Germany, Holland, Austria etc	
BERCK-HEYDE **Job** b. Haarlem. 1630 - 1693 Religious subjects, landscapes, winter scenes etc Exh: Holland, Belgium, Russia, Germany, Austria, US	
BERCKMAN **Hendrick** b. 1629 - 1679 Portrait artist Exh: Holland	
BEREA **Dimitrie** b. Bacau. 1908 - Portraits, landscapes & compositions Exh: London & most European countries	

BERGE **Auguste Charles de la** b. Paris. 1807 - 1842 Landscape artist Exh: PS & French AG's	*Ch de la Berge*
BERGEN (or BERGHEN) **Dirck van** b. Harlem. 1645 - 1690 ? Landscape & animal painter Exh: UK, Holland, Germany, Italy, France etc.	*D. V. D. Bergen.* *D.v.B.* *B. 1680* *Dv. Berghen*
BERGHEM **Nicolas**	See BERCHAM Nicolas
BERGLER (THE YOUNGER) **Joseph** b. 1753 - 1829 Historical subjects	*JB. JB. B. 1807 B.F* *J B. B. B*
BERGMULLER **John George** b. Dirkheim, Bavaria. 1688 - 1762 Portraits & historical subjects	*Bf. JB B. B. B JB.*
BERGSLIEN **Knud Larsen** b. Norway. 1827 - 1908 Portraits, still life & landscape artist Exh: UK & European AG's	*K Bergslien pinx 1870.*
BERKELEY **Stanley** Fl. London. ? - 1909 Animals, sporting & historical subjects Exh: RA, SS, NWS, GG	*St. B*
BERLIN **Sven Paul** b. 1911 - Painter & sculptor Exh: US AG's. X.	*SvenBerlin Sven. $*
BERNAERTS **Nicasius** b. Anvers. 1620 - 1678 Still life, landscapes & animal subjects Exh: France	*NB*

BERNARD **Adolphe** b. 1812 - ? Genre & portrait artist	
BERNIER **Camille** b. Colmar. 1823 - 1902 ? Landscape artist Exh: UK, France, Spain	*P. Bernier*
BEROUD **Louis** b. Lyons. 1852 - ? Portraits, allegorical subjects etc. Exh: PS, & French AG's	*Louis Beroud.* *1883.*
BERRETTINI **Pietro** b. 1596 - 1669 Religious & historical subjects Exh: Holland, France, Italy, Germany etc.	*P.C.* *P.C.*
BERRIE, RCA, ARCA **John Archibald Alexander** b. 1887 - Portrait artist Exh: RA & Principal exhibitions & AG's	*John. A. A. Berrie*
BERRISFORD, NDD, ATD **Peter** b. Northampton. 1932 - Oil & watercolourist Exh: X, Prov. AG's	*Berrisford*
BERRUGETE (or BERRUGUETTE) **Alonso** b. Paredes de Nava. 1486 - 1561 Historical subjects	*A Berrugete*
BERTHELEMY **Jean Simon** b. 1743 - 1811 Historical subjects Exh: France	*Berthélemy.*
BERTIN **Francois Edouard** b. Paris. 1797 - 1871 Landscape artist Exh: French AG's	*Edouard Bertin* *1836*
BERTIN **Jean Victor** b. Paris. 1775 - 1842 Landscape artist Exh: Holland, France	*J.V. Bertin*

BERTIN **Nicolas** b. Paris. 1668 - 1736 Biblical & mythological subjects etc Exh: France, Russia	*Bertin.1725*
BESCHEY **Balthasar** b. Anvers. 1708 - 1776 Portraits, historical & landscape artist Exh: France, Russia, Hungary	*Balt Bescheyf.* *Balt. Bescheij f*
BESCHEY **Jacob Andries** b. 1710 - 1786 Still life, historical & landscape subjects Exh: German AG's	*J. Beschey 1751*
BESNARD **Paul Albert** b. Paris. 1849 - 1934 Portrait & figure artist Exh: US & European AG's	*Resnnal*
BEST **Gladys** b. London. 1898 - Watercolourist Exh: RA, NEAC, NS, PS, & US	*B*
BETHUNE **Gaston** b. Paris. 1857 - 1897 Landscape artist Exh: French AG's	*Bethune*
BETTINI **Domenico** b. Florence. 1644 - 1705 Genre & still life painter	*BD*
BEUCKLAER **Joachim** b. Antwerp. 1530 - 1570 Domestic, game & still life subjects	*B. 1566*
BEYEREN **Abraham Hendricksz van** b. Holland. 1620 - 1675 ? Still life subjects Exh: UK, Russia & European AG'S	*ABf ABf AB*
BEZZI **Bartolomeo** b. 1851 - 1925 Landscape artist Exh: Germany, Italy, France	*B. Bezzi*

BIBIENA **Ferdinando da**	See GALLI Ferdinando
BICAT, OBE **Andre** b. 1909 - Painter & sculptor Exh: Paris, London & Prov. AG's	*Bicât*
BIDAULD **Jean Joseph Xavier** b. 1758 - 1846 Landscape artist Exh: France	*Jⁿ Bidauld.*
BIE **Adrian de** b. 1593 - 1668 Portrait artist	*℔*
BIE **Cornelis de** b. 1621 - 1654 Landscapes & biblical subjects Exh: Holland	*Cornelis, Bie 1648:*
BIEDERMANN **Johann Jakob** b. Switzerland. 1763 - 1830 Portraits, animals & landscape artist Exh: Switzerland, Germany etc	I·I·B·
BIEFVE **Edouard de** b. Brussels. 1808 - 1882 Historical subjects Exh: Belgian AG's	*E de Biefve*
BIELER, LLD, RCA, OSA, CGP, **FCA** **Andre** b. Lausanne. 1896 - Painter & sculptor Exh: Canada, US & European AG's	*André Bieler*
BIGIO **Francesco** b. Florence. 1482 - 1525 Portraits & historical subjects Exh: Germany, Italy, UK, France	*Æ F*
BILL, ARWA **John Gordon** b. London. 1915 - Landscape artist Exh: NEAC, RWA, Prov. AG's	JB

BILL, DWB, IPC, UAH, Hon. FAIR MOEV **Max** b. Switzerland. 1908 Painter & sculptor Exh: X, Europe	
BILLET **Pierre** b. France. 1837 - 1922 Genre & landscape artist Exh: UK & French AG's	
BILLOTTE **Rene** b. 1846 - 1915 Landscape artist Exh: Hungary, France, Germany etc	
BINCK **Jakob** b. Cologne. 1500? - 1569 Portrait artist	
BINET **Victor Jean Baptiste Barthelemy** b. Rouen. 1849 - 1924 Landscape artist Exh: France	
BINJE **Frans** b. Liege. 1835 - 1900 Animal & landscape painter Exh: France, Belgium	
BINNING, ARCA **Bertram Charles** b. Alberta. 1909 - Painter in oil media Exh: Perm. works in various Canadian AG's	
BIRCH **William Henry** b. Epsom. 1895 - 1968 Portrait & landscape artist Exh: RA, UK AG's	
BIRD **Mary Holden** Landscape watercolourist Exh: RA, RI, RSW, RBA, PS	
BIRKHEAD (nee RALSTON) **Margaret** b. Farnborough. 1934 - Panel design & landscape artist Exh: London & Prov. AG's, US	

BISCAINO **Bartolommeo** b. 1632 - 1657 Biblical & historical subjects Exh: Italy, Germany	B^A Bis°. Cenv^ts F. BA°Bis°. B^A Bis° BB.
BISCARRA **Giovanni Battista** b. Nice. 1790 - 1851 ? Historical subjects Exh: France, Italy	B
BISCHOFF **Henry** b. Lausanne. 1882 - Oil media artist & engraver Exh: US, Switzerland, Germany, France, Sweden etc	HBH
BISET **Charles Emmanuel** b. 1633 - ? Portraits, genre & historical subjects Exh: Germany, Belgium, Holland	CE Biset
BISHOP, RBA, NEAC **Edward** b. London. 1902 - London night scenes, cafes etc Exh: RA, NEAC, RBA, London & Prov. AG's, Europe	EB EB EB EB
BISHOP **Molly** Fl. 20th C. Portrait artist & illustrator Exh: RBA, R.Scot.A, RP, GI, SWA etc	Molly Bishop
BISSCHOP **Cornelis** b. Dortrecht. 1630 - 1674 Portrait & figure artist Exh: Holland	C. Bischop Fecit 1665 CB fec
BISSELL, ARWA, PS, ATD **Osmond Hick** b. Birmingham. 1906 - Portraits, land & sea scapes, industrial & architectural subjects etc Exh: RA, PS, NEAC, RBA, RI, ROI, NS etc	OBissell
BLACKHAM **Dorothy Isabel** b. Dublin. 1896 - Oil & watercolourist etc Exh: RA, RHA, RWEA, SGA etc	DB

BLADON, RBSA **Murray Bernard** b. Birmingham. 1864 - ? Portraits & landscape artist Works in Perm. collections	
BLAIN, NDD Iris b. London Painter in Gouache & oil media Exh: RA, RBA, WIAC, RWEA etc	
BLAKE William b. London. 1757 - 1827 Religious & historical subjects Exh: RA, London & Prov. AG's	
BLAKER, NDD, ARE Michael b. Hove. 1928 - Figurative painter Exh: RA, RE, Prov. AG's & US	
BLANCHARD Jacques b. Paris. 1600 - 1638 Portrait, religious & mythological subjects Exh: France, Austria, Hungary, US etc	
BLANCHE Jacques Emile b. Paris. 1861 - 1942 Portraits, still life, genre subjects etc Exh: Belgium, France, Holland	
BLAND Sydney Frances Josephine b. York. 1883 - Painter in tempera & watercolour media Exh: RP, SWA, RI, RWS etc	
BLARENBERGHE Louis Nicolas van b. Lille. 1716 - 1794 Battle scenes, landscapes & miniatures Exh: Holland, UK, France	
BLEECK Pieter van b. Holland. 1700 - 1764 Portrait artist Exh: SOA	
BLEECK Richard van b. Holland. 1670 - 1733 Portrait artist Exh: Holland, Austria, UK	

BLEKER (or BLEEKER) **Dirck** b. Haarlem. 1622 ? - 1672 Portraits & historical subjects etc Exh: Holland, Hungary	*Jonge . Bleker f* *.1643.*
BLEKER (BLECKER or BLICKER) **Gerrit Claesz** b. Haarlem. ? - 1656. Religious & landscape artist Exh: Holland, Austria, Hungary etc	*GCbde fecit.*
BLES **Hendrik de** b. Bovines. 1480 ? - 1550 ? Biblical, historical & landscape artist Exh: Russia & European AG's	*HdD Blef.*
BLIECK **Daniel de** b. Holland. ? - 1673 Architectural subjects Exh: Holland, Denmark, UK, Germany etc	D·D·BLIECK ANNO 1653 D·D· blieck·1651· D·D·B·1654
BLIN **Francois (or Francis)** b. Rennes. 1827 - 1866 Landscape artist Exh: France, Belgium	*f. Blin.*
BLINKS **Thomas** b. 1860 - 1912 Animal & sporting subjects Exh: RA, SS, London & Prov. AG's	*TB*
BLOCK **Anna Katharina** b. Nuremberg. 1642 - 1719 Miniaturist, floral & portrait artist	A C B.
BLOCK **Benjamin von** b. Lubeck. 1631 - 1690 Portraits & historical subjects	*Block.*
BLOCK **Eugene Francois de** b. 1812 - 1893 Genre artist Exh: Holland	*Eug de Block* *ℬB*
BLOCKLAND **Anthonie van Montfoort** b. Holland. 1532? - 1583 Biblical & historical subjects Exh: Germany, Holland, Austria, UK	*AB* *B*

BLOEMAERT **Abraham** b. Dortrecht. 1564 ? - 1651 Portraits, mythological, genre & historical subjects Exh: UK & European AG's	*Bloemaert. fe:* *1626* *Ablo Inven* *Ablo* *AB 6*
BLOEMAERT **Adrien** b. Utrecht. 1609 - 1666 Landscape artist Exh: Holland, Russia etc	*AB Bloemaert*
BLOEMAERT **Hendrick** b. Utrecht. 1601 ? - 1672 Portraits, historical, allegorical & genre subjects Exh: Holland, Germany, Hungary, Russia, etc.	*HB 1633*
BLOEMEN (or BLOMMEN) **Jan Frans van** b. 1662 ? - 1749 Landscape artist Exh: Russia, UK, & European AG's	*J.v.B.D.Y.*
BLOEMEN (called STANDARD) **Pieter van** b. Antwerp. 1649 - 1719 Battle scenes, fairs, portraits, animals & landscapes Exh: Russia, US & European AG's	*P.V.B.* *PB* *PB* *VB* *P.V.B* *1702*
BLOEMERS **Arnoldus** b. Amsterdam. 1786 - 1844 Floral & still life artist Exh: UK, France, Holland	*AB*
BLONDEEL **Lancelot** b. 1495? - 1581 ? Architectural ruins, conflagrations & religious subjects Exh: Holland, Belgium	*1545* *LAB* *LAB*
BLUNT, RBA **John Sylvester** b. Northants. 1874 - Street scenes & landscape artist Exh: RA & Prov. AG's	*SB*
BLYTH, RSA, ARSA, RSW **Robert Henderson** b. Glasgow. 1919 - Gouache, oil & watercolour media Exh: RSA, SSA, RSW	*R. Henderson Blyth*
BOARD **Edwin John** b. Torquay. 1886 - Landscape & marine artist Exh: RA, RWA	*EJ BOARD*

BOBA **George** b. Riems. 1550 ? - ? Portrait artist Exh: France	
BOCK (the elder) **Hans** b. Alsace. 1550 ? - 1624 Portraits & genre subjects	
BOCK **Theophile Emile Achille de** b. The Hague. 1851 - 1904 Landscape artist Exh: PS, Holland, UK, Germany etc	
BODDINGTON **Edwin Henry** Fl. 1853 - 1867 Landscape artist Exh: RA, BI, SS, UK AG's	
BODMER **Karl** b. Riesbach. 1809 - 1893 Animal & landscape artist Exh: European AG's	
BOE **Franz Didrik** b. Bergen. 1820 - 1891 Landscape & still life artist Exh: France, Austria etc	
BOECKHORST **Johann** b. Munster. 1605 - 1668 Historical & portrait artist Exh: Belgium, Sweden, Austria etc	
BOELLAARD **Margaretha Cornelia** b. Utrecht. 1795 - 1872 Genre & portrait artist	
BOEYERMANS **Theodor** b. 1620 ? - 1678 Historical & biblical subjects etc Exh: Holland, France, Germany	
BOGDANY **Jakob** b. Hungary ? - 1724 Floral & still life subjects Exh: Hungary, Sweden etc	

BOGUET Nicolas Didier b. Chantilly. 1755 - 1839 Landscape artist Exh: France	*D. Boguet 1821*
BOILLY Julien Leopold b. Paris. 1796 - 1874 Portrait artist Exh: France	*Jul. B!*
BOILLY Louis Leopold b. 1761 - 1845 Portrait & genre artist Exh: UK, Scandinavian & European AG's	*L Boilly 1802* *L Boilly* *L Boilly 1803.*
BOIRON Alexandre Emile b. 1859 - 1889 Genre artist Exh: PS	*ÆBoiron*
BOISFREMONT Charles Boulanger de b. Rouen. 1773 - 1838 Portrait,biblical & historical subjects Exh: France, Germany	*JB*
BOISSIER Andre Claude b. Nantes. 1760 - 1833 Portraits & biblical subjects	*AB*
BOISSIEU Jean Jacques de b. Lyons. 1736 - 1810 Portrait & landscape artist Exh: France, Germany, Switzerland etc	*B* *DB* *DB* *J.J. DB*
BOKS Evert Jan b. 1838 - ? Genre & portrait artist Exh: Holland	*E J Boks*
BOL Ferdinand b. Dortrecht. 1611 - 1680 Portraits & historical subjects Exh: UK, Scandinavian & European AG's	*Bol f.1676* *FRBOL* *Bol.* *FB* *FB* *B* *B*

BOL **Hans** b. Malines. 1534 - 1593 Landscape artist & miniaturist Exh: Germany, France, Sweden	*HBol.* *HB* *HB.1*
BOL **Pierre** b. Anvers. 1622 ? - 1674 ? Animals & still life artist Exh: UK, France, Hungary, Germany, Holland etc	*P. BVGL* *P.B*
BOLDINI **Jean** b. Italy. 1845 - 1931 Genre & portrait artist Exh: UK & European AG's	*Boldini* *Boldini*
BOLOMEY **Benjamin Samuel** b. Lausanne. 1739 ·1819 Portrait artist Exh: Holland	*Bolomay* *Bolomeij*
BOMPARD **Maurice** b. 1857 - 1936 Genre & marine artist Exh: France	*Maurice Bompard*
BONACCORSI **Antonio** b. 1826 - ? Portrait artist	*B.*
BONASONE **Giulio di Antonio** b. Bologne. 1498 ? - 1580 ? Biblical & mythological subjects	*VB.* *IVB*
BONAVIA **George** Fl. London. 1851 - 1876 Genre & portrait artist Exh: RA, BI, SS	*GB*
BOND **William Joseph J.C.** b. 1833 - 1926 Landscapes & coastal subjects & architectural subjects	*WJCBOND*
BONFILS **Robert** b. Paris. 1886 - Landscapes, nudes, floral & still life subjects Exh: France	*Robert bonfils 19*

BONHEUR **Marie Rosalie (Rosa)** b. Bordeaux. 1822 - 1899 Genre, animal & landscape artist Exh: UK, France etc	*Rosa Bonheur* *R.B*
BONIFAZIO b. Verona. 1487 - 1553 Biblical & historical subjects Exh: UK & European AG's	*Bonifazio*
BONNARD **Pierre** b. France. 1867 - 1947 Portraits, still life, genre & landscape subjects etc Exh: UK & European AG's	*Bonnard*
BONNAT **Leon Joseph Florentin** b. Bayonne. 1834 - 1923 Portrait, historical & landscape artist Exh: Holland, Germany, France, UK	*L⁾ Bonnat*
BONNER **George Gilbert** b. Toronto. 1924 - Painter in oil media Exh: Paris, London & Prov. AG's	*BONNER.*
BONNET **Philippe** b. Paris. 1927 - Painter in oil media Exh: US, Paris, UK, Stockholm, Italy etc	*Ph. Bonnet*
BONNET **Rudolf** b. Amsterdam. 1895 - Tempera, charcoal & pastel media Exh: Various European AG's	*R. BONNET*
BONVIN **Francois** b. Paris. 1817 - 1887 Portrait, still life, genre & landscape artist Exh: Holland, France, UK etc	*François Bonvin.*
BOOM **Karel** b. Holland. 1858 - ? Historical subjects Exh: Holland	*Ch Boom 1901*
BOONE **Daniel** b. 1630 ? - 1700 ? Genre subjects Exh: Holland	*D Boone*

BOONEN **Arnold** b. Dortrecht. 1669 - 1729 Genre & portrait artist Exh: Holland, Germany, Sweden etc	*A. Boonen.* *AB*
BOR (or BORRO) **Paulus** b. ? - 1638 Historical subjects Exh: Holland	*P Bor*
BORCH **Gerard** b. Zwolle. 1617 - 1681 Genre & portrait artist Exh: Holland, Hungary, Germany, Russia, France etc	*GB*
BORCHT (The Elder) **Hendrik van der** b. Brussels. 1583 - 1660 Still life, religious & historical subjects	*DB* *HVD* ✡
BORCHT (The Younger) **Hendrik van der** b. 1614 - 1654 Historical subjects	*AB* *AB* *AB*
BORCHT **Peter van der** b. 1600 ? - 1633 Figure & landscape artist	*PB*
BORDONE **Paris** b. Trevise. 1500 - 1571 Portrait, historical, biblical & mythological subjects Exh: Russia & European AG's	*PARIDIS BORDUNO.* *P. Bordone.* *P†B 1590* *P†B 1591* *P. Bordone* *P†B* *1580 P†B*
BOREEL, ARE **Wendela** b. France. 1895 - Etcher & painter in oils Exh: RA, NEAC	*Wendela Boreel*
BORGHEGIANO **Cherubino**	See ALBERTI

BORGOGNONE (known as Ambrogio Ambrogio da Fossano) b. Milan. 1455 - 1523 Biblical & historical subjects Exh: Germany, Italy, France, UK etc	*Ambrosio Bgogon*
BOROUGH-JOHNSON, PS, SGA, Ernest RBA, ROI, RI, RBC b. Salop. 1867 - ? Portraits, figure subjects & landscape artist Exh: PS, RA, RBA, RI, ROI, RP, UK, Europe etc	*EBJ monogram*
BORRAS **Nicolas** b. Spain. 1530 - 1610 Biblical subjects	*B.*
BORROW **William Henry** Fl. 1863 - 1890 Marine & landscape artist Exh: RA, BI, SS	*W.H.B.*
BORROWMAN, Capt. MA **Charles Gordon** b. Edinburgh. 1892 - 1956 Figures, animals & landscapes (Predominently Indian) Exh: RSA, RSW, WAG	*CA Borrowman CAB*
BORSSOM **Anthonie van** b. 1630 ? - 1677 Landscapes etc Exh: Holland, Hungary, UK, Germany	*A Borssom f. AB AO 1655*
BOS (or BOSCHE) **Jerome** b. Bois-le-Duc. 1450 ? - 1516 Biblical & bizarre subjects Exh: Russia, US & European AG's	*bosch bosch bos*
BOSBOOM **Johannes** b. The Hague. 1817 - 1891 Church interiors & landscapes Exh: Holland, Germany, France etc	*J Bosboom.*
BOSS **Eduard** b. Switzerland. 1873 - ? Genre & landscape artist Exh: Switzerland, France, Germany	*E. BOSS.*
BOSSE **Abraham** b. Tours. 1602 - 1676 Historical, genre, architectural & Portrait artist Exh: France	*ABfe 1620 B AB AB*

BOSSHARD **Rodolph Theophile** b. 1889 - Still life, landscapes & nudes Exh: European AG's	*R.h. Bonhard.*
BOSSI **Benigno** b. Italy. 1727 - 1793 Portraits & historical subjects Exh: Germany, France	*B. sc*
BOSSIEUX **Jean Jacques de** b. France. 1736 - 1810 Landscape artist	*DB 1770.*
BOTH **Andries Dirksz** b. Utrecht. 1608 -1650 Genre & landscape artist Exh: Germany, France, UK etc	*ABoth* *AB* *AB* *ABoth.630* *AB* *AB*
BOTH **Jan Dirksz** b. Utrecht. 1618 - 1652 Landscape artist Exh: UK, Scandinavian & European AG's	*Jan: Both Both Both* *Both Both Both* *Both f.*
BOTTICELLI **Sandro** b. Florence. 1444 - 1510 Portraits, religious, mythological, historical subjects etc Exh: UK, Russia, & European AG's	*Botticelli* *SB.*
BOTTINI **Georges** b. Paris. 1873 - 1906 Figures, nudes, genre & portrait artist Exh: France	*Georg Bottini* *George Bottini* **BOTTINI**

BOTTOMLEY **Albert Ernest** b. Leeds. 1873 - 1950 Landscape artist Exh: RA, RI, RBA, RCA	
BOTTOMLEY **John William** b. Hamburg. 1816 - 1900 Sporting & animal subjects Exh: RA, SS, BI, UK AG's, Germany	
BOUCHE **Louis Alexandre** b. France. 1838 - 1911 Landscape artist Exh: France	
BOUCHER **Francois** b. Paris. 1703 - 1770 Mythological, genre, historical, portrait & landscape artist Exh: UK, France, Germany, Switzerland etc	
BOUCHOR **Joseph Felix** b. France. 1853-1937 Genre & landscape artist Exh: France	
BOUCHOT **Francois** b. Paris. 1800 - 1842 Portrait, historical & mythological subjects	
BOUCKHORST **Jan Philipsz van** b. Haarlem. 1588 ? - 1631 Portrait & historical subjects Exh: Holland	
BOUDEWYNS **Adriaen Frans** b. Brussels. 1644 - 1711 Landscape & figure artist Exh: Holland, Spain, Hungary, France	
BOUDEWYNS **Nicolas** b. Brussels. 1760 - 1800 Landscape artist	

BOUDIN **Eugene Louis** b. France. 1824 - 1898 Portrait, still life, town & shore scenes etc Exh: UK, France, Belgium, Holland etc	*E. Boudin E. B* *E. Boudin E Boudin*
BOUGHTON, RA **George Henry** b. Nr. Norwich. 1833 - 1905 Portrait, figure, landscape, historical & sporting subjects Exh: RA, BI, GG, NG, London & Prov. AG's	*GHB GHB GHR GHB G.H.B*
BOUGUEREAU **William Adolphe** b. Rochelle. 1825 - 1905 Portrait, genre & mythological subjects Exh: Italy, France, Holland, Canada	*W·BOUGVEREAV. 1890*
BOUHOT **Etienne** b. France. 1780 - 1862 Town views & architectural subjects Exh: France	*Bouhot.* *1840*
BOULANGER **Clement** b. Paris. 1805 - 1842 Portrait, genre & historical subjects Exh: Holland, France	*clement* *Boulange*
BOULARD **Auguste** b. Paris. 1825 - 1897 Portrait, rustic, genre subjects etc Exh: Holland, France	*BOULARD.*
BOULOGNE (The Younger) **Louis de** b. Paris. 1654 - 1733 Historical, religious & mythological subjects Exh: France, Russia	*LB*
BOURCE **Henri Jacques** b. Anvers. 1826 ? - 1899 Historical, genre & landscape subjects Exh: Holland, UK, France	*Henri Bource* *1875*
BOURDON **Pierre Michel** b. Paris. 1778 - 1841 Portraits & religious subjects etc Exh: France	*Bourdon.*

BOURDON Sebastien b. Montpelier. 1616 - 1671 Portrait, historical, biblical & landscape artist Exh: Russia, UK, & European AG's	*Bourdon* *SB* *Bourdon* *S Bourdon*
BOURGEOIS Charles Guillaume Alexandre b. Amiens. 1759 - 1832 Miniaturist	*Bourgeoy*
BOURGEOIS du CASTELET Florent Fidele Constant b. France. 1767 - 1836 Portrait, historical & landscape artist Exh: France	*C B*
BOURGOGNE Pierre b. Paris. 1838 - 1904 Still life subjects Exh: RA, PS	*P.BOURGOGNE*
BOUSSINGAULT Jean Louis b. Paris. 1883 - 1943 Still life, portrait & genre subjects Exh: France	*L Boussingault*
BOUT Peeter b. Belgium. 1658 - 1702 Genre, figure & landscape artist Exh: Holland, France, Germany etc	*P: bout 1686* *B* *B* *B.*
BOUTIGNY Paul Emile b. Paris. 1854 - 1929 Historical, genre & landscape artist Exh: France	*BOUTIGNY 1887.*
BOUVIÈR Paul b. 1857 - ? Landscape artist Exh: France, Switzerland	*Paul Bouvier*
BOWDEN-SMITH Daisy Beatrice b. Gaya, India. 1882 - Watercolour & miniaturist Exh: RA, PS	*DBS*

BOWEN, RCA, ROI **Owen** b. Leeds. 1873 - ? Still life & landscape artist Exh: RA	*dwenBowen*
BOWERS **Stephen** Fl. London. 1874 - 1891 Landscapes & river views Exh: SS, NWS	*SB JB SB*
BOWKETT **Jane Maria** Fl. 19th C. Domestic subjects Exh: RA, SS, BI	*MB*
BOYDELL, ARCA, FIPA **Philip** b. Lancashire. 1896 - Oil & watercolourist Exh: RA, RBA, & UK, France, US	*BOYDELL*
BOYER d'AGUILLES **Jean Baptiste** b. France. 1645 - 1709 Historical subjects	*☆*
BOZE **Joseph** b. France. 1744 - 1826 Portrait artist Exh: France	*Boze*
BRABAZON **Hercules B.** b. Paris. 1821 - 1906 Landscape watercolourist Exh: NEAC, UK AG's	*HBB HBB HBB*
BRACQUEMOND **Felix** b. Paris. 1833 - 1914 Portrait & landscape artist Exh: France	*Bracquemond B* *F. Bracquemond B.*
BRADLEY **Basil** b. Hampstead. 1842 - 1904 Genre oil & watercolourist Exh: RA, SS, OWS, London & Prov. AG's	*·BB·*

BRADLEY **Florence** b. Yorkshire. Watercolourist & black/white drawings Exh: London & Prov. AG's	*Florence Bradley .*
BRADLEY, RCA, LRIBA **Frank** b. Manchester. 1903 - Exh: R. Cam.A, PS, various UK AG's, Norway, Germany etc	*Frank Bradley .*
BRADSHAW, ARCA, RCA, ARE,ATD **Brian** **MAFA, LA, RCA** b. Bolton. 1923 - Gouache, oil & watercolourist etc Exh: RA, RE & various London & Prov. AG's	*B. Bradshaw*
BRADSHAW **Gordon Alexander** b. Liverpool. 1931 - Landscape artist Exh: RA, RCA , London & Prov. AG's	*Gordon A Bradshaw 76* *GB . 76.* *GB . 76.*
BRAEKELEER **Adrien Ferdinand de** b. Anvers. 1818 - 1904 Genre artist Exh: Belgium, Germany, Canada	*Adrien De Braekeleer*
BRAEKELEER (The Elder) **Ferdinand de** b. Anvers. 1792 - 1883 Genre & historical subjects Exh: Holland, Germany, Belgium	*Ferdinand De Braekeleer* *1851 .*
BRAEKELEER **Henri de** b. Anvers. 1840 - 1888 Still life, genre, & landscape artist Exh: Belgium, Austria, Holland	*Henri De Braeke.leer*
BRAKENBURG **Richard** b. 1650 - 1702 Genre & portrait artist Exh: Holland, France, Germany, Hungary etc	*R . Brakenburg .* *R. Brakenburgh*
BRAMANTINO (SUARDI) **Bartolommeo** b. 1450 ? - 1529 Historical subjects Exh: US, UK	*BBramantino*
BRAMER **Leonard** b. Delft. 1596 - 1674 Portraits & historical subjects Exh: Holland, Germany, France, Austria, etc	*L Bramer* *L Bramer* *L. Bramer* *fecit* *1646* *AB* *L.B*

BRAMLEY, RA **Frank** b. Lincoln. 1857 - 1932 Genre & portrait artist Exh: RA, NEAC, GG, NG, SS, S. Africa	*B.F.*　*F.B.*
BRAND **Friedrich Auguste** b. Vienna. 1755 - 1806 Portraits, historical & landscape subjects Exh: France, Austria	*FB*
BRAND **Johann Christian** b. Vienna. 1722 - 1795 Landscape artist Exh: Germany, Austria, Italy	*Brand. fecit*　*J.ch.B*
BRANDARD **Robert** b. Birmingham. 1805 - 1862 Landscape artist Exh: RA, BI, SS, NWS	*RYB*
BRANDON **Jacques Emile Edouard** b. Paris. 1831 - 1897 Genre & historical subjects Exh: Holland, France	*Ed. Brandon*
BRANGWYN, ARA, RA, RE, Hon. **Mem. RSA, RMS, PSCA, VP, IAL,** **RWA & Int. Soc.s** **Sir Frank William** b. Bruges. 1867 - 1956 Architectural, bridge & river scenes marine subjects etc. Exh: RA.RSA,WAG,GI,RWS, GG, etc	*FrBrgn*　*B*
BRANWHITE **Charles** b. Bristol. 1817 - 1880 Landscape artist Exh: OWS, RA, BI, London & Prov. AG's	*C.B.*
BRANWHITE **Charles Brooke** b. Bristol. 1851 - 1929 Landscape artist Exh: SS, NWS	*C.B.B.*
BRAQUE **Georges** b. Argenteuil. 1882 - Cubism & neo-classical works etc. Exh: London (Tate) Paris, NY, Zurich, Tokyo etc	*G Braque*
BRASCASSAT **Jacques Raymond** b. Bordeaux. 1804 - 1867 Portraits, landscape & animal subjects Exh: Holland, France, Russia etc	*J. R. Brascassut 1835*

BRATBY **John Randall** b. London. 1928 - Portrait, landscape, marine etc Exh: London & Prov. AG's	*JOHN BRATBY* *John BRATBY.*
BRAY **Jacob de** b. Haarlem. 1625 - 1680 Historical subjects	*JB*
BRAY **Salomon de** b. Amsterdam. 1597 - 1664 Portraits etc Exh: UK, Germany, France, Holland	*S:Bray* *1675.*
BRAY-BAKER, AMTC **May** b. London. 1887 - Landscapes, flowers & garden subjects Exh: SWA & Prov. AG's	*MB*
BRAYER **Yves** b. Versailles. 1907 - Landscape artist Exh: France etc	*yves Brayer*
BREANSKI **Alfred de** Fl. 19th C. Landscape artist Exh: RA, SS, NWS, London & Prov. AG's etc	*AB*
BREBIETTE **Pierre** b. France. 1598 - 1650 ? Biblical & mythological subjects	*BR - 1634*
BREDA **Carl Fredrik van** b. Stockholm. 1759 - 1818 Portrait artist Exh: Stockholm, UK	*FBreda*
BREE **Mathieu Ignace van** b. Anvers. 1773 - 1839 Portraits & historical subjects Exh: Holland, Belgium, France	*Mg VanBrée 1827*

BREENBERG (or BREENBORCH) **Bartholomaus** b. 1599 - 1659 Genre, mythological & landscape artist Exh: European AG's	B Breenborch \mathcal{B} \mathcal{B} BB Bf B B
BREKELENKAM **Quiringh Gerritsz van** b. Holland. 1621 ? - 1668 Genre artist Exh: France, Germany, Hungary etc	Q·Brekelenkam. QB·1661 QVS 1654
BRENET **Albert Victor Eugene** b. Harfleur. 1903 - Naval, military & airforce artist Exh: France	AB
BRENET **Nicolas Guy** b. Paris. 1728 - 1792 Biblical, mythological & historical subjects Exh: France	Brenet N. Brenet N.
BRENT **Ralph Richard Angus** b. London. 1903 - Land & seascape artist Exh: RA, RBA, Prov. AG's, New Zealand	Angus Brent = Angus Brent
BRESLAU **Marie Louise Catherine** b. Munich. 1856 - 1928 Portrait & genre artist Exh: France, Switzerland	L.C.Breslau
BRESSLER **Emile Henri** b. Geneva. 1886 - Painter in oil media Exh: Switzerland, France etc	BRESSLER
BRETON **Emile Adelard** b. France. 1831 - 1902 Landscape artist Exh: UK, France, Holland, Belgium	emile breton.
BRETON **Jules Adolphe Aime Louis** b. France. 1827 - 1905 Portrait, genre & landscape artist Exh: Holland, France	Jules Breton Jules Breton.
BRETSCHNEIDER **Andreas 111** b. Dresden. 1578? - ? Miniaturist Exh: UK	AB AB AT

BREWER Henry Charles b. UK. 1866 - 1962 Landscape artist Exh: RA, RI, RSA, Australia, N. Zealand	*H.C.B.*
BREWER Henry William b. Oxford ? - 1903 Churches & Church interiors Exh: RA, SS, BI	HB HWB
BREWER, ARCA Leonard b. Manchester. 1875 - ? Architectural subjects Exh: Works in perm. collections	*L. Brewer*
BREWTNAL, RWS Edward Frederick b. 1846 - 1902 Genre & landscape oil & watercolourist Exh: RA, VA, Prov. AG's	*E.F.B.*
BREYDEL Frans b. Anvers. 1679 - 1750 Portrait, interiors & landscape artist Exh: Germany	*F Breydel* *F.Breydel*
BREYDEL Karel b. 1678 ? - 1733 Landscapes & battle scenes Exh: Belgium, Italy, UK, France, Germany	*K. breydel*
BRIARD Gabriel b. Paris. 1729 - 1777 Biblical & mythological subjects Exh: Italy, France	*G. B 1759*
BRIAULT Sidney Graham b. London. 1887 -- Portrait artist & illustrator Exh: RA, RP, NS	BRIAULT
BRICKDALE, RWS Eleanor Fortescue b. 1871 - 1945 Oil & watercolourist Exh: RA, WAG, RWS & Prov. AG's	HB ⓑ HB
BRIGGS, FIBP, FRPS William George b. London. 1888 - Painter in oil media Exh: ROI, London & Prov. AG's	*B*

BRIGHT, RWS Henry b. Suffolk. 1814 - 1873 Landscape artist Exh: RA, UK AG's, Canada	*H B 1834 HB*
BRIGHT Martin James Rodney b. Harrow. 1941 - Abstract & figurative subjects Exh: RA, RE, London & Prov. AG's	*Martin Bright*
BRIL (The Younger) Mattheus b. 1550 ? - 1584 Landscape artist Exh: France, Italy	*ØØ*
BRIL Paul b. Anvers. 1554 - 1626 Miniaturist & landscape artist Exh: UK, & European AG's	PAVOLO BRILLI P BRIL *P P* *P BRIL · 08.* *[box]*
BRINCKMANN Philipp Hieronymus b. 1709 - 1761 Landscapes & biblical subjects Exh: Germany	*PB*
BRISCOE Arthur John Trevor b. Birkenhead. 1873 - 1943 Marine artist Exh: RA, NEAC	*a.B*
BRIZE (or BRISE) Cornelis b. Haarlem. 1622 - 1670 Portraits, still life etc Exh: Holland	*C. Brize e. P.* *C Brise. f.*
BROCHART Constant Joseph b. Lille. 1816 - 1899 Portrait & genre artist Exh: UK, France	*BROCHART*
BROCK Charles Edmond b. London. 1870 - 1938 Genre & portrait artist Exh: RA, UK AG's	*CEB* *C.E.B*

BROCK, RI **Henry Matthew** b. Cambridge. 1875 - ? Black & white & watercolourist	*HMBrock*
BROECK **Crispin van den** b. 1524 - 1589 Historical & biblical subjects Exh: Holland, Belgium	CXB. ⬭ ₵ 15₅8 A ᴄBF ᴄBF
BROERS **Jaspar** b. Anvers. 1682 - 1716 Landscapes, genre & battle scenes Exh: Holland, Italy, Germany	*J B. Broers Fecit*
BROMLEY **Clough W.** Fl. London. 1870 - 1904 Landscapes & floral subjects Exh: RA, SS, NWS, Prov. AG's	CB C.B.
BROMLEY **William** Fl. 1835 - 1888 Genre & landscape artist Exh: RA, BI, SS	WB
BRONCKHORST **Gerrit** b. Utrecht. 1637 - 1673 Landscape artist Exh: Holland	*g˙ᵈʳ·vBronchorst f* B
BRONCKHORST **Jan Gerritsz van** b. Utrecht. 1603 - 1677 Historical & genre subjects Exh: Holland, Germany, Austria etc	*J van Bronchorst fecit* *J Bronchorst fecit* *J G Bronchorst fe* JG5 JB
BRONZINO **Angiolo di Cosimo**	See ALLORI Angiolo
BROOK **Eleanor Christina** Artist in oil media Exh: London & Prov. AG's	⊕ ⊕

BROOKER **William** b. London. 1918 - Painter in oid media Exh: RA, RWA & Prov. AG's	*Brooker.* *W.B.*
BROOKS **Jacob** b. Birmingham. 1877 - ? Rustic subjects, portraits, figure & landscape artist Exh: RA, RI, WAG, RSA & Prov. AG's	JACOB J BROOKS.
BROOKS **Thomas** b. Hull. 1818 - 1891 Genre subjects Exh: RA, BI, SS, VA, Prov. AG's	*(monogram)* 1870
BROSAMER **Hans** b. 1506?- 1554? Portraits & religious subjects Exh: Austria, Germany etc	HB HB B. *(HB tablet)*
BROUGHTON, SWA **Aya** b. Kyoto, Japan Oil & watercolourist Exh: RA, WIAC, NS, RBA, RI, ROI, PS etc	*Aya* *(monogram)*
BROUILLET **Pierre Andre** b. Austria. 1857 - 1920 Genre artist Exh: France	*André Brouillet*
BROUWER **Adriaen** b. 1606 ? - 1660 Figure & genre artist Exh: UK, Scandinavia & European AG's	*Brouwer* AB AB AB AB
BROWN, RSA **Alexander Kellock** b. Edinburgh. 1849 - 1922 Floral & landscape subjects Exh: RA, SS, NWS, GG, NG, Prov. AG's, Germany	AKB
BROWN **Ford Madox** b. Calais. 1821 - 1893 Landscapes, historical & biblical subjects Exh: RA, BI, London & Prov. AG's, Australia	*(monogram)* *(monogram)*
BROWN **Frederick** b. Chelmsford. 1851 - 1941 Genre & landscape artist Exh: RA, SS, London & Prov. AG's	FRED BROWN 1897

BROWN, RA **Sir John Arnesby** b. Nottingham. 1866 - 1955 Landscape artist Exh: RA, Prov. AG's, S. Africa	*aB*
BROWN **John Lewis** b. Bordeaux. 1829 - 1890 Military, Portrait & genre subjects Exh: US, France etc	*John Lewis Brown* *B.*
BROWN **Lucy Madox** b. 1843 - 1894 Watercolourist Exh: RA, etc	*MB*
BROWN **Nellie Gertrude** b. Wolverhampton Landscape artist Exh: RA	*NB †49*
BROWN **Reginald Victor** b. Brighton. 1897 - Painter in oil media Exh: RA, R. Cam.A & Prov. AG's	*R. V. BROWN.*
BROWN, R. Cam.A **Samuel John Milton** b. Liverpool. 1873 - ? Marine watercolourist Exh: RI, R.Cam.A, etc	*Sam J.M.Brown*
BROWNE, Hon. Mem. SAF **Charles Egerton** b. London. 1910 - Animals, figurative subjects & sculpture Exh: PS, LAS, SWLA, RBA, USA, NEAC, London & Prov. AG's	*Chas E. Browne.*
BROWNE **Clive Richard** b. Keelby. 1901 - Landscape artist Exh: RA, R.Scot.A, RHA, R.Cam.A, NS, ROI, RWEA, RBA	*CLIVE BROWNE.*
BROWNE, ATD, ASWA **Kathleen** b. Christchurch, N.Z. 1905 - Pen & wash, oil media etc Exh: PS, RA, R.Scot.A, RBA, SWA, WIAC, Prov. AG's & abroad	*Kathleen Browne*
BROWNING **Robert Barrett** b. 1846 - 1912 Painter & sculptor Exh: RA, GG, UK AG's, Paris	*RBB*

BRUANDET **Lazare** b. Paris. 1755 - 1804 Landscape artist Exh: France, Switzerland	*L Bruandet*
BRUCE, RSPP **The Hon. George J.D.** b. London. 1930 - Portraits, land & seascapes & still life subjects	*[signature] 67*
BRUEGHEL (or BREUGHEL) **Abraham** b. 1631 ? - 1690 Still life subjects. Exh: Holland, Italy, Sweden etc	*ABreugeLF Roma 1670.* *[monogram]* *[monogram]*
BRUEGHEL **Jan** b. Brussels. 1568 - 1625 Biblical, landscape & still life subjects Exh: UK & European AG's	*[monogram]*
BRUEGHEL (The Elder) **Pieter** b. Brueghel. 1528? - 1569 Historical, genre, village scenes etc Exh: Russia, US, UK & European AG's	PETRVS BRVEGEL. F: BRVEGEL P.B.
BRUGGINK **Jacob** b. Amsterdam. 1801 - 1855 Landscape artist	*[signature]*
BRUNIN **Leon de Meutter** b. Anvers. 1861 - ? Portrait & genre subjects Exh: Holland, France, Germany	*Léon Brunin*
BRUNTON, SSA **Elizabeth York** b. Scotland. 20th C. Oil & watercolourist Exh: RSA, GI, PS etc	*[monogram]*
BRUNTON, RMS **Violet** b. Yorkshire. 1878 - ? Miniaturist Exh: RA, Royal Min. Soc.	*VB*
BRUSSEL **Hermanus van** b. Haarlem. 1763 - 1815 Landscape artist Exh: Holland	*B.*

BRUSSEL **Paul Theodor van** b. Holland. 1754 - 1795 Still life & floral subjects Exh: Germany, France	*P.T.B.*　　　PTVꞖ
BRUYN **Bartholomaeus** b. 1493 - 1553 ? Historical & portrait artist Exh: Germany, Belgium, Austria, UK, France	HB 1550
BRUYN **Nicolaes de** b. Anvers. 1565 - 1652 Historical subjects Exh: Belgium, France	NB. NB NB RB RB
BUCKLAND **Arthur Herbert** b. Taunton. 1870 - ? Genre subjects Exh: RA, London & Prov. AG's, 　　　Paris	AB
BUCKLE, RI, RSMA **Claude** b. London. 1905 - Oil & watercolourist Exh: London & Prov. AG's	Claude Buckle
BUFFET **L'Abbe Paul** b. Paris. 1864 - ? Historical & landscape artist Exh: France, Algeria, Italy	PAVL BVFFET
BUHLER **Robert** b. London. 1916 - Portrait & landscape subjects etc Exh: RA, London & Prov. AG's	Robert Buhler.　　Buhler .
BUHOT **Felix Hilaire** b. Valognes. 1847 - 1898 Landscape artist Exh: France	Felix Buhot.
BUISSERET **Louis** b. Belgium. 1888 - ? Painter & engraver Exh: European AG's & US	
BUNDSEN **Jes** b. Assens. 1766 - 1829 Architectural & landscape artist Exh: Germany	

BUNNEY **John Wharlton** b. London. 1828 - 1882 Venetian scenes Exh: RA, Prov. AG's	
BURGDORFER **Daniel David** b. Berne. 1800 - 1861 Exh: Switzerland	
BURGESS, RI, ROI, ARBC **Arthur James Wetherall** b. Bombala, NSW 1879 - ? Marine artist Exh: RA, RI, ROI, PS & N.S. Wales	
BURGESS **Gelett** b. Boston, Mass. 1876 - ? Topographical & impressionist subjects Exh: US	
BURKE **Brenda** Fl. 19th - 20th C. Portraits & miniatures Exh: X	
BURKE, RBA **Harold Arthur** b. London. 1852 - ? Landscape, figure & portrait artist Exh: RA, SS, France etc	
BURLEIGH, RWS **Averil** b. UK. Fl. 1913 - 1950 Landscape watercolourist Exh: RA, PS	
BURN **Rodney Joseph** b. London. 1899 - Portraits, abstract & marine artist Exh: RA, NEAC, RWA & Prov. AG's	
BURNAT **Ernest** b. Vevey. 1833 - ? Landscape watercolourist	
BURNE **Winifred** b. Birkenhead. 1877 - ? Oil & watercolourist Exh: IS, London & Prov. AG's, Germany	

BURNE-JONES, Bt., ARA **Sir Edward Coley** b. Birmingham. 1833 - 1898 Religious, mythological & historical subjects Exh: RA, GG, NG, OWS, London & Prov. AG's	EBJ BJ EBJ EJB
BURNE-JONES **Sir Philip** b. London. 1861 - 1926 Portraits & architectural scenes Exh: London & Prov. AG's	B
BURR **Alexander Hohenlohe** b. Manchester. 1837 - 1899 Genre & historical subjects Exh: RSA, UK AG's	AB 1855
BURR **John** b. Edinburgh. 1831 - 1893 Portraits, genre & landscape artist Exh: RA, SS, OWS, RWS, Prov. AG's etc	J.Burr
BURRA **Edward** b. London. 1905 - Surrealist Exh: UK AG's, France	E3 ⊕
BURRAS, TCTA, SAM **Caroline Agnes** b. Leeds. 1890 - Portraits, landscapes & miniatures Exh: RA, RMS, PS, WAG, Prov. AG's	⊕
BURROUGHS, RMS, SWLA, FRSA, **Victor Hugh Seamark FRHS, SM** b. London. 1900 - Oil & watercolourist Exh: PS, RA, RI, RMS, SWLA, SM, R. Cam.A & Prov. AG's	VB
BURTON, RHA **Sir Frederick William** b. Ireland. 1816 - 1900 Portraits, genre, historical & landscape artist Exh: RA, OWS, London & Prov. AG's etc	F.W.B
BURTON **William Shakespeare** b. 1824 - 1916 Historical subjects Exh: RA, BI	WB
BURWELL **William Ernst** b. Kingston-on-Hull. 1911 - Oil & watercolourist Exh: RA, RI, NEAC, RHA, PS & Prov. AG's	Ernst Burwell

BUSH, ROI **Harry** b. Brighton. 1883 - 1957 Painter in oil media Exh: RA, ROI, RWA, PS, Canada etc	HARRY BUSH
BUSHI, ARCA, RWA, RE **Reginald Edgar James** b. Cardiff. 1869 - ? Landscape artist Exh: RA, France, Italy, US	
BUSK **E. M.** Fl. 1873 - 1889 Portrait artist Exh: R.A.	B
BUTIN **Ulysse Louis Auguste** b. St. Quentin. 1837 - 1883 Marine artist Exh: UK, France	
BUTLER **Alice Caroline** b. Bromley, Kent. 1909 - Miniaturist & watercolourist Exh: RA, RWA	
BUTLER (nee Thompson) **Lady Elizabeth Southerden** b. Lausanne. 1846 - 1933 Military & battle scenes Exh: RA, London & Prov. AG's	EB E.T.
BUTLER **John C.** b. Tunbridge Wells. 1952 - Wildlife artist Exh: US & UK Prov. AG's etc	JCButler
BUTLER, RWS **Mildred Anne** b. Ireland. 1858 - 1941 Genre, animal & landscape artist Exh: RA, NWS, SS, GG, NG	MB
BUTTER, BA **Edward James** b. London. 1873 - ? Landscapes & interior subjects Exh: RA, IS, GI	
BUTTERWORTH **Grace Marie** b. Hastings. Fl. 20th C. Miniaturist Exh: RA, RMS	

BUYS **Cornelis 11** b. Alkmaar. 1525 ? - 1546 Historical subjects Exh: Holland	C&B
BUYTEWECH **Willem Pieter** b. Rotterdam. 1585 ? - 1628 ? Biblical, genre, landscapes etc Exh: Germany	WBugt. Fnw.　BW　BW　WB WBfec　WB　WB
BYLERT **Jan van** b. Utrecht. 1603 - 1671 Portraits, historical & genre subjects Exh: Holland, Germany, Hungary, France, UK etc	Jbyl1re.Jes

C

CABANEL **Alexandre** b. Montpelier. 1824 - 1889 Portrait, mythological, historical subjects etc Exh: Russia, France	ALEX. CABANEL.
CABANEL **Pierre** b. Montpellier. 1838 - ? Genre & portrait artist Exh: France	Pierre Cabanel
CABAT **Nicolas Louis** b. Paris. 1812 - 1893 Landscape artist Exh: France	L.. Cabat
CABEL (or KABEL) **Adrian van der** b. Holland. 1631 ? - 1705 Portrait, marine, still life, biblical, mythological & landscape artist Exh: Holland	A.v Der Kabel　NK AK　V. Der Kabel
CACHOUD **Francois Charles** b. France. 1866 - ? Moonlight scenes & landscapes etc Exh: France, PS	FCachoud
CACKETT, SMA, BWS **Leonard** b. London. 1896 - Marine & landscape artist Exh: RI, ROI, RBA, RWA, RCA, SMA, PAS, RWS & Prov. AG's	Leonard Cackett

CADENHEAD, RSA, RSW,NEAC, **James FSA** b. Aberdeen. 1858 - 1927 Landscape artist Exh: AAS, RSA etc	
CAILLEBOTTE **Gustave** b. Paris. 1848 - 1894 Still life, portrait & landscape artist Exh: France	
CAINE, Mem. ACES, ABSM **Osmund** b. Manchester. 1914 - Oil & watercolourist etc Exh: RA, NEAC, RBA, RBSA, V & A, & London & Prov. AG's	
CALAME **Alexandre** b. Vevay. 1810 - 1864 Landscape artist Exh: Holland, Germany, Russia etc	
CALDARA **Polidoro** b. Italy. 1492 - 1543 Religious, mythological & portrait artist etc Exh: Russia, Italy, Austria, France	
CALDERON, RA **Philip Hermogenes** b. Poitiers. 1833 - 1898 Genre & historical subjects Exh: RA, UK AG's, Germany	
CALDWELL **Edmund** b. Canterbury. 1852 - 1930 Animals & sporting subjects Exh: RA, SS, NWS	
CALIARI **Carlo** b. Venice. 1570 - 1596 Portrait, biblical & historical subjects. Exh: France, Belgium, Italy etc	
CALIARI (called VERONESE) **Paolo** b. Verona. 1528 - 1588 Biblical & mythological subjects Exh: European AG's, UK etc	
CALLAM, ROI, FRSA, MSIA **Edward** b. Buckinghamshire Black & white, oil & watercolourist Exh: RA, PS, RI, ROI, RBA, RGI & Prov. AG's	

CALLANDE de CHAMPMARTIN **Charles Emile** b. France. 1797 - 1883 Portraits & historical subjects Exh: France	*C. Champmartin*
CALLCOTT, RA **Sir Augustus Wall** b. London. 1779 - 1844 Portraits, historical, marine & land-scape artist Exh: RA, UK AG's, Germany etc	*A.W. Callcott* CA^T A.W.C.
CALLCOTT **Charles** Fl. London. 1873 - 1877 Genre subjects Exh: RA, SS	ƆC
CALLET **Antoine Francois** b. Paris. 1741 - 1823 Historical & portrait artist Exh: France	*Callet.*
CALLOT **Jacques** b. Nancy. 1592 - 1635 Historical, biblical, genre & military subjects etc Exh: UK & European AG's	*Jac Callot In* *ℭ invent fec.* *Jac Callot* ℭ Ⅽ
CALLOW **John** b. Greenwich. 1822 - 1878 Marine artist & watercolourist Exh: RA, BI, SS, OWS	*J. Callow* *1864*
CALLOW, RWS **William** b. London. 1812 - 1908 Marine & landscape artist Exh: Ireland, UK AG's, Australia	ⓌW Ⓒ
CALS **Adolphe Felix** b. Paris. 1810 - 1880 Still life, figure, genre & landscape artist Exh: European AG's	*Cals* *Cals*
CALVERT **Frederick** Fl. 1811 - 1844 Oil, watercolourist & engraver Exh: London & Prov. AG's	*F. Calvert*

CAMBIASI (or CAMBIASO) **Luca** b. 1527 - 1585 Portrait, historical, allegorical & biblical subjects Exh: France, Germany, Italy	
CAMERON **David Young** b. Glasgow. 1865 - 1945 Landscape artist Exh: UK, Germany, US, France, S. Africa etc	
CAMERON **Hugh** b. Nr. Edinburgh. 1835 - 1920 Genre subjects Exh: UK AG's	
CAMOIN **Charles** b. Marseilles. 1879 - 1965 Portrait, still life, marine & landscape artist Exh: France	
CAMPAGNOLA **Domenico** b. Padua. 1484 - 1550 Mythological, historical & landscape artist	
CAMPAGNOLA **Giulio** b. Italy. 1481 - 1500 ? Miniaturist	
CAMPBELL **Felicity** b. 1909 - Animal subjects etc Exh: RA, RI	
CAMPHUYSEN **Dirk Rafelsz** b. Holland. 1586 - 1627 Winter scenes, landscapes etc	
CAMPHUYSEN **Govert Dircksz** b. Holland. 1624 ? - 1672 Portrait, figure, animal & genre artist Exh: Holland, Germany, France, UK etc	
CAMPI **Antonio** b. Cremona. 1536 ? - 1591 ? Historical & mythological subjects etc.	

CAMPIGLI **Massimo** b. Florence 1895 - Exh: Italy, France, US, Holland, London	*MASSIMO CAMPIGLI* *(AMPIGLI*
CANALETTO (or CANAL) **Antonio** b. Venice. 1697 - 1768 Landscapes, architectural & venetian subjects Exh: US, UK & European AG's etc	*A Canal f* *A.C* *A.G* *AC* *A.C.*
CANELLA **Giuseppe** b. Verona. 1788 - 1847 Marine & landscape artist Exh: Italy, France	*Canella 1830*
CANGIAGIO **Luca**	See **CAMBIASI** **(Luca)**
CANO **Alonso** b. Grenada. 1601 - 1667 Portraits, biblical & historical subjects Exh: Germany, Hungary, Russia, Spain etc	*AL CAᵠ* *A Cano* *AL°C°*
CANTARINI (called da Pesaro) **Simone** b. Nr. Pesaro. 1612 - 1648 Biblical & historical subjects Exh: Italy, Germany, Spain, France	*Cantarini*
CANUTI **Domenico Maria** b. Bologne. 1620 - 1684 Religious & mythological subjects Exh: France, Italy	*Ꮯ*
CANZIANI, RBA, FRGS **Estella L.M.** b. 1887 - Black & white, oil & watercolourist Exh: RA, RSA, RBA, RI & Prov. AG's	✪
CAP **Constant Aime Marie** b. Belgium. 1842 - ? Genre artist Exh: Belgium	*C. Cap*
CAPELLE **Jan van de** b. Amsterdam. 1630 - 1679 Marine subjects & winter landscapes Exh: Holland, Germany, Belgium, UK, Austria, Russia etc	*Capelle pinx*

C

CARACCI **Annibale** b. Bologna. 1560 - 1609 Landscapes & biblical subjects	AC
CARAVAGGIO **Michelangelo Merisi** b. Italy. 1562 - 1609 Portrait, religious, historical subjects etc. Exh: Scandinavian & European AG's etc	ΑΑ
CARAVAGGIO **Polidoro DA**	See CALDARA Polidoro
CARBONATI **Antonio** b. Mantoue. 1893 - Watercolourist Exh: Italy, France	Antonio Carbonati
CARDI (or CIGOLI) **Lodovico** b. Italy. 1559 - 1613 Religious & historical subjects Exh: France, Italy, Germany, Russia etc.	LC Œ
CARDON **Antoine Alexandre Joseph** b. Brussels. 1739 - 1822 Exh: Italy, Belgium	AC
CARDUCCI **Vicente** b. Florence. 1578 - 1638 Portraits, historical & religious subjects. Exh: Hungary, France, Russia, Spain	VINCENTº CARDVCHº 1630 VINCEINT: CARDVCHº
CARESME **Jacques Philippe** b. Paris. 1734 - 1796 Portraits, mythological & still life subjects Exh: France & European AG's	CARESMESP:
CAREY, ATD **Peter Leonard** b. Manchester. 1931 - Exh: London & Prov. AG's	Peter Carey. P.L.C.
CARLISLE **Elsie May Cecilia** b. London. 1882 - Portrait artist & miniaturist Exh: RA, WAG	EC 1928

CARLSTEDT **Kalle Frederik Oskar** b. Lieto. 1891 - Painter, graphic artist Exh: Russia, Sweden, Germany, Hungary, Switzerland etc	.KC. KC KC
CARO **Anita** b. New York. 19....? Abstract subjects etc Exh: London, Paris, Amsterdam, Zurich etc	*Anita de Caro*
CARO **Baldassare de** b. Italy. Fl. 18th C. Floral & still life subjects Exh: Italy, Germany	BC
CAROLUS-DURAN **Charles Emile Auguste Durand** b. Lille. 1838 - 1917 Portraits, historical & genre subjects Exh: Italy, France	*Carolus Duran* *CD.*
CARON **Antoine** b. Beauvais. 1521 - 1599 Portraits & historical subjects etc Exh: France	*A.*
CAROTTO **Giovanni Francesco** b. Verona. 1470 - 1546 Biblical & historical subjects	F JC M·D·X X X I
CARPEAUX **Jean Baptiste** b. France. 1827 - 1875 Portrait & genre artist Exh: France, Germany etc	B^t Carpeaux
CARPENTER **Margaret Sarah (nee Heddes)** b. Salisbury. 1793 - 1872 Portrait artist Exh: BM, UK AG's	M.C.
CARPENTIER **Evariste** b. Belgium. 1845 - ? Genre & historical artist Exh: Belgium, France	*Est Carpentier*
CARPIONI **Giulio** b. Venice. 1611 - 1674 Historical & mythological artist Exh: Hungary, Germany, Italy, UK	G C inv. G C.

CARRACCI **Agostino** b. Italy. 1557 - 1602 Portrait, religious & landscape artist Exh: UK, Germany, France, Italy, Austria etc	
CARRACCI **Annibale** b. Italy. 1560 - 1609 Portrait, religious, mythological, genre & landscape artist Exh: UK & European AG's	
CARRACCI **Antonio Marziale** b. Venice. 1583 - 1618 Historical, religious & landscape artist Exh: France, Belgium, Austria	
CARRACCI **Francesco** b. Italy. 1559 - 1622 Religious subjects Exh: Russia, Italy, France	
CARRACCI **Lodovico** b. Italy. 1555 - 1619 Portrait, religious & historical subjects Exh: UK, European AG's	

CARRE (or CARREE) **Abraham** b. Holland. 1694 - 1758 Genre & portrait artist Exh: Holland	*A Carré*
CARRE (or CARREE) **Franciscus** b. Holland. 1630 - 1669 Portrait & landscape artist Exh: Holland, UK	F(ARRE A÷ 1664
CARREE (or CARRE) **Michiel** b. Holland. 1657 - 1747 Landscape & animal subjects Exh: Holland, Germany, Russia, Austria, UK	*M. Carree. f*
CARRENO de MIRANDA **Don Juan** b. Spain. 1614 - 1685 Portraits & historical subjects Exh: Spain	CARº. Carí
CARRICK **John Mulcaster** Fl. London. 1854 - 1878 Landscape artist Exh: RA, BI, SS	JMA
CARRIERA **Rosalba** b. Venice. 1675 - 1757 Portraits, allegorical & genre subjects Exh: France, Italy, Austria	R R
CARRIERE **Eugene** b. France. 1849 - 1906 Portrait, genre & religious subjects etc. Exh: France, Switzerland, Belgium etc.	*Eugène Carrière*
CARSTENS **Frederik Christian** b. Denmark. 1762 - 1798 Portrait & genre artist Exh: Germany, Italy, etc	*FC*
CARTER **Hugh** b. Birmingham. 1837 - 1903 Portraits, genre & landscape artist Exh: RA, RI, NG, VA	HC
CARTER **John** b. London. 1910 - Landscape artist Exh: RIBA, RI & UK AG's	*John Carter*

CARTER **Samuel John** b. Norfolk. 1835 - 1892 Animals & sporting scenes Exh: RA, BI, SS, GG & Prov. AG's	*JC*
CASANOVA **Francesco Giuseppe** b. London. 1727 - 1802 Battle scenes, marine & landscape artist Exh: France, Germany, Russia, Austria etc.	*f Casanova fect*
CASSATT **Mary** b. Pittsburgh. 1844 - 1926 Figure & genre subjects Exh: UK, France etc.	*mary Cassatt* *Mary Cassatt* *Mary Cassatt*
CASSE **Rene Marie Roger** b. Paris. 1880 - Portrait & landscape artist Exh: France	*Roger Casse*
CASSIE, RSA, RSW **James** b. Scotland. 1819 - 1879 Landscape & marine artist Exh: RA, BI, SS, UK AG's	*JC* *JC* *JC* *JC 1871*
CASSIERS **Henry** b. Anvers. 1858 - ? Marine & landscape artist Exh: Holland, Belgium	*H Cassiers.*
CASSON **Hugh Maxwell** b. London. 1910 - Watercolourist Exh: RA, RCA, London & Prov. AG's	*Hugh Casson* *H.C.*
CASTAN **Gustave Eugene** b. Geneva. 1823 - 1892 Landscape artist Exh: Switzerland, France	*Gustave CASTAN*
CASTELLAN **Antoine Laurent** b. France. 1772 - 1838 Historical & landscape artist Exh: France	*ALC=*

CASTELLO **Bernado** b. Italy. 1557 - 1629 Portraits & religious subjects Exh: Italy, France	*BC* *BF* *BCin.*
CASTELNAU **Alexandre Eugene** b. France. 1827 - 1894 Genre & landscape artist Exh: France	*E. Castelnau.*
CASTIGLIONE **Giovanni Benedetto** b. Genoa. 1616 - 1670 Historical, animal, genre & landscape artist Exh: UK & European AG's	*GB* *BE* *BC* *BC* *CB* *CG.*
CASTRES **Edouard** b. Geneva. 1838 - 1902 Portrait, genre & landscape artist Exh: Switzerland, France	*E. Castres.*
CASTRO **Mary Beatrice de** b. Mortlake, Surrey. 1870 - Portrait & landscape watercolourist Exh: RA, SM, RMS	*MB*
CATENA **Vincenzo de Biagio** b. Trevigi. ? - 1531 Portraits & historical subjects	*Vincentius Catena* *Pinxit*
CATON-WOODVILLE **Dorothy Priestley** b. Chislehurst. 19th - 20th C. Watercolourist of portraits & miniatures Exh: RA, PS, RMS, US	*D.DWoodville* *C/27*
CATON-WOODVILLE **William Passenham** b. London. 1884 - Still life & 18th century subjects Exh: RA, WAG	*w.c.w*
CATTERMOLE **George** b. Norfolk. 1800 - 1868 Genre, historical, architectural & landscape artist Exh: RA, OWS, BI, & European AG's etc	*GC* *GC* *G.C.*
CAVE **James** Fl. 1801 - 1817 Landscapes & Architectural subjects Exh: RA, Prov. AG's	*.JC.* *.JC.*

CAVEDONE **Giacomo** b. Sassuolo. 1577 - 1660 Portraits, religious & historical subjects. Exh: France, Italy, Russia, Germany	*F Cavedone 1647* *Cavedone* *Ja*
CAXES **Eugenio** b. Madrid. 1577 - 1642 Biblical & historical subjects	*Caxes*
CAZES **Pierre Jacques** b. Paris. 1676 - 1754 Religious, historical, mythological & landscape artist Exh: Sweden, France	*Cazes.* *Cazes. p.t*
CAZIN **Jean Charles** b. France. 1841 - 1901 Genre & landscape artist Exh: Germany, France, Canada etc	*J.C. CAZIN*
CELSO LAGAR b. Salamanque. 1891 Genre artist Exh: Spain, US, Belgium, Germany, France etc	*Lagar.*
CEREZO **Mateo** b. Spain. 1635 - 1685 Religious & historical subjects Exh: Germany, Hungary, Spain	*M. Cerezo.*
CERIA **Edmond** b. France. 1884 - 1955 Portrait, still life, figure & landscape artist Exh: European AG's	*Ceria*
CERQUOZZI **Michelangelo** b. Rome. 1602 ? - 1660 Still life, historical, battle scenes etc Exh: France, Germany, Italy, Spain etc	*Mic. AB.*
CESARI **Giuseppe** b. Rome. 1560 ? - 1640 Religious & historical subjects Exh: France, Hungary, Germany, Italy, UK etc	*IOSEPH ARPINAS* *φ PIN.*
CESPEDES **Pablo de** b. Spain. 1538 - 1608 Portraits & religious subjects Exh: Spain	*Cespedes* *Cespedes.* *PC*

CEZANNE **Paul** b. France. 1839 - 1906 Portrait, still life, figure & landscapes etc Exh: UK, Europe, US etc. etc	*P. Cezanne*
CHABAS **Paul** b. Nantes. 1869 - 1937 Portrait, genre & landscape artist Exh: France	*Paul-Chabas*
CHAGALL **Marc** b. Vitebsk 1887 - Oil, gouache & watercolourist Exh: UK, US, European AG's etc	*Marc chagall* *Marc Chagall*
CHAIGNEAU **Jean Ferdinand** b. Bordeauz. 1830 - 1906 Animal & landscape artist Exh: UK, France	*J. Chaigneau*
CHALLE (or CHALLES) **Charles Michel Ange** b. Paris. 1718 - 1778 Allegorical, historical & landscapes etc Exh: France	*CM. Challe.*
CHALON **Alfred Edward** b. Geneva. 1780 - 1860 Portrait artist Exh: UK, France	*Œhalon.* *Œ*
CHAMBERLAIN, ROI, RSMA, NS **Trevor** b. Hertford. 1933 - Town, marine, & landscape oil & watercolourist Exh: RA, RBA, ROI, RSMA, NS, London & Prov. AG's, Europe etc	*T. Chamberlain*
CHAMPAIGNE **Philippe de** b. Brussels. 1602 - 1674 Portraits, religious & historical subjects Exh: France, Belgium, Switzerland, Germany etc	*Phil de Champaigne faciebat A° 1656* *ps De Champaignes* *Phil de Champaigne* - *PHISCHAMPAIGNE.P.*
CHANG, BA, Mem. RI, RWA **Chien-Ying** b. 1915 - Watercolourist Exh: RA, RI, RBA etc	張蒨英

CHANNING-RENTON **Capt. Ernest Matthew** b. Plymouth. 1895 - Painter of landscapes, battle scenes etc Exh: RSBA & Int. AG's	*Channing.*
CHAPLIN **Charles** b. 1825 - 1891 Portrait, genre, still life, landscape & figure subjects etc Exh: UK, France	*Ch. Chaplin* **CH**
CHAPMAN **Robert** b. Birmingham. 1933 - Portraits, still life, genre, nudes, landscapes & subjectivism Exh: Belgium, ROI, London & Prov. AG's etc	*Robert Chapman* *Chapman* *p* Chapman · Wales
CHAPPEL **Edouard** b. Anvers. 1859 - ? Still life artist. Exh: Germany, UK, France	*E.CHAPPEL*
CHAPRON **Nicolas** b. France. 1612 - 1656 Mythological subjects Exh: France, Russia etc	*NCHf.* *CJ*
CHARDIN **Jean Baptiste Simeon** b. Paris. 1699 - 1779 Genre, still life & portraits etc. Exh: UK & European AG's etc	*J chardin.f* *Chardin* CH CH *S Chardin . fecit* *J chardin* CH CH
CHARLES **James** b. 1851 - 1906 Portraits, landscapes & rustic scenes Exh: RA, NG, PS, NEAC etc	*JC*
CHARLET **Frantz** b. Brussels. 1862 - 1928 Portrait, genre, & landscape artist Exh: Belgium, France, UK	*frans charles*
CHARLET **Nicolas Joussaint** b. Paris. 1792 - 1845 Portrait, military & genre subjects Exh: France, Switzerland	*charlet*

CHARLIER **Jacques** 18th Century artist Mythological subjects, portrait & miniaturist Exh: UK, France	*J. Charlier*
CHARLOT **Louis** b. France. 1878 - 1951 Portrait, genre & landscape artist Exh: France, Japan	*Louis Charlot*
CHARLTON, RBA **John** b. Northumberland. 1849 - 1917 Portraits, battle scenes & sporting subjects. Exh: RA, SS, NWS, GG, NG, Prov. AG's, Australia	*JC*
CHARTIER **Alex Charles** b. Paris. 1894 - Abstract & impressionistic art etc Exh: France	*Alx Charles Chartier*
CHARTIER **Henri Georges Jacques** b. France. 1859 - 1924 Historical & military subjects Exh: France	*H Chartier*
CHASSERIAU **Theodore** b. S. America. 1819 - 1856 Portraits, Oriental subjects etc Exh: France	*Thᵉ Chassériau*
CHATTOCK, RE **Richard Samual** b. Solihull. 1825 - 1906 Landscape artist Exh: RA, NWS, SS etc	*R.S.C.*
CHAUVEAU **Francois** b. Paris. 1613 - 1676 Miniaturist	*F.* *F.C.* *∞*
CHAUVIER de LEON **Ernest Georges** b. Paris. 1835 - ? Landscape artist Exh: France	*Chauvier de Léon*
CHAUVIN, MAIA **Enid** b. London. 1910 - Exh: RA, RBA, ROI, AIA, SWA, RP, NS etc	*Chauvin*

CHAVANNES **Alfred** b. 1836 - 1894 Landscape artist Exh: Switzerland. Germany	*alfred Chavannes*
CHAZAL **Charles Camille** b. Paris. 1825 - 1875 Genre & portrait artist Exh: France	*Camille Chazal.*
CHECA Y SANZ **Ulpiano** b. Spain. 1860 - 1916 Genre & landscape artist Exh: France, S. America etc	*V. Checa*
CHELMINSKI **Jan** b. Poland. 1851 - ? Battle & military subjects Exh: UK, Belgium, France etc	*Jan V. Chelminski*
CHERET **Jules** b. Paris. 1836 - 1933 Dancers, figures & genre subjects etc Exh: European AG's	*Cheret*
CHERON **Louis** b. Paris. 1660 - 1715 Historical subjects Exh: Italy, France, UK	*L. C. inv.*
CHESSER **Sheila** b. Cheshire. 1915 - Exh: WIAC, RSA & Prov. AG's	*Sheila Chesser*
CHIARI **Fabrizio** b. Rome. 1621 - 1695 Religious subjects	*F C.*
CHIGOT **Eugene Henri Alexandre** b. 1860 - 1927 Marine, genre & historical artist Exh: France	*Eugène Chigot*
CHINTREUIL **Antoine** b. France. 1816 - 1873 Landscape artist Exh: France, Germany	*chintreuil.*

CHIPPERFIELD **Phyllis Ethel** b. Bloxham, Oxon. 1887 - Miniaturist & watercolourist Exh: RA, PS, WAG, RI, SM	*P.E.C.*
CHIRICO **Giorgio de** b. Volo. 1888 - Portraits, still life & landscapes etc Exh: France	*G. de Chirico*
CHOCARNE-MOREAU **Paul Charles** b. Dijon. 1855 - 1931 Humerous child studies etc Exh: France	CHOCARNE - MOREAU
CHODOWIECKI **Daniel Nicolas** b. Danzig. 1726 - 1801 Portraits, historical, genre & miniaturist Exh: Germany, Switzerland	*D. Chodowiecke* *D C*
CHOFFARD **Pierre Philippe** b. Paris. 1730 - 1809 Portrait, genre, & landscape artist Exh: France	*B.cho*
CHOLLET **Marcel de** b. Geneva. 1855 - ? Still life subjects etc Exh: France, Switzerland	*M^{cel} Chollet*
CHOMETON **Jean Baptiste** b. Lyon. 1789 - ? Portraits, town & landscapes, miniaturist etc. Exh: France	*EC* *CB*
CHRISTENSEN, SGA **Arent Laurits** b. Aarkus, Jutland. 1898 - Oil & watercolourist Exh: SGA, US, European & Scandinavian AG's etc	*Arent Christensen*
CHRISTIE **James Elder** b. Fifeshire. 1847 - 1915 Genre, children & portrait artist Exh: RA, SS, GG, NG, UK AG's, Paris	*J.E 84* *J.E.C*
CHRISTOFOROU **John** b. London. 1921 - Oil & Gouache media Exh: London, Paris & Prov. AG's	*Christoforou*

CIARDI **Guglielmo** b. Venice. 1843 - 1917 Genre, marine & landscape artist Exh: Germany, UK, France	C. CjARDj.
CIGNANI **Carlo** b. Italy. 1628 - 1719 Biblical & historical subjects etc Exh: UK & European AG's	Car Cign C Cig: CC1 C C CG CCJ
CIGOLI **Lodovico**	See CARDI Lodovico
CIPRIANI **Giovanni Battista** b. Florence. 1727 - 1785 Portraits, religious & historical subjects Exh: UK, Italy, France	GB^acipr.
CIRY **Michel** b. France. 1919 - Pastel, oil & watercolourist Exh: France, Belgium, Holland etc	MICHEL CIRY M̧C
CLACY **Ellen** Fl. 1870 - 1900 Genre subjects Exh: RA, SS, GG, Prov. AG's	E.C.
CLAESZ **Pieter** b. 1590 - 1661 Still life artist Exh: Holland, Germany, Hungary, Russia etc	P.1644 P.1651
CLAIRE **Charles** Fl. 19th - 20th C. Pastoral scenes Exh: Paris	CH. CLAIR
CLAIRIN **Georges Jules Victor** b. Paris. 1843 - 1919 Portraits, genre, landscapes etc Exh: France.	G. Clairin

C

CLAIRE George Fl. 1864 - 1873 Floral artist Exh: RA, BI, SS	*G.ClArE 1869.*
CLARKE Audrey M b. Leicestershire. 1926 Exh: London & Prov. AG's	*A.M.C.* *(AM.)*
CLARIS Antoine Gabriel Gaston b. France. 1843 - 1899 Genre & battle scenes Exh: France.	*Gaston Claris, 1891.*
CLAUDOT Jean Baptiste Charles b. France. 1733 - 1805 Still life & landscape artist Exh: France	*Claudotsec*
CLAUS Emile b. Belgium. 1849 - 1924 Genre & landscape artist Exh: Belgium, Germany, Italy etc	*Emile Claus*
CLAUSEN, RA Sir George b. London. 1852 - 1944 Portraits, still life, interiors, figure & landscape artist Exh: NEAC, RA, RWS	*G.CLAUSEN* *CLAUSEN.*
CLAY, BT Sir Arthur Temple Felix b. 1842 - 1928 Portrait, domestic & historical subjects Exh: RA, SS, NWS, GG, NG.	*A.C.*
CLAYS Paul Jean b. Bruges, 1819 - 1900 Marine artist Exh: Belgium, Germany, France, US & UK.	*P.J Clays*
CLEEF Henry van b. Antwerp. 1510 - 1589 Landscape artist	*VCV* *C AA*
CLEMENT Felix Auguste b. France. 1826 - 1888 Portrait, genre & historical subjects Exh: France, Italy	*Félix Clemeni*

CLEMENTS **Astell Maude Mary** b. Canterbury. 1878 - ? Miniaturist & watercolourist Exh: PS, RA	*M. Clements* *CM*
CLERCK **Hendrick de** b. Brussels. 1570 ? - 1629 ? Portraits. landscape & figure artist Exh: Holland, Belgium, Switzerland, Spain etc.	*·H· de·clerck·*
CLERGE **Auguste Joseph** b. France. 1891 - Portrait & landscape artist Exh: France	*clergé*
CLESINGER **Jean Baptiste** b. France. 1814 - 1883 Genre & landscape artist Exh: France. UK, etc	*s. clesinger.*
CLEVE **Hendrick 111 van** b. Anvers. 1525 - 1589 Landscape artist	*HC M* *MC M* *MC V*
CLIFFORD **Edward C.** b. Bristol. 1844 - 1907 Portraits & biblical subjects Exh: RA, SS, NWS, GG, NG etc	*EC*
CLIFFORD, MA **Robin** b. Gillingham. 1907 - Exh: RA, RBA, ROI, NEAC	*CR*
CLOUET (or JANNET) **Francois** b. Tours. 1522 ?- 1572 Portrait & historical artist Exh: France, Italy, Germany, Switzerland, UK, etc	*IANNET + 1563 +* *JANNET·C 1560*
CLUYSENAAR **Jean Andre Alfred** b. Brussels. 1837 - 1902 Genre & historical subjects Exh: France, Belgium, Germany etc	*Alf Cluysenaar*
COATES **Thomas John** b. Birmingham. 1941 - Portraits, industrial subjects, land- scapes, drawings & watercolourist Exh: ROI, RP, PAS, RBA, GS, CPS, RBSA, RA London & Prov. AG's	*TJCoates* *TJC*

COATS Mary b. Paisley. Fl. 1920's Still life, marine & landscape artist Exh: UK AG's	*M.*
COCK Cesar de b. 1823 - 1904 Landscape artist Exh: Belgium, France, UK	*Cesar De Cock*
COCK Xavier de b. 1818 - 1896 Animal & landscape artist Exh: Belgium, France	*Xavier De Cock*
COCKRAM, RCA, RI, MAFA George b. Birkenhead. 1861 - 1950 Sea & landscape watercolourist Exh: RA, RI & Prov. AG's	*George Cockram*
COCLERS Jean Baptiste Bernard b. Liege. 1741 - 1817 Portrait, genre & religious subjects Exh: Holland	*L·B·C.*
CODDE Pieter Jacobs b. Amsterdam. 1599 - 1678 Portraits, groups etc Exh: Holland, Belgium, Italy, Germany, UK, etc	*Podde*
CODNER, RP Maurice Frederick b. 1888 - Portrait artist Exh: RA, RP, ROI, RI, NEAC, PS	*Maurice Codner*
CODRINGTON Isabel b. 1894 - Figure & domestic subjects. Exh: RA, PS etc	*Ȼ*
COELLO Alonso Sanchez b. Valencia. 1515 - 1590 Historical & portrait artist Exh: Germany, UK, Spain	*Sanchez.F*
COELLO Claudio b. Madrid. 1630 - 1693 Historical subjects & portrait artist Exh: Hungary, Germany, UK, Spain etc	CLAVDIO. COELLO. F *C Coello* *C͟C*

COGELS **Joseph Charles** b. Brussels. 1786 - 1831 Landscape artist Exh: France, Germany	
COGNIET **Leon** b. Paris. 1794 - 1880 Historical & portrait artist Exh: UK, France	*Leon Cogniet*
COGNIET **Marie Amelie** b. Paris. 1789 - 1869 Genre artist Exh: France	*Amelie Cogniet*
COHEN **Ellen Gertrude** Fl. 19th - 20th C. Landscape artist Exh: RA, NWS, France	E.C.C
COIGNARD **Louis** b. France. 1810 - 1883 Animal & landscape artist Exh: France, Germany	L Coignard
COKER **Peter Godfrey** b. London. 1926 - Portrait, still life & landscape artist Exh: RA & London AG's	*Peter Coker*
COL **Jan David** b. Anvers. 1822 - 1900 Genre artist Exh: France, Austria, Belgium, US etc	*David Col*
COLAS **Alphonse** b. Lille. 1818 - 1887 Genre subjects. Exh: France	*Alph Colas*
COLE **George** b. Portsmouth (?). 1810 - 1883 Portrait, animal & landscape artist Exh: RA, BI, SS, UK AG's	G. Cole 1847
COLE, RA **George Vicat** b. Portsmouth. 1833 - 1893 Landscape artist Exh: RA, London & Prov. AG's	

COLE **Philip Tennyson** Fl. 1878 - 1889 Portraits & Domestic genre Exh: RA, UK AG's, Australia	
COLE **Philip William** b. Sussex. 1884 - Portrait & landscape artist Exh. RA, France	
COLEY **Alice Maria** b. Birmingham. 1882 - Miniatures, portrait & landscape artist Exh: RA, RMS, PS	
COLIN **Gustave Henri** b. Arras. 1828 - 1910 Landscape artist Exh: France	*Gustave Colin*
COLIN **Paul** b. Nancy. 1892 - Exh: France, US, Austria, Spain	*PAUL COLIN*
COLLANTES **Francisco** b. Madrid. 1599 - 1656 Landscapes, Historical & floral subjects Exh: France	
COLLART **Marie** b. Brussels. 1842 - ? Animal & landscape artist Exh: Belgium	*M Collart*
COLLIER **Arthur Bevan** Fl. London. 1855 - 1900 Landscape artist Exh: RA, Prov. AG's	ABC
COLLIER (or COLYER) **Evert** b. Holland. ? - 1702 Portraits & still life subjects Exh: Holland, Austria	
COLLINGWOOD RWS **William** b. Greenwich. 1819 - 1903 Landscape artist Exh: RA, UK AG's	*W.C. W.C.*

COLLINS **Cecil** b. Plymouth. 1908 - Oil, sketch & watercolourist Exh: London, Prov. & US. AG's	*Cecil Collins*
COLLINS **Charles Alston** b. London. 1828 - 1873 Genre & historical artist Exh: RA, BI, London & Prov. AG's	
COLLINS, ARCA **George Edward** b. Dorking. 1880 - ? Watercolourist & etcher Exh: RA, RBA, RI, RCA, Prov. AG's & Australia	
COLMORE, MBE **Nina** b. London. 1889 - Exh: NEAC, PS & London AG's	
COLOMBANO **Antonio Maria** b. Italy. FL. 1596 - 1616 Historical subjects	*Colombano*
COLOMBEL **Nicolas** b. France. 1644 - 1717 Religious subjects etc Exh: Hungary, Russia, France, Austria	*N Colombel.*
COLQUHOUN, DFA, **Ithel** b. Assam. 1906 - Exh: RA, CAS & London AG's	
COLSON **Guillaume Francois** b. Paris. 1785 - 1850 Historical subjects etc Exh: PS & French AG's	*Colson.*
COMERRE **Leon Francois** b. France. 1850 - 1916 Portrait. genre & figure artist Exh: France, Australia, Italy, etc	*Leon Comerre*
COMPAGNO **Scipione** b. Naples. 1624 ? - 1680 Biblical & historical subjects	*Scip:f*

COMPE **Jan Ten** b. Amsterdam. 1713 - 1761 Town & country scenes Exh: Holland, Germany, Russia etc	*J. un Compe*
CONCA **Sebastiano** b. 1679 ? - 1764 Historical & portrait artist Exh: Germany, Hungary, Italy, France, Spain etc	*Conca.*
CONCHILLOS Y FALCO **Juan** b. Valencia. 1641 - 1711 Historical subjects Exh: Spain	*Con Chilos*
CONGDON **William** b. Providence, USA. 1912 - Oil & watercolourist Exh: US, AG's, Rome, Venice etc	*WC*
CONGNET **Gillis** b. Anvers. 1538 - 1599 Historical & portrait artist Exh: Holland, Sweden, Germany etc	*Congnet fe*
CONINCK **Pierre Louis Joseph de** b. France. 1828 - 1910 Historical & genre subjects Exh: US, France	*P. De Coninck*
CONINXLOO **Gillis 111 van** b. Anvers. 1544 - 1607 Landscapes & historical subjects Exh: Holland, Denmark, Germany, Russia, Austria	
CONJOLA **Carl** b. Germany. 1773 - 1831 Landscape artist	*C*
CONNARD **Philip** b. Southport 1865 (1875?) - 1958 Landscape, marine & portrait artist Exh: RA, UK AG's	*PC PC PC*
CONSTABLE, RA **John** b. Suffolk. 1776 - 1837 Landscape artist Exh: RA, PS, France, Germany, Canada, US, London & Prov. AG's etc.	*Hampstead . 1828. 1829 . May 17 .* *Constable RA. John Constable RA*

CONSTABLE **Roddice** b. London. 1881 - Portrait miniaturist & landscape artist. Exh: RA, WAG, RMS	ℂℝ
CONSTANT **Benjamin** b. Paris. 1845 - 1902 Portraits & Eastern scenes etc Exh: PS, France, etc	BENJAMIN·CONSTANT
CONTARINI **Giovanni** b. Venice. 1549 - 1604 Historical, mythological & portrait artist Exh: Hungary, Italy	IOANNES CONTARENVS.F.
COOGHEN **Leendert van** b. Haarlem. 1610 - 1681 Religious subjects Exh: Holland	L V Cooghen
COOK **Aynsley James** b. London. 1934 - Wild life artist Exh: SWLA, London & Prov. AG's Norway	James Aynsley. ?
COOK, ARBA, FRSA etc **Sir Francis Ferdinand Maurice (Bt)** b. London. 1907 - Portraits, children, animals, still life & religious subjects, landscapes etc Exh: RA, ROI, RBA, NEAC & other London & Prov. AG's	(19.Francis Cook- 44.).
COOKE, RA **Edward William** b. 1811 - 1880 River & coastal scenes Exh: RA, BI, SS	E.W. Cooke. R.A
COOKE, **Jean Esme Oregon** b. London. 1927 - Portrait, marine & landscape artist Exh: RA, London & Prov. AG's	Jean E. Cooke
COOKE **John Percy** b. Tettenhall Portrait & landscape artist Exh: NSA, RWA, RBSA, London & Prov. AG's	Cooke
COOKE **Stanley** b. Mansfield, 1913 - Oil & watercolourist Exh: RA, RI, ROI & Prov. AG's	Stanley Cooke

COOPER, RA **Abraham** b. 1787 - 1868 Historical, sporting & battle scenes Exh: RA, BI, OWS, SS. London & Prov. AG's	*Cooper*
COOPER **Alexander** b. London. 1605 - 1660 Portrait & miniaturist Exh: Holland	
COOPER **Austin** b. Souris, Canada. 20th C. Watercolourist Exh: London, Paris, US, Australia etc	AUSTIN COOPER
COOPER **Edward** b. England. FL. 18th C. Portrait artist	E C.
COOPER, D.Sc., Ph.D, B.Sc., Del, **George Ralph** ARPS, FRSA b. Aylmerton. 1909 - Oil & watercolourist Exh: RA, ROI, RIBA etc	GRCooper 1954
COOPER, RDS, FRSA **John Hubert** b. Wigan. 1912 - Oil & watercolourist Exh: PS, BWS, Prov. AG's	JohnHcooper
COOPER **Phyllis** b. London. 1895 - Miniaturist & heraldic artist Exh: RA, RMS, RI, SWA	
COOPSE **Pieter** b. Holland. 17th Cent. Marine artist Exh: Sweden	PC
COOSEMANS **Alexander** b. 1627 ? - 1689 Still life subjects Exh: Belgium, Spain, Austria etc	AC.
COOSEMANS **Joseph Theodore** b. Brussels. 1828 - 1904 Landscape artist Exh: Belgium, France	JCuzemans

COPE **Sir Arthur Stockdale** b. London. 1857 - 1940 Portrait & landscape artist Exh: RA, UK AG's, Paris	
COPE, RA **Charles West** b. 1811 - 1890 Religious & historical subjects Exh: RA, BI, London & Prov. AG's, Australia	
COPNALL **Theresa Nora** b. Haughton - le -Skern. 1882 - Still life & portrait artist Exh: RA, WAG, PS, RSA & Prov. AG's	
COPSON **Horace** b. Bedford. 1903 - Watercolourist Exh: RI, RBA, RBSA, RWS, PS & Prov. AG's	
CORBET **Matthew Ridley** b. Lincolnshire. 1850 - 1902 Portraits, Italian genre & landscapes Exh: RA, UK AG's, S. Africa, Australia	
CORBOULD **Edward Henry** b. London. 1815 - 1915 Genre & historical subjects Exh: RA, SS, GG, NWS	
CORMON **Fernand Anne Piestre** b. Paris. 1845 - 1924 Portraits & historical subjects Exh: France	
CORNEILLE **Jean Baptiste** b. Paris. 1649 - 1695 Portraits, historical & biblical subjects Exh: France	
CORNELIS **Gouda van** b. Gouda. 1510 ? - 1550 Portrait artist Exh: Austria	
CORNET **Jacobus Ludovicus** b. Holland. 1815 - 1882 Genre & portrait artist Exh: Holland	

CORNWELL, SGA **Arthur Bruce** b. Vancouver. 1920 - B/White, oil & watercolourist etc Exh: RA, NEAC, SMA, SGA etc	*CORNWELL*
CORONA **Leonardo** b. Italy. 1561 - 1605 Religious & historical subjects	$£_{I.C.}$ $C\!L$
COROT **Camille Jean Baptiste** b. Paris. 1796 - 1875 Genre & landscape subjects etc Exh: UK, US, Canada & European AG's etc	COROT. C· COROT. COROT COROT COROT C COROT COROT C.C
CORREA **Diego** b. Spain. 1550 ?- ? Historical subjects Exh: Spain	*Correa*
CORREGIO **Antonio (Allegri) da** b. Correggio. 1494 - 1534 Landscapes, religious & mythological subjects Exh: International AG's	ANTOIVS DE ALEGRIS *Corregio. f* RE♡GIO *fecit*
CORT **Cornelis** b. Holland. 1533 ? - 1578 Historical & landscape artist	*C. C.*
CORTE **Juan de la** b. Madrid. 1597 - 1660 Portraits, battle scenes & historical subjects	H DÉCort.

CORTLANDT, FIAL, FRSA Lyn b. New York. 1926 - Exh: Europe, Japan, US, S. America	*Cortlandt*
CORTONA Pietro da	See **BERRETINI** Pietro da
COSGROVE Stanley b. Montreal. 1911 - Exh: Canada, US, Mexico	COSGROVE
COSSIAU Jan Joost von b. Holland. 1660 ? - 1734 ? Landscape artist Exh: Germany, France, Austria	J.J.D. Cossiau.
COSSIERS Jan b. 1600 - 1671 Biblical & historical subjects Exh: France, Holland, Belgium, Spain	COSSIERS FT:
COSTA (The Elder) Lorenzo b. Ferrara. 1460 ? - 1535 Portraits & biblical subjects Exh: Germany, France, Italy, Australia, UK	LAVRENTIVS COSTA · F · 1505
COSTANTINI, RI, SSN, ML Virgil b. Italy. 1882 - Figures & portrait artist Exh: RA, RI, RSA, ROI, GI, PS, US & Italy	VC
COSWAY Maria Cecilia Louisa Catherine b. Florence. 1759 - 1838 Miniaturist Exh: RA. Italy	Maria C del.
COSWAY, RA Richard b. Tiverton. 1742 - 1821 Miniatures & historical subjects Exh: RA, Germany, Italy, UK AG's	CRR CR CR
COT Pierre Auguste b. France. 1837 - 1883 Portrait & genre subjects Exh: France	P.A. Cot

COTMAN **Frederick George** b. Ipswich. 1850 - 1920 Portrait, genre & landscape artist Exh: RA, UK AG's, Paris	*F.G.C.* *F.S.C.*
COTMAN **John Sell** b. Norwich. 1782 - 1842 Portrait, landscape & marine artist Exh: RA, BI, SS, OWS, London & Prov. AG's	*J S Cotman.* *Cotman*
COTTET **Charles** b. France. 1863 - 1924 Portrait, marine & landscape artist Exh: France, Spain, Belgium, Germany, US, etc	*= Ch. Cottet =*
COUBINE **O.** b. 1883 - Figure. still life & landscape artist Exh: Switzerland, Germany, Japan, UK etc	*Coubine*
COUDER **Jean Alexandre Remy** b. Paris. 1808 - 1879 Still life, historical & genre subjects Exh: France	*Alex^dre Couder*
COUDER **Louis Charles Auguste** b. Paris. 1790 - 1873 Portrait, historical & mythological subjects etc Exh: France	*Auy Couder.*
COULDERY **Horatio Henry** b. London. 1832 - ? Animals & genre subjects Exh: RA, London & Prov. AG's, BI, SS	*HC*
COURANT **Maurice Francois Auguste** b. France. 1847 - 1925 Marine & landscape artist Exh: France	*Maurice Courant*
COURBET **Gustave** b. France. 1819 - 1877 Portraits, genre & landscape artist Exh: UK & European AG's etc	*G. Courbet* *G. Courbet.* *Gustave Courbet. 1866* *G.C.* *G. Courbet.* *1853* *G. Courbet*

COURDOUAN **Vincent Joseph Francois** b. Toulon. 1810 - 1893 Marine & landscape artist Exh: France	*v. courdouan 1868.*
COURT, ROI **Emily** b. Newport. FL. 20th C. Exh: RA, ROI, NEAC, Canada etc	*E Court*
COURTENS **Franz** b. 1854 - ? Landscape artist Exh: Belgium, France, Hungary, Germany etc	*Franz Courtens*
COURTIN **Jacques Francois** b. France. 1672 - 1752 Religious, genre & portrait artist Exh: Belgium, Russia	*Jac Courtin.*
COURTOIS **Gustave Claude Etienne** b. France. 1853 - 1924 Portrait & figure artist Exh: European AG's etc	*Gustave Courtois*
COURTOIS **Jacques** b. St. Hippolyte. 1621 - 1676 Battle scenes, portraits, landscapes & historical subjects Exh: France, Hungary, Germany, Italy, Spain	*B B B A A*
COUSIN (The Younger) **Jean** b. Soucy. 1522 ? - 1594 ? Portraits, historical subjects & miniatures Exh: France UK	*J Cousin*
COUTURE **Thomas** b. France. 1815 - 1879 Genre & historical subjects Exh: France, Holland, Germany, Italy, UK etc	*T. C.*
COUTURIER **Leon Antoine Lucien** b. Macon. 1842 - 1935 Marine, Military & battle scenes, landscapes etc Exh: France	*C*
COUTURIER **Philibert Leon** b. France. 1823 - 1901 Landscape, bird & animal subjects etc Exh: France	*P L Couturier*

COUVE DE MURVILLE-DESENNE, FIL, FIAL **Lucie-Renee** b. Madagascar. 1920 - Portrait, floral & marine subjects Exh: RWA, London & prov. AG's	
COVENTRY **Robert McGown** b. Glasgow. 1855 - 1914 Marine & landscape artist Exh: UK & European AG's	
COWPER **Frank Cadogan** b. UK. 1877 - 1958 Genre & historical subjects Exh: RA	
COX (The Elder) **David** b. Birmingham. 1783 - 1859 Figure & landscape artist Exh: RA, BI, SS, London & Prov. AG's etc	
COX (The Younger) **David** b. London. 1809 - 1885 Landscape artist Exh: London & Prov. AG's	
COX, ROI, RWA **David** b. Falmouth. 1914 - Exh: London, Prov. & European AG's US etc	
COX **Ernest Moses** b. Kettering. 1885 - Oil & watercolourist Exh: London & Prov. AG's	
COXIE **Michiel I** b. 1499 - 1592 Portraits, historical & religious subjects Exh: Russia, Germany, France, Belgium, Spain, Italy	
COYPEL **Antoine** b. Paris. 1661 - 1722 Historical & mythological subjects etc Exh: France, Hungary, Italy, UK, Russia	
COYPEL **Charles Antoine** b. Paris. 1694 - 1752 Portraits, historical & genre subjects Exh: France	

COYPEL **Noel** b. Paris. 1628 - 1707 Historical, Religious & portrait artist etc. Exh: France, Spain	*Noypel.*　　*Noypel*
COYPEL **Noel Nicolas** b. Paris. 1690 - 1734 Mythological & historical artist Exh: France, Germany, Switzerland etc	*nn.Coypel . fecietat 1732*　　*NN Coypel f 1728*
COZENS **John Robert** b. England. 1752 - 1799 Landscape artist Exh: RA & London AG's etc	*J Cozens*
CRABBELS **Florent Nicolas** b. Anvers. 1829 - 1896 Landscape artist Exh: Canada, Belgium	*flor Crabeels*
CRAEN **Laurens** Flourished Holland. 17th Century Still life subjects Exh: Middelbourg	*CL*
CRAESBEECK **Joos van** b. S. Brabant. 1608 ? - 1661 ? Portraits & humourous subjects Exh: France, Germany, Russia, Austria etc	**CB**　　*CB*
CRAEY **Dirck** b. Amsterdam ? - 1666 Portrait & historical artist Exh: Holland	*1650* *DCraey F.*
CRAIG, ROI, NPS **Frank** b. Kent. 1874 - 1918 Genre & portrait artist Exh: France, S. Africa, Australia	**F.C.**
CRAIG **James Stephenson** Fl. London. 1854 - 1870 Genre subjects Exh: UK AG's	*CJ 1868*
CRAMP, ATD **Jonathan David** b. Sussex. 1930 - Oil, Charcoal & Gouache media	*J. CRAMP*　　*J. Cramp.*　　*J.C.*

CRANACH **Lucas** b. Bavaria. 1472 - 1553 Religious, historical, landscape & portrait artist Exh: Scandinavia, Russia & European AG's	
CRANE, RWS **Walter** b. Liverpool. 1845 - 1915 Portrait, figure & landscape artist Exh: RA, OWS, NWS, GG, London & Prov. AG's	
CRAWFORD, RSA **Edmund Thornton** b. 1806 - 1885 Landscapes & coastal scenes Exh: RA, UK AG's	
CRAWHALL, RWS **Joseph** b. Newcastle. 1860 - 1913 Bird & animal subjects Exh: RA, UK AG's, Paris	
CRAWSHAW **Francis** b. Manchester. 1876 - ? Oil & watercolourist Exh: RA, RSA, RSW, NEAC, GI, ROI	
CRAWSHAW, RSW, BA, LL.M. **Lionel Townsend** B' Nr. Doncaster. 20th C. Oil & watercolourist Exh: RA, RSA, PS, RSW	
CRAYER **Jasper (or Caspar) de** b. Anvers. 1584 - 1669 Portrait & historical artist Exh: France, Holland, Germany, Belgium, UK etc	

CREDI **Lorenzo di** b. Florence. 1459 - 1527 Portraits, biblical & historical subjects Exh: Germany, France, US, Italy etc	*L Credi.*
CRESPI **Daniele** b. Italy, 1590 - 1630 Portraits & religious subjects Exh: France, Hungary, Italy, Germany, Austria	*D Crespi*
CRESWELL **Emily Grace** b. Leicester. 1889 - Portraits & miniaturist etc Exh: RBSA etc	*EG*
CRESWICK, RA **Thomas** b. Sheffield. 1811 - 1869 Landscape artist Exh: RA, BI, SS, UK & European AG's	*F 1541 TC 1840 TC E 1841*
CRETI **Donato** b. Italy. 1671 - 1749 Historical subjects Exh: Italy	*Creti -D-*
CREUTFELDER **Johann** b. Nuremberg. 1570 - 1636 Religious subjects Exh: Austria	*I.*
CRISTALL **Joshua** b. Cornwall. 1767 - 1847 Classical subjects, rustic genre & landscapes Exh: OWS, RA, BI, etc	*Joshua Cristall*
CRIVELLI **Carlo** b. Venice. 1435 ? - 1494 ? Religious subjects Exh: Germany, US, UK, Belgium, Hungary etc	CAROLVS·CRIVELLVS·VENEIVS·MILES·PINXIT·
CROFT, NDD, RWA **Richard John** b. London. 1935 - Oil media Exh: Ireland, X UK, US	*R.J.CROFT.*
CROFTS, RA **Ernest** b. Leeds. 1874 - 1911 Military & historical subjects Exh: RA, London & UK AG's, Germany	*C E*

CROIX **Pierre Frederik de la** b. France. 1709 ? - 1782 Portrait artist Exh: France, Holland	*P.F. De La Croix*
CROKE **Lewis Edmund** b. London. 1875 - ? Etchings & pastel artist Exh: RA, France, Italy, Canada & Prov. AG's	*LY. 25.*
CROME **John** b. Norwich. 1768 - 1821 Marine & landscape artist Exh: RA, London & Prov. AG's, Australia etc	*J Crome 1813*
CROME **William Henry** b. Norwich. 1806 - 1873 Landscape artist Exh: UK AG's	WHC
CROMPTON **Gertrude** b. 1874 - ? Watercolourist Exh: PS, IS, RI etc	*G. Crompton*
CRONSHAW, ARCA **James Henry** b. Accrington. 1859 - ? Landscape Artist Exh: London, Paris & Prov. AG's	*Kronshaw*
CROOK **Gordon Stephen** b. Richmond, Surrey. 1921 - Exh: London & Prov. AG's & US	*G.C*
CROSSLEY **Cuthbert** b. Halifax. 1883 - Oil & watercolourist Exh: RA, RSA, RI, RBA, PS	*CHx.*
CROTTI **Jean** b. 1878 - 1958 Surrealist & abstract subjects etc Exh: France	*Jean Crotti*
CROWTHER, ARCA, RBA **Deryck Stephen** b. Sheffield. 1922 - Oil, pencil & charcoal media etc Exh: RA, RBA & Prov. AG's	*Stephen Crowther*

CROWTHER, FIAL **Hugh Melville** b. Nr. Scarborough. 1914 - Oil & pastel media Exh: London & Prov. AG's	HUGH M. CROWTHER.
CRUIKSHANK **George** b. London. 1792 - 1878 Humourous & historical subjects Exh: London & Prov. AG's	*Geo Cruikshank* *Geo Cruikshank* *Geo Cruikshank.*
CRUMPLIN **Colin Frederick** b. England. 1946 - Abstract subjects Exh: US, London & Prov. AG's	CRUMPLIN.
CRUYL **Lievin** b. Belgium. 1640 - 1720 Sea & landscape artist Exh: France, Belgium	*CL*
CUNEO, RGI, PIPG **Terence Tenison** b. 1907 - Portrait & figure artist - also ceremonial, military & engineering subjects Exh: RA, RP, ROI, RWS	*Terence Cuneo.*
CUNINGHAM **Oswald Hamilton** b. Newry, Ireland. 1883 - Oil & watercolourist Exh: RA, RHA, PS	*Cuningham*
CURMAN **William Alan** b. Milwaukee, US. 1949 - Conceptual subjects Exh: New York, Milwaukee & other US AG's	*Billy Curman*
CURTIS, ARWA **Anthony Ewart** b. Wakefield. 1928 - Oil, watercolour & general media Exh: London & Prov. AG's	*AE*
CURTIS, FIAL, RISM, ARMS, **Vera G.** **AWPA** b. Christchurch, N.Z. Oil & watercolour media. miniaturist Exh: RI, RMS, SM, NEAC, PS, SWPP & N.Z. AG's	VERA. CURTIS.
CURZON **Paul Alfred de** b. France. 1820 - 1895 Landscapes etc Exh: France, Italy	*A. de Curzon*

CUYLENBORCH **Abraham van** b. Utrecht. 1620 ? - 1658 Mythological & landscape artist	*AC 1640* *AB* *AB* *AB* *AB*
CUYP **Aelbrecht** b. Dortrecht. 1620 - 1691 Portraits, still life, figure, marine & landscape artist Exh: UK, European AG's etc	*A:cüÿp.fecit. 1649* *Cuyp pinx*
CZECHOWICZ **Simon** b. Cracow. 1689 - 1775 Landscapes etc	*AC*
CZIMBALMOS **Magdolna Paal** b. Hungary Portraits etc Exh: France, Germany, Canada, US, X	*Magdolna Paal Czimbalmos*
CZIMBALMOS **Szabo Kalman** b. Hungary. 1914 - Oil, watercolour & tempera Exh: France, Canada, US, Germany, X	*K Sz. CZIMBALMOS 1970*

D

DABOS **Laurent** b. Toulouse. 1761 - 1835 Portrait & genre artist Exh: France	*dabos.1808*
DA COSTA, ROI, RP **John** b. Teignmouth. 1867 - 1931 Exh: RA, ROI, IS, European & Prov. AG's	*John da Costa*
DADD, RI, ROI **Frank** b. London. 1851 - 1929 Genre subjects Exh: RA, ROI, RBA, Australia	*F. D.*
DADDI **Bernado** b. Italy. 1512 ? - 1570 Genre & historical subjects	*[dice symbol]* *[B symbol]*

DAEGE **Eduard** b. Berlin. 1805 - 1883 Historical subjects Exh: Austria, Germany	18 **ED** 30
DAEYE **Hippolyte** b. Holland. 1873 - Figure & portrait artist Exh: Holland, Belgium, Germany, France, Italy etc	DAEYE
DAGNAN-BOUVERET **Pascal Adolphe Jean** b. Paris. 1852 - 1929 Mythological, genre & portrait artist Exh: France, Italy, Germany, Russia etc	PAJ
DAGNAUX **Albert Marie** b. Paris. 1861 - ? Portrait & landscape artist Exh: France	a. Dagnaux
DAHL **Johan Christian Clausen** b. Bergen. 1788 - 1857 Landscapes & Norwegian scenes etc Exh: Scandinavia, Germany	Dahl Dahl Dahl
DAINTREY **Adrian Maurice** b. London. 1902 - Portrait & landscape artist Exh: RA, London & Prov. AG's	amo
DAKEYNE **Gabriel** b. Yorkshire. 1916 - Portrait, marine, still life, landscapes etc. Exh: RA, RWS, SWA, RWEA, PS, London & Prov. AG's etc	Gabriel Dakeyne
DALBY **Claire** b. Scotland. 1944 - B/White & watercolourist Exh: RA, NEAC, London & Prov. AG's	claireDalby
DALEM **Hans van** FL. 17th C. Portrait artist Exh: Austria, Germany, France	HdF 1·48
DALGLISH **William** b. 1860(?) - 1909 Landscape artist Exh: RA, UK AG's	WD

DALI **Salvador** b. Figueras. 1904 - Surrealist Exh: International AG's	
DALLINGER VON DALLING **Alexander Johann** b. Vienna. 1783 - 1844 Landscape & animal subjects Exh: Austria	
DALL'OCA BIANCA **Angelo** b. Italy. 1858 - 1930 Genre artist & portraitist Exh: Germany, Italy, US, Brazil etc.	
DALY, ARCA **Jehan Emile** b. S. Wales. 1918 - B/White, oil & watercolourist Exh: RA, NEAC	
DALZIEL **Edward Gurden** b. London. 1849 - 1889 Genre & landscape artist Exh: RA, London & Prov. AG's	
DAMERON **Emile Charles** b. Paris. 1848 - 1908 Landscape artist Exh: France	
DAMOYE **Pierre Emmanuel** b. Paris. 1847 - 1916 Landscape artist Exh: France, Belgium, Canada etc	
DANBY **Francis** b. Wexford, 1793 - 1861 Landscapes & historical subjects Exh: RA, London & Prov. AG's Switzerland etc	
DANLOUX **Henri Pierre** b. Paris. 1753 - 1809 Portrait artist Exh: Germany, France, UK etc	

DARAGNES **Jean Gabriel** b. 1886 - 1950 Still life, genre & landscape subjects etc Exh: France	DARACNES
DARLING **Michael** b. London. 1923 - Oil & gouache media Exh: RA, NEAC, RBA	*NO*
DARONDEAU **Stanislas Henri Benoit** b. Paris. 1807 - 1841 Portrait, genre & historical artist Exh: France	*Darondeau*
D'ARPINO **Giuseppe Cesari** b. Nr. Naples. 1568 ? - 1640 Portraits, historical & battle scenes	Φ.PIN
DARWIN **Elinor Mary** b. Limerick Portrait artist Exh: NEAC, IS, RA, RHA	*Emd.* Ⓔ
DASVELDT **Jan H.** b. Amsterdam. 1770 - 1850 Animal & landscape artist Exh: Holland, France	ID.
DAUBIGNY **Charles Francois** b. Paris. 1817 - 1878 Landscape artist Exh: Russia, Canada, European AG's etc	*Daubigny.* *Daubigny* Ⅱ
DAUBIGNY **Karl Pierre** b. Paris. 1846 - 1886 Marine & landscape artist Exh: France, Holland, Germany etc	*Karl Daubigny*
DAUCHEZ **Andre** b. Paris. 1870 - 1943 Marine & landscape artist Exh: France, US, Germany, Belgium, Hungary, Spain etc	*André Dauchez*

DAUMIER **Honore** b. Marseilles. 1808 - 1879 Portraits, genre subjects etc Exh: European & US AG's	*h. Daumier* *h.D.* *h.D.* *h.D.* *h. Daumier* *h.D.* *h.D.* *hD* *h. Daumier* *h.D.* *h.D.* *hD* *h. Daumier* *h.D.* *h.D.* *H·D·*
DAUZATS **Adrien** b. Bordeaux. 1804 - 1868 Genre & architectural subjects Exh: France, Germany	*A DAUZATS* A DAUZATS
DAVID **Antonio** b. Venice. 1698 - ? Portrait artist	*AD*
DAVID **Hermine** b. Paris. 1886 - Portrait, genre & landscape artist Exh: France, UK	*hermine David*
DAVID **Jacques Louis** b. Paris. 1748 - 1825 Portraits & historical subjects etc Exh: Russia & European AG's	*L DAVID* LUD.DAVID. ROME *L.David* *L* *D* *D* *D* *D.*
DAVIDSON **Allen Douglas** b. London. 1873–1932 Figure & landscape artist Exh: RA, London & Prov. AG's	*DD* *DD*

DAVIDSON **Charles Topham** b. Redhill. 1848 - 1902 Landscape artist Exh: RA, RWS, SS	*signature* 1879
DAVIDSON **Daniel Pender** b. Camelon. 1885 - Portraits, still life, landscapes etc Exh: RA, PS, France, Belgium & Prov. AG's	D. Pender Davidson
DAVIDSON **Ezechiel** b. Hague, 1792 - ? Portrait, genre & historical subjects Exh: Holland, France	E. Davidson
DAVIDSON, DA **J. Nina** b. Hamilton. 1895 - B/White, tempera & watercolour artist Exh: RSA, GI, etc	*monogram*
DAVIDSON **Lilian Lucy** b. Co. Wicklow. FL. 20th C. Figures & landscapes Exh: PS. RHA	D
DAVIDSON **Thomas** Fl. 1863 - 1909 Genre & historical subjects Exh: RA, SS, BI	D Đ
DAVIDSON-HOUSTON **Aubrey Claude** b. Dublin. 1906 - Portrait artist Exh: RSA, RCA, RP, RBA, ROI, NS, PS	ACDH 1949.
DAVIES, RBA, RCA **Arthur Edward** b. Cardiganshire. 1893 - B/White, oil & watercolourist Exh: RA, RSA, RWA, France & Prov. AG's	A. Ross Edwards.
DAVIES, NDD, ATD **Austin Howard** b. Liverpool. 1926 - Oil & gouache media Exh: London & Prov. AG's	Austin
DAVIES **Mary Clare** b. London. 1928 - Abstract subjects & potter Exh: London & Prov. AG's	Davies

DAVIES, FIAL **Stephanie Joyce** b. Bristol. 1910 - Graphics, gouache & watercolourist Exh: London, Paris, Belgium, US Italy etc	
DAVIES **Thomas** b. Denbighshire. 1899 - Oil & watercolourist Exh: London & Prov. AG's	
DAVIES **W. Mitford** b. 1895 - Oil & watercolourist Exh: R Cam A	
DAVIS, RI **Frederick W.** b. 1862 - 1919 Genre & historical subjects Exh: NWS, SS, UK AG's, Paris	
DAVIS **George Horace** b. London. 1881 - Military subjects Exh: RA, & European AG's	
DAVIS, RA **Henry William Banks** b. London. 1833 - 1914 Animals & landscape artist Exh: RA, SS, BI, NG, UK AG's, Paris, Vienna	
DAVIS, RI **Lucien** b. Liverpool. 1860 - 1951 Genre, portraits & landscape artist Exh: UK AG's	
DAVIS **William** b. Dublin. 1812 - 1873 Landscape artist Exh: RA, UK AG'S etc.	
DAVISON **Minnie Dibdin** Fl. London. 1893 - 1910 Genre & portrait miniaturist Exh: RA, UK AG's	
DAWANT **Albert Pierre** b. Paris. 1852 - 1923 Portrait, genre & historical subjects Exh: France, US	

DAWSON **Alfred** FL. 19th C. Etcher & landscape artist Exh: RA, SS, BI	
DAWSON, FSAM **Charles Frederick** b. Rillington, Yorks Oil & watercolourist Exh: RA, IS, WAG & Prov. AG's	
DAWSON **Henry** b. Hull. 1811 - 1878 Marine & landscape artist Exh: RA, BI, SS, London & Prov. AG's	
DAWSON **Henry Thomas** Fl. Chertsey. 1860 - 1878 Marine artist Exh: RA, BI, SS, US AK'S	
DAWSON, RSW, SSA **Mabel** b. Edinburgh. 1887 - Birds & animal subjects Exh: RA, RSA, RSW, GI, New Zealand, Canada etc	
DAWSON, FRSA, RSMA **Montague** b. London. Marine artist Exh: RA	
DAYES **Edward** b. 1763 - 1804 Miniaturist & landscape artist Exh: London & Prov. AG's, Hungary	
DEAKINS **George Richard** b. Gosport, 1911 - Varied subjects. Oil, gouache etc Exh: PS, RSA, London & Prov. AG's. Europe, US etc	
DEBAT-PONSAN **Edouard Bernard** b. Toulouse. 1847 - 1913 Portrait & landscape artist Exh: Italy, France	
DECAMPS **Gabriel Alexandre** b. Paris. 1803 - 1860 Genre & historical artist Exh: Holland, France, Hungary, UK, Germany, Russia etc	

DECANIS **Theophile Henry** b. Marseilles. 1848 - ? Landscape artsit Exh: France	*T. Décanis*
DECHENAUD **Adolphe** b. France. 1868 - 1929 Portrait & genre subjects Exh: Italy, France	*A. Déchenaud.*
DECKER **Cornelis Gerritsz** b. Haarlem. ? - 1678 Landscape artist Exh: UK * European AG's	*Decker f.* ÇD C D. 1669 *Ç Decker . 1653* 1642
DEDINA **Jean** b. Czeckoslavakia. 1870 - ? Genre & portrait artist Exh: Paris, Prague	
DEFRANCE **Leonard** b. Liege. 1735 - 1805 Still life, historical & landscape subjects etc Exh: France, Russia, Italy	*L. Defrance de Liege* *L. Defrance Liege*
DEFREGGER **Franz von** b. Austria. 1835 - ? Genre & portrait artist Exh: Germany, Hungary, Austria	*F. Defregger*
DEGAS **Hilaire Germain Edgar** b. Paris. 1834 - 1917 Portraits, figures, dancers & ballet scenes etc Exh: UK, Europe, US etc	*Degas Degas Degas* *Degas Degas* *Degas Degas*
DEHN FULLER, FFPS, WIAC, NS **Cynthia** b. Portsmouth Artist in oils & gouache media Exh: London, Europe & Australia	*Franoyn.*
DEHODENCQ **Edme Alexis Alfred** b. Paris. 1822 - 1882 Historical, portraits, Eastern subjects etc Exh: France	*alfred Dehodencq*

DELACROIX **Ferdinand Victor Eugene** b. France. 1798 - 1863 Portrait, historical, genre & still life subjects Exh: UK & European AG's etc	*Eug. Delacroix 1844* *Eug Delacroix 1832* *Eug. Delacroix* EVG.D.ELACROIX EUG. DE LA CROIX EUG. DELACROIX F. 1834 *Eugene Delacroix* *E. Delacroix 1825* *E.D* *ED*
DELANOY **Hippolyte Pierre** b. Glasgow. 1849 - 1899 Portrait, still life, genre & landscape subjects etc Exh: France	*hippolyte Delanoy*
DELAROCHE **Charles Ferdinand** b. Paris. Flourished 19th Century Genre & portrait artist Exh: France	*de La Roche.*
DELASALLE **Angele** b. Paris. 1867 - 1938 Portrait & landscape artist Exh: France, Germany	*A. Delasalle*
DELAUNAY **Jules Elie** b. Nantes. 1828 - 1891 Portraits & historical subjects Exh: Italy, France etc	ELIE DELAUNAY-
DELAUNAY **Robert** b. Paris. 1885 - 1941 Portraits, landscapes, abstract art etc Exh: France	*r. delaunay*
DELEN **Dirk van** b. Heusden. 1605 ? - 1671 Landscapes, genre & architectural subjects Exh: Holland, Austria, UK, Belgium etc	*D Delen* D. van DELEN

DELIN **Johannes Josephus Nicolaus** b. Anvers. 1776 - 1811 Portraits & historical subjects	*J. Delin*
DELL **John H.** b. 1836(?) - 1888 Genre, animals, landscapes Exh: RA. BI, UK AG'S	*D/69*
DELOBBE **Francois Alfred** b. Paris. 1835 - 1920 Figure & genre subjects etc Exh: Germany, France	*A. Delobbe.*
DELORME **Pierre Claude Francois** b. Paris. 1783 - 1859 Portraits & historical subjects Exh: France	*Delorme*
DELPHY **Hippolyte Camille** b. France. 1842 - 1910 Landscape artist Exh: France	*H.C. Delpy.*
DELSENBACH **Johann Adam** b. Nuremburg. 1687 - 1765 Portrait & landscape artist	*AD D*
DELUERMOZ **Henri** b. Paris. 1876 - 1943 Animal, military & landscape artist Exh: France, US etc	*Deluermoz*
DEMARNE **Jean Louis** b. Brussels. 1744 - 1829 Animal & genre subjects etc Exh: French AG's	*DeMarne*
DEMEL **Richard** b. Poland. 1921 - Engraver, oil & b/white media Exh: RBA, London & Prov & Italian AG's	*R. Demel*
DEMONT **Adrien Louis** b. Douai. 1851 - 1928 Landscape & genre subjects etc Exh: France, Belgium, US, Australia etc	*adrien Demont*

DEMONT-BRETON **Virginie** b. France. 1859 - 1935 Portrait, genre & landscape artist Exh: US, Holland, Belgium, France	*Virginie Demont-Breton*
DEMORY **Charles Theophile** b. Arras. 1833 - 1895 Genre & historical subjects Exh: France	CH DEMORY.
DEMPSTER	See JONES Thomas Dempster
DENATO **Francesco** Flourished 15th Century Religious & historical subjects	D✝N
DENIS **Maurice** b. France. 1870 - 1943 Religious, figure, genre & landscapes etc Exh: France, Belgium, Italy	MAURICE DENIS *Maurice Denis* MAU. DENIS MAUD
DENIS **Simon Joseph Alexander Clement** b. Anvers. 1755 - 1813 Landscape artist Exh: France	*Denis.* *D.*
DENMAN **Gladys** b. Hampstead. 1900 - Portrait, landscape artist & miniaturist Exh: RP, RWA, SWA, RMS, SM, RI	DENMAN *GJD*
DENNER **Balthazar** b. Hamburg. 1685 - 1749 Miniaturist & portrait artist Exh: Holland, Germany, Hungary, Italy etc	*Denner feci* *1724* *Denner* *1726 feit* *B*
DENNEULIN **Jules** b. Lille. 1835 - 1904 Genre & landscape artist Exh: France	*J. Denneulin*

DENTON **Kenneth** b. Chatham. 1932 - Landscape & marine artist Exh: RSMA, London & Prov. AG's	*Kenneth Denton* *Kenneth Denton*
DEONON **Vivant Dominique** b. France. 1747 - 1825 Portrait, genre & landscape artist Exh: France	
DERAIN **Andre** b. France. 1880 - 1954 Portrait, figure, still life, genre & landscape artist Exh: France, etc	*aderain*
DERUET (or DERVET) **Claude** b. Nancy. 1588 - 1662 Portrait & historical subjects Exh: France	
DESAVARY **Charles Paul** b. Arras. 1837 - 1885 Landscape artist Exh: France	*CB DESAVARY*
DESBOUTIN **Marcellin Gilbert** b. France. 1823 - 1902 Portraits & genre subjects Exh: France	*M Dyboutin.* *MD*
DESBROSSES **Jean Alfred** b. Paris. 1835 - 1906 Landscape artist Exh: France	*JEAN DESBROSSES.*
DESCAMPS **Guillaume Desire Joseph** b. Lille. 1779 - 1858 Historical subjects Exh: Italy, France	*G. DESCAMPS*
DESCHAMPS **Louis Henri** b. France. 1846 - 1902 Genre, historical & rusttic subjects etc Exh: France	*Louis Deschamps*
DES CLAYES, Ass. RCA **Alice** b. Aberdeen. 1891 - Landscapes, animals & sporting subjects Exh: RA, PS, WAG & Canadian AG's	*ALICE DES Clayes.* *alice Des Clayes*

DESCOURS **Michel Hubert** b. Bernay. 1717 - 1775 Portraits & religious subjects Exh: France etc	*descourt.*
DESENNE, FIAL **Lucie Renee** b. Madagascar. 1920 - Portrait & marine subjects Exh: RWA, London & Prov. AG's	*c d m*
DESGOFFE **Blaise Alexandre** b. Paris. 1830 - 1901 Portrait & still life artist Exh: France	*Blaise-Desgoffe*
DESHAYS de COLLEVILLE **Jean Baptiste Henri** b. Colleville.(Fr.) 1729 - 1765 Historical artist Exh: France	*JBHDeshayes &B Deshays*
DESPORTES **Alexandre Francois** b. France. 1661 - 1743 Portraits & hunting scenes & still life subjects Exh: France, UK, Russia, Germany	*Desportes 1714 Desportes 1714* *Desportes Des Portes* *Des Portes*
DESVALLIERES **Georges** b. Paris. 1861 - 1950 Portrait, religious, mythological & figure painter Exh: France etc	*George Desvallieres* *G Desvallières*
DETAILLE **Jean Baptiste Edouard** b. Paris. 1848 - 1912 Historical & battle scenes Exh: France	*EdouARD DETAILLE*
DETMOLD **Edward Julius** b. London. 1883 - 1957 Flora & fauna watercolourist Exh: London & prov. AG's	*[monogram EJD]*

DETREZ **Ambroise** b. Paris. 1811 - 1863 Portraits & landscapes etc Exh: PS etc	*A Detrez*
DETTHOW **Eric** b. Sweden. 1893 - Figure & landscape artist Exh: France	*Detthow*
DETTMANN **Ludwig Julius Christian** b. Germany. 1865 - ? Genre artist Exh: Germany, France	*Ludwig Dettmann*
DEVAMBEZ **Andre Victor Edouard** b. Paris. 1867 - 1943 Genre artist Exh: Italy, France	*Andre Devambez*
DEVEDEUX **Louis** b. France. 1820 - 1874 Genre & historical subjects Exh: France etc	*L. DEVEDEUX*
DEVERIA **Achille Jacques Jean Marie** b. Paris. 1800 - 1857 Portraits, genre & mythological subjects Exh: French AG's	*AD*
DEVILLY **Louis Theodore** b. Metz, 1818 - 1886 Genre & historical artist Exh: France	*T. Devilly*
DEVOSGE **Claude Francois 111** b. France. 1732 - 1811 Portraits & historical subjects Exh: Italy, France	*f Devosges.*
DEWHURST **Wynford** b. Manchester. 1864 - ? Landscape artist Exh: UK AG's	*W.D W.D. W.D.*
DEXTER, RBA **Walter** b. Wellingborough. 1876 - 1958 Portraits, landscapes, domestic & still life subjects Exh: RA, RBA	*Walter Dexter. R·B·A* \[WD\]

DEYRIEUX **Georges** b. France. 1820 - 1868 Still life & floral subjects etc Exh: France	G·DEYRiEUX·1849
DEYROLLE **Theophile Louis** b. Paris. ? - 1923 Genre artist Exh: France	H Deyrolle
DIAZ de la PENA **Narcisse Virgile** b. Bordeaux 1807 - 1876 Genre & landscape artist Exh: European, UK, Canadian AG's etc	N. Diaz. N. Diaz N. Diaz II. D N. D N. Diaz. N-DIAZ.
DIBDIN **Thomas Colman** b. London. 1810 - 1893 Architectural & landscape artist Exh: BI, SS, RA	TCD
DICK **Isabel Elizabeth** b. UK. 20th C. Still life subjects Exh: RA, SWA	ID
DICKENS **Rosemary** b. Salisbury 1943 - Floral, birds, & landscape subjects etc. Exh: London & Prov. AG's	R Dickens Rosemary
DICKER **Molly** b. Kent. 1924 - Portrait, semi-abstract, landscape artist Exh: RBA, ROI, SWA, RA, Prov. AG's etc	Molly Dicker
DICKINSON **Lowes Cato** b. London. 1819 - 1908 Portrait artist Exh: RA, NPG	LDC 1878

DICKSEE, PRA **Sir Frank** b. London. 1853 - 1928 Genre & portrait artist Exh: RA, London & Prov. AG's, Australia	*F. D*
DICKSEE **Herbert Thomas** b. London. 1862 - 1942 Animal & historical subjects Exh: RA	*HD*
DICKSEE **John Robert** b. London. 1817 - 1905 Genre & portrait artist Exh: London & Prov. AG's	*JD*
DICKSON **Frank** b. Nr. Chester. 1862 - 1936 Landscape artist Exh: RA, London & Prov. AG's	*FD* *FD*
DIDIER **Jules** b. Paris. 1831 - 1892 Animal & landscape artist Exh: France	*JULES DIDIER*
DIDIER-POUGET **William** b. Toulouse. 1864 - 1959 Landscape artist Exh: Germany, France, US etc	*Didier_Pouget*
DIEHL **Gosta** b. Viipuri. 1899 - B/White, oil & watercolourist Exh: Paris, Stockholm, Oslo	*Diehl*
DIELMAN **Pierre Emmanuel** b. Belgium. 1800 - 1858 Landscape & animal subjects Exh: France, Italy, Switzerland	*P.E.D.* *P.D.*
DIEPENBEECK **Abraham van** b. Bois-le-Duc. 1599 - 1675 Portraits, animal & historical subjects Exh: Germany, Belgium. Holland, UK etc	*AD.* *A* *AD.* *BC* *AD* *ADi* *BD1664*

DIEPRAAM **Abraham** b. Holland. 1622 - 1670 Genre artist Exh: Germany, Holland etc	*Diepraam* 𝒜𝒟 *D P 1640* *A.*
DIERCKX **Pierre Jacques** b. Anvers. 1855 - ? Genre subjects Exh: Belgium, Germany	*Dierckx*
DIETRICY (or DIETRICH) **Christian Wilhelm Ernst** b. Weimar. 1712 - 1774 Genre, landscapes & historical subjects etc Exh: France, Belgium, Germany, UK, Italy, Austria etc	*Dietricy Pinx 1753* *Dietruy – fecit 1763.* *Dietricy fecit 1,745.*
DIGNIMONT **Andre** b Paris. 1891 - 1965 Portrait, figure & genre subjects Exh: France	*Dignimont*
DILLIS **Cantius von** b. Germany. 1779 - 1856 Landscape artist Exh: Germany	*Cantius D.*
DILLIS **George von** b. Germany. 1759 - 1841 Portrait & landscape artist Exh: Germany	*GD.* *G D.*
DILLON **Frank** b. London. 1823 - 1909 Egyptian & Oriental subjects Exh: UK, France, Germany	**F. Dillon**
DINET **Alphonse Etienne** b. Paris. 1861 - ? Arabian scenes etc Exh: France, Algeria, Australia	E DINET.

DINKEL, ARWS, ARCA **Ernest Michael** b. Huddersfield. 1894 - Oil, tempera & watercolourist Exh: RA, NEAC, R. Scot. A, RWS	*E M Dinkel*
DIONISY **Jan Michiel** b. Belgium. 1794 - ? Miniaturist & portrait artist	*J M D*
DITTENBERGER **Gustav** b. Germany. 1794 - 1879 Miniaturist, genre & historical artist	*GD* *D.*
DIXON, SSA, RSW **Anna** b. Edinburgh. Oil & watercolourist Exh: RSW, RA, RSA, GI. & Prov. AG's	*Anna Dixon*
DIXON **Charles** b. Goring. 1872 - 1934 Marine & historical subjects Exh: RA, London & Prov. AG's	*C D*
DOAR **M. Wilson** b. 1898 - Dog portraiture Exh: RSA, RBA, R.Cam.A, PAS	*DOAR*
DOBLE **Frank Sellar** b. Liverpool. 1898 - Oil & watercolourist Exh: WAG & Prov. AG's	*Frank S. Doble* *FD* *19 FD 27*
DOBSON, RWS, RA **William Charles Thomas** b. Hamburg. 1817 - 1898 Genre, oil & watercolourist Exh' RA, RWS, London & Prov. AG's Australia	*M 1887* *M 1886* *18 88 88* *18 89 89*
DODD, RA, RWS **Francis** b. Holyhead. 1874 - 1949 Landscapes & architectural views Exh: RA, RWS, NEAC	*FD*
DODD **William** b. Kendal. 1908 - Oil & watercolourist Exh: RBA, NEAC, RI, RSA, R.Cam.A, RWA	*W. DODD*

DOES (The Younger) **Jacob van der** b. Amsterdam. 1654 - 1699 Figures, animals, landscapes & historical subjects	*J Do-p*
DOES **Simon van der** b. Amsterdam. 1653 - 1717 Portraits, animals & landscape artist Exh: Holland, Germany, Belgium, France etc	*S V Does 1708 V Does 1699.*
DOLCI **Agnese** b. Italy. ? - 1686 Historical subjects Exh: France	*A Dolci*
DOLCI (or DOLCE) **Carlo** b. Florence. 1616 - 1686 Portraits & historical subjects Exh: France, Hungary, Italy, UK, Austria etc	*C Dolci*
DOLLMAN, RWS, RBC, RI **John Charles** b. Brighton. 1851 - 1934 Oil & watercolourist Exh: UK, Australia	*J.C.Dollman*
DOMERGUE **Jean Gabriel** b. Bordeaux. 1889 - 1962 Figure & portrait artist Exh: France	*Jean Gabriel Domergue*
DONCRE **Guillaume Dominique Jacques** b. France. 1743 - 1820 Still life & portrait artist Exh: France	*D.Doncre*
DONGEN **Kees van** b. Holland. 1877 - ? Landscape, genre, figure & portrait artist Exh: US & European AG's	*van Dongen.* *van Dongen*
DONKER **Pieter** b. Holland. 1635 ? - 1668 Historical subjects	*PD PD del*

DONNE, NDD, ATD, FRSA, SG Peter Ivan b. India. 1927 - Landscapes, oil, acrylic & watercolour, drawings, etc. Exh: London & Prov. AG's	*Peter Donne* *E Plli*
DONNE **Walter** b. England. 1867 - ? Landscape artist Exh: UK, France	**·WALTER DONNE·**
DORE **Paul Gustave Louis Christophe** b. Strasbourg. 1832 - 1883 Portraits, historical, allegorical, land- scapes & genre subjects etc Exh: European AG's etc	*G. Dore* *GD*
DORIGNY **Nicolas** b. Paris. 1652 - 1746 Historical subjects Exh: UK, France	*ND.*
DORN **Joseph** b. Germany. 1759 - 1841 Genre & historical subjects Exh: Austria, Germany	*D*
DORNEL **Jacques** b. 1775 - 1852 Historical & landscape artist Exh: Germany	*18 D 17*
DORNER (The Elder) **Johann Jakob** b. Germany. 1741 - 1813 Religious, historical, genre & land- scape artist Exh: Germany, Switzerland	*V̶D.* *ICD.* *Đ.*
DOSSI **Battista** b. Italy. 1474 ? - 1548 Humourous genre & landscape artist Exh: Italy	*[monogram]* *[monogram]*
DOSSI **Giovanni** b. Mantoue. 1479 ? - 1542 Portraits & historical subjects Exh: Germany, Hungary, Italy, France, UK etc	*GBDossi*
DOUCET **Henri Lucien** b. Paris. 1856 - 1895 Genre & historical subjects Exh: France	*L Doucet*

DOUGLAS **Edwin** b. Edinburgh. 1848 - ? Sporting, animal & genre artist Exh: RA, RSA etc	
DOUGLAS, PRSA **Sir William Fettes** b. Edinburgh. 1822 - 1891 Interiors, landscapes & historical genre Exh: RA, RSA, London & Prov. AG's	
DOV (or DOU) **Gerrit** b. Leyden. 1613 - 1675 Genre & portrait artist Exh: Russia & European AG's	
DOUZETTE **Louis** b. Germany. 1834 - ? Landscape artist Exh: Holland, Belgium, Germany, Russia etc	
DOW, RSW **Thomas Millie** b. Fifeshire. 1848 - 1919 Genre & landscape artist Exh: London & Prov. AG's	
DOWNARD **Ebenezer Newman** FL. 19th C. Portraits, genre, religious & landscape subjects Exh: RA, BI, SS	
DOWNIE, RSW **Patrick** b. Greenock. 19th C. Genre & landscape artist Exh: PS, RA, RSA, GI, SS & Prov. AG's	
DOYÉN **Gabriel Francois** b. Paris. 1726 - 1806 Portraits & historical subjects Exh: France	
DOYLE **Bentinck Cavendish** b. Worthing Flowers & marine artist Exh: RA, ROI & Prov. AG's	
DOYLE **Richard** b. London. 1824 - 1883 Caricaturist & painter of fairy scenes Exh: RA, GG, UK & Prov. AG's	

DRAPER **Herbert James** b. London. 1864 - 1920 Genre, classical & mythological subjects Exh: RA, NG, UK AG's, Paris	HJD HJD *D*
DRECHSLER **Johann Baptist** b. Vienna. 1756 - 1811 Floral & still life subjects Exh: Germany, Russia, Austria	*Drechsler. fn -*
DREVER **Adrian van** Flourished Holland 17th Century Marine & landscape artist Exh: Austria	*AD*
DREVET **Jean Baptiste** b. Lyon. 1854 - ? Marine & landscape artist Exh: France	*(monogram in circle)*
DRIELST **Egbert van** b. Holland. 1746 - 1818 Landscape artist Exh: Holland, France	*E. van Drielst* E. V. Dt
DRIFT **Johannes Adrianus van der** b. Holland. 1808 - 1883 Town scenes & landscape artist Exh: Holland	*ADD.*
DRING **Dennis William** b. London. 1904 - Portrait & landscape artist Exh: RA, RWS, RP	*WMauudring.*
DRING, ARCA, NSPC **James** b. London. 1905 - Oil & watercolourist Exh: RA, RBA, NSPS, NEAC, Prov. AG's, Europe & US	*(monogram)*
DROLLING **Martin** b. 1752 - 1817 Interiors, genre & portrait artist Exh: France, Germany	*Drolling*

DROLLING **Michel Martin** b. Paris. 1786 - 1851 Portraits & historical subjects Exh: France, Germany	*Drolling. M.*
DROOCH SLOOT (or DROOGSLOOT) **Joost Cornelisz** b. Utrecht. 1586 - 1666 Religious, historical subjects, fairs etc. Exh: Holland, Belgium, Germany, Russia, Spain etc	*K Drooch Sloot* *f 1630* *J.D.* *1651*
DROOST **Jan van** b. 1638 - 1694 Portrait, genre & historical subjects	*JDroost*
DROSSAERT **Jacob** Flourished 18th Century Landscapes, hunting scenes etc Exh: Holland	**BF**
DROUAIS **Jean Germain** b. Paris. 1763 - 1788 Biblical & historical subjects Exh: France	*Drouais J.*
DRUMMOND **Gordon L.T.** b. Sale, Cheshire. 1921 - Watercolour & miniaturist. Exh: RWS, RI, London & Prov. AG's	**GD**
DRUMMOND **James** b. Edinburgh. 1816 - 1877 Genre & historical subjects Exh: London & Prov. AG's	*D. 1856*
DRURY **Paul Dalou** b. UK. 1903 - Genre subjects Exh: RA, RE, etc.	**PD**
DUBBELS **Hendrik Jacobsz** b. Amsterdam. 1621 ? - 1676 ? Marine artist Exh: Holland, Italy, France, Denmark Germany	*Dubbels* *Dubbels.* *H.* *DVBBELS*
DUBBELS **Jan** Fl. 18th C. Marine artist Exh: Italy	*Dubbels*

DUBOIS **Desire** b. Calais. ? - 1889 Portrait & landscape artist Exh: France	*DuBois,1867*
DUBOIS **Francois** b. Paris. 1790 - 1871 Portraits & historical subjects etc Exh: France	FRANCOIS.DVBOIS
DUBOIS **Paul** b. France. 1829 - 1905 Portrait artist Exh: France, Hungary	*G Dubos*
DUBORDIEU **Pieter** b. France. ? - 1679 ? Portrait artist Exh: Germany, Holland, France	HD.
DUBOURCQ **Pierre Louis** b. Amsterdam. 1815 - 1873 Landscape artist Exh: Holland	*D* *D*
DUBOURG **Louis Fabricius** b. Amsterdam. 1693 - 1775 Portraits, miniaturist etc Exh: Germany	*L F D* *L F D B* *L F D* *L F D* L F D B
DUCHEMIN **Isaak** Flourished Belgium 17th Century Portraits & historical subjects	*P*
DUCIS **Louis** b. Versailles. 1775 - 1847 Portraits & historical subjects Exh: France	*L Ducis*
DUCK **Jacob** b. Utrecht. 1600 ? - 1661 ? Portraits, military & historical subjects Exh: Russia, & European AG's	*J Duck*

DUCLUZEAU **Marie Adelaide** b. Paris. 1787 - 1849 Portrait & genre artist Exh: France	
DUCORNET **Louis Joseph Cesar** b. Lille. 1806 - 1856 Biblical, historical & portrait artist Exh: France	C. DUCORNET
DUCQ **Jan le** b. The Hague. 1630 ? - 1676 Genre, military, animals & landscape artist Exh: France, Austria, UK etc	I D·661 I Duc
DUCREUX **Joseph** b. Nancy. 1735 - 1802 Portrait artist Exh: Austria, France, UK	
DUDLEY **John** b. Eton. 1915 - Portrait & landscape artist & miniaturist Exh: PAS, SM, RWS	
DUEZ **Ernest Ange** b. Paris. 1843 - 1896 Portrait, genre & landscape artist Exh: France, Germany, US	
DUFAU **Clementine Helene** b. France. 1869 - ? Genre & landscape artist Exh: France	
DUFAU **Fortune** b. France. 1770 - 1821 Portrait, historical, genre subjects etc. Exh: France	
DUFF, RI, RE, PAS, MA, LL.B. **John Robert Keitley** b. London. 1862 - ? Rustic genre Exh: RA, SS, RI, London & Prov. AG's etc	

DUFLOS **Philothee Francois** b. Paris. 1710 - 1746 Portrait & historical subjects Exh: Italy, France	*D.f.* *D.f.*
DUFRENOY **Georges Leon** b. France. 1870 - 1942 Figure & landscape artist Exh: Belgium, France	*Dufrenay*
DUFY **Raoul** b. Havre. 1877 - 1953 Portrait, figure, genre, still life & landscape artist Exh: UK, European AG's etc	*Raoul Dufy* *Raoul Dufy* *Raoul Dufy* *Raoul Dufy* *Raoul Dufy*
DUGHET **Gaspard** b. Rome. 1615 - 1675 Landscape artist Exh: UK & European AG's etc	*GD*
DUHEM **Henri Aime** b. France. 1860 - ? Landscape artist Exh: France	*HENRI DUHEM.*
DUJARDIN **Edward** b. Anvers. 1817 - 1889 Historical subjects Exh: Anvers	*Edward Du Jardin*

DUJARDIN **Karel** b. Holland. 1622 - 1678 Portrait, genre & landscape artist Exh: France, Holland, Germany, Belgium, Hungary etc	K. DU. IARDIN. fe K. DU. IARDIN. fe KAREL : DU : IARDIN : fec K: DuJARDIN K: Dv. IARDIN K: Du Jardin K J F
DUNANT **Jean Francois** b. Lyon. 1780 - 1858 Interiors, genre & historical subjects Exh: France	D^t
DUNCAN **Edward** b. London. 1803 - 1882 Marine & landscape artist Exh: RA, London & Prov. AG's	E Duncan
DUNCAN, RSA, RSW **John McKirdy** b. Dundee. 1866 - 1945 Genre, historical & landscape artist Exh: RA, VA, UK AG's	
DUNCAN **Lawrence** Fl. 1860 - 1891 Genre & landscape, oil & watercolourist Exh: London & Prov. AG's	D. 1862
DUNCAN **Ruth** b. Colorado. 1908 - Landscape artist Exh: France	RUTH DUNCAN
DUNCAN **Thomas** b. Scotland. 1807 - 1845 Genre & portrait artist Exh: RA, Scottish & UK AG's	Thomas Duncan Pinx

DUNKER **Balthasar Anton** b. Germany. 1746 - 1807 Landscape artist	*Df.*
DUNLOP, RBA **Ronald Ossory** b. Dublin. 1894 - Painter in oil media Exh: London RBA, NS etc	*RODunlop*
DUNN **Frances Cecilia Troyte** b. Clifton. 1878 - ? Religious subjects Exh: RBSA	*F.Dunn*
DUNOUY **Alexandre Hyacinthe** b. Paris. 1757 - 1841 Landscape artist Exh: France	*AD AD AD AD*
DUNOYER de SEGONZAC **Andre Albert Marie** b. France. 1884 - Still life, figure, genre & landscape artist Exh: European & US AG's	*A. Dunoyer de Segonzac*
DUNZ **Johannes** b. 1644 - 1736 Portrait & still life subjects Exh: Switzerland	*HD HD*
DUPLESSIS **Joseph Siffrein** b. France. 1725 - 1802 Portrait artist Exh: France, Germany	*J.S. Duplessis*
DUPONT **Francois Leonard** b. Belgium. 1756 - 1821 Miniaturist, genre, still life & portrait artist Exh: UK, France	*J. Dupont*
DUPRE **Jules** b. Nantes. 1811 - 1889 Genre, marine & landscapes etc Exh: France, Holland, Germany, Sweden etc	*Jules Dupré* *J. Dupré J.D.*

DUPRE **Julien** b. Paris. 1851 - 1910 Animal & landscape artist Exh: France, US etc	JULIEN DUPRÉ
DUPUY **Paul Michel** b. 1869 - ? Genre subjects Exh: France	*P. M. Dupuy*
DURAND-DURANGEL **Antoine Victor Leopold** b. Marseilles. 1828 - 1898 ? Genre subjects Exh: France	LEOPOLD DURANGEL
DURDEN, ROI **James** b. Manchester. 1878 - ? Genre artist Exh: RA, PS, AG etc	DURDEN/
DURER **Albrecht** b. Nuremberg. 1471 - 1528 Portraits, landscapes & historical subjects. Exh: International AG's & collections	*Albrecht Durer* *Albertus Dürer*
DURINGER **Daniel** b. 1720 - 1786 Animal, landscape & portrait artist Exh: Switzerland	
DURRANT, NDD, FRSA **Roy Turner** b. 1925 - Oil, gouache & watercolourist Exh: RA, London & Prov. AG's	
DUSART **Cornelis** b. Haarlem. 1660 - 1704 Genre & landscape artist Exh: Holland, Germany, Hungary, Russia, UK etc	*Crn du Sart f.* *1682* *Corn. Dusart*

DUTHOIT **Paul Maurice** b. Lille. 1858 - ? Genre subjects Exh: France	*Paul Duthoit*
DUTILLEUX **Henri Joseph Constant** b. Douai. 1807 - 1865 Portrait, still life, historical, land- scape subjects etc Exh: France	✠ C. DUTILLEUX
DUTTON **Harold John** b. Birmingham. 1889 - Pencil. oil, pastel & watercolour media Exh: RBSA & Prov. AG's	DUTTON
DUYTS **Gustave den** b. Belgium. 1850 - 1897 Landscape artist Exh: Belgium, France	Gustave Den Duyts
DYCE, RA, HRSA **William** b. Aberdeen. 1806 - 1864 Portraits, religious & historical subjects Exh: RA, RSA, BI, London & Prov. AG's, Germany	WD WD 1845
DYCK **Anton van** b. Anvers. 1599 - 1641 Portraits & historical subjects Exh: UK, US & European AG's	A·VAN DYCK ⅄⅄D Ant. van Dyck. fecit A°. van Dyck A. Vandyck. Ant van Dvck Dyck .f.
DYCK **Daniel van den** b. ? - 1670 Historical subjects	DD f. DD

DYCK **Floris van** b. Haarlem. 1575 - 1651 Still life artist Exh: Holland	*[signature]*
DYCKMANS **Josephus Laurentius** b. Lierre. 1811 - 1888 Genre artist Exh: Belgium	*J Dyckmans [signature]*

E

EARL **Maud** Fl. London/Paris. 1884 - 1908 Animal subjects Exh: RA, PS, US	*ME [monogram]* *NE [monogram]*
EAST, RA, RI, PRBA, RPE **Sir Alfred** b. Kettering. 1849 - 1913 Landscape artist Exh: RA, BI, NWS, RI etc	*AE [monogram]* *[AE monogram in octagon]*
EBEL **Fritz Carl Werner** b. Germany. 1835 - 1895 Landscape artist Exh: Germany	*F. Ebel [signature]*
EBERLE **Adolf** b. Munich. 1843 - 1914 Genre artist Exh: Germany	*Adolf Eberle [signature]*
ECKENBRECHER **Karl Themistocles von** b. Athens. 1842 - ? Oriental subjects, landscapes etc Exh: German AG's	*TvEckenbrecher [signature]* *T.v.E [monogram]*
ECKERT **Henri Amros** b. Germany. 1807 - 1840 Battle scenes, marine subjects etc Exh: Germany	*HAE [monogram]*
EDELFELT **Albert Gustaf Aristides** b. Helsinki. 1854 - 1905 Portrait genre & landscape artist Exh: Finland, Sweden, Russia, France, Denmark etc	*EDELFET [signature]*

EDEN **Denis William** b. Liverpool. 1878 - Portraits & historical subjects Exh: RA & Prov. AG's	DENIS - EDEN 1927 19 E 25
EDGECOMBE **Reginald Edward** b. 1885 - B/White, oil & watercolour media Exh: RBSA	
EDMONSTON **Samuel** b. Edinburgh. 1825 - ? Genre, landscape & marine artist Exh: RA, RSA	S. Edmonston. 1860
EDWARDES **May de Montravel** b. London. 1887 - Miniaturist Exh: PS, SA, RA, RI, SM etc	M. de M. -
EDWARDS, RI, RCA **Lionel D.R.** b. England. 1878 - Animals, sporting & landscape subjects Exh: London & Prov. AG's	Lionel Edwards
EECKELE (or EECKE) **Jan van** Flourished Bruges 16th Century Portraits & historical subjects	
EECKHOUT **Gerbrand van den** b. Amsterdam. 1621 - 1674 Portraits, historical & biblical scenes etc Exh: UK & European AG's	G. v. Eeckhout. fe. A 1655. Gv Eeckout
EECKHOUT **Jakob Joseph** b. Anvers. 1793 - 1861 Portraits, genre & historical subjects Exh: Holland, Belgium, France	JJE JJE.
EGGINGTON, RI. RCA **Wycliffe** b. Birmingham. 1875 - 1951 Landscape artist Exh: RA, PS, WAG & Prov. AG's	W. Egginton.

EHRMANN **Francois Emile** b. Strasbourg. 1833 - 1910 Genre & allegorical subjects Exh: France	F. EHRMANN
EISEN **Charles Dominique Joseph** b. Valenciennes. 1720 - 1778 Genre subjects etc Exh: European AG's	*Eisen~C 1750*
ELDRED **Charles D.** Fl. 1889 - 1909 Marine watercolourist Exh: US	[monogram]
ELDRIDGE, ARCA, ARWS, ASMP, **Mildred E** FRSA b. Wimbledon. 1909 - Oil & watercolourist Exh: RA, R. Scot. A, R.Cam.A, RHA, RWS etc	*mildred. E. Eldridge.*
ELGOOD, RI **George S.** b. Leicester. 1851 - 1935 Genre & landscape artist Exh: FAS, SS, RI, Prov. AG's, Australia	G.S.E.
ELIAERTS **Jean Francois** b. Belgium. 1761 - 1848 Genre & still life subjects Exh: France, Belgium	*J.F. Eliaerts*
ELIOT **Maurice** b. Paris. 1864 - ? Genre artist Exh: France	*Maurice Eliot*
ELLENRIEDER **Maria** b. Constance. 1791 - 1863 Portraits & historical subjects Exh: Switzerland, Germany	[monogram ME]
ELLIOT **Frank** b. London. 1858 - ? Portrait & landscape artist, oil & watercolour media Exh: RA.	[monogram]
ELLIOTT **Martha Beggs** b. 1892 - Still life, portrait & landscape artist Exh: X, US	*M. Van Elliott*

E

ELLIOTT **Robinson** b. Newcastle. 1814 - 1894 Portraits, genre, landscapes & biblical subjects Exh: RA, SS, BI, NWS, etc	*R Elliott*
ELLIOTT, PS, FBIS **Walter Albert** b. Wembley, Mddx. 1930 - Portraits, landscapes & allegorical subjects in various media Exh: PAS, London & Prov. AG's	*Walter A. Elliott*
ELLIS **Jeanie Wright** b. Perthshire Portraits & animal subjects Exh: RSA	*JwEllis*
ELLIS **Tristram J** b. England. 1844 - 1922 Landscape artist Exh: RA, NWS, GG	*T.E.*
ELMORE, RA **Alfred** b. Clonakelty. 1815 - 1881 Genre & historical subjects Exh: Australia, London & Prov. AG's	*Æ*
ELMORE **Richard** Fl. 1852 - 1885 Landscape artist Exh: RA, SS, UK AG's	*Æ*
ELSEN **Alfred** b. Anvers. 1850 - 1900 Landscape artist Exh: Belgium, UK, France	*A Elsen*
ELSHEIMER **Adam** b. Frankfurt, 1578? - 1620 Landscapes, historical, night & moonlight scenes Exh: European AG's	*Alsheimen* *Æ.P.* *Æ.* *Æ.* *AE*
ELWES **Simon** b. Rugby. 1902 - Portrait artist Exh: RA, London & Prov. AG's France	*Simon Elwes*

ELWYN **John** b. Dyfed, Wales. 1916 - Landscape artist Exh: RA, London & Prov. AG's	*John Elwyn*
EMPOLI (called CHIMENTI) **Jacopo** b. Empoli. 1554 - 1640 Historical subjects	*Empoli*
EMSLIE **Alfred Edward** Fl. London late 19th C. Genre oil & watercolourist Exh: RA, SS, OWS, NWS, GG, Paris	
ENGALIERE **Marius** b. Marseilles. 1824 - 1857 Town & country scenes Exh: France	*Engaliere '54*
ENGELBERTSZ **Cornelis** b. Leyde. 1468? - 1533 Biblical & historical subjects Exh: Holland, France, Germany, Hungary, UK etc	
ENGELBERTSZ **Luc** b. Leyde. 1495 - 1522 Portraits & historical subjects	
ENGELEN **Antoine Francois Louis van** b. Lierre. 1856 - ? Historical subjects Exh: Belgium	*Louis van Engelen*
ENGELEN **Piet van** b. Lierre. 1863 - ? Animal subjects Exh: Belgium, France	*Piet van Engelen*
ENGLISH **Grace** b. London. 1891 - 1956 Portrait & figure studies Exh: RA, NEAC, RP, NPS	*ŒNGLISH*
ENRAGHT-MOONY **Robert James** b. Athlone Landscape artist Exh: RA, PS, NEAC, Prov. & US AG's	

ENSCHEDE **Christina Gerarda** b. Haarlem. 1791 - 1873 Still life artist Exh: Holland	*C.Enschede*
ENSOR **James** b. Ostend. 1860 - 1949 Portrait, still life, genre & landscape artist Exh: Holland, Belgium, France	JAMES ENS C R
EPISCOPIUS **Johannes** b. Amsterdam. 1628 - 1671 Landscapes & historical subjects etc Exh: UK, Holland, Germany, Austria	*J* *J* *JF*
ERLER **Fritz** b. 1868 - 1940 Portraits & genre subjects Exh: France, Germany	*Erler*
ERMELS **Johann Franciscus** b. Germany. 1621 - 1693 Portrait, still life, historical & landscape subjects etc Exh: Germany, Italy, Austria	*HEf.*
ERNLE, SM **The Lady Barbara** Miniaturist Exh: RA, RBA	*A*
ERNST **Rudolph** b. Austria. 1854 - ? Genre & portrait artist Exh: Germany, Austria, France Canada	*R.Ernst.*
ERTZ, RBA, FRSA **Edward Frederick** b. Illinois. 1862 - 1954 Etcher, oil & watercolourist Exh: RA, RBA, London, Paris, Munich & US	*E·ERTz·* *&·&*
ESPAGNAT **Georges d'** b. Paris. 1870 - 1950 Portrait, still life, genre & landscape artist Exh: France	*Sd'E*
ESPINOSA **Jacinto Geronimo de** b. Cocentaina. 1600 - 1680 Biblical & religious subjects Exh: Russia, Hungary, Spain	*h.J. Espinosa 1670*

ESSELENS **Jacob** b. Amsterdam. 1626 - 1687 Landscape artist Exh: Holland, UK, Germany, France etc	*Esselens. F F.E.*
ETCHEVERRY **Hubert Denis** b. Bayonne. 1867 - ? Genre & portrait artist Exh: Italy, France	*D. Etcheverry*
ETTINGER **Josef Carl** b. Munich. 1805 - 1860 Landscape artist	*CE* (monogram)
EURICH, ARA **Richard Ernst** b. UK. 1903 - Portrait, genre & military subjects Exh: UK AG's, Paris	*ER ER ER*
EVANS, ARCA, FRSA **David Lloyd** b. England. 1916 - Painter in oil media Exh: RA	*D Lloyd Evans*
EVANS, RI **Ray** b. Cheshire. 1920 - Landscape watercolourist etc Exh: RA, RI, RSMA, London & Prov. AG's, US, Paris etc	*Ray Evans*
EVANS **Thomas Leonard** b. Cardingshire. 20th C. Landscapes, oil & watercolourist Exh: RA, RIBA, RI, USA, NEAC, R. Cam. A,& Prov. AG's	*T Leonard Evans*
EVERDINGEN **Albert van** b. Alkmaar, 1621 - 1675 Marine & landscape artist Exh: France, Germany, Holland, UK etc	*EVERDINGEN AV*
EVERDINGEN **Cesar Boetius van** b. Alkmaar. 1617 ? - 1678 Portraits, historical & genre subjects Exh: Holland, Germany, Stockholm etc	*CvE CvE 1650 CvE 1652*
EVERETT **Ethel F.** b. London. Childrens portrait artist Exh: RA & London & Prov. AG's	*ETHEL EVERETT EE EE*

EXLEY James Robert Granville b. Nr. Bradford. 1878 - ? Painter & engraver Exh: RA, RE	19 RGE 27
EYCK Jan (or Jehan) van b. Maeseyck. 1385 ? - 1441 Portraits, religious & historical subjects etc Exh: International AG's	JOHĒS · DE · EYCK · ME · FECIT · ANO · m̃cccc̃ · 33̃ · z̃i · OCTOBRIS Iohmnes de eyck fuit hic · 1434 · Actit ano dm · 1432 · 10 · die · ottobric · & ioh de Eyck ·
EYLES Charles b. London. 1851 - ? Landscape artist Exh: RA, RBA, RI	Chas. Eyles

F

FABRE Francois Xavier b. Montpellier. 1766 - 1837 Portrait, historical & landscape artist Exh: Italy, Spain, France	F. X. Fabre. Flor.
FACCINI Pietro b. Boulogne. 1560 - 1602 Portraits & historical subjects Exh: France, Italy	~A~

FAIRHURST, ARMS, MAFA **Enoch** b. Bolton. 1874 - ? Portrait miniaturist Exh: RA, RSA, R.Cam.A, RWA RMS, MAFA, WAG etc	E FAIRHURST 1926
FAIRHURST, FRIBA **Harry Smith** b. Blackburn Oil & watercolourist Exh: RA, London & Prov. AG's	
FAIRHURST, ARCA **Jack Leslie** b. London. 1905 - Portrait artist Exh: RA, RPS etc	Fairhurst
FAIRLESS **Thomas Ker** b. Hexham 1825(?) - 1853 Marine & landscape artist Exh: RA, Prov. AG's	TKF
FAITHORNE **William** b. London. 1616 - 1691 Portrait artist Exh: UK, AG's	F
FAIVRE-DUFFER **Louis Stanislas** b. Nancy. 1818 - 1897 Portraits, genre, religious & animal subjects Exh: France	L FAIVRE - DUFFER
FALBE **Joachim Martin** b. Berlin. 1709 - 1782 Genre artist	
FALCON, RBA, MA **Thomas Adolphus** b. Yorkshire. 1872 - ? Landscape artist Exh: London & Prov. AG's	
FALCONE **Aniello** b. Naples. 1607 - 1656 Battle scenes & historical subjects Exh: France, Italy, Spain	falcone Af Af AF AF

FALDONI **Antonio Giovanni** b. Italy. 1690? - 1770? Portrait & landscape artist	A.F.
FALENS **Carel van** b. Holland. 1683 ? - 1733 Military, hunting & genre subjects Exh: UK, Germany, Russia, France, Italy	c. vanfalens VFalens cr.F.
FALGUIERE **Jean Alexandre Joseph** b. Toulouse. 1831 - 1900 Portrait, figure & genre subjects Exh: Belgium, France etc	A Falguière
FALLER **Louis Clement** b. 1819 - 1901 Genre & portrait artist Exh: France	C Faller C Faller
FANTIN-LATOUR **Ignace Henri Jean Theodore** b. Grenoble. 1836 - 1904 Still life, historical, genre & figure artist Exh: France, Germany, Belgium, Italy, UK etc	Fantin 58
FANTIN-LATOUR **Victoria** b. Paris. 1840 - ? Still life artist Exh: France	V Duboury
FARASYN **Edgard** b. Anvers. 1858 - ? Genre, marine & landscape artist Exh: Belgium, Germany, France	Edg. Farasyn ANTWERPEN
FARMER **(MRS) Alexander** FL. 19th C. Genre & still life artist Exh: RA, SS, BI	Alex: Farmer.
FARQUHARSON, RSA, RA, RSW **David** b. Perth. 1839 - 1907 Landscape artist Exh: RA, London & Prov. AG's, Australia	D.F. 9. [monogram] [monogram]

FARRER **Thomas Charles** b. London. 1839 - 1891 Landscape artist Exh: RA, SS, UK AG's, US	
FAULTE **Michel** Flourished 17th Century Portraits, religious & historical subjects	
FAVART **Antoine Pierre Charles** b. Paris. 1784 - 1867 Historical subjects Exh: France	
FAVORY **Andre** b. Paris. 1888 - 1937 Portrait, figure, genre, still life & landscape artist Exh: France, Belgium, Russia, Sweden	
FAWSSETT **Ann** b. Sussex. 1937 - Abstract, birds, figure & landscape artist Exh: RA, YC, Prov. AG's	
FEARNLEY **Thomas** b. 1802 - 1842 Landscape artist Exh: Germany, Denmark, Sweden	
FEDDEN **A. Romilly** b. Nr. Bristol. 1875 - 1939 Landscapes & street scenes Exh: London & Prov. AG's	
FEDDES (van Harlingen) **Pieter** b. Harlingen. 1586 - 1634 Portrait & historical subjects	
FEI **Cheng-Wu** b. China. 1914 - Exh: RA, RI, RWA, RWS, NEAC, & Prov. AG's	
FELLINI **Giulio Cesare** b. 1600 ? - 1656 Animal & genre subjects	

FELLNER **Ferdinand August Michael** b. Germany. 1799 - 1859 Historical subjects	
FELON **Joseph** b. Bordeaux. 1818 - 1896 Historical & allegorical subjects etc Exh: France	*F*
FELS **Elias** b. 1614 - 1655 Portraits & historical subjects	*E Te ls*
FERG **Franz de Paula** b. Vienna. 1689 - 1740 Genre & landscape artist Exh: Germany, Hungary, Italy, Austria etc	*fP.J.Ferg* *FF* *FF* *XF*
FERGUSON **Nancy** b. Belfast. FL. 20th C. Oil & watercolourist Exh: RUA, RHA	*NFerguson 1953.*
FERNANDO **Winitha** b. Colombo. 1935 - Figurative artist Exh: PS, France, Switzerland, London AG's, Ceylon etc	*WINITHAF*
FERRARI **Gaudenzio** b. Valduggia. 1484 ? - 1546 Sacred & historical subjects Exh: Italy, Germany, Russia, France, UK	*Ferrari p*
FERRIER **Arthur** b. Glasgow. 1891 - Cartoon & Caricaturist	*ARthur·Ferrier*
FERRIER **Gabriel Joseph Marie Augustin** b. France. 1847 - 1914 Portraits & genre subjects Exh: Germany, France	*GABRIEL-FERRIER*
FESELEN **Melchior** b. ? - 1538 Historical subjects Exh: Germany	*MF* *MF*

FETI **Domenico** b. Rome. 1589 - 1624 Historical & mythological subjects Exh: Germany, Hungary, Italy, France, Austria	*D. Feti*
FEUERBACH **Anselme** b.1829 - 1880 Historical subjects Exh: Germany, Switzerland	*A. Feuerbach*
FEYEN **Jacques Eugene** b. France. 1815 - 1908 Genre subjects Exh: France	EUC. FEYEN.
FIALETTI **Odoardo** b. Bologna. 1573 - 1638 Biblical & mythological subjects Exh: UK, Italy	*Of*
FICHEL **Benjamin Eugene** b. Paris. 1826 - 1895 Portraits & genre subjects Exh: France, Holland, Belgium etc	E. FICHEL
FIDLER, ARCA **Constance Louise** b. England. 1904 - Portrait artist Exh: RBA, NEAC, & Prov. AG's	*Fidler*
FIDLER **Harry** b. Salisbury. ? - 1935 Genre & landscape artist Exh: London & Prov. AG's	*Fid.*
FIELDING **Newton** b. Huntington. 1799 - 1856 Animals & landscape artist Exh: OWS, London, France, US	*Newton Fielding* *1831*
FILDES, RA **Sir Luke** b. Liverpool. 1844 - 1927 Genre & portrait artist Exh: RA, London & Prov. AG's, Germany	SLF L.F.
FINCH **Sidney** b. London. 1917 - Space, abstract & portrait artist Exh: London & Southern UK AG's	*S Finch*

FINDLAY, ATD **Peter Gillanders** b. Madras. 1917 - Oil & watercolourist Exh: London & Prov. AG's	
FINNEMORE **Joseph** b. Birmingham. 1860 - 1939 Genre & Portrait artist Exh: RA	
FINNIE, ARE, SSSBA **John** b. Aberdeen. 1829 - 1907 Landscape artist Exh: RA, BI, SS, UK AG'S, Paris	
FIORI **Frederigo**	See **BAROCCI** **Frederigo**
FISCHER **Joseph** b. Vienna. 1769 - 1822 Portrait, religious, genre & landscape artist Exh: Austria	
FISHER **Alfred Hugh** b. London. 1867 - 1945 Landscapes & architectural subjects Exh: RA, SS, NWS, London & Prov. AG's, Paris	
FITZHERBERT, ARCA **Elizabeth** b. Sevenoaks. 1923 - Oil & watercolourist Exh: RA, RHA, AIA etc	
FLAD **Georg** b. Heidelberg. 1853 - 1913 Landscape artist Exh: Germany	
FLAMEN (or FLAMAND) **Albert** Flourished France 17th Century Portrait, genre & landscape artist Exh: UK, France	
FLAMENG **Leopold** b. Brussels. 1831 - 1911 Religious & historical subjects etc Exh: France	

FLANDERS **Dennis** b. London. 1915 - Landscape & town subjects Exh: RA, RWS, London & Prov. AG's	*Dennis Flanders.* *Dennis Flanders*
FLANDIN **Eugene Napoleon** b. Naples. 1803 - 1876 Landscapes & Eastern subjects Exh: France	*Eugene Flandin*
FLANDRIN **Hippolyte Jean** b. Lyons. 1809 - 1864 Portraits, religious & historical subjects etc Exh: France, Belgium, Italy	*H^{te} Flandrin* *H^{te} Flandrin*
FLANDRIN **Jules Leon** b. France. 1871 - 1947 Portraits, still life & landscapes Exh: France, Germany	*Jules FLANDRIN*
FLANDRIN **Paul Jean** b. Lyons. 1811 - 1902 Portrait, genre & landscape subjects etc Exh: France, Belgium	*Paul Flandrin*
FLEMAEL (or FLEMALLE) **Bertholet** b. Liege. 1614 - 1675 Portraits & historical subjects Exh: France, Germany, Belgium, Stockholm	*B. Flemael*
FLETCHER **Frank Morley** b. 1866 - 1949 Genre & portrait artist Exh: VA, London, Paris, Germany, US	*MF* (monogram in circle with arrow)
FLETCHER **Geoffrey Scowcroft** b. Bolton. 1923 - B/White drawings, portraits & land- scapes Exh: RA, NEAC	*GSF*
FLETCHER-WATSON, MEM, RI,RBA **James** b. Surrey. 1913 - Landscape, watercolourist Exh: RA, PS, RI, RBA, US, Prov. AG's	*J. Fletcher Watson.*
FLEURY **Pierre** b. Boulogne. 1900 - Marine & landscape artist Exh: France	*Pierre Fleury*

FLINCK (or FLINK) **Govert** b. Middelburg. 1615 - 1660 Portraits & historical subjects Exh: UK & European AG's	*Flinck f 1643* *G Flinck*
FLINT, RA, PRWS, RSW **Sir William Russell** b. Edinburgh. 1880 - 1969 Figure & landscape watercolourist Exh: RA, UK AG'S, France, Germany, Italy, US	*WRF*
FLOOD **Rex Grattan** b. Chorley, Lancs. 1928 - Aviation, wildlife & animal portraits Exh: SWLA, London & Prov. AG's	*Rex Flood*
FLORIS **Frans 1** b. Anvers. 1516 - 1570 Portraits & historical subjects etc Exh: Germany, Italy, France, UK, Sweden etc	*franc floris* FF FF FF *F Flore* *f florano* FF·f FF HF
FOGEL **Seymour** b. New York. 1911 - Oil, tempera & watercolourist Exh: US AG's X	*Fogel*
FOGGIE, ARSA, RSW **David** b. Dundee. 1878 - 1948 Portrait & figure artist Exh: RA, London & Prov. AG's, Germany	*David Fogie*
FOLKES, ATD, RWA, RI **Peter L.** b. Beaminster. 1923 - Semi-Abstract subjects Exh: US, RWA, RI, London & Prov. AG's	*Peter L Folkes.*
FONTANA **Lavinia** b. Bologna. 1552 - 1602 Portraits & historical subjects Exh: France, Italy, Russia, UK	*LAVINIA PROSPERI* *FONTANAE FAC·* *Lav. Fon. Pinxt*
FONTENAY **Louis Henri de** b. Amsterdam. 1800 - ? Genre & historical subjects Exh: France	*(monogram)*

FOORT **Karel** b. Ypres. 1510 - 1562 Historical subjects etc	
FORAIN **Jean Louis** b. Reims. 1852 - 1931 Still life, portrait & genre subjects etc Exh: UK & European AG's	
FORBES (Mrs. STANHOPE) ARWS **Elizabeth Adela** b. Ottowa. 1859 - 1912 Rustic genre & still life artist Exh: RA, SS, NWS, GG, NG, NEAC	
FORBIN **Louis Nicolas Philippe Auguste** **(Comte de)** b. France. 1777 - 1841 Historical & landscape artist Exh: France	
FORD **Henry Justice** b. 1860 - 1941 Romantic & historical subjects Exh: RA, FAS	
FORESTIER—WALKER **Mollie** b. Devon. 1912 - Oil, pencil & pastel media Exh: RS, PP, PAS, NS, PS	
FORSTER **Ernst Joachim** b. Germany. 1800 - 1885 Genre subjects Exh: Germany	
FORSYTH, ARCA, RI, FRSA **Gordon M.** b. 1879 - 1952 Exh: RA, RI & Prov. AG's	
FORTIN **Charles** b. Paris. 1815 - 1865 Genre artist Exh: France	
FORTUNY Y CARBO **Mariano** b. Reus. 1838 - 1874 Genre & historical subjects Exh: Spain, Denmark, Germany, Italy, US, S. America etc	

FOSSANO Ambrogio da	See BORGOGNONE
FOSSARD G.F.M. de FL. 20th C. Oil & watercolourist Exh: UK AG's	
FOSSATI Davide Antonio b. 1708 - 1780 Historical & landscape artist	
FOSTER, RSMA Deryck Arthur b. Bournemouth. 1924 Marine artist Exh: Bermuda, London & Prov. AG's	
FOSTER, RWS Myles Birket b. North Shields. 1825 - 1899 Landscapes & rustic scenes Exh: RA, RWS, OWS, London & Prov. AG's etc	
FOSTER, FZS William b. London. 1853 - 1924 Genre, still life, interiors & landscape artist Exh: RA, SS, NWS	
FOUGERAT Emmanuel b. Rennes. 1869 - ? Genre artist Exh: France	
FOUJITA Tsugouharu b. Tokyo. 1886 - Figure, animal, still life, genre & land- scape subjects etc Exh: Japan, France, Belgium, Germany, US. etc	
FOUQUERAY Dominique Charles b. France. 1872 - 1956 Portraits, historical, marine & military subjects Exh: PS, UK, Japan, US etc	
FOURMOIS Theodore b. Presles. 1814 - 1871 Landscape artist Exh: Belgium	

FOURNIER **Jean** b. 1700 ? - 1765 Portraits & historical subjects Exh: Holland	*J Fourniër*
FOWLE, ROI, CPS, **Lerclerc** b. Hants Oil & watercolourist etc. Exh: RA, RBA, RSA, NEAC, GG, etc.	*Leclerc Fowle*
FOWLER, RWS **Robert** b. Liverpool. 1853 - 1926 Mythological & allegorical subjects Exh: RA, RI, SS etc	*Rf R7*
FOX, SSSBA **Henry Charles** b. 1860(?) - 1922 Landscape artist Exh: RA, SS, Canada, Australia	*HC7 HEF. HCF.*
FOY **Andre** b. Paris. 1886 - Portrait & genre subjects Exh: France	*André Foy*
FRAGONARD **Jean Honore** b. Grasse. 1732 - 1806 Portrait, figure, genre & landscape subjects etc Exh: UK & European AG's	*Fragonard. Frago.*
FRANCAIS **Francois Louis** b. France. 1814 - 1897 Landscape & portrait artist Exh: France, Italy	*Français FRANCAIS* *1864*
FRANCESCHINI **Marco Antonio** b. 1648 - 1729 Historical, religious & mythological subjects Exh: Italy, Germany, France, Austria, Russia etc	*MAF In.*
FRANCIABIGIO	See **BIGIO** **Francesco**
FRANCIS, FRSA **Ivor Pengelly** b. Sussex. 1906 - Painter in oil media Exh: London & Prov. AG's X	*Francis I/48*

FRANCIS **John Deffett** b. Swansea. 1815 - 1901 Genre & portrait artist Exh: RA, BI, SS	*J.D.F.* (J.D.F.)
FRANCK **C.F.** b. 1758 - 1816 Landscape artist Exh: Holland	*C Franck Pinxit*
FRANCK **Hans Ulrich** b. 1603 - 1680 Historical subjects	HF HF
FRANCKEN (The Elder) **Ambrosius** b. 1544 - 1618 Historical subjects Exh: France, Belgium etc	AVfo AF AF
FRANCKEN (The Elder) **Hieronymus 1** b. 1540 - 1610 Religious & historical subjects Exh: France, Belgium, Austria etc	HF HF
FRANCKEN **Hieronymus 111** b. Bruges. 1611 - ? Historical artist	TF
FRANCKEN **Maximilien** b. ? - 1651 Genre & historical artist	MF.
FRANCKEN **Pieter H.** F.L. 17th C. Religious & historical subjects Exh: Holland	PF PF
FRANCOIS **Simon** b. Tours. 1606 - 1671 Portraits etc	F F F
FRANK **Franz Friedrich** b. 1627 - 1687 Portrait artist Exh: Austria	HF

FRANKLIN **John** b. 1800(?) - 1869(?) Architectural & historical subjects Exh: RA, SS, BI, London & Prov. AG's	*F F*
FRANK-WILL b. France. 1900 - Town scenes & landscape subjects	*FRANK·WILL*
FRANQUE **Jean Pierre** b. France. 1774 - 1860 Biblical & historical subjects Exh: France	*P franque.*
FRANQUELIN **Jean Augustin** b. Paris. 1798 - 1839 Biblical & historical artist Exh: France	*Franquelin.*
FRAPPA **Jose** b. France. 1854 - 1904 Genre & portrait artist Exh: France	*José FRAPPA*
FRASER (the Elder), ARSA **Alexander George** b. Edinburgh. 1786 - 1865 Genre, historical & landscape artist Exh: RA, ARSA, UK AG'S, US	*F*
FRASER, RSA **Alexander (Jnr)** b. Linlithgow. 1828 - 1899 Landscape artist Exh: RA, London & Prov. AG's	*A. F.*
FRASER **Donald Hamilton** b. London. 1929 - Painter in oils Exh: European & US. AG's	*Fraser*
FRASER **Francis Arthur** Fl. 1867 - 1883 Figure painter Exh: London & Prov. AG's	*FAF*
FRASER **George Gordon** Fl. 1880 - 1893 Landscape artist Exh: RA, UK AG's	*G.G.F.*

FRATREL (The Elder) **Joseph** b. Epinal. 1730 - 1783 Historical subjects Exh: Germany	
FRAYE **Andre** b. Nantes. 1888 - Military, marine & landscape subjects etc Exh: France, Algeria, UK, US etc	*André Fraye*
FRAZER, RSA **William Miller** b. Perthshire. 1865 - ? Landscape artist Exh: UK AG's	WMF
FREDERIC **Leon Henri Marie** b. Brussels. 1856 - ? Genre & historical subjects Exh: Belgium, France, Germany	*L Frederic*
FREEMAN, ARCS, B.Sc, **Frank** b. Barbados. 1901 - Landscape, figure & portrait artist	FF. 19/28
FREEMAN **William Henry** b. Paris. Fl. 19th C. Portrait artist Exh: PS	
FREETH **H. Andrew** b. Birmingham. 1912 - Portraits, landscapes, etchings, oil & watercolourist Exh: RA, RP, RWS, London & Prov. AG's	*H. A. Freeth.*
FREETH **James Wilfred** b. West Bromwich. 1872 - ? Oil & watercolourist Exh: RA, RHA, RBSA & Prov. AG's	
FREEZOR **George Augustus** Fl. 1861 - 1879 Figure artist Exh: RA & Prov. AG's	G.A.FREEZOR.72
FREMINET **Martin** b. Paris. 1567 - 1619 Portraits & historical subjects etc Exh: France	FREMINET FRE

FRENCH **Susan** b. London. 1912 · Stonepainting & landscape artist Exh: RA, London & Prov. AG's	*Susan French*
FRERE **Charles Theodore** b. Paris. 1814 · 1888 Eastern genre & landscapes Exh: France	T.H.FRERE
FREY **Johann Michael** b. 1750 · 1813 Battle scenes, animals & landscape subjects	MF
FREYBERG (nee STUNTZ) **Maria Electrina von** b. Strasbourg. 1797 · 1847 Genre & historical subjects Exh: Germany	E gels St.
FRIANT **Emile** b. Dieuze. 1863 · 1932 Portrait, genre & landscape artist Exh: France	E. Friant E. Friant
FRICK, RE, FZS **Winifred Marie Louise** b. Ramsgate Bird & animal subjects Exh: RA, RE, PS, SWA	
FRIEDENSON **Arthur A.** b. 1872 · ? Landscape & marine artist Exh: RA, UK AG's	ARTHUR. A. FRIEDENSON, 92
FRIERS, RUA **Rowel Boyd** b. Belfast. 1920 · Oil painter & cartoonist Exh: RUA, UK AG's, US	ROWEL FRIERS —
FRIES **Ernst** b. Heidelberg. 1801 · 1833 Portrait & landscape artist	EF

FRIESZ **Achille Emile Othon** b. France. 1879 - 1949 Portraits, landscapes, genre, still life subjects etc Exh: US & European AG's	*E. Othon Friesz*
FRIPP **Charles Edwin** b. London. 1854 - 1906 Watercolourist Exh: Germany, UK	C.E.F.
FRIPP, RWS **George Arthur** b. Bristol. 1813 - 1896 Landscape watercolourist Exh: UK AG's	G.A.F
FRIQUET de VAUROZE **Jacques Antoine** b. France. 1648 - 1716 Historical subjects Exh: France	*FdV*
FRISCH **Johann Christoph** b. Berlin. 1738 - 1815 Historical subjects Exh: Germany. France	*JCF fc.*
FRISTON **David Henry** Fl. London mid 19th C. Figure painter Exh: RA	D.H.F
FRITH **Clifford** b. London. 1924 - Oil & pencil media Exh: RA, London & Prov. AG's	*Clifford Frith*
FRITH, RA **William Powell** b. Yorkshire. 1819 - 1909 Genre, portrait & historical subjects Exh: RA, BI, SS, France, Belgium, Austria	*W.P.Frith*
FROHLICH **Anton** b. 1776 - 1841 Religious subjects	*AF*
FROMENTIN **Eugene** b. France. 1820 - 1876 Eastern landscapes, genre subjects etc Exh: US & European AG's	*Eug. Fromentin*

FRONTIER **Jean Charles** b. Paris. 1701 - 1763 Biblical & mythological subjects Exh: France	*Froutier.*
FRUH **Eugen** b. Switzerland. 1914 - Painter in oil media Exh: European AG's, Japan	*EF.*
FRUYTIERS **Philip** b. Antwerp. 1610 - 1666 Portraits & historical subjects Exh: Holland	*PF.*
FRY, RA **E. Maxwell** b. Cheshire. 1899 - Portraits & landscape artist Exh: RA & London AG's	*Fry 75*
FRY **William Arthur** b. Otley, Yorks. 1865 - ? Portraits, marine & landscape artist Exh: RHA, London & Prov. AG's	*W.A.Fry.*
FRYE **Thomas** b. Dublin. 1710 - 1762 Portrait artist Exh: NG & London & Prov. AG's.	*F*
FRYER, SMA **Wilfred Moody** b. London. 1891 - B/White, oil & watercolourist Exh: RA, RI, RBA & Prov. AG's	*W. M. Fryer.*
FUCHS **Lodewijk Juliaan** b. Lille. 1814 - 1873 Landscape artist Exh: Holland	*L.J.F.*
FUES **Christian Friedrich** b. Germany. 1772 - 1836 Genre & portrait artist	*F*
FUGER **Friedrich Heinrich** b. 1751 - 1818 Portraits, mythological subjects & miniatures etc Exh: Germany, Hungary, UK	*F*

F

FUHRICH **Josef von** b. 1800 - 1876 Religious subjects etc Exh: Austria, Italy	
FULLER, ROI, RCA **Leonard John** b. London. 1891 Portrait artist Exh: RA, ROI, RP, RCA, RNA, RSA, PS, London & Prov. AG's	LEONARD J. FULLER
FULLEYLOVE, RI **John** b. Leicester. 1845 - 1908 Genre, architectural & landscape artist Exh: RA, RI, SS, London & Prov. AG's	
FULLWOOD, RBA, FSA **John** b. 1931 Landscape watercolourist Exh: RA, PS	John Fullwood.
FURINI **Francesco** b. Florence. 1604 - 1646 Portrait & historical subjects Exh: France, Hungary, UK, Italy, Spain etc	furini
FURNERIUS **Abraham** b. 1628 ? - ? Landscape artist	A F.
FURSE **Roger Kemble** b. Kent. 1903 - Oil, gouache & watercolourist Exh: Paris, London & Prov. AG's X	rgafurse
FUSSLI **Jean Henri** b. Zurich. 1741 - 1825 Portraits, figure, genre subjects etc Exh: RA, Prov. AG's etc	A·F
FYT **Jan** b. Antwerp. 1609 - 1661 Animals, birds, flowers & still life subjects Exh: France, Belgium, Germany, Italy, UK, Spain	Joh. Fyt 1650

G

GAAL (or GAEL) **Barend** b. Harlem. 1620 ? - 1703 ? Landscapes, hunting & battle scenes etc Exh: France, Holland, Belgium, Russia	*B.Gael.f.* *BG*
GABBIANI **Antonio Domenico** b. Florence. 1652 - 1726 Historical & portrait artist Exh: France, Germany, Italy.	*CA*
GADDI **Taddeo** b. Florence. 1300 ? - 1366 Religious subjects Exh: Germany, France, Switzerland	*J Gaddi fecit*
GAGLIARDINI **Julien Gustave** b. Mulhouse. 1846 - 1927 Portraits, genre & landscape artist Exh: France	*Gagliardini*
GAGNEREAUX **Benigne** b. Dijon. 1756 - 1795 Portraits, mythological, genre & landscape artist Exh: France, Italy etc	*B Gagnereaux*
GAILLARD **Claude Ferdinand** b. Paris. 1834 - 1887 Portrait & historical artist Exh: France	*F J*
GALAND **Leon Laurent** b. France. 1872 - ? Figure & genre subjects Exh: France, Italy	*L". GALAND*
GALANIS **Demetrius Emmanuel** b. Athens. 1882 - 1966 Landscapes, still life subjects etc Exh: France	*D. Galanis.* *D.G*
GALARD **Gustave (Comte de)** b. Lille. 1777 ? - 1840 Portrait & landscape artist Exh: France	*G Galard*

GALE **William** b. London. 1823 - 1909 Portraits, Oriental, mythological, religious & historical subjects Exh: RA, SS, BI & Prov. AG's	
GALLAIT **Louis** b. Tournay. 1810 - 1887 Historical, genre & portrait artist Exh: Holland, Belgium, Germany, UK, France	
GALLAND **Pierre Victor** b. Geneva. 1822 - 1892 Landscape & portrait artist Exh: France	
GALLE **Jerome** Flourished 19th century Still life subjects Exh: France	
GALLI (called BIBIENA) **Ferdinando** b. Bologna. 1657 - 1743 Decorations & architechtural subjects	
GALLI **Giovanni Antonio** Flourished 17th Century Animal, genre & historical subjects Exh: Italy.	
GALLON **Robert** b. London. 1868 - 1903 Landscape artist Exh: RA, BI etc	
GALLOWAY, FMA **Vincent** b. Hull. 1894 - Portrait artist Exh: RP	
GAMBARO **Lattanzio** b. Brescia. 1530 ? - 1574 ? Portraits & historical subjects Exh: Italy	
GANDARA **Antonio de la** b. Paris. 1862 - 1917 Portrait, figure, still life & landscape artist Exh: France	

GANDOLFI **Gaetano** b. 1734 - 1802 Historical & mythological subjects Exh: Italy	
GARDELLE **Robert** b. Geneva. 1682 - 1766 Portrait artist Exh: Switzerland	
GARDINER, ARCA **Gerald** b. 1902 - Artist in oil media Exh: RA, RSA, NEAC & Prov. AG's	
GARDNER **Phyllis** b. Cambridge. 1890 - Watercolour & tempera media Exh: NEAC, RMS, London AG's etc	ΦΥΛΛΙΣ
GARDNER **William Biscombe** b. London. 1848(?) - 1919 Landscape artist Exh: RA, London & Prov. AG's	
GAREIS **Pius** b. Germany. 1804 - ? Portraits & historical subjects	
GARNERAY **Ambroise Louis** b. Paris. 1783 - 1857 Historical, marine, genre & landscape subjects etc Exh: France	
GARNIER **Etienne Barthelemy** b. Paris. 1759 - 1849 Portraits & historical subjects Exh: Italy, France	
GARNIER **Jules Arsene** b. Paris. 1847 - 1889 Genre & portrait artist Exh: France	
GAROFALO **Benvenuto**	See TISIO Benvenuto da Garofalo

GARRAND (The younger) **Marc** b. Bruges. 1561 - 1635 Portraits & historical subjects	*M Garrand* *1621*
GASSIES **Jean Bruno** b. Bordeaux. 1786 - 1832 Historical subjects Exh: France	*Gassier*
GASSNER **Simon** b. Steinberg. 1755 - 1820 Historical & landscape artist Exh: Germany	*SG*
GASTALDI **Andrea** b. Turin. 1810 - 1889 Historical artist Exh: France	*A. Gastaldi*
GATEHOUSE, ALAA **Rosalind** Flourished 20th Century Watercolourist Exh: RA, R. Cam.A, WAG	*RG*
GAUERMANN **Friedrich** b. Germany. 1807 - 1862 Animals, genre & landscape artist Exh: Germany, Austria	*·F.G.·*
GAUFFIER **Louis** b. France. 1761 - 1801 Portrait, historical & landscape artist Exh: France, UK	*L- Gauffier* *L Gauffier F.ᵗ*
GAUGUIN **Paul** b. Paris. 1848 - 1903 Tahitian scenes & figures, still life subjects, portraits etc Exh: US,UK, European AG's etc	*P Gauguin* **P.G.** *P.Go*
GAUGUIN **Paul Rene** b. Copenhagen. 1911 - Graphic artist & engraver etc Exh: Most European countries, Scandinavia, India, US etc	*Paul René Gauguin*

GAUTHEROT **Claude** b. Paris. 1729 - 1802 Figure, historical & portrait artist Exh: France	*Gautherot*
GAUTIER **Armand Desire** b. Lille. 1825 - 1894 Genre & still life subjects Exh: France	*A. Gautier*
GAUTIER **Louis Francois Leon** b. France. 1855 - ? Landscape artist Exh: France	*Louis-Gautier*
GAVARNI **Sulpice Guillaume Chevalier** b. Paris. 1804 - 1866 Watercolourist, gouache media etc Exh: European AG's	*Gavarni*
GEAR, DA **William** b. Methil. 1915 - Oil & gouache media Exh: European AG's, US, Japan, S. America etc	*Gear*
GEBHARD, NDD **Charles W.** b. London. 1923 - Exh: RA, RBA, London & Prov. AG's	*Gebhard*
GEBLER **Friedrich Otto** b. Dresden. 1838 - 1917 Animal subjects Exh: France, Germany	*O. Gebler*
GEDDES, ARA **Andrew** b. Edinburgh. 1783 - 1844 Genre, still life & portrait artist Exh: RA, BI, London & Prov. AG's	*AG AG AG AG AG.*
GEETS **Willem** b. Belgium. 1838 - ? Portraits & historical subjects Exh: Belgium. UK	*Willem Geets*
GEISSLER **J. Martin Friedrich** b. Nuremberg. 1778 - 1853 Architectural & landscape artist	*Kg.f F*

GELDER **Aart de** b. Dortrecht. 1645 - 1727 Historical & portrait artist Exh: France, Holland, Germany, Belgium, Russia, etc	*AN 1613 GG·F* *GR* *GAR* *GAR*
GELDER **Nicolaes van** b. Leyde. 1625 ? - 1677 Still life subjects Exh: Holland, Austria, Germany	*N Gelders*
GELDORP **Gortzius** b. 1553 - 1618 Historical & portrait artist Exh: Holland, Germany, Hungary, UK, Italy etc	*GG*
GELLEE (or LORRAINE) **Claude** b. France. 1600 - 1682 Marine & landscape artist Exh: UK & European AG's, Russia	CLAVDIO. G.I.V. ROMÆ 1644 CLAVDE GIl. ·I·V· FAICT·POVR·SON ALTESSE·LE·DVC·DE· ·BVILLON·A ROMA· 1648· *GL · I·V· ROMÆ. ·1645·* CLAVDIO IN ROMÆ 1639 *claudio f*
GENILLION **Jean Baptiste Francois** b. 1750 - 1829 Marine & landscape subjects etc Exh: France	*Genillion*
GENNARI (The Elder) **Benedetto** b. Italy. 1570 - 1610 Portraits & historical subjects	*B G IN*
GENOELS (The Younger) **Abraham** b. Anvers. 1640 - 1723 Landscapes & mythological subjects etc; Exh: Holland, Belgium, France	*A.G fecit* *GA* *A* *A* *GA*
GENSOLLEN **Victor Emmanuel** b. Toulon. 1859 - 1897 Genre & still life subjects Exh: France	*V. Gensollen*

GENTILLI, BA **Jeremy** b. London. 1926 - Oil & watercolourist Exh: ROI, RBA etc	*[signature: H.G.]*
GEORGE, RE, SSSBA **Sir Ernest** b. London. 1839 - 1922 Landscape, oil & watercolourist Exh: RA, SS, RE, London & Prov. AG's	*[signature: EG EG EG EG]*
GEORGHIOU **George Pol** b. Cyprus. 1901 - Painter in oil media Exh: London, Paris, Milan, Basle, Nicosia etc	*[signature: Geo P.G 51]*
GERARD **Le Baron Francois Pascal Simon** b. Rome. 1770 - 1837 Portraits & historical subjects Exh: European AG's	*[signature: B^ron Gerard B^ron Gérard]*
GERARD **Theodore** b. Belgium. 1829 - 1895 Genre artist Exh: Belgium, Austria, US, UK etc	*[signature: Theodore Gerard]*
GERBIER **Balthasar, Baron D'ouvilly** b. Middleburg. 1592 - 1667 Miniaturist & portrait artist	*[signature: B. Gerbier 1659]*
GERE, RWS **Charles March** b. Leamington. 1869 - 1957 Portrait & landscape artist Exh: SS, London & Prov. AG's	*[monogram: CM 1926, and three other CM monograms]*
GERICAULT **Jean Louis Andre Theodore** b. Rouen. 1791 - 1824 Animal, genre & historical subjects Exh: UK, France	*[signature: T Gericault & Gericault]*
GERKE **Johann Philipp** b. Cassel. 1811 - ? Historical subjects Exh: Germany	*[monogram: GP]*
GERNEZ **Paul Elie** b. 1888 - 1948 Still life, marine & landscape subjects etc Exh: UK, France	*[signature: Gernez]*

GERTLER **Mark** b. London. 1892 - 1939 Portraits, figures, still life, etc. Exh: UK AG's, Paris	*M.G.*
GERUNG **Matthias** b. 1500 ? - 1570 ? Historical subjects Exh: Germany	*MG* *1551*
GERVEX **Henri** b. Paris. 1852 - 1929 Portrait, mythological, genre & still life subjects etc Exh: France, Belgium	*H. Gervex*
GHISI **Adamo** b. Mantoue. 1530 ? - 1574 Genre, biblical & historical subjects	*ASP* *IS*
GHISI **Diana** b. Mantoue. 1536 ? - 1590 Genre, religious & historical subjects	*DS*
GHISOLFI **Giovanni** b. Milan. 1632 ? - 1683 Architectural & historical subjects Exh: UK, Germany	*GAE*
GIACOMOTTI **Felix Henri** b. France. 1828 - 1909 Portrait, genre & historical subjects Exh: France	*Giacomotti*
GIBBS **Thomas Binney** b. Darlington. 1870 - ? Portrait & landscape artist Exh: RA, PS, IS etc	*TCG*
GIBSON **David-Cooke** b. Edinburgh. 1827 - 1856 Genre Subjects Exh: Belgium, France, RA	*CG*
GIBSON **Mary Josephine** Fl. London late 19th C. Miniaturist Exh: RA	*M.J.G.*

GIESS **Jules Alfred** b. France. 1901 - Exh: Italy, France	A GIESS
GIETL **Josua von** b. Munich. 1847 - ? Landscape artist Exh: Germany	GIETL.
GIGOUX **Jean Francois** b. Besancon. 1806 - 1894 Portraits, genre & historical subjects Exh: France	Jean Gigoux
GILBERT, ROI **Albert Thomas Jarvis** b. London Portraits, landscapes & still life Exh: RA, ROI & Prov. AG's	GILBERT
GILBERT **Arthur Williams** b. 1819 - 1895 Landscape artist Exh: RA, BI, SS	A. G. 1860
GILBERT, RA, PRWS **Sir John** b. London. 1817 - 1897 Historical subjects Exh: RA, BI, SS, OWS, London & Prov. AG's etc	JG G G G
GILBERT **Victor Gabriel** b. Paris. 1847 - 1933 Genre artist Exh: French AG's	Victor Gilbert
GILCHRIST **Herbert H.** Fl. London 19th C. Portraits, genre & historical subjects Exh: RA, UK AG'S, Germany	H
GILES **William** b. Reading. 1872 - Genre & landscape artist Exh: RA, BM, Prov. AG's	G W W WG
GILL **Edmund** b. London. 1820 - 1894 Rivers, waterfalls, landscapes Exh: RA, SS, VA, Germany, etc.	E G 1870

GILLETT, RI **Edward Frank** b. Worlingham. 1874 - ? Oil & watercolourist Exh: RI, London & Prov. AG's	*F. G.*
GILLIARD **Claude** b. Bristol. 1906 - Landscape artist Exh: RWA, London & Prov. AG's	*CLAUDE 27 GILLIARD*
GILLIES **Margaret** b. London. 1803 - 1887 Portraits, genre, interiors & miniaturist Exh: RA, SS, BI, VA, BM, etc.	*M.G*
GILLIES, RA, RSA, RSW **Sir William George** b. 1894 - 1973 Portrait, still life & landscape artist Exh: RA, RSW, UK AG'S, etc.	*W.G.G.*
GILLIGAN **Barbara** b. London. 1913 - Painter in oil media Exh: London & Prov. AG's	*Barbara Gilligan*
GILLOT **Claude** b. Langres. 1673 - 1722 Burlesque & mythological subjects Exh: France etc	*G Gillot 1710*
GILLOT **Eugene Louis** b. Paris. Flourished 19th Century Genre artist Exh: France	*E.L. Gillot*
GILSOUL **Victor Olivier** b. Brussels. 1867 - ? Genre & landscape artist Exh: Belgium, Spain, France etc	*Victor Gilsoul*
GIMIGNANI **Giacinto** b. Italy. 1611 - 1681 Biblical & historical subjects Exh: Italy	*G̶ G̶*
GINGELEN **Jacques van** b. Anvers. 1801 - ? Landscape artist	*VG.*

GIORDANO Luca b. Naples. 1632 - 1705 Portraits & historical subjects Exh: European AG's	*L Giordano 1698*
GIRARD Paul Albert b. Paris. 1839 - 1920 Portrait & landscape artist Exh: France	*Albert Girard*
GIRARDET Eugene Alexis b. Paris. 1853 - 1907 Eastern genre & landscape subjects Exh: France, Algeria, Switzerland	*Eugéne Girardet*
GIRARDET Jules b. Versailles. 1856 - ? Portrait, genre & historical subjects Exh: France, Switzerland	*Jules Girardet*
GIRAUD Victor Julien b. Paris. 1840 - 1871 Genre artist Exh: France	*V Giraud*
GIRODET de ROUCY TRIOSON Anne Louis b. France. 1767 - 1824 Historical subjects, portraits etc Exh: France, Belgium, Switzerland	*Girodet a Rome 1791* *ALT 1813*
GLAIZE Auguste Barthelemy b. France. 1807 - 1893 Portrait, genre & historical artist Exh: France	*AGLAIZE 1848*
GLEDSTANES, RBA, FRSA etc Elsie Oil, pastel & watercolourist Exh: RA, RBA, RP, SWA, PAS. & Prov. AG's	*EG*
GLEHN Wilfred Gabriel de b. London. 1870 - ? Figure & genre artist Exh: UK, Australia	*W G de Glehn*
GLEIZES Albert b. Paris. 1881 - 1953 Cubist & abstract subjects Exh: France	*Alber Gleizes*

GLEIZES **Albert** (continued)	ALBERT GLEIZES 19..
GLENDENING (Junior) RBA **Alfred** b. ? - 1907 Genre & landscape artist Exh: RA, SS, London & Prov. AG's etc	*A.A.G* 1894
GLINK **Franz Xavier** b. Germany. 1795 - 1873 Historical subjects Exh: German AG's	
GODDARD **George Bouverie** b. Salisbury. 1832 - 1886 Animal & sporting subjects Exh: RA, WAG, etc	*G.B.G* *G.B.G* *G.B.G*
GODSON, MS, PAS **Ada Charlotte** b. Tenbury, Worcs. Painter in pastel & oil; miniaturist Exh: RA, PS, MS, PAS, RBA, RI etc	
GODWARD **John William** Fl. 1887 - 1909 Genre, figures & oriental subjects Exh: RA, UK AG'S	
GOEIMARE **Joos** b. 1575 - 1610 Animal & landscape artist	
GOENUETTE **Norbert** b. Paris. 1854 - 1894 Genre, landscape & Parisian scenes Exh: France.	*Norbert Goeneutte*
GOERG **Edouard Joseph** b. Sydney. 1893 - Genre, nude & figure subjects Exh: US, Denmark, France, Holland etc	*E.GOERG* *Ed.GOERG* *Goerg*

GOES **Hugo van der** b. Gand. 1420 ? - 1482 Religious subjects & miniatures Exh: Holland, Germany, Italy, UK, Russia, France, Austria	
GOFF **Robert Charles** b. London. 1837 - ? Landscape artist Exh: UK AG'S, Italy	*RG*
GOGH **Vincent Willem van** b. Zundert. 1853 - 1890 Genre, still life & landscape impressionist Exh: World-wide AG's & collections	*Vincent Vincent*
GOLDIE **Charles** b. London. FL. 19th C. Portrait, genre & historical subjects Exh: RA, BI, SS	
GOLDSMITH **William** b. Sleaford. 1931 - Abstract subjects Exh: London & Prov. AG's	*W Goldsmith*
GOLTZIUS **Hendrik** b. Mulbrecht. 1558 - 1616 Historical & mythological subjects etc Exh: Holland, Germany, Russia, France, Austria etc	
GOLTZIUS **Hubert** b. 1526 - 1583 Historical subjects Exh: France, Switzerland	
GOMEZ Y PASTOR **Jacinto** b. Spain. 1746 - 1812 Historical subjects Exh: Spain	*H Gomez*
GONDOUIN **Emmanuel** b. Versailles. 1883 - 1934 Portrait, figure & still life subjects Exh: France	*Gondovin.*
GONTCHAROVA **Nathalie** b. Moscow. 1881 - 1962 Painter & sculptor Exh: France	*N.Gontcharova N.G.*

GONZALES **Juan Antonio** b. Spain. 1842 - ? Genre & portrait artist Exh: Spain, France	
GOODALL, RWS **Edward Alfred** b. London. 1819 - 1908 Battle scenes, landscapes etc Exh: RA, BI, SS, OWS	
GOODALL, RA, **Frederick** b. London. 1822 - 1904 Landscapes, genre, biblical & Egyptian subjects Exh: RA, France, Germany, Australia, London & Prov. AG's	
GOODALL **John Strickland** b. Norfolk. 1908 - Exh: RA, London & Prov. AG's, US, India etc	
GOODMAN **Walter** b. London. 1838 - ? Genre & portrait artist Exh: RA, UK AG's	
GOODWIN, RWS, **Albert** b. Arundel. 1845 - 1932 Biblical, allegorical subjects. landscapes etc Exh: RA, OWS, London & Prov. AG's	
GOODWIN **Harry** b. ? - 1925 Genre, oil & watercolourist Exh: London & Prov. AG's	
GOOL **Jan van** b. The Hague. 1685 - 1763 Cattle & landscape artist Exh: Holland	
GORBITZ **Johan** b. Bergen. 1782 - 1853 Portrait & landscape artist Exh: Oslo	
GORDON, RBA **Robert James** Fl. late 19th C. Genre subjects Exh: RA, SS, UK, AG's	

GORE **Frederick Spencer** b. Surrey. 1878 - 1914 Landscape artist Exh: London & Prov. AG's	*SFG*
GOSSE, RBA, RE, FRSA **Laura Sylvia** b. 1881 - ? Exh: RA, RBA, RSPE, London & Prov. AG's, Canada, S. Africa etc	*Gosse*
GOSSELIN **Charles** b. Paris. 1834 - 1892 Landscape artist Exh: French AG's	*ch. Gosselin*
GOTCH **Thomas Cooper** b. Kettering. 1854 - 1931 Genre & landscape artist Exh: RA, SS, UK AG'S, Australia	*T.C.G.* *T.C.G.*
GOTLIB **Henri** b. Cracow. 1892 - Exh: Poland, Holland, France, Germany, UK etc	*GOTLIB*
GOTTLIEB **Leopold** b. 1883 - 1930 Portraits, religious subjects etc Exh: France, Austria, Switzerland	*leopold gottlieb*
GOUBIE **Jean Richard** b. Paris. 1842 - 1899 Landscapes & genre subjects Exh: France, US	*R. Goubie*
GOULDSMITH, RWA, RBA **Edmund** b. England. 1852 - 1932 Portrait & landscape artist Exh: London & prov. AG's	*EG.*
GOULINAT **Jean Gabriel** b. Tours. 1883 - Portrait, genre & landscape artist Exh: France	*J. G. Goulinat*
GOUPIL **Leon Lucien** b. Paris. 1834 - 1890 Portraits etc Exh: France	*Leon Goupil*

GOW, RA, RI Andrew Garrick b. London. 1848 - 1920 Portraits, genre, military & historical subjects Exh: RA, SS, NWS, GG, RI. Prov. AG's, S. Africa, Australia	
GOYA Y LUCIENTES Francisco Jose de b. Fuente de Todos. 1746 - 1828 Portraits, genre & historical subjects Exh: US, UK & European AG's etc	
GOYDER Alice Kirkby b. Bradford. 1875 - ? Animal subjects. watercolourist Exh: RA, RI	
GOYEN (or GOIEN) Jan Josefoz van b. Leyden. 1596 - 1665 Landscapes, portraits, sea & river scenes Exh: Holland, France, Belgium, Germany, Russia etc	
GOZZOLI Benozzo b. Florence. 1420 - 1497 Portraits, historical & landscape artist Exh: Germany, Italy, Hungary, UK	
GRACE Alfred Fitzwalter b. UK. 1844 - 1903 Landscape artist Exh: RA, SS, SBA	
GRAFF (or GRAF) Antoine b. 1736 - 1813 Portrait artist & miniaturist Exh. France, Germany	
GRAFF Johann Andreas b. Nuremberg. 1637 - 1701 Portraits, floral & landscape artist	

GRAHAM, RA Peter b. Edinburgh. 1836 - 1921 Coastal scenes & landscape artist Exh: RA, London & Prov. AG's, Australia	*(monogram)*
GRAHAM, HRSA Thomas Alexander Ferguson b. Scotland. 1840 - 1906 Portraits, coastal, country & oriental subjects Exh: RA, RSA, London & Prov. AG's	*T. Graham* *T. G*
GRANDI Ercole di Giulio Cesare b. Italy. 1465 ? - 1531 Portraits & historical subjects	*H Grandi* *1530*
GRANET Francois Marius b. Aix-en-Provence. 1775 - 1849 Architectural & historical subjects	*GRANET* *Granet* *GRANET*
GRANT Duncan James b. Nr. Inverness. 1885 - Portrait, still life & landscape artist Exh: Paris, London & Prov. AG's	*(monogram) DG*
GRANT, RA Sir Francis b. Perthshire. 1810 - 1878 ? Portraits & hunting scenes Exh: RA, BI, SS, London & Prov. AG's	*Francis Grant*
GRANT William James b. London. 1829 - 1866 Genre & historical subjects Exh: RA	*G 1866*
GRAVELOT Hubert Francois Bourguignon b. Paris. 1699 - 1773 Portrait, genre & historical subjects etc. Exh: UK, France	*HG = lot* *HG = lot*
GRAY, ARCA, FSA etc George Edward Kruger b. London. 1880 - Watercolourist Exh: RA, Paris, London & Prov. AG's	*George Kruger Gray* *K G*
GREBBER Pieter Fransz de b. Haarlem. 1600 ? - 1693 ? Portraits, religious & historical subjects Exh: Holland, France, Hungary, Germany etc	*Grebber* *PDG 1651* *P. DG* *P DG* *PDG* *PDG*

GREEN **Alfred H.** Fl. 1844 - 1862 Animal subjects Exh: RA, BI, SS	
GREEN **Anthony Eric Sandall** b. UK. 1939 - Figurative subjects Exh: UK & European AG's etc	
GREEN, RI **Charles** b. 1840 - 1898 Genre & historical painter Exh: RA, NWS, RI, Prov. AG's	
GREEN, IS **Elizabeth Shippen** Fl. 1920's Landscape oil & watercolourist Exh: UK & European AG'S	
GREEN **Henry Towneley** b. England. 1836 - 1899 Oil & watercolourist Exh: RA, RI, RBA, London & Prov. AG's etc	
GREENAWAY **Kate** b. London. 1846 - 1901 Genre oil & watercolourist, engraver Exh: SS, VA, UK AG's, Australia etc.	
GREENE **Mary Charlotte** b. Essex. 1860 - ? Landscape artist Exh: RA	
GREENHAM, RBA, RO **Robert Duckworth** b. London. 1906 - Portraits, marine, abstract, landscape subjects etc Exh: RA, RBA, ROI, London & Prov. AG's	
GREENLEES **Robert** b. 1820 - 1904 Landscape artist Exh: UK AG'S	
GREGORY, RWS **Charles** b. Surrey. FL. 19th - 20th C. Genre & historical subjects Exh: RA, SS, OWS. Prov. AG's, Australia	

GREGORY, RA, RI **Edward John** b. Southampton. 1850 - 1909 Portrait, genre & landscape artist Exh: RA, RI, NWS, GG, Germany, France etc	*E J G* *E J G. 78* *E J G*
GREIFFENHAGEN, RA **Maurice William** b. 1862 - 1931 Allegorical figures, portrait artist etc Exh: RA, SS, Germany, Italy, US etc	*M. G*
GREUZE **Jean Baptiste** b. France. 1725 - 1805 Portrait & figure artist Exh: UK & European AG's	*Greuze* *J. B Greuze* *J B. Greuze* *Greuze*
GREVEDON **Pierre Louis** b. Paris. 1776 - 1860 Portrait artist Exh: France, Italy	*Grevedon* *G G G*
GRIER **Louis** b. Melbourne. 1864 - 1922 Landscape & marine artist Exh: RA, SS, PS	*LG*
GRIERSON, RI, PAS **Charles MacIver** b. Ireland. 1864 - ? B/White, pastel, oil & watercolourist Exh: RA, RHA, RI, PAS, Prov. AG's Australia	*t. MacIm Grierson*
GRIFFIER (The Elder) **Jan** b. Amsterdam. 1652 ? - 1718 Landscape artist Exh: Holland, France, Germany, Hungary, Austria, UK etc	*J GRIFFIER:* *J. GRIFFIER:* *JG*
GRIFFIER **John** b. ? - 1750 ? Landscape artist Exh: UK	*j. C,*
GRIFFIER **Robert** b. London. 1688 - 1750 Still life & landscape artist Exh: Scandinavia, France, UK	*R Griffier*

GRIFFITHS **Gwenny** b. Swansea. 1867 - ? Portrait artist Exh: RA, PS, WAG, RP, London AG's, Hungary etc	
GRIFFITHS **Tom** Fl. late 19th C. Landscape artist Exh: RA, SS, UK AG'S	
GRIGGS **Frederick Landseer Maur** b. Hitchin. 1876 - 1938 Landscapes & architectural subjects Exh: BM, London & Prov. AG's	
GRIMALDI **Giovanni Francesco** b. Italy. 1606 - 1680 Religious & landscape subjects Exh: France, Hungary, Italy, Austria	
GRIMER (GRIMMER) **Abel** b. Anvers. 1573 - 1618 ? Religious, genre & landscape artist Exh: Holland, Belgium	
GRIMER **Jakob** b. Anvers. 1526 - 1590 ? Historical, genre & landscape artist Exh: Belgium, France, Hungary, Austria	
GRIMM, ROI, RP, PNS, etc **Stanley A.** b. London. 1891 - Portrait, figure & landscape artist Exh: RA, RP, ROI, NS, Prov. AG's, Europe, Russia, US	
GRIMSHAW **John Atkinson** b. Leeds. 1836 - 1893 Sunset & moonlight coastal, town & landscape subjects Exh: RA, GG, London & Prov. AG's etc	
GRIS **Jose Victoriano Gonzales** b. Madrid. 1887 - 1927 Genre, still life, cubist & abstract works Exh: US, Russia, Scandinavian & European AG's	

GRIS **Jose Victoriano Gonzales** (continued)	*Juan Gris*
GRISET **Ernest Henry** b. France. 1844 - 1907 Animal watercolourist Exh: SS, VA, London & Prov. AG's	EG EG
GROMAIRE **Marcel** b. France. 1892 - Portrait, figure & genre subjects Exh: France	Gromaire M. Gromaire G
GRONE, RBA **Ferdinand E.** Fl. Colchester 1880 - 1910 Landscape oil & watercolourist Exh: RBA, RI	F.E.G.
GRONLAND **Theude** b. Altona. 1817 - 1876 Still life subjects Exh: France, RA & UK AG's etc	Th. Grönland . 1858
GROS **Antoine Jean (Baron)** b. Paris. 1771 - 1835 Historical & mythological subjects Exh: France, Switzerland, UK etc	Gros 1804 Gros
GROSJEAN **Henry** b. France. 1869 - ? Landscape artist Exh: France	HENRY GROSJEAN
GROSPIETSCH **Florian** b. Protzan. 1789 - 1830 Landscape artist	FG 1826 FG
GROSS **Anthony** b. London. 1905 - Painter, etcher, engraver Exh: UK, US & European AG's	Anth Gross Anth Gross
GROSSMITH **W. Weedon** Fl. 1875 - 1890 Genre & portrait artist Exh: RA, SS, London & Prov. AG's	WG

GROUX **Charles Corneille Auguste de** b. Comines. 1825 - 1870 Genre subjects Exh: Belgium, France	*Ch. Degroux*
GRUN **Jules Alexandre** b. Paris. 1868 - 1934 Portrait & still life artist Exh: France	*Grün* *Grün*
GRUN **Maurice** b. 1869 - ? Portraits, interiors & moonlight scenes Exh: French AG's	*m.Grün*
GRUND **Norbert Joseph Carl** b. Prague. 1717 - 1767 Animals, battle scenes & landscape artist Exh: Germany	*N Grund*
GRUNER **Wilhelm Heinrich Ludwig** b. Dresden. 1801 - 1882 Genre & Portrait artist	*G*
GUARDI **Francesco** b. Venice. 1712 - 1793 Architectural, landscape & Venetian scenes etc Exh: UK, Russia & European AG's	*Fran.co Guardi* *F Guardi*
GUDE **Hans Fredrik** b. Norway. 1825 - 1903 Marine & landscape artist Exh: Germany, Scandinavia, France	*HGude*
GUDIN **Jean Antoine Theodore** b. Paris. 1802 - 1880 Marine & landscape artist Exh: RA, Holland, France, Germany, Belgium etc	*HC* *HG*
GUELDRY **Ferdinand Joseph** b. Paris. 1858 - ? Genre, river scenes, landscapes etc Exh: France	*F.GUELDRY*

GUERARD **Henri Charles** b. Paris. 1846 - 1897 Portraits & genre subjects Exh: UK, France	
GUERCINO **Giovanni Francesco Barbieri** b. Italy. 1591 - 1666 Portraits, religious, historical & landscape artist Exh: Russia, European AG's etc	
GUERIN **Charles Francois Prosper** b. France. 1875 - 1939 Portrait & figure studies Exh: France	
GUERIN **Pierre Narcisse** b. Paris. 1774 - 1833 Portraits & historical subjects Exh: Germany, France, Spain etc	
GUEST **George** b. Rotherham. 1939 - Portrait, interior, landscape figurative oil & watercolourist Exh: RWS, London & Prov. AG's, US, Australia, Dublin etc	
GUET **Edmond Georges** b. France. 1829 - ? Historical subjects Exh: France	
GUFFENS **Godfried Egide** b. Hasselt. 1823 - 1901 Portrait & historical artist Exh: Belgium, France, Germany etc	
GUIDO	See RENI Guido

GUIGNET **Jean Adrien** b. France. 1816 - 1854 Historical & landscape artist Exh: France	*Adrien Guignet*
GUIGOU **Paul Camille** b. France. 1834 - 1871 Landscape artist Exh: France, Switzerland	*Paul Guigou*
GUILLAUMET **Gustave Achille** b. France. 1840 - 1887 Still life, genre & eastern subjects etc Exh: France, Algeria	*G.Guillaumet*
GUILLAUMIN **Jean Baptiste Armand** b. Paris. 1841 - 1927 Landscape artist Exh: France	*Guillaumin*
GUILLEMET **Jean Baptiste Antoine** b. Chantilly. 1843 - 1918 Religious, marine & landscape artist Exh: France, Germany, Switzerland	*A. Guillemet*
GUILLEMINET **Claude** b. Paris. 1821 - ? Animals, poultry & landscape subjects Exh: France	*Guilleminet*
GUILLONNET **Octave Denis Victor** b. Paris. 1872 - ? Figure, genre & still life subjects etc Exh: France	*O Guillonnet*
GUINIER **Henri Jules** b. Paris. 1867 - 1927 Portrait & genre artist Exh: France, S. America	*H.Guinier*
GUNN **James Thomas** b. Gorebridge. 1932 - Oil, gouache & watercolourist Exh: RSA, RSW, SSA, X UK & Canada	*James T. Gunn*
GUNN **William Archibald** b. 1877 - ? Pastel & watercolourist Exh: London & Prov. AG's	*Gunn*

GUNTHER **Matthaus Matha** b. Bisenberg. 1705 - 1788 Portraits & genre subjects Exh: Germany	*G. inv.*
GUTHRIE, PRSA, RSW **Sir James** b. Greenock. 1859 - 1930 Genre, portrait, landscape & historical subjects Exh: France, Germany, Australia, UK AG'S	
GUTMAN **Nachum** b. Telenesht, Russia. 1893 - Oil, gouache & watercolourist Exh: Europe, S. Africa, US, London & S. America	
GUY **Edna W.** b. Sutton. 1897 - Watercolourist Exh: RA, RI, RSA, SWA, NS, SMA, PS etc	
GUYOT **Georges Lucien** b. Paris. 1885 - ? Animals, still life & landscape artist Exh: France	
GWYNNE-JONES, DSO, ARA **Allan** b. London. 1894 - Exh: London & Prov. AG's, France	
GYSELS (The Younger) **Frans 11** b. Leyden. ? - 1660 Portraits & historical subjects	

H

HAAG, RWS **Carl** b. Bavaria. 1820 - 1915 Portraits, eastern subjects, landscapes & miniaturist Exh: RA, BI, OWS, London & Prov. AG's	
HAAS **Johannes Hubertus Leonardus de** b. 1832 - 1908 Animal & landscape artist Exh: Belgium, Hungary, Holland, Germany	

HABERMANN (BARON) **Hugo van** **b.** Dillingen. 1849 - ? Portraits, genre & historical subjects Exh: Germany, Hungary	*Habermann 1888*
HACCURIA Maurice b. Goyer. 1919 - Exh: Holland, Belgium, France, Italy, Germany	*HAECURIA*
HACKER, RA Arthur b. London. 1858 - 1919 Portraits, genre & historical subjects Exh: RA, BI, GG, NG etc	*AH*
HACKERT **Johann Gottlieb** b. 1744 — 1773 ? Animal & landscape artist Exh: RA, SA, Italy, US	*G. Hackert 1770*
HACKNEY, RWS, RE, ARCA **Arthur** b. Yorkshire. 1925 - Oil & watercolourist Exh: RA, RE, RWS	*Arthur Hackney*
HAEN **Abraham 11 de** b. Amsterdam. 1707 - 1748 Landscape artist	*ADH*
HAERLEM (called CORNELISZ) **Cornelis van** b. Haarlem. 1562 - 1638 Biblical & historical subjects	*Cornely H CH CCH fin* *EPictor.* *CH 1633 CH 1614 CH 1619 GH GH*
HAGBORG **August Wilhelm Nikolaus** b. 1852 - 1925 Marine artist Exh: France, Sweden.	*HACBORG*
HAGEDORN, RBA, RSMA, NEAC etc **Karl** b. Berlin. 1889 - Oil & watercolourist Exh: Paris, London & Prov. AG's	*KH*

HAGEN **Joris van der** b. 1620 - 1669 Landscape artist Exh: Holland, France, Germany, Denmark, UK etc	*verhaege fe 1652* JC JC
HAGG **Arthur T.** b. 1895 - Exh: RI, NEAC, RBA, RA, ROI	*A. T. Hagg*
HAGGIS **John** b. London. 1897 - Portrait, figure & landscape artist Exh: RA, RPS, PS, WAG, ROI, RSA, NEAC, RWEA etc. Prov. AG's	*John Haggis*
HAGHE, HPRI **Louis** b. Tournay. 1806 - 1885 Interiors & historical subjects Exh: BI, NWS, Belgium, France	*L. Haghe* *fi Paul anvers 1845*
HAIG (HAGG), RE **Axel Herman** b. Gotland. 1835 - 1921 Architectural views Exh: London, Paris	18 (HAH) 80 18 (HAH) 96 19 (HAH) 03
HAILE **Richard Neville** b. London. 1895 Miniaturist Exh: RA, London & Prov. AG's	*R Haile*
HAINSWORTH **Thomas** b. Halifax. 1873 - ? Oil & watercolourist Exh: RA, WAG, Prov. AG's	*Hainsworth*
HAINZMAN **Karl Friedrich** b. Stuttgart. 1795 - 1846 Landscape artist Exh: Germany	H
HAITÉ, ROI, RI, SS **George Charles** b. Kent. 1855 - 1924 Landscape oil & watercolourist Exh: RA, RSBA, ROI, London & Prov. AG's	GCH GCH GCH GCH ⊜ ⊜

HALE **Edward Matthew** b. Hastings. 1852 - 1924 Military & marine subjects etc Exh: RA, SS, GG, NG etc	*SH*
HALES **Gordon Hereward** b. Derbyshire. 1916 - Industrial genre, sea & landscape artist Exh: RI, ROI, RBA, RSMA etc	*GORDON HALES*
HALL **Christopher Compton** b. Sussex. 1930 - Town & landscape artist Exh: RA, London & Prov. AG's	*C. C. Hall* *C. MAnn*
HALL, RBC **Frederick** b. Yorkshire. 1860 - 1921 Portraits, rustic genre & landscape subjects Exh: RA, SS, GG, France, Italy	*REDHall* *FH*
HALL **Gertrude** b. 1874 - ? Watercolourist Exh: PS, IS, RI etc	*G. Compton.*
HALL **Oliver** b. London. 1869 - ? Landscape artist Exh: RA, SS, France	*OH*
HALL **Sydney Prior** b. Newmarket. 1842 - 1922 Historical & genre subjects Exh: UK AG's	*S.P.H.*
HALL **Thomas P.** b. 19th C. Genre & historical subjects Exh: RA, BI, SS	*TPH*
HALLE **Neol** b. Paris. 1711 - 1781 Genre & mythological subjects Exh: Russia, France	*halle*

HALLETT, FIAL **Ellen Kathleen** b. Bristol. 1899 - B/White, oil & watercolourist etc Exh: RA, RBA, R.Cam. A, RE, RWA, RBSA, SWA, SGA & Prov. AG's	*E. K. Hallett* *E. K. Hallett*
HALLIDAY, Mem. NEAC **Charlotte Mary Irvine** b. London. 1935 - Topographical subjects Exh: RBA, RWS, NEAC, RA, London & Prov. AG's	*Charlotte Halliday* *CMH*
HALLIDAY **Michael Frederick** b. 1822 - 1869 Genre, portrait & landscape artist Exh: RA, NPG	
HALLION **Eugene** b. France. 1832 - ? Landscape artist Exh: PS	
HALONEN **Pekka** b. Finland. 1865 - ? Genre & landscape artist Exh: Finland. France	*P. Halonen* *1931*
HALS **Dirk** b. Haarlem. 1591 - 1656 Genre subjects Exh: France, Holland, Hungary, Germany, UK etc	**HALS** **1630** DH 1639 EI 1639 DH 1629
HALS (The Elder) **Frans** b. Anvers. 1580 ? - 1666 Portraits, genre & historical subjects Exh: Russia, UK & European AG's	FL AN° 1678 H H f Hals 1631 H H H AN° 1638 H FL FL
HALS (The Younger) **Frans Franszoon** b. Haarlem. 1618 - 1669 Interiors, genre & still life subjects Exh: Hungary, France, Holland, Germany, Russia	FHS 1640

HALS **Jan** b. Haarlem. ? - 1650 Figures & genre subjects Exh: Holland	*Johannss hals*
HALS **Nicolas Claes Fransz** b. 1628 ? - 1686 Landscape artist Exh: Holland	*HA*
HALS **Reynier Fransz** b. 1627 ? - 1671 Genre artist Exh: Holland	*Rynier Hals* *RH*
HALSWELLE, ARSA **Keeley** b. Richmond. 1832 - 1891 Genre & landscape artist Exh: RA, RSA, UK AG'S, Australia	*K.H.*
HAMERTON **Philip Gilbert** b. Laneside. 1834 - 1891 Landscape artist Exh: London & Prov. AG's etc	*PHG*
HAMILTON **Carl Wilhelm de** b. Brussels. 1668 - 1754 Reptiles, insects & floral subjects Exh: Germany, Finland, France	*C W D H · 1739*
HAMILTON **Eleanor G** Watercolourist Exh: RA, SWA, WIAC, RHA, PS, US etc	*Nora Hamilton*
HAMILTON **Ferdinand Phillpp de** b. Brussels. 1664 - 1750 Animals, birds, lizards, still life etc Exh: Switzerland, France, Hungary, Russia, Germany, Austria	*Philip F. de Hamillon*
HAMILTON **Johann Georg de** b. Brussels. 1672 - 1737 Still life, horses & hunting scenes Exh: Hungary, Germany, Italy, Austria	*J.G.v.H.*
HAMILTON **Philippe van** b. Brussels. 1664 - 1750 Animals & still life	*Ph. Ferd. de Hamilton ft 1741*

HAMILTON-FRASER **Donald** b. London. 1929 - Exh: London & Prov. AG's Paris etc	
HAMMAN **Edouard Jean Conrad** b. Ostend. 1819 - 1888 Historical & genre subjects Exh: Belgium, Holland, France	
HAMMOND **Gertrude Demain** b. London. ? - 1952 Genre watercolourist Exh: RA, SS, NWS, Paris	
HAMON **Jean Louis** b. France. 1821 - 1874 Genre subjects Exh: France, Italy	
HANCOCK **Jennetta Flora** Miniaturist Exh: RA, WAG, RI	
HANICOTTE **Augustin** b. France. 1870 - Marine artist Exh: France	
HANNAN, MA, ATD, FMA **Andrew** b. Glasgow. 1907 - Painter in oil media	
HANNEY, ARWA **Clifford** b. Somerset Painter in oil media Exh: RA, ROI, RBA, WAG, RWA & Prov. AG's	
HANOTEAU **Hector Charles Auguste Octave** **Constance** b. France. 1823 - 1890 Portraits, genre & landscape artist Exh: France	
HANSEN **Carl Frederik Sundt** b. Stavanger. 1841 - 1907 Genre subjects Exh: Norway, Germany, France	

HANSEN **Hans Nicolai** b. Copenhagen. 1853 - 1923 Genre & landscape artist Exh: RA, SS, Paris, Vienna, Copenhagen	
HANSEN **Sigvard Marius** b. Copenhagen. 1859 - ? Landscape oil & watercolourist Exh: RA, Germany, Sweden	
HANSTEEN **Asta** b. Norway. 1824 - 1908 Portraits & historical subjects Exh: Sweden	
HAQUETTE **Georges Jean Marie** b. Paris. 1854 - 1906 Portraits, genre & marine artist Exh: France, US, Australia	
HARDEN, ARCA **Gerald A.C.** b. Nr. Cheltenham. 1909 - B/White, oil & watercolourist etc Exh: RA, London & Prov. AG's	
HARDIE, RSA **Charles Martin** b. Edinburgh. 1858 - 1916 Genre, historical subjects Exh: RA, RSA, Paris, Australia	
HARDIE **Martin** b. London. 1875 - 1952 Landscape watercolourist Exh: RA, VA	
HARDIME **Pieter** b. Anvers. 1677 - 1758 Still life subjects Exh: Holland	
HARDING **Dorothea** b. London. 1898 - Genre, landscapes & miniaturist Exh: Paris	
HARDING **James Duffield** b. Deptford. 1798 - 1863 Landscape artist Exh: RA, BI, SS, SA etc	

HARDORFF (The Elder) **Gerold** b. Germany. 1769 - 1864 Portraits & historical subjects Exh: Germany	*GH*
HARDY **David** Fl. 1835 - 1870 Genre subjects Exh: RA, SSSBA, BI, VA	*DH*
HARDY, RBA **Dudley** b. Sheffield. 1866 - 1922 Genre, oriental & biblical subjects, land & seascapes. Exh: RA, SS, NWS, GG	*DH* *DH*
HARDY **Thomas Bush** b. Sheffield. 1842 - 1897 Marine oil & watercolourist Exh: RA, SS, VA, UK AG's	*T.B.H.* *T.B.H*
HARGITT, RI **Edward** b. Edinburgh. 1835 - 1895 Landscape artist Exh: RA, BI, SS, NWS etc	*EH*
HARGRAVE-SMITH **T.** b. Newport. 1909 - Watercolourist Exh: RA, RWS, London & Prov. AG's	*Hargrave Smith*
HARKER, MLAA **Ethel** Portraits, landscapes & still life etc Exh: WAG, R. Cam. A, & various AG's	*Harker.*
HARMS **Johann Oswald** b. Hamburg. 1643 - 1708 Architectural & landscape subjects Exh: Germany	*JC fe.g*
HARPER, RBSA, Hon.Sec.RSA **Edward S.** b. 1854 - ? Portrait & figure artist Exh: RA & Prov. AG's	*E SDER*
HARPER, RBSA **Edward Steel** b. 1878 - 1951 Landscape artist Exh: London & Prov. AG's	*ESH*

HARPIGNIES Henri Joseph b. France. 1819 - 1916 Landscape artist Exh: France	*L'Harpignies. 91* *L'Harpignies L'Harpignies*
HARPLEY, ARA Sydney Charles b. London. 1927 - Realist Painter & sculptor Exh: RA, Prov. & Scottish AG's, S. Africa, Belgium, Holland	*Harpley ³⁄₈*
HARRIS Suzanne C. b. London. 1909 - Portraits, landscapes etc Exh: London & Prov. AG's	*S.C. Harris.*
HARRIS, OBE Tomas b. London. 1908 - Painter in oil media Exh: France, Spain, US etc	*Tomasharris*
HARRISON, Mem. SSA Edward Stroud b. Edinburgh. 1879 - ? Exh: Paris & Prov. AG's	JAN 1927
HARRISON George L. Fl. 19th C. Genre subjects Exh: RA, Prov. AG's	*G.L.H.*
HARRISON, RSMA Ian b. Staines. 1935 - Portraits & marine subjects. Miniaturist Exh: RMS, London & Prov. AG's	*Ian Harrison ⁷⁄₇₃*
HARRISON Lowel Birge b. Philadelphia. 1854 - ? Landscape artist Exh: US, France	**Birge Harrison**
HARRISON Margaret Amy b. Madras, India. 1915 - Still life & landscape artist Exh: RI, ROI, RWS, SWA, PS, London & Prov. AG's	*Margot Harrison.* MARGOT HARRISON.

HARRISON **Mary** b. London. 1915 - Portraits, landscapes, still life subjects etc. Exh: RA, RSA, RBA, NEAC & London AG's etc	MARY KENT M.K.H.
HARRISON **Thomas Erat** Fl. London late 19th C. Painter, engraver & sculptor Exh: London & Prov. AG's	(T/H/E monogram in circle)
HARROP, FRSA, FSAM, MRST etc **Frederick Samuel** b. Stoke-on-Trent. 1887 - Oil & watercolourist Exh: RBA, London & Prov. AG's	F.S.H. 1954.
HARTLEY, RE, RWA **Alfred** b. Hertfordshire. ? - 1933 Painter & etcher Exh: RA, PS. Prov. AG's	Alfd Hartley AH
HARTLEY **William** b. Liverpool Watercolourist Exh: WAG, RI	WHC
HARTMANN **Johann Joseph** b. Mannheim. 1753 - 1830 Landscape subjects etc Exh: Germany	Hf
HARTNELL, LRAM **Katherine Grant** b. Bristol Etcher, figure painter etc Exh: RA, WAG, NEAC, SGA, RWA RSA	Katherine Hartnell
HARTRICK **Archibald Standish** b. Bangalor. 1864 - 1950 Figures, landscapes & genre subjects Exh: RA, RHA, WAG, RSA, etc.	A.S.H. A.S.H
HARTUNG **Hans Heinrich Ernst** b. Leipzig. 1904 - Abstract subjects Exh: France, Germany, Norway, UK	HARTUNG
HARTUNG **Heinrich** b. Coblentz. 1851 - 1919 Landscape artist Exh: Germany	H-I-H

HARVEY, PRSA **Sir George** b. 1806 - 1876 Genre, historical & landscape artist Exh: RA, BI, SS, London & Prov. AG's	*CH CH*
HARVEY, RBSA **John Rabone** Portrait & landscape artist Exh: RA, London & Prov. AG's	*J.R.Harvey*
HARVEY, FICS **Reginald Leonard** b. London. 1897 - Equine watercolourist Exh: London & Prov. AG's	*R\|Harvey R\|H.*
HARVEY-JONES **Dorothy** b. London. 1898 - Pastel & watercolourist Exh: RA	*1925.*
HASSALL, RI, RWA **John** b. 1868 - ? Painter in B/white & watercolour media Exh: London, Paris, etc	*H*
HASSAM **Childe** b. Boston (U.S.) 1859 - ? Genre, town & landscape subjects etc Exh: France, Germany, US, UK	*(monogram)*
HASTIE, SWA **Grace H.** Fl. 19th C. Floral subjects Exh: RA, SS, NWS, SWA	*G.H.H*
HASTINGS (Earl of Huntingdon) **John** b. London. 1901 - Mural paintings Exh: US, London & Prov. AG's.	*John J. Hastings Jh.*
HATT **Doris Brabham** b. Bath. 1890 - B/White, & oil media etc Exh: NEAC, NPS, RA, US & European AG's	*H*
HATTON **Helen Howard** b. 1860(?) - 1935 Figure painter Exh: RA, SS, NWS	*H.H.H.*

HATWELL Anthony b. London. 1931 - Painter & sculptor Exh: X	*[signature: Anthony]*
HAUCK August Christian b. Mannheim. 1742 - 1801 Portrait artist Exh: Holland	*[signature: A. C. Hauck pinx.]*
HAUDEBOURT Mme. Antoinette Cecile Hortense b. Paris. 1784 - 1845 Genre, landscapes & Italian subjects Exh: France	*[signature: V H Haudebout]*
HAUGHTON (The Younger) Moses b. England. 1772 - 1848 Portraits, genre & miniaturist Exh: RA, BI	*[monogram: MH in oval]*
HAUGHTON, PRUA, FRSA, Wilfred James FIAL, RUA b. Hillmount. 1921 - Oil & watercolourist Exh: RHA, RUA, RI etc	*[signature: Haughton '65]*
HAUSSOULLIER Guillaume b. Paris. 1818 - 1891 Historical subjects Exh: France	*[monogram: WH]*
HAVERMAET Piet van b. St. Nicolas. 1834 - 1897 Portraits & landscape artist Exh: Belgium	*[signature: P. Van Havermaet]*
HAVERMAN Margareta b. Amsterdam. 1720 - 1795 ? Fruit & floral subjects	*[signature: M Haverman]*
HAVERS Alice Mary b. Norfolk. 1850 - 1890 Genre & landscape artist Exh: RA, SS, PS & Prov. AG's	*[monogram: AH in circle]* *[monogram: AH]*
HAVINDEN, OBE, FSIA, RDI, Ashley Eldrid FRSA, FIPA etc b. 1903 - Painter, designer & typographer Exh: International exhibitions & AG's	*[signature: ASHLEY]*

HAWKINS **Harold Frederick Weaver** b. London. 1893 - Portrait, figure & landscape artist Exh: RA, NEAC, London & Prov. AG's	
HAY **George** b. Leith. 1831 - 1913 Genre subjects Exh: London & Prov. AG's	
HAYDEN **Fred** b. Wolverhampton. 1874 - ? Landscape artist Exh: London & Prov. AG's	
HAYDEN **Henri** b. Varsovie. 1883 · Still life, nudes, cubist & landscape subjects Exh: Germany, France, Scandinavia, Spain, Hungary, US etc	
HAYDON **Benjamin Robert** b. Plymouth. 1786 - 1846 Historical subjects Exh: London & Prov. AG's, Australia	
HAYLLAR, RBA **James** b. Chichester. 1829 - 1920 Portrait, genre & landscape artist Exh: RA, BI, SS London & Prov. AG's	
HAYMAN CHAFFEY **Frederick William** b. Hastings. 1920 - Oil & watercolourist Exh: RA, RI, RBA, NS, PS, Prov. AG's, Spain, Mexico	
HAYNES **Edward Trevanyon** Fl. 1867 - 1885 Genre & historical subjects Exh: RA	

HAYNES **John** FL. 19th C. Genre painter Exh: RA, BI, SS, Prov. AG's	*[signature]*
HAYTER **Sir George** b. London. 1792 - 1871 Portraits, historical subjects & miniaturist Exh: RA, NPG, VA, UK AG'S, Italy	*[signature]*
HAYWARD, ROI **Alfred Frederick William** b. Canada. 1856 - ? Portrait artist Exh: RA, PS	*[signature]* a7W Hayward
HAYWARD, RP, NEAC **Alfred Robert** b. London. 1875 - ? Landscapes, murals & portrait artist Exh: NEAC, RP, RA, Europe & US	*[signature]* Alfred Hayward.
HAYWARD-YOUNG **Eric** b. Sheffield. 1908 - Flowers, miniaturist etc Exh: RA	*[signature]* HAYWARD. YOUNG
HEALEY **Leonard Douglas** b. Cheshire. 1894 - Pastel, oil & watercolourist Exh: London & Prov. AG's	*[signature]* Leon 27 Healey *[monogram LDH]*
HEATHER **Marjorie Kate** b. Newbury. 20th C. Semi-caricature figure compositions & figures in landscapes. Oil & watercolourist Exh: RA, RP, RWA, RI, Paris, London & Prov. AG's	*[signature]* Marjorie Heather Heather
HEBERT **Antoine Auguste Ernest** b. France. 1817 - 1908 Portraits, genre & historical subjects Exh: Italy, France	**HEBERT**
HECHLE, RBA **Hilda** b. Derbyshire. Figure, portrait & landscape artist Exh: RA, RI, RBA, WAG, London & US. AG's	*[signature]* Hechle
HECHT, MFPS, NS **Godfrey** b. London. 1902 - Gouache, ink & oil media etc Exh: ROI, NS, SGA, & Prov. AG's	*[signature]*

HEDLEY **Ralph** b. Richmond. 1851 - 1913 Genre & landscape artist Exh: RA, SS, UK AG'S	*RH*
HEDOUIN **Pierre Edmond Alexandre** b. France. 1820 - 1889 Portraits, genre, landscapes & eastern subjects Exh: French AG's	*Edmond Hedouin*
HEEM **Jan Davidsz de** b. Utrecht. 1606 - 1684 Floral & still life subjects Exh: Russia, Scandinavia, UK & European AG's	*J.D. De Heem f.* *J. De Heem f. A. 1651,* *JD. 1665* *J.D. De Heem* *J.F.* *J.D. De Heem f.*
HEEMSKERK (The Elder) **Egbert van** b. Haarlem. 1610 - 1680 Genre, rustic interiors etc Exh: France, Italy, UK	*HR* *HK*
HEEMSKERK **Marten Jacobsz van veen** b. Nr. Haarlem. 1498 - 1574 Historical artist Exh: Holland	*Martinus Hemskerckius pingebat* *MK.* *DA* *M* *M*
HEERE **Lukas de** b. Gand. 1534 - 1584 Portraits & historical subjects Exh: UK, Scandinavia etc	*HE.*
HEGEDUS **Laszlo** b; Budapest. 1920 - Graphic art, oil & watercolourist Exh: London, Budapest, X Hungary, Australia etc	
HEICHERT **Otto** b. Germany. 1868 - ? Genre subjects Exh: Belgium, Germany	*Otto Heichert*
HEIL **Daniel van** b. Brussels. 1604 - 1662 Historical & landscape artist Exh: Germany, France, Austria	*D.V. Heil 1653* *DVH*

HEILBUTH **Ferdinand** b. Hamburg. 1826 - 1889 Genre artist Exh: Germany, France, UK, Australia	*Heilbuth-*
HEILMAIER **Emil** b. Germany. 1802 - 1836 Landscape artist	HE HE HE
HEIM **Francois Joseph** b. France. 1787 - 1865 Portraits & historical paintings Exh: France	*Heim*
HEINCE **Zacharie** b. Paris. 1611 - 1669 Portraits & genre subjects Exh: France	ZH
HEINONEN **Aarre** b. Lahti. 1906 - Oil & watercolourist Exh: Holland, France, Germany etc	*Aarre Heinonen*
HEINSIUS **Johann Ernst** b. Germany. 1740 - 1812 Portraits & genre subjects Exh: France	*Heinsius*
HEINZ (The Elder) **Joseph** b. Switzerland. 1564 - 1609 Historical subjects Exh: Switzerland, Germany, France, Italy, Austria.	IEF ФE H
HELCKE **Arnold** Fl. 1865 - 1898 Landscape & marine artist Exh: RA, SS, London & Prov. AG's	*A. H. 1868*
HELLEMONT (or HELMONT) **Matheus van** b. Brussels. 1622 ? - 1680 ? Rustic genre, market & interior scenes. Exh: France, Hungary, Austria	*M V HEllemont*
HELLEU **Paul Cesar** b. France. 1859 - 1927 Portrait, genre & silhouettes etc Exh: France, UK	*Helleu*

HELMBRECKER **Dirk Theodor** b. Haarlem. 1633 - 1696 Genre, & historical subjects Exh: Italy, France	*T H*
HELST **Bartholomeus van der** b. Haarlem. 1613 - 1670 Portrait artist Exh: Russia, UK & European AG's	*B. v. onder . helst 1645 Van der Helst* *Helst . fecit* *B. Van der helst 1656 BrH*
HEMESSEN **Jan Sanders** b. Nr. Anvers. 1504 - 1566 Genre & historical subjects Exh: Holland, Germany, Hungary, Russia, Spain etc	*HH* *1554*
HEMY, RA, RWS, RI **Charles Napier** b. Newcastle-on-Tyne. 1841 - 1917 Still life, genre, marine & landscape artist Exh: RA, BI, SS, OWS, NWS, GG, NG & Prov. AG's etc	*CH*
HENDERSON, RBA, FSA, FRIBA **Arthur Edward** b. Aberdeen. 1870 - 1956 Architectural subjects Exh: RA, RBA etc	*·AH·*
HENDERSON **Charles Cooper** b. Chertsey. 1803 - ? Animal & Sporting subjects Exh: RA, London & Prov. AG's etc	*C·H·D*
HENDERSON, RSW **Joseph** b. Perthshire; 1832 - 1908 Genre, portrait & marine artist Exh: RA, SS, RSW, UK AG'S	*HJ JH*
HENDRIKS **Wybrand** b. Amsterdam. 1744 - 1831 Portraits, genre, floral & landscape artist Exh: Holland	*W. Hendriks Pinxit 1796*
HENNEQUIN **Philippe Auguste** b. Lyons. 1762 - 1833 Portraits, mythological, historical, allegorical & landscape artist Exh: Belgium, France	*Hennequin*

HENNER Jean Jacques b. France. 1829 - 1905 Portraits & historical subjects Exh: France, Canada, Scandinavia etc	I/HENNER
HENNESSY, ROI William John b. Ireland. 1839 - 1920 Genre & landscape artist Exh: RA, SS, GG, UK AG's, US	*W.H.*
HENNING Christoph Daniel b. Nuremberg. 1734 - 1795 Portraits, town scenes etc Exh: Germany	*C d henning* *GD*
HENDRIQUEZ de CASTRO Gabriel b. Amsterdam. 1808 - ? Still life & floral subjects	*G. A. J. C.*
HENRY, RHA Paul b. 1876 - ? Oil & charcoal media Exh: London, Ireland, France, Canada, US, Australia etc	*PAUL HENRY.*
HENS Frans b. Anvers. 1856 - ? Marine artist Exh: Belgium	*frans Hens*
HENSEL Wilhelm b. 1794 - 1861 Portraits & historical subjects Exh: Germany	*HW* *HW* *W*
HENSHALL, ARWS, RWS John Henry b. Manchester. 1856 - ? Portraits & genre subjects Exh: RA, RWS, PS, SS, OWS, Prov. AG's	*Henry Henshall. RWS.*
HENTALL, FRSA Maurice Arthur b. London. 1920 - Portraits, wildlife & landscape artist Exh: Canada, US, Australia, Spain, Norway & London AG's	*MAURICE HENTALL* *M.A.HENTALL* *MOL*
HEPPLE Norman b. London. 1908 - Portrait & landscape artist Exh: RA, RP, NEAC, ROI, PS etc	*NORMAN HEPPLE* *Norman Hepple*

HERBELIN Jeanne Mathilde b. Brunoy. 1820 - 1904 Portrait & miniaturist Exh: France, Luxembourg	*M^{tx} Herbelin*
HERBERT Alfred b. ? - 1861 Marine artist & watercolourist Exh: RA, SS, BI, London & Prov. AG's	A H
HERBIN Auguste b. France. 1882 - 1960 Cubist & abstract subjects etc Exh: France	Herbin
HERDMAN, ARSA Duddington b. 1863 - 1922 Genre & portrait artist Exh: RA, UK AG'S	
HERDMAN, RSA, RSW Robert b. Rattray. 1829—1888 Genre, historical & portrait artist Exh: RA, Paris, US, Australia, UK AG's	1876
HERDMAN William Gawin b. Liverpool. 1805 - 1882 Landscape artist Exh: UK AG's	W.G.H. W.G.H
HEREAU Jules b. Paris. 1839 - 1879 Landscape artist Exh: France	*Jules Hereau 1864*
HERKOMER, RA, RWS, RI Sir Hubert von b. Bavaria. 1849 - 1914 Portrait, genre, historical & landscape artist Exh: RA, SS, OWS, RI, GG, NG, Germany, France, Holland etc	H H 75
HERLIN Auguste Joseph b. Lille. 1815 - 1900 Genre artist Exh: France	AHERLIN
HERLIN (The Elder) Friedrich b. Germany. 1435 - 1500 ? Historical subjects Exh: Germany	H.F

HERP (The Elder) **Willem van** b. Anvers. 1614 - 1677 Historical subjects Exh: France, Belgium, Sweden, Austria Ireland	*G·V·HERP* *JH*
HERR **Michael** b. Germany. 1591 - 1661 Allegorical & historical subjects	*MH.*
HERRERA **Alonso de** b. Spain. 1579 - ? Historical subjects	*A H*
HERRERA (The Younger) **Francisco de** b. Seville. 1622 - 1685 Still life, genre & historical subjects Exh: UK, Spain, Russia	*f Herrera* *1680*
HERRING **Benjamin** b. ? - 1871 Animal subjects Exh: BI, SS, Prov. AG's	*B Herring 1859.*
HERRING **John Frederick (Senior)** b. Surrey. 1795 - 1865 Animal & sporting subjects Exh: RA, SS, BI, UK & European AG's, US	*J.Fred H* *JFH 1848* *J.F.H.* *JFH*
HERRING **John Frederick (Junior)** b. ? - 1907 Sporting subjects Exh: RA, BI, SS	*JFHerring 1851.*
HERSCH **Eugen** b. Berlin. 1887 - Pastel, oil & watercolourist etc Exh: RA, RP, PAS etc	*Eugen Hersch*
HERTERICH **Heinrich Joachim** b. Hamburg. 1772 - 1852 Painter, lithographer & miniaturist	*H J H* *H.J.H.*

HERVIER **Louis Adolphe** b. Paris. 1818 - 1879 Genre & landscape artist Exh: Holland, France	*A. HERVIER - 49*
HERVIEU **Louise Jeanne Aimee** b. France. 1878 - 1954 Still life, genre, figure subjects etc Exh: France	*Louis Hervieu*
HERZ **Johann** b. Nuremberg. 1599 - 1635 Miniatures & religious subjects	*JH*
HERZINGER **Anton** b. 1763 - 1826 Animals, landscapes & mythological subjects	*A H*
HESELTINE **Phyllis** b. Essex. Portrait artist & watercolourist Exh: RA, R.Cam.A	*Phyllis Heseltine 27*
HESS **Carl** b. Dusseldorf. 1801 - 1874 Genre, animals & landscape artist Exh: Germany	*H*
HESS **Heinrich Maria von** b. Dusseldorf. 1798 - 1863 Historical artist Exh: Germany	*H*
HESS **Peter Heinrich Lambert von** b. Dusseldorf. 1792 - 1871 Genre & battle scenes Exh: Germany	*PH*
HEUDEBERT **Raymonde** b. Paris. 1905 - Portraits & landscape artist Exh: France, UK, Switzerland, US. etc	*Raymonde Heudebert*
HEUSCH **Guilliam de** b. Utrecht. 1638 - 1692 Landscape artist Exh: European AG's	*GHeusch GHeusch f GH*

HEUSCH **Guilliam de** (continued)	
HEUSCH **Jacob de** b. Utrecht. 1657 - 1701 Marine & landscape artist Exh: Russia, Italy, Austria etc	
HEUZE **Edmond Amedee** b. Paris. 1884 - Portraits, genre & circus scenes Exh: France	
HEWITT **Evelyn** b. London. 1882 - Miniaturist & pastel artist Exh: RA, RMS	
HEWITT, ARCA, RBSA **Geoffrey** b. Co. Durham. 1930 - Painter in oil media Exh: RA, R. Scot. A, RBA, RBSA, Prov. AG's & abroad	
HEWLAND **Elias Dalton** b. 1901 - Oil & watercolourist Exh: RA, RWS & London AG's	
HEYDEL **Paul** b. Dresden. 1854 - ? Genre & portrait artist Exh: Germany	
HEYDEN **Jacob van der** b. Strasbourg. 1573 - 1645 Portraits & landscapes & mytholog- ical subjects	
HEYDEN (or HEYDE) **Jan van der** b. 1637 - 1712 Still life, genre & landscape artist Exh: UK, Russia & European AG's	

HEYDEN (or HEYDE) Jan van der (continued)	*V.d. Heijden J v d Heijde.* *V Heijden f V.Dc VH*
HEYLBROUCK Michael b. Gand. 1635 - 1733 Painter and engraver	*M.b.*
HEYMANS Adriaan Josef b. Anvers. 1839 - 1921 Marine & landscape artist Exh: Belgium, France	*A.J. Heymans.*
HEYWORTH, ROI Richard b. 1862 - ? Landscape artist Exh: RA, ROI, London & Prov. AG's	*RH*
HICK, FRIBA, SMA Allanson b. 1898 - Oil & watercolourist Exh: RA, RBA, Paris etc	*— ALLANSON HICK —*
HICKEL Joseph b. Austria. 1736 - 1807 Portraitist	*J Hickel.*
HICKS, RA George Edgar b. Lymington. 1824 - 1905 Genre & portrait artist Exh: RA, SS, UK AG's, S. Africa	*G.E.H. GEH GEH G.E.H.*
HILDEBRANDT Ferdinand Theodor b. Stettin. 1804 - 1874 Portraits, genre & historical subjects Exh: Holland, Germany	*FH 1826 FH FH 1824 FH*
HILDREW Ken b. Woolwich. 1934 - Land & seascape artist. Printmaker etc. Exh: US, London & Prov. AG's	*Ken Hildrew*

HILL **Carl Frederick** b. Lund. 1849 - 1911 Landscape artist Exh: France, Scandinavia	*CFH*
HILL, RBA **James Stevens** b. Exeter. 1854 - 1921 Landscape & floral subjects Exh: RA, SS, RIBA, Prov. AG's	*J.S.H.*
HILL, NEAC, ROI, NS, UA **Robert William** b. Watford. 1932 - Oil & watercolourist. Exh: London & Prov. AG's	*Robert Hill.*
HILLEGAERT (The Elder) **Pauwels van** b. Amsterdam. 1595 - 1640 Portraits, military & historical subjects	*PVHf*
HILLEMACHER **Eugene Ernest** b. Paris. 1818 - 1887 Portraits, genre & historical subjects Exh: France	*Eugen Hillemacher*
HILLINGFORD **Robert Alexander** b. London. 1828 - 1907 Genre & historical subjects Exh: RA, BI, SS, UK AG's	*RH*
HIMPEL **Anthonis or Abraham** b. Amsterdam. 1634 - ? Genre, landscapes & historical subjects	*H.* *AH*
HIRD, MA **John Stalker** b. Ambleside. 1885 - ? Oil & watercolourist. Exh: Prov. AG's	*J.S. Hird* *Stalker Hird*
HIRSCH **Alphonse** b. Paris. 1843 - 1884 Genre & portrait artist Exh: France	*AH* *HSR*
HISBENS **(or HISBEL-PENN)** FL. Nuremberg. 17th C. Portrait artist	*HSB*

HITCHCOCK **Georges** b. Paris. 1850 - 1913 Genre & landscape artist Exh: US, Paris, Germany, Austria	*G.H*
HITCHCOCK **Harold** b. London. 1914 - Imaginary & visionary landscapes with figures. öil, acrylic & water- colourist. Exh: RA, US, London & Prov. AG's	*19 ⊞-⊞ 71* *19 ⊞-⊞ 75*
HITCHCOCK **Malcolm John** b. Salisbury. 1929 - Railway subjects, figurative pointilist in various media Exh: RA, PS, RW of EA. R.Cam.A, etc	*M.J. HITCHCOCK.* *MJH*
HITCHENS, CBE **Sydney Ivon** b. London. 1893 - Still life & landscape artist Exh: London & Prov. AG's, Italy, France, Holland	*Ivon Hitchens*
HOARE (The Younger) **Prince** b. Bath. 1755 - 1834 Portraits & historical subjects Exh: RA, Italy etc	*P Hoare 1821* *P Hoare*
HOBART, B.SC, RCA **John** b. London. 1922 - Oil & watercolourist Exh: R.Cam.A, RI etc	*J Hobart.*
HOBBEMA **Meyndert** b. Amsterdam. 1638 - 1709 Landscape artist Exh: UK & European AG's etc	*M Hobbema* *M: Hobbema. ft* *m. Bobbema* *M Hobbema* *M hobbema* *M Hobbema* *meyndert hobbema 1667* *M. Bobbema* *MH 1663*

HOBSON, FRIBA **Lawrence** b. Liverpool. 1872 - ? Oil & watercolourist Exh: R.Cam.A, London & Prov. AG's	*Lawrence Hobson*
HOCHARD **Gaston** b. Orleans. 1863 ? - 1913 Genre, architectural & historical subjects Exh: France	**Hochard**
HOCKEY, RBA, ROI **James Morey** b. London. 1904 - Portrait, landscape & floral oil & watercolourist Exh: RA, RBA, ROI etc	JAMES HOCKEY 19····
HODGES **Charles Howard** Flourished London. 18th Century Miniaturist Exh: SA, etc	*C. H. Hodges.* *1802*
HODGSON **Dora** b. Cheshire. 1891 - Miniaturist Exh: RA, RMS, WAG	*monogram* *1915*
HODGSON, RA, HFRPE **John Evan** b. London. 1831 - 1895 Genre, landscapes, eastern & Historical subjects Exh: RA, BI, SS etc	JEH IEH
HODLER **Ferdinand** b. Switzerland. 1853 - 1918 Portraits, genre, historical & landscape artist Exh: Switzerland	*F Hodler F. Hodler F. Hodler*
HOECKERT **Johan Fredrick** b. Sweden. 1826 - 1866 Genre subjects Exh: Germany. Austria, France	*F.O.Höckert*
HOEFNAGEL (or HUFNAGEL) **George** b. 1542 - 1600 Miniaturist & portrait artist	*monograms*
HOET (The Elder) **Gerard** b. Bommel. 1648 - 1733 Historical, genre & mythological subjects Exh: Russia, Holland, France, Germany, UK etc.	*G Hoet*

HOEVENAAR **Willem Pieter** b. Utrecht. 1808 - 1863 Genre subjects Exh: Holland	
HOEY (The Elder) **Nikolaus van** b. Anvers. 1631 - 1679 Religious, mythological & battle scenes Exh: Austria	
HOFF (The Younger) **Carl Heinrich** b. Dusseldorf. 1866 - 1904 Genre & portrait artist	
HOFFMANN **Hans** b. ? - 1591 ? Portraits, insects & floral subjects Exh: Austria, Hungary	
HOGARTH **William** b. London. 1697 - 1764 Portraits, Genre & Historical subjects Exh: Switzerland, UK, France etc	
HOGLEY **Stephen E.** Fl. 1874 - 1881 Landscape artist Exh: SS, Prov. AG's	
HOLBEIN (The Younger) **Hans** b. Augsbourg 1497 ? - 1543 Portraits & historical subjects Exh: France, Switzerland, UK, Spain, Belgium etc	
HOLBEIN **Sigmund** b. Augsbourg. 1465 ? - 1540 Portraits & religious subjects etc Exh: UK, Germany, Austria	
HOLDING, ARWS **Edgar Thomas** b. Lincolnshire. 1876 - ? Landscape artist	

HOLE, RSA, RWS, RE **William** b. Salisbury. 1846 - 1917 Genre & landscape artist Exh: RA, UK AG's	*WH WH*
HOLL, RA, ARWS **Frank Montague** b. London. 1845 - 1888 Portraits, historical & genre subjects Exh: RA, GG, BI, SS, NG, Prov. AG's Australis	*F.H.*
HOLLAND **George H.B.** b. 1901 - Portrait, still life & landscape artist Exh: RA, RSA, NEAC, RP. ROI & Prov. AG's	*G.H.B. Holland.*
HOLLAND **James** b. Burslem. 1800 - 1870 Landscapes & architectural scenes Exh: RA, RI, BI, London & Prov. AG's, Canada, US	*HHᴰ*
HOLLAND **John** Fl. Nottingham 19th C. Landscape artist Exh: BI, UK AG's	*JH*
HOLLAND **Mabel Constance Burnes** b. Dawlish, Devon. 1885 - Landscape artist Exh: RWA, London & Prov. AG's	*MH*
HOLLOWAY, RI **Charles Edward** b. Christchurch. 1838 - 1897 Marine & landscape artist Exh: RA, SS, NWS, GG etc	*CEH*
HOLMES, KCVO, RWS, NEAC, MA, **Sir Charles John FSA** b. Preston. 1868 - ? Landscape artist Exh: NEAC, RWS. London & Prov. AG's	*C.I.H.1926*
HOLROYD **Sir Charles** b. Leeds. 1861 - 1917 Landscapes, figures & architectual subjects Exh: RA, RDS, NG, IS, RE	*CH*
HOME, Pres. SSA 1915 - 17 **Robert** b. Edinburgh. 1865 - ? Portrait & landscape artist Exh: RA, RSA, SSA, GI & Prov. AG's	*R.HOME m.*

HONDECOETER **Gillis de** b. Antwerp. ? - 1638 Portraits, birds & landscape artist Exh: France, Holland, Germany etc	*GD'H* *G DH*
HONDECOETER **Melchior de** b. Utrecht. 1636 - 1695 Animals, birds, still life & landscape artist Exh: France, Holland, Belgium, Germany, Italy, UK etc	*M.D.Hondecoeter* *MDH* *M·DH*
HONDIUS **Abraham Danielsz** b. Rotterdam. 1625 ? - 1695 Animals, hunting & battle scenes etc Exh: Holland, France, UK, Germany, Russia, US	*Abraham Hondius* *AH*
HONDIUS (The Younger) **Hendrik** b. Amsterdam. 1597 ? 1644 ? Portraits, genre & landscape artist	
HONE (The Elder) **Nathaniel** b. Dublin. 1718 - 1784 Portraits & miniaturist Exh: SA, RA etc	*HN*
HONE, RHA **Nathanial (Junior)** b. Dublin. 1831 - 1917 Landscape artist Exh: UK AG's	*NH*
HONTHORST **Gerrit van** b. Utrecht. 1590 - 1656 Portraits & historical subjects etc Exh: UK, Italy, Hungary, Holland, France, Switzerland, Germany etc	*Honthorst* *GH* *Honthorst* *GH* *Honthorst* *GH* *GH* *Honthorst* *1644* *GH* *GH*

HOOCH (or HOOGH) **Pieter de** b. Rotterdam. 1629 - 1681 Genre subjects, portraits, interiors etc Exh: UK, France, Italy, Germany, Austria etc	*P. d'hooch. f. 1670*　　*P de hooch* *P. d'. hooch.*　　　　　*P.D.H* 　　　P.D.HOOGH *P. d. hooch*　　　　▷H　H P D HOOCH ·　　　P.·D.·H.
HOOD, RE **George Percy Jacomb** b. 1857 - 1929 Genre & portrait artist Exh: RE, RA, SS	*G.P.J.H*　　　*G.P.J.H*
HOOFT **Nicolas** b. The Hague. 1664 - 1748 Historical, genre & landscape artist Exh: Sweden, Germany	*Hooft*
HOOGSTRATEN **Dirk van** b. Anvers. 1596 ? - 1640 Religious & historical subjects Exh: Holland	*hoochstraten. fecit*　　**DH**
HOOGSTRATEN **Samuel van** b. Dortrecht. 1627 - 1678 Portraits, genre & historical artist Exh: Holland, Austria	*Samuel van Hooostraten* S̄vH̄　　H̄　　H̄
HOOK **Bryan** b. 1856 - ? Coastal scenes, landscapes & genre 　　　subjects Exh: RA, London & Prov. AG's	*B.H.*　　　*B.H.*
HOOK, RA, HFRPE **James Clarke** b. London. 1819 - 1907 Historical, rustic genre, sea & landscape artist Exh: RA, BI, London & Prov. AG's, Australia	*HC*

HOOPER **George W** b. Gurakhpur. 1910 - Oil & watercolourist Exh: RA & London AG's	*g.W.Hooper*
HOOPER **John Horace** Fl. London 19th C. Landscape artist Exh: SS, UK AG's	
HOPFGARTEN **August Ferdinand** b. Berlin. 1807 - 1896 Genre & historical subjects Exh: Germany	18 JAF 30 Roma.
HOPKINS **Eric Samuel** b. West Lavington. 1926 - Architectural, landscape, marine & figure subjects Exh: USA, ROI, RI, London AG's etc	*Eric S. Hopkins* U.A.
HOPKINS **Everard** b. 1860 - 1928 Watercolourist & illustrator Exh: NWS	*EH.*
HORNEL **Edward Atkinson** b. Victoria. 1864 - 1933 Genre & landscape artist Exh: UK AG's	*EAH. 81*
HORSLEY **Hopkins Horsley Hobday** b. Birmingham. 1807–1890 Landscape artist Exh: RA, BI, SS	
HORSNELL **Walter Cecil** b. Herts. 1911 - Landscapes, portraits, & figure artist Exh: RA, RBA, NPG. London & Prov. AG's	*Walter Horsnell*
HORST **Nicolaus van der** b. Anvers. 1598 - 1646 Portraits & historical subjects etc	NH *N.H*
HOSALI, M.Sc. **Nina Moti** b. London. 1898 - Painter in oils & mixed media. Exh: ROI, RBA, NS, Prov. AG's Paris, US etc	

HOSIASSON **Philippe** b. Odessa. 1898 - Painter in oil media Exh: US, France	*Hosiasson*
HOSKINS (The Elder) **John** b. England. ? - 1664 Portrait artist & miniaturist	HI
HOUBRAKEN **Arnold** b. Dortrecht. 1660 - 1719 Portraits, genre, religious & historical subjects Exh: France, Germany.	*A: Houbroken Fec.* *Houbraken* *AH* *AH* *H* *AH* *AH*
HOUBRON **Frederic Anatole** b. Paris. 1851 - 1908 Genre & landscape artist Exh: France	*Houbron*
HOUEL **Jean Pierre Louis Laurent** b. Rouen. 1735 - 1813 Genre, animal & landscape artist Exh: France	*jean hoüel*
HOUGHTON **Arthur Boyd** b. 1836 - 1875 Genre; oil & watercolourist Exh: RA, BI, SS, OWS, etc	A B H
HOUNSELL, ARCA **Francis William** b. London. 1885 - Landscape watercolourist Exh: RA	*F. W. Hounsell*
HOUSEMAN, SWA, SSWA **Edith Giffard** b. Herefordshire. 1875 - ? Portrait & landscape artist Exh: RA, RI, RBA, R.Scot.A, SSWA, SWA, SGA etc	*Houseman.*

HOUSTON, RSA **John Adam** b. Wales. 1812 - 1884 Genre & historical subjects Exh: RA, SBA, BI, UK AG's	*JAH RSA*
HOVE **Edmond Theodor van** b. Bruges. 1853 - ? Religious & genre subjects Exh: Belgium, Germany, UK	*E Van Hove*
HOVE **Hubertus van** b. Hague. 1814 - 1865 Architecture & landscape artist Exh: Holland, Germany	H.V.H.
HOWARD, BA **Charles** b. Montclair, N.J. 1899 - B/White, oil & gouache media Exh: X US, Australia etc	
HOWD **Michael** b. US. Painter in B/White & tempera media Exh: RA & US AG's	
HOWITT **William Samuel** b. 1765 - 1822 Sporting & hunting scenes Exh: SA. RA	
HOYTON, FRSA **Inez Estella** Artist in oil, watercolour media etc Exh: RA, London & Prov. AG's	
HUARD **Pierre** b. Paris. ? - 1857 Architectural subjects Exh: France	
HUARDEL-BLY **George** b. Orleans. 1872 - ? Painter, etcher & caricaturist Exh: London & Paris	
HUBBARD **Eric Hesketh** b. London. 1892 - 1957 Genre, architectural & landscape artist Exh: UK AG's	EHH

HUBER **Jean Daniel** b. Geneva. 1754 - 1845 Animal subjects Exh: Geneva	*[monogram] 1784* *[monogram]*
HUBER **Johann Rudolphe** b. Basle. 1668 - 1748 Portraits & historical subjects Exh: Switzerland	*Rudolphe Huber 1724*
HUBER **Leon Charles** b. Paris. 1858 - 1928 Animal subjects Exh: France	*Leon-Huber*
HUBER **Wolfgang** b, 1490 - 1553 Genre, religious & landscape artist Exh: Dublin, Germany	*WH* *[monogram]*
HUBERTI **Eduard Jules Joseph** b. Brussels. 1818 - 1880 Landscape painter Exh: Brussels, Antwerp	*Huberti*
HUCHTENBURG **Jan van** b. Haarlem. 1647 - 1733 Military subjects Exh: Holland, Belgium, France, London	*Hughtenburgs.* *I·HB* *HB* *J.B. Huchtenburgh* *HBfait.* *I VHB* *HB.f* *HB*
HUDSON **Thomas** b. 1701 - 1779 Portrait artist Exh: SA, NG, Dublin, Paris, New York	*Hudson* *Hudson*
HUE **Jean Francois** b. France. 1751 - 1823 Military, marine & landscape artist Exh: France	*J F Hue*
HUEBNER **Carl Wilhelm** b. Germany. 1814 - 1879 Genre artist Exh: Germany	*Carl Hübner Dusserdorf. 1846*

HUET (The Elder) **Jean Baptiste** b. Paris. 1745 - 1811 Animals & landscape artist Exh: France	*J B Huet Huet J. B. Huet*
HUET **Paul** b. Paris. 1803 - 1869 Landscape artist Exh: France	*P Huet Paul Huet*
HUGHES **Arthur** b. London. 1832 - 1915 Genre & romantic subjects Exh: RA, GG, NG etc	*[monogram] [monogram] [monogram]*
HUGHES, RWA **Donald** b. Bristol. 1881 - Watercolourist Exh: London & Prov. AG's	*Donald Hughes*
HUGHES **Edward** b. London. 1832 - 1908 Portrait artist Exh: RA, UK AG's	*E. HUGHES 1854*
HUGHES, RWS **Edward Robert** b. London. 1851 - 1914 Historical & genre artist Exh: RA, BI, OWS, GG. Germany, Italy etc	*ERH E.R.H.*
HUGHES, DA, SGA **Jim** b. Ayr. 1934 - Figure, landscape & abstract subjects Exh: SGH	*JH*
HUGHES, ROI **Talbot** b. London. 1869 - 1942 Genre subjects Exh: RA, ROI, WG, Prov. AG's	*[monogram]*
HUGO **Jean** b. Paris. 1894 - Illustrator & theatrical painter Exh: France	*jean Hugo*
HUGO **Victor-Marie** b. France. 1802 - 1885 Genre & landscape artist Exh: France	*Victor Hugo*

HUGTENBURG **(or HUCHTENBURGH)** **Jacob van** b. Haarlem. 1639 - 1675 Landscape artist	*JV.Hugtenburg* *HBurgh*
HUGUES **Paul Jean** b. Paris. 1891 - Interiors & genre subjects Exh: France	*Paul Hugues*
HUILLARD **Esther** FL. 19th — 20th C. Portrait & figure artist Exh: France	*E Huillard*
HULME **Frederick William** b. Swinton. 1816 - 1884 Landscape artist Exh: UK AG's, Canada	*FWH* *F.W.H.*
HULSMAN **Johann** FL. 17th C. Historical, genre & portrait artist Exh: Germany	*J.H.*
HULST **Frans de** b. Haarlem. 1610 ? - 1661 Landscape artist Exh: Holland, Sweden, France	*F. D . HVLST*
HULST **Pieter van der** b. Dortrecht. 1651 - 1727 Genre & portrait artist Exh: Italy, Holland	*P.VH f.*
HULSWIT **Jan** b. Holland. 1766 - 1822 Animal & landscape subjects Exh: Amsterdam, Frankfurt	*J.Hulswit*
HUMBERT **Jacques-Fernand** b. Paris. 1842 - ? Religious & portrait artist Exh: France, Holland, Geneva	*F.Humbert*
HUMPHREY **Ozias** b. Honiton. 1742 - 1810 Portrait artist & miniaturist Exh: RA, London & Prov. AG's	(H)

HUMPHREYS **David** b. London. 1937 - Landscape artist Exh: US, Switzerland, London AG's	*Humphreys*
HUMPHREYS, ATD **Mark** b. Monaco. 1925 - Oil, gouache media etc Exh: London & Prov. AG's	*MH.*
HUNDERTWASSER **Friedrich** b. Vienna. 1928 - Oil, tempera & watercolourist Exh: Italy, France, Japan, Germany, Switzerland, Holland, London etc	*Hundertwasser* HUNDERTWASSER
HUNT, RWS **Alfred William** b. Liverpool. 1830 - 1896 Landscape artist Exh: RA, UK AG's	*AWH 1871*
HUNT **Charles** b. London. 1803 - 1877 Humorous genre Exh: RA, London & UK AG's	*CH.*
HUNT, VP, RSW, ARSA **Thomas** b. Skipton. 1854 - 1929 Oil & watercolourist Exh: RSA, RA, London & Prov. AG's France	*Thos Hunt*
HUNT **Walter** b. London. 1861 - ? Animals, still life, genre subjects etc Exh: RA, London & Prov. AG's	*WH 18 97*
HUNT **William Henry** b. London. 1790 - 1864 Landscapes, rustic & floral subjects Exh: RA, RWS	*W. Hunt* *W Hunt*
HUNT, ARSA, RSW, OM **William Holman** b. London. 1827 - 1910 Portrait, religious, genre & imaginative subjects Exh: RA, OWS, GG, NG, etc	*WHH*
HUNTER, ARA, RI, RSW **Colin** b. Glasgow. 1841 - 1904 Coastal, sea & landscape artist Exh: RA, London & Prov. AG's	*CH*

HUNTER **John Young** b. Glasgow. 1874 - 1953 Genre, historical & landscape artist Exh: UK AG's	*J.Y.H.*
HUQUIER **Gabriel** b. Orleans. 1695 - 1772 Genre artist Exh: France	
HURRY **Leslie** b. London. 1909 - Oil, ink & watercolour media Exh: London & Prov. exhibitions. Canada, S. Africa etc	
HURTREL **Arsene Charles Narcisse** b. Lille. 1817 - 1861 Genre & military subjects Exh: PS, France	
HURTUNA **Josep Giralt** b. Barcelona. 1913 - Painter & engraver Exh: Spain, Italy, UK, US, Japan etc.	
HUTCHISON, RSA, RSW **Robert Gemmell** b. 1855 - 1936 Genre & still life subjects Exh: RA, RSA, ROI, Prov. AG's	
HUTCHISON, DA, Edin. **Shand Campbell** b. Dalkeith. 1920 - Oil, watercolourist etc Exh: SSA, RSA, etc	
HUTCHISON, HRA, PRSA, Hon.RA, **RSA, ARSA, RP.** **Sir William Oliphant** b. Kirkcaldy. 1889 - Portrait & landscape artist Exh: RA, RSA, NEAC, GI, IS	
HUTTER **E.** b. 1835 - 1886 Genre artist Exh: Vienna	*E. HÜTTER*
HUYGENS **Frederik - Lodewyh** b. Hague. 1802 - 1887 Genre artist Exh: Holland	

HURSMANS **Cornelis** b. Antwerp. 1648 - 1727 Landscape painter Exh: Belgium, Germany, France, London.	*Hüsman*
HUTTY **Alfred Heber** b. Michigan. 1878 - Genre subjects Exh: US AG's	
HUYSMANS **Jan Baptiste** b. Antwerp. 1826 - ? Historical, genre & oriental subjects Exh: Belgium	*J B Huysmans f.t*
HUYSMANS **P.J.** FL. 18th C. Landscape painter Exh: Belgium	*P J Huysmans*
HUYSUM **Jan van** b. Amsterdam. 1682 - 1749 Still life, floral & landscape painter Exh: Holland, Germany, Italy, France	*Jan J Huysum 1724* *Jan van Huijsum* *Jan Van Huijsum Fecit 1736* *Jan v Huijsum* *Jan Van Huijsum Fecit* *Jan. Van Huijsum fecit* *Huijsum. f.*
HUYSUM (The Elder) **Justus van** b. Amsterdam. 1659 - 1716 Portrait, floral, marine & landscape artist Exh: Holland, Belgium	*Justus Van Huijsum* *Jus V Huijsum*
HUYSUM (The Younger) **Justus van** b. Amsterdam. 1684 - 1707 Military subjects Exh: Holland	*H.*

HUYSUM **Michiel van** FL. 1729 - 1759 Floral subjects Exh: Holland	*M. Van Huysum*
HYRE **Laurent de la** b. 1606 - 1656 Portraits, architectural, historical & landscape artist	*L De la Hyre in f* *p. 1653* *L. de Lahyre* *Inv et fecit 1655*

I

IMPARATO **Francesco** b. Naples. 1530 ? - 1565 Historical subjects	*F. Imparato*
INCHBOLD **John William** b. Leeds. 1830 - 1888 Landscape artist Exh: SS, RA, VA, NG, UK AG's	(monogram) (monogram) (monogram)
INCLEDON **Marjorie M.** b. 1891 - Painter in oil media Exh: RA, ROI, RBA, RPS, etc	(monogram)
INDACO **Jacopo de Dell** b. Florence. 1476 - 1526 Historical subjects	*J D. Indaco* *1530*
ING **Harold** b. London. 1900 - Marine artist Exh: London & Prov. AG's	HAROLD ING D
INGEN **Willem van** b. 1651 ? - 1708 Historical & portrait painter Exh: Holland	*GV Ingen*
INGRES **Jean Auguste Dominique** b. France. 1780 - 1867 Historical, mythological & religious subjects Exh: France, NG, Italy, Sweden	INGRES Rᴬ.ᴬ1818 INGRES Rᴬ. INGRES (monogram)

INGRES Jean Auguste Dominique (continued)	*Ingres P. 1817*　　*Ingres.* *I Ingres 1866*　**MI**　⬭
INLANDER H. b. Vienna. 1925 - Painter in oil media Exh: WAG, RA, London & Prov. AG's Italy, etc	H. INLANDER
IRALA Yuso b. Madrid. 1680 - 1753 Historical & religious subjects Exh: Spain	M·Ira Puyuso
IRELAND Thomas Fl. 1880 - 1903 Landscape artist Exh: RA, SS, NWS, GG	⟊
IRVINE, RSW Robert Scott b. Edinburgh. 1906 - Watercolourist Exh: RSA, RSW, SSA, Prov. AG's U.S. Canada etc	R. Scott Irvine.
IRVING, OBE, RDI Laurence Henry Forster b. 1897 - Exh: RA, FAS, London & Prov. AG's etc	⼌
ISAAKSZ Pieter Franz b. 1569 - 1625 Historical & portrait painter Exh: Amsterdam, Copenhagen	Ps-1619　Ps-1619　Ps
ISABEY Jean Baptiste b. Nancy. 1767 - 1855 Portrait painter & miniaturist Exh: France, Spain, UK, Germany, Spain etc	J.Isabey 1817　🛡　I Isabey
ISABEY Louis Gabriel Eugene b. Paris. 1803 - 1886 Marine & genre artist Exh: France, US, Sweden.	E. Isabey 1841　E. Isabey
ISENBRANT (or YSENBRANT) Adriaen b. ? - 1551 Religious subjects Exh: Belgium, France, US	Ay.

ISENDYCK (or YSENDYCK) **Anton van** b. Anvers. 1801 - 1875 Historical & portrait painter Exh: Belgium, France	
ISRAELS **Joseph** b. Holland. 1824 - 1911 Portrait, still life, marine & landscape artist Exh: Holland, Paris, Berlin, London, Rome	
IWILL **Marie Joseph Leon Clavel** b. Paris. 1850 - 1923 Marine & landscape painter Exh: France	

J

JACKMAN **Iris Rachel** b. Dorset Flower subjects etc Exh: London & Prov. AG's	
JACKSON **Francis Ernest** b. UK. 1873 - 1945 Figures, architectural & landscape artist Exh: UK AG's	
JACKSON **Frank George** b. Birmingham. 1831 - 1905 Portrait, still life, genre & landscape artist Exh: London & Prov. AG's	
JACKSON, SSSBA **Frederick William** b. Nr. Manchester. 1859 - 1918 Landscape & marine artist Exh: RA, SS, UK AG's	
JACOB **Cyprien Max** b. 1876 - 1944 Theatrical & genre painter Exh: France	
JACOB (The Elder) **Julius** b. Berlin. 1811 - 1882 ? Historical, portrait & genre artist Exh: RA, France, Germany	

JACOBS **Jakob Albrecht Michael** b. Anvers. 1812 - 1879 Genre & landscape painter Exh: Belgium, Germany	*Jacob Jacobs ft*
JACOMB-HOOD, RPE, MVO, RBA **George Percy** b. Surrey. 1857 - 1929 Portrait, genre & historical subjects Exh: RA, SS, GG, NG, PS, NEAC etc	G.P.J.H
JACQUE **Charles Emile** b. Paris. 1813 - 1894 Animal & landscape painter Exh: France, Holland, England	*Ch. Jacques* *cg* *C·J*
JACQUEMART **Jules Ferdinand** b. Paris. 1837 - 1880 Watercolourist & engraver Exh: France	*JГ*
JACQUES **Raphael** b. Nancy. 1882 - 1914 Portrait & landscape artist Exh: France	*JR*
JACQUET **Gustave Jean** b. Paris. 1846 - 1909 Portraits & genre subjects Exh: France, UK, US	*G Jacquet*
JADIN **Louis Godefroy** b. Paris. 1805 - 1882 Animals, hunting scenes & landscape painter Exh: PS, France, London, Belgium	*G. Jadin*
JAENISCH **Hans** b. Eilenstedt. 1907 - Exh: France, Germany, US, etc	*tae*
JAGER **Gerard de** b. Dortrecht. ? - 1679 Marine artist Exh: Holland	*GD Jager: 1668*
JAMES, RWS **Francis Edward** b. Willington. 1849 - 1920 Floral & landscape artist Exh: RWS, SS, UK AG's	*f.G.J.*

JAMESON, RCA, RDS, FRSA **Kenneth Ambrose** b. Worcestershire. 1913 - Painter in oil media Exh: London & Prov. AG's X	*Jameson*
JANES, RWS, RE, RSMA **Norman** b. 1892 - Painter, etcher & engraver Exh: RA, RE, RWS, NEAC, SMA, etc	*Normanjanes* *NJ*
JANES, Mem. USA **Violeta** b. Buenos Aires. 20th C. Portraits & landscapes, floral subjects etc. Exh: RA, RP, ROI, RSA, London & Prov. AG's etc	*Violeta Janes*
JANNET **Francois**	See CLOUET Francois
JANSEN **Gerhard** b. Utrecht. 1636 - 1725 Genre artist Exh: Vienna, Holland	*G*
JANSON (The Elder) **Johannes** b. 1729 - 1784 Animals & landscape painter Exh: Holland, England, Sweden	*J. Janson*
JANSSENS (called van NUYSSEN) **Abraham** b. Antwerp. 1575 ? - 1632 Historical subjects Exh: Holland, Germany, Belgium, France, Austria etc	*A. Janssens*
JANSSENS **Victor Honore** b. Brussels. 1658 - 1736 Historical, religious & landscape subjects Exh: Belgium, France, Vienna	*V. Janssens* *Vh Janssens* *1730*
JARNEFELT **Eero Nikolai** b. Viborg. 1863 - ? Portrait & landscape painter Exh: Finland	*Eero Järnefelt*
JARVIS **Henry C.** b. 1867 - ? Landscape artist Exh: RA, RI, London & Prov. AG's	*H.C. JARVIS*

JEAN Antoine b. Ascoli 1690 ? - ? Historical & landscape painter Exh: Italy	*AF*
JEANRON Philippe Auguste b. France. 1809 - 1877 Genre & landscape subjects Exh: PS & French AG's	*Jeanron Jeanron*
JEFFERSON, ARCA Alan b. London. 1918 - Oil, gouache & watercolourist Exh: RA, RBA, NEAC, London & Prov. AG's	JEFFERSON AJ A
JEFFREY Edward b. 1898 - B/White & watercolourist Exh: NS, RBA, NI & Prov. AG's	e.jeffrey
JELGERHUIS Johannes b. 1770 - 1836 Genre, architectural, portrait & landscape subjects Exh: Holland	JJelgerhuys
JELGERSMA Tako b. Harlingen. 1702 - 1795 Marine & portrait artist Exh: Belgium, Holland, London, Vienna	TJ
JENNINGS, ARE, ARCA Philip O. b. London. 1921 - Etcher & watercolourist Exh: RA, London & Prov. AG's, US	POJ 1951
JENNINGS Reginald George b. London. 1872 - 1930 Portraits, figures, landscapes & miniatures Exh: RA, RI, SM.	RGJennings R
JENNINGS Walter Robin b. Staffs. 1927 - Portraits, landscapes & equestrian subjects Exh: RBSA, R.Cam.A, RWEA, RI, NEAC etc	WJennings
JESPER Charles Frederick b. UK. B/White, oil & watercolourist Exh: WAG, London & Prov. AG's	Chas.F Jesper CFJ

JESPERS **Floris Egide Emile** b. Antwerp. 1889 - Oil, watercolourist & etcher etc Exh: X international collections	*Jespers*
JOBLING **Robert** b. Newcastle. 1841 - 1923 Genre, river & marine subjects Exh: RA, SS. Prov. AG's etc.	RJ
JOBSON **Patrick** b. UK. 20th C. Oil, pastel, tempera & watercolour media Exh: London & Prov. AG's X	5 ⊕ 1
JOHNSON, RWS **Edward Killingworth** b. London. 1825 - 1896 Genre & landscape artist Exh: RA, SS, UK AG's, US	E.K.J.
JOHNSON, WIAC, PS, AWG **Esther Borough** FL. 19th - 20th C. B/White, pastel, oil & watercolour media Exh: RA, RI, ROI, PAS, PS etc	EBJ
JOHNSON, RI **Harry John** b. Birmingham. 1826 - 1884 Landscapes & genre subjects Exh: RA, BI, SS, NWS etc	HJ JH
JOHNSON **Henry** Fl. 19th C. Figure artist Exh: RA, SS, BI	Henry Johnson 1816
JOHNSON **Katherine** Architectural views, landscapes & flower subjects Exh: RA, RI, WAG & Prov. AG's	K.J.
JOHNSON **Robert** b. Auckland, N.Z. 1890 - Painter in oil media Exh: RCS, London & Paris	Robert Johnson
JOHNSTON **Alexander** b. Scotland. 1815 - 1891 Portraits & historical genre Exh: RA, UK AG's,	A.J.

JOHNSTON **Sir Harry Hamilton** b. London. 1858 - 1927 Portrait, figure, animal & landscape artist Exh: RA, Prov. AG's	
JOICEY **Richard Raylton** b. London. 1925 - Portrait, marine & landscape artist Exh: RSMA, RI	
JOLLAIN (The Younger) **Nicolas Rene** b. Paris. 1732 - 1804 Religious, historical & mythological subjects Exh: PS, France	
JOLLIVET **Pierre Jules** b. Paris. 1794 - 1871 Historical, still life & genre artist Exh: France	
JONCIERES **Leonce J.V. de** b. 1871 - ? Genre subjects Exh: France	
JONES, RCA **Charles** b. Cardiff. 1836 - 1892 Animal & landscape artist Exh: RA, BI, SS, NWS, Australia	
JONES **Ethel Gertrude** b. Liverpool Portrait & landscape artist Exh: WAG & Prov. AG's	
JONES **Langford** b. London. 1888 - Painter, engraver & sculptor Exh: RA & Prov. AG's etc	
JONES **Peter** b. London. 1917 - Oil & watercolourist etc Exh: RBA, RA & London AG's	
JONES, Ass. Mem. SAF **Thomas Dempster** b. N. Wales. 1914 - Portrait, equestrian & landscape artist Exh: RA, PS, RBA, RI, USA, R.CamA US, London & Prov. AG's etc	

JONG **Servaas de** b. 1808 - ? Historical & portrait painter Exh: Holland	Ḋ
JONGH **Claude de** b. ? - 1663 Landscape artist Exh: Amsterdam, London	G djongh fecit. C.D.J
JONGH **Frans de** b. ? - 1705 Historical painter Exh: Holland, Copenhagen	f. de jongh
JONGH **Ludolf** b. 1616 - 1679 Portrait, genre, battle scenes & landscape artist Exh: Holland, Dublin, Geneva, Germany, Russia	LDJongh L.D.Jongh Ludolf de Jongh 1690
JONGHE **Gustave Leonhard de** b. 1828 - 1893 Genre & portrait painter Exh: Belgium	Gustave De Jonghes
JONGKIND **Johan** b. Holland. 1819 - 1891 Marine & landscape painter Exh: PS, Belgium, Holland, France	Jongkind JongKind
JOORS **Eugene** b. Belgium. 1850 - ? Portraits, still life, animals & land- scape artist Exh: Holland, Belgium	Joors
JOPLING, RI **Joseph Middleton** b. London. 1831 - 1884 Portraits, genre, still life, landscapes etc Exh: RA, SS, NWS, GG, RI & Prov. AG's	18 65
JORDAENS **Hans** b. Delft. 1616 - 1680 Historical, marine & landscape artist Exh: Holland	Jean Jordaans

JORDAENS **Jacob** b. Antwerp. 1593 - 1678 Portraits, historical & mythological subjects Exh: France, Holland, Germany, Italy etc	*J. Jor-f 1653 J. Jor. le. 1646*
JORDAN **Edouard** b. Berlin. FL. 19th C. Historical subjects Exh: Germany	*E. Jordan*
JOSEPH **Amy** Watercolourist Exh: RA, RI, RBA, NEAC etc	*Amy Joseph*
JOUBERT **Leon** b. France. FL. 19th C. Landscape painter Exh: France, Montreal	*L. Joubert*
JOUVE **Paul** b. France. 1880 - Animal painter & illustrator Exh: France	*Paul Jouve Jouve*
JOUVENET **Jean Baptiste** b. Rouen. 1644 - 1717 Religious, historic & portrait painter Exh: France, Italy, Germany, Sweden, Russia	*J. Jouvenet pinxit 1707 Jouvenet pin 1689*
JOY **George William** b. Dublin. 1844 - 1925 Floral, genre & historical subjects Exh: RA, PS, France	*G. J.*
JOY **Thomas Musgrove** b. Kent. 1812 - 1866 Portraits, genre, sporting & historical subjects Exh: RA, SS, NWS, NI	*(TMJ monogram)*
JOYANT **Jules Romain** b. Paris. 1803 - 1854 Landscape painter Exh: France	*J. F*
JUAN **De Sevilla Romero y Escalante** b. Grenada. 1643 - 1695 Religious subjects Exh: Spain, Budapest	*S$\overset{A}{V}$*

JUNCOSA **Fray Joaquin** b. Spain. 1631 - 1708 Religious & historical subjects Exh: Italy, Spain	*J Juncosa*
JUNIUS **Isaak** FL. 17th C. Painter of battle scenes Exh: Holland, Budapest	*j junius.*
JUTSUM **Henry** b. London. 1816 - 1869 Genre & landscape artist Exh: RA, NWS, BI, VA, Prov. AG's	**HJ**
JUVENEL (The Elder) **Paul** b. Nuremberg. 1579 - 1643 Religious & historical subjects Exh: Nuremberg	*AP 1634* *AP*

K

KAA **Jan van der** b. Holland. 1813 - 1877 Portraits & interior scenes Exh: Holland, Belgium, Germany	*VK*
KADISH **Norman Maurice** b. London. 1916 - Portraits, genre, locomotives, still life and marine & religious subjects Exh: RA, ROI, RBA, SEA, London & Prov. AG's etc	*m. m. Kadish*
KAGER **Johan Mathias** b. Munich. 1575 - 1634 Historical, religious & miniaturist painter Exh: Germany	**MK** **MK**
KALDENBACH **Johan Anthoni** b. Holland. 1760 - 1818 Portrait artist Exh: Holland	*J.A. Kaldenbach*
KALF **Willem** b. Amsterdam. 1622 - 1693 Still life, interiors & genre subjects Exh: France, Hungary, UK, Holland, Russia, Belgium etc	*G Kalf 1689* *W. Kalf. 1659.* *VK*

KALF Willem (continued)	L𝐾 L𝐾 W·KALF·1643 L𝐾 L𝐾
KALRAET Barend van b. Holland. 1649 - 1737 Landscape painter Exh: Holland, Belgium	B·v kalra.t BVI KALRAAT
KANDEL David b. France. FL. 16th C. Floral subjects Exh: France	D𝐾 D.K 𝐾 D𝐾 1545
KANELBA Raymond b. 1897 - Painter in oil & gouache media Exh: RA, RP, France	kanelba
KAR, ARBS Chintamoni b. Bengal. 1915 - Oil, tempera & watercolour media Exh: PS, RA, RBA etc	C.Kar.
KARG Georg b. Germany. FL. 17th C. Portrait artist Exh: Germany	G·K·P.
KARUTH Ethel Fl. 1900 - 1908 Portraits & Miniaturist Exh: RA	Ɛ
KASTEELS Peter 11 b. Belgium. FL. 17th C. Painter of battle scenes Exh: Germany, Belgium	P KABEFLS
KAUFFMANN Angelica Catharina Maria Anna b. Switzerland. 1740 - 1807 Historical & portrait artist Exh: NPG, VA, France, Italy, Germany Vienna	Angelica Kauffman

KAUFFMANN Angelica Catharina Maria Anna (continued)	AK. fecit AK.
KAUFFMANN (The Elder) Hermann b. Hamburg 1808 - 1889 Genre artist Exh: Germany	H Kauffmann
KAY, RSW James b. Isle of Arran. 1858 - ? Street scenes, marine & landscape subjects Exh: Belgium, France, UK	James Kay RSW.
KAY, RSW Violet MacNeish b. Glasgow. 1914 - Oil & watercolourist Exh: RSA, RSW, RGI, etc	VIOLET. M. KAY.
KEATING, RHA John b. Limerick. 1889 - Oil & watercolourist Exh: London & Prov. AG's, X	CETCINN
KEAY, DA Harry b. 1914 - Painter in oil media Exh: RA, RSA, WAG, CEMA, RBSA etc	HKEAYJ
KEELHOFF Frans b. Belgium. 1820 - 1893 Landscape painter Exh: Belgium, Lyon, Vienna	I keelhoff
KEENE Charles Samuel b. 1823 - 1891 Cartoonist & illustrator	CK CK
KEERINCK Alexandre b. Antwerp. 1600 - 1652 Landscape artist Exh: France, Belgium, Holland	Kerings XF XF F FR K 1631 XF
KELLEN (The Younger) David van der b. Utrecht. 1827 - 1895 Historical, archaeological & genre subjects Exh: Holland, France	VDC

KELLER **Ferdinand** b. Germany. 1842 - 1922 Historical, portrait & landscape subjects Exh: France, Germany	FERDINAND KELLER *Ferdinand Keller* *K·1884*
KELLER **Georg** b. Frankfurt. 1568 - 1640 Historical & landscape subjects Exh: Germany	*GK* *C. K*
KELLER **Johann Heinrich** b. Zurich. 1692 - 1765 Genre artist Exh: Amsterdam, Stuttgart	*JKeller*
KELLERHOVEN **Moritz** b. Germany. 1758 - 1830 Historical & portrait artist Exh: Munich, Vienna	*MKfe*
KELLY **Charles Edward** b. Dublin. 1902 - Cartoonist, oil & watercolourist Exh: Dublin, UK	*C. E. KELLY* *CBK*
KELLY, RBA, RI, RBC **Robert Talbot** b. Birkenhead. 1861 - ? Genre, landscape & oriental subjects Exh: UK AG's	*R.Talbot.Kelly*
KELLY **Thomas Meikle** b. Glasgow. 1866 - ? Etcher, oil & watercolourist Exh: WAG, GI, RSA, SSA, RSW, etc	*T.M.Kelly*
KELSEY **Frank** Fl. 1887 - 1893 Marine artist Exh: RA, SS	*FK*
KEMP (The Elder) **Nicolaes de** b. Holland. 1574 - 1646 Marine artist Exh: Holland	*Kemp*

KEMP-WELCH, RI, RBC, RBA, RCA **Lucy Elizabeth** b. Bournemouth. FL. 19th - 20th C. Animal & landscape subjects etc Exh: RA, RI, London & Prov. AG's Australia, S. Africa	K.W SE.K-W
KENDALL, DA, FRZS, SWA, RGI **Alice R.** b. New York. ? - 1955 Exh: NEAC, PS, RA, RSA, SWA etc	A.R. Kendall. arK ARK
KENNEDY **Alexander Grieve** b. Liverpool. 1889 - Exh: London & Prov. AG's	"A MACULRIC"
KENNEDY **Cecil** b. 1905 - Portraits & floral subjects Exh: RA, RSA, RHA, London & Prov. AG's	Cecil Kennedy Cecil Kennedy
KENNEDY **Edward Sharard** b. England. FL. 19th C. Historical & rustic genre Exh: RA, SS, NWS etc	E.S.K.
KENNEDY **Thomas** b. London. 1900 - Portraits, game & landscape subjects Exh: RA, RSA	Thomas. Kennedy.
KENNEDY **William Denholm** b. Dumfries. 1813 - 1865 Portrait, historical, genre & landscape artist Exh: RA, SS, UK.AG's	رين
KENNINGTON, RA **Eric Henry** b. London. 1888 - 1960 Portraits & military subjects Exh: UK AG's	K
KENT **Leslie Harcourt** b. London. 1890 - Marine & landscape artist Exh: RA, RSA, PS, RBA, RSMA etc	LESLIE KENT
KENT **William** b. Yorkshire. 1684 - 1758 Historical, portrait & architectural subjects Exh: England, Italy	g Kent

KENT-BIDDLECOMBE **Jessica Doreen** b. Burnham-on-Sea. 1898 - Portraits & flower studies Exh: ROI	₿
KERCKHOVE (or KERKHOVE) **Joseph van den** b. Bruges. 1667 - 1724 Historical & portrait artist Exh: Belgium	*v.d. Kerckhove*
KERNKAMP **Anny** b. Antwerp. 1868 - ? Marine & portrait artist Exh: Holland	*Anny Kernkamp*
KERR **Frederick James** b. Neath. 1853 - ? Oil & watercolourist Exh: RA, RI, WAG, RWA etc	*Kerr.*
KERRICX **Willem Ignatius** b. Antwerp. 1682 - 1745 Religious subjects Exh: Holland	*G Kerricx*
KESSEL **Ferdinand van** b. Antwerp. 1648 - 1696 Still life, animals & landscape artist Exh: Holland, France, Austria etc	*F.V Kessel 1691*
KESSEL (The Elder) **Jan van** b. Antwerp. 1626 - 1679 Flowers, birds, insects & allegorical subjects Exh: European AG's	*J.V. Kessel 1670*
KESSEL **Jan 111 van** b. Amsterdam. 1641 - 1680 Landscape artist Exh: Holland, Germany, Italy, Vienna	*J van kessel* *J Kessel* *J v kessel*
KESSELL, FRSA, ARBSA **James Everett** b. Coventry. 1915 - Architectural subjects etc Exh: RA, RBA, ROI, RSMA, NS, PS etc	*Kessell '59*

KETEL **Cornelis** b. Gouda. 1548 - 1616 Portrait painter Exh: NPG, Holland	*C.Ketel.1597* Œ
KEYSER **Albert de** b. Antwerp. 1829 - 1890 Landscape artist Exh: Holland	*Albert De Keyser*
KEYSER **Clara de** b. Ghent. 1480 - 1560 ? Miniaturist	*CD Keyser*
KEYSER (The Elder) **Hendrik de** b. Utrecht. 1565 - 1621 Religious & genre painter Exh: Holland	ꟼ
KEYSER **Nicaise de** b. Belgium. 1813 - 1887 Historical & portrait artist Exh: Holland, Belgium, Germany, France	*Nc Keyser*
KEYSER **Thomas** b. Amsterdam. 1596 - 1667 Portrait painter Exh: Belgium, Germany, UK, France, Sweden	⻌ AN. 1627. T D. KEYSER · F AN° 1622 *T.D Keyser* ⻌ ⻌ ⻌
KIEFT **Jan** b. Holland. 1798 - 1870 Portrait painter Exh: Holland	*J: Kieft*
KIERS **Petrus** b. Holland. 1807 - 1875 Genre subjects Exh: France	*P. Kiersʃert*
KIFFER **Charles** b. Paris. 1902 - Theatrical & circus scenes Exh: France	*ch. Kiffer*

KIKOINE **Michel** b. Russia. 1892 - Landscapes & still life subjects Exh: Paris	*Kikoïne*
KILBURN, RMS **Joyce** b. London. 1884 - Watercolour portrait miniaturist Exh: RA, SWA, RMS, Prov. AG's. Canada, Australia .tc	JK
KILBURNE **George Goodwin** b. Norfolk. 1839 - 1924 Genre & sporting subjects Exh: RA, SS, NWS, GG, Prov. AG's Australia	GGK
KILIAN **Lukas** b. Germany. 1579 - 1637 Religious subjects Exh: Italy	CAL BKF XX XY
KINDERMANS **Jean Baptiste** b. Antwerp 1822 - 1876 Landscape artist Exh: Belgium	P. Kindermans
KING **Cecil George Charles** b. London. 1881 - 1942 Marine & landscape artist Exh: UK AG's, France	CK
KING, SSSBA **Haynes** b. Barbados. 1831 - 1904 Genre & landscape artist Exh: RA, BI, SS	HK HK
KINGSLEY **Sandra** b. 1948 - Figurative, abstract & landscape subjects etc Exh: Italy, London & Prov. AG's	Sandra Kingsley SKingsley
KINSOEN **Francois Joseph** b. Bruges. 1771 - 1839 Historical & portrait artist Exh: France, Belgium	F Kinsoen
KIOERBOE **Carl Fredrik** b. Sweden. 1799 - 1876 Animal, portraits & hunting scenes Exh: France, Sweden, Germany	Kjörboe

KIRBY John Kynnersley Oil & watercolourist Exh: NEAC, London & Prov. AG's	*KK*
KIRCHBACH Franck b. London. 1859 - 1912 Genre, landscape & historical subjects Exh: UK, Germany, Austria, France	*FK*
KISLING Moise b. Poland. 1891 - 1953 Portrait, still life, floral & landscape subjects Exh: US, France, Sweden, Israel, Russia	*Kisling Kisling*
KLAPHAUER Johann Georg FL. Germany. 17th C. Portrait artist	*GkF*
KLASS Friedrich Christian b. Dresden. 1752 - 1827 Genre & landscape artist Exh: Germany	*FK.*
KLEINHANS Robert Burton b. Reynoldsville, US. 1907 - Land & seascapes Exh: US AG's	*PETITJEAN*
KLENGEL Johann Christian b. Dresden. 1751 - 1824 Genre, mythological & landscape subjects Exh: Germany, Sweden	*Klengelf. Klengel*
KLIMT Gustave b. Vienna. 1862 - 1918 Portraits, allegorical & historical subjects Exh: IS, France, Germany	*GVSTAV KLIMT*
KLINGER Max b. Leipzig. 1857 - 1920 Historical, religious & genre subjects Exh: Germnay, Australia	*MC*
KLINGHOFFER Clara Esther b. Austria. 1900 - Portrait artist, various media Exh: GI & London AG's etc	*Klinghoffer*

KMIT **Michael** b. Stryj. 1910 Exh: European AG's	
KNAPTON **George** b. London. 1698 - 1778 Portrait artist Exh: NPG, UK AG's	
KNAUS, HFRA **Ludwig** b. Germany. 1829 - 1910 Genre & portrait subjects Exh: Germany, France, UK	
KNECHTELMAN **Lucas** FL. Germany. 16th C. Historical subjects Exh: Germany	
KNECHTELMAN **Marx** b. Germany. FL. 15thC. Historical & portrait artist Exh: Germany.	
KNEESHAW **Cecilia Margaret** b. 1883 - Exh: RI, RCA, PS, RSA etc	
KNELL **William Adolphus** b. 1805 - 1875 Marine artist Exh: RA, BI, SS, UK AG's	
KNELLER, B.Sc, **Frank** b. Bangor. 1914 - Dogs & equine subjects Exh: R. Scot. A, R.Cam.A, RSMP etc	
KNELLER **Sir Godfrey** b. Germany. 1646 - 1723 Portrait artist Exh: Belgium, Holland, Germany, NG, NPG, V & A, Vienna	
KNELLER **Johann Zacharias** b. Germany. 1644 - 1702 Portrait, still life & architectural Exh: Germany	

KNIGHT **Charles Parsons** b. Bristol. 1829 - 1897 Landscape & marine artist Exh: RA, BI, SS, UK,AG's, Hamburg	*CR 1870*
KNIGHT, RA, RWS **Dame Laura** b. 1877 - 1970 Circus, gipsy & theatrical subjects Exh: RA, UK AG's	*L. K.*
KNIGHT **Daniel Ridgway** b. Philadelphia 1839 - 1924 Genre & figure landscape subjects Exh: PS, France, US	*Ridgway Knight*
KNIGHT, RBA **Edward Loxton** b. Notts. 1905 Oil, pastel, gouache, watercolour media etc Exh: RA, RBA, RI, PS, London & Prov. AG's, US, S. Africa etc	*Loxton Knight*
KNIGHT, ARA, RP, RWA **Harold** b. Nottingham. 1874 - ? Animal & landscape artist Exh: London & Prov. AG's, PS, US, S. Africa	*Harold Knight*
KNIGHT **John Buxton** b. England. 1843 - 1908 Landscapes & rural scenes Exh: RA, Bradford, Australia, SSSBA.	*J Buxton Knight*
KNIGHT, RA **John Prescott** b. Stafford. 1803 - 1881 Genre & portrait artist Exh: RA, BI, UK AG's	*R*
KNIGHT **William** b. Leicester. 1871 - ? Landscape artist Exh: RA, RI, WAG, RWA etc	*Wm KNIGHT*
KNIGHT **William Henry** b. Newbury. 1823 - 1863 Genre subjects Exh: SS, RA, BI, Prov. AG's	*WHK.* *57*
KNOLLER **Martin** b. Austria. 1725 - 1804 Religious & historical subjects Exh: Munich, Italy, Austria	*Knoller. f.*

KNOLLYS **Courtenay Hugh** b. London. 1918 - Marine & landscape artist Exh: London & Prov. AG's	
KNOWLES, RBA **Davidson** Fl. 1879 - 1902 Animal & landscape artist Exh: RA, SS, Prov. AG's	
KNOX, ARUA **Harry Cooke** B. Newtonbutler. 1905 - Oil, pastel & watercolourist Exh: RUA, RHA, ROI	
KNYFF **Alfred de** b. Brusseis. 1819 - 1885 Marine & landscape artist Exh: Belgium, France	
KNYFF **Wouter** b. Holland. 1607 - 1693 Landscape artist Exh: Holland, France, Dublin, Russia, Sweden	
KOBELL **Ferdinand** b. Mannheim 1740 - 1799 Landscape subjects Exh: France, Germany, Bucharest	
KOBELL **Jan 1** b. Rotterdam. 1756 - 1833 Genre & landscape artist Exh: Holland	
KOBULADZE **Sergei** b. Akhaltsikhe. 1909 - Oil, charcoal, gouache media	
KOEDYCK **Isaac** b. Holland. 1616 - 1668 Genre & interior scenes Exh: Lille, Holland, Leningrad, Anvers	
KOEKKOEK **Barend Cornelis** b. Holland. 1803 - 1862 Landscape artist Exh: Holland, Germany, France, England	

KOEKKOEK **Barend Cornelis** (Continued)	*B.C.KoekKoek.f*
KOEKKOEK **Hermanus** b. Holland. 1815 - 1882 Marine artist Exh: England, Holland, Melbourne	
KOELMAN **Johan Daniel** b. Hague. 1831 - 1857 Animals & landscapes Exh: Holland	
KOENE **Jean** b. Belgium. 1532 - 1592 Historical & genre subjects Exh: Belgium	
KOENIG **Salomon** b. Amsterdam. 1609 - 1666 ? Portraits, genre & historical subjects	*S.Koenig 1633*
KOKOSCHKA **Oskar** b. Austria. 1886 - Landscapes & portrait artist Exh: UK, France, Germany	*OK OK OK*
KOLLONITSCH (Count) **Christian** b. Germany. 1730 - 1802 Portrait artist Exh: Germany	*C.KOLLonitsch PicfOR*
KONIG **Franz Niklaus** b. Bern. 1765 - 1832 Landscape artist Exh: Switzerland	
KONINCK **Jacob 1** b. Amsterdam. 1616 - 1708 Portrait & landscape subjects Exh: NG, Brussels, Rotterdam, Leningrad	*iKcnin*
KONINCK **Philips de** b. Amsterdam. 1619 - 1688 Portrait, historical & landscape subjects	*Pkoninck f.* *P-ko*

KONINCK Philips de (continued)	*P·koninck P-koning*
KONINCK Salomon b. Amsterdam. 1656 - ? Portrait, historical & genre subjects Exh: Holland, Belgium, Germany, France, Spain	*S Koninck*
KOOI Willem Bartel van der b. Holland. 1768 - 1836 Genre & portrait artist Exh: Holland	*B.v.d Kooi*
KOPP George b. Germany. 1570 - 1622 Historical & portrait subjects Exh: Germany	*Cĸ*
KOTASZ Karoly b. Budapest 1872 - ? Figure landscape artist Exh: Hungary	KOTASZ K
KRAFFT Johann Peter b. Germany. 1780 - 1856 Portrait, historical, genre & landscape artist Exh: France, Vienna	*R.*
KRAME Lambert b. Dusseldorf. 1712 - 1790 Historical subjects Exh: Germany, Italy	*L Krahe*
KRAUS Georg-Melchior b. Frankfurt. 1737 - 1806 Portrait & landscape artist Exh: Germany, France	*JMKraus· JMKraus*
KRAUS Philippe Joseph b. Germany. 1789 - 1864 Miniature portraits & landscapes Exh: Germany	*Ṙ*
KRAUSE Francois b. Germany. 1705 - 1752 Religious, portraits & genre subjects Exh: France	*F Krause*

KREMEGNE **Pinchus** b. Russia. 1890 - Genre & portrait painter Exh: Moscow, France	
KREMER **Petrus** b. Antwerp. 1801 - 1888 Genre & historical artist Exh: Holland, Montreal	
KRODEL (The Elder) **Matthias** b. Germany. ? - 1605 Portrait artist Exh: Germany	
KROHG **Per Lasson** b. Norway. 1889 - Genre & portrait artist Exh: Norway, France	
KRUG **Ludwig** b. Nuremberg. 1489 - 1532 Historical & religious subjects	
KRUMPIGEL **Karl** b. Prague. 1805 - 1832 Landscape artist	
KRUSEMAN **Cornelis** b. Amsterdam. 1797 - 1857 Historical, portrait & genre subjects Exh: Holland	
KRUSEMAN **Jan Adam Janszoon** b. Haarlem. 1804 - 1862 Portrait artist Exh: Holland, Germany	
KUFFNER **Abraham Wolfgang** b. Germany. 1760 - 1817 Portrait, historical & landscape subjects Exh: Germany	
KUGELGEN **Franz Gerhard von** b. Germany. 1772 - 1820 Religious, historical & portrait subjects Exh: Russia, Germany	

KULMBACH **Hans Suess von** b. Germany. 1480 - 1522 Religious & portrait artist Exh: Germany	*KH (monogram)*
KUMLEIN **Akke** b. Stockholm. 1884 - 1949 Oil & tempera media Exh: London & Stockholm	*akke Kumlien Kumlien*
KUPETZKI **Johann** b. Germany. 1667 - 1740 Portrait artist Exh: Germany, France, Vienna	*J Kupetzki.*
KUPKA **Frank** b. Czechoslovakia. 1871 - 1957 Genre artist & illustrator Exh: France	*Kupka*
KUYCK **Frans Pieter Lodewyk van** b. Antwerp. 1852 - 1915 Genre & landscape subjects Exh: Anvers	*Frans van Kuyck*
KUYCK **Jean Louis van** b. Antwerp. 1821 - 1871 Genre & animal subjects Exh: Belgium, Munich	*Louis Van Kuyck 1870*
KUYPER **Jacques** b. Amsterdam. 1761 - 1808 Landscape & historical subjects	*J Kuyper.*
KUYPERS **Dirk** b. Dortrecht. 1733 - 1796 Landscapes etc	*DK (monogram)*
KUYTENBROUWER (The Younger) **Martinus Antonius** b. Holland. 1821 - 1897 Hunting scenes & landscapes Exh: Brussels, Rotterdam	*Martinus*
KVAPIL **Charles** b. Antwerp. 1884 - Nudes, portraits, landscapes etc Exh: France, Holland, N. Africa	*KVAPIL*

KVAPIL **Charles** (continued)	
KWOK **David** b. Peiping, China. 1919 - Watercolourist Exh: China, London & US. AG's	

L

LAAR **Pieter van** b. Haarlem. 1512 ? - 1673 ? Fairs, Hunting scenes etc Exh: European AG's	
LABASQUE **Jean** b. Paris. 1902 - Genre subjects Exh: France, Algiers	
LABISSE **Felix** b. France. 1905 - Genre subjects & illustrator Exh: France, Belgium, Brazil, Monaco, Vienna	
LABITTE **Eugene Leon** b. France. 1858 - ? Landscape artist Exh: France	
LABOUREUR **Jean Emile** b. Nantes. 1877 - 1943 Genre subjects & illustrator Exh: France	
LACHTROPIUS **Nicolas** FL. 17th C. Still life subjects Exh: Amsterdam, Prague, Vienna	
LADELL **Edward** b. England. FL. 19th C. Still life subjects. Exh: RA, BI, SS, London & Prov. AG's	

LADENSPELDER **Johann** b. Holland. 1511 - ? Religious subjects	
LAERMANS **Eugene Jules Joseph** b. Brussels. 1864 - 1940 Genre & landscape artist Exh: Belgium, Germany, Russia, Vienna	
LAFAGE **Raymond de** b. Lyons. 1650 ? - 1684 Mythological subjects etc Exh: Holland, Germany, France, Austria	
La FARGUE **Paulus Constantin** b. Hague. 1732 - 1782 Landscape subjects Exh: NG, The Hague, Frankfurt	
LAFOND **Charles Nicolas Rafael** b. Paris. 1774 - 1835 Portraits & historical subjects Exh: France	
La FRESNAYE **Roger Noel Francois de** b. France. 1885 - 1925 Cubist Exh: France	
LAGAR **Celso** b. Spain. 1891 - Theatrical & marine subjects Exh: France, Spain	
LAGARDE **Pierre** b. Paris. 1853 - 1910 Historical & scenic artist Exh: PS, France	
LAGIER **Eugene** b. Marseilles. 1817 - 1892 Genre & portrait artist Exh: France	
LAGRENEE **Jean Jacques** b. Paris. 1739 - 1821 Historical subjects Exh: France	

LAGRENEE Louis Jean Francois b. Paris. 1725 - 1805 Genre & historical subjects Exh: UK, France, Russia, Spain etc	*Lagrenee* *JJ-1799* *Lagrenee* *1780*
LAGYE Victor b. Belgium 1825 - 1896 Genre artist Exh: Belgium, Cologne	*V. Lagye*
La HIRE Laurent de b. Paris. 1606 - 1656 Religious & historical subjects Exh: France, Italy, Prague, Budapest	*LH* L H
LAIRESSE Gerard de b. Liege. 1641 - 1711 Historical & portrait artist Exh: France, Germany, Holland	*G Lairesse* *G de L* ⟨monogram⟩ *G. Laire* *G de L* ⟨monogram⟩ *GL inventor* 16 ⟨GL⟩ 68 P GL *G. Lairesse* GL GL GL GL
LAITILA Atte b. Finland. 1893 - Oil, pastel & watercolourist Exh: Russia, Scandinavia & European AG's	*Laitila*
LAKE, ARCA, FRSA John Gascoyne b. 1903 - Oil, chalk, gouache & watercolour media Exh: NEAC, London & Prov. AG's	*John Lake.*
LALAING (Count) Jacques de b. London. 1858 - 1917 Genre artist Exh: France, Belgium	*J. de Lalaing*
LALLEMAND Georges b. Nancy. 1575 - 1635 Historical subjects	*G Lallemand* ⟨GL⟩ *LALe*

LALLEMAND **Jean Baptiste** b. Dijon. 1710 - 1805 Marine, hunting scenes & landscape artist Exh: SOA, France, Leningrad, Italy	*J B l'allemand*
LAMA **Giovanni Battista** b. Naples. 1660 - 1740 Historical & mythological subjects Exh: Naples	*B Lama*
LAMBE **Philip Agnew** b. 1897 - Painter in oil media Exh: PS. London & Prov. AG's	*AL*
LAMBEAUX **Jules** b. Antwerp; 1858 - 1890 Genre artist Exh: Anvers	*Jules Lambeaux*
LAMBERT **Jean** FL. Liege 15th C.	*LAM JAM*
LAMBERT **Louis Eugene** b. Paris. 1825 - 1900 Still life & animal subjects Exh: France, Amsterdam	*L. Eug Lambert*
LAMBERT **Philip David** b. Southampton. 1918 - Landscape artist Exh: RA, London & Prov. AG's etc	*Philip Lambert* /76
LAMBINET **Emile Charles** b. Verseilles. 1815 - 1877 Landscape artist Exh: France, UK	*Emile Lambinet*
LAMEN **Christoffel Jacobsz van der** b. Brussels. 1615 - 1651 Genre & interior scenes Exh: Germany, France, Copenhagen, Vienna	*VL*
LAMME **Arie Johannes** b. Holland. 1812 - 1900 Genre artist Exh: Dordrecht	*A*

LAMORINIERE Jean Pierre Francois b. Anvers. 1828 - 1911 Landscape artist Exh: Belgium, Liverpool	*Fçois Lamorinière*
LANA DA MODENA Lodovico b. Italy. 1597 - 1646 Historical & portrait artist Exh: Italy	*L lana* CLEF CLEF
LANCASTER, RI, ARE, RBA, ARCA Percy b. Manchester. 1878 - 1951 Landscape artist Exh: RA, London & Prov. AG's	*C* P
LANCE George b. Essex. 1802 - 1864 Still life, floral, genre & historical subjects Exh: RA, BI, SS, VA, UK AG's	*G L. 1851.*
LANCHESTER Mary b. 1864 - ? Flower subjects etc Exh: RA, RI, RBA & Prov. AG's	*ML*
LANCRET Nicolas b. Paris. 1690 - 1743 Genre, portrait & scenic subjects Exh: France, NG, Leningrad, Sweden	*Lancret Lancret Lancret*
LANDE Willem van b. Holland. 1610 - ? Historical subjects	*L*
LANDELLE Charles Zacharie b. France. 1812 - 1908 Genre & portrait subjects Exh: France, London, Amsterdam, Sydney	*Ch. Landelle*
LANDERER Ferdinand b. Austria. 1746 - 1795 Genre, landscapes & mythological subjects	*A A A*
LANDSEER Sir Edwin Henry b. London. 1802 - 1873 Portrait, animal, landscape & sporting subjects Exh: RA, BI, SS, OWS, London & Prov. AG's X	*Landseer.* EL

LANFRANCO **Giovanni** b. Parma. 1582 - 1647 Portraits & historical subjects Exh: UK, France, Italy, Russia etc	*J. Lanfranc*
LANG, RMS, Mem. PS, **George Ernest** b. London. Portraits, animal subjects etc Exh: PS, RI, RBA, RWS, RMS, RHA, R.Cam.A, SGA	LANG
LANGER **Robert Joseph Von** b. Dusseldorf 1783 - 1846 Historical subjects Exh: Germany	*R Langer.*
LANGLEY, RI **Walter** b. Birmingham 1852 - 1922 Genre & landscape artist Exh: RA, SS, NWS, London & Prov. AG's, Italy	Φangley. WL Ψ WŁ Ψ
LANGLOIS **Jean Charles** b. France 1789 - 1870 Battle scenes & landscapes Exh: France	*C Langlois*
LANINI **Bernardino** b. Vercelli. 1510? - 1578? Religious & historical subjects Exh: UK, Germany, France, Italy	*Bernardinus. Effigiabat 1543*
LANKESTER, BA, MB, B.CL, **CANTAB, MRCS, LRCP** **Lionel W.A.** b. Surrey. 1904 - B/white & watercolourist Exh: RWS & Prov. AG's	
LANOUE **Felix Hippolyte** b. Versailles. 1812 - 1872 Landscape artist Exh: France	

LANSINCK **J.W.** FL. Amsterdam 18th C. Genre artist Exh: Berlin	*J. W. Lansinck*
LANTARA **Simon Mathurin** b. France 1729 - 1778 Landscape artist Exh: France, Leningrad	*S¹ Lantara*
LAPARRA **William Julien Emile Edouard** b. Bordeaux. 1873 - 1920 Genre artist Exh: France	*William Laparra*
LA PATELLIERE **Amedee Marie Dominique Dubois De** b. Nantes. 1890 - 1932 Portrait & rurul subjects Exh: France	*A. de la Patelliere*
LAPI **Niccolo** b. Florence. 1661 - 1732 Historical subjects Exh: Florence	*N Lapi²*
LAPICQUE **Charles** b. France. 1898 - Marine & abstract artist Exh: France	*Lapicque*
LAPIS **Gaetano** b. Italy. 1706 - 1758 Historical subjects Exh: Italy	*G Lapis*
LAPOSTELET **Charles** b. France. 1824 - 1890 Marine & landscape artist Exh: RA, France	*Lapostolet*
LAPRADE **Pierre** b. France. 1875 - 1932 Genre subjects & illustrator Exh: France	*Laprade*
LAQUY **Willem Joseph** b. Germany. 1738 - 1798 Genre & interior scenes Exh: Amsterdam	*W.J. Laquy pinx*

LARGILLIERE **Nicolas De** b. Paris. 1656 - 1746 Portrait & historical artist Exh: France, Germany, Italy, Russia, NPG	*Largilliere* *f 1734* *Largilliere* *De Largilliere fecit*
LARIONOFF **Michel** b. Russia 1881 - Genre subjects Exh: France, US	*J. Larionoff*
LARIVIERE **Charles Philippe Auguste De** b. Paris 1798 - 1876 Portrait, military & genre subjects Exh: France	*JLarivière.*
LAROCK **Evrard** b. Belgium. 1865 - 1901 Genre artist Exh: Belgium	*E LAROCK*
LAROON (THE ELDER) **Marcel** b. Hague. 1653 - 1702 Portraits & interior scenes Exh: Amsterdam	*M. Laroon* *1700* **ML**
LA RUE **Philibert Benoit De** b. Paris. 1718 - 1780 Battle scenes, portraits & landscapes	*L. f De La rue 1760*
LASSAM **Susie** b. Dulwich. 1875 - ? Miniaturist Exh: RA, PS, WAG	*SL*
LASTMAN **Claes Pietersz** b. Haarlem. 1586? - 1625 Portraits & religious subjects Exh: Holland	*PL* **PL**
LASTMAN **Pieter Pietersz** b. Amsterdam. 1583 - 1633 Religious & mythological subjects Exh: Holland, Germany	*Lastman fecit.* *1614* **PL**

LASZLO DE LOMBOS **Philip Alexius De** b. Budapest. 1869 - ? Portrait artist Exh: SOA, NPG, Britain, Italy, France	*P.A. Laszlo*
LA THANGUE RA **Henry Herbert** b. England. 1859 - 1929 Rustic genre & landscape artist Exh: RA, SS, GG, NG, NEAC etc.	*H·H·L·*
LATOUCHE **Gaston De** b. France. 1854 - 1913 Genre artist Exh: France	*Gaston la Touche*
LATOUR **Jan** b. Liege. 1719 - 1782 Historical & portrait artist	*Latour pxct*
LATOUR **Maurice Quentin De** b. St. Quentin. 1704 - 1788 Portrait artist. Pastel media Exh: France, Germany, Russia	*La Tour La Tour*
LAUDER, RSA **James Eckford** b. Edinburgh. 1811 - 1869 Figures, historical & landscape painter Exh: UK AG's	*E K K*
LAUGEE **Desire Francois** b. France. 1823 - 1896 Historical & portrait subjects Exh: France, UK	*D. Laugee*
LAUR **Marie Yvonne** b. Paris. 1879 - Genre subjects Exh: France, Holland	*Yo Laur*
LAURE **Jean Francois Hyacinthe Jules** b. Grenoble. 1806 - 1861 Portrait painter Exch: France	*Jules Laure*
LAURENCIN **Marie** b. Paris. 1885 - 1956 Portraits & illustrator Exh: France	*Marie Laurencin* *Marie Laurencin*

LAURENS **Jean Paul** b. France. 1838 - 1921 Historical & religious subjects Exh: France, Brussels, Holland, Bucharest	*JeanPaul Laurens*
LAURENS **Jules Joseph Augustin** b. France. 1825 - 1901 Scenic & figure subjects Exh: France	*JULES LAURENS. J LAURENS*
LAURENT **Ernest Joseph** b. Paris. 1859 - 1929 Neo - impressionist Exh: France, Rotterdam	*Ernest Laurent*
LAURENT **Jean Antoine** b. France. 1763 - 1832 Portraits, miniatures & genre subjects Exh: France	*A Laurent*
LAURŒUS **Alexander** b. Denmark. 1783 - 1823 Interior & family scenes Exh: Sweden, Helsinki	*A Laurëus*
LAUTENSACK **Hans Sebald** b. Germany. 1524 - 1560 Genre & historical subjects Exh: Scandinavia	*H L°*
LAUTENSACK **Heinrich** b. Germany. 1522 - 1568 Religious & genre subjects	*H* *H.L.*
LAVAUDAN **Alphonse** b. Lyon. 1796 - 1857 Portrait & historical subjects Exh: Nancy, Versaille	*Lavaudan* *1838*
LAVERY. RA, RSA, RHA, HROI **& European Societies** **Sir John** b. Belfast. 1856 - ? Portraits, landscape artist etc. Exh: G.B. & European AG's, Canada, S. America etc.	*J Lavery*
LAVRUT **Louise** b. France 1874 - ? Portrait & genre artist Exh: France	*Louise Lavrut*

LAWLESS **Matthew James** b. Dublin. 1837 - 1864 Genre subjects Exh: RA	
LAWRENCE **Edith Mary** b. Surrey. 1890 - Portrait & landscape artist Exh: RA, NEAC, RI, NPS, SWA etc.	
LAWRENCE. PRA **Sir Thomas** b. Bristol. 1769 - 1830 Portrait artist Exh: RA, BI, SS, NG, NPG, VA, France, Germany, Holland etc.	
LAWRENSON **Charlotte Mary** b. Dublin. 1883 - Portrait artist Exh: RA, France, US	
LAWSON **Cecil Gordon** b. Shropshire. 1851 - 1882 Landscape artist Exh: RA, SS, GG, Prov. AG's	
LAWSON **Francis Wilfred** Fl. 1867 - 1918 Landscapes & allegorical subjects Exh: RA, UK AG's	
LAWSON **William** b. Yorkshire. 1893 - Watercolourist . Portraits & miniatures Exh: RA	
LAZERGES **Jean Raymond Hippolyte** b. France. 1817 - 1887 Religious, genre & landscape subjects Exh: France	
LEA **Frank Marsden** b. 1900 - Portrait artist Exh: London & Prov. AG's	
LEACH. FRSA **B.** B. Hong Kong. 1887 - Exh: London & Prov. AG's, Europe & Japan	

LEADER. RA **Benjamin Williams** b. Reading. 1831 - 1923 Landscape artist Exh: RA, SS, GG, London & Prov. AG's, Australia	B.W.LEADER. B.W.L.
LEANDRE **Charles Lucien** b. France. 1862 - 1930 Portrait artist Exh: France, PS	c. Léandre
LEAR **Edward** b. London. 1812 - 1888 Birds, animals, topographical & landscape subjects Exh: SS, UK AG's etc.	*(signature monograms)* 1847
LE BARBIER **Jean Jacques Francois** b. Rouen. 1738 - 1826 Genre & historical artist Exh: PS, France	Lebarbier
LEBASQUE **Henri** b. France. 1865 - 1937 Genre & scenic subjects Exh: France, PS	Lebasque Lebasque
LE BLANT **Julien** b. Paris. 1851 - ? Genre & historical subjects & illustrator Exh: PS, France	J. Le Blant
LE BLOND **Jean** b. Paris. 1635 - 1709 Historical subjects	Leblond
LE BORNE **Joseph Louis** b. Versailles. 1796 - 1865 Portrait, genre & landscape artist Exh: France	LeBorne
LE BOURG **Albert Charles** b. France. 1849 - 1928 Landscape artist Exh: France, Bucharest	a.Lebourg

LEBOUTEUX **Pierre Michel** b. Paris. 1683 - 1750 Portrait & historical subjects Exh: France	*P^re Lebouteux*
LE BRETON **Constant** b. France. 1895 - Portrait, landscape subjects & illustrator Exh: France	*C. LeBreton*
LE BRETON. MAFA, FIAL etc. **Edith** b. Salford. 1914 - Industrial street scenes etc. Exh: London & Prov. AG's	*de Breton*
LE BRUN **Charles** b. Paris 1619 - 1690 Historical & military subjects Exh: France, Italy, Germany, Geneva, Leningrad	*Car Le Brun 1650* *Le brun* *C L B* *B. F. 1653* *CLB* *C L B*
LE BRUN **Marie Louise Elizabeth Vigee** b. Paris. 1755 - 1842 Portraits, historical & landscape artist Exh: UK, Russia & European AG's	*M^me Le Brun f 1779* *L. E Vigee Le Brun 1788*
LEBSCHEE **Carl August** b. Poland. 1800 - 1877 Scenic & landscape subjects Exh: Germany	*L*
LE CLERC **David** b. Berne. 1679 - 1738 Portrait, historical & floral subjects Exh: Germany	*D Leclerc*
LE COMTE **Hippolyte** b. France. 1781 - 1857 Battle scenes, historical & landscape subjects Exh: French AG's	*H^te Lecomte*
LE COMTE **Paul** b. Paris. 1842 - 1920 Marine & landscape artist Exh: France	*Paul Lecomte*

LE DIEU **Thomas** b. 1890 - Portrait & landscape artist Exh: London & Prov. AG's	*T.LeDieu*
LE DRU **Hilaire** b. France. 1769 - 1840 Genre subjects Exh: France	*Hilaire Le Dru*
LEE **Frederick Richard** b. Barnstable. 1798 - 1879 Landscape artist Exh: RA, BI, VA, UK AG's, S. Africa	*FR Lee RA*
LEE **Joseph Johnston** b. 1867 - ? Battle scenes Exh: London & Prov. AG's. X	*Joseph Lee*
LEE **Rupert Godfrey** b. Bombay. 1887 - Artist & sculptor Exh: London & Prov. AG's. X	*Rupert Lee*
LEE-HANKEY. ARWS, RE, ROI. **William Lee** b. 1869 - 1952 Engraver, oil & watercolourist etc. Exh: RA, RWS, RE, ROI, PS etc.	*W Lee-Hankey*
LEE-JOHNSON **Eric** b. Fiji. 1908 - Exh: UK, New Zealand, X	*Lee-Johnson*
LEECH. RI. **George William** b. 1894 - Oil & watercolourist Exh: RA, RI, London & Prov. AG's	*Geo.W. Leech*
LEECH **John** b. London. 1817 - 1864 Hunting scenes, humourous subjects etc. Exh: London & Prov. AG's	*JL* *⚱* *JL*
LEECH. RHA. **William John** b. Dublin. 1881 - Genre, portrait & landscape artist Exh: PS, Ireland, etc.	*Leech*

LEEMANS **Egide Francois** b. Belgium. 1839 - 1883 Landscape artist Exh: Belgium	*E. F Leemans*
LEEMANS **Johannes** b. Holland. 1633 - 1688 Genre & still life subjects Exh: Amsterdam, Copenhagen	
LEEMPUTTEN **Frans Van** b. Belgium. 1850 - 1914 Genre & landscape artist Exh: Belgium	FRANS. VAN LEEMPUTTEN 1895
LEES. ARBA **H.E. Ida** b. Ryde, I.O.W. Moonlight landscapes etc. Exh: RA, WAG, French AG's	H.
LEESON. ATD. **Laurence Joseph** **b.** Leeds. 1930 - Oil, gouache, montage media Exh: London & Prov. AG's, Stockholm	LAURENCE LEESON 57. LAURENCE J LEESON 57
LEEUW **Alexis De** Fl. 19th C. Landscape artist	A. de Leeuw.
LEEUW **Gabriel Van Der** b. Dordrecht. 1645 - 1688 Hunting scenes & landscapes Exh: Stockholm, Vienna	G. L.
LE FAUCONNIER **Henri Victor Gabriel** b. France. 1881 - 1946 Composition & portrait artist Exh: France, Brussels, Moscow	Le Fauconnier
LEFEBVRE **Charles Victor Eugene** b. Paris. 1805 - 1882 Historical, genre & portrait artist Exh: France	Ch⁵ Lefebvre
LEFEBVRE **Claude** b. France. 1632 - 1675 ? Portrait artist Exh: PS, France, NPG	E.

LEFEBVRE **Jules Joseph** b. France. 1836 - 1911 Historical, genre & portrait artist Exh: PS, France	*Jules-Lefebvre*
LEFEVRE **Robert Jacques Francois Faust** b. France. 1755 - 1830 Historical & portrait artist Exh: France, Belgium	*Robert Lefevre 1804*
LEFORT **Jean Louis** b. Bordeaux. 1875 - ? Scenic & genre artist Exh: France	*JEAN LEFORT.*
LEGENDRE **Louis Felix** b. Paris. 1794 - ? Historical & landscape subjects	*L.g.*
LEGER **Fernand** b. France. 1881 - 1955 Composition, still life & genre subjects Exh: France, US	*F. LEGER*
LEGRAND **Jenny** b. Paris. 19th c. Interior scenes & still life subjects Exh: France	*Mlle Jenny Le Grand*
LEGRAND . **Louis Auguste Mathieu** b. Dijon. 1863 - 1951 Genre artist & illustrator	*Louis Legrand* *LLL*
LEGROS **Alphonse** b. Dijon. 1837 - 1911 Portrait & genre artist Exh: PS	*A. Legros.*
LEHMANN **Wilhelm Auguste Rudolf** b. Ottensen. 1819 - 1905 Genre & portrait artist Exh: France, Italy	*1874* *18 97*
LEIGH-PEMBERTON **John** b. London. 1911 - Oil, tempera & gouache media Exh: RA, ROI, NS, London & Prov. AG's	*LEIGH-PEMBERTON 65.*

LEIGHTON **Clare** b. London. 1901 - Painter & wood engraver Exh: RA, NEAC, Venice etc.	*Clare Leighton*
LEIGHTON **Edmund Blair** b. London. 1853 - 1922 Genre artist Exh: RA, London & Prov. AG's	E.B.L
LEIGHTON. PRA, RWS, HRCA, HRSW. **Lord Frederick** b. Scarborough. 1830 - 1896 Mythological & historical subjects Exh: RA, SS, OWS, GG, Germany, Australia	*Fred Leighton* F̄L̄ L
LEISHMAN **Robert** b. Fife. 1916 - Oil, gouache & watercolour media Exh: London, Prov. & Scottish AG's	*Robert Leishman*
LEITCH. RI. **William Leighton** b. Glasgow. 1804 - 1883 Landscape artist Exh: RA, BI, SS, NWS. London & Prov. AG's	*WLLeitch Rome 1835* ⟨monogram⟩ *WL Leitch 1837* ⟨monogram⟩
LE JEUNE **Henry L.** b. London. 1820 - 1904 Genre subjects Exh: RA, BI, SS, Prov. AG's	HJL
LE JEUNE **James George** b. Canada. 1910 - Oil & watercolourist Exh: RBA, SMA, SGA, NEAC, RP etc.	*J Le Jeune*
LEK. A.R. Cam.A, NDD, ATD. **Karel** b. Antwerp. 1929 - Etcher, engraver, oil, gouache, watercolourist etc. Exh: R.Cam.A, WAG, RBA, etc.	*K.LEK* *K Lek* K_L

LELEU **Alexandre Felix** b. France. 1871 - ? Theatrical & genre artist	*Alexandre Leleu*
LELEUX **Adolphe Pierre** b. Paris. 1812 - 1891 Historical, portrait & landscape artist Exh: France	*Adolphe Leleux*
LELIE **Adriaen De** b. Holland. 1755 - 1820 Portrait & genre subjects Exh: Holland	*A De Lelie.*
LELIENBERGH **Cornelis** Fl. Holland 17th.C Still life artist Exh: Holland, Germany, Vienna	*CL F*
LELOIR **Maurice** b. Paris 1853 - 1940 Historical subjects & illustrator	*Maurice Leloir*
LELY. Bt. **Sir Peter (Van Der Faes)** b. Westphalia. 1618 - 1680 Portrait artist Exh: NG, NPG, VA, France, Germany, Italy.	*P.D. Faës f PLd. PL* *P.V.D Lys PL P* *1650*
LEMAIRE **Francois** b. France. 1620 - 1688 Portrait artist Exh: France	*LA*
LEMBKE **Johann Philipp** b. Nuremburg 1631 - 1711 Portraits & battle scenes Exh: Holland, Sweden, Prague, Vienna	*HP HP HP* *1649*
LEMENS **Balthazar Van** b. Antwerp. 1637 - 1704 Portraits & historical scenes	**B.L.**

LE MATTAIS **Pierre Joseph** b. France. 1726 - 1759 Marine & mythological subjects	*PQ Lemettay*
LEMIRE **Antoine Sauvage** b. France. 1773 - ? Historical & portrait artist Exh: France	*Lemire A.*
LE MOINE **Francois** b. Paris. 1688 - 1737 Mythological, historical & genre subjects Exh: France, London, Munich, Leningrad, Sweden	*S. Lemoine 1703* *F Lemoyne* *F. lemoyne* *F le moyne Pinx*
LEMONNIER **Anicet Charles Gabriel** b. Rouen. 1743 - 1824 Historical, religious & genre subjects Exh: France	*Lemonnier f*
LEMORDANT **Jean Julien** b. St. Malo. 1882 - Marine, portrait & landscape subjects Exh: France	*J.J. Lemordant*
LENGERICH **Emanuel Heinrich** b. Germany. 1790 - 1865 Religious & historical subjects Exh: Germany	*H*
LENS **Andries** b. Antwerp. 1739 - 1822 Religious & historical subjects Exh: Belgium, Vienna	*AC Lens.*
LENS **Johannes Jacobus** b. Antwerp. 1746 - 1814 Religious & portrait subjects Exh: Belgium	*J.J Lens*
LEONARD **John Henry** b. Holderness. 1834 - 1904 Architectural & landscape artist Exh: RA, SS, London & Prov. AG's etc.	*JL*

LEPAULLE **Francois Gabriel Guillaume** b. Versailles. 1804 - 1886 Portrait, hunting scenes & genre subjects Exh: France, Budapest	*G. Lépaulle*
LEPERE **Auguste Louis** b. Paris. 1849 - 1918 Landscape & genre subjects Exh: PS, France	*A. Lepère A. Lepère.* *A. Lepère - A*
LEPICIE **Michel Nicolas Bernard** b. Paris. 1735 - 1784 Portrait, genre & religious subjects Exh: France, London, Leningrad	*Lepicies.*
LEPINE **Stanislas Victor Edouard** b. Caen. 1835 - 1892 Landscape subjects Exh: France, NG	*S. Lépine S. Lépine*
LEPOITTEVIN **Eugene Modeste Edmond** b. Paris. 1806 - 1870 Marine & figure landscapes Exh: France, Germany, Holland	*P*
LEPRIN **Marcel Francois** b. Cannes. 1891 - Landscapes & still life subjects Exh: France	*LEPRIN*
LERCHE **Vincent** b. Norway. 1837 - 1892 Religious & genre subjects Exh: Germany, Norway	*Vinc: St. Lerche*
LERIUS **Joseph Henri Francois Van** b. Belgium. 1823 - 1876 Historical & genre subjects Exh: Belgium	*J Van Lerius*
LEROLLE **Henry** b. Paris. 1848 - 1929 Religious, portrait & genre artist Exh: France, US, Budapest, Bucharest	*h. Lerolle Lerolle*

LEROUX **Georges Paul** b. Paris. 1877 - Landscape artist Exh: France	GEORGES LEROUX
LEROUX **Jules Marie Auguste** b. Paris. 1871 - ? Portrait, genre & historical subjects Exh: France	-AUGUSTE LEROUX-
LEROUX (The Elder) **Marie Guillaume Charles** b. Nantes. 1814 - 1895 Landscape artist Exh: France	charles le Roux
LE SIDANER **Henri Eugene Augustin** b. France. 1862 - 1939 Interior scenes, floral & landscape subjects Exh: France	LE SiDANER.
LESLIE **Cecil Mary** b. 1900 - Works in aquatint Exh: RA, RSA, London & Prov. AG's	CecilLeslie.
LESLIE. RA. **Charles Robert** b. London. 1794 - 1859 Portraits, historical & genre subjects Exh: RA, BI, VA, London & Prov. AG's, Australia	C. R. Leslie 1822
LESLIE, RA **George Dunlop** b. London. 1835 - 1921 Genre & landscape artist Exh: UK AG's, France, Germany Australia	CDL GDL GDL
LE SUEUR **Eustache** b. France. 1616 - 1655 Religious, historical & genre subjects Exh: France, Germany, NG, Geneva, Vienna	eustache.Le Sueur Le Sueur
LE SUEUR **Louis** b. Paris. 1746 - ? Animals & landscape artist	LE
LESZCZYNSKI **Michal Antoni** b. Poland. 1906 - B/white, oil & watercolourist Exh: RA, RI, NS, London AG's, U.S. etc.	M. Leszczynski

LEU **August** b. Dusseldorf. 1852 - 1876 Animal & landscape subjects	*A Leu 1849*
LEVY **Emile** b. Paris. 1826 - 1890 Portraits, genre & historical subjects Exh: France, Holland, Italy	*EMILE LEVY*
LEVY **Henri Leopold** b. Nancy. 1840 - 1904 Religious & historical subjects Exh: France, Bucharest	*Henri Lévy*
LEVY — DHURMER **Lucien** b. Alger. 1865 - 1953 Genre artist Exh: France	*L.L.Dhurmer*
LEWIS. RA. **John Frederick** b. London. 1805 - 1876 Eastern scenes, animals, figures & landscape artist Exh: RA, RI, OWS, London & Prov. AG's	*J.F. Lewis 1838*
LEWIS. A.R. Cam.A. **John R.** b. Lincoln Landscape watercolourist Exh: London & Prov. AG's	*John R. Lewis*
LEWIS. RBA, ROI, NDD, etc. **Michael Frederick Paul** b. Cheltenham. 1925 - B/white, gouache, oil & watercolourist Exh: RA, RWI, RBA, RWS, ROI & Various AG's	*Michael Lewis '51* *Michael Lewis*
LEWISON **Marjorie** b. Bristol. 1901 - Orientally influenced landscape & figure studies Exh: London & Prov. AG's, Japan	*MARJORIE*
LEYDEN **John Michael** b. Scotland. 1908 - Cartoonist, etcher & watercolourist Exh: NSA, London & Prov. AG's	*LEYDEN*
LEYDEN **Lucas Van** b. Holland 1494 - 1538 Religious & historical subjects Exh: France, Germany, Britain, Italy	*LVL. L. L. L. 1525 LVL 1527*

LEYDERDORP **Andries** b. Holland. 1789 - ? Genre & landscape subjects	A:L: A: L
LEYS (Baron) **Henri Jan Augustyn** b. Antwerp. 1815 - 1869 Portrait, historical & genre subjects Exh: Belgium, Holland, Germany, London, France	
LEYSTER **Judith** b. Haarlem. 1600 ? - 1660 Genre & interior scenes Exh: Holland, Germany, Paris, Sweden	1635 1631.
LHERMITTE **Leon Augustin** b. France. 1844 - 1925 Rural & landscape scenes Exh: France, US, Belgium, Montreal, Florence	L.Lhermitte
LHOTE **Andre** b. Bordeaux. 1885 - 1962 Genre & landscape subjects Exh: Paris, World Modern Art Galleries	A.LHOTE A.LHOTE.
LIDDERDALE. RBA. **Charles Sillem** b. London. 1831 - 1895 Landscape & genre artist Exh: RA, BI, SS	₵
LIERNUR **Maria Elisabeth** b. Paris. 1802 - ? Portraits & miniaturist	M. E N
LIES **Jozef Hendrik Hubert** b. Antwerp. 1821 - 1865 Historical & portrait artist Exh: Belgium	Joseph Lies
LIEVENS (The Younger) **Jan Andrees** b. Antwerp. 1644 - ? Genre & historical works Exh: Amsterdam	
LIEVENS (The Elder) **Johanis** b. Holland. 1607 - 1674 Portrait, historical, religious & genre artist Exh: Holland, Germany, France, Copenhagen, UK.	J. L.

LIGARI **Giovanni Pietro** b. Italy. 1686 - 1752 Religious & portrait subjects Exh: Italy	*Ligarro P.*
LILLFORD. ARCA, RBA. **Ralph** b. Doncaster. 1932 - Oil & B/white media Exh: London & Prov. AG's	*ualymirkpud*
LIMBORCH **Hendrik Van** b. The Hague. 1681 - 1759 Mythological, historical & portrait subjects Exh: Holland, France, Budapest	AD AD
LIMMER **Emil** b. Germany 1854 - ? Genre artist & illustrator Exh: Germany	ML
LIMOSIN **Leonard** b. Limoges. 1505 ? - 1577 ? Religious subjects	L L 1572 L L
LIN **Hans** Fl. Holland 17th.C Hunting & battle scenes Exh: Germany, Sienna, Vienna	H. L. Lin fe H · V · Lm
LINDEGREN **Amalia** b. Stockholm. 1814 - 1891 Genre & portrait artist Exh: Sweden	*Amelie Lindegren*
LINDNER. RBA, RWS. **Moffat Peter** b. Birmingham. 1852 - 1949 Landscape & marine artist Exh: RA, SS, NWS, GG, NG, NEAC, etc.	M·L
LINDSAY. KB, LLD, ARWS. **Sir Daryl** b. Creswick. 1889 - Oil & watercolourist Exh: London & Prov. AG's. X	*Daryl Lindsay*
LINDTMAYER (The Younger) **Daniel** b. 1552 - 1607 Religious & landscape subjects Exh: France, UK, US, Germany	DM. DM 1584

LINGELBACH **Johannes** b. Germany. ? - 1674 Marine, genre & landscape subjects Exh: Holland, France, NG, Britain, Germany	I. LINGELBACH JL B
LINNELL **James Thomas** b. 1826 - 1905 Genre, historical & landscape artist Exh: RA, UK AG's	J.J.L
LINNELL **John** b. London. 1792 - 1882 Portraits & genre, historical & landscape artist Exh: RA, BI, OWS, Prov. AG's etc.	J Linnell 1826 JL
LINNIG **Egidius** b. Antwerp. 1821 - 1860 Marine & landscape subjects Exh: Belgium, Germany	E .845
LINNIG **Jan Theodor Joseph** b. Antwerp. 1815 - 1891 Architectural & landscape artist	L fec 1851
LINNIG (The Elder) **Willem** b. Antwerp. 1819 - 1885 Genre & interior scenes Exh: Belgium, Germany, France	W Linnig S.or
LINNIG (The Younger) **Willem** b. Antwerp. 1842 ? - 1890 Historical, genre & scenic subjects Exh: Antwerp	Willem Linnig Junior
LINNQVIST **Hilding Gunnar Oskar** b. Stockholm. 1891 Oil & watercolourist Exh: Stockholm, France, Germany, US, UK, etc.	HL HL
LINT **Peter Van** b. Antwerp. 1609 ? - 1690 Portraits & religious subjects Exh: Belgium, France, Germany, Austria	P.v.L V V V
LINTON. PRI, HRSW. **Sir James Dromgole** b. London. 1840 - 1916 Portraits, figure subjects & historical artist Exh: RA, SS, NWS, GG, NG, London & Prov. AG's	JDL

L

LION **Pierre Joseph** b. Belgium. 1729 - 1809 Portrait & landscape artist Exh: Belgium	*Lion*
LIPPI **Filippo Di Tomaso** b. Florence. 1406 - 1469 Religious subjects Exh: France, Germany, Italy, NG, US	*FP*
LIPPI **Lorenzo** b. Florence. 1606 - 1665 Religious, historical & portrait artist Exh: Italy, France, Vienna	*L F.*
LIS **Jan** b. Holland. 1570 - 1629 Genre & historical artist Exh: Holland, France, Italy, Russia, Hungary, UK, etc.	*J Lis J L fecit J.L. fe.*
LISLE. RDS, Mem.WIAC, WGA **Georginia Lucy De** b. London Miniaturist, oil, watercolour & pastel media Exh: RA, PS, WAG, ROI, WIAG	*GLE GL*
LISSE **Dirck Van Der** b. Breda. ? - 1669 Mythological subjects Exh: France, Germany, England, Sweden, Vienna	*DL DL DL DL DL*
LIST **Georg Nikolaus** b. Germany. ? - 1672 ? Portrait artist	*GNL*
LISTER. ARCA. **Edward D'Arcy** b. Horsforth. 1911 - Oil, gouache & watercolourist Exh: RA & Prov. AG's	*Edward D'A. Lister. Edward DA Lister.*
LISTER. ARMS, KMS, FRSA, SM, etc. **Raymond George** b. Cambridge. 1919 - Silhouette & miniaturist Exh: R.Cam.A, RMS, RSA, USA Paris, etc.	*RL*
LITTLE **George Leon** b. London. 1862 - 1941 Animal & landscape artist Exh: UK AG's	*GLL*

LITTLE Robert W. b. London. 1855 - 1944 Flowers, interiors, genre & landscape artist Exh: RA, OWS, GG, London & Prov. AG's	*R. L.*
LITTLEJOHN. DA, ARSA William Hunter b. Scotland. 1929 - Painter in oil media Exh: London & Prov. AG's	*William Littlejohn* *WL*
LITTLEJOHNS. RBA John b. Devon. 1874 - ? Portrait & landscape artist Exh: London & Prov. AG's	*Littlejohns*
LIVENS Horace Mann b. London. 1862 - 1936 Floral, genre & landscape artist Exh: RA, UK AG's, Canada	*H.M.L*
LIVERMORE. SGA William Bernard b. London. 1890 - Etcher, pen , pencil & watercolourist Exh: RA, RI, RBA, SGA, etc.	*W.B. Bernard Livermore* *Livermore*
LLOYD. ROI, FRSA. Norman b. Hamilton, Australia. 1895 - Landscape artist Exh: RA, RI, France, Australia etc.	**NORMAN LLOYD**
LLOYD. ARCA. Percy b. Keighley, Yorks. 1886 - Landscape watercolourist Exh: RA, Prov. AG's etc.	*Percy Lloyd.*
LLOYD Reginal James b. Hereford. 1926 - Abstract & landscape artist Exh: RBA, RWA, London & Prov. AG's	*R.g. Lloyd* **R. J. LLOYD** *R.J.L.*
LLOYD, RBA W. Stuart Fl. UK. 20th C. Portrait & landscape artist Exh: UK AG's	*Stuart Lloyd.*
LOBRE Maurice b. Bordeaux. 1862 - 1951 Genre artist Exh: France	*M. Lobre*

LOCK. PS **Anton** b. 1893 - Etcher, oil & watercolourist etc. Exh: RA, PS, ROI, RBA, RWS, PAS, Prov. AG's	*[signature]*
LOCKHART **Ginette Bruce** b. Newcastle-on-Tyne. 1921 - Horse & animal subjects & surrealist Exh: US, Holland, France, London & Prov. AG's	*Ginette Bruce Lockhart.*
LOCKWOOD. NDD **Kenneth** b. Huddersfield. 1920 - B/white, gouache, scraper-board, watercolour media Exh: London & Prov. AG's, etc.	*[monogram K L]* KENNETH LOCKWOOD
LODGE **William** b. Leeds. 1649 - 1689 Portraits, landscapes & architectural subjects	*WL*
LOIR **Luigi** b. Austria. 1845 - 1916 Genre & landscape subjects Exh: France, Moscow, US, Prague, Vienna	LOIR LUIGI
LOMAZZO **Giovanni Paolo** b. Milan. 1538 - 1600 Genre subjects Exh: Milan, Vienna	P.L '571
LONDERSEEL **Assuerus Van** b. Antwerp. 1572 ? - 1635 Biblical & landscape subjects	AVL AV AV
LONDONIO **Francesco** b. Milan. 1723 - 1783 Landscapes, animals & genre subjects Exh: Italy, Austria	*[monogram F.L in oval]* *FL*
LONG **Edwin** b. Bath. 1829 - 1891 Portrait, genre & historical subjects Exh: RA, NPG, UK AG's, Australia	EDWIN LONG ROME.
LONGDEN. OBE, DSO **Major Alfred Appleby** b. Sunderland. ? - 1954 Landscape watercolourist Exh: RA, RI, N. Zealand	*[monogram]*

LONGHI **Alessandro** b. Venice. 1733 - 1813 Portrait artist Exh: Italy	
LONGUET **Alexandre Marie** b. France. ? - 1850 ? Marine, genre & historical subjects Exh: France	
LOO **Charles Andre** b. Nice. 1705 - 1765 Mythological, portrait, genre subjects Exh: France, London, US, Canada, Italy	
LOON **Peter Van** b. Belgium. 1600 ? - 1652 ? Historical & landscape artist	
LOON **Pieter Van** b. Haarlem. 1731 - 1784 Still life & floral subjects Exh: Belgium, Holland, Vienna, Lisbon	
LOON **Theodor Van** b. Belgium. 1629 - 1678 Religious & landscape subjects	
LOPEZ **Cristobal** Fl. Seville 16th C. Portraits & religious subjects Exh: Spain	
LOPEZ CANCIO **Mariana** b. Gijon, Spain. 1909 - Floral subjects etc. Exh: RA, RI, WIAC, S. America	
LORCH **Melchior** b. Denmark. 1527 - 1594 Portraits & historical subjects Exh: Germany, Denmark	

LORCK **Carl Julius** b. Trondheim. 1829 - 1882 Genre subjects Exh: Scandinavia, Germany.	*C Lorck*
LORIMER, ARWS **John Henry** b. Edinburgh. 1857 - 1936 Portrait, floral, genre & landscape artist Exh: UK AG's, US, Australia, France	*J.H.L* *JL* *18 H 82*
LORRAINE **Claude**	see **GELLEE** **Claude**
LOTIRON **Robert** b. Paris. 1886 - 1966 Landscape & genre subjects Exh: Paris	*Lotiron*
LOTTO **Lorenzo** b. Venice. 1480 - 1556 Portraits & historical subjects Exh: Italy, Germany, Hungary, UK, Russia, France, etc.	*.L. LOTVS. P* *1515*
LOTZE **Moritz Eduard** b. Germany. 1809 - 1890 Landscape subjects	*L 1832*
LOUIS **Aurelio** b. Pisa. 1556 - 1622 Historical & religious subjects Exh: Italy	*A.*
LOUND **Thomas** b. 1802 - 1861 Landscape artist Exh: VA, UK AG's	*I 1833*
LOUTHERBOURG **Philipp Jakob II** b. Strasbourg. 1740 - 1812 Battle scenes, landscape subjects Exh: France, NG, VA, US.	*L: J: de Loutherbourg*
LOUTREUIL **Maurice Albert** b. France. 1885 - 1925 Genre & figure landscapes Exh: France	*Loutreuil*

LOVE, NDD, RWA **Hazel** b. Somerset. 1923 - Oil & watercolourist Exh: RWA, AIA, etc. X	*HL*
LOWCOCK, RBA **Charles Frederick** Fl. Essex. 1878 - 1922 Genre subjects Exh: UK AG's	*CFL*
LOWE **George Theodore** B. Leeds. 1858 - ? B/white, oil & watercolourist Exh: London & Prov. AG's	*-Geo:T. Lowe.-*
LOWINSKY. NEAC **Thomas Esmond** b.1892 - Painter & illustrator Exh: London & Prov. AG's	*HL* (TEL)
LOWRY **Lawrence Stephen** b. Manchester. 1887 - Town & industrial scenes Exh: UK AG's, France	*L.S.LOWRY. 1964.*
LOXTON-KNIGHT. RBA **Edward** b. Notts. 1905 - Oil, gouache, pastel & watercolour media Exh: RA, RBA, RI, PS, US, S. Africa, London & Prov. AG's	*Loxton Knight*
LUBIENIECKI **Bogdan Theodor** b. Poland. 1653 - ? Historical & landscape subjects Exh: Germany, Budapest	*T.D.L.* *TDL Inv*
LUCAS **Albert Durer** b. Salisbury. 1828 - ? Floral subjects Exh: UK AG's	*A.D. Lucas 1881*
LUCAS **Horatio Joseph** b. 1839 - 1873 Landscape watercolourist Exh: RA, Prov. AG's	*HL 1865*
LUCAS. RA, RI **John Seymour** b. London. 1849 - 1923 Historical & genre subjects Exh: RA, SS, NWS, London & Prov. AG's, Australia	*JL*

LUCAS. RMS, (HS)FRHS, SWA, UA. **Suzanne** b. Calcutta. 1915 - Miniatures & watercolours of flowers, animals etc. Exh: RA,PS, RWS,FBS,SWLA,SWA, UA, US, Australia, London AG's	
LUCAS **William James** b. Cheshire. 1888 - Oil & watercolourist Exh: London & Prov. AG's	
LUCAS — ROBIQUET **Marie Aimee** b. France. 1864 - ? Genre subjects Exh: France	
LUCE **Maximilien** b. Paris. 1858 - 1941 Landscape & genre subjects, neo-impressionist Exh: France	
LUCIANO **Sebastiano** b. Venice. 1485 ? - 1547 Portraits & Historical subjects Exh: UK, US & European AG's	
LUDDINGTON. MBE **Leila** b. Aldershot Watercolourist Exh: RI, RBA, WIAC, NEAC, RSA, NS, etc.	
LUDOVICE (The Elder) **Albert** b. 1820 - 1894 Genre subjects Exh: NG, UK AG's	
LUDOVICI **Albert** b. Prague. 1852 - ? Figure & landscape subjects	
LUIGI (Called L'Ingegnio) **Andrea Di** b. Assisi. 1470 - 1512 ? Portraits & historical subjects	

LUKER **William, (Junior)** b. London. 1867 - ? Portraits, genre & landscape artist Exh: RA, SS, NWS & Prov. AG's	
LUMSDEN, RSA **Ernest Steven** b. London. 1883 - Landscape artist & watercolourist Exh: UK AG's	
LUND **Niels Moller** b. 1863 - 1916 Portrait, figure, architectural & landscape subjects Exh: UK AG's, Paris	
LUNDBERG **Gustaf** b. Sweden. 1695 - 1786 Portrait & historical works Exh: Stockholm	
LUNDENS **Gerrit** b. Holland. 1622 ? - 1677 ? Genre subjects & miniaturist Exh: Holland, Germany, Austria, UK Italy	
LUNOIS **Alexandre** b. Paris. 1863 - 1916 Genre subjects Exh: France, Spain	
LUPPEN **Gerard Josef Adrian Van** b. Antwerp. 1834 - 1891 Landscape artist Exh: Belgium, UK	
LURCAT **Jean** b. France. 1891 - 1966 Genre subjects Exh: US, France, Moscow, Vienna	
LUSURIER **Catherine** b. France. 1753 - 1781 Portrait artist Exh: France	
LUTGENDORFF (Baron De) **Ferdinand Karl Theodor** **Christoph Peter** b. Germany. 1785 - 1858 Genre, portraits & miniaturist	

LUYTEN **Jean Henri** b. Belgium. 1859 - ? Marine, genre & landscape subjects Exh: Belgium, Germany	*Henry Luyten*
LYDIS **Mariette** b. Vienna. Fl. 20th C. Genre subjects & illustrator Exh: France	*Mariette Lydis* **MLYDIS**
LYMAN **John Goodwin** b. Maine, US. 1886 - B/white, oil & watercolourist Exh: UK, France, US, Canada, S. America. etc.	*Lyman*
LYNCH **Albert** b. Lima (Peru). 1851 - ? Genre & portrait artist Exh: France, Australia	*AL*
LYONET **Pieter** b. Holland. 1708 - 1789 Genre subjects	*PL*
LYTTON. OBE, SSN **Neville** b. 1879 - ? Fresco, tempera & oil media Exh: RA, RBA, NEAC, RP, etc.	*NL*

M

MAAS **Arnold** b. Gouda. 1620 ? - 1664 Rustic genre & landscape artist Exh: France	*A Maas* *AV. Maas*
MAAS **Dirk** b. Haarlem. 1659 - 1717 Equine & battle scenes Exh: Holland, France, UK, Sweden	**DM** *D maas* **DM**
MAAS (or MAES) **Nicolas** b. Dort. 1632 - 1693 Portraits & interior subjects Exh: European AG's	*N. MÆS 1655.* N MAAS *N. Maas 1690*

MABUSE (known as GOSSART) **Jan De** b. Maubeuge. 1478 ? - 1533 Portraits, biblical subjects & miniaturist Exh: European AG's	*JMB* *MB* *JONN NALBODIUS* *INVENIT*
McADOO. ARCA, RUA, etc. **Violet** b. Co. Tyrone Oil & watercolourist Exh: RHA, RUA, SWA, USA etc.	*V. McAdoo*
MACALLUM, RSW **Hamilton** b. Kames. 1841 - 1896 Genre, marine & landscape artist Exh: RA, UK AG's, Germany, Australia	*HM*
MACARRON. RP **Ricardo** b. Madrid. 1926 - Figures, portraits, nature & landscape artist Exh: X Spain, Oslo, S. Africa, etc.	*R. MACARRON. 73*
MACBETH. RA, RI, RPE, RWS **Robert Walker** b. UK. 1848 - 1910 Landscape & rustic genre subjects Exh: RA, OWS, GG, NG, France, Germany	*R̄* *R̄*
McCANNELL. RWA, RBA, ARCA, **etc.** **Otway** b. Wallasey. 1883 - Pastel, Gouache, oil & watercolour media etc. Exh: RA, PS, London & Prov. AG's, Italy	*McC.*
McCULLOUGH **George** b. Belfast. 1922 - Pastel, gouache, oil & watercolour media Exh: RUA, London & Prov. AG's	*Geo McCullough*
MacDONALD. RMS, ARMS, **FRSA, UA** **Alastair James Henderson** b. Argyll. 1934 - Miniaturist & landscape artist Exh: RMS, RI, UA, USA	*⊠* *⊠* *Ⱥ*
MacDONALD. RMS **Lucy Winifred** b. London. 1872 - ? Miniaturist Exh: RA, RMS, Prov. AG's Canada etc.	*⋈*
McEVOY, ARA, NEAC **Arthur Ambrose** b. Wiltshire. 1878 - 1927 Interiors, portrait & landscape artist Exh: RA, NG, Prov. AG's, Paris	*McE.* *McE.*

McEVOY **Mary** b. UK. Portraits, flower studies & interiors Exh: RA, PS, NEAC	*[monogram M]*
McGLASHAN. RSA **Archibald. A** b. Paisley. 1888 - Painter in oil media Exh: RA, R.Scot.A. & Prov. AG's	*A McGlashan*
McGLYNN **Terry** b. UK. 1903 - Landscape artist Exh: London & Prov. AG's	*Mc Glynn*
Mac GONIGAL. PRHA, Hon.RA, **Hon.RSA. LL.D, (NC)** **Maurice Joseph** b. Dublin. 1900 - Portraits, genre, still life, landscape, oil & watercolourist etc. Exh: RA, RHA, Dublin US & European AG's	*MAC CONGAIL*
McGREGOR, RSA **Robert** b. Yorkshire, 1848 - 1922 Genre & landscape artist Exh: RA, PS, UK AG's	*RMg*
McINTYRE. RI, RCA **Donald** b. Yorkshire. 1923 - Landscape artist Exh: London & Prov. AG's	*D McINTYRE —*
McINTYRE **Raymond** Portrait, figure & landscape artist Exh: RA, NEAC & London AG's	*[monogram]*
McKAY. FRSA, PS **Eric Bruce** b. London. 1907 - Pastel, gouache & oil media Exh: NEAC, RBA, ROI, Canada, U.S.	*— McKAY —*
MACKAY, RSA **William Darling** b. Gifford. 1844 - 1924 Genre & landscape artist Exh: UK AG's	*WDM.*
McKELVEY. RHA **Frank** b. Belfast. 1895 - Portrait & landscape artist Exh: UK, US, Belgium	*FRANK McKELVEY —*

MACKENZIE. ARBSA **C.V.** b. 1889 - 1948 Oil & watercolourist Exh' RA, RWA, RSA, NEAC, RBA, RI, RBSA, WAG etc.	*C.V. MacKenzie.*
MACKENZIE **Winifred Emily** b. London. 1888 - Portrait artist Exh: RA, SWA, etc.	*[monogram WM]*
MACKERTICH. Mem.RBA, NEAC **Robin** b. Lucknow, India. 1921 - Portraits, figures, still life & landscape artist. Exh: RA, RWA, NEAC, RBA	*Robin Mackertich. R. Mackertich.* *R.M.*
MACKIE, RSA, RSW **Charles H.** b. Aldershot. 1862 - 1920 Genre & landscape artist Exh: RA, UK & European AG's	*C.H.M. [circled M] [circled M]*
MACLISE **Daniel** b. Cork. 1806 - 1870 Portraits, fables & historical subjects Exh: RA, BI, SS, etc.	*D. McClise Jan² 1828*
MacMIADHACHAIN **Padraig** b. Ireland. 1929 - Artist - various media Exh: Irish, UK & European AG's	*-mac miaḋacáin-*
MACTAGGART, RSA, RSW **William** b. Campbeltown. 1835 - 1910 Coastal scenes, genre & landscape artist Exh: RA, RSW, UK AG's	*[monogram] 58 [monogram] 6*
MACWHIRTER. RA, HRSA, RI **John** b. Edinburgh. 1839 - 1911 Landscape artist Exh: RA, NWS, GG & Prov. AG's etc.	*Mac W*
MADDOX **Ronald A.** b. Surrey. 1930 - Graphic art, oil & watercolourist Exh: RI, RBA, SGA, NEAC, SMA, PAS, RI, etc.	*- RONALD A. MADDOX -*
MADOU **Jean Baptiste** b. Brussels. 1796 - 1877 Genre subjects Exh: Holland, Belgium	*Madou MD*

MAES **Jan Baptist Lodewyck** b. Belgium. 1794 - 1856 Portrait, historical & genre subjects Exh: Holland, Germany	*Mans. pinx*
MAGANZA **Alessandro** b. Venice. 1556 - 1630 ? Portrait & religious subjects Exh: Italy	A M vic F.
MAGANZA **Giovanni Battista** b. Italy. 1513 ? - 1586 Portraits & religious subjects Exh: Italy	G B M T
MAGAUD **Dominique Antoine Jean Baptiste** b. Marseille. 1817 - 1899 Portrait, historical & genre subjects Exh: France	MAGAUD
Mager. RCA, USA **Frederick** b. 1882 - Oil & watercolourist Exh: PS, RA, RI, etc.	FM
MAGRITTE **Rene** b. Lessines. 1898 - 1967 Exh: UK, France, Holland, Belgium, US etc.	*magritte*
MAGY **Jules Eduard De** b. Metz. 1827 - 1878 Genre & landscape subjects Exh: PS, French AG's	*jules-Magy-*
MAHLAU **Alfred** b. Berlin. 1894 - Pen & ink, watercolourist etc. Exh: Switzerland, Germany, Holland, US	AM.
MAHONEY, NWS **James** b. Cork. 1816 - 1879 European architectural views Exh: RA, VA, UK AG's	↑↑ ↑↑ ↑↑ ⋀⋀
MAHU **Cornelis** b. Antwerp. 1613 - 1689 Still life subjects Exh: Belgium, Germany	C M HV · 1648

MAIGNAN **Albert Pierre Rene** b. France. 1845 - 1908 Historical, portrait & genre subjects Exh: France, Melbourne, Montreal	ALBERT MAIGNAN
MAILLART **Diogene Ulysses Napoleon** b. France. 1840 - 1926 Historical & portrait artist Exh: France	MAILLART
MAILLOL **Aristide Joseph Bonaventure** b. France. 1861 - 1944 Genre subjects Exh: France, Germany	Maillol
MAINSSIEUX **Lucien** b. France. 1885 - Still life, landscape subjects & illustrator Exh: Paris	Lucien Mainssieux M
MAINWARING **Geoffrey Richard** b. Australia. 1912 - Pastel, gouache, pen & wash, oil & watercolour media etc. Exh: Australian AG's	GMainwaring 1949
MAIR **Alexander** b. Germany. 1559 ? - 1620 ? Genre & portrait artist	MAIR A A M M
MAJOR **Isaac** b. Germany. 1576 ? - 1630 Historical & landscape artist	JM JM M
MALCLES **Jean-Denis** b. Paris. 1912 - Genre artist & illustrator Exh: France	Jean denis Malcles
MALI **Christian Friedrich** b. Germany. 1832 - 1906 Landscape & animal subjects Exh: France, Germany	Christian Mali

MALLET Jean Baptiste b. Grasse. 1759 - 1835 Genre, landscape & historical subjects Exh: France	
MALO Vincent b. Belgium. 1600 ? - 1650 ? Religious, battle scenes & landscape subjects Exh: Holland, London, Prague	
MAN Cornelis Willems De b. Delft. 1621 - 1706 Portrait & genre subjects Exh: Holland, Germany, France, Budapest	
MANDER (The Elder) Karel Van b. Belgium. 1548 - 1606 Religious & portrait artist Exh: Belgium, Holland, Austria	
MANDYN Jan b. Haarlem. 1500 - 1560 ? Imaginative & historical subjects Exh: Holland, France, Germany, Austria	
MANE-KATZ b. Russia. 1894 - 1962 Genre & figure compositions Exh: France, Israel, UK, US, Belgium, S. Africa, etc.	
MANET Edouard b. Paris. 1832 - 1883 Genre, portraits, still life, historical subjects etc. Exh: International AG's	

MANET **Edouard** (continued)	*[signatures: Manet]*
MANETTI **Rutilio Di Lorenzo** b. Sienna. 1571 - 1639 Religious & historical subjects Exh: Italy, France, Madrid	*[signature: RuMan]*
MANGLARD **Adrien** b. Lyon. 1695 - 1760 Historical, marine & landscape artist Exh: France, Hungary, Italy, Spain etc.	*[signature: A MANGLARD 1750]* *[monogram: AR]*
MANGUIN **Henri Charles** b. Paris. 1874 - 1949 Figure, still life & landscape subjects Exh: France, Belgium, UK, etc.	*[signature: Manguin]*
MANN **Alexander** b. Glasgow. 1853 - 1908 Genre & landscape artist Exh: RA, ROI, UK AG's, Paris	*[signature: A.M.]*
MANN **Cathleen** b. 1896 - 1959 Genre & floral paintings Exh: London & Prov. AG's	*[monogram: CM]*
MANNINI **Giacomo Antonio** b. Bologna. 1646 - 1732 Religious subjects Exh: Italy	*[monogram: AGM]*
MANNOZI **Giovanni** b. Italy. 1592 – 1636 Portraits, mythological, historical & genre subjects Exh: France, Italy	*[monogram: DG]* *[monogram: DG 1624]*
MANSFELD **Joseph George** b. Vienna. 1764 - 1817 Portrait & animal subjects	*[monogram]* *[signature: J.G.M]*

MANSON **George** b. Edinburgh. 1850 - 1876 Landscape artist Exh: UK AG's	
MANTEGNA **Andrea** b. Italy. 1431 - 1506 Religious, historical & mythological subjects Exh: Italy, France, UK, Spain, Germany, etc.	Andreas Mantinia C·P·F
MANUEL **Hans Rudolf** b. Switzerland. 1525 ? - 1572 Religious & portrait subjects Exh: Switzerland	
MANUEL **Niklaus** Fl. Switzerland. 15th - 16th C. Portraits & historical subjects	
MAPP. ARCA **John Ernest** b. Northampton. 1926 - Oil & watercolourist Exh: RA, London & Prov. AG's	
MARATTI **Carlo** b. Camerano. 1625 - 1713 Portraits, religious & historical subjects	Carlo Maratti
MARBEAU **Philippe** b. France. 1807 - 1861 Portrait & landscape subjects Exh: PS, & French AG's	Marbeau
MARCH **Esteban** b. Valencia. ? - 1660 Battle scenes, genre & religious subjects Exh: France, Spain	E.March 1650

MARCHAL **Charles Francois** b. Paris. 1825 - 1877 Genre & portrait artist Exh: France	*Charles Marchal*
MARCHAND **Andre** b. Aix-En-Provence. 1907 - Genre, portrait & landscape artist Exh: France	*andré marchand*
MARCHAND **Jean Hippolyte** b. Paris. 1883 - 1940 Genre, landscapes & illustrator Exh: France, London, US, Tokyo, Geneva, Berlin	*J Marchand*
MARCKE DE LUMMEN **Emile Van** b. France. 1827 - 1890 Landscape & animal subjects Exh: France, Holland, US, Edinburgh	*Em van Marcke*
MARCOUSSIS **Louis Casimir Ladislas Markous** b. Warsaw. 1883 - 1941 Cubist Exh: Paris, Berlin, Brussels, US	*Marcoussis*
MARE **Andre** b. France. 1885 - 1932 Genre artist & illustrator Exh: Paris	*and: mare*
MAREC **Victor** b. Paris. 1862 - 1920 Portrait & genre artist Exh: France	*Victor Mares*
MARELLI **Andrea** Fl. Italy. 16th C. Historical subjects	*(monogram)*
MARGETSON **William Henry** b. 1861 - 1940 Genre, figure & portrait artist Exh: RA, UK AG's	*W.H.M.*
MARIE **Adrien Emmanuel** b. France. 1848 - 1891 Genre subjects Exh: France, Australia	*A. Marie*

MARILHAT **Prosper Georges Antoine** b. France. 1811 - 1847 Landscape artist Exh: France, Russia, UK	*MARILHAT* *P.M.*
MARINITSCH **Christian De** b. France. 1868 - ? Genre subjects Exh: France	*G. de Marinitsch*
MARINUS **Ferdinand Joseph Bernard** b. Antwerp. 1808 - 1890 Marine, genre & landscape artist Exh: Belgium, Germany	*F. Marinus*
MARIS **Jacob Henricus** b. The Hague. 1837 - 1899 Genre & landscape artist Exh: Holland, Germany, UK	*J Maris* *J Maris* *J Maris*
MARIS **Matthijs** b. The Hague. 1839 - 1917 Genre & landscape subjects Exh: Holland, Canada	*M Maris* *M.M.* *M Maris* *M.M*
MARIS **Willem** b. The Hague. 1844 - 1910 Landscapes & animal subjects Exh: Holland, Germany, Canada, UK	*Willem Maris.* *Willem Maris*
MARKELBACH **Alexandre** b.. Antwerp. 1824 - 1906 Genre & historical subjects Exh: Belgium, Germany, France, Holland	*Aly Markelbach* *1879*
MARKS **Henry Stacy** b. London. 1829 - 1898 Animals, genre & historical subjects Exh: RA, BI, SS, GG, OWS, Prov. AG's, Germany	*HSM* *HMS*
MARLET **Jean Henri** b. France. 1771 - 1847 Religious & historical subjects Exh: France	*J h marlet.*

MARNY **Paul** b. Paris. Ex. from 1857 Landscape artist Exh: France	
MARONIEZ **Georges Philibert** b. France. 1865 - ? Marine, genre & landscape subjects Exh: France	
MAROT **Francois** b. Paris. 1666 - 1719 Religious & historical works Exh: France	
MARQUET **Pierre Albert** b. Bordeaux. 1875 - 1947 Genre & landscape subjects Exh: France, US, Scandinavia	
MARR **Joseph Heinrick Ludwig** b. Hamburg. 1807 - 1871 Genre & landscape artist Exh: Germany, Italy	
MARR. MA **Leslie** b. Durham. 1922 - Charcoal, oil & watercolour media Exh: London & Prov. AG's	
MARRIOTT **Frederick** b. 1860 - 1941 Landscape & architectural subjects Exh: RA, ROI	
MARSAL **Edovard Antoine** b. Montpellier. 1845 - ? Historical & genre subjects Exh: France	
MARSHALL. ARMS **Clemency Christian Sinclair** b. Fife. 1900 - Miniaturist. B/white, oil & watercolourist Exh: RA, PS, etc.	
MARSHALL, RWS **Herbert Menzies** b. Leeds. 1841 - 1913 Landscape & architectural subjects Exh: France, S. Africa, Australia	

MARSHALL **Thomas Falcon** b. Liverpool. 1818 - 1878 Portrait, genre, historical & landscape artist Exh: RA, BI, SS, VA	*T.F.M.*
MARTIN **Beatrice** b. Sevenoaks. 1876 - ? Watercolourist Exh: RA, RI, WAG	*B*
MARTIN. ARCA, AMTC, ACT **Dorothy Burt** b. Wolverhampton. 1882 - Etcher, watercolourist etc. Exh: RA, SWA, Prov. AG's etc.	*DB.*
MARTIN **Ethel** b. Sevenoaks. 1873 - Painter in oil media Exh: RA, RI, NEAC, ROI	*EEM*
MARTIN **Etienne Philippe** b. Marseille. 1858 - 1945 Landscape artist Exh: France	*Etienne Martin*
MARTIN **Jean Baptiste** b. Paris. 1659 - 1735 Historical & battle scenes Exh: France	*B Martin 1730*
MARTIN **John** b. Near Hexham. 1789 - 1854 Biblical, historical, architectural & landscape artist Exh: RA, BI, SS, London & Prov. AG's	*J Martin . 1840* *J.M*
MARTIN **Pierre Denis** b. Paris. 1663 ? - 1742 Battle scenes & Royal residential subjects Exh: France, Germany	*P D I Martin*
MARTIN. FSIA. SGA, FRSA **Ronald Arthur** b. Eastbourne. 1904 - Acrylic, w/colour & other media Exh: RA, RBA, RI, SGA, RSMA, London & Prov. AG's	*Ronald Martin.*
MARTINEAU **Robert Braithwaite** b. London. 1826 - 1869 Genre & historical subjects Exh: RA, London & Prov. AG's	*RBM*

MARTINEZ **Fray Antonio** b. Zaragoza. 1638 - 1690 Biblical subjects	*Martinez* *1670*
MARTINEZ **Sebastian** b. Jaen. 1602 - 1667 Historical & landscape artist	*S Martinez* *fecit. 1640*
MARTSS **Jan** Fl. 17th C. Battle scenes	**MD.I.s** **MDI.fe**
MARVAL **Jacqueline** b. France. 1866 - 1932 Still life & genre subjects Exh: Paris, Venice, Budapest	*marval*
MARVY **Louis** b. France. 1815 - 1850 Landscape artist Exh: France	**M** **JM**
MASON. ARCA, ATD **Bateson** b. Bradford. 1910 - Gouache, oil & watercolourist Exh: NEAC & Prov. AG's	*Bateson Mason*
MASON **Eric** b. London. 1921 - Landscapes, towns & river scenes, architectural subjects etc. Exh: London & Prov. AG's, US	*Ric Mason:* *M* *Ric Mason:* *m*
MASSE **Jean Baptiste** b. Paris. 1687 - 1767 Portraits & miniaturist Exh: France	*S.masse*
MATANIA **Fortunina** b. Naples. 1881 - 1963 Portraits, historical & military subjects etc. Exh: U.K. AG's	*JMatania*

MATET **Charles Paulin Francois** b. Montpellier. 1791 - 1870 Portrait & genre artist Exh: France	*Matet*
MATHAM **Jacob** b. Haarlem. 1571 - 1631 Portrait artist Exh: Holland	*M.se* *M*
MATHEWS **Denis** b. London. 1913 - Oil & watercolourist Exh: London & Prov. AG's	*Denis*
MATHEY **Paul** b. Paris. 1844 - ? Portrait, marine & landscape subjects Exh: France	*P. Mathey*
MATHIEU **Lambert Joseph** b. Belgium. 1804 - 1861 Historical, genre & portrait artist Exh: Belgium	*L M*
MATHIEU **Paul** b. Belgium. 1872 - ? Still life, interiors & landscape artist Exh: Belgium	*Paul Mathieu*
MATISSE **Henri** b. France. 1869 - 1954 Genre, landscapes & still life subjects Exh: International AG's	*Henri-Matisse* *Henri Matisse*
MATON **Bartholomaeus** b. Stockholm. 1643 ? - ? Genre & portrait artist Exh: Holland, Belgium, Austria	*M̃on* *M̃* *M̃*
MATOUT **Louis** b. France. 1811 - 1888 Portrait & landscape subjects Exh: France, Luxemburg	*L. Matout*

MATTHIOLI **Lodovico** b. Italy. 1662 - 1747 Religious, portraits & landscape artist Exh: Italy	*M̗F L̗F*
MAUFRA **Maxime Emile Louis** b. Nantes. 1861 - 1918 Marine & landscape artist Exh: France, US	*Maufra*
MAUPERCHE **Henri** b. Paris. 1602 - 1686 Landscape artist Exh: France	*H.M*
MAURER **Christoph** b. Zurich. 1558 - 1614 Portrait artist Exh: Zurich, Germany	*M M CM*
MAUVE **Anton** b. Holland. 1838 - 1888 Landscape & animal subjects Exh: Holland, Germany, US, UK	*A Mauve A Mauve. AM*
MAUZAISSE **Jean Baptiste** b. France. 1784 - 1844 Religious, historical & portrait subjects Exh: France	MAUZAISSE
MAX **Gabriel Cornelius** b. Prague. 1840 - 1915 Biblical, genre & portrait artist Exh: Germany, US, Holland etc.	*G.Max.*
MAYAN **Theophile Henri** b. Marseille. 1860 - ? Landscape & portrait artist Exh: France, UK	*Theo Mayan*
MAYER **Marie Francoise Constaxce La** **Martiniere** b. Paris. 1775 - 1821 Genre, portrait artist & miniaturist Exh: Russia, France	*C Mayer p 1819*
MAYER-MARTON. AM, OLB, ACM **HCM.** **George** b. Hungary. 1897 - Fresco, oil & watercolourist etc. Exh: Hungary, France, Germany, Belgium, UK, etc;	*Gmayermarton MM*

MAYERSON **Anna** b. Austria. 1906 - Painter & sculptor Exh: London & Prov. AG's	AM
MAYRHOFER **Johann Nepomuk** b. Austria. 1764 - 1832 Floral & still life subjects	
MAYS **Douglas Lionel** b. 1900 - B/white, oil & watercolourist Exh: RA, RBA, SGA, London & Prov. AG's, Canada	
MAZEROLLE **Alexis Joseph** b. Paris. 1826 - 1889 Historical, genre & portrait artist Exh: France	
MAZZOLA **Girolamo Francesco Maria** b. Parma. 1503 - 1540 Religious & portrait artist Exh: Italy, France, US, Britain, Russia	
MEADOWS **Joseph Kenny** b. Cardiganshire. 1790 - 1874 Genre subjects Exh: RA, SS, VA	
MECARINO **Domenico**	see **BECCAFUMI** (Domenico)
MECHAU **Jakob Wilhelm** b. Leipzig. 1745 - 1808 Historical & landscape artist Exh: Scandinavia	
MECKENEM **Israel** b. ? - 1503 ? Religious subjects Exh: France, Germany	
MEDULA (called IL SCHIAVONE) **Andrea** b. Dalmatia. 1522 - 1563 Portraits & historical subjects	

MEDWORTH. RBA **Frank Charles** Etcher, painter & engraver Exh: RA, RSA, RI, NEAC, London AG's, Italy, France	
MEEL (MIEL or MIELE) **Jan** b. Vlaardingen. 1599 - 1663 Fairs, markets, historical & landscape artist Exh: European AG's, US, etc.	
MEER **Barend Van Der** b. Haarlem. 1659 ? - ? Still life subjects Exh: Austria	
MEER (The Elder) **Jan Van Der** b. Holland. 1628 - 1691 ? Military scenes, sea & landscape artist Exh: France, Germany, Holland, Austria, etc.	
MEER **Jan Van Der** b. Delft. 1632 ? - 1675 Historical, architectural, genre & landscape subjects Exh: Holland, Germany, NG, Paris, Vienna	
MEER (The Younger) **Jan Van Der** b. Holland. 1655 ? - 1705 Animal & landscape artist Exh: Holland, Germany, Copenhagen	
MEGAN **Renier** b. Brussels. 1637 - 1690 Landscape artist Exh: Belgium, Vienna	
MEHEUT **Mathurin** b. France. 1882 - 1958 Genre & landscape subjects	
MEI **Bernardino** b. Sienna. 1615 ? - 1676 Genre subjects	
MEIL **Johann Wilhelm** b. Germany. 1733 - 1805 Historical & landscape artist Exh: Germany	

MEISSONIER **Jean Louis Ernest** b. Lyon. 1815 - 1891 Portraits, genre & historical subjects Exh: International AG's	
MEISSONIER **Justin Aurele** b. Turin. 1675 - 1750 Landscape & figure subjects etc. Exh: Italy, France	
MELDEMANN **Nicolaus** Fl. Germany 16th C. Genre subjects & battle scenes	
MELLAN **Claude** b. France. 1598 - 1688 Portrait & genre subjects Exh: France	
MELVILLE, RSW **Arthur** b. E. Linton. 1858 - 1904 Eastern subjects, oil & watercolourist Exh: RA, VA, UK AG's	
MEMLING **Hans** b. Mayence. 1430 ? - 1494 Portraits, religious & historical subjects Exh: Belgium, UK, US, Italy, Germany	
MENABUOI **Giusto Di Giovanni De** b. Florence. ? - 1393 Historical & religious subjects Exh: London	
MENAGEOT **Francois Guillaume** b. London. 1744 - 1816 Portraits, historical subjects etc. Exh: France, Italy	

MENARD **Marie Auguste Emile Rene** b. Paris. 1862 - 1930 Portrait & landscape artist Exh: Germany, Scandinavia, Belgium, etc.	*E. R. Menard*
MENAROLA **Crestano** b. Italy. ? - 1640 ? Historical subjects	
MENNESSIER **Auguste Dominique** b. Nancy. 1803 - 1890 Landscape subjects Exh: France	A. MENNESSIER
MENPES. RBA, RPE **Mortimer** b. Australia. 1860 - 1938 Genre & street scenes etc. Exh: RA, NWS, GG, SS, etc.	
MENTON **Frans** b. Holland. 1550 ? - 1615 Religious subjects Exh: Holland	
MENZEL **Adolf Friedrich Erdmann** b. Germany. 1815 - 1905 Genre subjects Exh: Germany, Russia	*Ad. Menzel Bul. 1877.*
MENZIES-JONES. BA **Llewelyn Frederick** b. Surrey. 1889 - Etcher & landscape artist Exh: RI, PAS, etc.	
MENZLER **Wilhelm** b. Germany. 1846 - ? Genre subjects Exh: Vienna, Budapest, Sydney	W. Menzler
MERCHANT **Henry** b. Southport Figure, still life, landscape & animal subjects Exh: RA, ROI, & Prov. AG's	H. Merchant
MERCIE **Marius Jean Antonin** b. Toulouse. 1845 - 1916 Portrait & genre subjects Exh: France	a. mercié

MERCKELBACH **Pieter** b. Holland. 1633 ? - 1673	
MERIAN (The Elder) **Matthaus** b. Basle. 1593 - 1650 Portrait, landscape & historical subjects Exh: Switzerland	
MERRIOTT. RI, PS, SMA, etc. **Jack** b. 1901 - Portrait & landscape artist Exh: RA, RWA, ROI, RI, RBA & Prov. AG's	
MERRITT **Anna Lea** b. Philadelphia. 1844 - ? Genre & portrait artist Exh: RA, NG, GG, etc.	
MERSON **Luc Olivier** b. Paris. 1846 - 1920 Historical subjects & illustrator Exh: France	
MERVYN. ARCM **Sonia** Pastel, oil & watercolour media Exh: RA, London & Prov. AG's	
MESDAG **Hendrik Willem** b. Holland. 1831 - 1915 Marine subjects Exh: Holland, Germany	
MESHAM **Isabel Beatrice** b. Eire. 1896 - Etcher, oil & aquatint media Exh: RA, PS, London AG's	
MESPLES **Paul Eugene** b. Paris. 1849 - ? Genre subjects & illustrator Exh: PS	
MESSENT **Charles** b. Felixtowe. 1911 - Oil, enamel & watercolour media Exh: PS, NEAC & Prov. AG's	

MESSIN **Charles** b. Nancy. 1620 - 1649 ? Historical subjects Exh: France	
METEYARD. RBSA **Sidney** b. UK. 1868 - 1947 Painter in oil, watercolour & tempera media Exh: RA, PS, London & Prov. AG's	
METHUEN. MA(Oxon), RA, RWS, **NEAC, PRWA, FSA, Hon.ARIBA** **Lord** b. 1886 - Figure & landscape artist Exh: RA, PS, London & Prov. AG's etc.	
METSU **Gabriel** b. Leyden. 1629 - 1667 Genre, historical & portrait artist Exh: US & European AG's	
METTENLEITER **Johann Jakob** b. Germany. 1750 - 1825 Portraits, genre & landscape artist Exh: Russia, Germany	
METTENLEITER **Johann Michael** b. Germany. 1765 - 1853 Religious, genre & historical subjects	
METZINGER **Jean** b. Nantes. 1883 - 1956 Cubist Exh: France	
MEULEN **Adam Francois Van Der** b. Brussels. 1632 - 1690 Portraits, landscapes & battle scenes Exh: International AG's	
MEULEN **Edmond Van Der** b. Brussels. 1841 - 1905 Still life & animal subjects Exh: Belgium, Holland	
MEULEN **Pieter Van Der** b. Brussels. Fl. 15th - 16th C. Portraits & battle scenes	

MEUNIER **Constantin Emile** b. Belgium. 1831 - 1905 Religious, historical & genre subjects Exh: Belgium, Paris, Germany	*C. Meunier. 1867*
MEYER (The Elder) **Dietrich** b. 1572 - 1658 Hunting scenes, genre & landscape subjects	*M 1599 DVF DM*
MEYER **F.W.** Landscape, marine & coastal subjects Exh: RA, SS, London & Prov. AG's	*F M*
MEYER **Hendrik de** b. Amsterdam. 1737 - 1793 Landscape subjects Exh: Holland, Germany	*H. De Meyer fecit*
MEYER **Rudolph Theodor** b. Zurich. 1605 - 1638 Historical & portrait artist Exh: Switzerland	*RM RM RM*
MEYERHEIM **Paul Friedrich** b. Berlin. 1842 - 1915 Genre, portrait & animal subjects Exh: France, Germany, Prague	*Paul Meyerheim*
MEYERS **Josy** b. 1902 - Oil & watercolourist Exh: European AG's, US, etc.	*. J. Meyers*
MICHALLON **Achille Etna** b. Paris. 1796 - 1822 Landscape artist Exh: France	*Michallon*
MICHAU **Theobald** b. Belgium. 1676 - 1765 Landscape & figure subjects Exh: France, Holland, Vienna, Budapest	*T. Michau*
MICHEL **Emile Francois** b. Metz. 1818 - 1909 Landscape subjects Exh: France	*Em. Michel*

MICHEL **Ernest Barthelemy** b. Montpellier. 1833 - 1902 Mythological & portrait artist Exh: France	*Ernest Michel*
MICHELANGELO (BUONARROTI) b. Italy. 1475 - 1564 Portraits, mythological & religious subjects etc. Exh: International AG's	Michel Ange AMaBOaRO. M.A.B.
MIDDERIGH **Jean Jacques** b. Paris. 1877 - ? Tempera, ink, oil & watercolour media Exh: Holland, Belgium, Germany, etc.	*JJ Midderigh*
MIDDLETON **John** b. Norwich. 1828 - 1856 Landscape, oil & watercolourist Exh: RA, SS, London & Prov. AG's	M. 1848
MIEL **Jan**	see **MEEL** Jan
MIEREVELD **Jan Van** b. Delt. 1604 - 1633 Portrait artist	M
MIEREVELD (or MIERVELT) **Michiel Janszoon Van** b. Delft. 1567 - 1641 Portrait artist Exh: France, NPG, Holland, Italy, US, Germany	M. Miereveld. M.M. Miereveld M. MIEREVELD

MIEREVELD (or MIERVELT) **Michiel Janszoon Van** (Continued)	M. MIEREVELD *M. Miereveld* *M. Mirvelt* *M. Miereveld*
MIERIS (The Elder) **Franz Van** b. Holland. 1635 - 1681 Genre & portrait artist Exh: France, Germany, NG, Britain, Holland	*F. van Mieris. 1676. f* *F. van Mieris 1675* *F. van Mieris fecit Anno 1680* *F. van Mieris* *F. van Mieris.* *F.V Mieris* *Franz van Mieris f.t 1651* *F. van Mieris* **FR** **FR** **FR** **FMR**
MIERIS (The Younger) **Frans Van** b. Holland. 1689 — 1763 Portrait & genre subjects Exh: Holland, UK, Italy, Germany	*F. V. Mieris Fecit A: 1730*
MIERIS **Willem Van** b. Holland. 1662 - 1747 Historical, genre, portrait & landscape subjects Exh: Belgium, France, NG, Italy, US	*W. van Mieris Fe Anno 1733* *W. van Mieris 1683* *W. van Mieris Fe 1722*
MIGNARD **Paul** b. Avignon. 1639 ? - 1691 Portrait artist Exh: France, Germany, Turin	*Migniard fecit* *Pa Mig.*

MIGNARD Pierre b. Troyes. 1612 - 1695 Portraits, historical artist & miniaturist Exh: Scandinavia, UK & European AG's	*Mignard pinxit 1690* *P. Mignard*
MIGNON Abraham b. 1640 - 1679 Floral & still life subjects Exh: Germany, Holland, Belgium, Italy, UK, France, etc.	*A. Mignon* *a. mignon 1665*
MIGNOT Victor b. Brussels. 1872 - ? Painter & engraver	
MILDE Karl Julius b. Hamburg. 1803 - 1875 Marine, historical & landscape artist	
MILE (MILLE or MILLET) Francois b. Antwerp. 1642 ? - 1679 ? Landscapes, allegorical subjects etc. Exh: France, Belgium, Italy, Germany, Russia	*F Mile 1679* *Mile*
MILEHAM. NSA Harry Robert b. London. 1878 - ? Portraits & historical figure subjects Exh: RA, NG, NSA, Prov. AG's, Italy, Canada, etc.	HARRY·R MILEHAM 1926
MILES Arthur Fl. 1851 - 1880 Portraits & genre subjects Exh: NG, UK AG's	18 57
MILES Thomas Rose Fl. 1869 - 1902 Marine & landscape artist Exh: RA, Prov. AG's, Australia	
MILICH Abram Adolphe b. Poland. 1884 - Portrait, still life & landscape subjects Exh: France, Australia, Switzerland	*Milich*
MILLAIS. BT, PRA, HRI, HRCA. Sir John Everett b. Southampton. 1829 - 1896 Portrait, figure & historical subjects etc. Exh: RA, BI, GG, NG, NWS, London & Prov. AG's, Italy Australia	*John Everett Millais* 18 73

MILLAIS John Guille b. Horsham. 1865 - 1931 Birds & animal subjects Exh: London & Prov. AG's	*[signature: JGM]*
MILLER Clive Beverly b. Bexley. 1938 - Painter in oil media Exh: London & Prov. AG's	*[signature: Miller.]*
MILLER. ARSA, RSA, RSW. John b. Glasgow. 1911 - Landscape artist Exh: R,Scot.A., SSA, RSW, etc.	*[signature: John Miller]*
MILLET Francois	see **MILE** Francois
MILLET Jean Francois b. France. 1814 - 1875 Portraits, genre & landscape artist Exh: International AG's	*[signatures: J.F Millet / F.Millet / J.F.Millet / F Millet / J.F.Millet / J.F.Millet]*
MILLICHIP. ATC.(London) Paul b. Harrow. 1929 - Painter in oil media Exh: RBA, London & Prov. AG's	*[signature: Millichip]*

MILLIGAN **Frances Jane Grierson** b. 1919 - B/white, oil & watercolourist Exh: RA, RBA, RSA, Prov. AG's	Frances J.G. Milligan.
MILLNER **William Edward** b. 1849 - 1895 Genre & animal subjects Exh: RA, SS, BI, London AG's etc.	WM
MILLS **David** b. Colchester. 1947 - Subtle kinetics, abstract subjects etc. Exh: London & Prov. AG's	David Mills D.M.
MILNER **Donald Ewart** b. Huddersfield. 1898 - Landscapes - oil, watercolour etc. Exh: RA, NEAC, RWA & Próv. AG's	D. E. Milner
MINDERHOUT **Hendrich Van** b. Rotterdam. 1632 - 1696 Marine & landscape artist Exh: Germany, Holland, Belgium, France, Spain	H.V. Minderhout
MINERS **Neil** b. Redruth. 1931 - Marine & landscape artist Exh: London & Prov. AG's, X UK	NEIL
MINGUET **Andre Joseph** b. Antwerp. 1818 - 1860 Architectural & still life subjects Exh: Belgium	A. Minguet
MIRO **Joan** b. Spain. 1893 - Cubist, surrealist artist Exh: Paris, New York, Spain etc.	Joan Miró. Miró
MIROU **Antoine** b. 1588 ? - 1661 ? Landscape artist Exh: European AG's, Russia	A M
MITCHELL **John Campbell** b. Campbeltown. 1862 - 1922 Landscape artist Exh: UK AG's, Germany	J.M.

MITCHELL **Leonard Victor** b. New Zealand Portrait, figure, still life & landscape artist Exh: RA, PS, UK & European AG's N. Zealand, Australia etc.	*Leonard V. Mitchell* *L.V.M*
MITELLI **Giuseppe Maria** b. Bologna. 1634 - 1718 Biblical & historical subjects	*GMF* *GM_M*
MOBERLY. MRI, NSA, BWS **Mariquita Jenny** b. Deptford, Kent. 1855 - ? Portrait, figure, still life, animal & landscape artist Exh: RA, RWA, RHA, RI, ROI, London & Prov. AG's S. Africa, S. America, US. etc.	*Moberly* *M*
MOCETTO **Girolamo** b. Verona. 1458 ? 1531 ? Portraits, religious & historical scenes Exh: UK, France, Italy	*HER°M*
MODIGLIANI **Amedeo** b. Italy. 1884 - 1920 Portraits, figure & genre subjects Exh: US, UK, France, Switzerland etc.	*modigliani*
MOHEDANO **Antonio** b. Lucena. 1560 - 1625 Religious subjects	*A. Mohedano 1620*
MOIRA, VP, RWS **Gerald Edward** b. London. 1867 - 1959 Mural, figure & landscape artist Exh: RA, London & Prov. AG's	*GM* *GM*
MOL **Pieter Van** b. Antwerp. 1599 - 1650 Portraits & religious subjects Exh: France, Germany, Holland	*MPL 1615* *MPL*
MOLENAER **Cornelis** b. Antwerp. 1540? 1589? Landscape & genre subjects Exh: France , Berlin, Moscow, Geneva, Madrid	*CM*
MOLENAER **Jan Miense** b. Haarlem. 1610 ? 1668 Rustic genre & landscape artist Exh: European AG's	*Molenaer* *Molenaer J M: Molenaer*

MOLENAER Jan Miense (Continued)	*F. Moleaer* *JM.olenaer*
MOLENAER Nicolaes (or Klaes) b. Haarlem. 1630 ?- 1676 Genre, winter scenes, landscapes etc. Exh. Russia & European AG's	*N Molenaar 1650* *A. molenaer*
MOLIN Carl Hjalmar Valentin b. Stockholm. 1868 - ? Etcher & Painter Exh: Italy, Stockholm, Holland Germany, US, etc.	*Hj Molin*
MOLS Robert Charles Gustave Laurens b. Antwerp. 1848 - 1903 Marine, still life, architectural & landscape artist Exh: Holland, France, Austria, etc.	*Robert Mols*
MOLYN Petrus Marius b. Rotterdam. 1819 - 1849 Genre subjects Exh: Holland	*P MM*
MOLYN (The Elder) Pieter b. London 1595 - 1661 Genre & landscape subjects Exh: Holland, France, Germany	*Molyn 1653.* *Molyn* M PM PM
MOLYN (The Younger) Pieter b. Haarlem. 1632 - 1701 Animals, storm & hunting scenes	*P Molyn* *P Molyn 1690*
MOMAL Jacques Francois b. Belgium. 1754 - 1832 Historical & portrait artist Exh: France	*I F Momal.*
MOMPER Frans De b. Antwerp. 1603 - 1660 Landscape artist Exh: Holland, France, Germany, Scandinavia, etc.	*f: momper. f d momper*
MOMPER Jodocus b. Antwerp. 1564 - 1635 Landscape artist Exh: Holland, France, Germany	*M:* *1618.*

MONDZAIN **Simon Francois Stanislas** b. Poland. 1890 - 1914 Landscape subjects & illustrator Exh: France	*Mondzain Mondzain*
MONET **Claude** b. Paris. 1840 - 1926 Composition, figure, still life & landscape etc. Exh: International AG's	*Claude - Monet* *Claude Monet 74. Claude Monet* *Claude Monet*
MONGIN **Antoine Pierre** b. Paris. 1761 ? - 1827 Battle scenes, animals & landscape subjects Exh: France	*Mongin f*
MONGINOT **Charles** b. France. 1825 - 1900 Still life, animal portraits & genre subjects Exh: France, Holland, Germany	*C. Monginot*
MONI **Louis De** b. Breda. 1698 - 1771 Genre subjects Exh: France, Belgium, Austria	*L: De Moni*
MONKMAN **Percy** b. Bradford. 1892 - Gouache, oil & watercolour media Exh: RBA, RI, London & Prov. AG's	*Monkman.*
MONNAIE. FIAL **Margaret Arnold** b. Maidenhead. 1890 - Crayon, oil & watercolourist Exh: RI, London & Prov. AG's	*M. A. Monnaie Monnaie*
MONNOYER **Jean Baptiste** b. Lille. 1636 - 1699 Floral subjects Exh: European AG's	*J: Baptiste J. Baptiste monn oyer* *J. Baptiste*
MONSIAUX **Nicolas Andre** b. Paris, 1754 - 1837 Historical subjects Exh: France	*Monsiau*

MONTAGNE **Agricol Louis** b. Avignon. 1879 - 1960 Genre & landscape subjects Exh: France	
MONTALBA. RWS **Clara** b. Cheltenham 1842 - 1929 Interiors, landscape & marine artist Exh: RA, OWS, BI, SS, NG, GG, etc.	
MONTANE **Roger** b. Bordeaux. 1916 - Painter in oil media Exh: France, US	
MONTEFIORE **Edward Levy** b. Barbados. 1820 -1894 Landscape artist Exh: VA, London & Prov. AG's, Paris, Australia	
MONTEN **Heinrich Maria Dietrich** b. Dusseldorf. 1799 - 1843 Battle scenes, historical & genre subjects Exh: Germany	
MONTENARD **Frederic** b. Paris. 1849 - 1926 Marine, genre & landscape subjects Exh: France, Australia	
MONTEZIN **Pierre Eugene** b. Paris. 1874 - 1946 Landscape artist Exh: France, Germany	
MONTICELLI **Adolphe Joseph Thomas** b. Marseille. 1824 - 1886 Composition, genre, still life & portrait artist Exh: France, Britain, Germany, US, Holland	
MONTMORENCY **Miles Fletcher De** b. Wallington. 1893 - Oil, Pastel & watercolourist Exh: RA, IS, PS, Italy, etc.	
MONVOISIN **Pierre Raymond Jacques** b. Bordeaux. 1794 - 1870 Historical & portrait artist Exh: France	

MOODY **Fanny** b. London. 1861 - ? Animal subjects Exh: RA, SS, BI, etc.	*F M*
MOONY. RBA, Mem.NSA. etc. **Robert James Enraght** b. Ireland. 1879 - ? Tempera, oil & watercolourist Exh: RA, RI, RBA, NEAC, RWA, RBSA, U S. etc.	
MOOR **Carel De** b. Holland. 1656 - 1738 Genre & portrait subjects Exh: France, Holland, Leningrad, Sweden	*C. De. Moor* *C D. M* *CDMOOR* *A° 1692* *C de Moor: 1715*
MOORE. ARWS **Albert Joseph** b. York. 1841 - 1893 Classical figure subjects Exh: RA, OWS, SS, NG, GG, London & Prov. AG's	
MOORE, RA, RWS **Henry** b. York. 1831 - 1895 Marine & landscape artist Exh: RA, SS, BI, GG, VA, UK AG's	
MOR **Antonis** b. Utrecht. 1519 - 1578 ? Portraits & historical subjects Exh: Russia, UK & European AG's	*Antony Mor.* *Antonius Mor fac^{at}* *f. 1545* *1549*
MORBELLI **Angelo** b. Italy. 1853 - 1919 Genre & landscape artist Exh: Italy	MORBELLI
MORDT **Gustav Adolph** b. Oslo. 1826 - 1856 Landscape artist Exh: Oslo, Stockholm	**C Mordt**
MORDUE, RMS, SWA **Truda** b. Hursley, Hants. 1909 - Watercolour, pastel artist & miniaturist Exh: RA, RI, FBA, RWS etc. X	

MOREAU Gustave b. Paris. 1826 - 1898 Mythological & historical subjects Exh: France	*Gustave-Moreau-*
MOREAU Jean Michel b. Paris. 1741 - 1814 Portrait & genre artist Exh: France	*J.M. moreau le jeune*
MOREAU Luc Albert b. Paris. 1882 - 1948 Genre & still life subjects etc. Exh: France, Germany, US	*Luc Albert Moreau*
MOREAU DE TOURS Georges b. France. 1848 - 1901 Portrait, military & genre subjects Exh: France	*MOREAU de TOURS*
MOREAU-NELATON Adolphe Etienne Auguste b. Paris 1859 - 1927 Landscape artist Exh: France, Germany	*E Moreau-Nelaton*
MOREELSE Paulus b. Utrecht. 1571 - 1638 Portrait, genre & historical subjects Exh: Holland, Germany, Belgium	*Moreelse More: fe: A° 1615* *P. moreelse 1630 1638 M PM M PM*
MOREL-FATIO Antonie Leon b. Rouen. 1810 - 1877 Marine subjects Exh: PS, France, Bucharest	*MOREL-FATIO*
MORGAN Alfred Fl. 1862 - 1902 Floral, genre, animal & landscape subjects Exh: RA, BI, SS, VA	*AM DA*
MORGAN Evelyn De b. 1855 - 1919 Pre-raphaelite artist Exh: GG, NG, London & Prov. AG's	(monogram)

MORGAN. ROI **Frederick** b. 1856 - 1927 Portraits, children, domestic & animal subjects Exh: RA, SS, BI, GG, NWS, etc.	*F.M.*
MORGAN **Robert** · b. Wales. 1921 - Graphic design & industrial landscapes Exh: London & Prov. AG's	*R.Morgan* *R.M.*
MORIN **Edmond** b. France. 1824 - 1882 Portrait & landscape artist Exh: France	*ED.MORIN*
MORISOT **Berthe Marie Pauline** b. France. 1841 - 1895 Portrait, genre & landscape subjects Exh: France, NG, US, Scandinavia	*Berthe Morisot*
MORISSET **Francois Henri E.** b. Paris. 1870 - ? Portrait, still life & landscape subjects Exh: France	*H.MORISSET*
MORLAND **George** b. Landon. 1763 - 1804 Marine, landscape & genre subjects Exh: NG, NPG, VA, UK, Paris	*G. Morland. pinx 1792* *G Morland 1792*
MORLEY **Harry** b. Leicester. 1881 - 1943 Figure & landscape artist Exh: RA, London & Prov. AG's	*H.M.*
MORLEY. RBA **Robert** b. 1857 - 1941 Animal, genre, landscape & historical subjects Exh: RA, SS, London & Prov. AG's	*RM*
MORLON **Paul Emile Antony** Fl. France. 19th - 20th C. Genre, marine, portrait & landscape artist Exh: French AG's	*A.Morlon*
MOROT **Aime Nicolas** b. Nancy. 1850 - 1913 Battle scenes, historical & portrait artist Exh: French AG's	*AIME MOROT*

MORRIS **J.C.** Fl. 1851 - 1861 Genre, animals & landscape artist Exh: London & Prov. AG's	
MORRIS. ARMS **Margaret** b. Lisbon. 1891 - Miniaturist Exh: RA, RMS, etc.	
MORRIS. RA **Philip Richard** b. Davonport. 1836 - 1902 Portraits, biblical, genre & historical subjects Exh: RA, London & Provs AG's, Australia	
MORRIS **William Bright** b. Salford. 1834 - ? Portrait, genre & landscape artist Exh: RA, ROI, Prov. AG's	
MORSS. ARCA **Edward James** b. Devon. 1906 - Painter in oil media Exh: London & Prov. AG's	
MORTEL **Jan** b. Holland. 1650 ? - 1719 Floral & genre subjects Exh: Holland, Stockholm	
MORTIMER. ARA **John Hamilton** b. Eastbourne. 1741 - 1779 Historical & portrait artist Exh: VA, NPG, London & Prov. AG's	
MOSSCHER **Jacob De** Fl. Holland. 16th - 17th C. Landscape artist Exh: Germany, Copenhagen	
MOSTAERT (The Elder) **Gillis** b. Holland. 1534 ? - 1598 Landscape artist Exh: Belgium, France, Austria, Scandinavia, etc.	
MOTTEZ **Victor Louis** b. Lille. 1809 - 1897 Historical & portrait artist Exh: France	

MOTTRAM. RBA **Charles Sim** Fl. London. 19th – 20th C. Coastal & marine artist Exh: RA, NWS, SS, London & Prov. AG's etc.	*C.S.M.*
MOUCHERON **Frederic De** b. Holland 1633 - 1686 Landscape artist Exh: France, Belgium, Holland, Germany, UK	*F. Moucheron fecit 1680* *Moucheron ft* *M.F*
MOUCHERON **Isaac De** b. Amsterdam. 1667 - 1744 Landscape artist Exh: France, Holland, Dublin, Moscow	*I. Moucheron* *I.d. Moucheron*
MOUCHET **Francois Nicolas** b. 1750 - 1814 Portrait , genre artist & miniaturist Exh: France	*Mouchet*
MOULES. RSW **George Frederick** b. 1918 - Watercolourist Exh: RA, RSA, WAG, GI, RBA, RSW etc.	*Moules*
MOULIGNON **Henri Antoine Leopold De** b. France. 1821 - 1897 Genre & portrait artist Exh: France	*Leopold de Moulignon*
MOUTTE **Jean Joseph Marie Alphonse** b. Marseille. 1840 - 1913 Genre & portrait artist Exh: France	*Alph^e Moutte*
MOYANO **Louis A** b. Liege. 1907 - Painter & engraver Exh: Belgium, France, etc.	*Moyano* *LM.*
MOZART **Anton** b. Germany. 1573 - 1625 Portrait, miniature & landscape subjects Exh: Germany, Switzerland	*AM*
MOZIN **Charles Louis** b. Paris. 1806 - 1862 Marine & landscape subjects Exh: France	*C. Mozin*

MUCHA **Alphonse** b. Czechoslovakia. 1860 - 1939 Genre subjects Exh: France	*Mucha*
MUCKLEY **Louis Fairfax** b. Stourbridge. Fl. 1890 - 1902 Genre subjects Exh: London & Prov. AG's	L\|F
MUENIER **Jules Alexis** b. France. 1863 - 1869 Genre subjects Exh: France	J·A·MUENIER
MULICH **Hans** b. Munich. 1515 - 1573 Portraits, historical subjects & miniaturist Exh: Germany	1540 HW
MULLER **Charles Louis Lucien** b. Paris. 1815 - 1892 Historical, portrait & genre subjects Exh: France, Germany, UK	C,L.MÜLLER.
MULLER **Morten** b. Norway. 1828 - 1911 Landscape artist Exh: Scandinavia, Germany	Morten Müller 55
MULLER **William James** b. Bristol. 1812 - 1845 Venetian & mid-Eastern scenes Exh: VA, UK & European AG's, Canada	WM WM WM.1841
MULREADY. RA **William** b. Ireland. 1786 - 1863 Portraits, genre , architectural, historical & landscape artist Exh: RA, BI, SA, NPG, VA, Prov. AG's, France	W Mulready 1803
MULRENIN, RHA **Bernard** b. Sligo. 1803 - 1868 Portrait & miniaturist Exh: RHA, NPG, UK AG's	B.M.
MUNIER **Emile** b. Paris. 1810 - ? Genre, portrait & landscape artist Exh: France	E.MUNIER

MUNNINGS, PRA, RSW **Sir Alfred James** b. 1878 - 1959 Horses & landscape, oil & watercolourist Exh: RA, RI, UK & European AG's	*a.J.M. AJm. AJM*
MUNNS. NSA, ASWA **Una Elaine** b. Warwickshire. 1900 - Portrait artist Exh: WAG, N. Zealand	*W*
MUNOZ **Sebastian** Fl. Spain. 1634 ? - 1709 Genre, portrait & landscape artist Exh: Spain	*Munoz*
MUNTHE **Ludvig** b. Norway. 1841 - 1896 Landscape artist Exh: Scandinavia, Germany, France, UK, etc.	*L.Munthe L.Munthe*
MUNZER **Adolf** b. Germany. 1870 - ? Landscape artist Exh: Germany	*Ad.Münzer.06.*
MURANT **Emanuel** b. Amsterdam. 1622 - 1700 ? Landscape artist Exh: Germany, Holland, US, UK	*E.M.*
MURILLO **Bartolome Esteban** b. Spain. 1617 ? - 1682 Religious, genre & portrait artist Exh: International AG's	*Murillo f Hispan Murillo f Hispan* *B.n Murillo f* *Bn.M Hisp.* BART°MVRI LLO en sevilla año 1670 *B̃MB* *BME*

MURRAY. MA, FRGS, FSA **Alexander Henry Hallam** b. London. 1854 - ? Architectural & landscape artist Exh: RA, London & Prov. AG's	*AA*
MURRAY **Charles Fairfax** b. 1849 - 1919 Genre, figure & landscape artist Exh: RA, GG, Prov. AG's	*CFM* *1870 CFM*
MURRAY. RA, HRSA, RSW **Sir David** b. Glasgow. 1849 - 1933 Landscape & marine artist Exh: RA, NWS, OWS, RSA, GG, Prov. AG's, Australia	*VM*
MURRAY. ARCA **William Grant** b. Portsoy. 1877 - 1950 Oil & watercolourist Exh: London & Prov. AG's	
MUSPRATT **Alicia Frances** b. Lancashire Exh: RA, PS, ROI, RBA, SWA, RP etc.	*Alicia F. Muspratt.*
MUSSCHER **Michael Van** b. Rotterdam. 1645 - 1705 Portraits, historical, town views & genre subjects Exh: Holland, Italy, Hungary, Germany, UK etc.	*M. V. Musscher 1690*
MUSZYNSKI. RBA, DA **Leszek Tadeusz** b. Poland. 1923 - Painter in oil media Exh: London & Prov. AG's	*L.T. Muszynski*
MUTER **Marie Mela** b. Warsaw. 1886 - Portraits, still life & landscape artist Exh: France, US, Spain, UK	*Muter*
MUTRIE **Annie Feray** b. Ardwick. 1826 - 1893 Floral & still life subjects Exh: RA, BI, VA	*AFM AFM*
MUTRIE **Martha Darlay** b. Manchester. 1824 - 1885 Fruit & floral subjects Exh: RA, VA, US, Australia	*M.D.M 1872*

MUYS **Nicolaes** b. Rotterdam. 1740 - 1808 Portrait & genre subjects Exh: Holland, Belgium	*N: Muys P:*
MY **Hieronymus Van Der** b. Holland. 1687 - 1761 Portrait artist Exh: Holland	*H Vand Mÿ fec* *H Vand My fec.*
MYN **Frans Van Der** b. Holland. 1719 - 1783 Portrait & genre subjects Exh: Holland, Belgium, Germany	*F Vander Mÿn*
MYN **Herman Van Der** b. Amsterdam. 1684 - 1741 ? Portrait, historical & floral subjects Exh: Germany, France, Moscow, Italy	*H Vander Myn*
MYNOTT. RBA **Derek G.** b. London. 1926 - Oil & watercolourist Exh: RA, RBA, US, Prov. AG's	*M*
MYNOTT **John Burnell** b. London. 1931 - Abstract subjects Exh: SAS & Prov. AG's	*mynott*
MYTENS **Jan** b. The Hague. 1614 - 1670 Portrait artist Exh: Holland, Germany, France, UK	*J Mijtens*

N

NAFTEL, RWS **Paul Jacob** b. Chanvel. 1817 - 1891 Landscape artist Exh: RWS, GG, VA, Prov. AG's	*PN*
NAIGEON **Jean Claude** b. Dijon. 1753 - 1832 Genre & portrait artist Exh: France	*Naigeon*

NALECZ **Halima** b. Poland Painter in oil media Exh: French & UK AG's	
NANTEUL-LEBŒUF **Celestin Francois** b. Rome. 1813 - 1873 Genre subjects - illustrator Exh: France	
NAPIER. RSW **Charles Goddard** b. Edinburgh. 1889 - Artist in B/white & watercolour media Exh: RSA, RSW, SSA, GI, US etc.	
NARBONNE **Eugene** b. France. 1885 - Portraits & landscape artist Exh: France, Holland, Germany	
NARDI **Angelo** b. Italy. 1584 - 1665 Genre & portrait artist Exh: Spain	
NARRAWAY **William Edward** b. London. 1915 - Portrait, genre & landscape artist Exh: RA, LG, RBA, NEAC, RP SPS, PS etc.	
NASH **Joseph** b. Marlow. 1808 - 1878 Interiors & architectural subjects Exh: RA, BI, NWS, OWS, PS, RWS etc	
NASH **Paul** b. Kent. 1889 - 1946 Landscape artist Exh: London & Prov. AG's, France	
NATHE **Christoph** b. Germany. 1753 - 1808 Portraits & landscape artist Exh: Germany	
NATOIRE **Charles Joseph** b. Nimes. 1700 - 1777 Portraits, historical & mythological subjects Exh: France, Italy, Sweden	

NATOIRE Charles Joseph (Continued)	*n.p.* *CNatoire*
NATTIER Jean Marc b. Paris. 1685 - 1766 Historical & portrait artist Exh: France, Russia, US, UK	*M Nattier* *Nattier Pinxit 1748* *Nattier pinxit. 1749.* *M Nattier*
NAUDET Thomas Charles b. Paris. 1778 - 1810 Landscape subjects Exh: France	
NAUDIN Bernard b. France. 1876 - 1940 Military & genre subjects Exh: France	*naudin*
NAUMANN Friedrich Gotthard b. Germany. 1750 - 1821 Portraits & historical subjects Exh: Germany, Hungary	*F Naumann.*
NAVEZ Francois Joseph b. Belgium. 1787 - 1869 Religious, historical & portrait artist Exh: Belgium, Holland, Germany	*FJNavez*
NEATBY. ABCA. RMS Edward Mossforth b. Leeds. 1888 - 1949 Portrait & landscape artist Exh: RA, RI, RP, IS, RBA, London & Prov. AG's	*Edward Neatby*
NEATBY William James b. Barnsley. 1860 - 1910 Architectural & decorative artist Exh: WAG, London & Prov. AG's	*WN*
NEBOT Balthasar Fl. London 18th C. Portrait & scenic subjects Exh: London AG's	*B Nebot. F.*

NECK **Jan Van** b. Naarden. 1635 - 1714 Portraits, mythological & historical subjects Exh: Holland, France, Russia etc.	*J V. Neck '701*
NEEFFS (or NEFS) The Elder **Pieter** b. Antwerp. 1578 ? - 1656 ? Church interiors & architectural subjects Exh: France, Holland, UK, Germany	*PETRVS NEFS 1633* *PEETER NEEFFS* *Deteer neefs*
NEEFFS (The Younger) **Pieter** b. Holland. 1620 - 1676 ? Church interiors Exh: Germany, Hungary, France, Austria etc.	*PEETER NEEffs*
NEER **Aart Van Der** b. Amsterdam. 1603 - 1677 Moonlight scenes & winter landscapes Exh: European & UK AG's	*AADeez. f* *ADI* *ADI.f* *ADI* *XX N* *XX ▽* *XX DI*
NEER **Eglon Hendrick Van Der** b. Amsterdam. 1634 - 1703 Portraits, genre, interiors & landscape artist Exh: European & UK AG's	*E.H van der Neer*
NEGRE **Nicolas Claes Van** b. ? - 1664 ? Portrait artist	*N Dan negre*
NEGRI **Pier Martire** b. Italy. 1601 ? - 1661 Historical & portrait artist Exh: Italy	*P M.*
NEILLOT **Louis** b. Vichy. 1898 - Landscape artist & illustrator Exh: France	**L NEILLOT**

NELLIUS **Martinus N** Fl. Holland. 1670 - 1706 Still life subjects Exh: Holland, Belgium, Leningrad	*[signature]*
NERENZ **Wilhelm** b. Berlin. 1804 - 1871 Historical & genre subjects Exh: Germany	*[monogram]*
NERLY **Friedrich** b. Germany. 1807 - 1878 Genre subjects Exh: Germany, Copenhagen	*[monogram]*
NETHERWOOD (NEE DYAS) ARCM **Edith MARY** b. Stockport Landscape artist Exh: R.Cam.A, ROI, RWA, WAG, RBSA	*E.M.Dyas.*
NETSCHER **Constantyn** b. The Hague. 1668 ? - 1723 Portrait & genre subjects Exh: Holland, France, UK	*C Netscher* *[monogram CN]* *Const.s Netscher:* *[monogram CN]*
NETSCHER **Gaspar** b. Heidelberg. 1639 - 1684 Interiors, genre & portrait artist Exh: France, Holland, Germany, UK	*G Netscher 1680* *C NETSCHER* *G Netscher A°1663* *C·N 1679*
NETSCHER **Theodore** b. Bordeaux. 1661 - 1732 Portraits & still life subjects	*T. Netscher 1719*
NETTI **Francesco** b. Italy. 1834 - 1894 Historical & genre subjects Exh: Italy	*Netti*

NETTLESHIP **John Trivett** b. Kettering. 1847 - 1902 Genre & animal subjects Exh; RA, SS, GG, NWS, NG etc.	*J.T.N.*
NEUHAUS **Fritz Berthold** b. Dusseldorf. 1882 - Landscape & animal subjects	*F.B.Neuhaus Sarajevo. 1917.*
NEUHUYS **Jan Antoon** b. Haarlem. 1832 - 1891 Genre & figure subjects Exh: Holland	*J.A.Neuhuys*
NEUMAN **Jan Hendrick** b. Cologne. 1819 - 1898 Portrait artist Exh: Amsterdam	*JH.Neuman*
NEUVILLE **Alphonse Marie De** b. France. 1835 - 1885 Battle scenes & genre subjects Exh: France, New York	*A De Neuville*
NEVEU (or NAIVEU) **Mathys** b. Leyden. 1647 - 1721 Portraits, interiors, genre & still life subjects Exh: Holland, Germany, Hungary, Switzerland, France etc.	*M.Naiveu*　　*M.Neveu 1703*
NEWCOMBE **William** b. Victoria, B.C. 1907 - Oil, watercolour & other media Exh: Europe, Canada, US, UK	*NEWCOMBE*
NEWTON **Algernon** b. London. 1880 - Town & landscape subjects . Exh: US, S. Africa, Australia, UK	*AD*　　*AD*
NEWTON. RI **John Edward** b. England. Fl. 19th C. Still life & landscape artist Exh: RA, SS, BI, NWS, London & Prov. AG's	*N*
NICHOLSON **Sir William** b. Newark. 1872 - Portraits, still life & genre subjects Exh: France, US, Italy, Argentine, UK	*(N.)*　　*.N.*

NICOL. RSA, ARA **Erskine** b. Leith. 1825 - 1904 Genre artist Exh: RA, BI, RSA, London & Prov. AG's	*NE*
NICOLIE **Paul Emile** b. Antwerp. 1828 - 1894 Genre subjects Exh: Holland	*Paul Emile Nicolie*
NICOLSON. ARE, RSW **John** b. London. 1891 - 1951 Painter & etcher Exh: RA, RP, France, Italy, etc.	*Nicolson*
NICOTERA **Marco Antonio** Fl. Naples. 1590 - 1600 Religious subjects Exh: Naples	*NN pe*
NIELSEN **Amaldus Clarin** b. Norway. 1838 - ? Landscape subjects Exh: Oslo	*Amaldus Nielsen*
NIEMANN **Edmund John** b. London. 1813 - 1876 Marine & landscape, oil & watercolourist Exh: RA, VA, London & Prov. AG's	*EJN 1837* *EJN*
NIEULANT (or NIEULANDT) **Willem Van** b. Antwerp. 1582 ? - 1635 ? Markets, town & landscape subjects Exh: Holland, France, Hungary, Austria	*GVIL MG VAN NIEVLANT*
NIGG **Joseph** b. Vienna. 1782 - 1863 Floral subjects Exh: Vienna, Russia	*Jos: Nigg*
NIKOS b. Valonica. 1930 - Painter in various media Exh: X	*NIKOS*
NISBET **M.H.** b. UK. Fl. 20th C. Genre & imaginative subjects Exh: London & Prov. AG's	*MHN*

NITTIS **Giuseppe de** b. Italy. 1846 - 1884 Genre subjects Exh: France	*De Nittis* *De Nittis* *De Nittis*
NIVINSKI **Iganti Ignatievitch** b. Moscow. 1881 - Oil & watercolourist	:WH: 1918
NOAKES. P.ROI, RP, Mem.NS, GOV, **FOBA, CPS, NDD** **Michael** b. Brighton. 1933 - Portraits & Landscape artist Exh: RA,ROI,RBA,RSMA,RP,NS,YC, CPS,RGI, London & Provs. AG's, US Canada etc.	Michael Noakes MICHAEL NOAKES 1954
NOBEL **John Sargeant** b. 1848 - 1896 Animal & sporting subjects Exh: RA, SS, UK AG's	J. S. Nobls
NOBLE. FZS **John Edwin** b. London. 1876 - ? Watercolourist — animal subjects Exh: RA, RSA, RI, RBA etc.	EDWIN NOBLE
NOBLE **John Rushton** b. Gateshead. 1927 - Painter & illustrator etc. Exh: RBA, RI, London & Prov. AG's Europe, US, etc.	John Noble 1957
NOE **Viscomte Amedee Charles Henri De** b. L'Isle De Noe. 1819 - 1879 Caricatures, genre subects etc.	noe 8.
NOEL **Alexis Nicolas** b. France. 1792 - 1871 Historical & landscape artist Exh: France	Noël
NOEL **Jules Achille** b. France. 1815 - 1881 Marine & landscape artist Exh: France	JULES NOEL
NOLLEKENS **Joseph Frans** b. Antwerp. 1702 - 1748 Portrait, genre & landscape artist Exh: Switzerland	J: Nol S. F I nols

NOLLI Carlo b. Italy. ? - 1770 Painter & engraver Exh: Italy	
NOLPE Pieter b. Amserdam. 1613 ? - 1652 Landscape artist Exh: Switzerland, Holland, Germany	
NONNOTTE Donat b. Besancon. 1708 - 1785 Historical & portrait artist Exh: France	
NONO Luigi b. Italy. 1850 — 1918 Historical & genre subjects Exh: Italy, S. America, Germany	
NOOMS Renier	see **ZEEMAN** Renier
NOORT Adam Van b. Antwerp. 1562 - 1641 Portraits, genre & historical subjects Exh: Belgium, France, Austria, etc.	
NOORT Lambert Van b. Holland. 1520 ? —1571 Religious subjects Exh: Belgium	
NOOY Wouterus De b. Holland. 1765 — 1820 Genre & landscape subjects Exh: Holland	
NORDENBERG Bengt b. Sweden. 1822 — 1902 Landscape & genre subjects Exh: Germany, Sweden	
NORFIELD Edgar George b. UK Oil & watercolourist Exh: RI, London & Prov. AG's	

NORMANN (or NORMAND) **Adelsteen** b. Norway. 1848 - 1918 Landscape artist Exh: France, Germany, Sweden, UK, etc.	*A. Normann*
NORRIS. ARCA **William** b. Gloucester. 1857 - ? Modern scriptoral subjects etc. Exh: RA, & Prov. AG's	*Wm Norris.*
NORTH. ARA, RWS **John William** b. London. 1842 - 1924 Genre & landscape artist Exh: RA, OWS, NG, GG, London AG's etc.	NW
NORTHCOTE **James** b. Plymouth. 1746 - 1831 Portraits & historical subjects Exh: RA, NPG, VA, London & Prov. AG's, Italy, Holland	*James Northcote*
NORTON **Peter John** b. Hampshire. 1913 - Landscapes, interiors & figurative subjects Exh: S. Africa, Egypt, France, London & Prov. AG's etc.	*Peter Norton* *P.N.*
NORTON. ARCA **Wilfred** b. Salop. 1880 - ? Exh: RA, London & Prov. AG's, France, Germany, US.	*W*
NOTER **Pierre Francois** b. Belgium. 1779 - 1843 Landscape subjects etc. Exh: Holland, Belgium	*P. F. D. N.*
NOTERMAN **Emmanuel** b. Belgium. 1808 - 1863 Portraits & genre subjects Exh: Holland, Belgium, Montreal, Moscow	*E. N.* *H*
NOTHNAGEL **Johann Andreas Benjamin** b. Germany. 1729 - 1804 Genre & landscape artist Exh: Germany	*N*
NOWELL **Arthur Trevethin** b. Garndiffel. 1862 - 1940 Domestic genre Exh: PS, London & Prov. AG's	*ATN*

NOWLAN. RMS Carlotta b. London. ? - 1929 Flowers, animals & portrait miniaturist Exh: RA, RMS, X.	
NOYER Philippe Henri b. Lyon. 1917 - Portraits & landscape artist Exh: Paris, New York	
NOZAL Alexandre b. Paris. 1852 - 1929 Landscape artist Exh: France, Australia	
NUR. MA A.S. Ali b. Egypt. 1906 - Painter, etcher, cartoonist Exh: Egypt, Italy, Stockholm, London	
NYMEGEN Dionys Van b. Rotterdam. 1705 - 1789 Portrait, historical, floral & landscape subjects Exh: Holland	
NYMEGEN Gerard Van b. Rotterdam. 1735 - 1808 Landscape & portrait artist	
NYPOORT Justus Van Den b. Utrecht. 1625 ? - 1692 ? Genre subjects Exh: Holland, Russia	

OAKES, ARA, RSA John Wright b. Cheshire. 1820 - 1887 Landscape artist Exh: RA, BI, VA, UK AG's	
O'BRIEN. PRHA, HRA, HRSA, DL William Dermod b. Co. Limerick. 1865 - ? Portraits, animals & landscape artist Exh: RA, RHA, RSA, London & Prov. AG's	

OCKENDON. ATD **Kathleen Ursula** b. London. 1913 - Watercolourist Exh: RA, London & Prov. AG's	(ŒK: 1953)
O'CONNOR **James Arthur** b. Dublin. 1792 - 1841 Landscape artist Exh: RA, SS, VA, London & Prov. AG's, France, Ireland	JAO.C 1836
O'CONNOR, RHA **John Scorrer** b. 1913 - Landscape artist Exh: UK AG's	
ODDI **Mauro** b. Parma. 1639 - 1702 Historical subjects	
OEFELE **Franciszek Ignacy** b. Poland. 1721 - 1797 Portrait artist Exh: Germany, Poland	
OESTERREICH **Mathias** b. Hamburg. 1716 - 1778 Painter & engraver	
OFFERMANS **Anthony Jacob** b. Holland. 1796 - 1839 ? Animal & landscape subjects Exh: Holland	
OFFICER. BA, MA, FRSA, ATD **David Adrian** b. Belfast Exh: RA, RI, France, S. Africa, Canada, Australia, US, etc.	adrian
OHL **Gabrielle** b. Madagascar. 1928 Black & white & oil media Exh: French AG's, UK, Belgium, Italy etc.	
OINONEN **Mikko Oskar** b. Finland. 1883 - Figure painter, landscapes etc. Exh: Scandinavia, Russia, Europe, UK, etc.	M. Oinonen

O

OKE **Henry Reginald** b. London. 1871 - ? Oil & watercolourist Exh: London & Prov. AG's	(HR)
OLIVER **Isaac** b. Rouen. 1556 ? - 1617 Portrait miniaturist Exh: Holland, UK	*J Oliver 1601*
OLIVER **John** b. London. 1616 - 1701 Portraits & religious subjects	*J Oliver* Ø
OLIVER **Peter** b. London. 1594 ? - 1647 Portrait miniaturist Exh: Holland, UK	*P. Oliver*
OLIVIE **Leon** b. France. 1833 - 1901 Portrait & genre subjects Exh: France	*Olivie*
OLLINGTON **Robin** b. London. 1929 - B/white & watercolourist etc. Exh: London & Prov. AG's	*Robin Ollington*
OMMEGANCK **Balthasar Paul** b. Antwerp. 1755 - 1826 Portrait, animal & landscape subjects Exh: Belgium, Holland, France, Germany	*BP Ommeganck 1807* *BP Ommeganck f:* *PB Ommeganck*
O'NEIL **Bernard** b. 1919 - Painter & sculptor Exh: RSA, SSA, Canada, London & Prov. AG's	O'NEIL
OOMS **Charles** b. Belgium. 1845 - 1900 Historical & genre subjects Exh: Belgium, Prague	*K Ooms*

OOST (The Elder) **Jacques Van** b. Bruges. 1601 - 1671 Portraits & historical subjects Exh: Holland, Germany, France, Russia, Austria, UK	*J Van oost*
OOSTERWICH (or OOSTERWIJK) **Maria Van** b. Nootdorp. 1630 - 1693 Flowers, fruit & still life subjects Exh: Germany, Italy, Austria, Holland, UK	*Maria Oosterwich f*
OPIE. RA **John** b. Nr. Truro. 1761 - 1807 Portraits, genre & historical subjects Exh: RA, BI, NG, NPG, London & Prov. AG's, US, France, Germany	*J. Opie 1801*
OPPENHEIMER **Sir Francis** b. London. 1870 - ? Painter & illustrator Exh: UK AG's	
OPPLER **Ernst** b. Hanover. 1867 - 1929 Portraits, genre, interiors & landscape artist Exh: Germany, Austria, UK	*Ernst Oppler*
OPSTAL (The Younger) **Gaspar Jacob Van** b. Antwerp. 1654 ? - 1717 Portraits & historical subjects Exh: Holland, Germany	*V. Opstal*
ORCHARDSON. RA **Sir William Quiller** b. Edinburgh. 1832 - 1910 Portraits & genre subjects Exh: RA, GG, NG, BI, London & Prov. AG's, Germany, Italy, Australia	*WQO*
ORIENT **Josef** b. Hungary. 1677 - 1747 Landscape & figure subjects Exh: Germany, Budapest, Vienna	*J. Orient. J. Orient.*
ORIOLO **Giovanni Da** b. ? - 1474 ? Portrait artist	*OPVS IOHÃNI ORIOLI +*
ORLEY **Jan Van** b. Belgium. 1665 - 1735 Portraits & historical subjects Exh: Belgium	*J.V.O.*

ORLEY **Richard Van** b. Brussels. 1663 - 1732 Historical & genre subjects Exh: Belgium, Prague	*R.V.O.*
ORMEROD, NS, SGA, SWE, AIAL, **FZS** **Stanley Horton** b. Morecombe, Lancs. 1918 - Wildlife subjects Exh: RCamA, MAFA, RE, SGA, NS, SWE, SWLA, London & Prov. AG's etc.	*Horton* *ORMEROD*
OROVIDA. RBA, WIAC **Camille Pissaro** b. Essex. 1893 - Etcher, painter in oil & tempera media Exh: RA, RBA, London & Prov. AG's US	*OROVIDA.* *OROVIDA*
ORPEN, RA, RWS, RHA **Sir William Newenham Montague** b. Stillorgan. 1878 - 1931 Genre & portrait artist Exh: NEAC, RA, UK AG's, Paris, US	*Orps* *orps*
OS **Jan Van** b. Holland 1744 - 1808 Marine, still life & floral subjects Exh: Holland, UK, Paris, Leningrad	*JVOs fecit* *J:Van Os. fe*
OS **Pieter Gerardus Van** b. The Hague. 1776 - 1839 Animals, landscapes & miniaturist Exh: Holland	*GJ.V.Of*
OSBORNE, RHA **William** b. Dublin. 1823 - 1901 Portrait & animal subjects Exh: UK AG's	*W*
OSOSKI. RBA **Gerald Judah** b. London. 1903 - 1981 Portraits, figures & landscapes etc. Exh: RA, RBA, NEAC, French & UK AG's	*GERALD OSOSKI.* *OSOSKI*
OSSENBECK **Jan Van** b. Rotterdam. 1624 ? - 1674 Genre & landscape subjects Exh: Germany, UK, France, Italy	*J. Ossenbeeck* *J.O.f*
OSSINGER **Michel** Fl. Germany. 16th C. Religious subjects	*M* *M*

OSTADE **Adriaen Van** b. Haarlam. 1610 - 1684 Village scenes, domestic interiors etc. Exh: International AG's	*A. Ostade 1648* *A. ostade* *A. ostade 1648.* *A Ostade* *A ostade 1647* *A⁰. A.O.* *A. Ostade. 1671* *AO* *AO.* *Nostade* *NO* *AO* *A v ostade* *AO* *NO* *NOstade 1672* *N* *A.o*
OSTADE **Isack Van** b. Haarlem. 1621 ? - 1649 ? Interiors, taverns, winter scenes & landscapes Exh: UK & European AG's etc.	*Isack. van Ostade* *J van ostade* *Ostade* *Isack van Ostade* *Isack ostade*
OSTENDORFER **Michael** b. Germany. 1490 ? - 1559 Historical & Portrait artist Exh: Germany, Hungary	MO 1543

OSTERHOUDT **Daniel Van** b. Tiel. 1786 - 1850 ? Landscape artist	D.V.O.
OSTERLIND **Anders** b. France. 1887 - 1960 Landscape artist Exh: France, Belgium, Holland	*And. Osterlind* *AO*
OSTERMAN **Bernhard** b. Sweden. 1870 - 1938 Portrait & genre subjects Exh: International AG's	*Bernhard Osterman*
OSWALD **Fritz** b. Zurich. 1878 - Landscape artist	*Fritz. Osswald.*
OTTINI **Felice** b. Italy. ? - 1697 Historical subjects	F. O. F.
OTTLEY **William Young** b. England. 1771 - 1836 Portrait artist Exh: RA, London & Prov. AG's	WYO W.Y.O WO
OUDENAERDE **Robert Van**	see **AUDENAERDE** **Robert Van**
OUDERRA **Pierre Jan Van Der** b. Antwerp. 1841 - 1915 Portraits & historical subjects Exh: Belgium, Holland	*P Van Der Ouderaa*
OUDOT **Roland** b. Paris, 1897 - Genre & landscape subjects & illustrator Exh: France, UK, US, Italy, Belgium	*Roland Oudot*
OUDRY **Jacques Charles** b. Paris. 1720 - 1778 Animal & floral subjects Exh: France	*J. C. Oudry*

OUDRY
Jean Baptiste
b. Paris. 1686 - 1755
Portraits, still life, animals, sporting
scenes & landscapes
Exh: UK, Russia & European AG's

OULESS. RA
Walter William
b. Jersey, C.I. 1848 - 1933
Portrait artist
Exh: RA, London & Prov. AG's, Italy

OURVANTZOFF
Miguel
b. St. Petersburg. 1897 -
Tempera, oil & watercolour media
Exh: Spain, US, S. America etc.

OUSEY
Harry
b. 1915 -
Ink, oil & watercolour media
Exh: London & Prov. AG's,
Australia etc.

OUTIN
Pierre
b. France. 1840 - 1899
Portrait & genre subjects
Exh: France

OUWATER
Isaak
b. Amsterdam. 1750 - 1793
Town scenes with figures
Exh: Holland, UK

OUWERKERK
Timotheus Wilhelmus
b. Holland. 1845 - 1910
Landscape artist
Exh: Holland

OVERBECK **Johann Friedrich** b. Germany. 1789 - 1869 Biblical & historical subjects Exh: Germany, Italy, Russia, Austria	
OZANNE **Pierre** b. Brest. 1737 - 1813 Marine artist Exh: France	
OZENFANT **Amedee** b. France. 1886 - 1966 Abstract & modern art Exh: France, London, New York	ozenfant. ozenfant P

PACHECO **Francisco** b. Spain. 1564 - 1654 Biblical & portrait artist Exh: Spain, France, Budapest	
PADER **Hilaire** b. Toulouse. 1607 - 1677 Religious & landscape subjects Exh: France	
PADGETT **William** b. England. 1851 - 1904 Landscape artist Exh: RA, GG, SS, NG, London & Prov. AG's	
PAGE. AIAL, LSIA **Albert Schiller** b. London. 1905 - Etcher & watercolourist Exh: RSA, RWS, London & Prov. AG's	
PAGE. Mem.SM **Patricia** b London. 1909 - Portrait miniaturist Exh. RWS, SM & London AG's etc.	
PAGET. RBA **Henry Marriott** b. England. 1856 - 1936 Portraits & historical subjects Exh: RA, GG, London & Prov. AG's	

PAGET Sidney E. b. 1861 - 1908 Portrait, genre & landscape artist Exh: RA, SS, UK AG's	*SP*
PAGET Walter Fl. London 19th C. Painter & illustrator	*WP WP*
PAGGI Giovanni Battista b. Genoa. 1554 - 1627 Religious subjects Exh: Italy	*BP*
PALAMEDES Anthonie b. Delft. 1601 - 1673 Portrait artist Exh: Holland, UK, US, France, Germany	*A. Palamedes APP. S*
PALIZZI Giuseppe b. Italy. 1812 ? - 1887 ? Landscape & animal subjects Exh: France, Bucharest	*G. Palizzi*
PALMA (IL GIOVANE) Jacopo b. Venice. 1544 - 1628 Biblical, mythological & historical subjects Exh: UK & European AG's	*JACOBVS PALMA -F.-* *Jacobus Palma fat* *Jacobus Palma f G. P. G P*
PALMER. RMS Eleanor Annie b. Bedford. 1867 - ? Watercolour portraits & miniatures Exh: RA, PS, London & Prov. AG's	*E. palmer*
PALMER Garrick b. Portsmouth. 1933 - Portrait, abstract & landscape artist Exh: US, European & UK AG's	*Garrick Palmer.*

PALMER, RWS **Samuel** b. Sainte-Marie Newington. 1805 - 1881 Landscape artist & watercolourist Exh: RA, BI, BM, VA, UK AG's	*(signature)* *(monogram $57)*
PALMER-JONES. FRIBA **William Jones** b. Huntingdon. 1887 - Pen, pencil & watercolourist Exh: RA, WAG, London AG's, France	*(signature: W.J. Palmer Jones.)*
PALTHE **Jan** b. Holland. 1719 - 1769 Portrait artist Exh: Holland	*I: PALTHE*
PANNETT **Juliet Kathleen** b. Hove. 1911 - Portrait & landscape artist Exh: RA, RP, RI	*(signature: Juliet Pannett.)*
PANNINI **Giovanni Paolo** b. Italy. 1691 - 1765 Architectural & landscape subjects Exh: France, UK, Germany, Italy	**I·P PANINI** *IB PANINI fecRoma*
PAPETY **Dominique Louis** b. Marseille. 1815 - 1849 Historical & genre subjects Exh: France, Germany	**DOM. PAPETY**
PAREDES **Juan De** b. Spain. ? - 1738 Historical subjects Exh: Spain	*(signature: J de Paredes)*
PARKER. LIFA **Caroline Maude** b. London Still life & landscape artist Exh: London & Prov. AG's	*(monogram)*
PARKER. ARMS, SSWA **Elizabeth Rose** b. Renfrewshire Portrait miniaturist & landscape artist Exh: London & Prov. AG's, Canada	*(monogram)*

PARKER **Herbert** b. N. Wales. 1908 - Landscape watercolourist Exh: RI, RCamA, PS, X, etc.	*H.PARKER.* *H.Parker.*
PARKER. RWS **John** b. Birmingham. 1839 - 1915 Genre & landscape artist Exh: RA, OWS, SS, GG, NG, etc.	*JP* *JP*
PARKER. ARCA **Richard Henry** b. Dewsbury. 1881 - 1930 Etcher, oil & watercolourist Exh: London & Prov. AG's, X	*·R·P·*
PARMIGIANO **Fabrizio Andrea** b. Italy. 1555 - 1600 ? Landscape artist Exh: Italy	*·2·1,F*
PARRIS **Edmund Thomas** b. London. 1793 - 1873 Genre, portrait, panorama & historical subjects Exh: BI, SS, VA, NPG	*ETP*
PARROCEL **Charles** b. Paris. 1688 - 1752 Military & historical subjects Exh: France, Belgium, Germany, UK	*Parrocel 1742*
PARROCEL **Joseph** b. Provence. 1646 - 1704 Battle scenes & historical subjects Exh: UK, France, Italy, Spain, etc.	*Josephe parrocel* *J. Jos. Par f*
PARRY, ARMS, FRSA **Sheila Harwood** b. Salford. 1924 - Gouache & oil media Exh: RWS, RMS, London & Prov. AG's, Australia etc.	*SHP*
PARSONS, RA, PRWS **Alfred** b. Somerset. 1847 - 1920 Landscape, oil & watercolourist Exh: RA, RI, NG, Paris, Berlin, Vienna	*A* *AP.* *AP* *AP*
PARSONS **Beatrice** Floral & genre subjects Exh: RA, London & Prov. AG's	*B.P.*

PARSONS. SGA, SWlA **Gwendolene Frances Joy** b. Lancashire. 1913 - Murals, floral & wildlife subjects Exh: RI, PS, SWLA, Belfast & Prov. AG's, X	*Joy Parsons*
PARTRIDGE. NEAC, RI **Sir Bernard** b. London. 1861 - ? Cartoonist, pastel, oil & watercolour media Exh: RA, London & Prov. AG's	*Bernard Partridge*
PASCIN **Julius Pinkas** b. Bulgaria. 1885 - 1930 Genre subjects Exh: Germany, US	*pascin* *pascin*
PASINELLI **Lorenzo** b. Bologna. 1629 - 1700 Religious & portrait artist Exh: Italy, Vienna, France	*L.P.F.*
PASINI **Alberto** b. Italy. 1826 - 1899 Genre & landscape subjects Exh: Italy, France, Montreal, Sydney	*A. Pasini*
PASMORE **John F.** Fl. London 19th C. Rustic genre, still life & animal subjects, etc. Exh: RA, BI, SS, London & Prov. AG's	*P* (monogram)
PASMORE. CBE, MA **Victor** b. Surrey. 1908 - Portraits, still life & landscape artist Exh: London & Prov. AG's, France	*VP.*
PASSAROTTI **Bartolomeo** b. Bologna. 1529 - 1592 Portraits & religious subjects Exh: Italy, Germany, France	*BP* (monogram)
PASSAVANT **Johann David** b. Frankfurt. 1787 - 1861 Genre & historical subjects Exh: Germany	*JPD.* (monogram)

PASSE (The Elder) **Crispin De** b. Holland. 1564 ? - 1637 Portraits & bibical subjects	
PATEL **Pierre** b. Picardy. 1605 ? - 1676 Landscapes & architectural subjects Exh: France, Russia, UK	*P Patel fils*
PATER **Jean Baptiste Joseph** b. France. 1695 - 1736 Genre subjects Exh: France, UK, Rusia, Montreal	*Pater JBY* *J B Pater 1731* *B Pater F* *Pater fe -*
PATISSOU **Jacques** b. Nantes. 1880 - 1925 Portrait, still life & genre subjects Exh: France	*J. Patissou*
PATON. ARE **Hugh** b. Glasgow. 1853 - 1927 Pastel, oil & watercolourist Exh: RA. RE. Prov. AG's, PS, US, Australia	
PATON. RSA **Sir Joseph Noel** b. Dunfermline. 1821 - 1901 Biblical, mythological, historical & imaginative subjects Exh: RA, RSA, Canada, Australia	
PATON. RSA, RSW **Walter Hugh** b. Scotland. 1828 - 1895 Landscape artist Exh: RSA, RA, RSW, Australia	
PATRIX **Michel** b. Cabourg. 1917 - Neo-cubism Exh: France, US	*michel patrix*
PATRY. RBA **Edward** b. London. 1856 - 1940 Genre & portrait artist Exh: RA, SS, PS, Belgium	

PATTEN **Alfred Fowler** b. London. 1829 - 1888 Figure & portrait artist Exh: UK AG's	
PATTEN, ARA **George** b. 1801 - 1865 Portrait, historical & mythological subjects Exh: RA, VA, NPG, UK AG's, Italy	
PAUDITZ (or PAUDISS) **Christoph** b. Saxony. 1618 ? - 1666 ? Portraits, still life & historical subjects Exh: Germany, Russia, Austria	*Chrisstoff Pauditz f & 1665* *C Pauditz*
PAULEMILE-PISSARRO b. France. 1884 - Landscape artist Exh: France	*Paulémile-Pissarro* *Paulémile*
PAULY **Horatius** b. Holland 1644 - 1686 ? Genre, portrait & still life subjects Exh: Florence, Vienna	
PAYNE, RWS **Henry A.** b. Birmingham. 1868 - 1939 Portrait, mural & landscape artist Exh: London & Prov. AG's	*H.P.*
PEACOCK. Mem. USA **Herbert L.** b. Norfolk. 1910 - Architectural & landscape subjects & miniaturist Exh: USA, NS, NEAC, RI, RMS, PAS, RWEA, PS, etc.	*Herbert Peacock* *H. L. P.*
PEACOCK **Ralph** b. London. 1868 - 1946 Portrait & landscape artist Exh: RA, GG, SS, Prov. AG's, France	*R. P.*
PEARCE **Charles Maresco** b. 1874 - 1964 Figure, still life, landscape & architectural subjects Exh: UK AG's	CMP

PEARS. ROI, PSMA **Charles** b. Pontefract. 1873 - 1958 Marine artist Exh: RA, NEAC, London & Prov. AG's	*Chas. Pears.*
PEDDER **John** b. Liverpool. 1850 - 1929 Landscape artist Exh: RA, SS, NWS, GG, London & Prov. AG's	*JP* *JP*
PEDDIE. DA **Archibald** b. Helensburgh. 1917 - Tempera, ink, oil & watercolour media Exh: RSA, SSA, GI, etc.	*ARch Peddie*
PEE **Jan Van** b. Amsterdam. 1641 ? - 1710 Genre subjects Exh: Russia, Holland	*N.f* *N.f*
PEGRAM **Frederick** b. 1870 - 1937 Genre subjects Exh: RA, London & Prov. AG's	*F.P.*
PELHAM **Thomas Kent** Fl. 1860 - 1891 Genre subjects Exh: RA, BI, SS, Prov. AG's	*JKP* *JKP.* *TKP*
PELLEGRINI **Alfred Heinrich** b. Basle. 1881 - Portraits, figure & genre subjects Exh: Germany, US, S. America	*A.H.Pellegrini* *AHP*
PELLEW **Claughton** b. Redruth. 1892 - Etcher & painter Exh: NEAC, London & Prov. AG's	*CP*
PELLY **Cicely E.** Figures & landscape artist Exh: WAG, Prov. AG's	*CPelly*
PELLY. ALAA **Rosalind** Watercolourist Exh: RA, R.Cam.A., WAG. etc.	*RP*

PELOUSE Leon Germain b. France. 1838 - 1891 Portraits & landscape artist Exh: France	*G Belouse*
PEMBERTON Muriel Alice b. Stoke-on-Trent. 1909 - Portrait, abstract, marine & landscape subjects etc. Exh: RA, RWS, US, Canada, France, China, Japan, London & Prov. AG's	*Muriel Pemberton* MURIEL PEMBERTON. M.Pemberton
PENCZ Georges Fl. Nuremberg. 1500 — 1550 Portraits & religious subjects Exh: Germany, France, Italy, Sweden	*GP* *E 1543* *CP* *CP* *GP* *GP*
PENLEY Edwin Aaron b. 1807 - 1870 Portraits, landscapes & miniaturist Exh: RA, RI, VA, UK AG's	*AP*
PENNE Charles Olivier De b. Paris. 1831 - 1897 Animal & landscape artist Exh: France	*Ol. de Penne*
PENNI Luca b. Florence. 1500 - 1556 Historical subjects Exh: France, Italy	*L.* P.R. R. L P R.
PENSTONE John Jewel Fl. 1835 - 1895 Genre, figure & portrait artist Exh: RA, London & Prov. AG's	*JP*
PEPLOE, RSA Samuel John b. Edinburgh. 1871 - 1935 Genre, still life & landscape artist Exh: UK AG's	SJP SJP
PEPPERCORN Arthur Douglas b. London. 1847 - 1926 Marine & landscape artist Exh: RA, SS, London & Prov. AG's, Holland, Germany	*þ*

PEPYN **Marten** b. Antwerp. 1575 ? - 1642 Portraits & historical subjects Exh: Belgium, Austria, Sweden	MP. in. f. 1626
PEQUIN **Charles Etienne** b. Nantes. 1879 - ? Portraits, still life & landscape subjects Exh: France	Pequin
PERCY **Sydney Richard** b. 1821? - 1886 Landscape artist Exh: RA, BI, SS, UK AG's	SRPercy 1885
PEREDA (the Elder) **Antonio** Fl. 15th - 16th C. Biblical subjects	AP
PEREDA **Antonio De** b. Valladolid. 1599 - 1669 Still life & religious subjects Exh: Germany, Spain, Belgium, Hungary, France, etc.	A. de Pereda 1650
PERELLE **Gabriel** b. France. 1603 ? - 1677 Landscape artist Exh: Germany, France	G
PERGAUT (or PERGAULT) **Dominique** b. France. 1729 - 1808 Historical, still life & landscape subjects Exh: France	Pergaut
PERIGAL **Arthur** b. London. 1816 - 1884 Landscape artist Exh: RSA, RA, Prov. AG's	AP P AP P P
PERKINS **Charles C.** b. Boston. 1823 - 1886 Painter & engraver	
PERMEKE **Constant** b. Antwerp. 1886 - 1951 Interiors, figures, marine & landscape artist	permeke 28 Permeke

PERRET **Aime** b. Lyon. 1847 - 1927 Genre & landscape subjects Exh: France	*Aimé Perret*
PERRET **Marius** b. France. 1853 - 1900 Genre & oriental subjects Exh: France	*MARIUS PERRET*
PERRIER **Guillaume** b. France. 1600 ? - 1656 Portraits & religious subjects Exh: France	*GP*
PERRIN **Alphonse Henri** b. Paris. 1798 - 1874 Religious & historical subjects Exh: France, Madrid	*A.S Perrin*
PERRONEAU **Jean Baptiste** b. Paris. 1715 - 1783 Portrait artist Exh: France, UK	*Perroneau*
PERUGINI **Charles Edward** b. Naples. 1839 - 1918 Genre & portrait artist Exh: RA, SS, NG, BI, etc.	*P*
PERUGINO (PIETRO VANNUCCI) **II** b. Nr. Perugia. 1446 ? - 1523 Portraits, religious & historical subjects Exh: UK & European AG's	*PP* *PP* *PETRVS PERVSINVS PINXIT* *PP* *PETRVS·PERVGINVS* *LE PERVGIN* *PETRVS·PERVGINVS*
PESCHEL **Carl Gottlob** b. Dresden. 1798 - 1879 Biblical subjects Exh: Germany	*CP*
PETERSEN **Eilif** b. Norway. 1852 - 1928 Portrait, historical & landscape subjects Exh: Germany, Scandinavia	*Eilif Petersen*

PETITJEAN **Edmond Marie** b. France. 1844 - 1925 Landscape artist Exh: France	*E. Petitjean*
PETRIE. RI, ROI **Graham** b. London. 1859 - ? Landscape artist Exh: London & Prov. AG's, X	*Graham Petrie.*
PETTAFOR **Charles R.** Fl. 1870 - 1900 Landscape & architectural views Exh: London & Prov. AG's	*℘*
PETTITT **Charles** Fl. London 19th C. Landscape artist Exh: SS, BI, London & Prov. AG's	*CP*
PETTITT **Edwin Alfred** b. Birmingham. 1840 - 1912 Landscape artist Exh: RA, Prov. AG's	*EA*
PETTITT **Wilfred Stanley** b. Gt. Yarmouth. 1904 - Portrait & landscape artist Exh: RA, London & Prov. AG's	*Wilfred S Pettitt.*
PETZL **Joseph** b. Munich. 1803 - 1871 Genre subjects Exh: Germany	*ZPS*
PEUGNIEZ **Pauline** b. Amiens. 1890 - Religious subjects & interior scenes Exh: France	*Pauline Peugniez*
PEYRON **Jean Francois Pierre** b. France. 1744 - 1814 Historical & portrait artist Exh: France	*P Peyron*
PEYSON **Pierre Frederic** b. Montpelier. 1807 - 1877 Portraits, genre & historical artist Exh: PS, & French AG's	*Peyson s m.*

PEZ **Aime** b. Belgium. 1808 - 1849 Historical, genre & portrait artist Exh: Belgium.	
PFEIFFER **Francois Joseph** b. Liege. 1778 - 1835	
PHILIPPOTEAUX **Henri Felix Emmanuel** b. Paris. 1815 - 1884 Military, historical & portrait artist Exh: France, UK.	
PHILLIP. RA **John** b. Aberdeen. 1817 - 1867 Scottish & Spanish genre subjects Exh: RA, RSA, BI, SS, London & Prov. AG's	
PHILLIPS. JP **Charles Gustave Louis** b. Montevideo. 1863 - ? Etcher, oil & watercolourist Exh: RSA, GI, etc.	
PHILLIPS **Walter Joseph** b. Barton-on-Humber. 1884 - Landscape artist Exh: VA, BM, London & Prov. AG's	
PHILLOTT **Constance** Fl. 1864 - 1904 Genre, historical & landscape artist Exh: RWS, UK AG's	
PHILPOT, RA **Glyn Warren** b. 1884 - 1937 Figure, portrait, genre & eastern subjects Exh: RA, UK AG's	
PHILPOT **Leonard** b. 1877 - ? Still life subjects etc. Exh: RA, RI, London & Prov. AG's US, N. Zealand	

PIATTI **Prosper** b. Ferrara. 1842 ? - 1902 Historial subjects Exh: Italy	*P. Piatti*
PIAUBERT **Jean** b. Bordeaux. 1900 - Abstract subjects Exh: France.	**PIAUBERT**
PIAZZA **Martino** b. Italy ? - 1527 ? Religious subjects Exh; Italy, UK	*MP*
PICABIA **Francis** b. Paris. 1879 - 1953 Abstract & genre artist Exh: France, Holland, US	*Picabia* *Francis Picabia*
PICARD **LOUIS** b. Paris. 1861 - ? Genre & portrait artist Exh: France	LOUIS PICARD
PICART LE DOUX **Charles Alexandre** b. Paris. 1881 - 1959 Genre, still life & landscape subjects etc. Exh: France, Russia	*Picart le Doux* 𝖢𝖫𝖣
PICASSO **Pablo** b. Spain. 1881 - 1975 Still life, cubist & abstract subjects etc. Exh: International AG's	*Picasso*
PICKERING **Evelyn** b. 1850 ? - 1919 Figure artist Exh: GG, NG, London & Prov. AG's	*ΦP*
PICKERSGILL, RA **Frederick Richard** b. London. 1820 - 1900 Historical genre Exh: RA, BI, VA, UK AG's	*FRP* *P.RA.* *P* FRP(R.A.)
PICOU **Robert** b. Tours. 1593 ? 1671 Genre & religious subjects Exh. France	*R P ser*

PIECH **Paul Peter** b. New York. 1920 - Expressionistic subjects Exh: London, Germany, US, Ireland, Japan	
PIERCE. RI **Charles E.** b. Edinburgh. 1908 - Oil, watercolour, pastel, pen, ink media etc. Exh: RA, RSA, Prov. AG's	
PIERCE. ARMS **Lucy Elizabeth** b. ? - 1950 Watercolourist Exh: RA, RI, London & Prov. AG's etc.	
PIERON **Gustave Louis Marie** b. Antwerp. 1824 - 1864 Landscape artist Exh: Belgium	
PIERRE **Dieudonne** b. Nancy. 1807 - 1838 Portraits, historical subjects & miniaturist Exh: France	
PIERRE **Gustave Rene** b. Verdun. 1875 - ? Portrait, genre & landscape subjects Exh: France	
PIERRE **Jean Baptiste Marie** b. Paris. 1713 - 1789 Religious & historical subjects Exh: France, Russia	
PIETER **Toert** b. Amsterdam. 1856 - ? Landscape, marine & genre subjects Exh: Holland, France	
PIETERSZ **Aert** b. Amsterdam. 1550 ? - 1612 Portrait & genre artist Exh: Holland, Germany	
PIGAL **Edme Jean** b. Paris. 1798 - 1872 Genre subjects Exh: France	

PIKE. SGA **Joseph** b. British. 1883 - Architectural subjects Exh: RA, SGA, PAS	*Joseph Pike*
PIKE **Leonard** b. London. 1887 - Oil, watercolourist etc. Exh: RA, PS, RI, RSA, RBA, RGI, PAS, RWA, Prov. AG's	*Leonard Pike*
PILAWSKI. NDD, ROI **Wieslaw** b. Russia. 1916 - Painter in oil media Exh: RA, ROI, RBA, NS, London & Prov. AG's	*W. Pilawski*
PILGRIM **Herbert Francis** b. London. 1915 - Animal studies etc. Exh: London & Prov. AG's	*H. Francis Pilgrim*
PILLEAU. RI, ROI **Henry** b. England. 1815 - 1899 Landscape & genre artist Exh: RA, SS, BI, NWS, RI, London & Prov. AG's	*HP (monogram)*
PILLEMENT **Jean** b. Lyon. 1728 - 1805 Landscape, marine, floral & genre artist Exh: France, Italy	*Jean Pillement* *Pillement*
PILS **Isidore Alexandre Augustin** b. Paris. 1813 - 1875 Historical & genre subjects Exh: France, UK, Belgium	*I. Pils* *I Pils*
PILSEN **Frans** b. Belgium. 1700 - 1784 Religious subjects Exh: Belgium	*F. P*
PIMM. ARBSA **Joseph Frank** b. 1900 - Etcher, painter in aquatint, watercolour etc. Exh: RA, RE, RHA, RSA, RWA, R.Cam.A., RI, RBA, PS etc.	*Joseph. F. Pimm*
PINE **Robert Edge** b. London. 1742 - 1788 Portrait & historical subjects Exh: NPG, RA, US	*RE Pine*

PINSON **Nicolas** b. Valence. 1640 - ? Religious & portrait artist Exh: France	*NP Inf*
PINWELL. RWS **George John** b. High Wycombe. 1842 - 1875 Genre & historical watercolourist Exh: OWS, London & Prov. AG's Australia	*Pinwell.* *CJP*
PIOLA (The Elder) **Domenico** b. Genos. 1627 - 1703 Religious & historical artist Exh: Italy	*Do. P.* *F.*
PIOMBO **Sebastiano**	See **LUCIANO** **Sebastiano**
PIOT **Rene** b. Paris. 1869 - 1934 Genre & still life subjects Exh: France	*René Piot*
PIPER. ARE, ARWA **Elizabeth** Etcher, oil & watercolourist Exh: RA, RE, WAG, RWA, France, Germany, US, etc.	*E.P.piper*
PIPER **John** b. Epsom. 1903 - War artist, architectural landscapes & abstract subjects Exh: Tate, UK AG's, Paris	*JP*
PISSARRO. NEAC **Lucien** b. Paris. 1863 - ? Engraver & landscape artist Exh: London & Prov. AG's	
PITCHFORTH **Roland Vivian** b. Wakefield. 1895 - Marine & landscape artist Exh: RA, RWS, London & Prov. AG's	*Pitchforth.* *RA. RWS.*
PITFIELD. NRD. Hon.FRMCM **Thomas Baron** b. 1903 - Pen, watercolourist etc. Exh: RA, London & Prov. AG's	*Thomas B Pitfield*

PITTMAN. ROI **Osmund** b. London. 1874 - ? Landscape artist Exh: RA, ROI, London & Prov. AG's	Φ
PLANASDURA. IIAL **E.** b. Barcelona. 1921 - Abstract art Exh: Spain, France, Switzerland, Italy, S. America. etc.	PLATISNRA
PLATT. ARCA **John Edgar** b. Leek. 1886 - Colour woodcut artist & painter Exh: London & Prov. AG's, X	John Platt JOHN 1946 19 62
PLATT **Stella** b. Bolton. 1913 - Oil & watercolourist Exh: RI, RBA, SWA, SGA & Prov. AG's	STELLA PLATT Stella Platt
PLATZER **Johann Georg** b. Austria. 1704 - 1761 Mythological, genre & historical subjects Exh: Germany, Russia, Austria, US, UK	J Platzer
POCOCK. RMS **Alfred Lyndhurst** b. 1881 - Watercolourist Exh: RA, London & Prov. AG's, Canada	19 A 26
POCOCK. ROI, RE, RI, PAS **Anna** b. London. 1882 - Portraits, figure & floral subjects Exh: RA, PS, Italy, Canada, US, N.Z., UK, Prov. AG's	(monogram)
POCOCK **Geoffrey Buckingham** b. London. 1879 - ? Portraits, architectural, & landscape subjects Exh: RA, ROI, NEAC, Prov. AG's	G.B.P
POCOCK **Lilian Josephine** b. London. Fl. 20th C. Figure artist Exh: RA, RSA, London & Prov. AG's	Pocock.
POEL **Egbert Van Der** b. Delft. 1621 - 1664 Interiors, landscapes, genre & conflagrations Exh: Russia, UK & European AG's	egbert vander poel Evander poel

POELENBURG **Cornelis Van** b. Utrecht. 1586 - 1667 Portraits, genre, historical & landscape artist Exh: UK & European AG's	*C.ble. Palemburg 1643* *PC 1648* *P.*
POINTELIN **Auguste Emmanuel** b. France. 1839 - 1933 Landscape artist Exh: France	*Aug. Pointelin*
POIRET **Paul** b. Paris ? - 1944 Still life & genre artist Exh: France	*PAUL POIRET*
POLAINE. SM, FIAL **Horace George William** b. London. 1910 - Portraits, still life, miniatures & landscape artist Exh: RI, RA, London & Prov. AG's etc.	*H. G. Polaine*
POLLOCK **Courtenay Edward Maxwell** b. Birmingham. 1877 - 1943 Figure & portrait artist Exh: RBA, UK AG's	*PoS*
POMEDELLO **Giovanni Maria** b. Italy. 1478 - 1537 ? Historical & genre artist Exh: Italy	
POND **Arthur** b. London. 1705 ? - 1758 Portrait artist Exh: NPG, BM	
PONSON **Luc Raphael** b. France. 1835 - 1904 Marine & landscape artist Exh: France	*R Ponson*
PONTIN **George** b. Sussex Marine subjects etc. Exh: RA, Prov. AG's, Australia	*George Pontin*
POOL **Juriaen** b. Amsterdam. 1665 ? - 1745 Portrait & genre artist Exh: Holland	*Pool*

POOLE, RA **Paul Falconer** b. Bristol. 1807 - 1879 Genre, historical & portrait artist Exh: RA, BI, SS, NG, VA, UK AG's, Paris, Hamburg	*PFP57*
POORTER **Bastiaan De** b. Holland. 1813 - 1880 Portrait artist Exh: Holland	*B. de Poorter* *ft. 1848. ○*
POORTER **Willem De** b. Holland. 1608 - 1648 ? Allegorical & historical subjects Exh: Holland, UK, Germany, Austria	**W. D. P.**
POPE **Gustav** b. 1852 - 1895 Portrait, genre & historical subjects Exh: UK AG's	*GP* (monogram)
PORCELLIS **Julius** b. Holland. 1609 ? - 1645 Marine artist Exh: Holland, Germany, France	*I. Pon*
PORTAELS **Jean Francois** b. Belgium. 1818 - 1895 Portrait, historical & genre artist Exh: Belgium, US, Germany etc.	*J Portaels*
PORTIELJE **Edward Antoon** b. Antwerp. 1861 - ? Genre subjects Exh: Belgium	*Edward Portielje*
PORTIELJE **Gerrard** b. Antwerp. 1856 - ? Genre subjects Exh: Belgium, Australia	*Gerard Portielje*
PORTNER **Alexander Manrico** b. Berlin. 1920 - Artist & portrait painter Exh: RA, RP, London & Prov. AG's US, X	A / P
POT **Heindrick Gerritsz** b. Haarlem. 1585 - 1657 Historical, portraits & genre subjects Exh: Holland, France, UK	*HPoT.* *HP* (monogram)

POTEMONT **Adolphe Theodore Jules Martial** b. Paris. 1828 - 1883 Landscape artist Exh: Paris	
POTHOVEN **Hendrick** b. Amsterdam. 1725 - 1795 Portrait artist Exh: Holland	
POTTER. RBA **Frank Huddlestone** b. London. 1845 - 1887 Genre & landscape artist Exh: RA, SS, GG, SA, London & Prov. AG's	
POTTER **Paulus** b. Enkhuizen. 1625 - 1654 Portraits, animals & landscape artist	
POTTER **Pieter Symonsz** b. Holland. 1597 ? - 1652 Biblical, military, portrait & still life subjects Exh: Holland, Germany, France, UK	
POUPART **Antoine Achille** b. Paris. 1788 - ? Landscape artist Exh: Paris	
POURBUS **Peeter Jansz** b. Gouda. 1510 ? - 1584 Historical & portrait artist Exh: Holland, Belgium, Sweden, UK	
POUSSIN **Gaspard**	see **DUGHET** **Gaspard**
POUSSIN **Nicolas** b. France. 1594 - 1665 Mythological, religious & landscape subjects Exh: Germany, France, UK, Scandinavia	
POWER **John Wardell** b. Sydney. 1881 - Abstract artist Exh: London & Prov. AG's, France	

POYNTER **Sir Edward James** b. Paris. 1836 - 1919 Genre & historical subjects Exh: RA, VA, London & Prov. AG's, Canada, Australia	
PRADIER **Jean Jacques** b. Geneva. 1792 - 1852 Portrait & historical subjects etc. Exh: France	*J PRADIƐR*
PRAMPOLINI **Enrico** b. Modena. 1894 - 1956 Figure studies Exh: Italy, France, Germany, US	*PRAMPOLINI.*
PRASSINOS **Mario** b. Istambul. 1916 - Etcher & Painter Exh: France	*prassinos*
PRATT. Mem.SWLA, FOBA **David Ellis** b. Kobe, Japan. 1911 - Portrait, marine, abstract, animal, nature & landscape artist Exh: London & Prov. AG's	*David Pratt.* *DAVID PRATT* *DAVIDE*
PRATT **William** b. Glasgow. 1855 - ? Genre subjects Exh: RA, RSA, PS, London & Prov. AG's, Germany	*WPatt*
PREISSLER **Johann Justin** b. Nuremberg. 1698 - 1771 Religious & genre subjects Exh: Germany, Italy	
PRESTEL **Theophilus** b. Germany. 1739 - 1808 Portraits & religious subjects	*AP*
PREVOST **Pierre** b. Montigny. 1764 - 1823 Panoramas & landscape subjects Exh: France, Belgium	*Prevost P fecit*
PRICE **James** Fl. London 19th C Landscape artist Exh: RA, SS, BI, London & Prov. AG's	*JP*

PRICE **Julius Mendes** b. ? - 1924 Genre subjects Exh: RA, SS, Prov. AG's, Paris	*J.M.P.* *J.M.P.*
PRICE **Leslie** b. 1915 - Portrait artist Exh: London & Prov. AG's	*Leslie Price*
PRIDE **John** b. Liverpool. 1877 - ? Etcher, artist in various media Exh: WAG, Prov. AG's, Spain	✝P
PRIEST. RP **Alfred** b. Harbourne. 1874 - ? Portrait artist & etcher Exh: RA, RI, London & Prov. AG's	*Alfd Priest 1926*
PRIESTMAN. RA, ROI **Bertram** b. Bradford. 1868 - 1951 Cattle, landscapes & coastal scenes Exh: RA, SS, NG, GG & Prov. AG's	**BP**
PRINET **Rene Francois Xavier** b. France. 1861 - 1946 Historical, portrait, genre & landscape subjects Exh: France	*R.X. Prinet* **R·X·PRINET** R·X·PRINET
PRINS **Pierre Ernest** b. Paris. 1838 - 1913 Landscape artist Exh: France, Germany	*Pierre Prins* *P. P.*
PRINSEP, RA **Valentine Cameron** b. Calcutta. 1836 - 1904 Portraits, genre & historical subjects Exh: NPG, RA, London & Prov. AG's, Germany, France	⊽
PRINTZ **Christian August** b. Norway. 1819 - 1867 Landscape & animal subjects Exh: Oslo	*CA Printz*

PRITCHETT Robert Taylor b. 1823 - 1907 Genre & landscape artist Exh: RA, VA, London & Prov. AG's	
PROFANT Wenzel b. Luxembourg. 1913 - Painter & sculptor Exh: Belgium, France, Germany, Switzerland, etc.	
PROTAIS Alexandre b. Paris. 1826 - 1890 Military subjects Exh: France	
PROUT Samuel Gillespie b. 1822 - 1911 Landscapes & architectural subjects Exh: VA, London AG's	
PROVIS Alfred Fl. 1843 - 1886 Interiors & genre subjects Exh: RA, BI, SS, VA	
PRUD'HON Pierre b. France. 1758 - 1823 Historical & portrait artist Exh: France, London	
PRYNNE, RBA Edward A. Fellowes b. 1854 - 1921 Portrait, figure & genre subjects Exh: RA, UK AG's	
PUJOL Alexandre Denis Abel De b. France. 1787 - 1861 Bibical & historical subjects Exh: France	
PULLAN Margaret Ida Elizabeth b. India. 1907 - Painter in oil media Exh: PS, RP, RBA, USA, Prov. AG's	
PULSFORD. ARSA Charles b. Leek. 1912 - Exh: RSA, SSA, London & Prov. AG's, France, etc.	

PUTZ **Leo** b. Germany, 1869 - ? Genre subjects Exh: Germany, Hungary	
PUVIS DE CHAVANNES **Pierre C.** b. Lyon. 1824 - 1898 Genre & portrait artist Exh: France, US, Germany, Melbourne	
PUY **Jean** b. France. 1876 - 1959 Portraits & landscape artist Exh: Paris, Zurich, Moscow	
PUYL **Gerard** b. Utrecht. 1750 - 1824 Portrait artist Exh: France, Holland	
PYLE **Howard** b. Wilmington. 1853 - 1911 Painter & illustrator Exh: Paris, US	
PYNAKER (or PYNACKER) **Adam** b. Nr. Delft. 1622 - 1673 Figures, animals, waterfalls & landscape artist Exh: UK & European AG's	

Q

QUADAL **Martin Ferdinand** b. Austria. 1736 - 1811 Portrait, genre & animal subjects Exh: Austria, Germany, Russia, RA, SA	
QUAGLIO (The Younger) **Domenico** b. Munich. 1786 - 1837 Architectural subjects Exh: Germany	

QUAGLIO **Lorenzo** b. Munich. 1793 - 1869 Portrait & genre artist Exh: Germany	*LQ 1825* LQ
QUAST **Pieter Jansz** b. Amsterdam. 1606 - 1647 Portraits, domestic & humourous genre subjects Exh: France, Austria, Russia, Holland, UK	*Pictorquast Jnr 1633* R. Q. Q. R. Q.
QUEBORNE **Crispyn Van Den** b. The Hague. 1604 - 1652 Portrait Artist Exh: Holland	
QUELLIN **Jean Erasmus** b..Antwerp. 1634 ? - 1715 Historical & portrait subjects Exh: France, Belgium	*Quellinus f A° 661* *Quellinus* *I.E.Quellinus Pict. Cæs Ma F A°1685.*
QUELVEE **François Albert** b. France. 1884 - Composition studies Exh: France	*François-Quelvée*
QUENNEL. Hon.ARIBA **Marjorie** b. Kent. 1883 - B/white, oil & watercolourist Exh: RA, London & Prov. AG's, US	
QUERFURT **August** b. Germany. 1696 - 1761 Battle & hunting scenes Exh: Germany, France	AQ AQ. AQ
QUESNEL **Augustin** b. Paris. 1595 - 1661 Portrait artist Exh: Hungary	AVG QVESNEL
QUESNEL (The Elder) **Francois** b. Edinburgh. 1543 - 1619 Historical & Portrait artist Exh: France, Italy	*f. Quesnel 1601*

QUINAUX **Joseph** b. Belgium. 1822 - 1895 Landscape artist Exh: Belgium, Australia	*J. quinaux*
QUINCKHARDT **Jan Maurits** b. Holland. 1688 - 1772 Portrait, historical & genre subjects Exh: Holland, France, UK	*J M Quinkhard pinxit 1744*
QUINCKHARDT **Julius** b. Amsterdam. 1736 - 1776 Genre subjects Exh: Holland	*Julius Quinkhard*
QUINTARD **Lucien Charles Justin** b. Nancy. 1849 - 1905 Landscape subjects Exh: France	*Lucien Quintard*
QUINTON **Alfred Robert** Fl. UK. 19th – 20th C. Landscape artist Exh: RA, SS, NWS, London & Prov. AG's	A.R.Q. A.R.Q.
QUIROS **Lorenzo** b. Spain. 1717 - 1789 Historical subjects Exh: Spain	*L Quiros.*
QUIZET **Alphonse Leon** b. Paris. 1885 - 1955 Landscape studies Exh: France, US, Copenhagen	*Quizet*

R

RACIM **Mohammed** b. Algiers. 1896 - Watercolourist Exh: European & Mid. Eastern AG's	*Mohammed Racim.* رسم محمد
RACKHAM **Arthur** b. London. 1867 - 1939 Figure & landscape artist. Illustrator. Exh: RI, RA, London & Prov. AG's, France, Spain	*Arthur Rackham* AR AR

RADCLYFFE **Charles Walter** b. Birmingham 1817 - 1903 Landscape artist Exh: RA, BI, SS, VA	
RADEMAKER **Abraham** b. Holland. 1675 - 1735 Landscape artist Exh: Holland, Belgium, London, Paris	
RADEMAKER **Gerrit** b. Amsterdam. 1672 - 1711 Historical & portrait artist Exh: Holland	
RADIMSKY **Venzel** b. Austria. 1867 - ? Landscape artist Exh: Paris, Prague	
RAFFAELLI **Jean Francois** b. Paris. 1850 - 1924 Portrait, genre & landscape subjects Exh: France	
RAFFET **Auguste** b. Paris. 1804 - 1860 Battle scenes Exh: France, UK, US	
RAGLESS **Max** b. Adelaide. 1901 - Oil & watercolourist Exh: Australia	
RAHL **Karl** b. Austria. 1770 - 1843 Portraits, historical & genre subjects Exh: Austria	
RAILTON **Herbert** b. Pleavington. 1858 - 1910 Landscape & architectural subjects Exh: UK AG's	
RAINBIRD **Victor Noble** b. Northsheilds. 1888 - Pastel, oil & watercolour media Exh: RA, WAG, London & Prov. AG's	

RAINEY **William** b. London 1852 - ? Genre & landscape subjects Exh: RA, RI, UK, Germany	
RAJON **Paul Adolphe** b. Dijon. 1843 ? - 1888 Genre subjects Exh: France, US	
RALLI **Theoddore Jacques** b. Greece. 1852 - 1909 Genre subjects Exh: Athens, Paris, Sydney	
RAMAUGE **Roberto** b. Argentina. 1890 - Landscape artist Exh: France	
RAMBERG **Johann Heinrich** b. Hanover. 1763 - 1840 Historical & portrait artist Exh: Germany, UK	
RAMSAY **David** b. Ayr. 1869 - ? Landscape watercolourist Exh: UK AG's	
RANC **Jean** b. Montpellier. 1674 - 1735 Portraits & historical subjects Exh: France, Spain	
RANKEN. VP. ROI, RI **William Bruce Ellis** b. Edinburgh. 1881 - Portrait, interior, flower & landscape artist Exh: NEAC, RS, RA, RI, NPS, RP, RSA, US, etc.	
RANKLEY **Alfred** b. 1819 - 1872 Genre & historical subjects Exh: RA, BI, SS, London & Prov. AG's	
RAOUX **Jean** b. Montpellier. 1677 - 1734 Genre, portrait & historical subjects Exh: France, Russia, Germany, UK	

RAFFAELLO **Santi** b. Urbino. 1483 - 1520 Portraits, religious & historical subjects Exh: International AG's	*raphaello* [RA monogram] *R.* *Raphael* *I.V.R.* *RV.* *RAPHAEL· VRBINAS* *R.*
RAPIN **Alexandre** b. France. 1839 - 1889 Landscape subjects Exh: France	**RAPIN**
RASSENFOSSE **Andrew Louis Armand** b. Liege. 1862 - 1934 Genre artist & illustrator Exh: Belgium, Italy	*a Rassenfosse*
RATCLIFF. OBE, FRIBA, AMTPI, **FFPS.** **John** b. Yorkshire. 1914 - Painter in oil media	[monogram]
RAU **Emil** b. Dresden. 1858 - ? Genre subjects Exh: London, Berlin	*E·RAU*
RAUCH **Charles** b. Strasbourg. 1791 - 1857 Genre, portrait & landscape artist Exh: France	*Cˡˢ Rauch*
RAVEL **Edouard John E.** b. Switzerland. 1847 - 1920 Genre & portrait artist Exh: Switzerland	E·RAVEL .
RAVEN **John Samuel** b. Suffolk. 1829 - 1877 Landscape artist Exh: BI, London & Prov. AG's	18 [monogram] 72 [monogram 1865]

RAVEN **Thomas** Fl. England 19th C. Landscape artist Exh: VA	
RAVENSWAY (The Younger) **Jan Van** b. Holland. 1815 - 1849 Landscape artist Exh: Holland	
RAVENSWAY (The Elder) **Jan Van** b. Holland. 1789 - 1869 Landscape & animal subjects Exh: Holland	
RAVESTEYN **Anthony Van** b. Holland. 1580 ? - 1669 Portrait artist Exh: Holland, Germany	
RAVESTEYN **Arnold Van** b. The Hague. 1615 - 1690 Portraits & mythological subjects Exh: Holland	
RAVESTEYN **Hubert Van** b. Holland. 1638 - 1692 ? Still life & genre subjects Exh: Holland, Germany, Austria etc.	
RAVESTEYN **Jan Anthonisz Van** b. The Hague. 1570 - 1657 Portrait artist Exh: Holland, France, Belgium, Germany, US, UK, etc.	
RAVIER **Auguste Francois** b. Lyon. 1814 - 1895 Landscape artist Exh: France	

RAY. AMC, SWA **Edith** b. 1905 - Oil & watercolourist etc. Exh: RI, RBA, RSA, RE, PS & Prov. AG's	*Ray*
RAYNER **Donald Lewis** b. Halstead, Essex. 1907 - Landscape watercolourist Exh: RA, RI, RBA, PS, Prov. AG's	D.L.RAYNER.
RAYNER, ARWS **Samuel** b. ? - 1874 Architectural subjects Exh: UK AG's	SR. 1870
READ. RWS **Samuel** b. Ipswich. 1816 - 1883 Architectural subjects Exh: RA, OWS, SS, London & Prov. AG's etc.	SR R SR
REALIER DUMAS **Maurice** b. Paris. 1860 - 1928 Genre subjects Exh: France	RÉALIER-DUMAS
RECHBERGER **Franz** b. Vienna. 1771 - 1841 Landscape artist Exh: Austria	HR R
RECLAM **Friedrich** b. Germany. 1734 - 1774 Portrait & landscape artist Exh: Germany, Holland	F. Reclam. pinxit
REDGRAVE, RA **Richard** b. London. 1804 - 1888 Genre & landscape artist Exh: RA, VA, NPG, France, Germany	RR
REDI **Tommaso** b. Florence. 1665 - 1726 Portraits, historical & allegorical subjects	T.Redi f
REDON **Odilon** b. Bordeaux. 1840 - 1916 Genre, portraits & still life subjects Exh: France, US, Holland.	odilon Redon R

REDON Odilon (Continued)	CDILON REDON adilonredon ODILON REDON ODILON REDON
REDOUTE Henri Joseph b. France. 1766 – 1852 Natural history subjects Exh: France	H·Jos Redouté
REDOUTE Pierre Joseph b. Belgium. 1759 - 1840 Floral subjects Exh: Belgium, France	P.J. Redouté fecit 1827 P.J. Redouté pinx
REDPATH, RSA, ARA Anne b. 1895 – 1965 Floral & landscape artist Exh: RA, RSA, GI, SSA, RBA etc.	Anne Redpath AR 1911
REEVE. RBA, ARE. Russell b. Norwich. 1895 - Etcher, oil & watercolourist etc. Exh: RA, NEAC, RP, PS, US., Canada, S. Africa etc.	Russell Reeve
REGAMEY Guillaume Urbain b. Paris. 1837 - 1875 Historical subjects Exh: France	Regamey Guillaume
REGEMORTER Ignatius Josephus Van b. Antwerp. 1785 - 1873 Genre, landscape subjects Exh: Holland, Belgium, Germany	Jgn. Van Regemorter iR
REGNAULT Henri Alexandre Georges b. Paris. 1843 - 1871 Historical, portrait & genre subjects Exh: France, Germany, US	HRegnault HRegnault
REGNAULT Jean Baptiste (Baron) b. Paris. 1754 - 1829 Mythological, historical & portrait artist Exh: France, Russia	Regnault De Rome 1786 Regnault

REGTERS **Tiebout** b. Holland. 1710 - 1768 Portraits & genre subjects Exh: Holland	*T Regters*
REHFOUS **Albert** b. Geneva. 1860 - ? Landscape artist Exh: Paris, Geneva	*A.Rehfous*
REICHMANN **Georg Friedrich** b. Germany. 1798 - 1853 Historical & portrait studies Exh: Germany	*GR* *GR*
REID **Sir George** b. Aberdeen. 1841 - 1913 Portrait & landscape artist Exh: RSW, RSA, UK, NPG, Australia	*R.*
REID **John Robertson** b. Edinburgh. 1851 - 1926 Genre, marine & landscape artist Exh: RA, RI, VA, UK, Australia, Germany	*John R. Reid* *J.R.R.*
REID **Stephen** b. Aberdeen. 1873 - 1948 Portraits & historical subjects Exh: RA, RBA, RI	STEPHEN REID/47
REIJERS **Nicolaas** b. Holland. 1719 - ? Portrait artist Exh: Holland	*N Reijers*
REILLY **Freda E.** Painter in pastel media Exh: PAS, London & Prov. AG's	*R.*
REITER **Barthelemy** b. Munich. ? - 1622 Religious, mythological & genre subjects	*BR*
REMBRANT (or RIJN) **Harmensz Van** b. Holland. 1606 - 1669 Portraits & historical subjects Exh: International AG's	*RL. Rs. Rij. Rijn.* 𝌆

REMBRANDT (or RIJN)
Harmensz Van

(Continued)

Rembrandt
f. 1666.

Rembrandt f

Rembrandt. f. v.

Rembrand P. f : 1640
Conterfeyt

Rembrandt. f. 1644.

Rt Inventor

Rembrandt f 1639

Rembrandt.
f. 1645.

Rembrandt f 1633

Rembrandt f

Rembrandt. f.
1634.

RHL. v.

Rijn f

Rt *Rn* *Rt* *Rt* *Rt* *Rt*

REMINGTON
Frederic
b. US. 1861 - 1909
Military & animal subjects
Exh: US

Frederic Remington '87 -

REMOND
Jean Charles Joseph
b. Paris. 1795 - 1875
Landscape artist
Exh: France

Remond

RENARD **Emile** b. France. 1850 - 1930 Portrait & genre artist Exh: France	EMILE RENARD.
RENEFER **Jean Constant Raymond** b. France. 1879 - 1957 Landscape subjects & illustrator Exh: Paris	renefer.
RENESSE **Constantin Adrien** b. Holland. 1626 - 1680 Genre & landscape artist Exh: Vienna	*(monogram)* *(monogram)*
RENI **Guido** b. Italy. 1575 - 1642 Religious & historical subjects Exh: France, Italy, Germany, UK, US, Scandinavia	Guido Reni faciebat G.R *(monogram)* G° R°° *(monogram)* *(monogram)* *(monogram)*
RENOIR **Pierre Auguste** b. Limoges. 1841 - 1919 Still life, genre, figure studies etc. Exh: International AG's	Renoir Renoir Renoir Renoir Renoir A. Renoir Renoir A. Renoir Renoir Renoir

RENOIR
Pierre Auguste

(Continued)

Renoir. 76

Renoir.

Renoir. 1916.

Renoir

Renoir. 81

Renoir

Renoir.

Renoir

RENTINCK
Arnold
b. Amsterdam. 1712 - 1774
Portraits & mythological subjects

AR

RESTOUT (The Younger)
Jean
b. Rouen. 1692 - 1768
Bibical, historical & portrait artist
Exh: France, Sweden

Restout 1734 *J. Restout 1734*

Restout *Restout*

RETHEL
Alfred
b. Germany. 1816 - 1859
Historical & portrait artist
Exh; Germany

A Rethel *AR* *AR*

A Rethel *AR* *AR*

AR *AR*

REYN (or RYN) **Jan Van De** b. Dunkirk. 1610 - 1678 Portraits & historical subjects Exh: France Belgium, Germany, UK, US	*J de Reyn 1660*
REYNAUD **Francois** b. Marseille. 1909 - Landscape & portrait artist Exh: France	*Fᵒⁱˢ Reynaud*
REYNOLDS. RI **Frank** b. 1876 - ? B/ white & watercolour media Exh: RA, RI	*Frank Reynolds.*
REYNOLDS **Frederick George** b. 1828 - 1921 Landscape artist Exh: London & Prov. AG's	*FR*
REYNOLDS. PRA **Sir Joshua** b. Devon. 1723 - 1792 Portraits & historical subjects Exh: International AG's	*J Reynolds*　　　SR 　　　　　　　　　　IR
REYNTJENS **Henrich Engelbert** b. Amsterdam. 1817 - 1859 Genre, portrait & historical subjects Exh: Holland, Vienna, Montreal	*H.E. Reyntjens. 1850*
RHEAD **George Woolliscroft** b. 1855 - 1920 Genre subjects Exh: London & Prov. AG's	*R*　　　　*R*
RHEAM **Henry Meynell** b. Birkenhead. 1859 - 1920 Genre subjects Exh: RI, UK AG's	*HMR*　　　*HMR.*
RHEEN **Theodorus Justinus** Fl. Holland. 18th C. Historical & portrait artist Exh: Holland	*T.J. Rheen*
RHEIN **Fritz** b. Germany. 1873 - ? Portrait, still life & landscape subjects Exh: Germany	*Fritz Rhein*

RHOMBERG **Joseph Anton** b. Germany. 1786 - 1855 Historical, genre & portrait subjects Exh: Germany	
RIBERA **Josef** b. Spain. 1588 - 1656 Biblical & portrait artist Exh: Spain, Italy, NG, France, Germany	*Joseph à Ribera Hispanus* *Jusepe de Ribera* *Espanol 1630* *Jusepe de Ribera.*
RIBERA **Pierre** b. Madrid. 1867 - ? Portrait & landscape artist Exh: Spain, France	*P. Ribera*
RIBOT **Theodule Augustin** b. France. 1823 - 1891 Historical, still life & portrait artist Exh: France, Holland, Germany	*t. Ribot t. Ribot* *t. Ribot. t Ribot*
RICARD **Louis Gustave** b. Marseille. 1823 - 1873 Portraits & still life subjects Exh: France, US, UK	*G. Ricard GR GR* *GR GR GR GR* *GR GR GR GR*

RICCHINO Francesco b. Italy. 1518 ? - 1568 ?	*F. Rizi*
RICCI Camillo b. Ferrara. 1580 - 1618 Portraits & historical subjects	*C Ricci 1617*
RICCI Marco b. Italy. 1676 - 1729 Historical & landscape subjects Exh: France, Italy, UK	*MRf* *MR*
RICCI Sebastian b. Nr. Venice. 1659 - 1734 Portraits, religious & historical subjects Exh: European AG's, UK, UK	*S. ricci 1730*
RICE Bernard Charles b. Innsbruck. 1900 - Painter & engraver Exh: London & Prov. AG's	*ƐR.*
RICH Alfred William b. Sussex. 1856 - 1921 Genre & landscape artist & watercolourist Exh: NEAC, BM, VA, UK AG's, Paris	<u>AWR</u>
RICHARD Alexandre Louis Marie Theodore b. France. 1782 - 1859 Landscape & genre subjects Exh: France	*T. Richard*
RICHARDS Ian Lindsay b. Australia. 1932 - Landscape artist Exh: Scottish, London & Prov. AG's	*Ian Richards 1975*
RICHARDSON John J. b. England. 1836 - 1913 Landscape artist	*John J Richardson*
RICHARDSON. (The Elder) Jonathan b. London. 1665 - 1745 Portrait artist Exh: NPG, VA	*J Richardson del* *1733.*

RICHARDSON, RSA, OWS **Thomas Miles (junior)** b. Newcastle. 1813 - 1890 Landscape oil & watercolourist Exh: VA, UK AG's	
RICHIR **Herman Jean Joseph** b. Belgium. 1866 - ? Portrait & genre subjects Exh: Belgium, UK	
RICHMOND, RA **George** b. Brompton. 1809 - 1896 Portraits & historical subjects Exh: RA, VA, NPG, UK AG's	
RICHMOND, RA **William Blake** b. London. 1842 - 1874 Historical & landscape artist Exh: RA, NPG, VA, UK AG's	
RICHTER **Adrian Ludwig** b. Dresden. 1803 - 1884 Landscapes & animal subjects Exh: Germany, US	
RICKETTS, RA **Charles** b. Geneva. 1866 - 1931 Genre & historical subjects Exh: RI, RA, UK AG's	
RICO Y ORTEGA **Martin** b. Madrid. 1833 - 1908 Genre & landscape subjects Exh: Spain, France, US	
RIDDEL. ARSA, RSW **James** b. Glasgow. ? - 1928 Portrait, genre & landscape artist Exh: RA, RSA, & Prov. AG's	
RIDEL **Louis Marie Joseph** b. France. 1866 - ? Genre subjects Exh: France, Holland	
RIEDEL **Anton Henrich** b. Dresden. 1763 - 1809 ? Portrait artist	

RIEDEL **August Heinrich** b. Germany. 1799 - 1883 Portraits, genre & historical artist Exh: Germany	
RIESENER **Louis Antoine Leon** b. Paris. 1808 - 1878 Religious, historical & genre subjects Exh: France	
RIETSCHOOF **Jan Claes** b. Holland. 1652 - 1719 Marine artist Exh: Holland, Sweden, Leningrad	
RIGAUD **Hyacinthe Francois Honore** b. France. 1659 - 1743 Portraits & historical subjects Exh: France, UK, Germany, etc.	
RIGAUD **Pierre Gaston** b. Bordeaux. 1874 - ? Marine & landscape artist Exh: France	
RIJN (or RYN)	see **REMBRANDT** Harmensz Van
RIKKERS **Willem** b. Amsterdam. 1812 - ? Portraits & interior subjects	
RILEY. FRSA **Frank W.** b. London. 1922 - Portraits, still life & landscape artist Exh: RA, London AG's	
RILEY **Thomas** Fl. London. 1880 - 1892 Painter & engraver	
RINGELING **Hendrick** b. Holland. 1812 - 1874 Portrait & genre subjects Exh: Holland	

RINGGLI **Gotthard** b. Zurich. 1575 - 1635 Historical subjects Exh: Switzerland	CR CR
RIOU **Edouard** b. France. 1833 - 1900 Landscape artist Exh: France	*Riou*
RIPPINGILLE **Edward Villiers** b. Kings Lynn. 1798 - 1859 Genre subjects Exh: UK AG's	E.V.R-1837
RIPSZAM **Henrik** b. Hungary. 1889 - Pastel, oil & watercolour media etc. Exh: France, Hungary, UK, Tokyo, S. America, etc.	*H. Ripszam*
RITCH-WEIMAR **Christophe** Fl. Germany. 1670 - Landscape artist	CR
RITCHIE. ARIBA **David Archibald Hugh** b. Lanark. 1914 - Pen & ink, oil, watercolour media etc. Exh: RI, London & Prov. AG's	RITCHIE
RITTER **Wilhelm Georges** b. Germany. 1850 - 1926 Landscape artist Exh: Germany	W.G.Ritter
RIVALS (or RIVALZ) **Jean Pierre** b. Languedoc. 1625 - 1706 Portraits, architectural & historical subjects	P. Rivalz 1670
RIVALZ **Antoine** b. Toulouse. 1667 - 1735 Portraits & historical subjects Exh: France	Rivalz 1730
RIVIERE **Benjamin Jean Pierre Henri** b. Paris. 1864 - 1951 Landscape artist Exh: France	

RIVIERE Benjamin Jean Pierre Henri (Continued)	*Henri RIVIÈre*
RIVIERE. RA **Briton** b. 1840 - 1920 Genre, historical & animal subjects Exh: RA, SS, BI, GG, Germany, Australia, etc.	*Briton Riviere 1869* *B* *B Riviere* *AB*
RIVIERE **Charles** b. France. 1848 - 1920 Still life & animal subjects Exh: France	CHARLES-RIVIÈRE
RIVIERE. MA **Hugh Goldwyn** b. London. 1869 - 1956 Portrait artist Exh: RA, London & Prov. AG's	*HRiviere*
ROBAUDI **Alcide Theophile** b. Nice. Fl. 19th C. Portrait, genre, historical & landscape artist Exh: France	*A. Robaudi.*
ROBB **Brian** b. Scarborough. 1913 - B/white & oil media Exh: London & Prov. AG's	*Brian Robb*
ROBBE **Louis Marie Dominique Romain** b. Belgium. 1806 - 1887 Animal landscapes Exh: Belgium, France	*Robbe.* *Robbe*
ROBELLAZ **Emile** b. Lausanne. 1844 - 1882 Genre subjects Exh: Switzerland, France	*E. Robellaz*
ROBERT **Alexandre Nestor Nicolas** b. Belgium. 1817 - 1890 Genre & portrait artist Exh: Belgium	*Robert*

ROBERT **Hubert** b. Paris. 1733 - 1808 Genre, architectural & landscape artist Exh: France, Belgium, US, Germany	*H ROBERT 1788* *H·ROBERT ROMA* *HR·1769* *H Robert* *·H· ROBERT·* *H·ROBERT F· ∧NO* *H·ROBERT F· ∧NO 1784·*
ROBERT **Leopold Louis** b. France. 1794 - 1835 Genre & landscape artist Exh: France, Germany	*L Robert 1831* *LR*
ROBERT **Nicolas** b. France. 1614 - 1685 Genre artist & miniaturist	*NR*
ROBERT-FLEURY **Joseph Nicolas** b. Cologne. 1797 - 1890 Historical & biblical subjects Exh: France, Holland, US	*J.N. Robert-fleury* *Robert-fleury* *N.*
ROBERT FLEURY **Tony** b. Paris. 1837 - 1912 Historical & genre subjects Exh: France, Germany, US	*TRobert-Fleury.*
ROBERTS. RI, RBA **Henry Benjamin** b. Liverpool. 1832 - 1915 Figure & genre artist Exh: RA, SS, NWS, BI, etc.	*HB*
ROBERTS **Marguerite Hazel** b. Llandudno. 1927 - Painter in pen & wash & oil media Exh: RA, R.Cam.A., London & Prov. AG's	*MR.*

ROBERTS. ROI Phyllis Kathleen b. London. 1916 - Portrait & landscape artist Exh: RA, PS, ROI, RBA, Prov. AG's etc.	*P.K. ROBERTS*
ROBERTS Walter James b. Doncaster. 1907 - B/white, oil & watercolourist Exh: London & Prov. AG's	*Walter J. Roberts* *R*
ROBERTSON. ARWS, RPE Charles b. 1844 - 1891 Genre & landscape artist Exh: RA, OWS, SS, NWS, London & Prov. AG's	*R*
ROBERTSON. RPE Henry Robert b. Windsor. 1839 - 1921 Portrait, genre, landscape artist & miniaturist Exh: RA, BI, NWS, SS, GG, etc.	*R*
ROBERTSON Janet b. London. 1880 - ? Portrait, miniature & landscape artist Exh: RA, NPS, RMS, etc.	*JR*
ROBERTSON Janet Elspeth b. 1896 - Watercolourist Exh: London & Prov. AG's, France, Canada, US, etc.	*J Elspeth Robertson .*
ROBERTSON Walford Graham b. 1867 - 1948 Portrait & landscape artist Exh: London & Prov. AG's	*RG* *RG* *RG*
ROBIE Jean Baptiste b. Brussels. 1821 - 1910 Still life subjects Exh: Belgium, Sydney	*J Robie*
ROBINSON. BA Agnes Agatha b. Winnipeg Still life & landscape artist etc. Exh: RA, PAS, SWA, IWAC, US, etc.	*Agnes "Agatha" Robinson* *AAR.*
ROBINSON Charles F. Fl. London. 19th C. Landscape artist Exh: RA, SS, NWS, London & Prov. AG's	*CR* *RR* *CR*

ROBINSON **Douglas F.** b. London. 1864 - 1929 Figure & marine artist Exh: RA, SS, France	D.R. D.R.
ROBINSON **Mabel C.** b. London. 1875 - ?	R
ROBINSON **Sir John Charles** b. Nottingham. 1824 - 1912 Floral & landscape artist Exh: RA, VA, RE	J(R J(R
ROCHEBRUNE **Octave Guillaume De** b. France. 1824 - 1900 Genre subjects Exh: France	OR
ROCHEGROSSE **Georges Antoine** b. Versailles. 1859 - 1938 Genre subjects Exh: France	G. Rochegrosse
ROCHLING **Karl** b. Germany. 1855 - 1920 Battle scenes Exh: Germany	C.Röchling
ROCHUSSEN **Charles** b. Rotterdam. 1824 - 1894 Historical subjects Exh: Holland	CR
RODE **Niels** b. Copenhagen. 1742 ? - 1794 Genre subjects Exh: Holland	N:Rode:p
RODMELL. RI, SMA, FRSA **Harry Hudson** b. 1896 - Marine artist Exh: RA, RI, SGA, SMA, Prov. AG's, France, etc.	HARRY HUDSON RODMELL
ROEDIG **Johannes Christianus** b. The Hague. 1751 - 1802 Floral artist Exh: Holland, Leningrad	C.Roedig

ROELOFS **Willem** b. Amsterdam. 1822 - 1897 Landscape subjects Exh: Holland, Belgium, France	*W: Roelofs. f.*
ROEPEL **Coenraet** b. The Hague. 1678 - 1748 Still life & floral subjects Exh: Holland, Germany	*Coenraet Roepel f*
ROESTRAETEN (ROESTRATEN) **Pieter Van** b. Haarlem. 1630 ? - 1700 Still life & portrait artist Exh: Germany, Holland, France, US, UK	*P. Roestraeten 1691*
ROGER **Louis** b. Paris. 1874 - 1953 Historical & genre subjects Exh: France, Bucharest	*Louis Roger* *Roger*
ROGHMAN **Roeland** b. Amsterdam. 1597 - 1686 Landscape subjects Exh: Germany, France, London	*R*
ROLL **Alfred Philippe** b. Paris. 1846 - 1919 Portrait, military & landscape subjects Exh: France	*aRoll*
ROLLINSON. RCA **Sunderland** b. Knaresborough. 1872 - ? Etcher, tempera, oil & watercolourist etc. Exh: RA, RBA, RI, RWS, R.Scot.A., Prov. AG's, Europe, US	*S. Rollinson.*
ROMANET **Ernest Victor** b. Paris. 1876 - ? Floral subjects Exh: France	*E. Romanet*
ROMANI **Juana** b. Italy. 1869 - 1924 Portrait & historical subjects Exh: France	*Juana Romani*
ROMBOUTS **Theodor** b. Antwerp. 1597 - 1637 Portraits & historical subjects Exh: Holland, Germany, Russia, France, Austria	*T Rombouts* *12ᵗⁱ. 1637*

ROMER **Zofja** b. Dorpat. 1885 - Portraits & landscape artist Exh: UK, Poland, Russia, France, US, Italy, etc.	*Z Romez*
ROMYN **Conrad** b. London. 1915 - Biblical subjects, sea & landscapes, figure compositions & illustrator Exh: RA, RSBA, RCA, RI, Scandinavian, French & UK AG's	*Romyn · ROMYN C.R. CR*
RONALD. RSW **Alan Ian** b. Edinburgh. 1899 - Oil & watercolourist Exh: UK, Australia, US & European AG's	*A.I.Ronald*
RONALDSON. MA **Thomas Martine** b. Edinburgh. 1881 - ? Portrait artist Exh: RA, RSA, PS, WAG	*MR*
RONDANI **Francesco Maria** b. Parma. 1490 - 1548 Religious subjects Exh: Germany, Russia	*FMRondani 1530*
RONDEL **Henri** b. Avignon. 1857 - 1919 Historical & portrait subjects Exh: France	*H. RONDEL*
RONNER-KNIP **Henriette** b. Amsterdam. 1821 - 1909 Genre & animal subjects Exh: Holland, France, Belgium	*Henriette Ronner*
RONOT **Charles** b. France. 1820 - 1895 Biblical, portrait & genre subjects Exh; France	*C. RONOT.*
ROOKE. ARE **Noel** b. London. 1881 - 1953 Painter & engraver Exh: London & Prov. AG's	*Noel Rooke*
ROOKE. RWS **Thomas Matthew** b. London. 1842 - 1942 Portrait, religious, architectural & landscape artist Exh: RA, NWS, NG, GG, OWS, etc.	*GR TMR*

ROOS Jacob b. Rome. 1682 - ? Landscape subjects Exh: France, Germany	*Rosa. F*
ROOS Johann Heinrich b. Otterberg. 1631 - 1685 Portraits & animal subjects Exh: Russia, European AG's	*JH Roospt 1684* *JHR*
ROOS Johann Melchior b. Frankfurt. 1659 - 1731 Historical, portrait & animal subjects Exh; Germany, Holland	*JMRoos* *JMRoos. Fecit.1716.* *JMR*
ROOSENBOOM Margarete b. The Hague. 1843 - 1896 Floral artist Exh: Holland	*Marg.t RoosenBoom*
ROPS Felicien Joseph Victor b. Belgium. 1833 - 1898 Genre subjects Exh: France, Belgium, UK	*Félicien Rops* *F Rops 76* *F Rops*
ROQUEPLAN Camille Joseph Etienne b. France. 1803 - 1855 Genre & landscape subjects Exh: France, Germany, US, UK	*Camille Roqueplan*
ROSA Salvator b. Italy. 1615 - 1673 Genre, battle scenes, marine, landscape & historical subjects Exh: European AG's, US, UK, etc.	*Salvator Rosa* *Salvator Rosa* *SR SR SR SR R* *SR SR R SR SR*

ROSA Salvator (Continued)	Salvator Rosa Sal. Rosa.
ROSAPINA Francesco b. Italy. 1762 - 1841 Genre subjects Exh: Italy	*R* *FR*
ROSE, ARCA, RSA Gerard De b. Accrington. 1921 - Portrait artist Exh: X, London & Prov. AG's, Australia, US	Gerard De Rose .
ROSE. RBA, ROI, FFPS Muriel b. London. 1923 - Landscape artist, print maker etc. Exh: RA, RSA, RGI, Paris, US, S. Africa, Prov. AG's, etc.	Muriel Rose MR
ROSIER Jean Guillaume b. Belgium. 1858 - 1931 Historical & portrait artist Exh: Belgium, US	J. G. Rosier
ROSLIN Alexandre b. Sweden. 1718 - 1793 Portrait artist Exh: Scandinavia, France	Le Chev Roslin
ROSS. MSIA Victor b. Nowawes. 1899 - Pen & wash, oil media, etc. Exh: London AG's, Germany	VR
ROSSEELS Jacob b. Antwerp. 1828 - 1912 Landscape subjects Exh: Belgium	J. Rosseels J. Rosseels
ROSSELLI Matteo b. Florence. 1578 - 1650 Portraits & historical subjects Exh: France, Hungary, Italy	MR 608
ROSSER. Mem.USA John b. London. 1931 - Genre subjects, town & landscapes Exh: RI, ROI, NEAC, US, PS, R.Cam.A., London & Prov. AG's X. UK, US.	R

ROSSET-GRANGER **Paul Edouard** b. France. 1853 - ? Portrait & genre subjects Exh: France	*E. Rosset-Granger*
ROSSETTI **Gabriel Charles Dante** b. London. 1828 - 1882 Portraits, figure & historical subjects Exh: NG, NPG, VA, Prov. AG's, US.	*DCR*
ROSSI **Joseph** b. France. 1892 - 1930 Figure & landscape artist Exh: France, US	*Rossi*
ROSSI **Lucius** b. Rome. 1846 - 1913 Genre & portrait artist Exh: France	*Lucius Rossi*
ROSSITER. PAS **Walter** b. Bath. 1871 - ? Architectural & landscape artist Exh: RA, RI, PS, PAS	*W. Rossiter.*
ROTENBECK **George Daniel** b. Nuremberg. 1645 - 1705 Historical & portrait artist	*GDR.S.*
ROTHENSTEIN **Sir William** b. Bradford. 1872 - 1945 Portraits, landscapes & interior scenes Exh: UK AG's, Canada, Germany, US, Australia	*WMR* *WR* *WR*
ROTIG **Georges Frederic** b. Le Havre. 1873 - 1961 Animal subjects Exh: France	*G.F. Rötig*
ROTTENHAMMER **Johann** b. Munich. 1564 - 1625 Mythological & biblical subjects Exh: Holland, Belgium, Germany, France, Italy, UK, etc.	*J. Rottenhammer* *1608*
ROTTMANN **Carl** b. Germany. 1795 - 1850 Landscape artist Exh: Germany	*R* *R*

ROUART **Ernest** b. Paris. 1874 - 1942 Figure studies Exh: France	
ROUAULT **Georges** b. Paris. 1871 - 1958 Biblical; portrait & landscape subjects Exh: France, US	
ROUBILLE **Auguste Jean Baptiste** b. Paris. 1872 - 1955 Genre subjects Exh: France	
ROUILLARD **Jean Sebastien** b. Paris. 1789 - 1852 Historical & portrait artist Exh: France	
ROULLET **Gaston** b. France. 1847 - 1925 Marine & landscape artist Exh: France	
ROUSSEAU **Henri** b. Paris. 19th C. Portraits & genre artist Exh: France	
ROUSSEAU **Henri Julien Felix** b. France. 1844 - 1910 Portraits, genre & landscape artist Exh: France, US	
ROUSSEAU **Jean Jacques** b. Paris. 1861 - ? Figure, animal & landscape subjects Exh: France	
ROUSSEAU **Philippe** b. Paris. 1816 - 1887 Still life, genre & landscape artist Exh: France	

ROUSSEAU **Theodore** b. Paris. 1812 - 1867 Landscape subjects Exh: France, Holland, US, London, Belgium	*TH.Rousseau* *TH. Rousseau. THR.*
ROUSSEAU-DECELLE **Rene** b. France. 1881 - 1964 Genre subjects Exh: France	*R Rousseau-Decelle*
ROUSSEL **Ker Xavier** b. France. 1867 - 1944 Genre & mythological subjects Exh: France, Russia, Scandinavia	*K.X. roussel.*
ROUX **Emile** b. France. 19th C. Marine & landscape subjects Exh: France	*E.ROUX*
ROWAN **Alexander** Fl. Mid 19th C. Religious subjects Exh: RA, BI	*R*
ROWLANDSON **Thomas** b. London. 1756 - 1827 Historical, portrait & landscape artist Exh: RA, VA, London & Prov. AG's	*Rowlandson*
ROWLEY **Jean** b. Mersey Island. 1920 - Nature subjects, oil & ceramics media Exh: RBA & Southern UK AG's	*JEAN ROWLEY* *ROWLEY* *R*
ROWNTREE. ARWS **Kenneth** b. Scarborough. 1915 - Oil & watercolourist Exh: AIA, London & Prov. AG's	*Kenneth Rowntree* *KR.*
ROY **Pierre** b. Nantes. 1880 - 1950 Genre subjects & illustrator Exh: France, US, UK	*Pierre Roy*

ROYBET
Ferdinard
b. France. 1840 - 1920
Portrait & genre subjects
Exh: France, US, Canada, Russia etc.

ROYE
Jozef Van De
b. Antwerp. 1861 - ?
Still life subjects
Exh: Belgium

ROYER
Henri Paul
b. Nancy. 1869 - ?
Genre, portrait & landscape subjects
Exh: France

ROZIER
Dominique Hubert
b. Paris. 1840 - 1901
Still life subjects
Exh: France

RUBENS
Peter Paul
b. Siegen. 1577 - 1640
Portraits, historical, genre &
landscape artist
Exh: International AG's

RUBIN **Reuven** b. Roumania. 1893 - Oil & watercolourist Exh: France, Italy, Israel, US, UK	ראובן rubin
RUBIO **Luigi** b. Rome. ? - 1882 Historical & portrait artist Exh: Italy, Poland	*L. Rubio* *Genéve*
RUDING-BRYAN **Charles Dudley** b. Bristol. 1884 - Architectural subjects etc. Exh: London & Prov. AG's	CDRB
RUIPEREZ **Luis** b. Spain. 1832 - 1867 Historical, genre & portrait artist	*Ruiperez*
RUISDAEL (or RUYSDAEL) **Jacob Isaakszoon** b. Haarlem. 1628 ? - 1682 Landscape subjects Exh: Holland, Belgium, France, UK, US, etc.	*vRuisdael* *Ruisdael* *Ruysdael in. 1649* *JR.661.* *Ruisdael* *Ruysdael f.* *JR. 1661.* *Ruisdael* *JRF 1660* *JRF.* *JR R R R R*
RUISDAEL (or RUYSDAEL) **Jakob Salomonsz** b. Haarlem. 1630 ? - 1681 Landscape artist Exh: Holland, France, Hungary, Scandinavia	*JR* *JR*

RUISDAEL (or RUYSDAEL) **Salomon Van** b. Holland. 1600 ? - 1670 Landscape artist Exh: UK & European AG's etc.	*RUYSDAEL . 1662* *SRuysdael 1650* *SRuysdael 1649* *Ruysdael fecit 1650* *SvR 1635* *SR* *SvR* *SR* *SvR*
RUITH **Horace Van** Fl. 1888 - 1914 Portrait, figure, genre & landscape artist Exh: RA, UK AG's, Germany	*FR.* *FR.*
RUL **Henri Pieter Edward** b. Antwerp. 1862 - ? Landscape artist Exh: Belgium, Holland	*Henry Rul*
RUNDT **Carl Ludwig** b. Germany. 1802 — 1868 Architectural, landscapes & genre subjects Exh: Germany	*CR*
RUPPRECHT **Tini** b. Munich. 1868 - ? Landscape artist	*Tini Rupprecht*
RUSINOL **Santiago** b. Barcelona. 1861 - 1931 Landscape artist Exh: France	*S. Rusinol*
RUSKIN. HRWS **John** b. London. 1819 - 1900 Architectural, floral & landscape artist Exh: OWS, RWS, London & Prov. AG's	*JR JR JR JR JR VR*
RUSS **Karl** b. Vienna. 1779 - 1843 Historical subjects	*K R*

RUSSELL **Capt. Harold Alain** b. France. 1893 - Fish, insects, land & seacape artist Exh: RSA, London & Prov. AG's, France	
RUSSELL. ARA **Walter** b. Boston. 1871 - ? Child portraits Exh: UK, US, Spain, Italy	
RUSSELL-ROBERTS **Ethel Marguerite de Vilieneuve** Landscape artist Exh: RI, SWA, London & Prov. AG's	
RUSSON **Agatha** b. Wisconsin, US. 1903 - Crayon, oil & watercolourist Exh: ROI, RBA, London & Prov. AG's	
RUTHERSTON. Hon.MA., RWS **Albert Daniel** b. Bradford. 1881 - 1953 Figure & landscape artist Exh: NEAC, RI, France, Italy, S. America, etc.	
RUTLAND (Duchess of) **Violet.** b. Lancashire. 19th C. Sculptor & portrait artist Exh: RA, London & Prov. AG's, France, US	
RUTTER. ARCA **Thomas William** b. Yorkshire. 1874 - ? Landscape artist Exh: RA, ROI, R.Cam.A.	
RUYSCH **Rachel** b. Amsterdam. 1664 - 1750 Fruit & floral subjects Exh: France, Belgium, Austria, Germany, UK	
RUYTEN **Jean** b. Antwerp. 1813 - 1881 Historical, architectural,landscapes & interior scenes Exh: Germany, France, Belgium, Holland	
RUYTENSCHILDT **Abraham Jan** b. Amsterdam. 1778 - 1841 Genre & landscape subjects	

RUZICKA **Othmar** b. Vienna. 1877 - ? Genre & portrait artist	*Othmar Ruzicka*
RYAN **Adrian** b. London. 1920 - Oil & watercolourist Exh: RA, London & Prov. AG's	*Ryan*
RYAN **June** b. London. 1925 - Portrait artist & miniaturist Exh: RI, London AG's etc.	*June Ryan*
RYCK **Pieter Cornelisz Van** b. Delft. 1568 - 1635 ? Genre subjects Exh: Holland	*PVR p.*
RYCKAERT **David I** b. Antwerp. 1560 - 1607 Genre & figure subjects	*DR*
RYCKAERT **David II** b. Antwerp. 1596 - 1642 Landscapes & interiors Exh: Belgium	*DR* *DR*
RYCKERE **Bernard** b. Belgium. 1535 ? - 1590 Biblical subjects Exh: Belgium	*R* *R* *R*
RYCKKALS **Frans** b. Holland. 1600 - 1647 Genre, still life & landscape subjects Exh: Holland, Germany, Belgium	*FRNS 1640*
RYDER. RMS, SWA, etc. **Margaret Elaine** b. Sheffield. 1908 - Portrait, floral, landscape artist & miniaturist Exh: RA, PS, PAS, Prov. AG's	*ME Ryder.*
RYLAND. RI **Henry** b. Biggleswade. 1856 - 1924 Classical figure subjects Exh: RA, GG, NG, NWS, London & Prov. AG's	*H. R.*

RYLAND. RBA, SWA, ROI, etc. **Irene** Still life & landscape artist Exh: RA, NEAC, Prov. AG's, PS, Canada	*Irene Ryland*
RYSBRACK **Pieter** b. Antwerp. 1655 - 1729 Figure & landscape artist	*P Rysbraer*
RYSSELBERGHE **Theodore** b. Belgium. 1862 - 1926 Genre & portrait artist Exh: Holland, Belgium, France	*Théov Ro 1888*

S

SAAGMOLEN **Martinus** b. Holland. 1620 - 1669 Historical subjects	
SACCHI **Andrea** b. Italy. 1599 - 1661 Historical & portrait artist Exh: Italy, France, Spain, Germany	*A Sacchi 1650*
SACCHI **Carlo** b. Pavia. 1616 - 1706 Historical subjects	*C. Sacchi 1705*
SADELER **Aegidius** b. Antwerp. 1570 - 1629 Religious subjects Exh: Germany, Austria	*Æ Æ.S Æeg. S. Æ*
SADLER. MSIA **Geoffrey. M.** b. London Gouache, oil & watercolourist Exh: WAG, London & Prov. AG's	*Geoff sadler*
SADLER. RBA **Walter Dendy** b. Dorking. 1854 - 1923 Interior & genre artist Exh: RA, GG, SS, London & Prov. AG's	*WDS Sᵃ*

SAEMREDAM **Jan Pietersz** b. Holland. 1565 - 1607	
SAFTLEVEN **Herman** b. Rotterdam. 1609 ? - 1685 Landscape artist Exh: France, Holland, Germany, Hungary, UK, etc.	*Herman Saft Leven* *f.A. Utrecht. Anno 1665*
SAHAI. ARIBA **Virendra** b. India. 1933 - Ink, oil & watercolourist Exh: London & Prov. AG's, France	
SAIN **Edouard Alexandre** b. France. 1830 - 1910 Portrait & genre artist Exh: France, US	*E. Sain*
SAINT ANDRE **Simon Bernard De** b. Paris. 1614 - 1677 Portrait & still life subjects Exh: France	*St A.*
SAINT AUBERT **Antoine Francois** b. France. 1715 - 1788 Genre subjects Exh: France	*St Aubert*
SAINT AUBIN **Gabriel Jacques De** b. Paris. 1724 - 1780 Genre & portrait artist Exh: France	*SA*
SAINT GERMIER **Joseph** b. Toulouse. 1860 - 1925 Genre subjects Exh: France	*J. Saint-Germier*
SAINT JEAN **Simon** b. Lyon. 1808 - 1860 Floral artist Exh: France, London, Holland	*Saint-Jean*
SAINT MARCEL-CABIN **Charles Edme** b. Paris. 1819 - 1890 Animal & landscape subjects Exh: France	EDME St-MARCEL *Saint-marcel*

SAINT PIERRE **Gaston Casimir** b. France. 1833 - 1916 Portrait & genre subjects Exh: France	*G. Saintpierre*
SAINT-SAENS b. France. ? - 1890 ? Floral & animal subjects Exh: France	*C Saint-Saëns*
SAINTIN **Henri** b. Paris. 1846 - 1899 Landscape subjects Exh: France	*Henri Saintin*
SALA **Juan** b. Barcelona. 1867 - 1918 Genre & landscape subjects	*Jean* **SALA**
SALADINI **Achille** b. Lyon ? - 1895 Landscape artist Exh: France	*Saladini*
SALISBURY. RPS, CVO, LL.D. **Frank O.** b. Harpenden. 1874 - 1962 Portraits & historical subjects etc Exh: RA, RI, RP, Prov. AG's, Canada, US, etc.	*Frank O Salisbury*
SALKELD. ARHA **Cecil Ffrench** b. Assam. 1908 - Tempera, pencil, oil media etc. Exh: London & Prov. AG's, Germany, US, Canada	
SALLAERT **Antoine** b. Brussels. 1590 ? - 1657 ? Historical & portrait artist Exh: Belgium, Spain	ANT SALLAERT A S A^S
SALLINEN **Tyko Konstantin** b. Finland. 1879 - ? Portrait & landscape artist Exh: Scandinavia, Germany	*Sallinen*
SALMON. DA **James Marchbank** b. Edinburgh. 1916 - Pen/ink, oil & watercolourist Exh: RA, RSA, SSA, RSW, Prov. AG's, Germany, etc.	*J Marchbank Salmon*

SALMSON **Hugo Frederik** b. Stockholm. 1844 - 1894 Genre & portrait subjects Exh: Sweden. France	HUGO SALMSON
SALOME **Emile** b. Lille. 1833 - 1881 Genre & landscape subjects Exh: France	E. Salomé
SALOMON **Bernard** b. Lyon. 1506 ? - 1561 ? Exh: France	BB
SALTZMAN. BS **William** b. Minnesota, US. Abstract & surrealistic subjects etc. Exh: Principal US AG's	W. Saltzman
SALVAT **Francois Martin** b. France. 1892 - Genre, portrait & landscape artist Exh: France	Salvat
SAMACHINI **Orazio** b. Bologna. 1532 - 1577 Religious subjects Exh: Italy	Horatios
SAMBACH **Franz Gaspard** b. Germany. 1715 - 1795 Religious subjects Exh: Germany, Vienna	C Sambach. 1778
SAMBOURNE **Linley** b. UK. 1844 - 1910 Illustrator, cartoonist & painter Exh: RA, France	LS.
SAND **Maurice** b. Paris. 1823 - 1889 Genre subjects Exh: France	M. SAND
SANDERS. ARMS **Margery Beverly** b. London. 1891 - Miniaturist & portrait artist Exh: PS, RA, RMS, WAG, Prov AG's, Canada	MS

SANDRART **Jan** b. Frankfurt. 1588 - 1679 ? Religious subjects Exh: Germany	
SANDRART **Joachim** b. Frankfurt-on-Maine. 1606 - 1688 Portraits, landscapes & historical subjects Exh: Germany, Holland, Italy etc.	
SANDYS **Frederick** b. England. 1832 - 1904 Portrait & figure artist Exh: RA, UK, Melbourne	
SANT. RA **James** b. London. 1820 - 1916 Portrait, allegorical & genre subjects Exh: RA, London AG's, Australia, Germany	
SANTAFEDE **Francesco** b. Italy. 1519 - ? Religious subjects	
SANTAMARIA Y SEDANO **Marceliano** b. Spain. 1866 - ? Genre subjects Exh: Spain, Chile	
SANTERRE **Jean Baptiste** b. France. 1651 - 1717 Historical & portrait artist Exh: France, Russia	
SANTI **Raffaello**	see **RAFFAELLO** Santi
SARACENI (or SARRACINO) **Carlo** b. Venice. 1585 - 1620 Religious subjects Exh: Italy	
SARGENT **John Singer** b. Florence. 1856 - 1925 Portrait & genre artist Exh: RA, RI, RSA, UK, US, Paris	

SARLUIS **Leonard** b. The Hague. 1874 - 1949 Genre subjects & illustrator Exh: France	**SARLUIS**
SARTO **Andrea Del**	see **D'AGNOLO** **Andrea**
SASSOFERRATO **(called Giovanni Battista Salvi)** b. Sassoferrato. 1609 - 1685 Religious subjects Exh: European AG's, Russia, US, UK	*S. Ferrato*
SAUBER **Robert** b. London. 1868 - 1936 Genre & portrait artist Exh: RA, SS, London & Prov. AG's, France	*S*
SAUERWEID **Alexandre Ivanovitch** b. Russia. 1783 - 1844 Military subjects Exh: Russia	*Æ*
SAUNIER **Noel** b. Vienna. 1847 - 1890 Genre subjects Exh: France	*Noël Saunier - 1887 -*
SAUTER **Rudolf Helmut** b. Bavaria. 1895 - Portraits, still life, semi-abstract & landscape artist Exh: RA, RSA, IS, RP, WAG, US, etc.	*Rudolf Sauter* *R.S.* *R.H. Sauter* *R.S.*
SAUVAIGE **Louis Paul** b. Lille. 1827 - 1885 Marine & landscape subjects	*L.P. Sauvaige*
SAVAGE. VP.PAS etc **Ernest George** b. London. 1906 - Landscapes in pastel, watercolour & gouache media Exh: RI, PAS, RWS, London & Prov. AG's. X	*ERNEST SAVAGE*

SAVAGE **Francis B.** b. Wallasey. 1908 - Oil &watercolourist Exh: RA, PS, RI, ROI, RSW, GI etc.	*Savage*
SAVERY **Roeland** b. Courtrai. 1576 - 1639 Animals, floral & landscape subjects Exh: Russia, European AG's	R . SAVERY. SR. RS
SAVIN **Maurice Louis** b. France. 1894 - Figure & genre subjects Exh: France, UK, Poland, Scandinavia	*savin*
SAVOYEN **Carel Van** b. Antwerp. 1621 ? - 1665 Religious & historical subjects Exh: Holland, France	C.V.S.
SAVREUX **Maurice** b. Lille. 1884 - Landscape & still life subjects Exh: France, US	*Maurice Savreux*
SAXTON **Christopher Richard** b. Retford. 1909 - B/white, pastel & watercolourist Exh: London & Prov. AG's	RICHARD SAXTON
SAXTON **Colin** b. Mirfield (UK). 1927 - Abstract (optical effects) & landscape artist Exh: London & Prov. AG's, Yugoslavia	SAXTON
SAY **William** b. England. 1768 - 1834 Genre, Portrait & landscape artist	(WS)
SCALBERT **Jules** b. France. 1851 - ? Floral, genre & historical subjects Exh: France	Scalbert
SCALES **Edith Marion** b. Newark. Fl. 20th C. Oil & watercolourist Exh: RA, PS, RSA, ROI, RI, WAG, RBA, etc.	SCALES

SCANLAN **Robert** b. Eire. 1908 - Painter & illustrator Exh: London & Prov. AG's, France, Rumania, etc.	*Scanlan*
SCHAAL **Solange** b. France. 1899 - Genre, portrait & landscape artist Exh: France	SCHAAL
SCHADOW **Wilhelm** b. Berlin. 1788 - 1862 Religious & portrait artist Exh: Germany	*W Schadow*　　WW　　WW
SCHAEFELS **Hendrik Frans** b. Antwerp. 1827 - 1904 Marine & historical subjects Exh: Belgium	*Hendrik.J Schaefels pix*　　HF.
SCHAEFELS **Lucas** b. Antwerp. 1824 - 1885 Still life & floral subjects Exh: Belgium	*Luc·Schaefels fecit*
SCHAEP **Henri Adolphe** b. Holland. 1826 - 1870 Marine artist Exh: Antwerp	*Henri Schaep ft*
SCHAEPKENS **Theodor** b. Germany. 1810 - 1883 Genre subjects Exh: Germany	*Th·S.*　　*Th·S*
SCHAFER. RBA **Henry Thomas** Fl. London. 19th — 20th C. Genre artist & sculptor Exh: RA, GG, NWS, SS, etc.	H.T.S
SCHAFFNER **Martin** b. Germany. 1478 ? - 1546 ? Religious & portrait subjects Exh: Germany, France	ISt　　M　　M
SCHALCKEN **Godfried** b. Dortrecht. 1643 - 1706 Portraits & genre subjects Exh: European AG's, UK	*G.Schalckenpinx*　　*GS pinxit*　　*GS.f.*

SCHALLHAS **Carl Philipp** b. Germany. 1767 - 1797 Landscape & genre subjects Exh: Budapest	*RC. Schallhas. ft.*
SCHAMPHELEER **Edmond De** b. Brussels. 1824 - 1899 Landscape artist Exh: Belgium	*E DE Schampheleer*
SCHATTENHOFER **Amalia Von** b. Germany. 1763 - 1840 Portrait & genre subjects	*A Bf* *B* *B* *AB*
SCHAUFFELIN (The Younger) **Hans** b. Germany. 1515 - 1582 ?	*H* *H S* *H*
SCHAUFFELIN **Hans Leonard** b. Nuremberg. 1480 ? - 1538 ? Religious & portrait artist Exh: Germany, Austria	*HSL*
SCHEFFER **Ary** b. Germany. 1795 - 1858 Historical & portrait artist Exh: France, Germany, UK, US	*Ary Scheffer* *Ary Scheffer 1833* *ary Scheffer*
SCHEFFER **Henry** b. The Hague. 1798 - 1862 Religious & genre & portrait artist Exh: Germany, Holland, France	*henry Scheffer*
SCHEITS **Matthias** b. Hamburg. 1640 ? - 1700 ? Genre subjects Exh: Germany	*MS*
SCHELLINKS **Daniel** b. Amsterdam. 1627 - 1701 Marine & landscape artist Exh: Vienna, Turin	*DS.*

SCHELLINKS **Willem** b. Amsterdam. 1627 - 1678 Figure, marine & landscape artist Exh: Holland, Italy, US, UK, Germany	W. S. WS
SCHELVER **August Franz** b. Germany. 1805 - 1844 Military subjects & hunting scenes etc. Exh: Germany	Æ S 1892
SCHENCK **August Friedrich Albrecht** b. Denmark. 1828 - 1901 Landscape & animal subjects Exh: France, UK	Schenck
SCHENDEL **Petrus Van** b. Belgium. 1806 - 1870 Genre & historical subjects Exh: Belgium, Germany, Holland	PVS
SCHEYERER **Franz** b. Prague. 1770 - 1839 Landscape artist Exh: Austria	Scheÿerer
SCHIAMINOSSI **Raffaello** b. Italy. 1529 - 1622 Religious & historical scenes	RF L RF RÆ
SCHIAVONE **Andrea**	see MEDULA Andrea
SCHIERFBERK **Helena Sofia** b. Finland. 1862 - ? Genre subjects Exh: Helsinki	H.Schjerfberk
SCHIFF **Mathias** b. France. 1862 - 1886 Portrait artist Exh: France	M Schiff
SCHILCHER **Anton Von** b. Germany. 1795 - 1827 Military & genre subjects	A A A

SCHIRMER **Johann Wilhelm** b. Germany. 1807 - 1863 Biblical & landscape subjects Exh: Germany	
SCHLEGER. FSIA **Hans** b. Germany Exh: UK AG's, France, US, etc.	
SCHLEICH **August** b. Munich. 1814 - 1865 Animal subjects Exh: Munich	
SCHLICHTEN **Johann Franz Von Der** b. Germany. 1725 - 1795 Genre subjects Exh: Germany	
SCHLITTGEN **Hermann** b. Germany. 1859 - 1930 Genre & portrait artist & caricaturist Exh: Germany	
SCHMID **Matthias** b. Austria. 1835 - 1923 Historical & genre subjects Exh: Germany, Austria	
SCHMIDT **Georg Friedrich** b. Berlin. 1712 - 1775 Portrait artist Exh: Paris, Germany	
SCHMIDT **George Adam** b. Dordrecht. 1791 - 1844 Genre subjects Exh: Holland, Germany	
SCHMUTZLER **Leopold** b. Austria. 1864 - ? Historical, portraits & genre subjects Exh: Germany, Hungary	
SCHNEE **Hermann** b. Germany. 1840 - 1926 Landscape artist Exh: Germany	

SCHNEID. PL.D. **Otto** b. Czechoslovakia. 1900 - Pastel, gouache, oil & watercolourist etc. Exh: Italy, US, Canada	*Otto Schneid*
SCHNEIDER **Amable Louis** b. Paris. 1824 - 1884 Exh: France	*Am Schneider*
SCHNEIDER **Otto J** b. Atlanta. 1875 - ? Painter & engraver	*Schneider*
SCHNETZ **Jean Victor** b. Versailles. 1787 - 1870 Historical, genre & portrait artist Exh: France	*v.ʳ Schnetz*
SCHNITZLER **Michael Johann** b. Germany. 1782 - 1861 Still life subjects Exh: Germany	
SCHNORR VON CAROLSFELD **Hans Veit Friedrich** b. Germany. 1764 - 1841 Portrait, genre & historical subjects Exh: Germany	
SCHNORR VON CAROLSFELD **Julius Veit Hans** b. Leipzig. 1794 - 1872 Religious & genre subjects Exh: Germany	1819. 1819 18 17.
SCHODLBERGER **Johann Nepomuk** b. Vienna. 1779 - 1853 Landscape artist Exh: Austria	*Joh Nep Schödlberger Sec. Vienna 1813* *Joh. Nep. Schödlberger fec Vienræ 1817*
SCHOEN **Erhard** Fl. Germany. 16th C. Religious subjects Exh: Germany, France	

SCHOENFELDT **John Henry** b. Swabia. 1619 - 1680 ? Landscape & biblical subjects	*J.H. S.P.*
SCHOEVAERDTS **Mathieu** b. Brussels. 1665 ? - 1692 ? Village festive scenes & landscape artist Exh: Belgium, Germany, Italy, Scandinavia	*m. Schoevaerts*
SCHOMMER **Francois** b. Paris. 1850 - 1935 Portraits, historical & genre subjects Exh: France	Schommer
SCHONGAUER **Martin** b. Germany. 1445 ? - 1491 Religious subjects Exh: Germany, Austria	M✝S Ma.s McS
SCHONLEBER **Gustav** b. Germany. 1851 - 1917 Marine, landscape & architectural subjects Exh: Germany	*G Schönleber*
SCHOPFER (The Elder) **Hans** Fl. Germany. 1531 - 1564 Portrait & historical subjects Exh: Germany, Sweden	HS
SCHORN **Carl** b. Dusseldorf. 1803 - 1850 Historical & genre subjects Exh: Germany	S
SCHOTEL **Petrus Jan** b. Holland. 1808 - 1865 Marine & landscape subjects Exh: Holland, Germany	*P J J.chotel*
SCHOUBRŒCK **Pieter** b. Belgium. 1570 - 1607 Historical & landscape subjects Exh: Germany, Vienna, Copenhagen	PE SCHVBRVCK 1606 S S S
SCHOUMAN **Aert** b. Holland. 1710 - 1792 Portrait & animal landscapes etc. Exh: Holland, Paris, Leningrad	*A:Schouman.* A S

SCHOUMAN **Isaak** b. Holland. 1801 ? - ? Military & landscape subjects	
SCHREYER **Adolf** b. Frankfurt. 1828 - 1899 Animal & landscape & genre subjects Exh: Germany, UK	
SCHRODTER **Adolf** b. Germany. 1805 - 1875 Genre subjects Exh: Holland, Germany	
SCHRORER **Hans Friedrich** Fl. Germany. 17th C. Painter & engraver	
SCHULER **Jules Theophile** b. Strasburg. 1821 - 1878 Historical & landscape subjects Exh: Germany, France	
SCHULTZBERG **Anselm** b. Sweden. 1862 - 1945 Landscape artist Exh: Scandinavia	
SCHUMANN **Johann Gottlob** b. Dresden. 1761 - 1810 Portrait & landscape artist	
SCHUT **Cornelis** b. Antwerp. 1597 - 1655 Religious subjects Exh: Holland, Belgium, Germany	
SCHUTTER **Jean Louis De** b. Antwerp. 1910 - Genre & animal subjects Exh: Belgium, Holland	
SCHUZ **Christian Georg** b. Germany. 1718 - 1791 Landscape artist Exh: Germany	

SCHWARTZ **Alfred** b. Berlin. 1833 - ? Portrait artist	*Alf. Schwarz*
SCHWARTZE **Therese** b. Amsterdam. 1852 - 1918 Genre & portrait artist Exh: Holland, Italy	*Th. Schwartze*
SCHWENINGER (The Elder) **Karl** b. Vienna. 1818 - 1887 Animal, genre & landscape subjects Exh: Vienna	*C Schweninger?*
SCOREL **Jan Van** b. Holland. 1475 - 1562 Religious, historical & portrait artist Exh: Holland, Germany, Italy, Austria, UK	
SCOTT **Georges Bertin** b. Paris. 1873 - ? Military subjects Exh: Paris, Rome	*Georges Scott*
SCOTT **Gerald** b. Surrey. 1916 - Drawings & sculpture Exh: RA, RWA & Prov. AG's	*Gerald Scott*
SCOTT **Walter** b. Edinburgh Etcher & landscape artist Exh: R.Cam.A., RSA, GI, RSH, Prov. AG's	*Walter Scott* *W. Scott*
SCOTT **William Bell** b. Edinburgh. 1811 - 1890 Genre & historical subjects Exh: RSA, RA, SS, BI, VA, Prov. AG's	

SEBILLAU **Paul** b. Bordeaux. ? - 1907 Landscape artist Exh: France	*P. Sebilleau*
SEBRON **Hippolyte Victor Valentin** b. France. 1801 - 1879 Architectural, portrait & landscape subjects Exh: France, Belgium, New York	*H Sebron*
SEDDON. PL.D., FMA, ARCA **Richard Harding** b. Sheffield. 1915 - Oil & watercolourist Exh: RA, RBA, RIBA, NEAC, RBA, Prov. AG's	*RS*
SEDELMAYER **Joseph Anton** b. Munich. 1797 - ? Landscape artist Exh: Germany	*S S*
SEDOFF **G.S.** b. Russia. 1831 ? - 1886 Genre subjects Exh: Russia	*Gr Sedoff*
SEE **Mathilde** b. Paris. Fl. 20th C. Floral artist Exh: Paris	*Mathild See*
SEEGER **Karl Ludwig** b. Germany. 1808 - 1866 Landscape artist Exh: Germany	*K. Se R.*
SEEL **Adolf** b. Germany. 1829 - 1907 Architectural, genre & portrait artist Exh: Germany	*A Seel.*
SEGAL. FIAL, RBA, NRD **Hyman** b. London. 1914 - Pastel, charcoal, oil media etc. Exh: RP, RBA, WEA, Prov. AG's, PS, E. Africa etc.	*Segal*
SEGALL **Lasar** b. Russia. 1890 - 1957 Abstract studies Exh: Brazil, US, European AG's	*Lasar Segall* סגל *Lasar Segall*

SEGANTINI **Giovanni** b. Italy. 1858 - 1899 Genre, religious & landscape subjects Exh: Italy, Germany, Holland, UK, Austria, etc.	*G Segantini*
SEGHERS **Cornelius Johannes Adrianus** b. Antwerp. 1814 - 1875 Historical subjects Exh: Belgium	*CS C.S CS.*
SEGHERS **Daniel** b. Antwerp. 1590 - 1661 Floral subjects Exh: Belgium, France, Vienna, Geneva	*D: Seghers Soc^{tis} Jesu 1647 D Seghers Soc^{tis} Jesu 1645* *DS ·DS*
SEGHERS **Francois** b. Brussels. 1849 - ? Floral artist Exh: Belgium	*Franchois Seghers fecit*
SEIGNAC **Guillaume** b. France. Fl. 19th - 20th C Genre subjects Exh: France	*G·SEIGNAC*
SEINSHEIM (Count) **August Carl** b. Munich. 1789 - 1869 Religious & genre subjects Exh: Germany	*S*
SEITZ **Otto** b. Munich. 1846 - 1912 Genre subjects Exh: Germany	*Otto Seitz*
SELB **Josef** b. Germany. 1784 - 1832 Painter & lithographer	*JS*
SELIGMANN **Kurt** b. Basle. 1900 - 1962 Abstract & surrealist artist Exh: US	*Seligmann*

SELIM **Jewed** b. Ankara. 1920 - Painter & sculptor Exh: London, Egypt, India etc.	*Jevad Selim*
SELLIER **Charles Francois** b. Nancy. 1830 - 1882 Portrait & genre subjects Exh: France	
SELMY **Eugene Benjamin** b. France. 1874 - ? Genre subjects Exh: France, Bucharest	*E. Selmy*
SELOUS (or SLOUS) **Henry Courtney** b. London. 1811 - 1890 Portrait, historical, genre & landscape artist Exh: RA, SS, BI, London & Prov. AG's	
SEM (GOURSAT B.Sc.) b. France. 1863 - 1934 Genre subjects & caricaturist Exh: UK	**SEM** *SEM*
SENAVE **Jacques Albert** b. Belgium. 1758 — 1829 Portrait, genre & historical subjects Exh: France, Belgium	*Senave.*
SENIOR **Mark** b. Hanging Heaton. 1864 - 1927 Genre, figure & landscape artist Exh: RA, UK AG's	*MS.*
SENIOR. ARCA **Oliver** b. Nottingham. 1880 - Portrait, figure & landscape artist Exh: London & Prov. AG's	SENIOR
SEPO **Severo** b. Italy. 1895 - Painter & sculptor Exh: Italy	*Severo Pozzati Sepo*
SERGE (MAURICE FEAUDIERRE) b. Paris. 1901 - Theatrical subjects Exh: France	**SERGE**

SERGENT Lucien Pierre b. France. 1849 - 1904 Battle scenes Exh: France	
SERRUR Henry Auguste Calixte Cesar b. France. 1794 - 1865 Battle scenes, portrait & genre subjects Exh: France	*Serrur*
SERUSIER Louis Paul Henri b. Paris. 1863 - 1927 Genre, landscape, & portrait artist	*PSérusier*
SERVIN Amedee Elie b. Paris. 1829 - 1885 Genre , landscape & animal subjects Exh: France	*A.SERVIN*
SEURAT Georges Pierre b. Paris. 1859 - 1891 Neo-impressionist, figure studies etc. Exh: European AG's, US, UK	*Seurat Seurat Seurat Seurat Seurat Seurat*
SEVERIN. RA, RSA (Belgium) Mark b. 1906 - Painter & engraver Exh: RA, London & Prov. AG's	
SEVERINI Gino b. Italy. 1883 - 1966 Abstract & cubist painter Exh: Italy, Germany, France	*Severini*
SEVERN Arthur b. England. 1842 - 1931 Marine & landscape artist Exh: UK, France	*Arthur Severn A.I*

SEYD. FRSA, Mem. USA **Eileen** Oil & watercolourist Exh: RA, ROI, RBA, NS, PS, etc.	*Seyd*
SEYSSAUD **Rene** b. Marseille. 1867 - 1952 Still life, marine & landscape artist Exh: France, US	*Seyssaud*
SHACKLETON. RSMA, SWLA **Keith Hope** b. Weybridge. 1923 - B/white & oil media Exh: London & Prov. AG's	*Keith Shackleton .*
SHALDERS **George** b. 1826 - 1873 Figure & landscape artist Exh: UK AG's	*GS*
SHANNON. RA, ARPE **Charles Haslewood** b. Lincolnshire. 1865 - 1937 Portrait & figure subjects Exh: RA, NEAC, SS, NG, London & Prov. AG's	C.H.S. Ⓢ CHS S
SHARP **Joseph Henry** b. US. 1859 - 1934 Figure & landscape subjects Exh: US	*J.H.Sharp*
SHARP. ARCA **Miles** b. Yorkshire. 1897 - Painter & engraver Exh: RA, R.Scot.A., RI, RWA, RBSA, London & Prov. AG's	*MILES SHARP*
SHARPLEY. AMICE **Reginald** b. 1879 - Etcher & watercolourist Exh: RA, London & Prov. AG's	*R Sharpley.*
SHAW **Byam John** b. Madras. 1872 - 1919 Genre artist Exh: RA, London & Prov. AG's	[B] Ⓑ
SHEPHERD **S. Horne** b. Dundee. 1909 - Pastel, oil, watercolour media etc. Exh: RSA, SSA, London & Prov. AG's, US	*S. Horne Shepherd.*

SHEPPARD. FZS **Raymond** b. 1913 - B/white & watercolourist Exh: RA, RI, RSA, RBA	*RAYMOND SHEPPARD*
SHERWIN **Frank** b. Derby. 1896 - Marine & landscape watercolourist Exh: RA, RI, RSMA, etc.	*FRANK SHERWIN* *FRANK SHERWIN*
SHIELDS **Frederick James** b. Hartlepool. 1833 - 1911 Genre, oil & watercolourist Exh: London & Prov. AG's	
SHIELS **Anthony Nicol** b. Salford. 1938 - Painter in oil & gouache media Exh: London & Prov. AG's	
SHIRLAW **Walter** b. Paisley. 1838 - 1909 Portrait, genre & landscape artist Exh: UK AG's, US, Germany, France	
SHOOSMITH **Thurston Laidlaw** b. Northampton. 1865 - 1933 Landscape watercolourist Exh: London & Prov. AG's	*TLS*
SHORE. WIAC **Agatha Catherine** b. London. 1878 - ? Portrait, interior & landscape artist Exh: NEAC, IS, NPS, PS, London & Prov. AG's	
SHORT, RA **Sir Frank** b. London. 1857 - 1945 Landscape oil & watercolourist Exh: RA, VA, UK AG's, France	
SHUCKARD **Frederick P** Fl. UK. 1869 - 1901 Genre & floral subjects Exh: RA, SS, London & Prov. AG's	*F.P. SHUCKARD* *— 1870*
SIBERECHTS **Jan** b. Antwerp. 1627 - 1703 Figures, cattle & landscape artist Exh: Germany, France, Belgium, Russia, etc.	*J. Siberechts. f* *1664*

SICARD **Nicolas** b. Lyon. ? - 1920 Genre subjects Exh: France	N Sicard
SIEFFERT **Paul** b. Paris. 1874 - ? Figures & portrait studies Exh: France	P. Sieffert.
SIEGER **Victor** b. Vienna. 1843 ? - 1905 Genre subjects Exh: Vienna, Munich	VS
SIEURAC **Francois Joseph Juste** b. France. 1781 - 1832 Miniaturist Exh: France	
SIGALON **Xavier** b. France. 1787 - 1837 Historical, portraits & genre subjects Exh: France	X Sigalon
SIGNAC **Paul** b. Paris. 1863 - 1935 Landscape & genre subjects Exh: European AG's, Uk, US	P. Signac 99 P. Signac 1897 P. Signac 96 P. Signac 90
SIGNOL **Emile** b. Paris. 1804 - 1892 Portraits & historical subjects Exh: France	Emile Signol
SIGNORINI **Telemaco** b. Florence. 1835 - 1901 Landscape artist Exh: Italy	Signorini
SILLEN **Herman Gustaf** b. Stockholm. 1857 - 1908 Marine artist Exh: Sweden	H.af Sillen

SILLINCE. RBA, ARWS, SGA, FSIA **William A** b. London. 1906 Watercolourist etc. Exh: RA, NEAC, RBA, RWS, RSA	*sillince*
SIMA **Miron** b. Russia. 1902 - Oil & gouache media etc. Exh: Germany, Israel, France, S. Africa, US	*ומרון סימא*
SIMBERG **Hugo Gerhard** b. Finland. 1873 - 1917 Genre & portrait artist Exh: Finland	*HS*　　*HS*
SIMON **Francois** b. Marseille. 1818 - 1896 Portrait, genre & landscape artist Exh: France	*Simon Fsois*
SIMON **Franz** b. Czechoslovakia. 1877 - Landscape artist Exh: Prague, Paris	⬤
SIMON **Johanan** b. Berlin. 1905 - Painter in oil media Exh: France, Israel Italy, S. Africa, US, etc.	*יוחנן סימון*
SIMON **Lucien** b. Paris. 1861 - 1945 Genre & portrait artist Exh: France, Italy, US	*Simon*
SIMONS **Frans** b. Antwerp. 1855 - 1919 Portraits, still life, genre & landscape artist Exh: Antwerp	*Frans Simons*
SIMONS **Michiel** b. Utrecht. ? - 1673 Still life subjects Exh: Holland	*M.S.*
SIMONSEN **Niels** b. Copenhagen. 1807 - 1885 Genre & military subjects Exh: Scandinavia, Germany	*N Simonsen*

SIMPSON **Henry** b. Narton. ? - 1921 Genre subjects Exh: RA, Holland	*AS*
SIMPSON **Joseph** b. Carlisle. 1879 - Portraits, genre & landscape artist Exh: UK, Stockholm, France, etc.	*SIMPSON*
SIMPSON **William** b. Glasgow. 1823 - 1899 Historical & landscape subjects Exh: UK, France, S. Africa	*Wⁿ Simpson*
SINCLAIR. ARCA, etc. **Beryl Maude** b. Bath. 1901 - Painter in oil media Exh: RA, NEAC, SWA, WIAC, etc.	*B.S.*
SINDING **Otto Ludvig** b. Norway. 1842 - 1909 Landscape subjects Exh: Scandinavia, Munich	*Otto Sinding*
SINIBALDI **Jean Paul** b. Paris. 1857 - 1909 Genre subjects Exh: France	*Paul Sinibaldi*
SIPILA **Sulho Wilhelmi** b. Aland. 1895 - Sculptor, oil & watercolourist Exh: Holland, Russia, Scandinavia, Germany, etc.	*Sulho*
SIRANI **Giovanni Andrea** b. Bologna. 1610 - 1670 Historical subjects Exh: Italy, Sweden	*J. A. Sirani 1661*
SIRETT **Arthur James** b. London. 1902 - Watercolourist Exh: RBA, London & Prov. AG's	*ARTHUR SIRETT*
SISLEY **Alfred** b. Paris. 1839 - 1899 Landscape artist Exh: European AG's, UK, US, etc.	*Sisley 72* *Sisley. 72*

SISLEY **Alfred** (Continued)	*Sisley·73 Sisley Sisley Sisley. Sisley 92*
SJOLLEMA **Dirck Pieter** b. Holland. 1760 - 1840 Marine & landscape artist Exh: Holland	*D.Sjollema Fecit 1825*
SKARBINA **Franz** b. Berlin. 1849 - 1910 Landscape artist Exh: Germany	*F. Skarbina*
SKEAPING. FSAM **John** b. Liverpool. Figure & landscape artist Exh: WAG, London & Prov. AG's	*JS*
SKIPWORTH **Frank Markham** Fl. 1882 - 1916 Figure & portrait artist Exh: RA, SS, WG	*FMS* *FMS 83*
SKOLD **Ottel** b. China. 1894 - Portraits, figures, still life & landscape artist Exh: Scandinavia, France, Germany, etc.	*Otel.*
SKREDSWIG **Christian Eriksen** b. Denmark. 1854 - 1924 Landscape artist Exh: Scandinavia, France	*Chr Skredsvig* *Christian Skredsvig.*
SLABBAERT **Karel** b. Holland. 1619 ? - 1654 Genre & portrait artist Exh: Holland, Germany	*K. SLABBA*

SLABBAERT Karel (Continued)	
SLEATOR. ARHA, RHA **James Sinton** b. Ireland Portrait, still life & landscape artist Exh: London, Scottish & Irish AG's	
SLEE. AMTC **Mary** b. Carlisle. Miniaturist Exh: RA, RMS, RSA, RBSA, WAG, etc.	
SLEIGH. RBSA **Bernard** b. Birmingham. 1872 - ? Oil & watercolourist Exh: RA, Prov. AG's, Canada, US	
SLINGELAND **Pieter Cornelisz Van** b. Leyden. 1640 - 1691 Portraits, genre subjects & miniaturist Exh: Holland, Germany, Italy, UK, Russia, etc.	
SLINGENEYER **Ernest** b. Belgium. 1820 - 1894 Historical subjects Exh: Belgium, Germany	
SLOCOMBE **Frederick Albert** b. London. 1847 - ? Genre & landscape artist Exh: RE, NWS, London & Prov. AG's	
SMALL. RI **William** b. Edinburgh. 1843 - ? Genre, land & coastal subjects etc. Exh: RA, NWS, GG, & Prov. AG's	
SMALLFIELD. ARWS **Frederick** b. London. 1829 - 1915 Genre & portrait artist Exh: RA, SS, BI, NWS, OWS, GG & Prov. AG's	
SMART. ROI, RWA, RBC **Borlase** b. Devonshire. 1881 - Seascape & architectural subjects Exh: RA, RSA, PS, WAG, RI, R.Cam.A., Prov. AG's, etc.	

SMART. RE Douglas Ion b. UK. 1879 - Etcher & watercolourist Exh: London & Prov. AG's	
SMETH Hendrick b. Antwerp. 1865 - ? Genre & landscape subjects Exh: Belgium	*H. De Smeth*
SMETHAM James b. Yorkshire. 1821 - 1889 Portraits, biblical & imaginative subjects Exh: RA, SS, BI, London & Prov. AG's	J. SMETHAM
SMITH Alfred b. Bordeaux. 1853 - ? Portrait & landscape artist Exh: France	*AS*
SMITH. ARCA, ARWS, RWS, RSW Arthur Reginald b. Skipton-in-Craven. Fl. 19th-20th C. Figure, landscape & marine artist Exh: London & Prov. AG's, Australia	*A·R·Smith.*
SMITH Carl b. Oslo. 1859 - 1917 Genre & portrait artist Exh: France, Holland, Italy	*C.T.Smith*
SMITH. AMTC Catherine b. London, 1874 - ? Painter & etcher Exh: RA, London & Prov. AG's	*S*
SMITH, FRSA Frederick Richard b. Harascombe. 1876 - ? Genre, marine & landscape aritst Exh: RA, RSA, London & Prov. AG's, Paris	*F.R.Smith.*
SMITH George b. Chichester. 1714 - 1776 Landscape artist Exh: London & Prov. AG's	*G. Smith '755*
SMITH. RSA George b. Midlothian. 1870 - ? Animal & landscape artist Exh: London & Prov. AG's, Italy	*G. Smith*

SMITH **Jack Carrington** b. Tasmania. 1908 - Oil & watercolourist Exh: London & Prov. AG's	*Carrington Smith*
SMITH **James Burrell** Fl. 19th C. Landscape artist Exh: SS, VA	
SMITH **John** b. UK. 1652 ? - 1742 Genre & portrait artist	*JS Fec.*
SMITH. CBE **Sir Matthew** b. Yorkshire. 1879 - Still life, figure & landscape artist Exh: London & Prov. AG's, Europe, Japan, US, etc.	*MS MS*
SMITH, Mem. NEAC **Norman** b. Walsall. 1910 - Landscapes & still life subjects Exh: RA, RSA, RWA, NEAC	*Normansmith*
SMITH-HALD **Frithjof** b. Norway. 1846 - 1903 Landscape artist Exh: France, Germany, Norway	*Smith-Hald*
SMITS **Eugene** b. Antwerp. 1826 - 1912 Historical & genre subjects Exh: Belgium	*E. Smils.*
SMITS **Gaspar** b. Holland. 1635 ? - 1707 ? Historical & portrait artist	*S 1661*
SMYTHE. RA, RWS, RI **Lionel Percy** b. London. 1839 - 1918 Rustic genre & landscape artist Exh: RA, SS, BI, NWS, OWS, Australia	*LS*
SMYTHE. ARSW **Minnie** b. London Watercolourist Exh: London & Prov. AG's	

SNYDERS **Frans** b. Belgium. 1579 ? - 1657 Still life, animal & hunting scenes etc. Exh: France, Germany, Russia, Belgium, UK	*F. Snyders* *F. Snyders. fecit* *F. Snyders - fecit. 1632* *F. Snijderss. fecit.* *F Sneyders* *fr: Sneyders. pinx. 1646*
SNYERS **Peter** b. Antwerp. 1681 - 1752 Portrait, still life & landscape subjects Exh: Belgium, Holland, NG, Germany	*P. Snyers* **P. Snyers**
SOAMES **Corisande Wentworth** b. 1901 - Genre & portrait artist Exh: RA, RBA, RP, London & Prov. AG's	*—⊂○⊃—*
SOHN **Carl** b. Berlin. 1805 - 1867 Portrait & historical subjects Exh: Germany	*C Sohn 1849*
SOLIMENA **Francesco** b. Italy. 1657 - 1747 Religious, portrait & mythological subjects Exh: France, Italy, UK, Germany	*Solimena* *francesco*
SOLIS (The Elder) **Virgil** b. Nuremberg. 1514 - 1562 Mythological, portrait & genre subjects	*VS* *NS* *VS*
SOLOMAN **Abraham** b. London. 1824 - 1862 Genre & historical subjects Exh: RA, BI, UK AG's	*AS* *1861*

SOLOMAN. RA, PRBA **Joseph Solomon** b. London. 1860 - 1927 Portraits, mythological & historical subjects Exh: RA, NG, SS, London & Prov. AG's	SJS (monogram) (monogram)
SOLOMON **Simeon** b. London. 1840 - 1905 Religious & mythological subjects etc. Exh: RA, SS, NG, GG, London & Prov. AG's	(monogram)
SOLVYNS **Balthazar** b. Antwerp. 1760 - 1824 Marine artist	(monogram)
SOMER **Jan Van** b. Amsterdam. 1645 - 1699 ? Genre & portrait artist	(monogram) (monogram)
SOMER **Paul Van** b. Antwerp. 1576 - 1621 Portraits & historical subjects Exh: NPG, Copenhagen	P/S PS PS fc
SOMERS **Louis Jean** b. Antwerp. 1813 - 1880 Genre & historical subjects Exh: Belgium	Louis Somers St Antwerpen
SOMERSET **Nina Evelyn Mary** Decorative & ecclesiastical artist Exh: PS, SWA, Prov. AG's	(monogram)
SOMM **Francois Clement Sommier** b. Rouen. 1844 - 1907 Genre subjects & caricaturist Exh: France	(butterfly device) (butterfly in circle) (SH monogram in circle)
SON **Joris Van** b. Belgium. 1623 - 1667 Still life subjects Exh: Belgium, Scandinavia	J.V.S.
SONJE **Jan Gabriel** b. Delft. 1625 ? - 1707 Landscape artist Exh: Germany, Holland, France	Isonyef J

SOOLMAKER **Jan Frans** b. Antwerp. 1635 - 1685 ? Landscape & animal subjects Exh: Belgium, UK, Holland	*F. F. Soolmaker. f. F. FS.*
SORENSEN **Carl Frederick** b. Denmark. 1818 - 1879 Marine artist Exh: Scandinavia	*C Frederik Sörensen*
SOROLLA Y BASTIDA **Joaquin** b. Spain. 1863 - 1923 Marine, portraits & genre subjects Exh: Spain, Italy, US	*Y. Sorolla Bastida*
SOUCHON **Francois** b. France. 1787 - 1857 Historical, portrait & landscape artist Exh: France	*Souchon Souchon*
SOUKENS **Jan** Fl. Holland. 1678 - 1725 Genre & landscape subjects	*(I - S) 1678 Sou fec 1689*
SOULAGES **Pierre Jean Louis** b. Rodez, France. 1919 - Oil & watercolourist Exh: Germany, Holland, Hungary, Scandinavia, US, S. America, etc.	*Soulages*
SOUMY **Joseph Paul Marius** b. France. 1831 - 1863 Genre & portrait artist Exh: France	*Jh Soumy*
SOURDY **Louise** b. Paris. 1900 - Portrait & landscape artist Exh: France	*L. Sourdy*
SOUTHALL **Derek** b. Coventry. 1930 - Exh: London & Prov. AG's, Austria, Germany, etc.	*Derek Southall.*
SOUTHALL, RWS **Joseph Edward** b. Birmingham. 1861 - 1944 Genre, figure & landscape artist Exh: UK AG's, Paris	*[1925] JS JS JS [JS 1941] S*

SOUTINE **Haim** b. Russia. 1894 - 1943 Genre, portraits, still life & landscape artist Exh: Russia, US & European AG's	
SOUVERBIE **Jean** b. France. 1891 - Composition, figure & still life subjects Exh: Paris, US	
SOYER **Paul Constant** b. Paris. 1823 - 1903 Genre subjects Exh: France, Glasgow	
SPACKMAN. RBA, RMS, FRSA, **AR.Cam.A., etc.** **Cyril Saunders** b. Cleveland, Ohio. 1887 - Sculptor, etcher & painter Exh: RA, PS, WAG, R.Cam.A., RBSA, RWEA, US, etc.	
SPADA **Leonello** b. Bologna. 1576 - 1622 Biblical subjects Exh: Italy, France, UK	
SPARKS (Mrs. Spooner) **Wendy R.S.** b. Kingston-on-Thames. 1930 - Religiously inspired meta- psychological subjects Exh: London & Prov. AG's, France, Germany, US, Australia, Greece, etc.	
SPAULL **Leslie Charles** b. London. 1914 - B/white, oil & watercolourist Exh: RA & Prov. AG's	
SPEAR.RA, ARCA **Ruskin** b. 1911 - Exh: RA, London & Prov. AG's, US, Australia, Russia, Belgium, etc.	
SPECKARD **Hans** b. Brussels. ? - 1577 ? Portraits & genre subjects Exh: Germany, Italy, Austria	
SPECKTER **Erwin** b. Hamburg. 1806 - 1835 Portrait & religious subjects Exh: Germany	

SPEED **Harold** b. London. 1872 - 1957 Portraits, figures & historical subjects Exh: NG, UK AG's, Paris	
SPEER **Martin** b. Germany. 1700 - 1765 Historical subjects Exh: Germany	
SPEHNER-BENEZIT **Marie Salome** b. France. 1870 - 1950 Portrait artist Exh: France	
SPENCE **Robert** b. Tynemouth. 1871 - 1964 Landscapes & historical subjects Exh: UK AG's	
SPENCE **T. Everard** Portrait & landscape artist Exh: RA, RBA, RHA, RUA & Prov. AG's	
SPENCE **Thomas Ralph** b. Nr. Richmond. 1855? - ? Landscape artist & decorator Exh: UK AG's	
SPENCELAYH **Charles** b. Rochester. 1865 - ? Miniaturist, portrait & figure artist Exh: RA, London & Prov. AG's	
SPENCER, RA **Sir Stanley** b. Cookham. 1892 - 1959 Figures & religious subjects Exh: RA, London & Prov. AG's	
SPILBERG (The Younger) **Johann** b. Dusseldorf. 1619 - 1690 Portrait & genre subjects Exh: Germany, Holland, Italy	
SPILLING **Karl** b. Germany. 1872 - ?	

SPILMAN **Hendrik** b. Amsterdam. 1721 - 1784 Portraits & landscape artist Exh: Holland	*H.S Spm fecit*
SPINNY **Guillaume Jean Joseph De** b. Brussels. 1721 - 1785 Portrait artist Exh: Holland	*G^me Spinny*
SPIRO **Eugen** b. Germany. 1874 - ? Still life, portrait, genre & landscape subjects Exh: Germany	*Eugen Spiro*
SPITZWEG **Carl** b. Munich. 1808 - 1885 Genre & landscape artist Exh: Germany	*Spitzweg*
SPRADBERY. DCM **Walter Ernest** b. London. 1889 - Oil & watercolourist Exh: RA, RI, London & Prov. AG's, Italy	*WALTER E. SPRADBERY.*
SPRANGER **Bartholomew** b. Antwerp. 1546 - 1611 Portraits, allegorical, historical & landscape artist Exh: Belgium, Hungary, Austria, France, Italy, etc.	*B. Sprangers ft 1590*
SPRINGER **Cornelis** b. Amsterdam. 1817 - 1891 Landscape & architectural subjects Exh: Holland, Germany	*S*
SPRINGINKLEE **Hans** b. Germany. ? - 1540 Painter & engraver	*HSK* *HSK*
SPRUYT **Philippe Lambert Joseph** b. Belgium. 1727 - 1801 Oil & watercolourist	*P* *P* *S.P*
SPURRIER **Steven** b. London. 1878 - 1961 Figure & landscape artist Exh: UK AG's	*S.S.* *S.S.*

STAAL **Gustave** b. France. 1817 - 1882 Portrait artist Exh: France	G.STAAL
STACEY. BWS, ROI, RBA **Walter S** b. London. 1846 - 1929 Genre, figure & landscape artist Exh: RA, RI, ROI, RBA, NWS, SS, Prov. AG's	W.S.Stacey ⩔ WSS
STALBURCH **Jan Van** Fl. Belgium. 16th C. Painter & engraver	VS
STALLAERT **Joseph** b. Belgium. 1825 - 1903 Historical subjects Exh: Belgium	Jos Stallaert
STALPAERT **Peeter** b. Holland. 1572 ? - 1635 ? Marine & landscape artist Exh: Holland	stalpaxt AP
STAMPA **George Loraine** b. Constantinople. 1875 - 1951 Figure & portrait artist Exh: London & Prov. AG's	G.L.S.
STANDAERT **Pieter Van**	see **BLOEMEN** Pieter Van
STANHOPE **John Roddam Spencer** b. Cannon Hall. 1829 - 1908 Pre Raphaelite School Exh: UK AG's	J RSS⚹
STANILAND. FRSA, LRCP, MRCS **Bernard Gareth** b. Canterbury. 1900 - Sculptor, oil & watercolourist Exh: London & Prov. AG's	B.Raniland
STANILAND. RI **Charles Joseph** b. England. 1838 - 1916 Genre & historical subjects Exh: RA, SS, BI, NWS, VA, Prov. AG's	CJSTANILAND CJS

STANLEY **Lady Dorothy (née Tennant)** b. 1855 - 1926 Genre & portrait artist Exh: RA, NG, London & Prov. AG's	
STANNARD **Emily (née Coppin)** b. Norwich. 1803 - 1885 Still life & floral studies Exh: BI, SS, London & Prov. AG's	
STANNARD. Mem. RSA, RBA **Henry John Sylvester** b. London. 1870 - 1951 Landscape artist Exh: RA, RI, PS, RBA, Prov. AG's	
STANNARD **Joseph** b. Norwich. 1797 - 1830 Portraits, figures, landscape & marine artist Exh: NS, BI, SS, VA, Prov. AG's	
STANNARD **Lilian (Mrs Silas)** b. Woburn. 1884 - 1938 Landscapes & floral subjects Exh: London & Prov. AG's	
STANTON **Clark** b. Birmingham. 1832 - 1894 Genre subjects Exh: RSA, Scotland	
STANZIONI **Massimo** b. Naples. 1585 - 1656 Religious subjects Exh: Italy, NG, US, France	
STAPLES. BT **Sir Robert Ponsonby** b. 1853 - 1943 Portrait, genre & landscape artist Exh: RA, GG, SS, London & Prov. AG's	
STARR **Louisa (Mrs Canziani)** b. London. 1845 - 1909 Portraits, genre & historical subjects Exh: RA, SS, Prov. AG's	
STAVEREN **Jan Adriensz Van** b. Leyden. 1625 ? - 1668 Portrait, genre & landscape subjects Exh: Holland, Paris, UK	

STAVEREN Jan Adriensz Van (Continued)	*STAVEREN*
STEELE Jeffrey b. Cardiff. 1931 - Systematic constructivist Exh: UK, US, France, Holland, Switzerland, etc.	*Jeffrey Steele*
STEELINK Willem b. Amsterdam. 1856 - 1928 Landscape artist Exh: Holland	*Wilm Steelink*
STEEN Jan Havicksz b. Leyden. 1626 - 1679 Genre, tavern scenes etc. Exh: International AG's	*STEEN· Stien JS* *Steen 1672 J.Steen J* *Sttn Steen Steen*
STEENWYCK Abraham b. Holland. 1640 ? - 1698 Still life subjects Exh: Holland	*AB.S*
STEENWYCK (The Elder) Hendrik Van b. Holland. 1550 ? - 1603 Architectural & church interiors Exh: Holland, Germany, Russia, France, Austria, etc.	*1573 HVS*
STEENWYCK (The Younger) Hendrik Van b. Amsterdam. 1580 ? - 1649 Historical, architectural & interior scenes Exh: UK, Russia & European AG's	*Henr. v. Steenwyck 1604* *H.V.STEIN.1642*
STEENWYCK Herman b. Delft. 1612 - 1662 ? Still life subjects Exh: Holland, Germany	*H.Steenstryck 1661*

STEEPLE John b. ? - 1887 Landscapes & coastal scenes Exh: RA, SS, VA, Prov. AG's	*S*
STEER. RI Henry Reynolds b. London. 1858 - 1928 Genre & landscape artist Exh: RA, NWS, SS, RI, WAG & Prov. AG's	*HTEER.* *PR*
STEER Philip Wilson b. Cheshire. 1860 - 1942 Portraits, genre & landscape artist Exh: RA, NEAC, GG, SS, London & Prov. AG's	*PW. Sltr. 92*
STEFANI Fossano Da	see **BORGOGNONE** Ambrogio
STEIGER Frederic b. Rumania. 1899 - Portraits & abstract subjects Exh: London, Canada, US, etc.	*FredericSteiger*
STEIN August Ludwig b. Germany. 1732 - 1814 Religious portrait & genre subjects Exh: Germany	*S.f.*
STEINER Emmanuel b. Switzerland. 1778 - 1831 Painter & engraver	*E.st.f*
STEINLEN Theophile Alexandre b. Switzerland. 1859 - 1923 Genre subjects Exh: France, Germany, Switzerland	*Steinlen steinlen* *TAR*
STELLA Jacques De b. Lyon. 1596 - 1657 Biblical & historical subjects Exh: France, Italy, Germany, Austria, etc.	✶F. ROMÆ .I.✶ FECIT. ✶ ▫FROMÆ 1625. *Stella* *faciebant* *JS* ✶ . *S* ✶ *1635.*

STELLA Jacques De (Continued)	
STENGELIN Alphonse b. Lyon. 1852 - ? Marine, portraits, landscapes & animal subjects Exh: France, Holland	*Stengelin* *Stengelin*
STEPHAN Joseph b. Germany. ? - 1786 Animal & landscape subjects Exh: Germany	
STERNE Maurice b. Libau. 1877 - ? Portraits, figures, still life & landscape artist Exh: US	
STEUBEN Charles August Baron De b. Germany. 1788 - 1856 Portraits & historical subjects Exh: Germany, Russia, France	
STEVENS Alfred b. Brussels. 1823 - 1906 Portrait & genre artist Exh: Belgium, France, US, Germany, etc.	
STEVENS. BA George Alexander b. London. 1901 - Portrait & landscape artist Exh: NEAC, London & Prov. AG's	
STEVENS Peeter b. Belgium. 1567 - 1624 ? Landscape artist Exh: Germany, France, Austria	PE·STEPH·I·F P S
STEWART. RMS Hilda Joyce b. London. 1891 - Portrait miniaturist Exh: RA, RMS, London & Prov. AG's Canada	

STEWART **William** b. Greenwich. 1886 - Painter & Illustrator Exh: RA, RBA	*W S*
STILKE **Hermann Anton** b. Berlin. 1803 - 1860 **Historical & portrait artist** Exh: Germany	*HA S.t* *HA S.t*
STILLMAN (NEE SPARTALI) **Marie** b. London. 1844 - 1927 Pre-raphaelite painter Exh: RA, SS, GG, NG, NWS	*AD .91.*
STIMMER **Tobias** b. Switzerland. 1539 - 1584 Portrait, genre & religious subjects Exh: Switzerland	*TS* *T S.* *TS* *TS*
STOBBAERTS **Jan** b. Antwerp. 1838 - 1894 ? Animal & genre subjects Exh: Belgium, Holland, France	*Jan Stobbaerts*
STOCK **Henry John** b. London. 1853 - 1931 Portrait & genre subjects Exh: RA, RI, GG & Prov. AG's	*HJ STOCK*
STOCKER **Hans** b. Basle. 1896 - Exh: Switzerland, Germany	*Stocker*
STOFFE **Jan Jacobsz Van Der** b. Leyden. 1611 - 1682 Battle scenes Exh: Holland, Germany, Austria	*JV. Stoffe. 1649*
STOKES, RA, VP RWS **Adrian Scott** b. Southport. 1854 - 1935 Landscape, genre & marine artist Exh: RA, SS, UK AG's	*A.S.* *A.S.* *A.S.*
STOKES **Marianne (née Preindlsberger)** b. Gratz. 1855 - 1927 Genre & portrait artist Exh: RA, SS, Prov. AG's	*M S* *M S*

STOLKER **Jan** b. Amsterdam. 1724 - 1785 Portraits, & allegorical subjects Exh: Holland	*JL.* *JS*
STOLL **Leopold** Fl. Germany. 19th C. Floral artist Exh: Leningrad	*L Stoll*
STONE **Marcus C** b. London. 1840 - 1921 Historical & genre subjects Exh: RA, London & Pro. AG's, Australia	MARCUS STONE. M. ST.
STOOP **Dirk** b. Utrecht. 1618 ? - 1681 Military & landscape subjects Exh: Holland, France, Germany, UK	D. S.
STOOP **Maerton** b. Holland. 1620 ? - 1647 Genre & military subjects Exh: Holland, Germany, Hungary	*M Soop*
STORCK **Abraham** b. Amsterdam. 1635 ? - 1710 ? Marine & landscape subjects Exh: Holland, France, London, US, Germany, UK	A Storck Fec *AS*
STORCK **Jacobus** Fl. Amsterdam. 17th C. Marine & landscape artist Exh: Holland, US, UK, Germany, Russia	J. STORCK J S
STOREY. ARA **George Adolphus** b. London. 1834 - 1919 Portrait & genre artist Exh: RA, SS, BI, NWS, Prov. AG's, Germany	*GAS* *GAS*
STORSTEIN **Aage** b. Stavanger. 1900 - Painter in oil & fresco media	*storstein* *Aa.S*
STORY **Julian Russel** b. England. 1850 - 1919 Genre & portrait artist Exh: US, Paris, Budapest	*Julian Story*

STOTHARD. RA **Thomas** b. London. 1755 - 1834 Historical, portrait & genre subjects Exh: NG, RA, BI, SS, Prov. AG's etc.	*T. Stothard*
STOTT. ARA **Edward** b. England. 1859 - 1918 Rustic genre & landscape artist Exh: RA, NEAC, NG, GG, & Prov. AG's	*ES*
STRAET **Jan Van Der** b. Bruges. 1523 - 1605 Religious & genre subjects Exh: Italy, Belgium, Austria	*Joan Stradani Opus*
STRAETER (or STREATER) **Robert** b. London. 1624 - 1680 Portraits, still life, historical & landscape artist	*R Straeter 1670*
STRAIN. SMA **E. Hilary** b. Ayrshire. 1884 - Portrait artist Exh: RA, PS, RSA, RP, GI, SMA, WAG, etc.	*Hilary Strain 1927.*
STRALEN **Antoni Van** b. Holland. 1594 ? - 1641 Landscape artist Exh: Holland, Germany, Scandinavia	*AVS.*
STRANG, RA **William** b. Dumbarton. 1859 - 1921 Genre, figure & portrait artist Exh: RA, UK AG's, Paris	*SW* *S*
STRAUCH **Georg** b. Nuremberg. 1613 - 1675 Historical subjects Exh: Austria	*GS*
STRAUCH **Lorenz** b. Nuremberg. 1554 - 1630 Portrait & architectural subjects Exh: Germany, Italy	*S* *S. 1617*
STREEK **Hendrick Van** b. Amsterdam. 1659 - 1719 Interior scenes & genre subjects Exh: Holland, Russia	*H. v. Streek f.*

STREEK **Jurian Van** b. Amsterdam. 1632 ? - 1687 Portrait & still life subjects Exh: France, Holland, Austria	*J. v. Streek fec.*
STREETON **Sir Arthur** b. Australia. 1867 - 1943 Landscape artist Exh: RA, SSSBA, Australia	*Arthur Streeton*
STRICKLAND **Dorothy Enid** b. Kent. 1899 - Painter & sculptor Exh: Rhodesia, S. Africa, etc.	*DⱭ*
STROOBANT **Francois** b. Brussels. 1819 - 1916 Architectural & landscape subjects Exh: Belgium	*F. STROOBANT FS F. S J. S*
STRUDWICK **John Melhuish** b. 1849 - 1937 Genre subjects Exh: RA, SS, London & Prov. AG's	*JMS 1873 JMS 1893*
STRUPP **J.** Fl. Germany.18th C. Floral artist Exh: Germany	*Strupp Pinxt.*
STRUTT. RBA, ARPE **Alfred William** b. New Zealand. 1856 - 1924 Portrait, genre & animal subjects Exh: RA, SS, NWS, London & Prov. AG's	*aWS A. St.*
STRUTT **William** b. 1826 - 1915 Genre, animals & portrait artist Exh: RA, SS, NG, Prov. AG's	*WAS 1877*
STRUYS **Alexander Theodore Honore** b. Belgium. 1852 - ? Genre & portrait artist Exh: Belgium, US	*Alexander Struys*
STRY **Abraham Van** b. Dortrecht. 1753 - 1826 Portraits, interiors, still life, animals & landscape subjects Exh: Holland, Belgium, US	*A Van Stry. F*

STUART **Charles** Fl. 1854 - 1893 Still life & landscape artist Exh: RA, BI, SS	**CS**
STUART-BROWN **Henry James** b. Bathgate. 1871 - ? Etcher, oil & watercolourist Exh: RA, RSA, London & Prov. AG's, Australia etc.	*Henry James Brown*
STUBENRAUCH **Hans** b. Germany. 1875 - ? Painter & illustrator	*Hans Stubenrauch*
STUBENRAUCH **Philipp Von** b. Vienna. 1784 - 1848 Genre subjects	*PS*
STUCK **Franz Von** b. Germany. 1863 - 1928 Portrait, genre & landscape subjects Exh: Germany, Italy, Belgium, etc.	*FRANZ STVCK*
STUCKELBERG **Ernst** b. Basle. 1831 - 1903 Portrait & historical artist Exh: Switzerland, Germany	ESTÜCKELBERG.
STURGESS-LIEF **Christopher Patric** b. Berlin. 1937 - Pastel, oil, watercolour media etc. Exh: London & Prov. AG's	STURGESS-LIEF.
STURMER **Johann Heinrich** b. Germany. 1774 - 1855 Genre, portrait & landscape subjects Exh: Germany	*SH*
STURMER **Karl** b. Berlin. 1803 - 1881 Battle scenes, genre & landscape subjects Exh: Germany	*CK*
STURTEVANT **Erich** b. Germany. 1869 - ? Historical & landscape subjects	E.STURTEVANT

STUVEN **Ernst** b. Hamburg. 1660 - 1712 Still life & floral subjects Exh: Germany	*Ernst Stuwenly* E.S
STYKA **Adam** b. Poland. 1890 - Genre & eastern subjects Exh: France	ADAM STYKA *Adam Styka*
STYKA **Jan** b. France. 1858 - 1925 Religious, historical & genre subjects Exh: Poland, Italy	*Jan Styka*
STYKA **Tade** b. Poland. 1889 - Portraits, genre & animal subjects Exh: Paris, Germany, New York	**TADÉ. STYKA—**
SUBLEYRAS **Pierre Hubert** b. France. 1699 - 1749 Portraits & historical subjects Exh: France, Italy, Russia, Austria, UK, etc.	*Subleyras* *P. Subleyras 1740* *P SVBLEYRAS* *pxit 1730* *P Subleyras*
SUCHET **Joseph Francois** b. Marseille. 1824 - 1896 Marine artist Exh: France	*J.b Suchet*
SUDDABY **Rowland** b. Yorkshire. 1912 - Oil & watercolourist Exh: London & Prov. AG's, X	*R. Suddaby.*
SUE **Marie Louis** b. Bordeaux. 19th C. Still life, portrait & landscape subjects Exh: France	*LSue*
SUKER **Arthur** Fl. 1866 - 1890 Landscape & marine artist Exh: RA, UK AG's, Australia	AS

SUMMERHAYS. RMS, ARBSA, AWSA, etc. **Dora** b. 1883 - 1955 Miniaturist & watercolourist Exh: RA, RWEA, WAG, PS, RMS, etc.	
SURVAGE **Leopold** b. Moscow. ? - 1879 Cubist & abstract subjects Exh: France, US, Italy, Moscow	
SUSENIER **Abraham** b. Holland. 1620 ? - 1664 Still life & landscape artist Exh: Holland, Germany	
SUSTERMAN **Cornelis** b. Antwerp. 1600 ? - 1670 Portrait & historical subjects	
SUSTRIS **Frederik** b. Italy. 1540 ? - 1599 Religious subjects Exh: Italy, Germany	
SUTCLIFFE **Irene** b. Nr. Whitby. 1883 - ? Miniaturist Exh: RA, RSA	
SUTTON. ARCA, FRSA. **Hector McDonald** b. S. Staffordshire. 1903 - Pastel, gouache, oil media Exh: London & Prov. AG's	
SUTTON **Philip** b. Dorset. 1928 - Exh: London & Prov. AG's, US	
SUVEE **Joseph Benoit** b. Bruges. 1743 - 1807 Historical & portrait artist Exh: Belgium, France	
SWAN **John Macallan** b. England. 1847 - 1910 Animal, genre & landscape subjects Exh: UK, Holland, Australia, Canada	

SWANENBURGH **Willem Isaaksz** b. Holland. 1581 - 1612 Historical & portrait artist	
SWANEVELT **Herman Van** b. Holland. 1600 ? - 1655 Landscape artist Exh: France, Italy, UK, Austria, Germany	H . SWANEVELT PARIS 1654 H Swanevelt f H SWANEVELT
SWANWICK **Betty** b. London. 1915 - Imaginative compositions, watercolourist Exh: RA, & UK AG's	Betty Swannick
SWART **Jan** b. Holland. 1500 ? - 1553 ? Religious & historical subjects Exh: Belgium, Germany, Paris, London	
SWEBACH **Bernard Edouard** b. Paris. 1800 - 1870 Genre & military subjects Exh: France, Belgium	E. Swebach E: SW 1823 E: SW:
SWEBACH **Jacques Francois Jose** b. France. 1769 - 1823 Portrait, historical & battle scenes Exh: France	J. Swebach
SWEERTS **Michele** b. Brussels. 1624 - 1664 Genre subjects Exh: Holland, Germany, Russia, UK	

SWINDEN. ARCA, AMC, ACTC **Ralph Leslie** b. Meriden, US. 1888 - Oil & watercolourist Exh: London & Prov. AG's	*R.L. Swinden*
SYLVESTRE **Joseph Noel** b. France. 1847 - 1926 Battle scenes, portrait & historical subjects Exh: France	**SYLVESTRE PiNx**
SYMONS **William Christian** b. London. 1845 - 1911 Portrait, genre, historical, still life & landscape artist Exh: RA, NWS, GG, SS, ROI, Prov. AG's	W.C.S.
SZYMANOVSKI **Waclaw** b. Warsaw. 1859 - 1930 Genre subjects Exh: Poland	W.Szymanowski

T

TABAR **Francois Germain Leopold** b. Paris. 1818 - 1869 Historical & landscape subjects Exh: France	L Tabar
TAILLASSON **Jean Joseph** b. Bordeaux. 1745 - 1809 Historical & genre subjects Exh: France	Taillasson JJ.
TALBOT-KELLY. RI **Capt. Richard Barrett** b. Birkenhead. 1896 - Birds & historical figure subjects Exh: RA, RI, PS, Prov. AG's	.T ‾IKI‾
TANGUY **Edward Michael** b. Jersey, C.I. 1938 - Portraits & landscapes in oil & acrylic Exh: NSPSP, London & Prov. AG's	TANGUY
TANZIO **Antonio D'enrico** b. Italy. 1575 ? - 1635 Religious & portrait artist Exh: Italy	Ꜳ A A

TARDIEU **Jean Charles** b. Paris. 1765 - 1830 Historical subjects Exh: France	*C. Tardieu*
TARDIEU **Victor Francois** b. Lyon. 1870 - ? Genre, figure & marine subjects Exh: France	*Victor Tardieu*
TARRATT **John Garfield** Figure & landscape subjects etc. Exh: WAG, RSA, London & Prov. AG's	
TASSAERT **Octave** b. Paris. 1800 - 1874 Genre & historical subjects Exh: France	*O Tassaert 1852 Oct Tassaert* *O Tassaert*
TATE. RMS, SWA, FRSA **Barba** b. Uxbridge. 1927 - Portraits, genre, floral & still life subjects Exh: London & Prov. AG's, Italy, France, etc.	*Barba Tate*
TATE **Barba & James**	see **TATE Barba &** **TATE James** Works executed jointly
TATE **James** b. Chatham. 1914 - Genre, abstract & animal subjects Exh: London & Prov. AG's, Italy, France, etc.	*Tate*
TATTEGRAIN **Francis** b. France. 1852 - 1915 Marine, portraits & historical subjects Exh: France	*Francis TATTEGRAIN* *F.TATTEGRAIN*
TAUBERT **Bertoldo** b. Italy. 1915 - Portrait, figure & landscape artist Exh: France	*B. Taubert*
TAUNAY **Nicolas Antoine** b. Paris. 1755 ? - 1830 Military, genre & landscape artist Exh: PS, France, Russia, UK, etc.	*TAUNAY*

TAVERNIER **Francois** b. Paris. 1659 - 1725 Mythological & religious subjects	*F Tavernier*
TAVERNIER **Paul** b. Paris. 1852 - ? Portrait & genre artist	*Paul Tavernier.* *P. Tavernier*
TAYLER **Edward** b. Orbe. 1828 - 1906 Portrait artist & miniaturist Exh: RA, SS, RI, London & Prov. AG's	E.T. Ŧ
TAYLER **Frederick** b. Hertfordshire. 1804 - 1889 Figures, landscapes & sporting scenes Exh: RA, BI, OWS, etc.	F·T
TAYLOR **Charles William** b. Wolverhampton. 1878 - 1960 Genre, landscape artist & engraver Exh: UK AG's	WT WT
TAYLOR. RBSA **Edwart Robert** b. Hanley. 1838 - 1911 Portrait, biblical, genre, coastal & landscape subjects etc. Exh: RA, BI, NG, GG, SS, NWS, etc.	ERT ET
TAYLOR **Frederick** b. London. 1875 - ? Architectural & landscape artist Exh: UK AG's, Canada	FT
TAYLOR. ARA **Leonard Campbell** b. Oxford. 1874 - ? Painter in oil media Exh: RA, RI, London & Prov. AG's	*L. Campbell Taylor*
TAYLOR. RMS **Norah Helen** b. London. 1885 - Painter & miniaturist Exh: RA, PS, US., Canada, Australia etc.	N\|H.
TELFER **William Walker** b. Falkirk. 1907 - Portrait & landscape artist Exh: RSA, RSW, SSA, GI	*TELFER.* *telfer.*

TEMPESTA **Antonio** b. Florence. 1555 - 1630 Processions, battle & hunting scenes, landscapes & historical subjects Exh: Italy, Germany, France	*A. Tempesta* *1620* **A̅** **AT** **Æ** **A** **Æ** **Ɛ F**
TENCY **Jean Baptiste L** Fl. Belgium. 18th C. Marine & landscape subjects Exh: Belgium	*LBL Tency. f.*
TENIERS **Abraham** b. Antwerp. 1629 ? - 1670 Genre & landscape subjects Exh: European & UK AG's	*Teniers f*
TENIERS (The Younger) **David** b. Antwerp. 1610 - 1690 Historical, genre, landscapes, fairs, village scenes etc. Exh: International AG's	*D. Teniers. F* *DAVID · TENIERS* *DAVID. TENIERS Fec* *D · TENIERS · F* *· 1651 ·* *·D· TENIERS · F·* *D. Teniers. F.* *D· TENIERS · F* *D · TENIERS · Fec* *1650* Ð Ɗ *D·TENIERS F* Ð Ɗ *D · TENIERS F* *D · TENIERS · Fec* Ð Ð *D TENIERS · Fec* *D.T.* *DAVID TENIERS Fec* Ð·F *Aº 1645.*

TENNANT Dorothy b. UK. ? - 1926 Genre artist Exh: RA, NG, GG, etc.	
TENNIEL Sir John b. London. 1820 - 1914 Portraits, genre subjects & illustrator Exh: RI, NWS, SSSBA, VA, Prov.AG's, etc.	1870
TENRE Charles Henry b. France. 1864 - 1926 Genre subjects Exh: Paris	HENRY TENRÉ
TERBURG (also known as BORCH) Gerard b. Zwolle. 1617 - 1681 Portraits, genre & domestic subjects etc.	G. Terburg fcit
TER MEULEN Frans Pieter b. Holland. 1843 - 1927 Animal & landscape subjects Exh: Holland, Belgium, UK, Germany	Tre Meulen
TESTA Pietro b. Italy. 1611 - 1650 Allegorical & portrait & historical subjects Exh: Italy, France, Russia, Austria	P. Testa
TESTELIN Henri b. Paris. 1616 - 1695 Portraits & historical subjects	H. Testelin 1680
TESTELIN Louis b. Paris. 1615 - 1655 Portraits & historical subjects	Testelin L 1640
TETAR VAN ELVEN Jan Baptiste b. Amsterdam. 1805 - 1879 Genre subjects Exh: Holland, Germany, Belgium	J. B. Tv. E
THACKERAY Lance b. ? - 1916 Genre & sporting scenes Exh: London & Prov. AG's	LT

THAULOW **Fritz** b. Norway. 1847 - 1906 Genre & landscape artist Exh: France, Germany, US, Sweden	*Fritz Thaulow*
THEAULON **Etienne** b. France. 1739 - 1780 Genre & landscape subjects Exh: France	*E Theaulon*
THELOT **Antoine Charles** b. France. 1853 - ? Historical, portrait & landscape subjects Exh: France	*TC*
THEODORE. Lt.Com.RNR. **Henry Frank** b. London. 1892 - Landscape & marine artist Exh: RA	*Frank Theodore*
THEUVENOT **Alexandre Jean Baptiste** Fl. France. 19th C. Genre & animal subjects Exh: PS	A.THEUVENOT
THIEL **Ewald** b. Germany. 1855 - ? Painter & illustrator	EWALD THIEL
THIELE **Johann Friedrich Alexandre** b. Dresden. 1747 - 1803 Landscape subjects Exh: Germany, Norway	*JF*
THIELEN **Jan Philip Van** b. Mechlin. 1618 - 1667 Floral artist Exh: Holland, Belgium	*J.P. v. Thielen 1648 J.P.V Thielen 1660*
THIER **Barend Hendrik** b. Holland. 1751 - 1814 Genre & landscape artist	*B Thier f. 1773*
THIEROT **Henri Marie J.** b. Reims. 1863 - 1905 Genre, portrait & landscape artist Exh: France, Germany	*H. Thierot.*

THIERRAT **Augustin Alexandre** b. Lyon. 1789 - 1870 Floral & genre subjects Exh: France	*Thierriat* *Lyon*
THIRION **Charles Victor** b. France. 1833 - 1878 Genre subjects Exh: France	V . THIRION
THIRION **Eugene Romain** b. Paris. 1839 - 1910 Historical & portrait artist Exh: France	*Eug Thirion*
THOMA **Hans** b. Germany. 1839 - 1924 Religious, portrait, genre & landscape subjects Exh: Germany, US, Sweden, Austria, etc.	*Hans Thoma* ℋℎ
THOMAS **Adolphe Jean Louis** Fl. Paris. 19th C. Landscape artist Exh: PS	*A Louis Thomas*
THOMAS **Albert Gordon** b. Glasgow. 1893 - Tempera, oil & watercolourist Exh: RSA, RSW, SSA, GI, Prov. AG's	A GORDON THOMAS 26
THOMAS. ARBSA **Charles** b. Birmingham. 1883 - Pastel, oil, watercolourist, etc. Exh: RA & Prov. AG's	19 28 CT
THOMAS **Gerard** b. Antwerp. 1663 - 1720 Genre subjects Exh: Belgium	G THOMAS fe
THOMAS **Laura Estelle Owen** b. London. 1897 - Painter in oil & gouache media Exh: RA & Prov. AG's	LTE

THOMAS. WIAC, RBA, NEAC, FRSA. **Margaret** b. London. 1916 - Portrait, still life & landscape artist Exh: RA, RSA, RBA, NEAC, London & Scottish AG's	*Margaret Thomas.* MT *Margaret Thomas.*
THOMAS **Paul** b. Paris. 1859 - ? Genre, interior scenes & portraits Exh: France, US	Paul Thomas
THOMAS. RPE **Percy** b. London. 1846 - 1922 Portraits, genre, landscape & architectural subjects Exh: RA, SS, London & Prov. AG's	₱
THOMAS. R.Cam.A. **Walter** b. Liverpool. 1894 - Marine artist Exh: RI, R.Cam.A., London & Prov. AG's	WALTER THOMAS
THOMAS **William Cave** b. London. 1820 - ? Historical, genre, Pre-Raphaelite School Exh: VA, NG, London & Prov. AG's	⟨monogram⟩
THOMAS. FRSA **Winifred M.** b. Pengam. 1910 - Gouache, oil & watercolourist Exh: RBSA, London & Prov. AG's	W̅
THOMPSON. RCA **Constance Dutton** Pastel, oil & watercolourist Exh: RA, RBA, WAG, R.Cam.A. Prov. AG's	⟨monogram⟩
THOMSON. RMS **Emily Gertrude** b. Glasgow. Portrait, figure artist; miniaturist Exh: London & Prov. AG's, Belgium, Canada	⟨monogram⟩
THOMSON **Margaret Stanley** b. Ormskirk. 1891 - Etcher, watercolourist etc. Exh: WAG, London & Prov. AG's, Canada	⟨monogram⟩

THORBURN **Archibald** b. 1860 - 1935 Birds & animal subjects Exh: RA, SS, London & Prov. AG's	*Archibald Thorburn* 1901 A.T.
THORBURN, ARA **Robert** b. Dumfries. 1818 - 1885 Painter & miniaturist Exh: RA, UK AG's	R.T.
THORNE-WAITE **Robert** b. England. 1842 - ? Genre & landscape subjects Exh: RA, RI, UK, Sydney	R. Thorne Waite
THORNLEY. NSA, ABWS, RWS, etc. **Morgan Alfred** b. Cardiff. 1897 - Landscape artist Exh: NSA, RWS, BWS	M.A. Thornley NSA ABWS.
THORNLEY **William** b. France. 1857 - ? Landscape, marine & architectural subjects Exh: PS, European AG's	THORNLEY
THORNYCROFT, SWA **Helen** Fl. 1864 - 1912 Genre, floral, landscape & religious subjects Exh: RA, SS, NWS, NG	H
THORS **Joseph** Fl. 1863 - 1884 Landscape artist Exh: RA, BI, SS	J. THORS
THULDEN **Theodor Van** b. Holland. 1606 - 1676 Religious & genre subjects Exh: Belgium, Germany, France, Spain	T. Van Thulden. fec A° -1654 T.vT. M. TM
TIDEMAND **Adolphe** b. Norway. 1814 - 1876 Genre & historical subjects Exh: Holland, Germany, Scandinavia	Ad. Tidemand Df
TIEPOLO **Giovanni Battista** b. Venice. 1696 - 1770 Genre, religious & historical subjects Exh: European AG's, Russia, UK, US	B. Tiepolo 1750 G. TIEPOLO F.

TIEPOLO Giovanni Battista (Continued)	BT.° ℬ.° ℬ.ˢ ℬ.° ℬ.ᵃ ℬ. B
TIEPOLO Giovanni Domenico b. Venice. 1727 - 1804 Religious & genre subjects Exh: Italy, Spain, Germany, France, Hungary, etc.	Ɖ Tiepolo
TIFFIN Walter Francis b. 1817 - 1900 Landscape artist & miniaturist Exh: RA, BI, SS	*(monogram)*
TILBORG (The Elder) Egidius b. Antwerp. 1578 - 1632 Genre & landscape subjects Exh: France	Ƀ° Ƀ
TILLEMANS Peter b. Antwerp. 1684 - 1734 Figures, animals, battle scenes & landscape artist Exh: Belgium, Russia, UK	P. Tillemans. 1730. P.T. P.T.
TILSON. ARCA Joe b. London. 1928 - Painter & sculptor Exh: France, US, Japan, London & Prov. AG's	Joe Tilson.
TINAYRE Jean Paul Louis b. France. 1861 - ? Military & genre subjects Exh: France	LOUIS TINAYRE
TINDALL. RBA William Edwin b. Scarborough. 1863 - ? Landscape artist Exh: RA, London & Prov. AG's	!!! Edwin Tindall
TINDLE. ARA David b. Huddersfield. 1932 - Realist, portraits, still life & landscape artist Exh: RA, Italy, France, Germany, US, Switzerland, Belgium & UK AG's	David Tindle DT. DT.
TINTORETTO Jacopo b. Venice. 1518 ? - 1594 Religious, historical & portrait artist Exh: International AG's	Ɠmo Tintoretto

TISCHBEIN **Friedrich** b. Germany. 1750 - 1812 Portrait artist Exh: Germany, Holland, Austria	*Tischbein* *Tischbein* *Tischbein* *p: 1789* *F Tischbein.*
TISCHBEIN (The Elder) **Johann Heinrich** b. Germany. 1722 - 1789 Historical, portrait & genre subjects Exh: Germany, Holland, UK	*J. Tischbein* *1753.*
TISCHBEIN (The Younger) **Johann Heinrich** b. Germany. 1742 - 1808 Portrait & landscape subjects Exh: Germany	*JH*
TISCHBEIN **Johann Heinrich Wilhelm** b. Germany. 1751 - 1829 Historical, portrait & genre subjects Exh: Germany, Russia	*Tischbein*
TISDALL **Hans** b. 1910 - Painter & designer Exh: London, France, Germany, Switzerland	*tisdall*
TISIO **Benvenuto Da Garofalo** b. Garofalo. 1481 - 1559 Historical, mythological subjects Exh: European AG's, Russia, etc.	*B.Garofolo* *B. Tisio. fe : 1550*
TISSIE-SARRUS b. France. 1780 - 1868 Portraits & genre subjects Exh: France	*Tissie-Sarrus.*
TISSIER **Ange** b. Paris. 1824 - 1876 Genre & portrait artist Exh: France	*Ange Tissier*
TISSOT **James Jacques Joseph** b. Nantes. 1836 - 1902 Religious, historical & genre subjects Exh: PS, RA, SS, GG, Prov. AG's, Belgium, France	*J. Tissot* *JJT* *JJ.T.* *T* *J.J 1850* *JJT*

TITCOMB **William Holt Yates** b. Cambridge. 1858 - ? Genre subjects Exh: SSSBA, Prov. AG's, US, France	W.H.Y. TITCOMB
TITIAN **(Tiziano Vecelli)** b. Capo Del Cadore. 1477 ? — 1576 Religious, historical, mythological & portrait artist Exh: International AG's	TITIANVS + Tizianus .F. TICIANVS . F. TICIAN TITIANVS·ÆQVES·CÆS· TITIANI OPVS· TITIANVS · F. TITIANV̄ TITIANVS·F TITIANUSEques TITIANVS·F CES. f 1543
TITO **Ettore** b. Italy. 1859 - 1941 Genre subjects Exh: Italy, US, Germany, Austria, France	E. Tito
TOBAR **Don Alonso Miguel De** b. Spain. 1678 - 1758 Religious & portrait artist Exh: Spain, France, Germany, UK etc.	A M De Tobar AM de Tobar
TODD, RA, RWS **Arthur Ralph Middleton** b. Cornwall. 1891 - 1966 Genre, portrait & landscape oil & watercolourist Exh: RA, RWS, UK AG's	M·T.
TOGNI **Ponziano** b. Switzerland. 1906 - Painter in tempera, fresco & oil media Exh: Switzerland, Italy	P. Togni
TOL **Dominicus Van** b. 1635 ? - 1676 Genre, interiors & portrait artist Exh: Holland, Germany, France, Russia, US, etc.	DV. Tol.

TOLMAN Ruel Pardee b. Vermont, US. 1878 - Illustrator & portrait artist	
TOMLINSON. ARCA, RBA Reginald Robert b. Overton, Hants. 1885 - Portrait artist Exh: RA, ROI, RP, NEAC, RBA, PS	
TONKS Myles Denison Boswell b. Nr. Chatham. 1890 - Landscape, oil & watercolourist Exh: RA, NEAC, London & Prov. AG's	
TOOBY Charles Richard b. London. 1863 - 1918 Landscape artist Exh: Germany, UK	
TOOKEY. ARBSA Olwen b. Birmingham. 1910 - Portrait artist Exh: RA, PS, RP, RBA, London & Prov. AG's	
TOORENBURG Gerrit b. Amsterdam. 1737 ? - 1785 Architectural & landscape subjects Exh: Holland	
TOOROP Jan b. Java. 1858 - 1928 Portrait & genre subjects Exh: Holland, Belgium, Germany	
TOPHAM, RWS Francis William b. Leeds. 1808 - 1877 Genre subjects Exh: RA, BI, SS, VA, London & Prov. AG's	
TOPHAM. RI Frank William Warwick b. London. 1838 - 1929 Genre & historical subjects Exh: RA, NG, SS, NWS, GG, BI, Prov. AG's, Australia	
TOPINO-LEBRUN Francois Jean Baptiste b. Marseille. 1769 - 1801 Historical subjects Exh: France	

TORENVLIET **Jacob** b. Leyden. 1635 ? - 1719 Genre & portrait artist Exh: Holland, France, Hungary, Germany, Scandinavia, etc.	*J. Torenvliet f.*
TORRENTS Y DE AMAT **Stanislas Pierre Nolasque** b. Marseille. 1839 - 1916 Portrait & genre subjects Exh: France, Spain	*Torrents*
TOSELAND **Peter Harold** b. Broughton, Northants. 1917 - Portraits, landscapes & topographical subjects Exh: RA, RI, Prov. AG's	*Peter Toseland*
TOUCHAGUES **Louis** b. France. 1893 - Portraits, genre subjects & illustrator Exh: France, UK	*Touchagues*
TOULMIN. FRGS, AMIMI, AM **Inst.W.** **John** b. 1911 - Gouache & watercolourist Exh: London & Prov. AG's	*JTOULMIN* PL
TOULOUSE-LAUTREC-MONFA **Henri Marie Raymonde De** b. France. 1864 - 1901 Portraits, figure & genre subjects Exh: International AG's	*TLautrec* *HLautrec* *HLautrec* (various monograms)
TOURNEMINE **Charles Emile De** b. Toulon. 1812 - 1872 Marine & landscape artist Exh: France	*Ch. de Tournemine.*
TOURSEL **Augustin Victor Hippolyte** b. France. 1812 - 1853 Historical & landscape artist Exh: France	*Augustin Toursel. A Toursel*

TOUSSAINT **Fernand** b. Brussels. Fl. 19th – 20th C. Genre subjects Exh: France	*Toussaint*
TOWNSEND **Patty** Fl. UK. 19th - 20th C. Genre & landscape artist Exh: RA, NWS, SS, London & Prov. AG's	*P P*
TRAFFELET **Frederic Edward** b. Berne. 1897 - Fresco, oil & watercolourist Exh: Switzerland, X.	*Traffelet*
TRAIN **Thomas** b. Carluke. 1890 - Portrait & landscape artist Exh: Scottish & Prov. AG's	*T. TRAIN.*
TRAQUAIR. HRSA **Pheobe Anna** b. Dublin. 1852 - 1936 Painter & illustrator Exh: European AG's, US, UK	*R*
TRAUTMANN **Johann Georg** b. Germany. 1713 - 1769 Portraits & genre subjects Exh: Germany, Italy	*J.G Trautman fec*
TRAVIES DE VILLERS **Joseph** b. France. 1804 - 1859 Portraits & religious subjects Exh: France	*P.J. Traviés*
TREW **Cecil G** b. Bristol. 1897 - B/white & watercolourist Exh: RWEA, BMA, VA, Prov. AG's, France, etc.	*G*
TRIBE. SPS, FRBS, etc. **Barbara** b. Sydney, N.S.W. 1913 - Floral, animal, eastern subjects etc. Gouache, pen & ink, watercolourist & sculptor Exh: RA, Australia, Bangkok, Japan US & Europe	*Barbara Tribe.F.R.B.S.*
TRINQUESSE **Louis Rolland** b. Paris. 1746 - 1800 ? Genre & portrait artist Exh: France, Germany	*L R Trinquesse fecit.*

TRINQUIER **Antonin** b. France. 1833 - ? Genre & still life subjects Exh: France	*A.Trinquier.*
TROKES **Heinz** b. Duisberg. 1913 - Exh: Italy, Japan, Germany, US France, Spain, etc.	*Trökes 64*
TRONCY **Emile** b. France. 1860 - ? Genre subjects Exh: France, Italy	E.TRONCY
TROOSTWYK **Wouter Joannes Van** b. Amsterdam. 1782 - 1810 Landscape artist Exh: Holland	*W.J vT*
TROST **Andreas** b. Austria. ? - 1708 Genre, mythological & architectural subjects	*T A A*
TROUILLEBERT **Paul Desire** b. Paris. 1829 - 1900 Portrait, genre & landscape artist Exh: France	*Trouillebert*
TROUVE **Eugene** b. Paris. 1808 - 1888 Landscape artist Exh: PS	*Eug trouvé*
TROY **Francois De** b. Toulouse. 1645 - 1730 Portraits, historical & genre subjects Exh: Germany, Italy, France, UK, Austria, etc.	*De Troy*
TROY **Jean Francois De** b. Paris. 1679 - 1752 Historical, genre & portrait artist Exh: France, Italy, Germany, UK, Russia	DE TROY. 1723. *De Troy* *JF De Troy* I DETROY

TROYON **Constant** b. France. 1810 - 1865 Animal & landscape subjects Exh: France, Germany, Holland, US, UK, etc.	*C. TROYON C. TROYON* *C. TROYON C. TROYON*
TRUBNER **Alice (née Auerbach)** b. Bradford. 1875 - 1916 Portrait, still life, interiors & landscape artist Exh: Berlin, Frankfurt & German AG's	*A.T. a.T.*
TRUBNER **Wilhelm** b. Germany. 1851 - 1917 Historical, genre & portrait subjects Exh: Germany, Italy, US	*W. Trübner . München*
TSCHAGGENY **Charles Philogene** b. Brussels. 1815 - 1894 Genre & animal subjects Exh: Belgium, Germany	*C Tschaggeny*
TSCHAGGENY **Edmond Jean Baptiste** b. Brussels. 1818 - 1873 Animal subjects Exh: Belgium, France, Germany	**Ŧ** . $\frac{3}{56}$
TSCHUMI **Otto** b. Switzerland. 1904 - Surrealist Exh: France, Holland, Switzerland, US, Sweden, S. America etc.	*Tschumi*
TUKE. RA, RWS **Henry Scott** b. York. 1858 - 1929 Genre, coastal scenes & portrait artist Exh: RA, NEAC, GG, NG, SS, NWS, Prov. AG's, Australia	*H.ST H.S.T*
TUNNICLIFFE. RA, RE **Charles, Frederick** b. Langley. 1901 - Engraver, oil & watercolourist Exh: RA, London & Prov. AG's	*C.F. Tunnicliffe* Ŧ Ŧ
TURNER **Charles** b. England. 1773 - 1857 Portrait & genre subjects Exh: ARA, NPG, Prov. AG's	*Turner*

TURNER George Fl. 19th C. Landscape artist Exh: SS, London & Prov. AG's	*Geo Turner*
TURNER. RA Joseph Mallord William b. London. 1775 - 1851 Land & seascapes, venetian & historical subjects Exh: RA, NG, NPG, VA, Prov. AG's, France, US, Canada, etc.	*JMWT* IMWT *T*
TURNER. RGI, UA William b. Andover. 1877 - ? Portrait artist Exh: RA, RBA, USA, RSA, RGI, PS, etc.	*W*
TURNER. FRSA, ARCA, RCA William McAllister b. Flintshire. 1901 - Etcher, oil painter Exh: RCA, RSA, RWA, WAG, London & Prov. AG's, US, etc.	*W. Mc Allister Turner.*
TURNER, FRSA William Ralph b. Manchester. 1920 - Landscapes, portraits, towns & industrial architectural subjects Exh: RBA, RI, London & Prov. AG's	*William Turner*
TURNEY. ABWS Arthur Allin b. Shercock. 1896 - Marine watercolourist Exh: BWS & Prov. AG's	*A Turney.*
TURTON Dorothy Babara Jessie b. Cape Colony, S.A. 20th Cent. — Portraits, landscapes, interiors etc., oil, watercolour & miniaturist Exh: RMS, USA, London & Prov. AG's, US	*DOROTHY TURTON* *DOROTHY TURTON* *T*
TURYN Adam b. 1908 - Painter in oil media, B/white etc. Exh: RA, RSA, SSA, PS, Prov. AG's	*↑*
TUSHINGHAM Sidney b. Burslem. 1884 - 1968 Landscape artist Exh: RA, UK AG's	*T̄S*
TUSQUETS Y MAIGNON Ramon b. Spain. ? - 1904 Genre & portrait artist Exh: Italy, Spain	*R. Tusquets 1955*

TYRRELL-LEWIS **Dione** b. London. 1903 - Landscape artist Exh: SWA, NEAG, London & Prov. AG's	*D*
TYRWHITT. RBA, MA **Walter Spencer Stanhope** b. Oxford. 1859 - 1932 Architectural & landscape artist Exh: RA, RI, RBA, London & Prov. AG's	*WSTyrwhitt*

U

UCHERMANN **Karl** b. Norway. 1855 - ? Animal subjects Exh: Oslo, France, US	*Karl Uchermann 1880*
UCHTERVELDT **Jakob** b. Rotterdam. 1635 ? - 1710 ? Interiors, market scenes & portraits, etc. Exh: Holland, Germany, France, US, Hungary	*J. Uchtervelt*
UDEN **Lucas Van** b. Antwerp. 1595 - 1672 ? Landscape & figure artist Exh: European AG's	*Lucas Van Uden* *LVV* *L.V. VDEN 1650*
UHDE **Friedrich** b. Germany. 1848 - 1911 Biblical & genre subjects Exh: Germany, US, France	*Fv Uhde*
UILENBURG (or UYLENBURGH) **Gerard** b. Amsterdam. 1626 ? - 1690 ? Portraits, genre & landscape artist	*G. Vilenburg*
ULFSTEN **Nicolay** b. Norway. 1855 - 1885 Marine & landscape artist Exh: Norway	*n Ulfsten*
ULFT **Jacob Van Der** b. Gorinchem. 1627 - 1689 Animals, town scenes, genre & landscape artist Exh: Holland, Germany, France, Russia	*JVd. Ulft 1660*

ULLMAN **Eugene Paul** b. New York. 1877 - 1953 Portrait, figure & landscape artist Exh: US, Paris, Germany	*Eugene Paul Ullman*
ULMANN **Benjamin** b. France. 1829 - 1884 Historical & genre subjects Exh: France	*B. ULMANN*
ULRICH **Heinrich** b. Nuremberg. 1572 ? - 1621 Portrait, religious & landscape artist	*HV HV HV*
UNDEN **Lily Anne-Marie** b. Longwy. 1908 - Floral paintings etc. Exh: European AG's	*Unden*
UNDERWOOD. RMS, RBA **Anne** b. E. Grinstead. 1876 - ? Miniaturist & portrait artist Exh: RA, London & Prov. AG's	*(monogram)*
UNDERWOOD **Leon** b. 1890 - Portraits, genre & Mexican scenes Exh: UK AG's	*Leon U Leon U 29 Leon U/39*
UNGER **Edouard** b. Germany. 1853 - 1894 Historical & genre subjects Exh: Germany	*W. Unger*
URBAN **Hermann** b. New Orleans. 1866 - ? Landscape artist Exh: Germany, Hungary	*H. URBAN.*
URQUHART. MA, RBA **Murray** b. Kirkcudbright. 1880 - Portrait, historical & landscape artist Exh: RA, NEAC, RBA, RPP, & Prov. AG's	*MURRAY URQUHART*
URRABIETA ORTIZ Y VIERGE **Daniel** b. Madrid. 1851 - 1904 Genre subjects & illustrator Exh: Australia, France, Spain	*VIERGE*

UTRILLO **Maurice** b. Paris. 1883 - 1955 Genre, figure & landscape artist Exh: International AG's	*Maurice Utrillo*
UTTER **Andre** b. Paris. 1886 - 1948 Still life, genre & landscape subjects	*A. Utter.* 19 29 *André Utter*
UYTTENBROECK **Moyses Van** b. The Hague. 1590 ? - 1648 Mythological & landscape subjects Exh: Holland, Germany, Belgium, Hungary	M V.W. M v W Brovck 1625 M V BROVCK. MVWBR
UYTTERSCHAUT **Victor** b. Brussels. 1847 - 1917 Marine artist Exh: Belgium	*V. Uy Herschaut*

V

VACCARO **Andrea** b. Naples. 1598 ? - 1670 Biblical & historical subjects Exh: Italy, France, Madrid, Germany	ᵍⁱ C ᴄⱽ. Cⱽ. Sⱽ. XX
VADDER **Lodewyk De** b. Brussels. 1605 - 1655 Landscape subjects Exh: Belgium, Germany, France	*l de vadder* ℔
VAERTEN **Joannes Cornelius Maria** b. Belgium. 1909 - Tempera, oil & watercolour media Exh: European AG's	*Janvaerten*

VAILLANT Jacques Gaston Emile b. France. 1879 - 1934 Portraits & landscapes etc. Exh: France	*Jacques Vaillant*
VAILLANT Wallerant b. France. 1623 - 1677 Portrait artist Exh: Holland, France, NG, VIA	*W. Vaillant 1670* WV WV WF WF. WV
VALADON Jules Emmanuel b. Paris. 1826 - 1900 Genre & portrait artist Exh: France	J. VALADON
VALADON Maria b. France. 1865 - 1938 Still life, genre & portrait artist Exh: France	*Suzanne Valadon*
VALCKENBORG (or VALKENBORCH) Martin Van b. Belgium. 1535 - 1612 Portraits, genre & landscape artist Exh: Germany, Italy	*M.V. Valckenborg* VV
VALCKERT Werner b. Holland. 1585 ? - 1627 ? Portraits, historical subjects Exh: Holland, Germany	W V VA
VALDES Lucas De b. Seville. 1661 - 1724 Portraits & religious subjects Exh: Spain	RᵍL.
VALENSI Henry b. France. 1883 - Landscape subjects Exh: Paris	*Henry Valensi*
VALENTIN Jean Le b. Coulommiers. 1594 - 1632 Genre & historical subjects Exh: European AG's, Russia, UK	*M. valentin 1630*

V

VALESIO **Francesco** b. Bologne. 1560 ? - ? Portraits & landscape artist	*(signature marks)*
VALESIO **Giovanni Luigi** b. Italy. 1583 ? - 1650 ? Religious subjects & miniaturist Exh: Italy	*(signature marks)*
VALKENBORCH **Frederick** b. Antwerp. 1570 ? -1623 Genre & landscape subjects Exh: Holland, Germany, Norway	*(monogram)* 1607
VALKENBORCH **Lucas Van** b. Belgium. 1530 ? - 1597 Genre & landscape artist Exh: Belgium, Germany, France, Holland	*(monogram)*
VALLET **Edouard** b. Geneva. 1876 - 1929 Genre & landscape artist Exh: Switzerland	Ed.Vallet
VALLMITJANA **Abel** b. Barcelona. 1910 - Painter & sculptor Exh: X, UK, Europe, Israel, US	AbelVallmitjana Abel Vollmitjana
VALLOTTON **Felix Edouard** b. Lausanne. 1865 - 1925 Still life, portraits & genre subjects Exh: Switzerland, France, US, UK	F.VALLOTTON. F . VALLOTTON
VALMIER **Georges** b. France. 1885 - 1937 Composition & still life subjects Exh: Paris	G.VALMIER
VALTAT **Louis** b. France. 1869 - 1952 Still life, figure, genre & landscape subjects Exh: France	L. Valtat
VAN ABBE. ARE, RBA, SGA **Salomon** b. Amsterdam. 1883 - Etcher oil & watercolourist Exh: RA, PS, RHA, RWEA, WAG, S. Africa, etc.	S.Van Abbe Abbe

VANDENBERGH. FZS Raymond John b. London. 1889 - Animal, figure & landscape artist Exh: RA, RI, PAS, etc.	*R.g. Vandenbergh*
VANNI Giovanni Battista b. Italy. 1599 - 1660 Religious subjects Exh: Italy	*GV 1638*
VANNI Michelangelo b. Sienna. 1583 - 1671	*M·V·V.*
VANNI Rafaello b. Sienna. 1587 - 1678 Religious subjects Exh: Italy	*RAF.ASEN*
VANNUCCI Pietro	see PERUGINO II
VAN VEEN Stuyvesant b. New York. 1910 - Painter in oil, watercolour etc. Exh: US AG's, X	*S.·v·v.*
VAROTARI Alessandro b. Padua. 1588 - 1648 Portraits & historical subjects Exh: Italy, Germany, Hungary, Spain, Austria, etc.	*Alex° Varot°*
VAROTARI Dario b. Verona. 1539 - 1596 Religious subjects Exh: Italy	*D° Varotari* **DAR .V.** *D° Varotari Darius.*
VASARELY Victor b. Hungary. 1908 - Painter in oil, gouache etc.	*Vasarely—*

VASARI **Giorgio** b. Italy. 1511 - 1574 Religious subjects Exh: Italy, France, Germany, Austria	GEORG.ARRET.
VASQUEZ Y OBEDA **Carlos** Fl. Spain. 19th C. Genre & portrait artist Exh: Spain, Paris	Carlos VAZQUEZ.
VASTAGH **Geza** b. Austria. 1866 - 1919 Animal & landscape subjects Exh: Germany, Hungary	Vastagh Gy.
VAUTHIER **Pierre Louis Leger** b. Pernambuco. 1845 - 1916 Landscape artist Exh: France, Belgium	Pierre Vauthier
VAUTIER (The Edler) **Benjamin** b. Germany. 1829 - 1898 Genre subjects Exh: Germany, France, Switzerland	B Vautier
VAYSON **Paul** b. France. 1842 - 1911 Rustic genre & landscape artist Exh: France	P. VAYSON
VEBER **Jean** b. Paris. 1868 - 1928 Genre subjects Exh: France, S. America	Jean Veber
VECELLI **Tiziano**	see **TITIAN** **Tiziana Vecelli**
VECELLIO **Tiziano** b. Venice. 1570 ? - 1650 ? Portraits & historical subjects	TF.
VEEN **Adrien Van De** b. Delft. 1589 - 1680 Painter & engraver	

VEEN Otto Van b. Leyden. 1556 - 1629 Bibical & portrait artist Exh: Belgium, Holland, France, UK, Germany	
VEIT Philippe b. Berlin. 1793 - 1877 Biblical & architectural subjects Exh: Germany	
VELASQUEZ Diego Rodriguez De Silva Y b. Seville. 1599 - 1660 Portraits, religious & genre subjects Exh: Spain, Germany, UK, France, US, etc.	*DD Velasquez p 1650* *D D Velasquez* *DD Velasquez*
VELDE Adriaen Van De b. Amsterdam. 1636 - 1672 Genre & landscape artist Exh: International AG's	*A v Velde f 1667* — *A.V. velde f 1665* — *A.V.velde. f 1667* — *A. V. velde f 1668.* — *A. V. velde. f 1666* — *A.v. velde. f 1660* — *A: v. velde. f. 1673* — *A.V. velde 1670* — *A. V. velde. f 1669 f* — *A v d velde f* — *A V. velde. f 1671* — **A.V.V.F.** — *A. V. V. F.* — *A. V. Velde*
VELDE Esaias Van De b. Amsterdam. 1591 ? – 1630 Battle scenes & landscape artist Exh: Holland, Germany, France, Austria, etc.	*E VANDEN · VELDE 1614* *EV*

VELDE **Esaias Van De** (Continued)	*(signature marks: E.V.V. variants)*
VELDE **Peter Van De** b. Antwerp. 1634 - 1687 Marine artist Exh: Belgium, Russia, Scandinavia, Holland, France	*(signatures: P.V.V. and PVV)*
VELDE (The Younger) **Willem Van De** b. Leyden. 1633 - 1707 Marine artist Exh: Holland, Belgium, France, UK' Germany, etc.	*(signatures: W. Vand Velde, W.V.V., W Velde f 1685, WVV, WVV, W: van de velde, W. v velde f, W. v. velde f.)*
VENENTI **Giulio Cesare** b. Bologna. 1642 - 1697 Painter & engraver	*(monogram marks)*
VERA **Paul Bernard** b. Paris. 1882 - Genre subjects & illustrator Exh: Paris, New York	*Paul Vera*
VERBEECK **Francois Xavier Henri** b. Antwerp. 1686 - 1755 Battle scenes etc. Exh: Belgium	*verbeeck alle 3 1713*
VERBEECK **Pieter Cornelis** b. Haarlem. 1610 - 1654 Hunting scenes Exh: Holland, Germany, Italy, UK	*VB*

VERBOECKHOVEN **Eugen Joseph** b. Belgium. 1798 ? – 1881 Portrait, animal & landscape subjects Exh: Belgium, Germany, UK, France, etc.	*Eugène Verboeckhoven*
VERBOECKHOVEN **Louis** b. Belgium. 1802 - 1889 Marine artist Exh: Belgium, France, Germany	*Louis Verboeckhoven*
VERBRUGGE **Jean Charles** b. Bruges 1756 - 1831 Interior scenes & landscapes Exh: Holland	*CB Brugge*
VERBURGH **Medard** b. Belgium. 1886 - Still life, marine, figure & landscape subjects Exh: Belgium, US	*B. Vaburg b.*
VERDIER **Francois** b. Paris. 1651 - 1730 Religious & historical subjects Exh: France	*Verdier*
VERDIER **Marcel Antoine** b. Paris. 1817 - 1856 Portrait & genre artist Exh: PS, France	*M. Verdier*
VERDIJK **Gerard** b. Holland. 1934 - Painter in oil media Exh: UK, European AG's, US	*G Verdijk*
VERDUSSEN **Jan Peeter** b. Antwerp. 1700 ? - 1763 Battle & hunting scenes Exh: France, Belgium, Italy	*P · VERDVSSEN*
VERGELLI **Giuseppe Tiburzio** Fl. Italy. 17th C. Historical, architectural & landscape subjects Exh: France	*VTC*
VERHAERT **Pieter** b. Antwerp. 1852 - 1908 Landscape & genre subjects Exh: Belgium, France, US	*Piet Verhaert*

VERHAGEN **Pierre Jean Joseph** b. Belgium. 1728 - 1811 Historical subjects Exh: Belgium, Austria	*P.J. Verhaghen*
VERHAS **Jan Francois** b. Belgium. 1834 - 1896 Genre subjects Exh: Belgium, France	*Jan Verhas*
VERHEYDEN **Isidoor** b. Antwerp. 1846 - 1905 Portrait & landscape artist Exh: Belgium, France	*IS Verheyden*
VERHEYDEN **Mattheus** b. Holland. 1700 - 1776 ? Historical & portrait artist Exh: Amsterdam	*M. Verheyden* *M. Verheyden* *M C Verheyden* *M. Verheyden* *M. Verheyden. Fecit* *M Verheyden. Fecit 1750*
VERHOEVEN-BALL **Adrien Joseph** b. Antwerp. 1824 - 1882 Genre, floral & portrait artist Exh: Belgium, France, Canada	*AJ Verhoeven F.* ⅄
VERKOLYE **Jan** b. Amsterdam. 1650 - 1693 Portrait, genre & historical subjects Exh: Holland, Germany, Russia, UK, etc.	*I. VERKOLJE 1685* **VK** *I VERCOLIE* *I. VERKOLJE* *IVRf*

VERKOLYE **Nicolaas** b. Delft. 1673 - 1746 Historical & portrait artist Exh: Holland, Germany, France, Russia	*N Verkolje fecit* *N.v K f* *N.v.K f* *N.V.*
VERLAT **Charles Michel Maria** b. Antwerp. 1824 - 1890 Portraits & animal subjects Exh: Holland, Belgium, Germany	*cVERlat*
VERMEYEN **Jan Cornelisz** b. Holland. 1500 ? - 1559 Portraits & historical subjects	*15 45*
VERNET (known as CARLE) **Antoine Charles Horace** b. Bordeaux. 1758 - 1836 Battle & hunting scenes, historical subjects Exh: France, Germany, etc.	*CVernet* *Carle Vernet* *Carle Vernet.* *Carle Vernet* *Curle Vernen.* *C V. C Vet.*
VERNET **Claude Joseph** b. Avignon. 1714 - 1789 Marine & landscape artist Exh: UK & European AG's	*J·Vernet S* *J·Vernet f. 1774.* *Joseph Vernet 1753* *Joseph Vernet* *Vernet* *Joseph Vernet* *Jvernet. f*

VERNET Claude Joseph (Continued)	J. Vernet 1760 J. Vernet. S 1765 J. Vernet. S. 1751 J. Vernet S. 1761 Joseph Vernet S Roma .1748. J. Vernet . 1770 Vernet S 1763 J. Vernet. S 1770 J Vernet . 1762 J Vernet S Roma 1748
VERNET Emile Jean Horace b. Paris. 1789 - 1863 Military, historical & portrait artist Exh: France, Holland, UK	H. Vernet H Vernet H.V.
VERON Alexandre Paul Joseph b. Paris. 1773 - ? Historical & floral subjects Exh: France	Veron Bellecourt
VERON Alexandre Rene b. France. 1826 - 1897 Landscape subjects Exh: France	AVERON
VERONESE Paolo	see CALIARI (Paolo)
VERSCHAEREN Jean Antoine b. Antwerp. 1803 - 1863 Portrait & landscape subjects Exh: Belgium	J A Verschaeren ft
VERSCHURING Henrik b. Holland. 1627 - 1690 Battle scenes, genre & landscape artist Exh: Holland, Germany, France, Russia, UK	H. Verschuring H.Vg H. VERSCHVRING F. 1653. HS

VERSCHUUR **Wauterus** b. Amsterdam. 1812 - 1874 Battle scenes & landscapes Exh: Holland, US, Germany, etc.	*W. Verschuur*
VERSTAPPEN **Martin** b. Antwerp. 1773 - 1853 Landscape artist Exh: France	*M Verstappen f*
VERSTEEG **Michiel** b. Holland. 1756 - 1843 Landscape artist Exh: Holland, France, Germany	*M versteegh Fecit*
VERSTRAETE **Theodor** b. Belgium. 1850 - 1907 Landscape artist Exh: Belgium, Germany	*THEOD VERSTRACTE*
VERTES **Marcel** b. Hungary. 1895 - 1961 Genre subjects	*Verts*
VERWEE **Alfred Jacques** b. Belgium. 1838 - 1895 Animal & landscape subjects Exh: Belgium, Holland, France	*Alfred Verwee*
VEYRASSAT **Jules Jacques** b. Paris. 1828 - 1893 Animal & landscape subjects Exh: France	*J. Veyrassat* J V
VIARDOT **Leon** b. Dijon. 1805 - 1900 Portrait artist Exh: France	*Léon Viardot*
VIBERT **Pierre Eugene** b. Switerland. 1875 - 1937 Genre subjects & illustrator Exh: Switzerland, France	*P.E Vibert*
VICKERS **Vincent Cartwright** b. London. 1879 - Pen & ink media, watercolourist etc. Exh: RA, London & Prov. AG's	*V.*

VICTOR (or FICTOOR) **Johan** b. Amsterdam. 1620 - 1676 Portraits, genre, landscapes & historical subjects Exh: European AG's	*f c 1640* *Jan fictoor*
VIDAL **Eugene Vincent** b. Paris. Fl. 19th - 20th C. Genre & portrait artist Exh: France	*Eug VIDAL*
VIDAL **L.** b. France. 1754 ? - ? Still life subjects Exh: France	*L vidal. px.*
VIDAL **Vincent** b. France. 1811 - 1887 Portrait artist Exh: France	*V. Vidal* *V. Vidal*
VIEILLEVOYE **Josef Bartholomeus** b. Belgium. 1788 - 1855 Historical & portrait artist Exh: Belgium	*B. Vieillevoye* *Anvers 1828*
VIEN **Joseph Marie** b. Montpellier. 1716 - 1809 Religious & historical subjects Exh: French AG's	*Vien. f 1753* *jos. m. Vien* *1766* *Vien fils 1808* *J.V* *J.V*
VIGEE — LE BRUN **Marie Louise Elizabeth**	see LE BRUN
VIGNAL **Pierre** b. France. 1855 - 1925 Landscape artist Exh: France	*Vignal* *Vignal*
VIGNE **Felix De** b. Belgium. 1806 - 1862 Historical, genre & portrait artist Exh: Belgium	*F De Vigne* *FD*

VIGNON **Claude** v. Tours. 1593 - 1670 Religious & historical subjects Exh: France, Italy	
VIGNON **Claude Francois** b. Paris. 1633 - 1703 Historical subjects Exh: Paris	
VIGNON **Victor Alfred Paul** b. France. 1847 - 1909 Landscape subjects Exh: France	
VILLAMENA **Francisco** b. Assisi. 1566 - 1624 Portraits & religious subjects Exh: Italy, Austria	
VILLARD **Antoine** b. France. 1867 - 1934 Landscape subjects Exh: France, Germany, Russia	
VILLERS **Gaston De** b. Brussels. 1870 - ? Still life, portrait, figure & landscape studies Exh: French AG's	
VILLON **Jacques** b. France. 1875 - 1963 Abstract & subist studies Exh: France, US	
VINCENT **Francois Andre** b. Paris. 1746 - 1816 Historical & portrait artist Exh: France	
VINCENT CALBRIS **Sophie** b. Rouen. 1822 - 1859 Landscape artist Exh: France	
VINCI **Leonardo Da** b. Italy. 1452 - 1519 Portraits, mythological, religious & historical subjects Exh: International AG's	

VINCI Leonardo Da (Continued)	*l.DA Vinci 1507* *LDV* *LDV* *LDV F* *LDV.* *LDV* *LDV*
VINCK Franz Kaspar Huibrecht b. Antwerp. 1827 - 1903 Historical, genre & portrait artist Exh: Belgium	*Franz Vinck*
VINCKEBONS David b. Belgium. 1576 - 1629 Genre & landscape artist Exh: Holland, Belgium, Germany, France	*David Vinck = Boong fecit* *DB* *RB* *DVS* *D.V.B*
VINEA Francesco b. Italy. 1845 - 1902 Genre subjects Exh: Italy, US, Paris, London	*F.Vinea*
VINNE Vincent Jans Van Der b. Haarlem. 1736 - 1811 Landscape & portrait artist Exh: Holland	*V. van d Vinne*
VIOLA Giovanni Battista b. Bologna. 1576 - 1622 Landscape artist Exh: Italy	*B.Viola 1615*
VIOLLAT Eugene Joseph b. ? - 1901 Landscape artist Exh: France	*E Viollat*
VLAMINCK Maurice De b. Paris. 1876 - 1958 Portraits, still life & landscape subjects etc. Exh: UK & European AG's	*Vlaminck* *Vlaminck*

VLEUGHELS **Nicolas** b. Paris. 1668 - 1737 Portraits, genre & historical subjects Exh: France, Germany, Russia	*N. Vleughels 1727*
VLEUGHELS **Philippe** b. Antwerp. 1619 - 1694 Portraits & historical subjects Exh: France	*P. VLEUGHELS 1690*
VLIET **Jan Georg Van Der** b. Delft. 1610 ? - ? Genre & historical subjects Exh: Holland	*JV JG J.G.f JG*
VOGEL **Hugo** b. Germany. 1855 - 1934 Genre, portrait & historical subjects Exh: Germany, Austria	*Hugo Vogel*
VOGELER **Heinrich Johann** b. Germany. 1872 - ? Genre subjects Exh: Germany	*D. Vogelaer*
VOILLES **Jean** b. Paris. 1744 - 1796 Portrait artist Exh: France, Russia	*Voilles*
VOILLEMOT **Andre Charles** b. Paris. 1823 - 1893 Genre & portrait artist Exh: France	*CH. VOILLEMOT*
VOIRIN **Jules Antoine** b. Nancy. 1833 - 1898 Military subjects Exh: France	*J. Voirin*
VOIS **Adrian De** b Utrecht. 1631 - 1680 Genre & portrait artist Exh: Holland, Belgium, France, UK, Germany	*ADois f. ADois.f. AD* *ADois. ADois* *AD AD ADf ADf*

VOKES **Arthur Ernest** b. UK. 1874 - ? Sculptor, portrait & landscape artist Exh: RA, RI, RP	
VOLAIRE **Jacques Antoine** b. Toulon. 1729 - 1802 Genre & marine subjects Exh: France, Austria, Russia	*le che^r Volaire. f.*
VOLKMANN **Hans Richard Von** b. Germany. 1860 - 1927 Landscape artist Exh: Germany	*HR.v.V.*
VOLLEVENS (The Younger) **Jans** b. The Hague. 1685 - 1758 Portrait artist Exh: Holland	*Jan: Vollevens*
VOLLMER **Adolf Friedrich** b. Hamburg. 1806 - 1875 Marine & landscape artist Exh: Germany	*der* *N*
VOLLON **Alexis** b. Paris. 1865 - ? Landscape & genre subjects Exh: France	*a. Vollon*
VOLLON **Antoine** b. Lyon. 1833 - 1900 Genre, still life & landscape subjects Exh: France, Belgium, Russia	*A. Vollon*
VOOGD **Hendrik** b. Amsterdam. 1766 - 1839 Landscape artist Exh: Holland, France	*H. Voogd*
VOORHOUT **Johannes** b. Holland. 1647 - 1773 Portraits, genre, historical & allegorical subjects Exh: Holland, Germany, Sweden	*M*
VORTEL **Wilhelm** b. Dresden. 1793 - 1844 Landscape artist	*V*

VOS **Cornelis De** b. Hulst. 1585 ? - 1651 Historical & portrait artist Exh: Belgium, France, Russia, Germany, Austria, US	*C DE VOS*
VOS **Marten De** b. Antwerp. 1532 - 1603 Portraits & historical subjects Exh: European AG's	*M Vos. f*　　*M DE VOS* *M·D·V·* *F 1601*　　*DV*　　*B B*
VOS **Paul De** b. Hulst. 1596 - 1678 Still life, battle & hunting scenes Exh: Russia, US & European AG's	*P de Vos 1650.*
VOS **Simon De** b. Antwerp. 1603 - 1676 Historical, genre & portrait subjects Exh: Belgium, Germany, France, Holland, Etc.	*S·De Vos.f* *1670*　　*SD*
VOUET **Simon** b. Paris. 1590 - 1649 Historical & portrait artist Exh: US, Russia, European AG's etc.	*Simon Vouet*　*A*　*S*　*SV*
VRANCX **Sebastien** b. Antwerp. 1573 ? - 1647 Historical, battle & hunting scenes Exh: Holland, Germany, Spain, Austria, France, etc.	*S Vrancx ft*　*SV 1621*　*SV*
VRIENDT **Albrecht** b. Belgium, 1843 - 1900 Genre & historical subjects Exh: Belgium, Germany	*A Lbrecht De Vriendt*
VRIENDT **Juliaan De** b. Belgium. 1842 - 1935 Portrait, genre & historical subjects Exh: Belgium, France, US	*JULIAAN DE VRIENDT*
VRIES **Adriaen De** b. The Hague. 1550 ? - 1626 Portrait artist Exh: Holland	*AS. AS. AS. AS. AS. AV*

VRIES **Jan Reynier De** b. Haarlem. 1657 ? - ? Portrait & landscape artist	*R.v vries f*
VRIES **Roelof** b. Haarlem. 1631 ? - 1681 ? Landscape artist Exh: Germany, Holland, Russia, Scandinavia, France, etc.	*yR* *R* *R*
VROOM **Hendrik Cornelisz** b. Haarlem. 1566 - 1640 Marine & landscape artist Exh: Belgium, Holland, Hungary, Portugal, UK	*VROOM-1619*
VUCHT **Jan Van Der** b. Rotterdam. 1603 ? - 1637 Architectural subjects Exh: Germany, Russia	*I. V.*
VUILLARD **Edouard** b. France. 1868 - 1940 Genre, still life, figure & portrait artist Exh: France, Germany, etc.	*E Vuillard E Vuillard*
VUILLEFROY **Felix Dominique De** b. Paris. 1841 - ? Animal subjects Exh: France	*Vuillefroy*
VYTLACIL **Vaclav** b. New York. 1892 - Cubist & abstract artist Exh: US AG's	*VACLAV VYTLACIL*

WAAL **Justus De** b. Utrecht. 1747 - ? Landscape & village scenes	*J. D W*
WAARD **Antonie** b. The Hague. 1689 - 1751 Historical, portrait, genre & animal subjects Exh: Holland	*A. D W. F NAS*

WACKIS **B.** Fl. France. 17th C. Floral artist Exh: France	
WADDINGTON **Roy** b. Yorkshire. 1917 - Oil & watercolourist Exh: RA, RSA, NEAC	
WADE. ATD **Dorothy** b. Liverpool. 1926 - Etcher. graphic, oil & gouache media Exh: London & Prov. AG's	
WADE **Thomas** b. Wharton. 1828 - 1891 Genre & landscape artist Exh: RA, BI, London & Prov. AG's	
WAEL **Cornelis De** b. Antwerp. 1592 - 1667 Historical & military subjects Exh: Belgium, France, Austria	
WAEL (The Younger) **Jan Baptiste De** b. Antwerp. 1632 - ? Genre artist	
WAEL **Lucas Janszen De** b. Antwerp. 1591 - 1661 Historical & landscape subjects Exh: Belgium, Norway	
WAGENBAUR **Maximilian Joseph** b. Germany. 1774 - 1829 Animal & landscape subjects Exh: Germany	
WAGHORN. RWA **Tom** b. London. 1900 - Watercolourist Exh: RA, RI, RBA, NEAC, RWA, Prov. AG's	
WAGNER **Otto** b. Germany. 1803 - 1861 Landscape & architectural subjects Exh: Germany, Norway	

WAGNER **Pierre** b. Paris. 1897 - Marine & landscape artist Exh: French AG's	PIERRE WAGNER
WAGON **Peter** b. Surrey. 1906 Architectural watercolourist Exh: London & Prov. AG's	Wagon 1974
WAGREZ **Jacques Clement** b. Paris. 1846 - 1908 Portraits & genre subjects Exh: France	JACQVES WAGREZ
WAINWRIGHT, RWS **William John** b. Birmingham. 1855 - 1931 Portraits, genre & historical subjects Exh: OWS, UK AG's, Paris	WJW
WAITE. RBA **Edward William** Fl. London. 19th — 20th C. Landscape artist Exh: RA, SS, NG, London & Prov. AG's, S. Africa	E.W.W
WAKEFIELD **Larry Hilary Edward** b. Cheltenham. 1925 - Abstract expressionist & figurative subjects Exh: Paris, London & Prov. AG's	L. Wakefield L.W
WALCKIERS **Gustave** b. Brussels. 1831 - 1891 Landscape & architectural subjects Exh: Belgium	Walckiers
WALES-SMITH. Capt. RN, PAS **SMA** **Douglas** Portraits, flowers, land & seascape artist Exh: RA, ROI, RI, PS, etc.	WALES SMITH
WALFORD **Bettine C.** b. London. 1905 - Pen & ink, pencil, pastel, watercolour media, etc. Exh: RA, RI, RBA, PS, NEAC, NS, SWA, WIAC, etc.	Bettine C. Walford
WALHAIN **Charles Albert** b. Paris. 1877 - 1936 Genre & portrait artist Exh: France	Ch. Walhain

WALKE **Annie** Painter in oil media Exh: RA, RBA, ROI, NEAC, Prov. & European AG's	*AW.*
WALKER. ARA **Arthur George** b. London. 1861 - ? Painter, sculptor & illustrator Exh: RA, RSA, PS, Italy, Germany, US	*AGWalker*
WALKER. ARCA **Edward** b. Bradford. 1879 - ? Etcher, landscape watercolourist etc. Exh: RA, London & Prov. AG's	EDWARD WALKER
WALKER. RHA **Francis S.** b. Ireland. 1848 - 1916 Genre & landscape artist Exh: RA, NWS, SS, London & Prov. AG's	*F.S.W*
WALKER **Frederick** b. London. 1840 - 1875 Genre & landscape artist Exh: RA, OWS, NPG, VA, London & Prov. AG's	*FW* *FW* *F.W 1863*
WALKER **Horatio** b. Canada. 1858 - 1938 Genre & landscape artist Exh: NG, US AG's	*Walker*
WALKER, RWS **William Eyre** b. Manchester. 1847 - 1930 Landscape artist & watercolourist Exh: RWS, UK AG's	*W.E.W. RWS*
WALLACE **Harold Frank** b. Yorkshire. 1881 - ? Landscape & sporting scenes Exh: UK AG's	*F*
WALLAERT **Pierre Joseph** b. Lille. 1753 ? - 1812 ? Marine & landscape artist Exh: France	*P. Wallaert*
WALLER **Samuel Edward** b. Gloucester. 1850 - 1903 Animal & genre subjects Exh: ROI, London & Prov. AG's, Australia	*S.E Waller.*

WALLIS **Arthur George** b. Exeter. 1862 - ? Landscape artist Exh: London & Prov. AG's	
WALLIS, RI **Henry** b. London. 1830 - 1916 Landscape, portrait & historical subjects Exh: RA, RI, VA, NPG, UK AG's	
WALRAVEN **Isaac** b. Amsterdam. 1686 - 1765 Historical & genre subjects Exh: Holland	
WALSHAW. BWS **Charles Moats** b. Coventry. 1884 - Landscape artist Exh: BWS, RBSA, London & Prov. AG's	
WALTER **Pierre Francois Prosper** b. Nancy. 1816 - 1855 Genre subjects Exh: France	
WALTERS. RBA **George Stanfield** b. Liverpool. 1838 - 1924 Marine & landscape artist Exh: RA, SS, NWS, BI, London & Prov. AG's	
WALTERS **Samuel** b. London. 1811 - 1882 Marine artist Exh: RA, BI, SS, Prov. AG's	
WALTON **Cecile** b. Glasgow. 1891 - Genre subjects, illustration & sculptress Exh: UK AG's	
WALTON **Frank** b. London. 1840 - 1928 Marine & landscape artist Exh: UK, Australia, South Africa etc.	
WALTON **Violet** b. Bootle. 1901 - Oil & watercolourist Exh: WAG, London & Prov. AG's	

WANDELAAR **Jan** b. Amsterdam. 1690 - 1759 Portraits & religious subjects	*J.W*
WANS **Jan Baptiste** b. Antwerp. 1628 - 1684 Landscape artist Exh: Belgium	*J.C.W.*
WAPPERS **Baron Gustave De** b. Antwerp. 1803 - 1874 Portraits, genre & historical subjects Exh: Belgium, Holland, Germany, US.	*B Gustaf Wappers*
WARBURTON **Samuel** b. Douglas. I.O.M. 1874 - ? Miniaturist, portrait & landscape artist Exh: RA, RMS, WAG & Prov. AG's	*S.W.* *SW*
WARD, RA **Edward Matthew** b. Pimlico. 1816 - 1879 Historical subjects Exh: RA, NPG, VA, UK AG's, Germany	*E.M.W.*
WARD **Enoch** b. Parkgate. 1859 - 1922 Marine & landscape artist Exh: London & Prov. AG's	*E.W.*
WARD. RA **James** b. London. 1769 - 1859 Landscape, genre & animal subjects Exh: RA, BI, SS, London & Prov. AG's	*JWR* *JWS*
WARD **James Charles** Fl. 1830 - 1859 Still life & landscape artist Exh: London & Prov. AG's	*J.C.W.*
WARD **John Stanton** b. Hereford. 1917 - Portraits, architecture, still life & landscape artist Exh: RA, London & Prov. AG's	*John Ward*
WARD **Sir Leslie ('Spy')** b. London. 1851 - 1922 Portrait artist & caricaturist Exh: UK AG's	*LMW*

WARD. RE, ARWS, ARCA **Thomas William** b. Sheffield. 1918 - Etching, gouache, oil & watercolour media Exh: RA, RWS, NEAC, RBA, RE, etc.	*TWWard.*
WARDLE **Arthur** b. London. 1864 - 1949 Animal & sporting subjects Exh: RA, SS, NWS, London & Prov. AG's	*AW* *A.W.*
WARNBERGER **Simon** b. Germany. 1769 - 1847 Landscape artist Exh: Germany	*S̄W.*
WAROQUIER **Henry De** b. Paris. 1881 - Still life, genre & landscape artist Exh: Paris	*Henry de WAROQUIER* *H de W* *Henry deWaroquier*
WARREN. DPA **Charles Wyatt** b. Caernarvon. 1908 - Painter in oil media Exh: R.Cam.A., London & Prov. AG's	*CHAS. WYATT WARREN*
WARRENER **William Thomas** Fl. 1887 - 1892 Domestic genre Exh: UK AG's, Paris	*W.T.W*
WARSHAWSKY **Alexander** b. Cleveland, US. 1887 - Portraits & still life subjects Exh: Paris, US	*A. D. Warshawsky*
WASHINGTON **Georges** b. Marseille. 1827 - 1910 Arabian scenes Exh: France	*G Washington*
WATELET **Louis Etienne** b. Paris. 1780 - 1866 Landscape artist Exh: France, Germany	*Watelet*

WATERFORD **Lady Louisa** b. Paris. 1818 - 1891 Genre, biblical & mythological subjects Exh: GG, London AG's	
WATERHOUSE, RA **Alfred** b. Liverpool. 1830 - 1905 Landscape & architectural subjects Exh: London & Prov. AG's	
WATERHOUSE, RA **John William** b. Rome. 1849 - 1917 Mythological & historical subjects Exh: RA, UK AG's, Paris, Australia etc.	
WATERLO **Anthonie** b. Lille. 1609 ? - 1690 Landscape artist Exh: Holland, Italy, Germany, France	
WATERLOW **Sir Ernest Albert** b. London. 1850 - 1919 Animal & landscape artist Exh: RA, RWS, SSSBA, London & Prov. AG's, Australia	
WATERS. NS **Billie** b. Richmond. 1896 - Painter in oil & tempera media Exh: RA, ROI, NEAC, SWA, NS, Prov. AG's etc.	
WATERSCHOODT **Heinrich Van** b. Antwerp. ? - 1748 Battle scenes, genre & floral subjects Exh: Germany	
WATHERSTON. SWA, UA **Marjory Violet** b. London. 20th C. Portrait, figure & landscape artist Exh: RA, RSA, PS, RI, ROI, RP, London & Prov. AG's	
WATKINS **Franklin C.** b. New York. 1894 - Landscape artist Exh: US AG's	

WATKINS **John** Fl. London. 19th C. Mythological & genre subjects Exh: RA, SS, NWS, GG, VA, etc.	
WATKINS. RI **William Arthur** b. 1885 - Pastel, oil & watercolourist Exh: RA, RI, RBA, London & Prov. AG's	
WATSON. MSIA **Charles Clixby** b. 1906 - B/white & watercolour media Exh: London & Prov. AG's	
WATSON **George** b. Scotland. 1767 - 1837 Portrait artist Exh: RA, RSA, UK AG's	
WATSON **John Bernard** b. Yorkshire. 1924 - Pen, oil, crayon & watercolourist Exh: London & Prov. AG's	
WATSON. RWS, RBA **John Dawson** b. Sedburgh. 1832 - 1892 Genre & landscape artist Exh: RA, SS, BI, OWS, GG, VA & Prov. AG's	
WATSON **Sydney Robert** b. Middlesex. 1892 - Painter in oil & tempera. Exh: NEAC, RA, London & Prov. AG's	
WATTEAU **Francois Louis Joseph** b. France. 1758 - 1823 Military, genre & historical subjects Exh: French AG's	
WATTEAU **Jean Antoine** b. France. 1684 - 1721 Fetes, genre subjects etc. Exh: Russia, UK & European AG's	

WATTEAU **Louis Joseph** b. France. 1731 - 1798 Genre, landscape & military subjects Exh: France	*J watteau* *L. Watteau 1774* *L. watteau* *L. Watteau* *L Watteau* *L. Watteau -1790* *L Watteau 1793*
WATTS. SWA **Dorothy** b. London. 1905 - Watercolourist Exh: RA, RI, RBA, SWA, Prov. AG's	*DOROTHY WATTS.*
WATTS. OM, RA, HRCA **George Frederick** b. London. 1817 - 1904 Portraits & historical subjects Exh: RA, VA, NG, NPG, Prov. AG's, US, Germany, France, etc.	*GFW* *G.F.W 1850*
WATTS **Meryl** b. 1910 - Oil & watercolourist Exh: RA, London, Prov. & European AG's, US	*Meryl Watts.*
WAUTERS **Emile Charles** b. Brussels. 1846 - 1933 Historical, portrait, landscape artist Exh: Belgium, Holland, RA, Germany	*E. Wauters* *Emile Wauters*
WAUTERS **Jef** b. Belgium. 1927 - Painter in oils	*Jef h t*
WAXSCHLUNGER **Johann Paul** b. Germany. 1660 ? - 1724 Floral, animal & landscape subjects Exh: Germany	*W*
WAY **Charles Jones** b. Darmouth. 1834 - 1900 Landscape oil & watercolourist Exh: Canada, Switzerland, UK AG's	*W 1869*

WAY **Thomas Robert** b. 1861 ? - 1913 Painter & lithographer	*RW* T.R.W.
WEBB **Clifford Cyril** b. London. 1895 - 1972 Landscapes, views & architectural subjects Exh: RA, NEAC & Prov. AG's	*CC*
WEBB **James** b. 1825? - 1895 Marine & landscape artist Exh: RA, BI, SS, VA, UK AG's, Australia	*J.W by. JW*
WEBBE **William J.** Fl. 19th C. Genre, animal & landscape artist Exh: RA, SS, BI, & Prov. AG's	*W WJW*
WEBER **Otto** b. Berlin. 1832 – 1888 Genre, animal & landscape subjects Exh: France, Australia, UK	*Otto Weber*
WEBSTER **Alfred George** Genre, architectural & landscape artist Exh: RA, SS, London & Prov. AG's	*A.G.W*
WEBSTER **Herman Armour** b. New York. 1878 - Landscape artist Exh: US, Germany, Italy, France, UK	*Herman Webster*
WEBSTER **Roland Harding** b. Chester. 1873 - ? Pastel, oil & watercolourist Exh: London & Prov. AG's	*W*
WEBSTER, RA **Thomas** b. London. 1800 - 1886 Portraits, genre & historical subjects Exh: RA, VA, UK AG's	*TW TW TW*
WEEDON **Augustus Walford** b. London. 1838 - 1908 Landscape artist Exh: RA, SSSBA, Paris, Australia, etc.	*A.W.Weedon*

WEEKES **William** Fl. 1865 - 1904 Genre & animal subjects Exh: London AG's	*W*
WEEKS **Lord Edwin** b. Boston. 1849 - 1903 Genre, landscape & Eastern subjects Exh: US AG's, France	E.L.WEEKS
WEENIX **Jan** b. Amsterdam. 1640 - 1719 Animals, birds, fruit, flowers, portraits & landscape subjects Exh: Russia, US, UK & European AG's	*JsWeenix 1715 JW. JW*
WEERDT **Adriaan De** b. Brussels. 1510 - 1590 ? Mythological & religious subjects	*BW AV.*
WEERTS **Jean Joseph** b. France. 1847 - 1927 Religious, genre & portrait artist Exh: France	J.J.WEERTS. 1887
WEGELIN **Adolf** b. Germany. 1810 - 1881 Landscape & architectural subjects Exh: Germany, Russia	*AW*
WEGUELIN, RWS **John Reinhard** b. South Stokes. 1849 - 1927 Genre & historical subjects Exh: RA, London & Prov. AG's, S. Africa	*JRW J.R.W.*
WEHME **Zacharias** b. Dresden. 1550 ? - 1606 Portrait artist Exh: Germany	*ZW 1591*
WEIGHT **Carel Victor Morlais** b. London. 1908 - Portraits, landscapes & imaginative subjects Exh: RA, US, France, Russia, Canada etc.	*Carel Weight.*
WEINER **Wilhelm** b. Poland. 1922 - Portraits, landscapes & genre subjects inc. insects Exh: Poland, Italy, UK, X	*Weiner·77*

WEINGOTT **Victor Marcus** b. London. 1887 - Figure & landscape artist Exh: RA, London & Prov. AG's	*V. M. WEINGOTT*
WEIR **Halcyon Dora Murray** b. London. 1912 - Animal portraiture	*Halcyon Weir*
WEIR **Harrisson William** b. Lewes. 1824 - 1906 Animal & landscape subjects Exh: RA, SSBA, VA, BI, NWS	*Weir Del*
WEIR. ROI, RBA, etc. **H. Stuart** Painter & sculptor Exh: RA, RSA, ROI, RBA, SWA, NEAC, PS, Prov. AG's, US, etc.	*H Stuart Weir*
WEIR **William** b. Glasgow. Land & seascape artist Exh: Scotland	*Weir*
WEIR-LEWIS **Nina May** Still life, figure & landscape artist Exh: RI, ROI, WAG, IS, SWA & Prov. AG's	*WEir - Lewis*
WEIROTTER **Franz Edmund** b. Innsbruck. 1730 - 1771 Landscape artist Exh: Austria, Germany, Hungary	*F.E.W.* *F.W.*
WEISGERBER **Albert** b. Germany. 1878 - 1915 Genre subjects Exh: Germany	WEISGERBER
WEISS **Bartholomaus Ignaz** b. Munich. 1740 ? - 1814 Genre subjects & miniaturist Exh: Germany	*BN*
WEISSENBRUCH **Johannes** b. The Hague. 1824 - 1880 Landscape artist Exh: Holland, UK	*Wf*

WEISZ **Adophe** b. Budapest. 1868 - ? Genre & portrait artist Exh: France	*A.Weisz.*
WELLER **J.** b. 1698 - ? Portrait artist Exh: London	
WELLINGTON. Hon. ARCA **Hubert Lindsay** b. Gloucester. 1879 - Painter in oil media Exh: NEAC, RA, Italy	*H.L.Wellington*
WELLS, RA **Henry Tanworth** b. London. 1828 - 1903 Portraits, genre & miniaturist Exh: RA, NG, UK AG's	*H.J.W.*
WELLS **Josiah Robert** Fl. 19th C. Marine & coastal subjects Exh: RA, NWS, SS, London & Prov. AG's	JRW
WENDELSTADT **Carl Friedrich** b. Germany. 1786 - 1840 Portrait, genre & landscape artist Exh: Germany	
WERENSKIOLD **Erik Theodor** b. Norway. 1855 - 1938 Portrait, genre & landscape subjects Exh: Scandinavia	*Erik Werenskiold* *Erik Werenskiold 1883*
WERGE-HARTLEY. NDD, ATD **Alan** b. Leeds. 1931 - Marine landscapes Exh: Prov. AG's, X, UK	
WERNER **Fritz** b. Berlin. 1827 - 1908 Historical & genre subjects Exh: Germany	

WERTMULLER **Adolf Ulrik** b. Stockholm. 1751 - 1811 Portrait, figure & historical subjects Exh: Belgium, Sweden, France, US, Spain	*A.Wertmuller sud à Lyon 1781*
WESSON. RI, RBA, RSMR **Edward** b. London. 1910 - Landscape & marine artist Exh: RA, RI, RBA, RSMA, London & Prov. AG's, Holland, Germany, etc.	*Edward Wesson. Wesson Edward Wesson. Wesson.*
WEST. PRA **Benjamin** b. Pennsylvania. 1738 - 1820 Portraits & historical subjects Exh: RA, UK AG's, US	*B. West 1800*
WEST. RSW **David** b. Lossiemouth Watercolourist Exh: RA, RSA, GI, RHA, Europe, S. America	*DAVID WEST.*
WEST, VP RWS **Joseph Walter** b. Hull. 1860 - 1933 Genre & landscape artist Exh: UK AG's, Paris	*[monogram] [monogram in oval]*
WESTALL **Richard** b. England. 1765 - 1836 Mythological, genre & landscape subjects Exh: RA, NPG, NG, VA, London & Prov. AG's	**RW**
WESTBY. RMS **Grace Mary Stanley** b. Sydney. 1896 - Miniaturist Exh: RA, RMS, London & Prov. AG's	*[monogram]*
WESTENBERG **Pieter George** b. Holland. 1791 - 1873 Architectural & landscape subjects Exh: Holland	*[monogram PGW in circle]*
WESTERBEEK **Cornelis** b. Sassenheim. 1844 - 1903 Landscape & animal subjects Exh: Holland, US	*C Westerbeek.*

WESTLAKE **Nathaniel Hubert John** b. Romsey. 1833 - 1921 Biblical subjects Exh: UK AG's	*N-W*
WESTON **Florence** Figure, floral & landscape artist Exh: RBSA, London & Prov. AG's	*(F.W.)*
WETHERBEE. RI, ROI **George Faulkner** b. Cincinnati. 1851 - 1920 Genre, landscape & mythological subjects Exh: RA, NG, GG, NWS, SS, S. Africa, etc.	*GFWetherbee - 1887* *G F W*
WEVER **Cornelis** Fl. Amsterdam. 18th C. Portrait artist Exh: Amsterdam	*C. Wever Pinx 177-*
WEXELSEN **Christian Delphin** b. Norway. 1830 - 1883 Landscape artist Exh: Norway	*C. Wexelsen*
WEYDEN **Roger** b. Belgium. 1400 ? - 1464 Portraits & religious subjects Exh: Belgium, Germany, US, France, UK	*V Y*
WHAITE, RWS, PRCamA **Henry Clarence** b. Manchester. 1828 - 1912 Genre & landscape artist Exh: RA, RI, SS, OWS, UK AG's	*H.C.W.*
WHARTON **Samuel Ernest** b. Beeston. 1900 - Oil & watercolourist Exh: PS, UK Prov. AG's	*S. E. Wharton*
WHEELWRIGHT **Rowland** b. Ipswich. 1870 - ? Genre subjects Exh: London & Prov. AG's	*RWheelwright*

WHISTLER. PRBA **James Abbott MacNeill** b. Lowell, US. 1834 - 1903 Genre & portrait artist Exh: RA, SS, London & Prov. AG's, European AG's	*Whistler* *Whistler.* *-Whistler* (with butterfly monogram marks)
WHITCOME, DFC, MSIA **Sydney** b. Cheshire. 1916 - Oil & gouache media Exh: London & Prov. AG's	*whitcombe /49.*
WHITE **Arthur** b. Sheffield. Landscape & marine artist Exh: ROI, London & Prov. AG's	*Arthur White-*
WHITE, RWS **Ethelbert** b. Isleworth. 1891 - 1972 Landscape oil & watercolourist Exh: UK AG's	*EW*
WHITE **Gleeson** b. 1851 - 1898 Painting & decorative art Exh: London & Prov. AG's	*G.W.* *GW*
WHITE. RI **John** b. Edinburgh. 1851 - 1933 Portrait, genre, marine & landscape artist Exh' RA, NWS, SS, GG, London & Prov. AG's	*J.White* *JW*
WHITEHEAD **Tom** b. Yorkshire. 1886 - Portrait, genre & landscape artist Exh: London & Prov. AG's	*W.*

WHITFIELD **George** Figure artist Exh: London & Prov. AG's	
WHITING **Frederic** b. London. 1874 - ? Genre & portrait artist Exh: London & Prov. AG's	FREDERIC WHITING
WHITING. ARBS **Onslow** Sculptor, portrait & animal subjects Exh: RA, London & Prov. AG's, PS	
WHYMPER. RI **Charles** b. London. 1853 - 1941 Bird, animal, landscape subjects etc. Exh: RA, GG, SS, NWS, Prov. AG's	CW
WICKENDEN **Robert** b. Rochester, UK. 1861 - ? Portrait, genre & landscape artist Exh: France, Germany, Belgium, US, UK.	R.J.W'94
WIDHOPFF **D.O.** b. Russia. 1867 - 1933 Still life & landscape artist Exh: France	T. O. Widhopff
WIERINGEN **Cornelis Claesz Van** b. Haarlem. 1580 ? - 1633 Marine & landscape artist Exh: Holland, Spain	CCVieringen CGV CW
WIGMANA **Gerard** b. Holland. 1637 - 1741 Genre subjects Exh: Holland	wigmana
WIGNEY **Lorna Fiske** b. Cheshunt, Herts. 1916 - Portrait artist Exh: RP, RBSA, ROI, UAS, Prov. AG's	Lorna Wigney
WIIK **Maria Katarina** b. Finland. 1853 - 1928 Genre & portrait artist Exh: Finland	M.Wiik.

WILDENS **Jan** b. Antwerp. 1586 - 1653 Landscapes & hunting scenes Exh: France, Holland, Austria, Germany, Belgium	*J Wildens*
WILES. LSIA **E. Alec** b. Southampton. 1924 - Portrait, marine & landscape artist Exh: RA, RP, RBA, SGA, Prov. AG's	*Alec*
WILKENS **Theodorus** b. Amsterdam. 1690 - 1748 Landscape artist Exh: Holland, Belgium, Germany, Austria	*TW. 1736*
WILKIE. RA **Sir David** b. Fife. 1785 - 1841 Historical, genre & portrait artist Exh: RA, BI, NPG, NG, VA, Prov. AG's, US, Germany, etc.	*David Wilkie* *W 1819* *W* *D Wilkie* *W 1820* *W*
WILKIN **Frank. W.** b. London. 1800 ? - 1842 Portrait artist, miniaturist & historical subjects Exh: London & Prov. AG's	*FWW*
WILKINSON **Charles A.** b. Paris. 1830 - ? Landscape artist Exh: RA, NWS, SS, GG, France, Australia	*(A)*
WILKINSON. CBE, PRI **Norman** b. Cambridge. 1878 - 1934 Marine Artist Exh: RA, RI, London & Prov. AG's	*Norman Wilkinson*
WILLAERTS **Abraham** b. Utrecht. 1603 ? - 1669 Marine, portrait & genre subjects Exh: Holland, Germany, France, UK	*A. Willa...* *ABW* *ABW* *FECIT ANNO 1654* *AB W*
WILLEMS **Florent** b. Belgium. 1823 - 1905 Portrait & genre subjects Exh: Belgium, Holland, Germany, Austria	*Florent Willems* *F. Willems*

WILLIAM **Alfred Walter** Fl. 19th C. Landscape artist Exh: RA, BI, SS, VA, Prov. AG's	*AW*
WILLIAMS **Alfred Mayhew** b. 1823 - 1905 Landscape artist & watercolourist Exh: RA, SS, VA	*A.M.W 1891*
WILLIAMS **Edward** b. London. 1782 - 1855 Landscape artist & miniaturist Exh: RA, BI, SS, VA, London & Prov. AG's	*EW*
WILLIAMS **Edward Charles** b. 1807 - 1881 Landscape & coastal subjects Exh: RA, SS, BI, & Prov. AG's	*EW ms*
WILLIAMS **George Augustus** b. 1814 - 1901 Coastal, landscape & moonlight scenes Exh: RA, BI, London & Prov. AG's etc.	*G↑W 1850* *GAW*
WILLIAMS **Hughes Harry** b. 1892 - 1953 Exh: RA, RCA, Prov. AG's, US	*H. HUGHES WILLIAMS*
WILLIAMS **Idris Elgina** b. 1918 - Painter in oil & pastel media, etcher Exh: London & Prov. AG's	*Elgina* *I.E.Cw.*
WILLIAMS **John Haynes** b. 1836 - 1908 Genre artist & illustrator Exh: RA, UK AG's	*Jno H-W*
WILLIAMS. ARDS, RDS **Juliet Nora** Floral & landscape artist Exh: RA, ROI, London & Prov. AG's	*JNV*
WILLIAMS. AR.Cam.A. **Margaret Lindsay** b. Cardiff. 20th C. Portraits & decorative subjects Exh: RA, R.Cam.A. WAG, NSA, US, etc.	*Margaret Lindsay Williams*

WILLIAMSON **Frederick** Fl. London. 19th C. Landscape & animal subjects Exh: RA, NWS, GG, BI, SS, VA, Australia	*F.W*
WILLIAMSON **W.H.** Fl. 1853 - 1875 Marine artist Exh: RA, BI, SS, Prov. AG's	*W.H.W.* *1861*
WILLIS **Patricia Marjorie** b. Canada. 1914 - Portrait, floral & landscape artist	*P.M. Willis.*
WILLOUGHBY **Vera** Watercolourist & illustrator	*X.*
WILSON **Charles E.** Fl. Sheffield. 1890 - 1900 Genre, oil & watercolourist Exh: NWS, VA, Prov. AG's	*C.E.W.*
WILSON. MC **Capt. George** b. Lille. 1882 - B/white, oil & watercolourist Exh: RA, RP, NEAC, WAG, etc.	*GW*
WILSON **Hugh Cameron** b. Glasgow Portrait, figure & landscape artist Exh: London & Scottish AG's	*H. Cameron Wilson* *HCW*
WILSON **John** b. Ayr. 1774 - 1855 Marine & landscape artist Exh: SSSBA, VA, Scottish & Prov. AG's	*J WILSON 1828*
WILSON **John** b. Halifax Landscape artist Exh: WAG, London & Prov. AG's	*Jno Wilson.*
WILSON **John James** b. London. 1818 - 1875 Landscape & marine artist Exh: UK AG's	*J.J.W* *JJW*

WILSON **Mary G.W.** b. Falkirk. Landscape artist Exh: RSA, PAS, London & Prov. AG's	m.G.m.m.
WILSON **Oscar** Genre artist Exh: RA, NWS, SS, Prov. AG's	OW
WILSON. RA **Richard** b. Montgomeryshire. 1714 - 1782 Portraits & landscape artist Exh: RA, SA, NG, VA, NPG, Prov. AG's, Germany, Canada, Australia	Rich=Wilson 1771
WILSON **Stanley R.** b. London. 1890 - Oil & watercolourist Exh: RA, London & Prov. AG's	Stanley R. Wilson
WILSON. RI **Thomas Walter** b. London. 1851 - ? Genre, architectural & landscape artist Exh: RA, SS, NWS, Prov. AG's, Australia	T.W.W.
WIMMER **Rudolf** b. Germany. 1849 - 1915 Genre & portrait artist Exh: Germany	R
WIMPERIS. VPRI **Edmund Morison** b. Chester. 1835 - 1900 Landscape artist Exh: RA, NWS, SS, NG, GG, VA, Australia	EMW EMW EMW
WINDUS **William Lindsay** b. Liverpool. 1822 - 1907 Genre & historical subjects Exh: RA, BI, SS & Prov. AG's	WL
WINGATE. PRSA **Sir James Lawton** b. Glasgow. 1846 - 1924 Landscapes & moonlight scenes Exh: RA, RSA, Prov. AG's	W
WINGFIELD **James Digman** b. ? - 1872 Genre & landscape artist Exh: RA, BI, SS, London & Prov. AG's	JDW

WINGHE **Jeremias Van** b. Brussels. 1578 – 1645 Historical & portrait artist Exh: Germany	
WINNE **Lieven De** b. Belgium. 1832 - 1880 Portrait & historical artist Exh: Belgium	
WINNICOTT. MA, NRD **Alice Buxton** b. 1891 - Oil & watercolourist Exh: RA, R.Cam.A. London & Prov. AG's	
WINTER **Joseph Georg** b. Munich. 1751 - 1789 Hunting scenes & landscapes	
WINTERHALTER **Franz Xaver** b. Germany. 1806 - 1873 Portrait artist Exh: NPG, Germany, US, France, Italy	
WINTOUR, ARSA **John Crawford** b. Edinburgh. 1825 - 1882 Genre & landscape artist Exh: RSA, UK AG's	
WINTZ **Raymond** b. Paris. 1884 - Landscapes & genre subjects Exh: France	
WINZER **Charles Freegrove** b. Varsovie. 1886 - Spanish & Oriental subjects Exh: London AG's, Paris, Moscow, Venice, US, India	
WIHGMAN. LAA, SAM **Frances** b. Birkenhead. 1888 - Portraits, landscape artist & miniaturist Exh: WAG, RCA & Prov. AG's	

WIRGMAN **Theodor Blake** b. 1848 - 1925 Portrait, genre & historical subjects Exh: RA, SS, GG, NG, NWS, NPG, Prov. AG's, US	*T. B. Wirgman* T.B.W
WISSING **Willem** b. Amsterdam. 1653 - 1687 Portrait artist Exh: Holland, NPG	*G. Wissing*
WIT **Jacob De** b. Amsterdam. 1695 - 1754 Mythological, genre, portraits & historical subjects Exh: Holland, germany, France, Russia, Belgium	*J. de Wit f. 1754* *J. de Wit F. 1753* *JD fecit.* *Jacob* *JD*
WITHERS. ROI **Alfred** b. London. 1856 - 1932 Architectural & landscape artist Exh: RA, SS, GG, VA, Prov. AG's	A.W.
WITHOOS **Peter** b. Holland. 1654 - 1693 Animals, insects & floral subjects Exh: Holland, Germany, Austria, UK	*P.W.* *P.W.*
WITTE **Emanuel De** b. Alkmaar. 1617 - 1692 Church interiors Exh: Holland, Germany, Belgium, France, UK	*E. De . Witte* ED·W
WITTE **Gaspar De** b. Antwerp. 1624 - 1681 Landscape artist Exh: Belgium, Germany, Hungary, France, etc.	CASPARDEWITTE G.D.W
WITTEL **Gaspare Van** b. Utrecht. 1653 - 1736 Architectural & landscape subjects Exh: France, Italy, Spain, Austria	G.V.W G.V.W
WOCHER **Marquard Fidel Dominikus** b. 1760 - 1830 Portrait & landscape miniaturist Exh: Switzerland, Germany	MWOCHER BASEL.ANNO 1804

WOHLGEMUTH **Michel** b. Nuremberg. 1434 - 1519 Portraits & religious subjects Exh: France, Germany	
WOLF. RI **Joseph** b. Germany. 1820 - 1899 Bird & animal subjects Exh: RA, NWS, BI, SS, RI, VA & Prov. AG's	
WOLFAERTS **Artus** b. Antwerp. 1581 - 1641 Historical subjects Exh: Spain	
WOLFE **Edward Harris** b. Johannesburg. 1897 - Portrait, marine, landscape, still life subjects Exh: London, European & US AG's etc.	
WOLFGANG **Gustav Andreas** b. Germany. 1692 - 1775 Painter & engraver	
WOLLASTON. SGA, DFA, ATD, **FIAL.** **Charles** b. Cheshire. 1914 - Oil & watercolourist Exh: PS, SGA, RBA, RSA, RHA, R.Cam.A. RP, NEAC, etc.	
WOLMARK **Alfred Aaron** b. Varsovie. 1877 - 1961 Still life, portraits & landscape artist Exh: RA, London & Prov. AG's	
WOLVERSON. NDD, ATD **Margaret Elizabeth** b. Weston-Super-Mare. 1937 - Portraits, animals landscapes & miniaturist Exh: RMS, X UK, US	

WONDER **Pieter Christoffel** b. Utrecht. 1780 - 1852 Portrait, interior scenes & genre subjects Exh: Holland, NPG, RA, BI	*P.C.W.F* *P.C.W.F*
WOOD, RA **Francis Derwent** b. Keswick. 1871 - 1926 Portraits & figure artist. Sculptor Exh: RA, UK AG's	*F.D.W.1919*
WOOD **Robert Sydney Rendle** b. Plymouth. 1895 - Landscape artist Exh: GI, RWA, RHA, SSA, RSW	*Rendle* *Wood.*
WOODINGTON **Walter** b. London. 1916 - Portrait & landscape artist Exh: RA, London AG's, etc.	*W. Woodington*
WOODS, RA **Henry** b. Warrington. 1846 - 1921 Rustic, venetian & genre subjects Exh: RA, London & Prov. AG's, S. Africa	*HW*
WOODS. MA **John Goodrich Wemyss** Watercolourist Exh: RA, London & Prov. AG's	*WGW*
WOODVILLE. RI **Richard Caton** b. 1856 - 1926 Military & battle scenes Exh: RA, NG, BI, NWS, Prov. AG's	*R.C.W.* *R.C.W.*
WOODWARD **Thomas** b. Pershore. 1801 - 1852 Portraits, genre, animals & sporting subjects Exh: RA, BI, London & Prov. AG's	*FCW 1837*
WOOG **Raymond** b. Paris. 1875 - ? Portraits, still life & landscape artist Exh: France	*Ⓦ*
WOOLF **Michael Angelo** b. London. 1837 - 1899 Genre artist & caricaturist Exh: UK AG's	*F.W.*

WORLIDGE **Thomas** b. Peterborough. 1700 - 1766 Portrait artist & miniaturist Exh: NPG, VA, London & Prov. AG's	*J.W*
WORMS **Jules** b. Paris. 1832 - 1924 Genre subjects Exh: France	*J WORMS*
WORRALL. RA **Ella** b. Liverpool. 1863 - ? Landscape artist & miniaturist Exh: RA & Prov. AG's	*EllORRALL*　　*EllE*
WORSFOLD **Maud Beatrice** Portrait artist Exh: RA & Prov. AG's	*monogram*
WORTLEY **Archibald Stuart James** b. 1849 - 1905 Portraits & sporting subjects Exh: RA, GG, NG, London & Prov. AG's, etc.	*monogram*
WOSTRY **Carlo** b. Trieste. 1865 - ? Portrait, historical & genre subjects Exh: Italy	*Wostry*
WOUTERS **Gomar** b. Antwerp. 1649 ? - ? Historical subjects	*G.W.*
WOUTERS **Jan Ludewick** b. Belgium. 1731 - ? Landscape artist Exh: Belgium	*il DeWouters*
WOUWERMAN **Jan** b. Haarlem. 1629 - 1666 Landscape with animals & figures Exh: European AG's, UK, Russia	*Jwouwrman*

WOUWERMAN **Philips** b. Haarlem. 1619 - 1668 Hunting & battle scenes, fairs, landscapes etc. Exh: International AG's	*Ph. Wouwerman* *Pi·w* *Psw* *PW* *Ps·w* *Ps·w* *Pw.* *Ps·w* *Ps·w* *PW* *Ps·w* *Ps·w* *PW* *Psw* *Ps·w* *PW* *Ps·w* *Ps·w*
WOUWERMAN **Pieter** b. Haarlem. 1623 - 1682 Battles, military subjects & landscapes Exh: Belgium, Austria, Russia, Holland, Germany, France, UK, etc.	*P.·rv.* *P.·w* *Pw*
WRIGHT. AMTC **Alice Maud** b. London Miniaturist Exh: RA, RI, London & Prov. AG's	*AMW.*
WRIGHT. MSIA **Edward** b. Liverpool, 1912 - Painter & graphic designer Exh: London & Prov. AG's, S. America	*WRight.*
WRIGHT. FBS.Comm. F.Inst.C. **Gordon Butler** b. Darlington. 1925 - Continental landscape & marine artist Exh: France, UK & Prov. AG's, etc.	*G.B. Wright*
WRIGHT, RWS **John William** b. London. 1802 - 1848 Genre artist & watercolourist Exh: RA, BM, UK AG's	*JWW 1841* *JWW 1840*
WRIGHT **Robert W.** Fl. London. 1871 - 1906 Genre artist Exh: RA, SS, London & Prov. AG's	*Rob. W Wright.* *1886.*

WULFHAGEN **Franz** b. Germany. 1624 - 1670 Portraits & religious subjects Exh: Germany	*F.W*
WULFRAET **Margaretha** b. Holland. 1678 - 1741 Genre, historical & portrait artist Exh: Helsinki	*M.v*
WUNNENBERG **Carl** b. Germany. 1850 - 1929 Genre subjects Exh: Germany, UK	C.WÜNNENBERG
WUST **Alexander** b. Dordrecht. 1837 - 1876 Landscape artist Exh: Belgium, Holland, US	*A. Wust*
WUTKY **Michael** b. Austria. 1739 - 1823 Landscape artist Exh: Vienna, Poland, Budapest	*M.Wutky* *n.Wutky*
WUZER **Johann Matthias** b. Austria. 1760 - 1838 Still life & portrait artist Exh: Austria	*M.Wuzer*
WYBURD **Francis John** b. London. 1826 - ? Genre & historical subjects Exh: London & Prov. AG's	*F.J.W. 1867* *F.J.W.*
WYCK **Thomas** b. Holland. 1616 ? - 1677 Interiors, markets & marine subjects Exh: Russia, European AG's, UK, etc.	*Tvryck Tvryck. Tvryck Tv* *Tvryck Tvryck Tvryck Tv*
WYETH. ARCA **Paul James Logan** b. London. 1920 - Mural & portrait artist Exh: RA, London & Prov. AG's, US, Canada, Australia	*Paul Wyeth-* *Paul Wyeth* *PW* *PW*

WYLD **William** b. London. 1806 - 1889 Landscape artist Exh: RA, NWS, SSSBA, VA, BM, France, Holland	*W Wyld.*
WYLIE **Robert** b. Isle of Man. 1839 - 1877 Genre & landscape artist Exh: UK AG's, US	*Wylie*
WYLLIE, OBE, SMA, etc. **Harold Lt. Col.** b. London. 1880 - ? Marine artist Exh: RA, SMA, RI & Prov. AG's	*Harold Wyllie*
WYLLIE. RA, RI **William Lionel** b. London. 1851 - 1931 Marine & coastal subjects Exh: RA, NWS, SS, GG, Prov. AG's, Australia	*WLW W.L.W. WLWyllie 1870*
WYNANTS **Jan** b. Haarlem. 1630 ? - 1684 Landscape artist Exh: International AG's	*J JWijnants F Wijnan B f . 1672* *Fc Wijnants. f J Wynant N.1660* *J. Wijnants. f A 1675 J Wijnants 1659* *J Wynant f A 1668 JW JW* *JW JW JW* *JW JW JW* *JW JW JW*

WYNEN **Dominicus Van** b. Amsterdam. 1661 - 1690 ? Imaginative & genre subjects	*Ascanius* *DX*
WYTSMAN **Rodolphe** b. Belgium. 1860 - 1927 Landscape subjects Exh: Belgium	*R. Wytsman*

X

XAVERY **Jacob** b. The Hague. 1736 - 1769 ? Floral & historical subjects	*J. Xavery. f*

Y

YANEZ **Fernando** b. Spain. ? - 1560 ? Historical subjects	*F Yanez*
YATES **Frederick** b. 1854 - 1919 Landscape & portrait artist Exh: London & Prov. AG's	*J.Y.* *J.Y.* *F.Y.* *F.Y.*
YATES. RI **Hal** b. Manchester. 1907 - Landscapes etc., watercolourist Exh: RA, RI, RWS, USA, NOAS, RBA, RSA, MAFA	*Hal Yates* *Hal Yates*
YATES **Mary** b. Chislehurst. 1891 - Landscape artist & sculptor Exh: RA, RSA, PAS, Prov. AG's	
YEAMES, RA **William Frederick** b. Taganrog. 1835 - 1918 Genre & historical subjects Exh: RA, BI, UK AG's	

YEEND-KING Lilian b. Paris. 1882 - Landscape artist Exh: RA, RI, ROI, Prov. AG's	
YEOMAN. FSIA Antonia b. Australia. 1913 - Pen/ink & watercolourist Exh: RSA, SGA, London & Prov. AG's	
YKENS Pieter b. Antwerp. 17th Century artist Portraits & historical subjects	
YON Edmund Charles Joseph b. Paris. 1836 - 1897 Landscape artist Exh: France, Belgium	
Young Jean b. London. 1914 - Birds, still life, figure & landscape artist Exh: RA, RBA, NEAC, London & Prov. AG's	
YVON Adolphe b. France. 1817 - 1893 Religious, genre, portrait & military subjects Exh: France, Italy, UK, etc.	

Z

ZACCHIA Lorenzo b. Italy. 1524 - 1587 ? Religious subjects Exh: Italy	
ZAIS Giuseppe b. Italy. 1709 - 1784 Historical & landscape subjects Exh: Italy, Spain, Germany, UK	
ZAK Eugene b. Russia. 1884 - 1926 Portrait artist Exh: Paris	

ZAMPIERI **Domenico** b. Bologna. 1581 - 1641 Portraits, landscapes & historical subjects Exh: European AG's, Scandinavia, UK	*D. ZAMPIERI F 1640* *D⁰ Zampieri*
ZARRAGA **Angel** b. Mexico. 1886 - 1946 Portrait, figure, allegorical & still life subjects	*Angel ZARRAGA*
ZAUFFELY **Johann Joseph** b. Germany. 1733 - 1810 Genre, portrait & historical subjects Exh: Germany, Austria, US, UK, France	*ℱ ℱ1780 ℱ*
ZEEMAN **Renier (Nooms)** b. Amsterdam. 1623 ? - 1667 ? Marine & coastal scenes Exh: Holland, France, Germany, US, UK, etc.	*R Noomszeeman E Zeeman Zeeman*
ZEITBLOM **Bartholome** b. Germany. 1455 ? - 1518 ? Biblical subjects Exh: Germany, France, UK	*B. B.*
ZELGER **Jacob Joseph** b. Switzerland. 1812 - 1885 Landscape subjects Exh: Switzerland, France	*J Zelger*
ZELLER **Georg Eugen** b. Zurich. 1889 - Pencil & oil media Exh: Switzerland	*EZeller*
ZIAR **Elizabeth Rosemary** b. St. Ives. 1919 - Watercolourist Exh: RI, RBSA, SWA, UA, France, etc.	*ℝ.*
ZICKENDRAHT **Bernhard** b. Germany. 1854 - 1937 Portrait & genre artist Exh: Germany	*B. Zickendraht*
ZIEGLER **Henry Bryan** b. London. 1793 - 1874 Portraits & landscape artist Exh: London & Prov. AG's	*ℤ HM*

ZIEGLER **Jules Claude** b. Langres. 1804 - 1856 Portraits & historical subjects Exh: French AG's	*J.Ziegler*
ZIEM **Felix Francois Georges Philibert** b. France. 1821 - 1911 Marine, architectural, still life & landscape subjects Exh: France, Germany, Holland, UK	*Ziem*
ZIESEL **Georg Frederik** b. Belgium. 1756 - 1809 Floral subjects & miniaturist Exh: Belgium	*Gff Ziesel*
ZIMMERMANN **Franz** b. Austria. 1864 - ? Historical & genre subjects Exh: Germany	*18 Z 34* *Z 35*
ZIMMERMANN **Friedrich** b. Germany. 1823 - 1884 Landscape artist Exh: France, Switzerland	*Frdr Zimmermann.*
ZINGG **Jules Emile** b. France. 1882 - Marine, genre & landscape artist Exh: French AG's, Tokyo, Tunisia	*ZINGG*
ZINKEISEN **Anna Katrina** b. Kilereggan. 1901 - Portrait artist & sculptress Exh: RA, SAF	*AZ*
ZO **Henri** b. France. 1873 - 1933 Figure, genre, portrait & landscape artist Exh: France, London, US	*Henri A. Zo.*
ZOCCHI **Giuseppe** b. Florence. 1711 - 1767 Historical, genre & landscape artist Exh: France	*J Zocchi 1760*
ZOMER **Jan Pietersz** b. Amsterdam. 1641 - 1726 Painter & engraver	*J.P Z*

ZONARO **Fausto** b. Italy. 1854 - 1929 Genre, portrait & oriental subjects Exh: Italy	*F. Zonaro*
ZORN **Anders Leonard** b. Sweden. 1860 - 1920 Portrait & figure studies Exh: Sweden, US, Italy, Paris, Germany	*Zorn · 88* *Zorn 88* *Zorn* *Zorn*
ZUBER **Henri** b. France. 1844 - 1909 Landscape artist Exh: France	*H. Zuber*
ZUBER-BUHLER **Fritz** b. Switzerland. 1822 - 1896 Portrait & genre subjects Exh: Switzerland, France	*Zuber-Buhler*
ZUBERLEIN **Jakob** b. Germany. 1556 - 1607 Portrait artist Exh: Germany	*Ƶ*
ZULAWSKI. SMP, AIA **Marek** b. Rome. 1908 - Painter Exh: RA, London & Prov. AG's, Italy, US, Australia, Finland, etc.	*Marek*
ZULOAGA Y ZABALET A **Ignacio** b. Spain. 1870 - 1943 Portrait, figure & genre subjects Exh: Spain, France, Italy, Germany, Russia, US	*I. Zuloaga*
ZURBARAN **Francisco De** b. Spain. 1598 - 1664 Portraits & historical subjects Exh: European AG's, UK, Russia, US	*f. Zurbaran 1650* *F Zurbaran* *F Dz vRBARAN*

ZWAERDECROON **Bernardus** b. Utrecht. 1617 ? - 1654 Portrait artist Exh: Holland	*BZ B.Z*
ZWENGAUER **Anton** b. Munich. 1810 - 1884 Landscape artist Exh: Germany, Switzerland	*Zwgr.* *1831*
ZYDERVELD **Willem** b. Amsterdam. 1796 ? - 1846 Genre subjects Exh: Haarlem	*W= Zijderveld*
ZYL **Gerard Pietersz Van** b. Holland. 1607 ? - 1665 Portraits & genre subjects Exh: Germany, Holland, Belgium	*G.V. Zyl*

MONOGRAMS

Those wishing to identify the artist relating to any particular monogram should bear in mind the procedure adopted in classification:—

1. Monograms have been alphabetically classified by the first letter of the monogram even where joined to, or is part of a subsequent letter.

2. Where this does not apply the uppermost letter has been taken as the classifying factor.

3. Where neither rule applies any letter which is predominent in the monogram has been used.

4. Where all letters are superimposed and cannot be classified as above the monogram has been cross-indexed separately under two or more letters according to position and legibility.

Normal alphabetical procedure has been adopted with any second letter contained in the monogram. A two-letter marginal index has been provided for ease of reference but any additional letters in the monogram will be found to be in alphabetical order wherever possible.

Some monograms have been found where, by reason of their indefinite or illegible character, it has not been possible to adopt the above procedure. These have been included under the "Unclassified" heading at the end of this section which also contains borderline items taken from the main text.

In many signatures and monograms, particularly those from earlier periods, the letter J appears as letter I, the letter T as J or F, letter G as C etc. It is important to remember that in order to simplify the classification of this section all letters have been read as they appear and not necessarily the letters they are meant to represent.

ADAMSON, MSIA **George Worsley** b. New York. 1913— Graphics, illustration & humorous subjects Exh: RA, WAG, Liverpool, US Inst. of Graphic Arts (NY)	
ALTDORFER **Albrecht** b. Altdorff - Bavaria 1488 - 1538 Mythological, biblical & historical subjects Exh: Germany, France, Austria	
ALTHAUS **Fritz B.** Fl. late 19th C Marine & landscape artist Exh: RA, SS, Prov. AG's	
AMMAN **Justus** b. Zurich 1539 - 1591 Historical & mythological subjects	
ARMFIELD **Maxwell** b. Ringwood 1882 - Tempera & watercolourist RA, PS, & Prov. AG's etc	
ARNOLD **Jonas** b. ? - 1669 Portraits, architectural, historical & floral subjects Exh: German AG's etc	
MARELLI **Andrea** Fl. Italy. 16th C. Historical subjects	
MILES **Arthur** Fl. 1851 - 1880 Portraits & genre subjects Exh: NG, UK AG's	
NEWTON **Algernon** b. London. 1880 - Town & landscape subjects Exh: US, S. Africa, Australia, UK	
WOLMARK **Alfred Aaron** b. Varsovie. 1877 - 1961 Still life, portraits & landscape artist Exh: RA, London & Prov. AG's	

ABBEY, RA Edwin Austin b. Philadelphia. 1852—1911 Historical subjects Exh: RA, France, etc.	*AA*
ADAM Albrecht b. Bavaria. 1786—1862 Portraits, landscapes, battles & military subjects Exh: X French & German collections	AA A
ANDRIESSEN Anthony b. Amsterdam 1746 - 1813 Still life & landscape artist Exh: Holland, France	AA
ANSTED William Alexander Fl. London. Late 19th C. Landscape artist Exh: RA, VA, London & Prov. AG's	A4 AA
APPIANI Andrea b. Milan 1754 - 1817 Portraits, mythological & historical subjects Exh: Italy, Russia, France, Germany etc	AA
ATKINSON W.A. Fl. London. 1849 - 1867 Genre & historical subjects Exh: RA, BI, SS	XAX
GLENDENING (Junior) RBA Alfred b. ? - 1907 Genre & landscape artist Exh: RA, SS, London & Prov. AG's etc	A.A.G
HUGHES Arthur b. London. 1832 - 1915 Genre & romantic subjects Exh: RA, GG, NG etc	AA
LONGDEN. OBE, DSO Major Alfred Appleby b. Sunderland. ? - 1954 Landscape watercolourist Exh: RA, RI, N. Zealand	AA
LUIGI (Called L'Ingegnio) Andrea Di b. Assisi. 1470 - 1512 ? Portraits & historical subjects	A.A.P.

POCOCK. ROI, RE, RI, PAS Anna b. London. 1882 - Portraits, figure & floral subjects Exh: RA, PS, Italy, Canada, US, N.Z., UK, Prov. AG's		**AA**
ROBINSON. BA Agnes Agatha b. Winnipeg Still life & landscape artist etc. Exh: RA, PAS, SWA, IWAC, US, etc.		
STORSTEIN Aage b. Stavanger. 1900 - Painter in oil & fresco media		
ALAUX Francois b. Bordeaux. 1878 - ? Landscape & marine artist Exh: France, Italy, Spain etc		
BADILE Antonio b. Verona 1480 - 1560 Historical, biblical & portrait artist Exh: Spain, Italy, Austria, France		**AB**
BARLAND Adam Fl. London. 1843 - 1863 Landscape artist Exh: London & Prov. AG's		
BARLOW Florence E. Fl. London. 1873 - 1909 Figure & animal subjects Exh: RA, London & Prov. AG's		
BARNES Robert Fl. 1873 - 1891 Genre subjects Exh: RA, Vienna		
BAYER August von b. Germany 1803 - 1875 Interiors & architectural subjects Exh: German AG's		
BADIALE Alessandro b. 1623 - 1668 Portraits & historical & biblical subjects		

BALESTRA **Antonio** b. Verona 1666 - 1740 Historical subjects Exh: Italy, Denmark	*AB I P.R.* *ABf.* *ABf.*
BEER **Arnould** b. Anvers. 1490 ? - 1542 Biblical & historical subjects	*Æ B.* *ÆB*
BELLUCCI **Antonio** b. Italy. 1654 - 1726 Portraits, mythological subjects etc Exh: Germany, Italy	*A.B.* *A.B* *AB.*
BERNARD **Adolphe** b. 1812 - ? Genre & portrait artist	*AB* *AB* *AB*
BEYEREN **Abraham Hendricksz van** b. Holland. 1620 - 1675 ? Still life subjects Exh: UK, Russia & European AG'S	*·ABf* *ABf* *AB*
BIE **Adrian de** b. 1593 - 1668 Portrait artist	*AB*
BLINKS **Thomas** b. 1860 - 1912 Animal & sporting subjects Exh: RA, SS, London & Prov. AG's	*B*
BLOCKLAND **Anthonie van Montfoort** b. Holland. 1532? - 1583 Biblical & historical subjects Exh: Germany, Holland, Austria, UK	*AB*
BLOEMAERT **Abraham** b. Dortrecht. 1564 ? - 1651 Portraits, mythological, genre & historical subjects Exh: UK & European AG's	*AB* *AB b*
BLOEMERS **Arnoldus** b. Amsterdam. 1786 - 1844 Floral & still life artist Exh: UK, France, Holland	*AB*

BOISSIER **Andre Claude** b. Nantes. 1760 - 1833 Portraits & biblical subjects	
BOONEN **Arnold** b. Dortrecht. 1669 - 1729 Genre & portrait artist Exh: Holland, Germany, Sweden etc	
BOSSE **Abraham** b. Tours. 1602 - 1676 Historical, genre, architectural & Portrait artist Exh: France	
BOTH **Andries Dirksz** b. Utrecht. 1608 -1650 Genre & landscape artist Exh: Germany, France, UK etc	
BOTTOMLEY **Albert Ernest** b. Leeds. 1873 - 1950 Landscape artist Exh: RA, RI, RBA, RCA	
BRAMER **Leonard** b. Delft. 1596 - 1674 Portraits & historical subjects Exh: Holland, Germany, France, Austria, etc	
BREANSKI **Alfred de** Fl. 19th C. Landscape artist Exh: RA, SS, NWS, London & Prov. AG's etc	
BRENET **Albert Victor Eugene** b. Harfleur. 1903 - Naval, military & airforce artist Exh: France	
BRETSCHNEIDER **Andreas 111** b. Dresden. 1578? - ? Miniaturist Exh: UK	
BRISCOE **Arthur John Trevor** b. Birkenhead. 1873 - 1943 Marine artist Exh: RA, NEAC	

AB	**BROUWER** **Adriaen** b. 1606 ? - 1660 Figure & genre artist Exh: UK, Scandinavia & European AG's	*AB* *AB* *AB* *AB*
	BROWN, RA **Sir John Arnesby** b. Nottingham. 1866 - 1955 Landscape artist Exh: RA, Prov. AG's, S. Africa	*aB*
	BRUEGHEL (or BREUGHEL) **Abraham** b. 1631 ? - 1690 Still life subjects. Exh: Holland, Italy, Sweden etc	*AB*
	BUCKLAND **Arthur Herbert** b. Taunton. 1870 - ? Genre subjects Exh: RA, London & Prov. AG's, Paris	*AB*
	BURR **Alexander Hohenlohe** b. Manchester. 1837 - 1899 Genre & historical subjects Exh: RSA, UK AG's	*A·B 1855*
	CERQUOZZI **Michelangelo** b. Rome. 1602 ? - 1660 Still life, historical, battle scenes etc Exh: France, Germany, Italy, Spain etc	*AB.*
	COLLIER **Arthur Bevan** Fl. London. 1855 - 1900 Landscape artist Exh: RA, Prov. AG's	*ABC*
	CUYLENBORCH **Abraham van** b. Utrecht. 1620 ? - 1658 Mythological & landscape artist	*AB* *AB* *AB* *AB*
	GALLI **Giovanni Antonio** Flourished 17th Century Animal, genre & historical subjects Exh: Italy.	*AB*
	RIVIERE. RA **Briton** b. 1840 - 1920 Genre, historical & animal subjects Exh: RA, SS, BI, GG, Germany, Australia, etc.	*AB*

SCHATTENHOFER **Amalia Von** b. Germany. 1763 - 1840 Portrait & genre subjects	*A B f* *AB*	AB
FLAMEN (or FLAMAND) **Albert** Flourished France 17th Century Portrait, genre & landscape artist Exh: UK, France	*AB* *ABF*	
ALBERTI (called BORGHEGIANO) **Cherubino** b. Borgo San Sepulcro. 1553 - 1615 Historical subjects, portraits etc Exh: France, Italy	*AB*^C *AB*^C *AB*^C	
HOUGHTON **Arthur Boyd** b. 1836 - 1875 Genre; oil & watercolourist Exh: RA, BI, SS, OWS, etc	*A B H*	
RIBERA **Josef** b. Spain. 1588 - 1656 Biblical & portrait artist Exh: Spain, Italy, NG, France, Germany	*AR* *AR* *AR* *AR*	
STEENWYCK **Abraham** b. Holland. 1640 ? - 1698 Still life subjects Exh: Holland	*AB.S*	
WILLAERTS **Abraham** b. Utrecht. 1603 ? - 1669 Marine, portrait & genre subjects Exh: Holland, Germany, France, UK	*BW* *BW* *BW*	
ARMYTAGE **Charles** Fl. London. 1863 - 1874 Domestic genre Exh: SS, London & Prov. AG's	*CA*	AC
CANALETTO (or CANAL) **Antonio** b. Venice. 1697 - 1768 Landscapes, architectural & venetian subjects Exh: US, UK & European AG's etc	*A.C.* *AC* *A.C* *A C*	
CARACCI **Annibale** b. Bologna. 1560 - 1609 Landscapes & biblical subjects	**A C**	

CARDON Antoine Alexandre Joseph b. Brussels. 1739 - 1822 Exh: Italy, Belgium	*AC*
CARRACCI Agostino b. Italy. 1557 - 1602 Portrait, religious & landscape artist Exh: UK, Germany, France, Italy, Austria etc	*[monogram forms]*
CLAY, BT Sir Arthur Temple Felix b. 1842 - 1928 Portrait, domestic & historical subjects Exh: RA, SS, NWS, GG, NG.	A.C.
COOPER Alexander b. London. 1605 - 1660 Portrait & miniaturist Exh: Holland	*Ⱥ.*
COOSEMANS Alexander b. 1627 ? - 1689 Still life subjects Exh: Belgium, Spain, Austria etc	**AC.**
COYPEL Antoine b. Paris. 1661 - 1722 Historical & mythological subjects etc Exh: France, Hungary, Italy, UK, Russia	*A.C. fecit 1694*
CURTIS, ARWA Anthony Ewart b. Wakefield. 1928 - Oil, watercolour & general media Exh: London & Prov. AG's	*AC*
CUYLENBORCH Abraham van b. Utrecht. 1620 ? - 1658 Mythological & landscape artist	*AC 1640*
CZECHOWICZ Simon b. Cracow. 1689 - 1775 Landscapes etc	*AC*
CALAME Alexandre b. Vevay. 1810 - 1864 Landscape artist Exh: Holland, Germany, Russia etc	AC ACT AC7

BLOCK Anna Katharina b. Nuremberg. 1642 - 1719 Miniaturist, floral & portrait artist	ACB.	AC
CLEEF Henry van b. Antwerp. 1510 - 1589 Landscape artist		
DAVIDSON-HOUSTON Aubrey Claude b. Dublin. 1906 - Portrait artist Exh: RSA, RCA, RP, RBA, ROI, NS, PS	ACDH 1949.	
GLENDENING (Junior) RBA Alfred b. ? - 1907 Genre & landscape artist Exh: RA, SS, London & Prov. AG's etc		
GOODWIN, RWS, Albert b. Arundel. 1845 - 1932 Biblical, allegorical subjects. landscapes etc Exh: RA, OWS, London & Prov. AG's		
HILL Carl Frederick b. Lund. 1849 - 1911 Landscape artist Exh: France, Scandinavia		
SCHUT Cornelis b. Antwerp. 1597 - 1655 Religious subjects Exh: Holland, Belgium, Germany		
DAWSON Alfred FL. 19th C. Etcher & landscape artist Exh: RA, SS, BI		AD
DEVERIA Achille Jacques Jean Marie b. Paris. 1800 - 1857 Portraits, genre & mythological subjects Exh: French AG's		
DIEPENBEECK Abraham van b. Bois-le-Duc. 1599 - 1675 Portraits, animal & historical subjects Exh: Germany, Belgium, Holland, UK etc		

529

DIEPRAAM **Abraham** b. Holland. 1622 - 1670 Genre artist Exh: Germany, Holland etc	
DUCLUZEAU **Marie Adelaide** b. Paris. 1787 - 1849 Portrait & genre artist Exh: France	
DUNOUY **Alexandre Hyacinthe** b. Paris. 1757 - 1841 Landscape artist Exh: France	
DURER **Albrecht** b. Nuremberg. 1471 - 1528 Portraits, landscapes & historical subjects. Exh: International AG's & collections	
BORCHT (The Younger) **Hendrik van der** b. 1614 - 1654 Historical subjects	
CARRACCI **Annibale** b. Italy. 1560 - 1609 Portrait, religious, mythological, genre & landscape artist Exh: UK & European AG's	
DRIFT **Johannes Adrianus van der** b. Holland. 1808 - 1883 Town scenes & landscape artist Exh: Holland	
DAVID **Antonio** b. Venice. 1698 - ? Portrait artist	
DALLINGER VON DALLING **Alexander Johann** b. Vienna. 1783 - 1844 Landscape & animal subjects Exh: Austria	

LIMBORCH Hendrik Van b. The Hague. 1681 - 1759 Mythological, historical & portrait subjects Exh: Holland, France, Budapest		AD
ANTONELLO da Messina 'b. Messina 1414 ?- 1493 ? Portraits, historical & religious subjects Exh: UK & principal European AG's		
EVERDINGEN Albert van b. Alkmaar, 1621 - 1675 Marine & landscape artist Exh: France, Germany, Holland, UK etc		
VOIS Adrian De b Utrecht. 1631 - 1680 Genre & portrait artist Exh: Holland, Belgium, France, UK, Germany		
WAARD Antonie b. The Hague. 1689 - 1751 Historical, portrait, genre & animal subjects Exh: Holland		
EAST, RA, RI, PRBA, RPE Sir Alfred b. Kettering. 1849 - 1913 Landscape artist Exh: RA, BI, NWS, RI etc		AE
ELMORE, RA Alfred b. Clonakelty. 1815 - 1881 Genre & historical subjects Exh: Australia, London & Prov. AG's		
ELSHEIMER Adam b. Frankfurt, 1578? - 1620 Landscapes, historical, night & moonlight scenes Exh: European AG's		
PETTITT Edwin Alfred b. Birmingham. 1840 - 1912 Landscape artist Exh: RA, Prov. AG's		
PRYNNE, RBA Edward A. Fellowes b. 1854 - 1921 Portrait, figure & genre subjects Exh: RA, UK AG's		

SADELER **Aegidius** b. Antwerp. 1570 - 1629 Religious subjects Exh: Germany, Austria	
TATE **Barba & James**	see TATE Barba & TATE James **Works executed jointly**
TEMPESTA **Antonio** b. Florence. 1555 - 1630 Processions, battle & hunting scenes, landscapes & historical subjects Exh: Italy, Germany, France	

ABELS **Jacobus Theodorus** b. Amsterdam. 1803–1866 Landscape artist Exh: Holland	
ASKEW **Felicity Katherine Sarah** b. London 1894 - Sporting subjects & sculpture Exh: PS, WAG, SSA, Berlin, Italy etc	
FALCONE **Aniello** b. Naples. 1607 - 1656 Battle scenes & historical subjects Exh: France, Italy, Spain	
FALDONI **Antonio Giovanni** b. Italy. 1690? - 1770? Portrait & landscape artist	
FISHER **Alfred Hugh** b. London. 1867 - 1945 Landscapes & architectural subjects Exh: RA, SS, NWS, London & Prov. AG's, Paris	
FRANCKEN (The Elder) **Ambrosius** b. 1544 - 1618 Historical subjects Exh: France, Belgium etc	

FRASER, RSA Alexander (Jnr) b. Linlithgow. 1828 - 1899 Landscape artist Exh: RA, London & Prov. AG's	*A. F.*
FURNERIUS Abraham b. 1628 ? - ? Landscape artist	*A. F.*
FUSSLI Jean Henri b. Zurich. 1741 - 1825 Portraits, figure, genre subjects etc Exh: RA, Prov. AG's etc	*A·F*
GRACE Alfred Fitzwalter b. U.K. 1844 - 1903 Landscape artist Exh: RA, SS, SBA	*A.F.G.*
JEAN Antoine b. Ascoli 1690 ? - ? Historical & landscape painter Exh: Italy	*AF*
MUTRIE Annie Feray b. Ardwick. 1826 - 1893 Floral & still life subjects Exh: RA, BI, VA	*AFM AFM*
VRIES Adriaen De b. The Hague. 1550 ? - 1626 Portrait artist Exh: Holland	*AF*
BOUDEWYNS Adriaen Frans b. Brussels. 1644 - 1711 Landscape & figure artist Exh: Holland, Spain, Hungary, France	*AF·B·*
SCHELVER August Franz b. Germany. 1805 - 1844 Military subjects & hunting scenes etc. Exh: Germany	*AFS* *1899*
FALCON, RBA, MA Thomas Adolphus b. Yorkshire. 1872 - ? Landscape artist Exh: London & Prov. AG's	(monogram)

AF	**FERG** **Franz de Paula** b. Vienna. 1689 - 1740 Genre & landscape artist Exh: Germany, Hungary, Italy, Austria etc	
	SCHIRMER **Johann Wilhelm** b. Germany. 1807 - 1863 Biblical & landscape subjects Exh: Germany	
AG	**ALDEGREVER** **Henry** b. Westphalia. 1502 - 1566? Portraits, biblical, historical & mythological subjects Exh: Germany, Hungary, France, UK, Ireland	
	ALLEGRAIN **Etienne** b. Paris. 1653 - 1736 Landscape artist Exh: France	
	ARMFIELD **George** Fl. London. 1840 - 1875 Canine subjects Exh: RA, BI, SS, UK AG's	
	GEDDES, ARA **Andrew** b. Edinburgh. 1783 - 1844 Genre, still life & portrait artist Exh: RA, BI, London & Prov. AG's	
	GENOELS (The Younger) **Abraham** b. Anvers. 1640 - 1723 Landscapes & mythological subjects etc; Exh: Holland, Belgium, France	
	GILBERT **Arthur Williams** b. 1819 - 1895 Landscape artist Exh: RA, BI, SS	
	GOW, RA, RI **Andrew Garrick** b. London. 1848 - 1920 Portraits, genre, military & historical subjects Exh: RA, SS, NWS, GG, RI. Prov. AG's, S. Africa, Australia	
	GOYDER **Alice Kirkby** b. Bradford. 1875 - ? Animal subjects. watercolourist Exh: RA, RI	

534

GRAFF **Johann Andreas** b. Nuremberg. 1637 - 1701 Portraits, floral & landscape artist		**AG**
WALLIS **Arthur George** b. Exeter. 1862 - ? Landscape artist Exh: London & Prov. AG's		
WEBSTER **Alfred George** Genre, architectural & landscape artist Exh: RA, SS, London & Prov. AG's	A.G.W	
HACKER, RA **Arthur** b. London. 1858 - 1919 Portraits, genre & historical subjects Exh: RA, BI, GG, NG etc		**AH**
HANNAN, MA, ATD, FMA **Andrew** b. Glasgow. 1907 - Painter in oil media		
HARTLEY, RE, RWA **Alfred** b. Hertfordshire. ? - 1933 Painter & etcher Exh: RA, PS. Prov. AG's		
HAVERS **Alice Mary** b. Norfolk. 1850 - 1890 Genre & landscape artist Exh: RA, SS, PS & Prov. AG's		
HELCKE **Arnold** Fl. 1865 - 1898 Landscape & marine artist Exh: RA, SS, London & Prov. AG's	A.H. 1868	
HERRERA **Alonso de** b. Spain. 1579 - ? Historical subjects		
HERZINGER **Anton** b. 1763 - 1826 Animals, landscapes & mythological subjects		

535

HIRSCH **Alphonse** b. Paris. 1843 - 1884 Genre & portrait artist Exh: France	
HOSALI, M.Sc. **Nina Moti** b. London. 1898 - Painter in oils & mixed media. Exh: ROI, RBA, NS, Prov. AG's Paris, US etc	
HOUBRAKEN **Arnold** b. Dortrecht. 1660 - 1719 Portraits, genre, religious & historical subjects Exh: France, Germany.	
HUGHES **Arthur** b. London. 1832 - 1915 Genre & romantic subjects Exh: RA, GG, NG etc	
HAEN **Abraham 11 de** b. Amsterdam. 1707 - 1748 Landscape artist	
PELLEGRINI **Alfred Heinrich** b. Basle. 1881 - Portraits, figure & genre subjects Exh: Germany, US, S. America	
HONDIUS **Abraham Danielsz** b. Rotterdam. 1625 ? - 1695 Animals, hunting & battle scenes etc Exh: Holland, France, UK, Germany, Russia, US	
HERBERT **Alfred** b. ? - 1861 Marine artist & watercolourist Exh: RA, SS, BI, London & Prov. AG's	
LIEVENS (The Younger) **Jan Andrees** b. Antwerp. 1644 - ? Genre & historical works Exh: Amsterdam	
STAVEREN **Jan Adriensz Van** b. Leyden. 1625 ? - 1668 Portrait, genre & landscape subjects Exh: Holland, Paris, UK	

AH

STILKE **Hermann Anton** b. Berlin. 1803 - 1860 Historical & portrait artist Exh: Germany		AH
ARP **Jean Hans** b. Strasbourg 1887 - 1966 Painter & sculptor Exh: GB, US, France, Switzerland etc		
HIMPEL **Anthonis or Abraham** b. Amsterdam. 1634 - ? Genre, landscapes & historical subjects		
VOORHOUT **Johannes** b. Holland. 1647 - 1773 Portraits, genre, historical & allegorical subjects Exh: Holland, Germany, Sweden		
SEVERN **Arthur** b. England. 1842 - 1931 Marine & landscape artist Exh: UK, France		AI
ACKLAND **Judith** b. Bideford, Devon Landscape watercolourist Exh: RA, Derby, Huddersfield & Huddersfield		AJ
ASSELYN (or ASSELIN) **Jan** b. 1610 - 1652 ? Landscape artist Exh: Holland, Belgium, Germany, Hungary, France etc.		
JEFFERSON, ARCA **Alan** b. London. 1918 - Oil, gouache & watercolourist Exh: RA, RBA, NEAC, London & Prov. AG's		
JOHNSTON **Alexander** b. Scotland. 1815 - 1891 Portraits & historical genre Exh: RA, UK AG's, Paris		

AJ	**MUNNINGS, PRA, RSW** **Sir Alfred James** b. 1878 - 1959 Horses & landscape, oil & watercolourist Exh: RA, RI, UK & European AG's	A·J·M. AJm. AJM
	RUYTENSCHILDT **Abraham Jan** b. Amsterdam. 1778 - 1841 Genre & landscape subjects	AR 1813
	TANZIO **Antonio D'enrico** b. Italy. 1575 ? - 1635 Religious & portrait artist Exh: Italy	A A
AK	**CABEL (or KABEL)** **Adrian van der** b. Holland. 1631 ? - 1705 Portrait, marine, still life, mythological & landscape artist Exh: Holland	AK NK
	KAUFFMANN **Angelica Catharina Maria Anna** b. Switzerland. 1740 - 1807 Historical & portrait artist Exh: NPG, VA, France, Italy, Germany Vienna	AK· AK. fecit
	KNELL **William Adolphus** b. 1805 - 1875 Marine artist Exh: RA, BI, SS, UK AG's	AK AK.
	VRIES **Adriaen De** b. The Hague. 1550 ? - 1626 Portrait artist Exh: Holland	AK.
	BROWN, RSA **Alexander Kellock** b. Edinburgh. 1849 - 1922 Floral & landscape subjects Exh: RA, SS, NWS, GG, NG, Prov. AG's, Germany	AKB
AL	**LANDERER** **Ferdinand** b. Austria. 1746 - 1795 Genre, landscapes & mythological subjects	A A
	LANKESTER, BA, MB, B.CL, **CANTAB, MRCS, LRCP** **Lionel W.A.** b. Surrey. 1904 - B/white & watercolourist Exh: RWS & Prov. AG's	L 1953

LEYDERDORP **Andries** b. Holland. 1789 - ? Genre & landscape subjects	A:L: A: L AL
LONGHI **Alessandro** b. Venice. 1733 - 1813 Portrait artist Exh: Italy	A
LOUIS **Aurelio** b. Pisa. 1556 - 1622 Historical & religious subjects Exh: Italy	A.
LYNCH **Albert** b. Lima (Peru). 1851 - ? Genre & portrait artist Exh: France, Australia	AL
MERRITT **Anna Lea** b. Philadelphia. 1844 - ? Genre & portrait artist Exh: RA, NG, GG, etc.	AD AD AL
CANO **Alonso** b. Grenada. 1601 - 1667 Portraits, biblical & historical subjects Exh: Germany, Hungary, Russia, Spain etc	AL°C°
CASTELLAN **Antoine Laurent** b. France. 1772 - 1838 Historical & landscape artist Exh: France	ALC:
POCOCK. RMS **Alfred Lyndhurst** b. 1881 - Watercolourist Exh: RA, London & Prov. AG's, Canada	19 AP 26
RICHTER **Adrian Ludwig** b. Dresden. 1803 - 1884 Landscapes & animal subjects Exh: Germany, US	ALR
ANDREWS **Lilian** b. 1878 - Watercolourist of birds & animals Exh: RA, RSA, & Prov. AG's	A

ARENTSZ **Arent** b. Amsterdam 1586 - 1635 Landscape artist Exh: Holland, Paris, London	
MacDONALD. RMS,ARMS, **FRSA, UA** **Alastair James Henderson** b. Argyll. 1934 - Miniaturist & landscape artist Exh: RMS, RI, UA, USA	
MAGANZA **Alessandro** b. Venice. 1556 - 1630 ? Portrait & religious subjects Exh: Italy	
MAHLAU **Alfred** b. Berlin. 1894 - Pen & ink, watercolourist etc. Exh: Switzerland, Germany, Holland, US	
MAIR **Alexander** b. Germany. 1559 ? - 1620 ? Genre & portrait artist	
MANN **Alexander** b. Glasgow. 1853 - 1908 Genre & landscape artist Exh: RA, ROI, UK AG's, Paris	
MANTEGNA **Andrea** b. Italy. 1431 - 1506 Religious, historical & mythological subjects Exh: Italy, France, UK, Spain, Germany, etc.	
MAUVE **Anton** b. Holland. 1838 - 1888 Landscape & animal subjects Exh: Holland, Germany, US, UK	
MAYERSON **Anna** b. Austria. 1906 - Painter & sculptor Exh: London & Prov. AG's	
MAZZOLA **Girolamo Francesco Maria** b. Parma. 1503 - 1540 Religious & portrait artist Exh: Italy, France, US, Britain, Russia	

MEDULA (called IL SCHIAVONE) **Andrea** b. Dalmatia. 1522 - 1563 Portraits & historical subjects	
MELVILLE, RSW **Arthur** b. E. Linton. 1858 - 1904 Eastern subjects, oil & watercolourist Exh: RA, VA, UK AG's	
MIROU **Antoine** b. 1588 ? - 1661 ? Landscape artist Exh: European AG's, Russia	
MORGAN **Alfred** Fl. 1862 - 1902 Floral, genre, animal & landscape subjects Exh: RA, BI, SS, VA	
MOZART **Anton** b. Germany. 1573 - 1625 Portrait, miniature & landscape subjects Exh: Germany, Switzerland	
MURRAY. MA, FRGS, FSA **Alexander Henry Hallam** b. London. 1854 - ? Architectural & landscape artist Exh: RA, London & Prov. AG's	
BURLEIGH, RWS **Averil** b. UK. Fl. 1913 - 1950 Landscape watercolourist Exh: RA, PS	
CLARKE **Audrey M** b. Leicestershire. 1926 Exh: London & Prov. AG's	
DAINTREY **Adrian Maurice** b. London. 1902 - Portrait & landscape artist Exh: RA, London & Prov. AG's	
MANGLARD **Adrien** b. Lyon. 1695 - 1760 Historical, marine & landscape artist Exh: France, Hungary, Italy, Spain etc.	

AM	**WILLIAMS** **Alfred Mayhew** b. 1823 - 1905 Landscape artist & watercolourist Exh: RA, SS, VA	*A.M.W 1891*
	WRIGHT. AMTC **Alice Maud** b. London Miniaturist Exh: RA, RI, London & Prov. AG's	*A.M.W.*
AN	**COPE** **Sir Arthur Stockdale** b. London. 1857 - 1940 Portrait & landscape artist Exh: RA, UK AG's, Paris	*an*
	GELDER **Nicolaes van** b. Leyde. 1625 ? - 1677 Still life subjects Exh: Holland, Austria, Germany	*AN 1613 CG.F*
	NARDI **Angelo** b. Italy. 1584 - 1665 Genre & portrait artist Exh: Spain	*N.*
	NOWELL **Arthur Trevethin** b. Garndiffel. 1862 - 1940 Domestic genre Exh: PS, London & Prov. AG's	*AN*
AO	**OSTERLIND** **Anders** b. France. 1887 - 1960 Landscape artist Exh: France, Belgium, Holland	*AO*
	OSTADE **Adriaen Van** b. Haarlam. 1610 - 1684 Village scenes, domestic interiors etc. Exh: International AG's	*N. AO AO. NO* *AO AP NO A.o A.O.*
AP	**AARTSEN (or Aertsen)** **Pieter** b. Amsterdam. 1507—1575 Still life, genre, religious, architectural & historical subjects Exh: Holland, Germany, Belgium, Hungary, Russia, etc.	*AR AR AP*

ANGEL **Philips** b. Middelbourg 1616 - 1684 Still life & genre subjects etc Exh: Germany	
PARSONS, RA, PRWS **Alfred** b. Somerset. 1847 - 1920 Landscape, oil & watercolourist Exh: RA, RI, NG, Paris, Berlin, Vienna	
PATTEN **Alfred Fowler** b. London. 1829 - 1888 Figure & portrait artist Exh: UK AG's	
PENLEY. RI **Aaron Edwin** b. 1807 - 1870 Portraits, landscape & rustic genre artist Exh: RA, NWS, BI, SS	
PERIGAL **Arthur** b. London. 1816 - 1884 Landscape artist Exh: RSA, RA, Prov. AG's	
PORTNER **Alexander Manrico** b. Berlin. 1920 - Artist & portrait painter Exh: RA, RP, London & Prov. AG's US, X	
POUPART **Antoine Achille** b. Paris. 1788 - ? Landscape artist Exh: Paris	
PRESTEL **Theophilus** b. Germany. 1739 - 1808 Portraits & religious subjects	
TRAQUAIR. HRSA **Pheobe Anna** b. Dublin. 1852 - 1936 Painter & illustrator Exh: European AG's, US, UK	
POTEMONT **Adolphe Theodore Jules Martial** b. Paris. 1828 - 1883 Landscape artist Exh: Paris	

AP	**PALAMEDES** **Anthonie** b. Delft. 1601 - 1673 Portrait artist Exh: Holland, UK, US, France, Germany	*APP.*
	GHISI **Adamo** b. Mantoue. 1530 ? - 1574 Genre, biblical & historical subjects	
	STALPAERT **Peeter** b. Holland. 1572 ? - 1635 ? Marine & landscape artist Exh: Holland	
	PEZ **Aime** b. Belgium. 1808 - 1849 Historical, genre & portrait artist Exh: Belgium.	
AQ	**QUERFURT** **August** b. Germany. 1696 - 1761 Battle & hunting scenes Exh: Germany, France	AQ AQ. AQ
AR	**RACKHAM** **Arthur** b. London. 1867 - 1939 Figure & landscape artist. Illustrator. Exh: RI, RA, London & Prov. AG's, France, Spain	
	RADEMAKER **Abraham** b. Holland. 1675 - 1735 Landscape artist Exh: Holland, Belgium, London, Paris	
	RANKLEY **Alfred** b. 1819 - 1872 Genre & historical subjects Exh: RA, BI, SS, London & Prov. AG's	
	RAVESTEYN **Anthony Van** b. Holland. 1580 ? - 1669 Portrait artist Exh: Holland, Germany	
	REDPATH, RSA, ARA **Anne** b. 1895 — 1965 Floral & landscape artist Exh: RA, RSA, GI, SSA, RBA etc.	1911

RENTINCK **Arnold** b. Amsterdam. 1712 - 1774 Portraits & mythological subjects	*AR*	**AR**
RETHEL **Alfred** b. Germany. 1816 - 1859 Historical & portrait artist Exh; Germany	*AR AR AR AR AR AR*	
RHOMBERG **Joseph Anton** b. Germany. 1786 - 1855 Historical, genre & portrait subjects Exh: Germany	*AR*	
RIEDEL **August Heinrich** b. Germany. 1799 - 1883 Portraits, genre & historical artist Exh: Germany	*AR*	
RUSSON **Agatha** b. Wisconsin, US. 1903 - Crayon, oil & watercolourist Exh: ROI, RBA, London & Prov. AG's	*AR*	
FEDDEN **A. Romilly** b. Nr. Bristol. 1875 - 1939 Landscapes & street scenes Exh: London & Prov. AG's	*aRf*	
KENDALL, DA, FRZS, SWA, RGI **Alice R.** b. New York. ? - 1955 Exh: NEAC, PS, RA, RSA, SWA etc	*arK* *ARK*	
QUINTON **Alfred Robert** Fl. UK. 19th – 20th C. Landscape artist Exh: RA, SS, NWS, London & Prov. AG's	A.R.Q. Æ.R.Q.	
ADAMSON **Sydney** b. Dundee. Fl. 1908 - 1920 Portraits & landscape artist Exh: RA, UK, AG's	*AS* (in box)	**AS**
GRAFF (or GRAF) **Antoine** b. 1736 - 1813 Portrait artist & miniaturist Exh: France, Germany	*AS* *1809*	

AS

SACCHI Andrea b. Italy. 1599 - 1661 Historical & portrait artist Exh: Italy, France, Spain, Germany	
SALLAERT Antoine b. Brussels. 1590 ? - 1657 ? Historical & portrait artist Exh: Belgium, Spain	
SAUERWEID Alexandre Ivanovitch b. Russia. 1783 - 1844 Military subjects Exh: Russia	
SCHILCHER Anton Von b. Germany. 1795 - 1827 Military & genre subjects	
SCHLEICH August b. Munich. 1814 - 1865 Animal subjects Exh: Munich	
SCHOUMAN Aert b. Holland. 1710 - 1792 Portrait & animal landscapes etc. Exh: Holland, Paris, Leningrad	
SCHRODTER Adolf b. Germany. 1805 - 1875 Genre subjects Exh: Holland, Germany	
SEDELMAYER Joseph Anton b. Munich. 1797 - ? Landscape artist Exh: Germany	
SEINSHEIM (Count) August Carl b. Munich. 1789 - 1869 Religious & genre subjects Exh: Germany	
SHORE. WIAC Agatha Catherine b. London. 1878 - ? Portrait, interior & landscape artist Exh: NEAC, IS, NPS, PS, London & Prov. AG's	

SIEURAC **Francois Joseph Juste** b. France. 1781 - 1832 Miniaturist Exh: France		**AS**
SIMPSON **Henry** b. Narton. ? - 1921 Genre subjects Exh: RA, Holland		
SMITH **Alfred** b. Bordeaux. 1853 - ? Portrait & landscape artist Exh: France		
SOLOMAN **Abraham** b. London. 1824 - 1862 Genre & historical subjects Exh: RA, BI, UK AG's		
SPEED **Harold** b. London. 1872 - 1957 Portraits, figures & historical subjects Exh: NG, UK AG's, Paris		
STOKES, RA, VP RWS **Adrian Scott** b. Southport. 1854 - 1935 Landscape, genre & marine artist Exh: RA, SS, UK AG's		
STORCK **Abraham** b. Amsterdam. 1635 ? - 1710 ? Marine & landscape subjects Exh: Holland, France, London, US, Germany, UK		
SUKER **Arthur** Fl. 1866 - 1890 Landscape & marine artist Exh: RA, UK AG's, Australia		
VOUET **Simon** b. Paris. 1590 - 1649 Historical & portrait artist Exh: US, Russia, European AG's etc.		
SUSENIER **Abraham** b. Holland. 1620 ? - 1664 Still life & landscape artist Exh: Holland, Germany		

AS	**HARTRICK** Archibald Standish b. Bangalor. 1864 - 1950 Figures, landscapes & genre subjects Exh: RA, RHA, WAG, RSA, etc.,	A.S.H. A.S.H
	SANDYS Frederick b. England. 1832 - 1904 Portrait & figure artist Exh: RA, UK, Melbourne	
	STRUTT. RBA, ARPE Alfred William b. New Zealand. 1856 - 1924 Portrait, genre & animal subjects Exh: RA, SS, NWS, London & Prov. AG's	A. St.
AT	**ARMSTRONG** Thomas b. Manchester 1835 - 1911 Figure artist etc. Exh: RA, GG, & Prov. AG's	
	TEMPESTA Antonio b. Florence. 1555 - 1630 Processions, battle & hunting scenes, landscapes & historical subjects Exh: Italy, Germany, France	A AT
	THORBURN Archibald b. 1860 - 1935 Birds & animal subjects Exh: RA, SS, London & Prov. AG's	A.T.
	TROST Andreas b. Austria. ? - 1708 Genre, mythological & architectural subjects	
	TRUBNER Alice (née Auerbach) b. Bradford. 1875 - 1916 Portrait, still life, interiors & landscape artist Exh: Berlin, Frankfurt & German AG's	A.T. a.T.
	TURYN Adam b. 1908 - Painter in oil media, B/white etc. Exh: RA, RSA, SSA, PS, Prov. AG's	
	CAMPI Antonio b. Cremona. 1536 ? - 1591 ? Historical & mythological subjects etc.	ATCA

UNDERWOOD. RMS, RBA **Anne** b. E. Grinstead. 1876 - ? Miniaturist & portrait artist Exh: RA, London & Prov. AG's	AU
AKEN **Jan van** b. Holland. 1614 - ? Landscape artist	AV
d'AGNOLO **Andrea (called Andrea del Sarto)** b. Florence. 1487 - 1531 Portraits, biblical & historical subjects	
VERHOEVEN-BALL **Adrien Joseph** b. Antwerp. 1824 - 1882 Genre, floral & portrait artist Exh: Belgium, France, Canada	
VILLAMENA **Francisco** b. Assisi. 1566 - 1624 Portraits & religious subjects Exh: Italy, Austria	
VOLLMER **Adolf Friedrich** b. Hamburg. 1806 - 1875 Marine & landscape artist Exh: Germany	
VRIES **Adriaen De** b. The Hague. 1550 ? - 1626 Portrait artist Exh: Holland	
VOKES **Arthur Ernest** b. UK. 1874 - ? Sculptor, portrait & landscape artist Exh: RA, RI, RP	
DYCK **Anton van** b. Anvers. 1599 - 1641 Portraits & historical subjects Exh: UK, US & European AG's	
DREVER **Adrian van** Flourished Holland 17th Century Marine & landscape artist Exh: Austria	

NEER **Aart Van Der** b. Amsterdam. 1603 - 1677 Moonlight scenes & winter landscapes Exh: European & UK AG's	
KEERINCK **Alexandre** b. Antwerp. 1600 - 1652 Landscape artist Exh: France, Belgium, Holland	
WATERLO **Anthonie** b. Lille. 1609 ? - 1690 Landscape artist Exh: Holland, Italy, Germany, France	
LONDERSEEL **Assuerus Van** b. Antwerp. 1572 ? - 1635 Biblical & landscape subjects	
AVONT **Pieter van der** b. Antwerp 1600 - 1632 Religious subjects, landscapes etc Exh: European AG's Russia	
STRALEN **Antoni Van** b. Holland. 1594 ? - 1641 Landscape artist Exh: Holland, Germany, Scandinavia	
VELDE **Adriaen Van De** b. Amsterdam. 1636 - 1672 Genre & landscape artist Exh: International AG's	
VEEN **Adrien Van De** b. Delft. 1589 - 1680 Painter & engraver	
ALLEN, RWS, RSW **Robert Weir** b. 1852 - 1942 Land & Seascape artist Exh: European & UK AG's	

WALKE **Annie** Painter in oil media Exh: RA, RBA, ROI, NEAC, Prov. & European AG's	
WARDLE **Arthur** b. London. 1864 - 1949 Animal & sporting subjects Exh: RA, SS, NWS, London & Prov. AG's	
WATERHOUSE, RA **Alfred** b. Liverpool. 1830 - 1905 Landscape & architectural subjects Exh: London & Prov. AG's	
WATERLO **Anthonie** b. Lille. 1609 ? - 1690 Landscape artist Exh: Holland, Italy, Germany, France	
WEGELIN **Adolf** b. Germany. 1810 - 1881 Landscape & architectural subjects Exh: Germany, Russia	
WILLIAM **Alfred Walter** Fl. 19th C. Landscape artist Exh: RA, BI, SS, VA, Prov. AG's	
WINNICOTT. MA, NRD **Alice Buxton** b. 1891 - Oil & watercolourist Exh: RA, R.Cam.A. London & Prov. AG's	
WITHERS. ROI **Alfred** b. London. 1856 - 1932 Architectural & landscape artist Exh: RA, SS, GG, VA, Prov. AG's	
WOLFAERTS **Artus** b. Antwerp. 1581 - 1641 Historical subjects Exh: Spain	
CALLCOTT, RA **Sir Augustus Wall** b. London. 1779 - 1844 Portraits, historical, marine & land- scape artist Exh: RA, UK AG's, Germany etc	

AW	**HUNT, RWS** Alfred William b. Liverpool. 1830 - 1896 Landscape artist Exh: RA, UK AG's	AWH 1871
	KUFFNER Abraham Wolfgang b. Germany. 1760 - 1817 Portrait, historical & landscape subjects Exh: Germany	AWK
	RICH Alfred William b. Sussex. 1856 - 1921 Genre & landscape artist & watercolourist Exh: NEAC, BM, VA, UK AG's, Paris	AWR
	STRUTT. RBA, ARPE Alfred William b. New Zealand. 1856 - 1924 Portrait, genre & animal subjects Exh: RA, SS, NWS, London & Prov. AG's	aWS
AY	**ISENBRANT (or YSENBRANT)** Adriaen b. ? - 1551 Religious subjects Exh: Belgium, France, US	Ay.
	KILIAN Lukas b. Germany. 1579 - 1637 Religious subjects Exh: Italy	
	FOORT Karel b. Ypres. 1510 - 1562 Historical subjects etc	
AZ	**ZINKEISEN** Anna Katrina b. Kilereggan. 1901 - Portrait artist & sculptress Exh: RA, SAF	AZ
B	**BECCAFUMI (called MECARINO)** Domenico b. Siena. 1486 - 1551 Religious & historical subjects Exh: Germany, Italy, Russia, Switzerland, UK	B
	BEHAM Barthel b. Nuremberg. 1502 - 1540 Portraits & historical paintings Exh: France, Holland, Germany, US etc	B

BERGLER (THE YOUNGER) Joseph b. 1753 - 1829 Historical subjects	
BILL, ARWA John Gordon b. London. 1915 - Landscape artist Exh: NEAC, RWA, Prov. AG's	
BORRAS Nicolas b. Spain. 1530 - 1610 Biblical subjects	
BOUCHER Francois b. Paris. 1703 - 1770 Mythological, genre, historical, portrait & landscape artist Exh: UK, France, Germany, Switzerland etc	
BOUDEWYNS Nicolas b. Brussels. 1760 - 1800 Landscape artist	
BOUT Peeter b. Belgium. 1658 - 1702 Genre, figure & landscape artist Exh: Holland, France, Germany etc	
BRACQUEMOND Felix b. Paris. 1833 - 1914 Portrait & landscape artist Exh: France	
BRANGWYN, ARA, RA, RE, Hon. Mem. RSA, RMS, PSCA, VP, IAL, RWA & Int. Soc.s Sir Frank William b. Bruges. 1867 - 1956 Architectural, bridge & river scenes marine subjects etc. Exh: RA.RSA,WAG,GI,RWS, GG, etc	
BURGESS Gelett b. Boston, Mass. 1876 - ? Topographical & impressionist subjects Exh: US	
BURNE-JONES Sir Philip b. London. 1861 - 1926 Portraits & architectural scenes Exh: London & Prov. AG's	

B	**BUSK** E. M. Fl. 1873 - 1889 Portrait artist Exh: R.A.	
	DADDI Bernado b. Italy. 1512 ? - 1570 Genre & historical subjects	
	MARTIN Beatrice b. Sevenoaks. 1876 - ? Watercolourist Exh: RA, RI, WAG	
	MEI Bernardino b. Sienna. 1615 ? - 1676 Genre subjects	
	TIEPOLO Giovanni Battista b. Venice. 1696 - 1770 Genre, religious & historical subjects Exh: European AG's, Russia, UK, US	
	BENSUSAN-BUTT, RBA John Gordon b. Colchester. 1911 - Landscape watercolourist Exh: RA, NEAC, RBA & Prov. AG's	
BA	**ARDEN** Blanche b. Leeds 1925 - Philosophical portrayals, portraits, landscapes etc Exh: PS, French AG's etc	
	BARLAND Adam Fl. London. 1843 - 1863 Landscape artist Exh: London & Prov. AG's	
	BARLOW Florence E. Fl. London. 1873 - 1909 Figure & animal subjects Exh: RA, London & Prov. AG's	
	BARNES Robert Fl. 1873 - 1891 Genre subjects Exh: RA, Vienna	

BIE **Adrian de** b. 1593 - 1668 Portrait artist	
BLINKS **Thomas** b. 1860 - 1912 Animal & sporting subjects Exh: RA, SS, London & Prov. AG's	
BLOCKLAND **Anthonie van Montfoort** b. Holland. 1532? - 1583 Biblical & historical subjects Exh: Germany, Holland, Austria, UK	
BLOEMERS **Arnoldus** b. Amsterdam. 1786 - 1844 Floral & still life artist Exh: UK, France, Holland	
BONACCORSI **Antonio** b. 1826 - ? Portrait artist	
BOSSE **Abraham** b. Tours. 1602 - 1676 Historical, genre, architectural & Portrait artist Exh: France	
BUCKLAND **Arthur Herbert** b. Taunton. 1870 - ? Genre subjects Exh: RA, London & Prov. AG's, Paris	
BROUWER **Adriaen** b. 1606 ? - 1660 Figure & genre artist Exh: UK, Scandinavia & European AG's	
SCHATTENHOFER **Amalia Von** b. Germany. 1763 - 1840 Portrait & genre subjects	
FLAMEN (or FLAMAND) **Albert** Flourished France 17th Century Portrait, genre & landscape artist Exh: UK, France	

BA	**BAIRD, ROI** Nathaniel Hughes John b. Roxburghshire 1865 - ? Portraits, landscapes & equestrian subjects	
	BORCHT (The Younger) Hendrik van der b. 1614 - 1654 Historical subjects	
BB	**BAKER, SWA** Blanche Fl. Bristol. 1869 - 1893 Landscape artist Exh: RA, SS, NWS	
	BEHAM Barthel b. Nuremberg. 1502 - 1540 Portraits & historical paintings Exh: France, Holland, Germany, US etc	
	BISCAINO Bartolommeo b. 1632 - 1657 Biblical & historical subjects Exh: Italy, Germany	
	BOISFREMONT Charles Boulanger de b. Rouen. 1773 - 1838 Portrait,biblical & historical subjects Exh: France, Germany	
	BREENBERG (or BREENBORCH) Bartholomaus b. 1599 - 1659 Genre, mythological & landscape artist Exh: European AG's	
	VOS Marten De b. Antwerp. 1532 - 1603 Portraits & historical subjects Exh: European AG's	
	BLADON, RBSA Murray Bernard b. Birmingham. 1864 - ? Portraits & landscape artist Works in Perm. collections	
BC	**BRUEGHEL (or BREUGHEL)** Abraham b. 1631 ? - 1690 Still life subjects. Exh: Holland, Italy, Sweden etc	

556

CASTELLO **Bernado** b. Italy. 1557 - 1629 Portraits & religious subjects Exh: Italy, France	\mathcal{BC}	\mathcal{BF}	\mathcal{BC} in.

BC

CASTIGLIONE **Giovanni Benedetto** b. Genoa. 1616 - 1670 Historical, animal, genre & landscape artist Exh: UK & European AG's	BC	\mathbb{E}	\mathcal{CB}
CHOMETON **Jean Baptiste** b. Lyon. 1789 - ? Portraits, town & landscapes, miniaturist etc. Exh: France	\mathbb{EC}		\mathcal{GB}
COURTOIS **Jacques** b. St. Hippolyte. 1621 - 1676 Battle scenes, portraits, landscapes & historical subjects Exh: France, Hungary, Germany, Italy, Spain	\mathbf{B}	\mathcal{B}	\mathcal{B}
DOYLE **Bentinck Cavendish** b. Worthing Flowers & marine artist Exh: RA, ROI & Prov. AG's		\mathbf{BCD}	
BERCHEM (or BERGHEM) **Nicolas (or Claes)** b. Amsterdam. 1620 - 1683 Hunting & coastal scenes, landscapes etc Exh: S. Africa, UK & European AG's	\mathcal{BF}	\mathcal{JB}	\mathcal{f}
LE BRUN **Charles** b. Paris 1619 - 1690 Historical & military subjects Exh: France, Italy, Germany, Geneva, Leningrad		$\mathcal{BL.}$ $F,1655$	
BORROWMAN, Capt. MA **Charles Gordon** b. Edinburgh. 1892 - 1956 Figures, animals & landscapes (Predominently Indian) Exh: RSA, RSW, WAG		\mathcal{CB}	
BALE **C.T.** Fl 19th C. Still life subjects Exh: RA, SS & UK AG's		\mathcal{CB}	
BROECK **Crispin van den** b. 1524 - 1589 Historical & biblical subjects Exh: Holland, Belgium	\mathcal{CVB}	\mathcal{CVBF}	\mathcal{CVBF}

BD	**BETTINI** **Domenico** b. Florence. 1644 - 1705 Genre & still life painter	**BD**
	BOSSIEUX **Jean Jacques de** b. France. 1736 - 1810 Landscape artist	*DB* 1770.
	CARO **Baldassare de** b. Italy. Fl. 18th C. Floral & still life subjects Exh: Italy, Germany	*BC*
BE	**DIEPENBEECK** **Abraham van** b. Bois-le-Duc. 1599 - 1675 Portraits, animal & historical subjects Exh: Germany, Belgium. Holland, UK etc	*BC*
	BLOCK **Eugene Francois de** b. 1812 - 1893 Genre artist Exh: Holland	*BB*
	BRONCKHORST **Gerrit** b. Utrecht. 1637 - 1673 Landscape artist Exh: Holland	*B*
BF	**BATESON** **Edith** b. Cambridge Fl. 19th - 20th C. Painter of varied subjects Exh: PS, RA, RBA, NEAC, IS, & Prov. AG's	*EB*
	BRAMLEY, RA **Frank** b. Lincoln. 1857 - 1932 Genre & portrait artist Exh: RA, NEAC, GG, NG, SS, S. Africa	*B.F.*
	FOSTER, RWS **Myles Birket** b. North Shields. 1825 - 1899 Landscapes & rustic scenes Exh: RA, RWS, OWS, London & Prov. AG's etc	*BF*
	BRICKDALE, RWS **Eleanor Fortescue** b. 1871 - 1945 Oil & watercolourist Exh: RA, WAG, RWS & Prov. AG's	*EB*

GUERCINO **Giovanni Francesco Barbieri** b. Italy. 1591 - 1666 Portraits, religious, historical & landscape artist Exh: Russia, European AG's etc	*B. f*　　　*BF*	**BF**
BOL **Ferdinand** b. Dortrecht. 1611 - 1680 Portraits & historical subjects Exh: UK, Scandinavian & European AG's	*B*	
BROWN **Ford Madox** b. Calais. 1821 - 1893 Landscapes, historical & biblical subjects Exh: RA, BI, London & Prov. AG's, Australia	*ffB*　　*fB*	
BEJOT **Eugene** b. Paris. 1867 - 1931 Landscape subjects etc. Exh: London, Paris	*ℰȝ*	**BG**
BEST **Gladys** b. London. 1898 - Watercolourist Exh: RA, NEAC, NS, PS, & US	*Bᵍ*	
BORCH **Gerard** b. Zwolle. 1617 - 1681 Genre & portrait artist Exh: Holland, Hungary, Germany, Russia, France etc	*GtB*	
GAAL (or GAEL) **Barend** b. Harlem. 1620 ? - 1703 ? Landscapes, hunting & battle scenes etc Exh: France, Holland, Belgium, Russia	*BG*	
GENNARI (The Elder) **Benedetto** b. Italy. 1570 - 1610 Portraits & historical subjects	*B G in*	
BOWDEN-SMITH **Daisy Beatrice** b. Gaya, India. 1882 - Watercolour & miniaturist Exh: RA, PS	*BS*	
BURKE, RBA **Harold Arthur** b. London. 1852 - ? Landscape, figure & portrait artist Exh: RA, SS, France etc	*tB.*	**BH**

559

BH	**BOUCKHORST** **Jan Philipsz van** b. Haarlem. 1588 ? - 1631 Portrait & historical subjects Exh: Holland	*BH; e.22.*
	HOLBEIN (The Younger) **Hans** b. Augsbourg 1497 ? - 1543 Portraits & historical subjects Exh: France, Switzerland, UK, Spain, Belgium etc	BH
	HOLBEIN **Sigmund** b. Augsbourg. 1465 ? - 1540 Portraits & religious subjects etc Exh: UK, Germany, Austria	SHB SHB
	HOOK **Bryan** b. 1856 - ? Coastal scenes, landscapes & genre subjects Exh: RA, London & Prov. AG's	B.H. B.H.
BJ	**BALLANTINE, RSA** **John** b. Kelso. 1815 - 1897 Historical, genre & portrait artist Exh: RA, UK AG's	JB
	BATEMAN, RA, ARWS **James** b. Kendal. 1893 - 1959 Landscape artist Exh: RA, UK AG's	JB JB
	BEDFORD **John Bates** b. Yorkshire. 1823 - ? Genre, historical & portrait artist Exh: RA, BI, UK AG's	18 JB 60 JB
	BISCARRA **Giovanni Battista** b. Nice. 1790 - 1851 ? Historical subjects Exh: France, Italy	B
	BRONCKHORST **Jan Gerritsz van** b. Utrecht. 1603 - 1677 Historical & genre subjects Exh: Holland, Germany, Austria etc	JB
	BUNDSEN **Jes** b. Assens. 1766 - 1829 Architectural & landscape artist Exh: Germany	JB

BEICH **Joachim Franz** b. Ravensbourg. 1665 - 1748 Landscape artist Exh: France, Germany, Austria	*ℬ*				
BERGMULLER **John George** b. Dirkheim, Bavaria. 1688 - 1762 Portraits & historical subjects	*ℬf.*	*ℬ*	*ℬ.*	*ℬ.*	*ℬ* *ℬB.*
BOWERS **Stephen** Fl. London. 1874 - 1891 Landscapes & river views Exh: SS, NWS	*ℬ*				
EECKHOUT **Gerbrand van den** b. Amsterdam. 1621 - 1674 Portraits, historical & biblical scenes etc Exh: UK & European AG's	*ℬ*				
KENT-BIDDLECOMBE **Jessica Doreen** b. Burnham-on-Sea. 1898 Portraits & flower studies Exh: ROI	*ℬ*				
KILIAN **Lukas** b. Germany. 1579 - 1637 Religious subjects Exh: Italy	*B KF*				
BOULOGNE (The Younger) **Louis de** b. Paris. 1654 - 1733 Historical, religious & mythological subjects Exh: France, Russia	*2ℬ*				
LEACH. FRSA **B.** B. Hong Kong. 1887 - Exh: London & Prov. AG's, Europe & Japan	*Bℒ.*				
LEMENS **Balthazar Van** b. Antwerp. 1637 - 1704 Portraits & historical scenes	**B.L.**				
LINGELBACH **Johannes** b. Germany. ? - 1674 Marine, genre & landscape subjects Exh: Holland, France, NG, Britain, Germany	**BL**				

BJ

BK

BL

BL	**BELIN** **Jean** b. Caen. 1653 - 1715 Still life subjects. Exh: France	*Bef*
BM	**BROWN** **John Lewis** b. Bordeaux. 1829 - 1890 Military, Portrait & genre subjects Exh: US, France etc	*B.*
	BARLOW **Mary** b. Manchester 1901 - Landscapes & animal subjects Exh: R. Cam.A. WAG	*MB*
	MULRENIN, RHA **Bernard** b. Sligo. 1803 - 1868 Portrait & miniaturist Exh: RHA, NPG, UK AG's	*B.M.*
	MURILLO **Bartolome Esteban** b. Spain. 1617 ? - 1682 Religious, genre & portrait artist Exh: International AG's	*BMB B ME*
	MICHELANGELO (BUONARROTI) b. Italy. 1475 - 1564 Portraits, mythological & religious subjects etc. Exh: International AG's	*MBF*
	MARTINEAU **Robert Braithwaite** b. London. 1826 - 1869 Genre & historical subjects Exh: RA, London & Prov. AG's	*RM*
BN	**BEGEYN** **Abraham Jansz** b. 1637 - 1697 Landscape artist Exh: Holland, Germany, France etc	*AB*
	BENNETT **Newton** Fl. UK. ? - 1914 Landscape artist Exh: RA, SS, NWS	*NB NB*
	BROWN **Nellie Gertrude** b. Wolverhampton Landscape artist Exh: RA	*NB /49*

BLACKHAM **Dorothy Isabel** b. Dublin. 1896 - Oil & watercolourist etc Exh: RA, RHA, RWEA, SGA etc	*[monogram]*	**BO**
BARLOW **Francis** b. Lincolnshire 1626 - 1702 Portraits, animals & wildlife subjects Exh: London & Prov. AG's	*[monogram B]*	**BP**
PARSONS **Beatrice** Floral & genre subjects Exh: RA, London & Prov. AG's	*B.P.*	
PRIESTMAN. RA, ROI **Bertram** b. Bradford. 1868 - 1951 Cattle, landscapes & coastal scenes Exh: RA, SS, NG, GG & Prov. AG's	*BP*	
PAGGI **Giovanni Battista** b. Genoa. 1554 - 1627 Religious subjects Exh: Italy	*BP*	
BECKER **Philipp Jacob** b. Germany. 1759 - 1829 Landscape & town scenes Exh: Germany	*[monogram B]*	
RIVIERE. RA **Briton** b. 1840 - 1920 Genre, historical & animal subjects Exh: RA, SS, BI, GG, Germany, Australia, etc.	*[monogram]*	**BR**
SALOMON **Bernard** b. Lyon. 1506 ? - 1561 ? Exh: France	*B*	
HAYDON **Benjamin Robert** b. Plymouth. 1786 - 1846 Historical subjects Exh: London & Prov. AG's, Australia	*BRH 1823* *B. R. H.*	
HELST **Bartholomeus van der** b. Haarlem. 1613 - 1670 Portrait artist Exh: Russia, UK & European AG's	*BrH*	

BR	**SCHMID** **Matthias** b. Austria. 1835 - 1923 Historical & genre subjects Exh: Germany, Austria	*[monogram]*
BS	**BACH** **Alois** b. 1809 - 1893 Genre, historical, animal & landscape artist Exh: Germany	*[monogram]*
	BASSANO **Jacopo** b. 1516? - 1592 Portraits, biblical & mythological subjects Exh: Many European AG's, US, Scandinavia etc	*[monogram]*
	BERLIN **Sven Paul** b. 1911 - Painter & sculptor Exh: US AG's. X.	*[monogram]*
	SHAW **Byam John** b. Madras. 1872 - 1919 Genre artist Exh: RA, London & Prov. AG's	*[monograms]*
	SINCLAIR. ARCA, etc. **Beryl Maude** b. Bath. 1901 - Painter in oil media Exh: RA, NEAC, SWA, WIAC, etc.	*[monogram]*
	BOSSI **Benigno** b. Italy. 1727 - 1793 Portraits & historical subjects Exh: Germany, France	*B.sc*
BT	**BOEYERMANS** **Theodor** b. 1620 ? - 1678 Historical & biblical subjects etc Exh: Holland, France, Germany	*[monogram]*
	TIEPOLO **Giovanni Battista** b. Venice. 1696 - 1770 Genre, religious & historical subjects Exh: European AG's, Russia, UK, US	*BT° B° B B° B°*
BV	**BRUNTON, RMS** **Violet** b. Yorkshire. 1878 - ? Miniaturist Exh: RA, Royal Min. Soc.	*VB*

564

BRUSSEL **Hermanus van** b. Haarlem. 1763 - 1815 Landscape artist Exh: Holland		**BV**
BURROUGHS, RMS, SWLA, FRSA, **Victor Hugh Seamark FRHS, SM** b. London. 1900 - Oil & watercolourist Exh: PS, RA, RI, RMS, SWLA, SM, R. Cam.A & Prov. AG's		
BAYES **Walter** b. London Fl. 19th-20th C. Landscape artist Exh: RA & UK AG's		**BW**
BURNE **Winifred** b. Birkenhead. 1877 - ? Oil & watercolourist Exh: IS, London & Prov. AG's, Germany		
WEISS **Bartholomaus Ignaz** b. Munich. 1740 ? - 1814 Genre subjects & miniaturist Exh: Germany		
LEADER. RA **Benjamin Williams** b. Reading. 1831 - 1923 Landscape artist Exh: RA, SS, GG, London & Prov. AG's, Australia		
WEERDT **Adriaan De** b. Brussels. 1510 - 1590 ? Mythological & religious subjects		
BROOKS **Thomas** b. Hull. 1818 - 1891 Genre subjects Exh: RA, BI, SS, VA, Prov. AG's		
BRUNTON, SSA **Elizabeth York** b. Scotland. 20th C. Oil & watercolourist Exh: RSA, GI, PS etc		**BY**
BUNNEY **John Wharlton** b. London. 1828 - 1882 Venetian scenes Exh: RA, Prov. AG's		

BZ	**ZWAERDECROON** **Bernardus** b. Utrecht. 1617 ? - 1654 Portrait artist Exh: Holland	*BZ* *B·Z*
C	**BROOK** **Eleanor Christina** Artist in oil media Exh: London & Prov. AG's	(monogram)
	CANZIANI, RBA, FRGS **Estella L.M.** b. 1887 - Black & white, oil & watercolourist Exh: RA, RSA, RBA, RI & Prov. AG's	(monogram)
	COUTURIER **Leon Antoine Lucien** b. Macon. 1842 - 1935 Marine, Military & battle scenes, landscapes etc Exh: France	C
	VACCARO **Andrea** b. Naples. 1598 ? - 1670 Biblical & historical subjects Exh: Italy, France, Madrid, Germany	(monogram) c
CA	**AMMAN** **Justus** b. Zurich 1539 - 1591 Historical & mythological subjects	(monogram)
	ANDRIESSEN **Christiaan** b. Amsterdam 1775 - ? Historical, genre & landscape artist	CA.
	ARMYTAGE **Charles** Fl. London. 1863 - 1874 Domestic genre Exh: SS, London & Prov. AG's	(monogram)
	CARON **Antoine** b. Beauvais. 1521 - 1599 Portraits & historical subjects etc Exh: France	CA.
	COLEY **Alice Maria** b. Birmingham. 1882 - Miniatures, portrait & landscape artist Exh: RA, RMS, PS	(monogram)

566

COOPER, RA **Abraham** b. 1787 - 1868 Historical, sporting & battle scenes Exh: RA, BI, OWS, SS. London & Prov. AG's	
GOODWIN, RWS, **Albert** b. Arundel. 1845 - 1932 Biblical, allegorical subjects. landscapes etc Exh: RA, OWS, London & Prov. AG's	
HILL **Carl Frederick** b. Lund. 1849 - 1911 Landscape artist Exh: France, Scandinavia	
COOPER **Alexander** b. London. 1605 - 1660 Portrait & miniaturist Exh: Holland	
NEWTON **Algernon** b. London. 1880 - Town & landscape subjects Exh: US, S. Africa, Australia, UK	
CARRACCI **Annibale** b. Italy. 1560 - 1609 Portrait, religious, mythological, genre & landscape artist Exh: UK & European AG's	
BURRAS, TCTA, SAM **Caroline Agnes** b. Leeds. 1890 - Portraits, landscapes & miniatures Exh: RA, RMS, PS, WAG, Prov. AG's	
RENESSE **Constantin Adrien** b. Holland. 1626 - 1680 Genre & landscape artist Exh: Vienna	
CHALON **Alfred Edward** b. Geneva. 1780 - 1860 Portrait artist Exh: UK, France	
FAVART **Antoine Pierre Charles** b. Paris. 1784 - 1867 Historical subjects Exh: France	

CA

CA	**SCHUT** **Cornelis** b. Antwerp. 1597 - 1655 Religious subjects Exh: Holland, Belgium, Germany	
	KILIAN **Lukas** b. Germany. 1579 - 1637 Religious subjects Exh: Italy	
	CLARKE **Audrey M** b. Leicestershire. 1926 Exh: London & Prov. AG's	
	NAUDET **Thomas Charles** b. Paris. 1778 - 1810 Landscape subjects Exh: France	
	CALDARA **Polidoro** b. Italy. 1492 - 1543 Religious, mythological & portrait artist etc Exh: Russia, Italy, Austria, France	
	CALIARI (called VERONESE) **Paolo** b. Verona. 1528 - 1588 Biblical & mythological subjects Exh: European AG's, UK etc	
	GELDER **Aart de** b. Dortrecht. 1645 - 1727 Historical & portrait artist Exh: France, Holland, Germany, Belgium, Russia, etc	
	RENESSE **Constantin Adrien** b. Holland. 1626 - 1680 Genre & landscape artist Exh: Vienna	
	STOREY. ARA **George Adolphus** b. London. 1834 - 1919 Portrait & genre artist Exh: RA, SS, BI, NWS, Prov. AG's, Germany	
	ALIGNY **Claude-Felix Theodore** b. Chaumes. 1798 - 1871 Historical & landscape artist Exh: French AG's	

WILKINSON Charles A. b. Paris. 1830 - ? Landscape artist Exh: RA, NWS, SS, GG, France, Australia		CA
BAXTER Charles b. London. 1809 - 1879 Portraits & miniaturist Exh: RA, VA, SS, Prov. AG's		CB
BENSO Giulio b. 1601 ? - 1668 Religious subjects		
BISSCHOP Cornelis b. Dortrecht. 1630 - 1674 Portrait & figure artist Exh: Holland		
BOURGEOIS du CASTELET Florent Fidele Constant b. France. 1767 - 1836 Portrait, historical & landscape artist Exh: France		
BRANWHITE Charles b. Bristol. 1817 - 1880 Landscape artist Exh: OWS, RA, BI, London & Prov. AG's		
BROMLEY Clough W. Fl. London. 1870 - 1904 Landscapes & floral subjects Exh: RA, SS, NWS, Prov. AG's		
BUYS Cornelis 11 b. Alkmaar. 1525 ? - 1546 Historical subjects Exh: Holland		
CASTIGLIONE Giovanni Benedetto b. Genoa. 1616 - 1670 Historical, animal, genre & landscape artist Exh: UK & European AG's		
CHOMETON Jean Baptiste b. Lyon. 1789 - ? Portraits, town & landscapes, miniaturist etc. Exh: France		

CRAESBEECK **Joos van** b. S. Brabant. 1608 ? - 1661 ? Portraits & humourous subjects Exh: France, Germany, Russia, Austria etc	**CB** **℅**
BARBER **Charles Burton** b. Yarmouth. 1845 - 1894 Genre, portraits & animal subjects Exh: RA, UK AG's	**G.?.B.**
BRANWHITE **Charles Brooke** b. Bristol. 1851 - 1929 Landscape artist Exh: SS, NWS	**C.B.B.**
BEGAS **Karl Joseph** b. 1794 - 1854 Portraits, genre & historical subjects Exh: German AG's	**CBF** **cBF.**
CASTELLO **Bernado** b. Italy. 1557 - 1629 Portraits & religious subjects Exh: Italy, France	**BF**
BALE **C.T.** Fl 19th C. Still life subjects Exh: RA, SS & UK AG's	**CB**
CALLCOTT **Charles** Fl. London. 1873 - 1877 Genre subjects Exh: RA, SS	**CC**
CIGNANI **Carlo** b. Italy. 1628 - 1719 Biblical & historical subjects etc Exh: UK & European AG's	**CI** **C** **C** **C** **CI**
CONJOLA **Carl** b. Germany. 1773 - 1831 Landscape artist	**CC**
COROT **Camille Jean Baptiste** b. Paris. 1796 - 1875 Genre & landscape subjects etc Exh: UK, US, Canada & European AG's etc	**C.C**

CB

CC

CORT **Cornelis** b. Holland. 1533 ? - 1578 Historical & landscape artist	*C. C.*	CC
WEBB **Clifford Cyril** b. London. 1895 - Landscapes, views & architectural subjects Exh: RA, NEAC & Prov. AG's		
COLLINS **Charles Alston** b. London. 1828 - 1873 Genre & historical artist Exh: RA, BI, London & Prov. AG's		
EVERETT **Ethel F.** b. London. Childrens portrait artist Exh: RA & London & Prov. AG's		
GERE, RWS **Charles March** b. Leamington. 1869 - 1957 Portrait & landscape artist Exh: SS, London & Prov. AG's		
CANUTI **Domenico Maria** b. Bologne. 1620 - 1684 Religious & mythological subjects Exh: France, Italy		CD
COX, ROI, RWA **David** b. Falmouth. 1914 - Exh: London, Prov. & European AG's US etc		
DAVIDSON **Charles Topham** b. Redhill. 1848 - 1902 Landscape artist Exh: RA, RWS, SS	*1879*	
DECKER **Cornelis Gerritsz** b. Haarlem. ? - 1678 Landscape artist Exh: UK * European AG's	*C D. 1669*	
DOV (or DOU) **Gerrit** b. Leyden. 1613 - 1675 Genre & portrait artist Exh: Russia & European AG's		

CD	**DAWSON, FSAM** **Charles Frederick** b. Rillington, Yorks Oil & watercolourist Exh: RA, IS, WAG & Prov. AG's	
	HEUSCH **Guilliam de** b. Utrecht. 1638 - 1692 Landscape artist Exh: European AG's	
	HONDECOETER **Gillis de** b. Antwerp. ? - 1638 Portraits, birds & landscape artist Exh: France, Holland, Germany etc	
	JONGH **Claude de** b. ? - 1663 Landscape artist Exh: Amsterdam, London	
	LESLIE, RA **George Dunlop** b. London. 1835 - 1921 Genre & landscape artist Exh: UK AG's, France, Germany Australia	
	MAN **Cornelis Willems De** b. Delft. 1621 - 1706 Portrait & genre subjects Exh: Holland, Germany, France, Budapest	
	MOOR **Carel De** b. Holland. 1656 - 1738 Genre & portrait subjects Exh: France, Holland, Leningrad, Sweden	
	RUDING-BRYAN **Charles Dudley** b. Bristol. 1884 - Architectural subjects etc. Exh: London & Prov. AG's	
CE	**CALDWELL** **Edmund** b. Canterbury. 1852 - 1930 Animals & sporting subjects Exh: RA, SS, NWS	
	CROFTS, RA **Ernest** b. Leeds. 1874 - 1911 Military & historical subjects Exh: RA, London & UK AG's, Germany	

BROCK Charles Edmond b. London. 1870 - 1938 Genre & portrait artist Exh: RA, UK AG's	*CEB*　　*C.E.B*	CE
CLIFFORD Edward C. b. Bristol. 1844 - 1907 Portraits & biblical subjects Exh: RA, SS, NWS, GG, NG etc	*[monogram in box]*	
FRIPP Charles Edwin b. London. 1854 - 1906 Watercolourist Exh: Germany, UK	*C.E.F.*	
HOLLOWAY, RI Charles Edward b. Christchurch. 1838 - 1897 Marine & landscape artist Exh: RA, SS, NWS, GG etc	*CEH*	
JONES Ethel Gertrude b. Liverpool Portrait & landscape artist Exh: WAG & Prov. AG's	*[monogram]*	
KELLY Charles Edward b. Dublin. 1902 - Cartoonist, oil & watercolourist Exh: Dublin, UK	*CBK*	
LAWRENCE Edith Mary b. Surrey. 1890 - Portrait & landscape artist Exh: RA, NEAC, RI, NPS, SWA etc.	*[monogram]*	
WILSON Charles E. Fl. Sheffield. 1890 - 1900 Genre, oil & watercolourist Exh: NWS, VA, Prov. AG's	*C.E.W.*	
CHAUVEAU Francois b. Paris. 1613 - 1676 Miniaturist	*F.*　　*[monogram]*	CF
COWPER Frank Cadogan b. UK. 1877 - 1958 Genre & historical subjects Exh: RA	*[monogram]*	

CF	**GOODALL, RA,** **Frederick** b. London. 1822 - 1904 Landscapes, genre, biblical & Egyptian subjects Exh: RA, France, Germany, Australia, London & Prov. AG's	
	LOWCOCK, RBA **Charles Frederick** Fl. Essex. 1878 - 1922 Genre subjects Exh: UK AG's	
	FELLINI **Giulio Cesare** b. 1600 ? - 1656 Animal & genre subjects	
	MURRAY **Charles Fairfax** b. 1849 - 1919 Genre, figure & landscape artist Exh: RA, GG, Prov. AG's	
CG	**COELLO** **Claudio** b. Madrid. 1630 - 1693 Historical subjects & portrait artist Exh: Hungary, Germany, UK, Spain etc	
	GOLDIE **Charles** b. London. FL. 19th C. Portrait, genre & historical subjects Exh: RA, BI, SS	
	GREEN, RI **Charles** b. 1840 - 1898 Genre & historical painter Exh: RA, NWS, RI, Prov. AG's	
	COLLINS, ARCA **George Edward** b. Dorking. 1880 - ? Watercolourist & etcher Exh: RA, RBA, RI, RCA, Prov. AG's & Australia	
	CRESWELL **Emily Grace** b. Leicester. 1889 - Portraits & miniaturist etc Exh: RBSA etc	
	CORNELIS **Gouda van** b. Gouda. 1510 ? - 1550 Portrait artist Exh: Austria	

LAWSON **Cecil Gordon** b. Shropshire. 1851 - 1882 Landscape artist Exh: RA, SS, GG, Prov. AG's	C G L
CHAPLIN **Charles** b. 1825 - 1891 Portrait, genre, still life, landscape & figure subjects etc Exh: UK, France	CH
CHARDIN **Jean Baptiste Simeon** b. Paris. 1699 - 1779 Genre, still life & portraits etc. Exh: UK & European AG's etc	CH CH
HAAG, RWS **Carl** b. Bavaria. 1820 - 1915 Portraits, eastern subjects, landscapes & miniaturist Exh: RA, BI, OWS, London & Prov. AG's	CH CH
HAERLEM (called CORNELISZ) **Cornelis van** b. Haarlem. 1562 - 1638 Biblical & historical subjects	CH CH CH.1619 CH 1633 CH 1614
HAMMOND **Gertrude Demain** b. London. ? - 1952 Genre watercolourist Exh: RA, SS, NWS, Paris	CH
HANNEY, ARWA **Clifford** b. Somerset Painter in oil media Exh: RA, ROI, RBA, WAG, RWA & Prov. AG's	CH
HEMY, RA, RWS, RI **Charles Napier** b. Newcastle-on-Tyne. 1841 - 1917 Still life, genre, marine & landscape artist Exh: RA, BI, SS, OWS, NWS, GG, NG & Prov. AG's etc	CH
HERDMAN, ARSA **Duddington** b. 1863 - 1922 Genre & portrait artist Exh: RA, UK AG'S	DH
HOLROYD **Sir Charles** b. Leeds. 1861 - 1917 Landscapes, figures & architectual subjects Exh: RA, RDS, NG, IS, RE	CH

CG

CH

CH	**HORSLEY** **Hopkins Horsley Hobday** b. Birmingham. 1807–1890 Landscape artist Exh: RA, BI, SS	
	HOWARD, BA **Charles** b. Montclair, N.J. 1899 - B/White, oil & gouache media Exh: X US, Australia etc	
	HUNT **Charles** b. London. 1803 - 1877 Humorous genre Exh: RA, London & UK AG's	
	BOUGHTON, RA **George Henry** b. Nr. Norwich. 1833 - 1905 Portrait, figure, landscape, historical & sporting subjects Exh: RA, BI, GG, NG, London & Prov. AG's	
	HENDERSON **Charles Cooper** b. Chertsey. 1803 - ? Animal & Sporting subjects Exh: RA, London & Prov. AG's etc	
	HENNING **Christoph Daniel** b. Nuremberg. 1734 - 1795 Portraits, town scenes etc Exh: Germany	
	SHANNON. RA, ARPE **Charles Haslewood** b. Lincolnshire. 1865 - 1937 Portrait & figure subjects Exh: RA, NEAC, SS, NG, London & Prov. AG's	
	CROSSLEY **Cuthbert** b. Halifax. 1883 - Oil & watercolourist Exh: RA, RSA, RI, RBA, PS	
	MACKIE, RSA, RSW **Charles H.** b. Aldershot. 1862 - 1920 Genre & landscape artist Exh: RA, UK & European AG's	
CI	**CALLOT** **Jacques** b. Nancy. 1592 - 1635 Historical, biblical, genre & military subjects etc Exh: UK & European AG's	

CODRINGTON **Isabel** b. 1894 - Figure & domestic subjects. Exh: RA, PS etc		CI
PHILLOTT **Constance** Fl. 1864 - 1904 Genre, historical & landscape artist Exh: RWS, UK AG's		
HOLMES, KCVO, RWS, NEAC,MA, **Sir Charles John** **FSA** b. Preston. 1868 - ? Landscape artist Exh: NEAC, RWS. London & Prov. AG's	C·I·H·1926	
CASSIE, RSA, RSW **James** b. Scotland. 1819 - 1879 Landscape & marine artist Exh: RA, BI, SS, UK AG's	*1871*	CJ
CAVE **James** Fl. 1801 - 1817 Landscapes & Architectural subjects Exh: RA, Prov. AG's		
CHAPRON **Nicolas** b. France. 1612 - 1656 Mythological subjects Exh: France, Russia etc	CJ	
CRAIG **James Stephenson** Fl. London. 1854 - 1870 Genre subjects Exh: UK AG's	*1868*	
GILBERT, RA, PRWS **Sir John** b. London. 1817 - 1897 Historical subjects Exh: RA, BI, SS, OWS, London & Prov. AG's etc		
GUTHRIE, PRSA, RSW **Sir James** b. Greenock. 1859 - 1930 Genre, portrait, landscape & historical subjects Exh: France, Germany, Australia, UK AG'S		
JACQUE **Charles Emile** b. Paris. 1813 - 1894 Animal & landscape painter Exh: France, Holland, England	C·J	

CJ	**JANSEN** **Gerhard** b. Utrecht. 1636 - 1725 Genre artist Exh: Vienna, Holland	
	JESPER **Charles Frederick** b. UK. B/White, oil & watercolourist Exh: WAG, London & Prov. AG's	
	PHILPOT, RA **Glyn Warren** b. 1884 - 1937 Figure, portrait, genre & eastern subjects Exh: RA, UK AG's	
	TENNIEL **Sir John** b. London. 1820 - 1914 Portraits, genre subjects & illustrator Exh: RI, NWS, SSSBA, VA, Prov.AG's, etc.	
	DROOCH SLOOT (or DROOGSLOOT) **Joost Cornelisz** b. Utrecht. 1586 - 1666 Religious, historical subjects, fairs etc. Exh: Holland, Belgium, Germany, Russia, Spain etc	
	STANILAND. RI **Charles Joseph** b. England. 1838 - 1916 Genre & historical subjects Exh: RA, SS, BI, NWS, VA, Prov. AG's	
	WINTOUR, ARSA **John Crawford** b. Edinburgh. 1825 - 1882 Genre & landscape artist Exh: RSA, UK AG's	
CK	**KARUTH** **Ethel** Fl. 1900 - 1908 Portraits & Miniaturist Exh: RA	
	KEENE **Charles Samuel** b. 1823 - 1891 Cartoonist & illustrator	
	KELLER **Georg** b. Frankfurt. 1568 - 1640 Historical & landscape subjects Exh: Germany	

578

KETEL **Cornelis** b. Gouda. 1548 - 1616 Portrait painter Exh: NPG, Holland	\mathcal{CK}	CK
KING **Cecil George Charles** b. London. 1881 - 1942 Marine & landscape artist Exh: UK AG's, France	\mathcal{CK}	
KNIGHT **Charles Parsons** b. Bristol. 1829 - 1897 Landscape & marine artist Exh: RA, BI, SS, UK.AG's, Hamburg	\mathcal{CK}_{1870}	
KOPP **George** b. Germany. 1570 - 1622 Historical & portrait subjects Exh: Germany	\mathcal{CK}	
KRUMPIGEL **Karl** b. Prague. 1805 - 1832 Landscape artist	\mathcal{K} $\mathcal{K}\overline{831}$	
KLAPHAUER **Johann Georg** FL. Germany. 17th C. Portrait artist	\mathcal{CKF}	
CARRACCI **Agostino** b. Italy. 1557 - 1602 Portrait, religious & landscape artist Exh: UK, Germany, France, Italy, Austria etc	\mathcal{C} \mathcal{CL} \mathcal{L}	CL
CORONA **Leonardo** b. Italy. 1561 - 1605 Religious & historical subjects	\mathcal{CL}	
CRAEN **Laurens** Flourished Holland. 17th Century Still life subjects Exh: Middelbourg	\mathcal{CL}	
CRANACH **Lucas** b. Bavaria. 1472 - 1553 Religious, historical, landscape & portrait artist Exh: Scandinavia, Russia & European AG's	\mathcal{CL}_{OS}^{IC}	

CRUYL **Lievin** b. Belgium. 1640 - 1720 Sea & landscape artist Exh: France, Belgium	
LAIRESSE **Gerard de** b. Liege. 1641 - 1711 Historical & portrait artist Exh: France, Germany, Holland	
ALLPORT **Lily C.** Fl. London. 1891 - 1900 Genre & landscape artist Exh: RA	
LE BRUN **Charles** b. Paris 1619 - 1690 Historical & military subjects Exh: France, Italy, Germany, Geneva, Leningrad	
BELL **Alexander Carlyle** Fl. 1866 - 1891 Landscape artist Exh: RA, SS, NWS	
LELIENBERGH **Cornelis** Fl. Holland 17th.C Still life artist Exh: Holland, Germany, Vienna	
MESSIN **Charles** b. Nancy. 1620 - 1649 ? Historical subjects Exh: France	
COLE **Philip William** b. Sussex. 1884 - Portrait & landscape artist Exh. RA, France	
LUDOVICE (The Elder) **Albert** b. 1820 - 1894 Genre subjects Exh: NG, UK AG's	
WHISTLER. PRBA **James Abbott MacNeill** b. Lowell, US. 1834 - 1903 Genre & portrait artist Exh: RA, SS, London & Prov. AG's, European AG's	

CL

ENGELBERTSZ **Luc** b. Leyde. 1495 - 1522 Portraits & historical subjects	
CONINXLOO **Gillis 111 van** b. Anvers. 1544 - 1607 Landscapes & historical subjects Exh: Holland, Denmark, Germany, Russia, Austria	
AMEROM **Cornelius Hendrik** b. Arnheim 1804 - Portrait & landscape artist	
COATS **Mary** b. Paisley. Fl. 1920's Still life, marine & landscape artist Exh: UK AG's	
GRIMER **Jakob** b. Anvers. 1526 - 1590 ? Historical, genre & landscape artist Exh: Belgium, France, Hungary, Austria	
MANN **Cathleen** b. 1896 - 1959 Genre & floral paintings Exh: London & Prov. AG's	
MAURER **Christoph** b. Zurich. 1558 - 1614 Portrait artist Exh: Zurich, Germany	
MELLAN **Claude** b. France. 1598 - 1688 Portrait & genre subjects Exh: France	
METSU **Gabriel** b. Leyden. 1629 - 1667 Genre, historical & portrait artist Exh: US & European AG's	
MOLENAER **Cornelis** b. Antwerp. 1540 ? - 1589 ? Landscape & genre subjects Exh: France, Berlin, Moscow, Geneva, Madrid	

CL

CM

MONTALBA. RWS **Clara** b. Cheltenham 1842 - 1929 Interiors, landscape & marine artist Exh: RA, OWS, BI, SS, NG, GG, etc.	
SCHNITZLER **Michael Johann** b. Germany. 1782 - 1861 Still life subjects Exh: Germany	
MENAROLA **Crestano** b. Italy. ? - 1640 ? Historical subjects	
MICHELANGELO (BUONARROTI) b. Italy. 1475 - 1564 Portraits, mythological & religious subjects etc. Exh: International AG's	
BARKER **Cicely Mary** b. Croydon 1895 - Figure painter & children's illustrator Exh: RI, PS, SWA, SGA	
CASTRO **Mary Beatrice de** b. Mortlake, Surrey. 1870 - Portrait & landscape watercolourist Exh: RA, SM, RMS	
COUVE DE MURVILLE-DESENNE, **FIL, FIAL** **Lucie-Renee** b. Madagascar. 1920 - Portrait, floral & marine subjects Exh: RWA, London & prov. AG's	
BUTTERWORTH **Grace Marie** b. Hastings. Fl. 20th C. Miniaturist Exh: RA, RMS	
HALLIDAY, Mem. NEAC **Charlotte Mary Irvine** b. London. 1935 - Topographical subjects Exh: RBA, RWS, NEAC, RA, London & Prov. AG's	
HARDIE, RSA **Charles Martin** b. Edinburgh. 1858 - 1916 Genre, historical subjects Exh: RA, RSA, Paris, Australia	

MAHU Cornelis b. Antwerp. 1613 - 1689 Still life subjects Exh: Belgium, Germany	*c M AHV · 1648*	CM
PEARCE Charles Maresco b. 1874 - 1964 Figure, still life, landscape & architectural subjects Exh: UK AG's	*CMP*	
MANDER (The Elder) Karel Van b. Belgium. 1548 - 1606 Religious & portrait artist Exh: Belgium, Holland, Austria	*monogram*	
NETSCHER Constantyn b. The Hague. 1668 ? - 1723 Portrait & genre subjects Exh: Holland, France, UK	*CN monogram*	CN
NETSCHER Gaspar b. Heidelberg. 1639 - 1684 Interiors, genre & portrait artist Exh: France, Holland, Germany, UK	*C·N 1679*	
COPNALL Theresa Nora b. Haughton - le -Skern. 1882 - Still life & portrait artist Exh: RA, WAG, PS, RSA & Prov. AG's	*CTN monogram*	
BORROWMAN, Capt. MA Charles Gordon b. Edinburgh. 1892 - 1956 Figures, animals & landscapes (Predominently Indian) Exh: RSA, RSW, WAG	*CGB monogram*	CO
BERRETTINI Pietro b. 1596 - 1669 Religious & historical subjects Exh: Holland, France, Italy, Germany etc.	*PC monogram*	CP
CONNARD Philip b. Southport 1865 (1875?) - 1958 Landscape, marine & portrait artist Exh: RA, UK AG's	*PC monogram* *PC monogram*	
PELLEW Claughton b. Redruth. 1892 - Etcher & painter Exh: NEAC, London & Prov. AG's	*CP monogram*	

CP	**PESCHEL** **Carl Gottlob** b. Dresden. 1798 - 1879 Biblical subjects Exh: Germany	
	PETTAFOR **Charles R.** Fl. 1870 - 1900 Landscape & architectural views Exh: London & Prov. AG's	
	PETTITT **Charles** Fl. London 19th C. Landscape artist Exh: SS, BI, London & Prov. AG's	
	PICKERSGILL, RA **Frederick Richard** b. London. 1820 - 1900 Historical genre Exh: RA, BI, VA, UK AG's	
	CALDERON, RA **Philip Hermogenes** b. Poitiers. 1833 - 1898 Genre & historical subjects Exh: RA, UK AG's, Germany	
CR	**CARRIERA** **Rosalba** b. Venice. 1675 - 1757 Portraits, allegorical & genre subjects Exh: France, Italy, Austria	
	CHAPMAN **Robert** b. Birmingham. 1933 - Portraits, still life, genre, nudes, landscapes & subjectivism Exh: Belgium, ROI, London & Prov. AG's etc	
	CLIFFORD, MA **Robin** b. Gillingham. 1907 - Exh: RA, RBA, ROI, NEAC	
	CONSTABLE **Roddice** b. London. 1881 - Portrait miniaturist & landscape artist. Exh: RA, WAG, RMS	
	COSWAY, RA **Richard** b. Tiverton. 1742 - 1821 Miniatures & historical subjects Exh: RA, Germany, Italy, UK AG's	

584

LESLIE. RA. **Charles Robert** b. London. 1794 - 1859 Portraits, historical & genre subjects Exh: RA, BI, VA, London & Prov. AG's, Australia		**CR**
RICKETTS, RA **Charles** b. Geneva. 1866 - 1931 Genre & historical subjects Exh: RI, RA, UK AG's		
RIETSCHOOF **Jan Claes** b. Holland. 1652 - 1719 Marine artist Exh: Holland, Sweden, Leningrad		
RITCH-WEIMAR **Christophe** Fl. Germany. 1670 - Landscape artist		
ROBINSON **Charles F.** Fl. London. 19th C. Landscape artist Exh: RA, SS, NWS, London & Prov. AG's		
ROBINSON **Mabel C.** b. London. 1875 - ?		
ROCHUSSEN **Charles** b. Rotterdam. 1824 - 1894 Historical subjects Exh: Holland		
ROMYN **Conrad** b. London. 1915 - Biblical subjects, sea & landscapes, figure compositions & illustrator Exh: RA, RSBA, RCA, RI, Scandinavian, French & UK AG's		
ROSSETTI **Gabriel Charles Dante** b. London. 1828 - 1882 Portraits, figure & historical subjects Exh: NG, NPG, VA, Prov. AG's, US.		
ROTTMANN **Carl** b. Germany. 1795 - 1850 Landscape artist Exh: Germany		

CR	**RUNDT** **Carl Ludwig** b. Germany. 1802 – 1868 Architectural, landscapes & genre subjects Exh: Germany	←ԐR⠄⠄⠄
	BEAVIS, RWS **Richard** b. Exmouth. 1824 - 1896 Rustic genre, animals, coastal & landscape subjects Exh: RA, SS, BI, OWS, NWS, GG, NG, & European AG's	℞ℬ
	DIXON **Charles** b. Goring. 1872 - 1934 Marine & historical subjects Exh: RA, London & Prov. AG's	C·ℛℰ.
	EXLEY **James Robert Granville** b. Nr. Bradford. 1878 - ? Painter & engraver Exh: RA, RE	19 ℞ℭℰ 27
	ROWAN **Alexander** Fl. Mid 19th C. Religious subjects Exh: RA, BI	℞ℛ
	SPENCE **Thomas Ralph** b. Nr. Richmond. 1855? - ? Landscape artist & decorator Exh: UK AG's	T.R.S.
	MACBETH. RA, RI, RPE, RWS **Robert Walker** b. UK. 1848 - 1910 Landscape & rustic genre subjects Exh: RA, OWS, GG, NG, France, Germany	℞⌁
CS	**SCOREL** **Jan Van** b. Holland. 1475 - 1562 Religious, historical & portrait artist Exh: Holland, Germany, Italy, Austria, UK	ℭ₅
	SEGHERS **Cornelius Johannes Adrianus** b. Antwerp. 1814 - 1875 Historical subjects Exh: Belgium	CS C.S CS.
	SHALDERS **George** b. 1826 - 1873 Figure & landscape artist Exh: UK AG's	GS

SMITH. AMTC **Catherine** b. London, 1874 - ? Painter & etcher Exh: RA, London & Prov. AG's		CS
STUART **Charles** Fl. 1854 - 1893 Still life & landscape artist Exh: RA, BI, SS	**CS**	
SUSTERMAN **Cornelis** b. Antwerp. 1600 ? - 1670 Portrait & historical subjects	16 Ⓢ 61.	
SARACENI (or SARRACINO) **Carlo** b. Venice. 1585 - 1620 Religious subjects Exh: Italy		
LIDDERDALE. RBA. **Charles Sillem** b. London. 1831 - 1895 Landscape & genre artist Exh: RA, BI, SS		
MOTTRAM. RBA **Charles Sim** Fl. London. 19th — 20th C. Coastal & marine artist Exh: RA, NWS, SS, London & Prov. AG's etc.	⟨·S·M·	
STURMER **Karl** b. Berlin. 1803 - 1881 Battle scenes, genre & landscape subjects Exh: Germany		
CRESWICK, RA **Thomas** b. Sheffield. 1811 - 1869 Landscape artist Exh: RA, BI, SS, UK & European AG's	F 1841 F 1841	CT
THOMAS. ARBSA **Charles** b. Birmingham. 1883 - Pastel, oil, watercolourist, etc. Exh: RA & Prov. AG's	CT	
GIBBS **Thomas Binney** b. Darlington. 1870 - ? Portrait & landscape artist Exh: RA, PS, IS etc		

CT	**TERBURG (also known as BORCH)** **Gerard** b. Zwolle. 1617 - 1681 Portraits, genre & domestic subjects etc.	$\mathcal{G}_{\mathcal{B}}$	TB	TB	
	DOBSON, RWS, RA **William Charles Thomas** b. Hamburg. 1817 - 1898 Genre, oil & watercolourist Exh' RA, RWS, London & Prov. AG's Australia	18 TB 88			
CV	**COLE, RA** **George Vicat** b. Portsmouth. 1833 - 1893 Landscape artist Exh: RA, London & Prov. AG's	VC			
	COSTANTINI, RI, SSN, ML **Virgil** b. Italy. 1882 - Figures & portrait artist Exh: RA, RI, RSA, ROI, GI, PS, US & Italy	VC			
	VERNET (known as CARLE) **Antoine Charles Horace** b. Bordeaux. 1758 - 1836 Battle & hunting scenes, historical subjects Exh: France, Germany, etc.	C V.	C yet.		
	VIGNON **Claude** v. Tours. 1593 - 1670 Religious & historical subjects Exh: France, Italy	CV			
	VOLLMER **Adolf Friedrich** b. Hamburg. 1806 - 1875 Marine & landscape artist Exh: Germany	V del			
	BARBER, RWS **Charles Vincent** b. Birmingham. 1784 - 1854 Landscape artist Exh: RA, RWS, Prov. AG's	C. VB₁₈₄₄			
	BROECK **Crispin van den** b. 1524 - 1589 Historical & biblical subjects Exh: Holland, Belgium	VB	BF	BF	CVB.
	EVERDINGEN **Cesar Boetius van** b. Alkmaar. 1617 ? - 1678 Portraits, historical & genre subjects Exh: Holland, Germany, Stockholm etc	CE	CE 1650	CE 1652	

FALENS **Carel van** b. Holland. 1683 ? - 1733 Military, hunting & genre subjects Exh: UK, Germany, Russia, France, Italy	*Ov.F.*	**CV**
QUEBORNE **Crispyn Van Den** b. The Hague. 1604 - 1652 Portrait Artist Exh: Holland	*CQ CQ*	
SAVOYEN **Carel Van** b. Antwerp. 1621 ? - 1665 Religious & historical subjects Exh: Holland, France	*C.V.S.*	
VERGELLI **Giuseppe Tiburzio** Fl. Italy. 17th C. Historical, architectural & landscape subjects Exh: France	*VC*	
ANNIGONI **Pietro** b. Milan 1910 - Portrait artist Exh: RA, Rome, Turin, Paris etc	*ott.*	**CW**
CALLOW, RWS **William** b. London. 1812 - 1908 Marine & landscape artist Exh: Ireland, UK AG's, Australia	*W C*	
COLLINGWOOD RWS **William** b. Greenwich. 1819 - 1903 Landscape artist Exh: RA, UK AG's	*W W.e. W.C.*	
CRANE, RWS **Walter** b. Liverpool. 1845 - 1915 Portrait, figure & landscape artist Exh: RA, OWS, NWS, GG, London & Prov. AG's	*C W*	
GILES **William** b. Reading. 1872 - Genre & landscape artist Exh: RA, BM, Prov. AG's	*W G*	
WHYMPER. RI **Charles** b. London. 1853 - 1941 Bird, animal, landscape subjects etc. Exh: RA, GG, SS, NWS, Prov. AG's	*CW*	

WIERINGEN **Cornelis Claesz Van** b. Haarlem. 1580 ? - 1633 Marine & landscape artist Exh: Holland, Spain	*CW monogram*
WINZER **Charles Freegrove** b. Varsovie. 1886 - Spanish & Oriental subjects Exh: London AG's, Paris, Moscow, Venice, US, India	*CW monogram*
COPE, RA **Charles West** b. 1811 - 1890 Religious & historical subjects Exh: RA, BI, London & Prov. AG's, Australia	*monogram*
HAMILTON **Carl Wilhelm de** b. Brussels. 1668 - 1754 Reptiles, insects & floral subjects Exh: Germany, Finland, France	C W D H · 1739
COOKE, RA **Edward William** b. 1811 - 1880 River & coastal scenes Exh: RA, BI, SS	*monogram*
RADCLYFFE **Charles Walter** b. Birmingham 1817 - 1903 Landscape artist Exh: RA, BI, SS, VA	*monogram*
RIKKERS **Willem** b. Amsterdam. 1812 - ? Portraits & interior subjects	*monogram*
WINGHE **Jeremias Van** b. Brussels. 1578 — 1645 Historical & portrait artist Exh: Germany	*monogram*
WAY **Charles Jones** b. Darmouth. 1834 - 1900 Landscape oil & watercolourist Exh: Canada, Switzerland, UK AG's	*monogram* 1869
WAINWRIGHT, RWS **William John** b. Birmingham. 1855 - 1931 Portraits, genre & historical subjects Exh: OWS, UK AG's, Paris	*monograms*

DELSENBACH **Johann Adam** b. Nuremburg. 1687 - 1765 Portrait & landscape artist		D
DENIS **Simon Joseph Alexander Clement** b. Anvers. 1755 - 1813 Landscape artist Exh: France		
DOSSI **Battista** b. Italy. 1474 ? - 1548 Humourous genre & landscape artist Exh: Italy		
JONG **Servaas de** b. 1808 - ? Historical & portrait painter Exh: Holland		

DA

DALLINGER VON DALLING **Alexander Johann** b. Vienna. 1783 - 1844 Landscape & animal subjects Exh: Austria	
HAMILTON-FRASER **Donald** b. London. 1929 - Exh: London & Prov. AG's Paris etc	

DB

BOISSIEU **Jean Jacques de** b. Lyons. 1736 - 1810 Portrait & landscape artist Exh: France, Germany, Switzerland etc	
BURGDORFER **Daniel David** b. Berne. 1800 - 1861 Exh: Switzerland	
DENNER **Balthazar** b. Hamburg. 1685 - 1749 Miniaturist & portrait artist Exh: Holland, Germany, Hungary, Italy etc	
DIEPENBEECK **Abraham van** b. Bois-le-Duc. 1599 - 1675 Portraits, animal & historical subjects Exh: Germany, Belgium. Holland, UK etc	

DB	**BORCHT (The Elder)** **Hendrik van der** b. Brussels. 1583 - 1660 Still life, religious & historical subjects	*DB monogram*
	TERBURG (also known as BORCH) **Gerard** b. Zwolle. 1617 - 1681 Portraits, genre & domestic subjects etc.	*BT monogram*
DC	**CHODOWIECKI** **Daniel Nicolas** b. Danzig. 1726 - 1801 Portraits, historical, genre & miniaturist Exh: Germany, Switzerland	*DC*
	DAUBIGNY **Charles Francois** b. Paris. 1817 - 1878 Landscape artist Exh: Russia, Canada, European AG's etc	*DC monogram*
	DAVIDSON **Charles Topham** b. Redhill. 1848 - 1902 Landscape artist Exh: RA, RWS, SS	*monogram 1879*
	DECAMPS **Gabriel Alexandre** b. Paris. 1803 - 1860 Genre & historical artist Exh: Holland, France, Hungary, UK, Germany, Russia etc	*D.C. DC D.C. D.C. D.C.*
	DAWSON, FSAM **Charles Frederick** b. Rillington, Yorks Oil & watercolourist Exh: RA, IS, WAG & Prov. AG's	*CFD monogram*
	FOUQUERAY **Dominique Charles** b. France. 1872 - 1956 Portraits, historical, marine & military subjects Exh: PS, UK, Japan, US etc	*DCHF monogram DCHF monogram*
	ROSSETTI **Gabriel Charles Dante** b. London. 1828 - 1882 Portraits, figure & historical subjects Exh: NG, NPG, VA, Prov. AG's, US.	*DCR*
DD	**DAVIDSON** **Allen Douglas** b. London. 1873–1932 Figure & landscape artist Exh: RA, London & Prov. AG's	*DD DD*

BLIECK **Daniel de** b. Holland. ? - 1673 Architectural subjects Exh: Holland, Denmark, UK, Germany etc	D·D·B·1651	DD
DAEGE **Eduard** b. Berlin. 1805 - 1883 Historical subjects Exh: Austria, Germany	18 ED 30	DE
DARWIN **Elinor Mary** b. Limerick Portrait artist Exh: NEAC, IS, RA, RHA	ED	
DETMOLD **Edward Julius** b. London. 1883 - 1957 Flora & fauna watercolourist Exh: London & prov. AG's	EJD	
DUFLOS **Philothee Francois** b. Paris. 1710 - 1746 Portrait & historical subjects Exh: Italy, France	D.f. D.f.	DF
DUNKER **Balthasar Anton** b. Germany. 1746 - 1807 Landscape artist	·Df·	
DROSSAERT **Jacob** Flourished 18th Century Landscapes, hunting scenes etc Exh: Holland	DF	
DURINGER **Daniel** b. 1720 - 1786 Animal, landscape & portrait artist Exh: Switzerland	D. D	
FARQUHARSON, RSA, RA, RSW **David** b. Perth. 1839 - 1907 Landscape artist Exh: RA, London & Prov. AG's, Australia	D.F. DF D	
CRAYER **Jasper (or Caspar) de** b. Anvers. 1584 - 1669 Portrait & historical artist Exh: France, Holland, Germany, Belgium, UK etc	DC DC D.C.	DG

DG	**GALANIS** **Demetrius Emmanuel** b. Athens. 1882 - 1966 Landscapes, still life subjects etc Exh: France	*D. G*
	GIBSON **David-Cooke** b. Edinburgh. 1827 - 1856 Genre Subjects Exh: Belgium, France, RA	*G*
	MAN **Cornelis Willems De** b. Delft. 1621 - 1706 Portrait & genre subjects Exh: Holland, Germany, France, Budapest	*Dm* *Dm*
DH	**DELL** **John H.** b. 1836(?) - 1888 Genre, animals, landscapes Exh: RA. BI, UK AG'S	*DH/69*
	HALS **Dirk** b. Haarlem. 1591 - 1656 Genre subjects Exh: France, Holland, Hungary, Germany, UK etc	*DH 1639* *DH 1629* *DH 1639*
	HARDING **Dorothea** b. London. 1898 - Genre, landscapes & miniaturist Exh: Paris	*DH*
	HARDY **David** Fl. 1835 - 1870 Genre subjects Exh: RA, SSSBA, BI, VA	*DH*
	HARDY, RBA **Dudley** b. Sheffield. 1866 - 1922 Genre, oriental & biblical subjects, land & seascapes. Exh: RA, SS, NWS, GG	*DH* *DH*
	HODGSON **Dora** b. Cheshire. 1891 - Miniaturist Exh: RA, RMS, WAG	*DH 1915*
	HOOCH (or HOOGH) **Pieter de** b. Rotterdam. 1629 - 1681 Genre subjects, portraits, interiors etc Exh: UK, France, Italy, Germany, Austria etc	*DH*

FEDDES (van Harlingen) **Pieter** b. Harlingen. 1586 - 1634 Portrait & historical subjects			DI
DORNER (The Elder) **Johann Jakob** b. Germany. 1741 - 1813 Religious, historical, genre & land- scape artist Exh: Germany, Switzerland			DI
DORNEL **Jacques** b. 1775 - 1852 Historical & landscape artist Exh: Germany			
DORN **Joseph** b. Germany. 1759 - 1841 Genre & historical subjects Exh: Austria, Germany			DJ
DRUMMOND **James** b. Edinburgh. 1816 - 1877 Genre & historical subjects Exh: London & Prov. AG's			
PENSTONE **John Jewel** Fl. 1835 - 1895 Genre, figure & portrait artist Exh: RA, London & Prov. AG's			
DICKSEE **John Robert** b. London. 1817 - 1905 Genre & portrait artist Exh: London & Prov. AG's			
KANDEL **David** b. France. FL. 16th C. Floral subjects Exh: France			DK
KEYSER (The Elder) **Hendrik de** b. Utrecht. 1565 - 1621 Religious & genre painter Exh: Holland			
KOELMAN **Johan Daniel** b. Hague. 1831 - 1857 Animals & landscapes Exh: Holland			

KUYPERS **Dirk** b. Dortrecht. 1733 - 1796 Landscapes etc	
DANLOUX **Henri Pierre** p. Paris. 1753 - 1809 Portrait artist Exh: Germany, France, UK etc	
DAVID **Jacques Louis** b. Paris. 1748 - 1825 Portraits & historical subjects etc Exh: Russia & European AG's	
DAVIDSON **Lilian Lucy** b. Co. Wicklow. FL. 20th C. Figures & landscapes Exh: PS. RHA	
VINCI **Leonardo Da** b. Italy. 1452 - 1519 Portraits, mythological, religious & historical subjects Exh: International AG's	
DUBOURCQ **Pierre Louis** b. Amsterdam. 1815 - 1873 Landscape artist Exh: Holland	
MAAS **Dirk** b. Haarlem. 1659 - 1717 Equine & battle scenes Exh: Holland, France, UK, Sweden	
MEYER (The Elder) **Dietrich** b. 1572 - 1658 Hunting scenes, genre & landscape subjects	
MILLS **David** b. Colchester. 1947 - Subtle kinetics, abstract subjects etc. Exh: London & Prov. AG's	
MONTEN **Heinrich Maria Dietrich** b. Dusseldorf. 1799 - 1843 Battle scenes, historical & genre subjects Exh: Germany	

Column labels (left margin):
DK
DL
DM

VOS Marten De b. Antwerp. 1532 - 1603 Portraits & historical subjects Exh: European AG's	*DVF*		DM
DENATO Francesco Flourished 15th Century Religious & historical subjects	*D✝N*		DN
PIOLA (The Elder) Domenico b. Genos. 1627 - 1703 Religious & historical artist Exh: Italy	*Do.P.F.*		DO
DAVIS, RI Frederick W. b. 1862 - 1919 Genre & historical subjects Exh: NWS, SS, UK AG's, Paris	*FD*		DP
DIEPRAAM Abraham b. Holland. 1622 - 1670 Genre artist Exh: Germany, Holland etc	*DP 1640*		
QUAGLIO (The Younger) Domenico b. Munich. 1786 - 1837 Architectural subjects Exh: Germany	*DQ.f*	*D.Q* *DQ*	DQ
DOYLE Richard b. London. 1824 - 1883 Caricaturist & painter of fairy scenes Exh: RA, GG, UK & Prov. AG's	*RD*		DR
DRURY Paul Dalou b. UK. 1903 - Genre subjects Exh: RA, RE, etc.	*BD*		
RAMSAY David b. Ayr. 1869 - ? Landscape watercolourist Exh: UK AG's	*.DR.*		
ROBINSON Douglas F. b. London. 1864 - 1929 Figure & marine artist Exh: RA, SS, France	*D.R.* *D.R.*		

DR	**RYCKAERT** **David I** b. Antwerp. 1560 - 1607 Genre & figure subjects	*DR*
	RYCKAERT **David II** b. Antwerp. 1596 - 1642 Landscapes & interiors Exh: Belgium	*DR* *R*
DS	**DOWNIE, RSW** **Patrick** b. Greenock. 19th C. Genre & landscape artist Exh: PS, RA, RSA, GI, SS & Prov. AG's	*Ɖ.*
	GHISI **Diana** b. Mantoue. 1536 ? - 1590 Genre, religious & historical subjects	*DS*
	SCHELLINKS **Daniel** b. Amsterdam. 1627 - 1701 Marine & landscape artist Exh: Vienna, Turin	*D S.*
	SEGHERS **Daniel** b. Antwerp. 1590 - 1661 Floral subjects Exh: Belgium, France, Vienna, Geneva	*DS* *DS*
	STOOP **Dirk** b. Utrecht. 1618 ? - 1681 Military & landscape subjects Exh: Holland, France, Germany, UK	*D.S.*
	STRICKLAND **Dorothy Enid** b. Kent. 1899 - Painter & sculptor Exh: Rhodesia, S. Africa, etc.	*Ð*
	SUMMERHAYS. RMS, ARBSA, **AWSA, etc.** **Dora** b. 1883 - 1955 Miniaturist & watercolourist Exh: RA, RWEA, WAG, PS, RMS, etc.	*DS*
DT	**DAVIDSON** **Thomas** Fl. 1863 - 1909 Genre & historical subjects Exh: RA, SS, BI	*D* *Ð*

DUNANT **Jean Francois** b. Lyon. 1780 - 1858 Interiors, genre & historical subjects Exh: France	D^t	DT
TENIERS (The Younger) **David** b. Antwerp. 1610 - 1690 Historical, genre, landscapes, fairs, village scenes etc. Exh: International AG's	D D D D D D D.T. D.F	
TINDLE. ARA **David** b. Huddersfield. 1932 - Realist, portraits, still life & landscape artist Exh: RA, Italy, France, Germany, US, Switzerland, Belgium & UK AG's	DT. DT.	
BERGEN (or BERGHEN) **Dirck van** b. Harlem. 1645 - 1690 ? Landscape & animal painter Exh: UK. Holland, Germany, Italy, France etc.	D.V.B. B.1680	DV
VINCKEBONS **David** b. Belgium. 1576 - 1629 Genre & landscape artist Exh: Holland, Belgium, Germany, France	DVB DVB D.V.B	
DYCK **Daniel van den** b. ? - 1670 Historical subjects	DD DD f.	
DEONON **Vivant Dominique** b. France. 1747 - 1825 Portrait, genre & landscape artist Exh: France	DVf,	
HEIL **Daniel van** b. Brussels. 1604 - 1662 Historical & landscape artist Exh: Germany, France, Austria	DVH	
HOOGSTRATEN **Dirk van** b. Anvers. 1596 ? - 1640 Religious & historical subjects Exh: Holland	DVH	
FRIQUET de VAUROZE **Jacques Antoine** b. France. 1648 - 1716 Historical subjects Exh: France	DV	

DV	**LISSE** **Dirck Van Der** b. Breda. ? - 1669 Mythological subjects Exh: France, Germany, England, Sweden, Vienna	
	NYMEGEN **Dionys Van** b. Rotterdam. 1705 - 1789 Portrait, historical, floral & landscape subjects Exh: Holland	
	OSTERHOUDT **Daniel Van** b. Tiel. 1786 - 1850 ? Landscape artist	D.V.O.
DW	**DALGLISH** **William** b. 1860(?) - 1909 Landscape artist Exh: RA, UK AG's	
	WYNEN **Dominicus Van** b. Amsterdam. 1661 - 1690 ? Imaginative & genre subjects	
E	**BARNES** **E.C.** b. London Fl. 19th C. Genre, Domestic & interior subjects Exh: RA, SS, BI, & Prov. AG's	
	BURRA **Edward** b. London. 1905 - Surrealist Exh: UK AG's, France	
	DAVID **Jacques Louis** b. Paris. 1748 - 1825 Portraits & historical subjects etc Exh: Russia & European AG's	
	HOEFNAGEL (or HUFNAGEL) **George** b. 1542 - 1600 Miniaturist & portrait artist	
	LINNIG **Egidius** b. Antwerp. 1821 - 1860 Marine & landscape subjects Exh: Belgium, Germany	

Artist	Monogram
MENZIES-JONES. BA Llewelyn Frederick b. Surrey. 1889 - Etcher & landscape artist Exh: RI, PAS, etc.	
ALBANI (or ALBANO) Francesco b. Bologna. 1578 - 1660 Religious & mythological subjects Exh: Works in principal European collections	
ALEXANDER, RSA Edwin b. 1870 - 1926 Flower, bird & animal subjects Exh: RSA, RNS.	
ELMORE, RA Alfred b. Clonakelty. 1815 - 1881 Genre & historical subjects Exh: Australia, London & Prov. AG's	
GOODALL, RWS Edward Alfred b. London. 1819 - 1908 Battle scenes, landscapes etc Exh: RA, BI, SS, OWS	
HORNEL Edward Atkinson b. Victoria. 1864 - 1933 Genre & landscape artist Exh: UK AG's	
DAGNAN-BOUVERET Pascal Adolphe Jean b. Paris. 1852 - 1929 Mythological, genre & portrait artist Exh: France, Italy, Germany, Russia etc	
PRYNNE, RBA Edward A. Fellowes b. 1854 - 1921 Portrait, figure & genre subjects Exh: RA, UK AG's	
PETTITT Edwin Alfred b. Birmingham. 1840 - 1912 Landscape artist Exh: RA, Prov. AG's	
BAKER, SWA Blanche Fl. Bristol. 1869 - 1893 Landscape artist Exh: RA, SS, NWS	

BARCLAY **Edgar** b. London 19th C. Landscape, figure & genre subjects Exh: RA, GG, NG	*EB*
BARNES **E.C.** b. London Fl. 19th C. Genre, Domestic & interior subjects Exh: RA, SS, BI, & Prov. AG's	*(monogram)*
BAWDEN, RA **Edward** b. Braintree. 1903 - Military & landscape watercolourist Exh: London & Prov. AG's	*EB* *EB*
BISHOP, RBA, NEAC **Edward** b. London. 1902 - London night scenes, cafes etc Exh: RA, NEAC, RBA, London & Prov. AG's, Europe	*EB EB EB EB*
BOUDIN **Eugene Louis** b. France. 1824 - 1898 Portrait, still life, town & shore scenes etc Exh: UK, France, Belgium, Holland etc	*E.B*
BRICKDALE, RWS **Eleanor Fortescue** b. 1871 - 1945 Oil & watercolourist Exh: RA, WAG, RWS & Prov. AG's	*(EB monogram in circle)*
BRONCKHORST **Gerrit** b. Utrecht. 1637 - 1673 Landscape artist Exh: Holland	*EB*
BURRA **Edward** b. London. 1905 - Surrealist Exh: UK AG's, France	*EB (EB monogram in circle)*
BUSH', ARCA, RWA, RE **Reginald Edgar James** b. Cardiff. 1869 - ? Landscape artist Exh: RA, France, Italy, US	*(EB monogram in circle)*
BUTLER (nee Thompson) **Lady Elizabeth Southerden** b. Lausanne. 1846 - 1933 Military & battle scenes Exh: RA, London & Prov. AG's	*EB*

BATESON **Edith** b. Cambridge Fl. 19th - 20th C. Painter of varied subjects Exh: PS, RA, RBA, NEAC, IS, & Prov. AG's		**EB**
BOROUGH-JOHNSON, PS, SGA, **Ernest** **RBA, ROI, RI, RBC** b. Salop. 1867 - ? Portraits, figure subjects & landscape artist Exh: PS, RA, RBA, RI, ROI, RP, UK, Europe etc		
BURNE-JONES, Bt., ARA **Sir Edward Coley** b. Birmingham. 1833 - 1898 Religious, mythological & historical subjects Exh: RA, GG, NG, OWS, London & Prov. AG's		
JOHNSON, WIAC, PS, AWG **Esther Borough** Fl. 19th - 20th C. B/White, pastel, oil & watercolour media Exh: RA, RI, ROI, PAS, PS etc		
LEIGHTON **Edmund Blair** b. London. 1853 - 1922 Genre artist Exh: RA, London & Prov. AG's		
CALDWELL **Edmund** b. Canterbury. 1852 - 1930 Animals & sporting subjects Exh: RA, SS, NWS		**EC**
CLACY **Ellen** Fl. 1870 - 1900 Genre subjects Exh: RA, SS, GG, Prov. AG's		
COLLIER (or COLYER) **Evert** b. Holland. ? - 1702 Portraits & still life subjects Exh: Holland, Austria		
COOPER **Edward** b. England. Fl. 18th C. Portrait artist		
CROFTS, RA **Ernest** b. Leeds. 1874 - 1911 Military & historical subjects Exh: RA, London & UK AG's, Germany		

ETTINGER **Josef Carl** b. Munich. 1805 - 1860 Landscape artist	
COHEN **Ellen Gertrude** Fl. 19th - 20th C. Landscape artist Exh: RA, NWS, France	E.C.C
DETMOLD **Edward Julius** b. London. 1883 - 1957 Flora & fauna watercolourist Exh: London & prov. AG's	
SCHMIDT **Georg Friedrich** b. Berlin. 1712 - 1775 Portrait artist Exh: Paris, Germany	ŒE.S

DELACROIX **Ferdinand Victor Eugene** b. France. 1798 - 1863 Portrait, historical, genre & still life subjects Exh: UK & European AG's etc	ℰD ℰ.D
DOUGLAS **Edwin** b. Edinburgh. 1848 - ? Sporting, animal & genre artist Exh: RA, RSA etc	
DRURY **Paul Dalou** b. U.K. 1903 - Genre subjects Exh: RA, RE, etc.	
DUNCAN **Edward** b. London. 1803 - 1882 Marine & landscape artist Exh: RA, London & Prov. AG's	
EDEN **Denis William** b. Liverpool. 1878 - Portraits & historical subjects Exh: RA & Prov. AG's	19 ED 25
WITTE **Emanuel De** b. Alkmaar. 1617 - 1692 Church interiors Exh: Holland, Germany, Belgium, France, UK	ED·W

ERTZ, RBA, FRSA **Edward Frederick** b. Illinois. 1862 - 1954 Etcher, oil & watercolourist Exh: RA, RBA, London, Paris, Munich & US		EE
EVERETT **Ethel F.** b. London. Childrens portrait artist Exh: RA & London & Prov. AG's		
MARTIN **Ethel** b. Sevenoaks. 1873 - Painter in oil media Exh: RA, RI, NEAC, ROI		
FITZHERBERT, ARCA **Elizabeth** b. Sevenoaks. 1923 - Oil & watercolourist Exh: RA, RHA, AIA etc		EF
FORSTER **Ernst Joachim** b. Germany. 1800 - 1885 Genre subjects Exh: Germany		
FREYBERG (nee STUNTZ) **Maria Electrina von** b. Strasbourg. 1797 - 1847 Genre & historical subjects Exh: Germany		
FRIES **Ernst** b. Heidelberg. 1801 - 1833 Portrait & landscape artist		
FRUH **Eugen** b. Switzerland. 1914 - Painter in oil media Exh: European AG's, Japan		
FORBES (Mrs. STANHOPE) ARWS **Elizabeth Adela** b. Ottowa. 1859 - 1912 Rustic genre & still life artist Exh: RA, SS, NWS, GG, NG, NEAC		
BREWTNAL, RWS **Edward Frederick** b. 1846 - 1902 Genre & landscape oil & watercolourist Exh: RA, VA, Prov. AG's		

EG	**GEORGE, RE, SSSBA** **Sir Ernest** b. London. 1839 - 1922 Landscape, oil & watercolourist Exh: RA, SS, RE, London & Prov. AG's	EG EG EG EG
	GILL **Edmund** b. London. 1820 - 1894 Rivers, waterfalls, landscapes Exh: RA, SS, VA, Germany, etc.	EG 1870
	GLEDSTANES, RBA, FRSA etc **Elsie** Oil, pastel & watercolourist Exh: RA, RBA, RP, SWA, PAS, & Prov. AG's	EG
	GRISET **Ernest Henry** b. France. 1844 - 1907 Animal watercolourist Exh: SS, VA, London & Prov. AG's	EG EG
	DALZIEL **Edward Gurden** b. London. 1849 - 1889 Genre & landscape artist Exh: RA, London & Prov. AG's	EGD EGD
EH	**CRAWFORD, RSA** **Edmund Thornton** b. 1806 - 1885 Landscapes & coastal scenes Exh: RA, UK AG's	E.H
	HARGITT, RI **Edward** b. Edinburgh. 1835 - 1895 Landscape artist Exh: RA, BI, SS, NWS etc	EH
	HERDMAN, RSA, RSW **Robert** b. Rattray. 1829—1888 Genre, historical & portrait artist Exh: RA, Paris, US, Australia, UK AG's	RH RH 1876
	HEWITT **Evelyn** b. London. 1882 - Miniaturist & pastel artist Exh: RA, RMS	EH
	HOPKINS **Everard** b. 1860 - 1928 Watercolourist & illustrator Exh: NWS	EH.

BODDINGTON Edwin Henry Fl. 1853 - 1867 Landscape artist Exh: RA, BI, SS, UK AG's	EHB.	EH
HUBBARD Eric Hesketh b. London. 1892 - 1957 Genre, architectural & landscape artist Exh: UK AG's	EHH	
LENGERICH **Emanuel Heinrich** b. Germany. 1790 - 1865 Religious & historical subjects Exh: Germany	HL	
PHILLOTT **Constance** Fl. 1864 - 1904 Genre, historical & landscape artist Exh: RWS, UK AG's	⊄	EJ
CRAWFORD, RSA **Edmund Thornton** b. 1806 - 1885 Landscapes & coastal scenes Exh: RA, UK AG's	EJC	
DOUGLAS **Edwin** b. Edinburgh. 1848 - ? Sporting, animal & genre artist Exh: RA, RSA etc	♠⃝	
GREGORY, RA, RI **Edward John** b. Southampton. 1850 - 1909 Portrait, genre & landscape artist Exh: RA, RI, NWS, GG, Germany, France etc	EJG E.J.G.78 EJG	
POYNTER **Sir Edward James** b. Paris. 1836 - 1919 Genre & historical subjects Exh: RA, VA, London & Prov. AG's, Canada, Australia	EJP	
JOHNSON, RWS **Edward Killingworth** b. London. 1825 - 1896 Genre & landscape artist Exh: RA, SS, UK AG's, US	E.K.J.	EK
LADELL **Edward** b. England. FL. 19th C. Still life subjects. Exh: RA, BI, SS, London & Prov. AG's	Ǝ	EL

EL	**LANDSEER** **Sir Edwin Henry** b. London. 1802 - 1873 Portrait, animal, landscape & sporting subjects Exh: RA, BI, SS, OWS, London & Prov. AG's X	*(monogram EL)*
	LAUDER, RSA **James Eckford** b. Edinburgh. 1811 - 1869 Figures, historical & landscape painter Exh: UK AG's	*(monogram E)*
	LEAR **Edward** b. London. 1812 - 1888 Birds, animals, topographical & landscape subjects Exh: SS, UK AG's etc.	*(three monograms EL)*
	LUMSDEN, RSA **Ernest Steven** b. London. 1883 - Landscape artist & watercolourist Exh: UK AG's	*(monogram EL)*
	MONTEFIORE **Edward Levy** b. Barbados. 1820 -1894 Landscape artist Exh: VA, London & Prov. AG's, Paris, Australia	*(two monograms ELM)*
EM	**ELLIOT** **Frank** b. London. 1858 - ? Portrait & landscape artist, oil & watercolour media Exh: RA.	*(monogram E)*
	MURANT **Emanuel** b. Amsterdam. 1622 - 1700 ? Landscape artist Exh: Germany, Holland, US, UK	*E.M.*
	ASSEN **Jacob Walter van** b. 1475 - 1555 Portraits & religious subjects Exh: Germany, Holland, UK.	*(monogram)*
	DARWIN **Elinor Mary** b. Limerick Portrait artist Exh: NEAC, IS, RA, RHA	*(monogram Emd)*
	NETHERWOOD (NEE DYAS) ARCM **Edith MARY** b. Stockport Landscape artist Exh: R.Cam.A, ROI, RWA, WAG, RBSA	*E.M.Dyas.*

WARD, RA **Edward Matthew** b. Pimlico. 1816 - 1879 Historical subjects Exh: RA, NPG, VA, UK AG's, Germany	*E.M.W.*	EM
WIMPERIS. VPRI **Edmund Morison** b. Chester. 1835 - 1900 Landscape artist Exh: RA, NWS, SS, NG, GG, VA, Australia	*EMW* *EMW* *EMW*	
NORFIELD **Edgar George** b. UK Oil & watercolourist Exh: RI, London & Prov. AG's	*EN*	EN
NOTERMAN **Emmanuel** b. Belgium. 1808 - 1863 Portraits & genre subjects Exh: Holland, Belgium, Montreal, Moscow	*E.N.*	
DOWNARD **Ebenezer Newman** FL. 19th C. Portraits, genre, religious & landscape subjects Exh: RA, BI, SS	*END*	
BRUGGINK **Jacob** b. Amsterdam. 1801 - 1855 Landscape artist	*EB*	EP
PATRY. RBA **Edward** b. London. 1856 - 1940 Genre & portrait artist Exh: RA, SS, PS, Belgium	*EP* *.18XX98* *XP*	
PICKERING **Evelyn** b. 1850 ? - 1919 Figure artist Exh: GG, NG, London & Prov. AG's	*EP*	
PARRIS **Edmund Thomas** b. London. 1793 - 1873 Genre, portrait, panorama & historical subjects Exh: BI, SS, VA, NPG	*ETP*	
QUESNEL (The Elder) **Francois** b. Edinburgh. 1543 - 1619 Historical & Portrait artist Exh: France, Italy	*FQ*	EQ

EQ	**STANZIONI** **Massimo** b. Naples. 1585 - 1656 Religious subjects Exh: Italy, NG, US, France	ŒMX
ER	**EURICH, ARA** **Richard Ernst** b. UK. 1903 - Portrait, genre & military subjects Exh: UK AG's, Paris	Œ Œ Œ
	RENI **Guido** b. Italy. 1575 - 1642 Religious & historical subjects Exh: France, Italy, Germany, UK, US, Scandinavia	E°R⁰
	RICE **Bernard Charles** b. Innsbruck. 1900 - Painter & engraver Exh: London & Prov. AG's	ŒR.
	ROBINSON **Charles F.** Fl. London. 19th C. Landscape artist Exh: RA, SS, NWS, London & Prov. AG's	⊞R
	RYCKERE **Bernard** b. Belgium. 1535 ? - 1590 Biblical subjects Exh: Belgium	R R R
	EDGECOMBE **Reginald Edward** b. 1885 - B/White, oil & watercolour media Exh: RBSA	RE
	ELDRED **Charles D.** Fl. 1889 - 1909 Marine watercolourist Exh: US	DRE
	HUGHES, RWS **Edward Robert** b. London. 1851 - 1914 Historical & genre artist Exh: RA, BI, OWS, GG. Germany, Italy etc	ERH E.R.H.
	RUSSELL-ROBERTS **Ethel Marguerite de Vilieneuve** Landscape artist Exh: RI, SWA, London & Prov. AG's	E.R.R.

TAYLOR. RBSA **Edwart Robert** b. Hanley. 1838 - 1911 Portrait, biblical, genre, coastal & landscape subjects etc. Exh: RA, BI, NG, GG, SS, NWS, etc.	*ERT*
SCHOEN **Erhard** Fl. Germany. 16th C. Religious subjects Exh: Germany, France	(monogram) (monogram) (monogram)
SOUTHALL, ARWS, NEAC **Joseph Edward** b. Birmingham. 1861 - 1944 Genre, figure & landscape artist Exh: UK AG's, Paris	(monogram 1925) (monogram) (monogram) (monogram 1941)
STANNARD **Emily (née Coppin)** b. Norwich. 1803 - 1885 Still life & floral studies Exh: BI, SS, London & Prov. AG's	*ES* *1870*
STOTT. ARA **Edward** b. England. 1859 - 1918 Rustic genre & landscape artist Exh: RA, NEAC, NG, GG, & Prov. AG's	(ES in circle)
STUVEN **Ernst** b. Hamburg. 1660 - 1712 Still life & floral subjects Exh: Germany	**E.S**
GREEN, IS **Elizabeth Shippen** Fl. 1920's Landscape oil & watercolourist Exh: UK & European AG'S	*E.S.G* *E.S.G* *E.S.G.E*
KENNEDY **Edward Sharard** b. England. FL. 19th C. Historical & rustic genre Exh: RA, SS, NWS etc	*E. S. K.*
STEINER **Emmanuel** b. Switzerland. 1778 - 1831 Painter & engraver	*E. st. f*
SWEBACH **Bernard Edouard** b. Paris. 1800 - 1870 Genre & military subjects Exh: France, Belgium	*E: S W* *1823* *E: S W:*

ER

ES

ET	**BUTLER (nee Thompson)** **Lady Elizabeth Southerden** b. Lausanne. 1846 - 1933 Military & battle scenes Exh: RA, London & Prov. AG's	*E.T.*
	TAYLER **Edward** b. Orbe. 1828 - 1906 Portrait artist & miniaturist Exh: RA, SS, RI, London & Prov. AG's	*E.T.* *ET*
	TAYLOR. RBSA **Edwart Robert** b. Hanley. 1838 - 1911 Portrait, biblical, genre, coastal & landscape subjects etc. Exh: RA, BI, NG, GG, SS, NWS, etc.	*ET*
	HAYNES **Edward Trevanyon** Fl. 1867 - 1885 Genre & historical subjects Exh: RA	*ET 80*
EV	**DRIELST** **Egbert van** b. Holland. 1746 - 1818 Landscape artist Exh: Holland, France	**E.V.Dᵗ**
	RIPPINGILLE **Edward Villiers** b. Kings Lynn. 1798 - 1859 Genre subjects Exh: UK AG's	*E.V.R-1837*
	VELDE **Esaias Van De** b. Amsterdam. 1591 ? – 1630 Battle scenes & landscape artist Exh: Holland, Germany, France, Austria, etc.	*EVV* *E.VV* *E.V.V* *EVV* *EV*
EW	**WARD** **Enoch** b. Parkgate. 1859 - 1922 Marine & landscape artist Exh: London & Prov. AG's	*E.W.*
	WHITE, RWS **Ethelbert** b. Isleworth. 1891 - 1972 Landscape oil & watercolourist Exh: UK AG's	*EW*
	WILLIAMS **Edward** b. London. 1782 - 1855 Landscape artist & miniaturist Exh: RA, BI, SS, VA, London & Prov. AG's	*EW*

WAITE. RBA Edward William Fl. London. 19th – 20th C. Landscape artist Exh: RA, SS, NG, London & Prov. AG's, S. Africa	*E.W.W*	EW
FAITHORNE William b. London. 1616 - 1691 Portrait artist Exh: UK, AG's		F
FELLNER Ferdinand August Michael b. Germany. 1799 - 1859 Historical subjects		
FOSTER, FZS William b. London. 1853 - 1924 Genre, still life, interiors & landscape artist Exh: RA, SS, NWS		
FUGER Friedrich Heinrich b. 1751 - 1818 Portraits, mythological subjects & miniatures etc Exh: Germany, Hungary, UK		
HALL, RBC Frederick b. Yorkshire. 1860 - 1921 Portraits, rustic genre & landscape subjects Exh: RA, SS, GG, France, Italy		
LEYSTER Judith b. Haarlem. 1600 ? - 1660 Genre & interior scenes Exh: Holland, Germany, Paris, Sweden		
WALLACE Harold Frank b. Yorkshire. 1881 - ? Landscape & sporting scenes Exh: UK AG's		
MEMLING Hans b. Mayence. 1430 ? - 1494 Portraits, religious & historical subjects Exh: Belgium, UK, US, Italy, Germany		FA
FACCINI Pietro b. Boulogne. 1560 - 1602 Portraits & historical subjects Exh: France, Italy		

FA	**BOUDEWYNS** **Adriaen Frans** b. Brussels. 1644 - 1711 Landscape & figure artist Exh: Holland, Spain, Hungary, France	𝔸𝔽 B.f.
	FRASER **Francis Arthur** Fl. 1867 - 1883 Figure painter Exh: London & Prov. AG's	FAF
	REITER **Barthelemy** b. Munich. ? - 1622 Religious, mythological & genre subjects	FR
	FROHLICH **Anton** b. 1776 - 1841 Religious subjects	AT F
	BARTOLOZZI **Francesco** b. Florence 1725? - 1815 Portrait & figure artist Exh: UK & European AG's	ℱBf
FB	**BOL** **Ferdinand** b. Dortrecht. 1611 - 1680 Portraits & historical subjects Exh: UK, Scandinavian & European AG's	F·B FB ℬ ℬ
	BOUCHER **Francois** b. Paris. 1703 - 1770 Mythological, genre, historical, portrait & landscape artist Exh: UK, France, Germany, Switzerland etc	ℱℬ
	BRAMLEY, RA **Frank** b. Lincoln. 1857 - 1932 Genre & portrait artist Exh: RA, NEAC, GG, NG, SS, S. Africa	F.B.
	BRAND **Friedrich Auguste** b. Vienna. 1755 - 1806 Portraits, historical & landscape subjects Exh: France, Austria	ℱℬ
	FOSTER, RWS **Myles Birket** b. North Shields. 1825 - 1899 Landscapes & rustic scenes Exh: RA, RWS, OWS, London & Prov. AG's etc	ℬ

BROWN **Ford Madox** b. Calais. 1821 - 1893 Landscapes, historical & biblical subjects Exh: RA, BI, London & Prov. AG's, Australia		FB
BUHOT **Felix Hilaire** b. Valognes. 1847 - 1898 Landscape artist Exh: France		
CARRACCI **Francesco** b. Italy. 1559 - 1622 Religious subjects Exh: Russia, Italy, France		FC
CARSTENS **Frederik Christian** b. Denmark. 1762 - 1798 Portrait & genre artist Exh: Germany, Italy, etc		
CHAUVEAU **Francois** b. Paris. 1613 - 1676 Miniaturist		
CHIARI **Fabrizio** b. Rome. 1621 - 1695 Religious subjects		
CRAIG, ROI, NPS **Frank** b. Kent. 1874 - 1918 Genre & portrait artist Exh: France, S. Africa, Australia		
CRAIG **James Stephenson** Fl. London. 1854 - 1870 Genre subjects · Exh: UK AG's		
CRESWICK, RA **Thomas** b. Sheffield. 1811 - 1869 Landscape artist Exh: RA, BI, SS, UK & European AG's		
COWPER **Frank Cadogan** b. UK. 1877 - 1958 Genre & historical subjects Exh: RA		

FC	**FUES** **Christian Friedrich** b. Germany. 1772 - 1836 Genre & portrait artist		
	BIGIO **Francesco** b. Florence. 1482 - 1525 Portraits & historical subjects Exh: Germany, Italy, UK, France		
FD	**DADD, RI, ROI** **Frank** b. London. 1851 - 1929 Genre subjects Exh: RA, ROI, RBA, Australia		
	DAVIS, RI **Frederick W.** b. 1862 - 1919 Genre & historical subjects Exh: NWS, SS, UK AG's, Paris		
	DICKSEE, PRA **Sir Frank** b. London. 1853 - 1928 Genre & portrait artist Exh: RA, London & Prov. AG's, Australia		
	DICKSON **Frank** b. Nr. Chester. 1862 - 1936 Landscape artist Exh: RA, London & Prov. AG's		
	DOBLE **Frank Sellar** b. Liverpool. 1898 - Oil & watercolourist Exh: WAG & Prov. AG's		
	DODD, RA, RWS **Francis** b. Holyhead. 1874 - 1949 Landscapes & architectural views Exh: RA, RWS, NEAC		
	FARQUHARSON, RSA, RA, RSW **David** b. Perth. 1839 - 1907 Landscape artist Exh: RA, London & Prov. AG's, Australia		
	FRANCIS **John Deffett** b. Swansea. 1815 - 1901 Genre & portrait artist Exh: RA, BI, SS		

WOOD, RA **Francis Derwent** b. Keswick. 1871 - 1926 Portraits & figure artist. Sculptor Exh: RA, UK AG's	F.D.W.1919
CRAWSHAW **Francis** b. Manchester. 1876 - ? Oil & watercolourist Exh: RA, RSA, RSW, NEAC, GI, ROI	Œ
BRICKDALE, RWS **Eleanor Fortescue** b. 1871 - 1945 Oil & watercolourist Exh: RA, WAG, RWS & Prov. AG's	HF3
GRONE, RBA **Ferdinand E.** Fl. Colchester 1880 - 1910 Landscape oil & watercolourist Exh: RBA, RI	F.E.G.
JACKSON **Francis Ernest** b. UK. 1873 - 1945 Figures, architectural & landscape artist Exh: UK AG's	FEJ
WEIROTTER **Franz Edmund** b. Innsbruck. 1730 - 1771 Landscape artist Exh: Austria, Germany, Hungary	F.E.W.
FABRE **Francois Xavier** b. Montpellier. 1766 - 1837 Portrait, historical & landscape artist Exh: Italy, Spain, France	ff
FERG **Franz de Paula** b. Vienna. 1689 - 1740 Genre & landscape artist Exh: Germany, Hungary, Italy, Austria etc	FF FF
FLORIS **Frans 1** b. Anvers. 1516 - 1570 Portraits & historical subjects etc Exh: Germany, Italy, France, UK, Sweden etc	FF FF F. FF
FRANK **Franz Friedrich** b. 1627 - 1687 Portrait artist Exh: Austria	FFF

FD

FE

FF

FF	**FREEMAN, ARCS, B.Sc,** **Frank** b. Barbados. 1901 Landscape, figure & portrait artist	FF. 19 28
	PRINS **Pierre Ernest** b. Paris. 1838 - 1913 Landscape artist Exh: France, Germany	P. P.
FG	**GAUERMANN** **Friedrich** b. Germany. 1807 - 1862 Animals, genre & landscape artist Exh: Germany, Austria	F.G.
	GILLETT, RI **Edward Frank** b. Worlingham. 1874 - ? Oil & watercolourist Exh: RI, London & Prov. AG's	F. G.
	GOODALL, RA, **Frederick** b. London. 1822 - 1904 Landscapes, genre, biblical & Egyptian subjects Exh: RA, France, Germany, Australia, London & Prov. AG's	FG FG FG FG FG
	GROSPIETSCH **Florian** b. Protzan. 1789 - 1830 Landscape artist	FG 1826 FG
	COTMAN **Frederick George** b. Ipswich. 1850 - 1920 Portrait, genre & landscape artist Exh: RA, UK AG's, Paris	F.G.C. F.S.C.
	GEISSLER **J. Martin Friedrich** b. Nuremberg. 1778 - 1853 Architectural & landscape artist	JFg.f F
	JACKSON **Frank George** b. Birmingham. 1831 - 1905 Portrait, still life, genre & landscape artist Exh: London & Prov. AG's	F.G.J.
	JAMES, RWS **Francis Edward** b. Willington. 1849 - 1920 Floral & landscape artist Exh: RWS, SS, UK AG's	F.G.J

618

REYNOLDS **Frederick George** b. 1828 - 1921 Landscape artist Exh: London & Prov. AG's		**FG**
SCHMIDT **Georg Friedrich** b. Berlin. 1712 - 1775 Portrait artist Exh: Paris, Germany		
FISHER **Alfred Hugh** b. London. 1867 - 1945 Landscapes & architectural subjects Exh: RA, SS, NWS, London & Prov. AG's, Paris		**FH**
FOX, SSSBA **Henry Charles** b. 1860(?) - 1922 Landscape artist Exh: RA, SS, Canada, Australia		
HERLIN (The Elder) **Friedrich** b. Germany. 1435 - 1500 ? Historical subjects Exh: Germany		
HOLL, RA, ARWS **Frank Montague** b. London. 1845 - 1888 Portraits, historical & genre subjects Exh: RA, GG, BI, SS, NG, Prov. AG's Australis		
HULSMAN **Johann** FL. 17th C. Historical, genre & portrait artist Exh: Germany		
FRANCKEN **Hieronymus 111** b. Bruges. 1611 - ? Historical artist		
HOVE **Hubertus van** b. Hague. 1814 - 1865 Architecture & landscape artist Exh: Holland, Germany		
FUHRICH **Josef von** b. 1800 - 1876 Religious subjects etc Exh: Austria, Italy		**FI**

FJ	**FINNIE, ARE, SSSBA** John b. Aberdeen. 1829 - 1907 Landscape artist Exh: RA, BI, SS, UK AG'S, Paris	
	FRANKLIN John b. 1800(?) - 1869(?) Architectural & historical subjects Exh: RA, SS, BI, London & Prov. AG's	
	FRATREL (The Elder) Joseph b. Epinal. 1730 - 1783 Historical subjects Exh: Germany	
	GAILLARD Claude Ferdinand b. Paris. 1834 - 1887 Portrait & historical artist Exh: France	
	FREEMAN William Henry b. Paris. Fl. 19th C. Portrait artist Exh: PS	
	FREETH James Wilfred b. West Bromwich. 1872 - ? Oil & watercolourist Exh: RA, RHA, RBSA & Prov. AG's	
	WYBURD Francis John b. London. 1826 - ? Genre & historical subjects Exh: London & Prov. AG's	
FK	**KELLER** Ferdinand b. Germany. 1842 - 1922 Historical, portrait & landscape subjects Exh: France, Germany	
	KIRCHBACH Franck b. London. 1859 - 1912 Genre, landscape & historical subjects Exh: UK, Germany, Austria, France	
	KLASS Friedrich Christian b. Dresden 1752 - 1827 Genre & landscape artist Exh: Germany	

KNELLER, B.Sc, **Frank** b. Bangor. 1914 Dogs & equine subjects Exh: R. Scot. A, R.Cam.A, RSMP etc	*7K*	FK
KOBELL **Ferdinand** b. Mannheim. 1740 - 1799 Landscape subjects Exh: France, Germany, Bucharest	*FK*	
LONDONIO **Francesco** b. Milan. 1723 - 1783 Landscapes, animals & genre subjects Exh: Italy, Austria	*F.L* *FL*	FL
GRIGGS **Frederick Landseer Maur** b. Hitchin. 1876 - 1938 Landscapes & architectural subjects Exh: BM, London & Prov. AG's	*FL* F.L.G F.L.G.	
HUYGENS **Frederik - Lodewyh** b. Hague. 1802 - 1887 Genre artist Exh: Holland	*F. L. H. del. et Sc*	
MAGER. RCA. USA **Frederick** b. 1882 - Oil & watercolourist Exh: PS, RA, RI, etc.	*FM*	FM
MARRIOTT **Frederick** b. 1860 - 1941 Landscape & architectural subjects Exh: RA, ROI	*FM* *FM 1904*	
MENTON **Frans** b. Holland. 1550 ? - 1615 Religious subjects Exh: Holland	*FM*	
MOODY **Fanny** b. London. 1861 - ? Animal subjects Exh: RA, SS, BI, etc.	*F M*	
MORGAN. ROI **Frederick** b. 1856 - 1927 Portraits, children, domestic & animal subjects Exh: RA, SS, BI, GG, NWS, etc.	*F.M.*	

FM	**BENNETT** Frank Moss b. Liverpool. 1874 - 1953 Genre & historical subjects Exh: UK AG's, SAF	FMB
	MIERIS (The Elder) Franz Van b. Holland. 1635 - 1681 Genre & portrait artist Exh: France, Germany, NG, Britain, Holland	FR FR FR FR
	SKIPWORTH Frank Markham Fl. 1882 - 1916 Figure & portrait artist Exh: RA, SS, WG	FMS FMc
FN	**NERLY** Friedrich b. Germany. 1807 - 1878 Genre subjects Exh: Germany, Copenhagen	
	KONIG Franz Niklaus b. Bern. 1765 - 1832 Landscape artist Exh: Switzerland	FK
FO	**OVERBECK** Johann Friedrich b. Germany. 1789 - 1869 Biblical & historical subjects Exh: Germany, Italy, Russia, Austria	
	FIALETTI Odoardo b. Bologna. 1573 - 1638 Biblical & mythological subjects Exh: UK, Italy	Of
	OTTINI Felice b. Italy. ? - 1697 Historical subjects	F. O. F.
FP	**LIPPI** Filippo Di Tomaso b. Florence. 1406 - 1469 Religious subjects Exh: France, Germany, Italy, NG, US	FP
	PEGRAM Frederick b. 1870 - 1937 Genre subjects Exh: RA, London & Prov. AG's	F.P.

PILSEN **Frans** b. Belgium. 1700 - 1784 Religious subjects Exh: Belgium	*F.P*	FP
PROVIS **Alfred** Fl. 1843 - 1886 Interiors & genre subjects Exh: RA, BI, SS, VA	*AP*	
DUNOUY **Alexandre Hyacinthe** b. Paris. 1757 - 1841 Landscape artist Exh: France	*AD*	FQ
RAVESTEYN **Jan Anthonisz Van** b. The Hague. 1570 - 1657 Portrait artist Exh: Holland, France, Belgium, Germany, US, UK, etc.	*R*	FR
RECHBERGER **Franz** b. Vienna. 1771 - 1841 Landscape artist Exh: Austria	*FR*	
ROSAPINA **Francesco** b. Italy. 1762 - 1841 Genre subjects Exh: Italy	*FR*	
HUGHES, RWS **Edward Robert** b. London. 1851 - 1914 Historical & genre artist Exh: RA, BI, OWS, GG. Germany, Italy etc	*FRH*	
PICKERSGILL, RA **Frederick Richard** b. London. 1820 - 1900 Historical genre Exh: RA, BI, VA, UK AG's	*FRP*　　　*FRP(R.A.)*	
FRANCOIS **Simon** b. Tours. 1606 - 1671 Portraits etc	*F*　*F*　*F*	FS
SANDYS **Frederick** b. England. 1832 - 1904 Portrait & figure artist Exh: RA, UK, Melbourne	*FS*	

FS	**SANTAFEDE** **Francesco** b. Italy. 1519 - ? Religious subjects	
	SHIELDS **Frederick James** b. Hartlepool. 1833 - 1911 Genre, oil & watercolourist Exh: London & Prov. AG's	
	SIMON **Franz** b. Czechoslovakia. 1877 - Landscape artist Exh: Prague, Paris	
	SMALLFIELD. ARWS **Frederick** b. London. 1829 - 1915 Genre & portrait artist Exh: RA, SS, BI, NWS, OWS, GG & Prov. AG's	
	SOOLMAKER **Jan Frans** b. Antwerp. 1635 - 1685 ? Landscape & animal subjects Exh: Belgium, UK, Holland	
	STROOBANT **Francois** b. Brussels. 1819 - 1916 Architectural & landscape subjects Exh: Belgium	
	HARROP, FRSA, FSAM, MRST etc **Frederick Samuel** b. Stoke-on-Trent. 1887 - Oil & watercolourist Exh: RBA, London & Prov. AG's	
	SUSTRIS **Frederik** b. Italy. 1540 ? - 1599 Religious subjects Exh: Italy, Germany	
	WALKER. RHA **Francis S.** b. Ireland. 1848 - 1916 Genre & landscape artist Exh: RA, NWS, SS, London & Prov. AG's	
FT	**FRYE** **Thomas** b. Dublin. 1710 - 1762 Portrait artist Exh: NG & London & Prov. AG's.	

TAYLER **Frederick** b. Hertfordshire. 1804 - 1889 Figures, landscapes & sporting scenes Exh: RA, BI, OWS, etc.	F.T	FT
TAYLOR **Frederick** b. London. 1875 - ? Architectural & landscape artist Exh: UK AG's, Canada	FT	
CAROTTO **Giovanni Francesco** b. Verona. 1470 - 1546 Biblical & historical subjects	F 𝕴𝕮 M·D·X X I	
VALESIO **Francesco** b. Bologne. 1560 ? - ? Portraits & landscape artist	V	FV
DYCK **Floris van** b. Haarlem. 1575 - 1651 Still life artist Exh: Holland	ᵬ	
VALKENBORCH **Frederick** b. Antwerp. 1570 ? -1623 Genre & landscape subjects Exh: Holland, Germany, Norway	𝒱𝒲 1607	FW
WALKER **Frederick** b. London. 1840 - 1875 Genre & landscape artist Exh: RA, OWS, NPG, VA, London & Prov. AG's	FW FW F.W 1863	
WATKINS **Franklin C.** b. New York. 1894 - Landscape artist Exh: US AG's	F.W.	
WEENIX **Jan** b. Amsterdam. 1640 - 1719 Animals, birds, fruit, flowers, portraits & landscape subjects Exh: Russia, US, UK & European AG's	Ɉᵥ. Ɉᵥ	
WEIROTTER **Franz Edmund** b. Innsbruck. 1730 - 1771 Landscape artist Exh: Austria, Germany, Hungary	F.W.	

FW	**WEST, VP RWS** **Joseph Walter** b. Hull. 1860 - 1933 Genre & landscape artist Exh: UK AG's, Paris	
	WESTON **Florence** Figure, floral & landscape artist Exh: RBSA, London & Prov. AG's	
	WILLIAMSON **Frederick** Fl. London. 19th C. Landscape & animal subjects Exh: RA, NWS, GG, BI, SS, VA, Australia	*F. W*
	WOOLF **Michael Angelo** b. London. 1837 - 1899 Genre artist & caricaturist Exh: UK AG's	*F.W.*
	WULFHAGEN **Franz** b. Germany. 1624 - 1670 Portraits & religious subjects Exh: Germany	**F.W**
	WYNANTS **Jan** b. Haarlem. 1630 ? - 1684 Landscape artist Exh: International AG's	
	BURTON, RHA **Sir Frederick William** b. Ireland. 1816 - 1900 Portraits, genre, historical & landscape artist Exh: RA, OWS, London & Prov. AG's etc	*F.W.B*
	HULME **Frederick William** b. Swinton. 1816 - 1884 Landscape artist Exh: UK AG's, Canada	*FₘₕX* *F.W.H.*
	JACKSON, SSSBA **Frederick William** b. Nr. Manchester. 1859 - 1918 Landscape & marine artist Exh: RA, SS, UK AG's	*F.W.J.*

LAWSON **Francis Wilfred** Fl. 1867 - 1918 Landscapes & allegorical subjects Exh: RA, UK AG's	*FWL FWL*	**FW**
TOPHAM, RWS **Francis William** b. Leeds. 1808 - 1877 Genre subjects Exh: RA, BI, SS, VA, London & Prov. AG's	*[monogram] FWT*	
YATES **Frederick** b. 1854 - 1919 Landscape & portrait artist Exh: London & Prov. AG's	*F.Y. F.Y.*	**FY**
GROMAIRE **Marcel** b. France. 1892 - Portrait, figure & genre subjects Exh: France	*G*	**G**
GUNTHER **Matthaus Matha** b. Bisenberg. 1705 - 1788 Portraits & genre subjects Exh: Germany	*G. inv.*	
HOEFNAGEL (or HUFNAGEL) **George** b. 1542 - 1600 Miniaturist & portrait artist	*[monogram]*	
PERELLE **Gabriel** b. France. 1603 ? - 1677 Landscape artist Exh: Germany, France	*G*	
ALDEGREVER **Henry** b. Westphalia. 1502 - 1566? Portraits, biblical, historical & mythological subjects Exh: Germany, Hungary, France, UK, Ireland	*[monogram G]*	**GA**
ARMFIELD **George** Fl. London. 1840 - 1875 Canine subjects Exh: RA, BI, SS, UK AG's	*[monogram GA]*	
GENOELS (The Younger) **Abraham** b. Anvers. 1640 - 1723 Landscapes & mythological subjects etc; Exh: Holland, Belgium, France	*[monograms GA GA GA GA]*	

GLENDENING (Junior) RBA **Alfred** b. ? - 1907 Genre & landscape artist Exh: RA, SS, London & Prov. AG's etc	
GOODWIN, RWS, **Albert** b. Arundel. 1845 - 1932 Biblical, allegorical subjects. landscapes etc Exh: RA, OWS, London & Prov. AG's	
GOYDER **Alice Kirkby** b. Bradford. 1875 - ? Animal subjects. watercolourist Exh: RA, RI	
GRIMER (GRIMMER) **Abel** b. Anvers. 1573 - 1618 ? Religious, genre & landscape artist Exh: Holland, Belgium	
GODSON, MS, PAS **Ada Charlotte** b. Tenbury, Worcs. Painter in pastel & oil; miniaturist Exh: RA, PS, MS, PAS, RBA, RI etc	
GABBIANI **Antonio Domenico** b. Florence. 1652 - 1726 Historical & portrait artist Exh: France, Germany, Italy.	
GHISOLFI **Giovanni** b. Milan. 1632 ? - 1683 Architectural & historical subjects Exh: UK, Germany	
FRIPP, RWS **George Arthur** b. Bristol. 1813 - 1896 Landscape watercolourist Exh: UK AG's	
GOW, RA, RI **Andrew Garrick** b. London. 1848 - 1920 Portraits, genre, military & historical subjects Exh: RA, SS, NWS, GG, RI. Prov. AG's, S. Africa, Australia	
GREEN **Alfred H.** Fl. 1844 - 1862 Animal subjects Exh: RA, BI, SS	

LIST **Georg Nikolaus** b. Germany. ? - 1672 ? Portrait artist	
GELDER **Aart de** b. Dortrecht. 1645 - 1727 Historical & portrait artist Exh: France, Holland, Germany, Belgium, Russia, etc	
STEVENS. BA **George Alexander** b. London. 1901 - Portrait & landscape artist Exh: NEAC, London & Prov. AG's	
STOREY. ARA **George Adolphus** b. London. 1834 - 1919 Portrait & genre artist Exh: RA, SS, BI, NWS, Prov. AG's, Germany	
BEJOT **Eugene** b. Paris. 1867 - 1931 Landscape subjects etc. Exh: London, Paris	
BELOT **Gabriel** b. Paris. 1882 - Portrait & genre subjects Exh: France, Japan	
BONAVIA **George** Fl. London. 1851 - 1876 Genre & portrait artist Exh: RA, BI, SS	
BOTTINI **Georges** b. Paris. 1873 - 1906 Figures, nudes, genre & portrait artist Exh: France	
BOWDEN-SMITH **Daisy Beatrice** b. Gaya, India. 1882 - Watercolour & miniaturist Exh: RA, PS	
BRADSHAW **Gordon Alexander** b. Liverpool. 1931 - Landscape artist Exh: RA, RCA , London & Prov. AG's	

GA

GB

GB	**BRIARD** **Gabriel** b. Paris. 1729 - 1777 Biblical & mythological subjects Exh: Italy, France	*G. B 1759*
	BRUCE, RSPP **The Hon. George J.D.** b. London. 1930 - Portraits, land & seascapes & still life subjects	*signature*
	BARBER **Charles Burton** b. Yarmouth. 1845 - 1894 Genre, portraits & animal subjects Exh: RA, UK AG's	*G.B.B.*
	GODDARD **George Bouverie** b. Salisbury. 1832 - 1886 Animal & sporting subjects Exh: RA, WAG, etc	*G.B.G* *G.B.G.* *G.B.G*
	MAGANZA **Giovanni Battista** b. Italy. 1513 ? - 1586 Portraits & religious subjects Exh: Italy	*G B M I*
	POCOCK **Geoffrey Buckingham** b. London. 1879 - ? Portraits, architectural, & landscape subjects Exh: RA, ROI, NEAC, Prov. AG's	*GBP*
	BORCH **Gerard** b. Zwolle. 1617 - 1681 Genre & portrait artist Exh: Holland, Hungary, Germany, Russia, France etc	*GTB*
GC	**CARPIONI** **Giulio** b. Venice. 1611 - 1674 Historical & mythological artist Exh: Hungary, Germany, Italy, UK	*GC inv.* *G C.*
	CATTERMOLE **George** b. Norfolk. 1800 - 1868 Genre, historical, architectural & landscape artist Exh: RA, OWS, BI, & European AG's etc	*GC* *GC* *G.C.*
	COURBET **Gustave** b. France. 1819 - 1877 Portraits, genre & landscape artist Exh: UK & European AG's etc	*G.C.*

630

CROOK **Gordon Stephen** b. Richmond, Surrey. 1921 - Exh: London & Prov. AG's & US		GC
GELLEE (or LORRAINE) **Claude** b. France. 1600 - 1682 Marine & landscape artist Exh: UK & European AG's, Russia		
GREGORY, RWS **Charles** b. Surrey. FL. 19th - 20th C. Genre & historical subjects Exh: RA, SS, OWS. Prov. AG's, Australia		
CRESWELL **Emily Grace** b. Leicester. 1889 - Portraits & miniaturist etc Exh: RBSA etc		
HAITÉ, ROI, RI, SS **George Charles** b. Kent. 1855 - 1924 Landscape oil & watercolourist Exh: RA, RSBA, ROI, London & Prov. AG's		
GERE, RWS **Charles March** b. Leamington. 1869 - 1957 Portrait & landscape artist Exh: SS, London & Prov. AG's		
THOMAS. ARBSA **Charles** b. Birmingham. 1883 - Pastel, oil, watercolourist, etc. Exh: RA & Prov. AG's		
CAROLUS-DURAN **Charles Emile Auguste Durand** b. Lille. 1838 - 1917 Portraits, historical & genre subjects Exh: Italy, France		GD
DECKER **Cornelis Gerritsz** b. Haarlem. ? - 1678 Landscape artist Exh: UK * European AG's		

DILLIS **George von** b. Germany. 1759 - 1841 Portrait & landscape artist Exh: Germany	
DITTENBERGER **Gustav** b. Germany. 1794 - 1879 Miniaturist, genre & historical artist	
DORE **Paul Gustave Louis Christophe** b. Strasbourg. 1832 - 1883 Portraits, historical, allegorical, land- scapes & genre subjects etc Exh: European AG's etc	
DRUMMOND **Gordon L.T.** b. Sale, Cheshire. 1921 - Watercolour & miniaturist. Exh: RWS, RI; London & Prov. AG's	
DUGHET **Gaspard** b. Rome. 1615 - 1675 Landscape artist Exh: UK & European AG's etc	
GIBSON **David-Cooke** b. Edinburgh. 1827 - 1856 Genre subjects Exh: Belgium, France, RA	
AMOUR **George Denholm** b. 1864 - 1934 Sporting genre Exh: RA	
HEUSCH **Guilliam de** b. Utrecht. 1638 - 1692 Landscape artist Exh: European AG's	
HONDECOETER **Gillis de** b. Antwerp. ? - 1638 Portraits, birds & landscape artist Exh: France, Holland, Germany etc	
LESLIE, RA **George Dunlop** b. London. 1835 - 1921 Genre & landscape artist Exh: UK AG's, France, Germany Australia	

WITTE **Gaspar De** b. Antwerp. 1624 - 1681 Landscape artist Exh: Belgium, Germany, Hungary, France, etc.	G.D.W	GD
GOULDSMITH, RWA, RBA **Edmund** b. England. 1852 - 1932 Portrait & landscape artist Exh: London & prov. AG's	G.	GE
BROCK **Charles Edmond** b. London. 1870 - 1938 Genre & portrait artist Exh: RA, UK AG's	CEB	
HICKS, RBA **George Elgar** b. Lymington. 1824 - 1914 Portrait, domestic, biblical & historical genre Exh: RA, BI, SS, GG, S. Africa	G.E.H. GEH GEH G.E.H.	
GOODALL, RA, **Frederick** b. London. 1822 - 1904 Landscapes, genre, biblical & Egyptian subjects Exh: RA, France, Germany, Australia, London & Prov. AG's	G G G G G	GF
GRIMALDI **Giovanni Francesco** b. Italy. 1606 - 1680 Religious & landscape subjects Exh: France, Hungary, Italy, Austria	G F G	
GRIGGS **Frederick Landseer Maur** b. Hitchin. 1876 - 1938 Landscapes & architectural subjects Exh: BM, London & Prov. AG's	FL	
REYNOLDS **Frederick George** b. 1828 - 1921 Landscape artist Exh: London & Prov. AG's	FR	
WATTS. OM, RA, HRCA **George Frederick** b. London. 1817 - 1904 Portraits & historical subjects Exh: RA, VA, NG, NPG, Prov. AG's, US, Germany, France, etc.	GFW G.F.W 1850	
WETHERBEE. RI, ROI **George Faulkner** b. Cincinnati. 1851 - 1920 Genre, landscape & mythological subjects Exh: RA, NG, GG, NWS, SS, S. Africa, etc.	GFW	

GG	**GARDINER, ARCA** **Gerald** b. 1902 - Artist in oil media Exh: RA, RSA, NEAC & Prov. AG's		
	GELDORP **Gortzius** b. 1553 - 1618 Historical & portrait artist Exh: Holland, Germany, Hungary, UK, Italy etc		
	GOLDIE **Charles** b. London. FL. 19th C. Portrait, genre & historical subjects Exh: RA, BI, SS		
	GRIFFITHS **Gwenny** b. Swansea. 1867 - ? Portrait artist Exh: RA, PS, WAG, RP, London AG's, Hungary etc		
	MANNOZI **Giovanni** b. Italy. 1592 — 1636 Portraits, mythological, historical & genre subjects Exh: France, Italy		
	PERKINS **Charles C.** b. Boston. 1823 - 1886 Painter & engraver		
	FRASER **George Gordon** Fl. 1880 - 1893 Landscape artist Exh: RA, UK AG's		
	GUERARD **Henri Charles** b. Paris. 1846 - 1897 Portraits & genre subjects Exh: UK, France		
	KILBURNE **George Goodwin** b. Norfolk. 1839 - 1924 Genre & sporting subjects Exh: RA, SS, NWS, GG, Prov. AG's Australia		
GH	**CHARDIN** **Jean Baptiste Simeon** b. Paris. 1699 - 1779 Genre, still life & portraits etc. Exh: UK & European AG's etc		

HARDORFF (The Elder) **Gerold** b. Germany. 1769 - 1864 Portraits & historical subjects Exh: Germany	
HARVEY, PRSA **Sir George** b. 1806 - 1876 Genre, historical & landscape artist Exh: RA, BI, SS, London & Prov. AG's	
HAY **George** b. Leith. 1831 - 1913 Genre subjects Exh: London & Prov. AG's	
HITCHCOCK **Georges** b. Paris. 1850 - 1913 Genre & landscape artist Exh: US, Paris, Germany, Austria	
HOBBEMA **Meyndert** b. Amsterdam. 1638 - 1709 Landscape artist Exh: UK & European AG's etc	
HONTHORST **Gerrit van** b. Utrecht. 1590 - 1656 Portraits & historical subjects etc Exh: UK, Italy, Hungary, Holland, France, Switzerland, Germany etc	
HUQUIER **Gabriel** b. Orleans. 1695 - 1772 Genre artist Exh: France	
BOUGHTON, RA **George Henry** b. Nr. Norwich. 1833 - 1905 Portrait, figure, landscape, historical & sporting subjects Exh: RA, BI, GG, NG, London & Prov. AG's	
HASTIE, SWA **Grace H.** Fl. 19th C. Floral subjects Exh: RA, SS, NWS, SWA	
HENDRIQUEZ de CASTRO **Gabriel** b. Amsterdam. 1808 - ? Still life & floral subjects	

GH	**WILLIAMS** **George Augustus** b. 1814 - 1901 Coastal, landscape & moonlight scenes Exh: RA, BI, London & Prov. AG's etc.	
GI	**GIMIGNANI** **Giacinto** b. Italy. 1611 - 1681 Biblical & historical subjects Exh: Italy	
	GOEIMARE **Joos** b. 1575 - 1610 Animal & landscape artist	
	GRUNER **Wilhelm Heinrich Ludwig** b. Dresden. 1801 - 1882 Genre & Portrait artist	
GJ	**GILBERT, RA, PRWS** **Sir John** b. London. 1817 - 1897 Historical subjects Exh: RA, BI, SS, OWS, London & Prov. AG's etc	
	GRANT **Duncan James** b. Nr. Inverness. 1885 - Portrait, still life & landscape artist Exh: Paris, London & Prov. AG's	
	GRANT **William James** b. London. 1829 - 1866 Genre & historical subjects Exh: RA	
	JOY **George William** b. Dublin. 1844 - 1925 Floral, genre & historical subjects Exh: RA, PS, France	
	DENMAN **Gladys** b. Hampstead. 1900 - Portrait, landscape artist & miniaturist Exh: RP, RWA, SWA, RMS, SM, RI	
	JAMES, RWS **Francis Edward** b. Willington. 1849 - 1920 Floral & landscape artist Exh: RWS, SS, UK AG's	

636

HONTHORST **Gerrit van** b. Utrecht. 1590 - 1656 Portraits & historical subjects etc Exh: UK, Italy, Hungary, Holland, France, Switzerland, Germany etc	*GH*	*GH*	*GH*	GJ
PINWELL. RWS **George John** b. High Wycombe. 1842 - 1875 Genre & historical watercolourist Exh: OWS, London & Prov. AG's Australia	*CJP*	*PG*		
TARRATT **John Garfield** Figure & landscape subjects etc. Exh: WAG, RSA, London & Prov. AG's	*JTG*	*JTG*		
GODWARD **John William** Fl. 1887 - 1909 Genre, figures & oriental subjects Exh: RA, UK AG'S	*JWG*	*JWG*	*JWG*	
KELLER **Georg** b. Frankfurt. 1568 - 1640 Historical & landscape subjects Exh: Germany	*GK*			GK
KOEDYCK **Isaac** b. Holland. 1616 - 1668 Genre & interior scenes Exh: Lille, Holland, Leningrad, Anvers	*CK*			
KARG **Georg** b. Germany. FL. 17th C. Portrait artist Exh: Germany	**G·K·P·**			
GANDOLFI **Gaetano** b. 1734 - 1802 Historical & mythological subjects Exh: Italy	*LL* *Tr etfec*			GL
GASSNER **Simon** b. Steinberg. 1755 - 1820 Historical & landscape artist Exh: Germany	*GL*			
GREVEDON **Pierre Louis** b. Paris. 1776 - 1860 Portrait artist Exh: France, Italy	*G*	*G*	*G*	

LAIRESSE Gerard de b. Liege. 1641 - 1711 Historical & portrait artist Exh: France, Germany, Holland	*G de L* *G de L*	

GL

LALLEMAND Georges b. Nancy. 1575 - 1635 Historical subjects	

LANCE George b. Essex. 1802 - 1864 Still life, floral, genre & historical subjects Exh: RA, BI, SS, VA, UK AG's	*G L.1851.*

LEEUW Gabriel Van Der b. Dordrecht. 1645 - 1688 Hunting scenes & landscapes Exh: Stockholm. Vienna	*G.L.*

LUNDENS Gerrit b. Holland. ? - 1677 ? Miniature protraits & genre subjects Exh: Holland, Germany, London, Rome	

MESSIN Charles b. Nancy. 1620 - 1649 ? Historical subjects Exh: France	

LISLE. RDS, Mem.WIAC, WGA Georginia Lucy De b. London Miniaturist, oil, watercolour & pastel media Exh: RA, PS, WAG, ROI, WIAG	

HARRISON George L. Fl. 19th C. Genre subjects Exh: RA, Prov. AG's	*G.L.H.*

LUMSDEN, RSA Ernest Steven b. London. 1883 - Landscape artist & watercolourist Exh: UK AG's	*GL____1931*

STAMPA George Loraine b. Constantinople. 1875 - 1951 Figure & portrait artist Exh: London & Prov. AG's	*G.L.S.*

CLEMENTS **Astell Maude Mary** b. Canterbury. 1878 - ? Miniaturist & watercolourist Exh: PS, RA	
MANSON **George** b. Edinburgh. 1850 - 1876 Landscape artist Exh: UK AG's	
MOIRA, VP, RWS **Gerald Edward** b. London. 1867 - 1959 Mural, figure & landscape artist Exh: RA, London & Prov. AG's	GM GM
MOSTAERT (The Elder) **Gillis** b. Holland. 1534 ? - 1598 Landscape artist Exh: Belgium, France, Austria, Scandinavia, etc.	
GREENE **Mary Charlotte** b. Essex. 1860 - ? Landscape artist Exh: RA	
MAN **Cornelis Willems De** b. Delft. 1621 - 1706 Portrait & genre subjects Exh: Holland, Germany, France, Budapest	
FORSYTH, ARCA, RI, FRSA **Gordon M.** b. 1879 - 1952 Exh: RA, RI & Prov. AG's	
MITELLI **Giuseppe Maria** b. Bologna. 1634 - 1718 Biblical & historical subjects	
HARDIE, RSA **Charles Martin** b. Edinburgh. 1858 - 1916 Genre, historical subjects Exh: RA, RSA, Paris, Australia	CMH CMH C.M.H
GOENUETTE **Norbert** b. Paris. 1854 - 1894 Genre, landscape & Parisian scenes Exh: France.	

GM

GN

GAREIS **Pius** b. Germany. 1804 - ? Portraits & historical subjects	
GERKE **Johann Philipp** b. Cassel. 1811 - ? Historical subjects Exh: Germany	
PALMA (IL GIOVANE) **Jacopo** b. Venice. 1544 - 1628 Biblical, mythological & historical subjects Exh: UK & European AG's	
PATTEN, ARA **George** b. 1801 - 1865 Portrait, historical & mythological subjects Exh: RA, VA, NPG, UK AG's, Italy	
PENCZ **Georges** Fl. Nuremberg. 1500 — 1550 Portraits & religious subjects Exh: Germany, France, Italy, Sweden	
PERRIER **Guillaume** b. France. 1600 ? - 1656 Portraits & religious subjects Exh: France	
PHILPOT, RA **Glyn Warren** b. 1884 - 1937 Figure, portrait, genre & eastern subjects Exh: RA, UK AG's	
POPE **Gustav** b. 1852 - 1895 Portrait, genre & historical subjects Exh: UK AG's	
JACOMB-HOOD, RPE, MVO, RBA **George Percy** b. Surrey. 1857 - 1929 Portrait, genre & historical subjects Exh: RA, SS, GG, NG, PS, NEAC etc	
CAMPAGNOLA **Domenico** b. Padua. 1484 - 1550 Mythological, historical & landscape artist	

GALLON **Robert** b. London. 1868 - 1903 Landscape artist Exh: RA, BI etc			**GR**
GATEHOUSE, ALAA **Rosalind** Flourished 20th Century Watercolourist Exh: RA, R. Cam.A, WAG			
PELLY. ALAA **Rosalind** Watercolourist Exh: RA, R.Cam.A., WAG. etc.			
RADEMAKER **Gerrit** b. Amsterdam. 1672 - 1711 Historical & portrait artist Exh: Holland			
REICHMANN **Georg Friedrich** b. Germany. 1798 - 1853 Historical & portrait studies Exh: Germany			
RENI **Guido** b. Italy. 1575 - 1642 Religious & historical subjects Exh: France, Italy, Germany, UK, US, Scandinavia			
RHEAD **George Woolliscroft** b. 1855 - 1920 Genre subjects Exh: London & Prov. AG's			
RICARD **Louis Gustave** b. Marseille. 1823 - 1873 Portraits & still life subjects Exh: France, US, UK			
RICHMOND, RA **George** b. Brompton. 1809 - 1896 Portraits & historical subjects Exh: RA, VA, NPG, UK AG's			

GR	**RINGGLI** **Gotthard** b. Zurich. 1575 - 1635 Historical subjects Exh: Switzerland	*GR* monograms
	ROBERTSON **Walford Graham** b. 1867 - 1948 Portrait & landscape artist Exh: London & Prov. AG's	*RG* monograms
	COOPER, D.Sc., Ph.D, B.Sc., Del, **George Ralph ARPS, FRSA** b. Aylmerton. 1909 - Oil & watercolourist Exh: RA, ROI, RIBA etc	*GRC* monogram
GS	**SCHALCKEN** **Godfried** b. Dortrecht. 1643 - 1706 Portraits & genre subjects Exh: European AG's, UK	*G pinxit Gs.f.*
	SHALDERS **George** b. 1826 - 1873 Figure & landscape artist Exh: UK AG's	*GS*
	SWANENBURGH **Willem Isaaksz** b. Holland. 1581 - 1612 Historical & portrait artist	*GS* monograms
	ELGOOD, RI **George S.** b. Leicester. 1851 - 1935 Genre & landscape artist Exh: FAS, SS, RI, Prov. AG's, Australia	*G.S.E.*
	FLETCHER **Geoffrey Scowcroft** b. Bolton. 1923 - B/White drawings, portraits & land- scapes Exh: RA, NEAC	*GSF*
	WALTERS. RBA **George Stanfield** b. Liverpool. 1838 - 1924 Marine & landscape artist Exh: RA, SS, NWS, BI, London & Prov. AG's	*G S. W*
GT	**FRASER (the Elder), ARSA** **Alexander George** b. Edinburgh. 1786 - 1865 Genre, historical & landscape artist Exh: RA, ARSA, UK AG'S, US	*GF* monogram

GREEN Henry Towneley b. England. 1836 - 1899 Oil & watercolourist Exh: RA, RI, RBA, London & Prov. AG's etc	
TREW Cecil G b. Bristol. 1897 - B/white & watercolourist Exh: RWEA, BMA, VA, Prov. AG's, France, etc.	
GIRODET de ROUCY TRIOSON Anne Louis b. France. 1767 - 1824 Historical subjects, portraits etc Exh: France, Belgium, Switzerland	
GALLOWAY, FMA Vincent b. Hull. 1894 - Portrait artist Exh: RP	
SHORT, RA Sir Frank b. London. 1857 - 1945 Landscape oil & watercolourist Exh: RA, VA, UK AG's, France	
VANNI Giovanni Battista b. Italy. 1599 - 1660 Religious subjects Exh: Italy	
VENENTI Giulio Cesare b. Bologna. 1642 - 1697 Painter & engraver	
KUGELGEN Franz Gerhard von b. Germany. 1772 - 1820 Religious, historical & portrait subjects Exh: Russia, Germany	
CONINXLOO Gillis 111 van b. Anvers. 1544 - 1607 Landscapes & historical subjects Exh: Holland, Denmark, Germany, Russia, Austria	
NYMEGEN Gerard Van b. Rotterdam. 1735 - 1808 Landscape & portrait artist	

GT

GV

GV	**SCHMIDT** **George Adam** b. Dordrecht. 1791 - 1844 Genre subjects Exh: Holland, Germany	*G.v.S.*
	WITTEL **Gaspare Van** b. Utrecht. 1653 - 1736 Architectural & landscape subjects Exh: France, Italy, Spain, Austria	G.V.W G.V.W
GW	**GALE** **William** b. London. 1823 - 1909 Portraits, Oriental, mythological, religious & historical subjects Exh: RA, SS, BI & Prov. AG's	*monogram*
	GILES **William** b. Reading. 1872 - Genre & landscape artist Exh: RA, BM, Prov. AG's	*monograms*
	GOODMAN **Walter** b. London. 1838 - ? Genre & portrait artist Exh: RA, UK AG's	*monogram*
	GROSSMITH **W. Weedon** Fl. 1875 - 1890 Genre & portrait artist Exh: RA, SS, London & Prov. AG's	*monogram*
	WAINWRIGHT, RWS **William John** b. Birmingham. 1855 - 1931 Portraits, genre & historical subjects Exh: OWS, UK AG's, Paris	*signature*
	WHITE **Gleeson** b. 1851 - 1898 Painting & decorative art Exh: London & Prov. AG's	G.W. GW
	WILSON. MC **Capt. George** b. Lille. 1882 - B/white, oil & watercolourist Exh: RA, RP, NEAC, WAG, etc.	*monogram*
	WOUTERS **Gomar** b. Antwerp. 1649 ? - ? Historical subjects	G W.

WOUWERMAN **Pieter** b. Haarlem. 1623 - 1682 Battles, military subjects & landscapes Exh: Belgium, Austria, Russia, Holland, Germany, France, UK, etc.		GW
BIRD **Mary Holden** Landscape watercolourist Exh: RA, RI, RSW, RBA, PS		H
FAIRHURST, FRIBA **Harry Smith** b. Blackburn Oil & watercolourist Exh: RA, London & Prov. AG's		
GILCHRIST **Herbert H.** Fl. London 19th C. Portraits, genre & historical subjects Exh: RA, UK AG'S, Germany		
HATT **Doris Brabham** b. Bath. 1890 - B/White, & oil media etc Exh: NEAC, NPS, RA, US & European AG's		
HITCHCOCK **Harold** b. London. 1914 - Imaginary & visionary landscapes with figures. oil, acrylic & water- colourist. Exh: RA, US, London & Prov. AG's		
HONDIUS (The Younger) **Hendrik** b. Amsterdam. 1597 ? 1644 ? Portraits, genre & landscape artist		
HOWD **Michael** b. US. Painter in B/White & tempera media Exh: RA & US AG's		
HUYSUM (The Younger) **Justus van** b. Amsterdam. 1684 - 1707 Military subjects Exh: Holland		
MEMLING **Hans** b. Mayence. 1430 ? - 1494 Portraits, religious & historial subjects Exh: Belgium, UK, US, Italy, Germany		

HA	**ADAM** **Heindrich** b. Nordlingen. 1787—1862 Landscape artist Exh: Germany	*HA 1832*
	ASPER **Hans John** b. Zurich 1499 - 1571 Portraits, game & still life & landscape subjects Exh: Germany	*HA*
	AVERCAMP **Henri van** b. Amsterdam 1585 - 1663? Landscapes, marine & animal subjects Exh: Holland, Germany, Hungary, Italy, UK etc	*HA HA HA*
	GOES **Hugo van der** b. Gand. 1420 ? - 1482 Religious subjects & miniatures Exh: Holland, Germany, Italy, UK, Russia, France, Austria	*VA R*
	HANNAN, MA, ATD, FMA **Andrew** b. Glasgow. 1907 - Painter in oil media	*AH*
	HOPFGARTEN **August Ferdinand** b. Berlin. 1807 - 1896 Genre & historical subjects Exh: Germany	*18 AH 30 Roma.*
	ECKERT **Henri Amros** b. Germany. 1807 - 1840 Battle scenes, marine subjects etc Exh: Germany	*HAE*
	HENDERSON, RBA, FSA, FRIBA **Arthur Edward** b. Aberdeen. 1870 - 1956 Architectural subjects Exh: RA, RBA etc	*AH*
HB	**BOCK (the elder)** **Hans** b. Alsace. 1550 ? - 1624 Portraits & genre subjects	*HB 1591 HB.*
	BOL **Hans** b. Malines. 1534 - 1593 Landscape artist & miniaturist Exh: Germany, France, Sweden	*HB*

BORSSOM **Anthonie van** b. 1630 ? - 1677 Landscapes etc Exh: Holland, Hungary, UK, Germany	
BRIGHT, RWS **Henry** b. Suffolk. 1814 - 1873 Landscape artist Exh: RA, UK AG's, Canada	
BROSAMER **Hans** b. 1506?- 1554? Portraits & religious subjects Exh: Austria, Germany etc	
BRUYN **Bartholomaeus** b. 1493 - 1553 ? Historical & portrait artist Exh: Germany, Belgium, Austria, UK, France	
HUCHTENBURG **Jan van** b. Haarlem. 1647 - 1733 Military subjects Exh: Holland, Belgium, France, London	
BRABAZON **Hercules B.** b. Paris. 1821 - 1906 Landscape watercolourist Exh: NEAC, UK AG's	
BERCKMAN **Hendrick** b. 1629 - 1679 Portrait artist Exh: Holland	
BISCHOFF **Henry** b. Lausanne. 1882 - Oil media artist & engraver Exh: US, Switzerland, Germany, France, Sweden etc	
BALEN (The Elder) **Hendrik van** b. Antwerp 1575 ?- 1632 Religious, allegorical & mythological subjects Exh: Holland, France, Belgium, Germany, Italy, UK etc.	
ROBERTS. RI, RBA **Henry Benjamin** b. Liverpool. 1832 - 1915 Figure & genre artist Exh: RA, SS, NWS, BI, etc.	

HB	**BREWER** **Henry William** b. Oxford ? - 1903 Churches & Church interiors Exh: RA, SS, BI	
	WAROQUIER **Henry De** b. Paris. 1881 - Still life, genre & landscape artist Exh: Paris	
HC	**CAMERON** **Hugh** b. Nr. Edinburgh. 1835 - 1920 Genre subjects Exh: UK AG's	
	CARTER **Hugh** b. Birmingham. 1837 - 1903 Portraits, genre & landscape artist Exh: RA, RI, NG, VA	
	CASSON **Hugh Maxwell** b. London. 1910 - Watercolourist Exh: RA, RCA, London & Prov. AG's	
	CONNARD **Philip** b. Southport 1865 (1875?) - 1958 Landscape, marine & portrait artist Exh: RA, UK AG's	
	COULDERY **Horatio Henry** b. London. 1832 - ? Animals & genre subjects Exh: RA, London & Prov. AG's, BI, SS	
	HAINZMAN **Karl Friedrich** b. Stuttgart. 1795 - 1846 Landscape artist Exh: Germany	
	HAMMOND **Gertrude Demain** b. London. ? - 1952 Genre watercolourist Exh: RA, SS, NWS, Paris	
	HERDMAN, ARSA **Duddington** b. 1863 - 1922 Genre & portrait artist Exh: RA, UK AG'S	

HESS **Carl** b. Dusseldorf. 1801 - 1874 Genre, animals & landscape artist Exh: Germany	
HESS **Heinrich Maria von** b. Dusseldorf. 1798 - 1863 Historical artist Exh: Germany	
HOFF (The Younger) **Carl Heinrich** b. Dusseldorf. 1866 - 1904 Genre & portrait artist	
HUNTER, ARA, RI, RSW **Colin** b. Glasgow. 1841 - 1904 Coastal, sea & landscape artist Exh: RA, London & Prov. AG's	
BINCK **Jakob** b. Cologne. 1500? - 1569 Portrait artist	
SAFTLEVEN **Herman** b. Rotterdam. 1609 ? - 1685 Landscape artist Exh: France, Holland, Germany, Hungary, UK, etc.	
HORSLEY **Hopkins Horsley Hobday** b. Birmingham. 1807–1890 Landscape artist Exh: RA, BI, SS	
CALDERON, RA **Philip Hermogenes** b. Poitiers. 1833 - 1898 Genre & historical subjects Exh: RA, UK AG's, Germany	
HARPER, RBSA **Edward Steel** b. 1878 - 1951 Landscape artist Exh: London & Prov. AG's	
CLEVE **Hendrick 111 van** b. Anvers. 1525 - 1589 Landscape artist	

HC	**WHAITE, RWS, PRCamA** **Henry Clarence** b. Manchester. 1828 - 1912 Genre & landscape artist Exh: RA, RI, SS, OWS, UK AG's	H.C.W.
HD	**DAUMIER** **Honore** b. Marseilles. 1808 - 1879 Portraits, genre subjects etc Exh: European & US AG's	h.D. h.D. h.D. h.D. h.D. h.D. h.D. h.D. h.D. H.D.
	DAWSON **Henry** b. Hull. 1811 - 1878 Marine & landscape artist Exh: RA, BI, SS, London & Prov. AG's	HD
	DELL **John H.** b. 1836(?) - 1888 Genre, animals, landscapes Exh: RA. BI, UK AG'S	D/69
	DICKSEE **Herbert Thomas** b. London. 1862 - 1942 Animal & historical subjects Exh: RA	HD
	DUBORDIEU **Pieter** b. France. ? - 1679 ? Portrait artist Exh: Germany, Holland, France	HD.
	HARDING **Dorothea** b. London. 1898 - Genre, landscapes & miniaturist Exh: Paris	D H
	DALEM **Hans van** FL. 17th C. Portrait artist Exh: Austria, Germany, France	HD.Df 1·48
	FOSSATI **Davide Antonio** b. 1708 - 1780 Historical & landscape artist	ADf:

ERMELS **Johann Franciscus** b. Germany. 1621 - 1693 Portrait, still life, historical & land- scape subjects etc Exh: Germany, Italy, Austria		**HE**
HALLION **Eugene** b. France. 1832 - ? Landscape artist Exh: PS		
HAMMAN **Edouard Jean Conrad** b. Ostend. 1819 - 1888 Historical & genre subjects Exh: Belgium, Holland, France		
HEERE **Lukas de** b. Gand. 1534 - 1584 Portraits & historical subjects Exh: UK, Scandinavia etc		
HEILMAIER **Emil** b. Germany. 1802 - 1836 Landscape artist		
HERDMAN, RSA, RSW **Robert** b. Rattray. 1829—1888 Genre, historical & portrait artist Exh: RA, Paris, US, Australia, UK AG's		
BODDINGTON **Edwin Henry** Fl. 1853 - 1867 Landscape artist Exh: RA, BI, SS, UK AG's		
HALS (The Elder) **Frans** b. Anvers. 1580 ? - 1666 Portraits, genre & historical subjects Exh: Russia, UK & European AG's		**HF**
HERLIN (The Elder) **Friedrich** b. Germany. 1435 - 1500 ? Historical subjects Exh: Germany		

FOX, SSSBA Henry Charles b. 1860(?) - 1922 Landscape artist Exh: RA, SS, Canada, Australia	
FISHER Alfred Hugh b. London. 1867 - 1945 Landscapes & architectural subjects Exh: RA, SS, NWS, London & Prov. AG's, Paris	
FLORIS Frans 1 b. Anvers. 1516 - 1570 Portraits & historical subjects etc Exh: Germany, Italy, France, UK, Sweden etc	
FRANCKEN (The Elder) Hieronymus 1 b. 1540 - 1610 Religious & historical subjects Exh: France, Belgium, Austria etc	
FORD Henry Justice b. 1860 - 1941 Romantic & historical subjects Exh: RA, FAS	
FRISTON David Henry Fl. London mid 19th C. Figure painter Exh: RA	

GLENDENING (Junior) RBA Alfred b. ? - 1907 Genre & landscape artist Exh: RA, SS, London & Prov. AG's etc	
GOLTZIUS Hendrik b. Mulbrecht. 1558 - 1616 Historical & mythological subjects etc Exh: Holland, Germany, Russia, France, Austria etc	
GOLTZIUS Hubert b. 1526 - 1583 Historical subjects Exh: France, Switzerland	
GUDIN Jean Antoine Theodore b. Paris. 1802 - 1880 Marine & landscape artist Exh: RA, Holland, France, Germany, Belgium etc	

HAY George b. Leith. 1831 - 1913 Genre subjects Exh: London & Prov. AG's		HG
HAITÉ, ROI, RI, SS George Charles b. Kent. 1855 - 1924 Landscape oil & watercolourist Exh: RA, RSBA, ROI, London & Prov. AG's		
HARDEN, ARCA Gerald A.C. b. Nr. Cheltenham. 1909 - B/White, oil & watercolourist etc Exh: RA, London & Prov. AG's		
HARTUNG Heinrich b. Coblentz. 1851 - 1919 Landscape artist Exh: Germany		HH
HEMESSEN Jan Sanders b. Nr. Anvers. 1504 - 1566 Genre & historical subjects Exh: Holland, Germany, Hungary, Russia, Spain etc		
HERKOMER, RA, RWS, RI Sir Hubert von b. Bavaria. 1849 - 1914 Portrait, genre, historical & landscape artist Exh: RA, SS, OWS, RI, GG, NG, Germany, France, Holland etc		
HOLBEIN (The Younger) Hans b. Augsbourg 1497 ? - 1543 Portraits & historical subjects Exh: France, Switzerland, UK, Spain, Belgium etc		
HUBBARD Eric Hesketh b. London. 1892 - 1957 Genre, architectural & landscape artist Exh: UK AG's		
JACOMB-HOOD, RPE, MVO, RBA George Percy b. Surrey. 1857 - 1929 Portrait, genre & historical subjects Exh: RA, SS, GG, NG, PS, NEAC etc		
MEMLING Hans b. Mayence. 1430 ? - 1494 Portraits, religious & historical subjects Exh: Belgium, UK, US, Italy, Germany		

HH	**HOLLAND** James b. Burslem. 1800 - 1870 Landscapes & architectural scenes Exh: RA, RI, BI, London & Prov. AG's, Canada, US	
	FREEMAN William Henry b. Paris. Fl. 19th C. Portrait artist Exh: PS	
	HATTON Helen Howard b. 1860(?) - 1935 Figure painter Exh: RA, SS, NWS	H.H.H.
	LA THANGUE RA Henry Herbert b. England. 1859 - 1929 Rustic genre & landscape artist Exh: RA, SS, GG, NG, NEAC etc.	H·H·L·
HI	**HEYDEN** Jacob van der b. Strasbourg. 1573 - 1645 Portraits & landscapes & mythological subjects	
	HOSKINS (The Elder) John b. England. ? - 1664 Portrait artist & miniaturist	
	IRVING, OBE, RDI Laurence Henry Forster b. 1897 - Exh: RA, FAS, London & Prov. AG's etc	
	HOYTON, FRSA Inez Estella Artist in oil, watercolour media etc Exh: RA, London & Prov. AG's	
HJ	**HENDERSON, RSW** Joseph b. Perthshire; 1832 - 1908 Genre, portrait & marine artist Exh: RA, SS, RSW, UK AG'S	
	HOLLAND John Fl. Nottingham 19th C. Landscape artist Exh: BI, UK AG's	

HOOK, RA, HFRPE **James Clarke** b. London. 1819 - 1907 Historical, rustic genre, sea & landscape artist Exh: RA, BI, London & Prov. AG's, Australia	
HOOPER John Horace Fl. London 19th C. Landscape artist Exh: SS, UK AG's	
JOHNSON, RI **Harry John** b. Birmingham. 1826 - 1884 Landscapes & genre subjects Exh: RA, BI, SS, NWS etc	
JUTSUM Henry b. London. 1816 - 1869 Genre & landscape artist Exh: RA, NWS, BI, VA, Prov. AG's	
HAGGIS John b. London. 1897 - Portrait, figure & landscape artist Exh: RA, RPS, PS, WAG, ROI, RSA, NEAC, RWEA etc. Prov. AG's	
WOODWARD **Thomas** b. Pershore. 1801 - 1852 Portraits, genre, animals & sporting subjects Exh: RA, BI, London & Prov. AG's	
DRAPER Herbert James b. London. 1864 - 1920 Genre, classical & mythological subjects Exh: RA, NG, UK AG's, Paris	
DUNZ Johannes b. 1644 - 1736 Portrait & still life subjects Exh: Switzerland	
HERTERICH **Heinrich Joachim** b. Hamburg. 1772 - 1852 Painter, lithographer & miniaturist	
JOHNSTON **Sir Harry Hamilton** b. London. 1858 - 1927 Portrait, figure, animal & landscape artist Exh: RA, Prov. AG's	

HJ	**PHILLIP. RA** **John** b. Aberdeen. 1817 - 1867 Scottish & Spanish genre subjects Exh: RA, RSA, BI, SS, London & Prov. AG's	
	ERNLE, SM **The Lady Barbara** Miniaturist Exh: RA, RBA	
HK	**CORBOULD** **Edward Henry** b. London. 1815 - 1915 Genre & historical subjects Exh: RA, SS, GG, NWS	
	HAGEDORN, RBA, RSMA, NEAC etc **Karl** b. Berlin. 1889 - Oil & watercolourist Exh: Paris, London & Prov. AG's	
	HEEMSKERK (The Elder) **Egbert van** b. Haarlem. 1610 - 1680 Genre, rustic interiors etc Exh: France, Italy, UK	
	KING, SSSBA **Haynes** b. Barbados. 1831 - 1904 Genre & landscape artist Exh: RA, BI, SS	
	KOENE **Jean** b. Belgium. 1532 - 1592 Historical & genre subjects Exh: Belgium	
	KULMBACH **Hans Suess von** b. Germany. 1480 - 1522 Religious & portrait artist Exh: Germany	
HL	**LAUTENSACK** **Hans Sebald** b. Germany. 1524 - 1560 Genre & historical subjects Exh: Scandinavia	
	LAUTENSACK **Heinrich** b. Germany. 1522 - 1568 Religious & genre subjects	

656

LEES. ARBA **H.E. Ida** b. Ryde, I.O.W. Moonlight landscapes etc. Exh: RA, WAG, French AG's	**H.**
LINNQVIST **Hilding Gunnar Oskar** b. Stockholm. 1891 - Oil & watercolourist Exh: Stockholm, France, Germany, US, UK, etc.	HL FL
LORIMER, ARWS **John Henry** b. Edinburgh. 1857 - 1936 Portrait, floral, genre & landscape artist Exh: UK AG's, US, Australia, France	JL 15 H 82 J.H.L
LOVE, NDD, RWA **Hazel** b. Somerset. 1923 - Oil & watercolourist Exh: RWA, AIA, etc. X	HL
LOWINSKY. NEAC **Thomas Esmond** b.1892 - Painter & illustrator Exh: London & Prov. AG's	4L
LUCAS **Horatio Joseph** b. 1839 - 1873 Landscape watercolourist Exh: RA, Prov. AG's	JL 1865
LUDDINGTON. MBE **Leila** b. Aldershot Watercolourist Exh: RI, RBA, WIAC, NEAC, RSA, NS, etc.	[HL]
TOULOUSE-LAUTREC-MONFA **Henri Marie Raymonde De** b. France. 1864 - 1901 Portraits, figure & genre subjects Exh: International AG's	(FL) (FL) (FL) (FL) (FL) (FL) (FL) (FL)
PEACOCK. Mem. USA **Herbert L.** b. Norfolk. 1910 - Architectural & landscape subjects & miniaturist Exh: USA, NS, NEAC, RI, RMS, PAS, RWEA, PS, etc.	H. L. P.

MACALLUM, RSW Hamilton b. Kames. 1841 - 1896 Genre, marine & landscape artist Exh: RA, UK AG's, Germany, Australia	*HM*
MARR Joseph Heinrick Ludwig b. Hamburg. 1807 - 1871 Genre & landscape artist Exh: Germany, Italy	**HM**
MAUPERCHE Henri b. Paris. 1602 - 1686 Landscape artist Exh: France	*H:M*
MOORE, RA, RWS Henry b. York. 1831 - 1895 Marine & landscape artist Exh: RA, SS, BI, GG, VA, UK AG's	*qMA* *HM* *Hm*
MORLEY Harry b. Leicester. 1881 - 1943 Figure & landscape artist Exh: RA, London & Prov. AG's	*H.M.*
MULICH Hans b. Munich. 1515 - 1573 Portraits, historical subjects & miniaturist Exh: Germany	*1540* *HM*
HANSEN Hans Nicolai b. Copenhagen. 1853 - 1923 Genre & landscape artist Exh: RA, SS, Paris, Vienna, Copenhagen	*HM.80*
BENNETT Harriet M. b. UK. Fl. 1877 - 1892 Genre subjects Exh: RA, RWS	*HMB*
LIVENS Horace Mann b. London. 1862 - 1936 Floral, genre & landscape artist Exh: RA, UK AG's, Canada	*H.ML*
MARSHALL, RWS Herbert Menzies b. Leeds. 1841 - 1913 Landscape & architectural subjects Exh: France, S. Africa, Australia	*H.M.M.*

Paget. RBA **Henry Marriott** b. England. 1856 - 1936 Portraits & historical subjects Exh: RA, GG, London & Prov. AG's	*HMP*	**HM**
RHEAM **Henry Meynell** b. Birkenhead. 1859 - 1920 Genre subjects Exh: RI, UK AG's	HMR HMR.	
MARKS **Henry Stacy** b. London. 1829 - 1898 Animals, genre & historical subjects Exh: RA, BI, SS, GG, OWS, Prov. AG's, Germany	HMS	
HALS **Nicolas Claes Fransz** b. 1628 ? - 1686 Landscape artist Exh: Holland	HN	**HN**
HONE (The Elder) **Nathaniel** b. Dublin. 1718 - 1784 Portraits & miniaturist Exh: SA, RA etc	HN	
HAIG (HAGG), RE **Axel Herman** b. Gotland. 1835 - 1921 Architectural views Exh: London, Paris	18 Ⓐ 80 18 Ⓐ 96 19 Ⓐ 03	**HO**
HALL **Oliver** b. London. 1869 - ? Landscape artist Exh: RA, SS, France	Ⓗ	
HARRISON **Thomas Erat** Fl. London late 19th C. Painter, engraver & sculptor Exh: London & Prov. AG's	ⓉⒺ	
HEINZ (The Elder) **Joseph** b. Switzerland. 1564 - 1609 Historical subjects Exh: Switzerland, Germany, France, Italy, Austria.	ƳEF ΦE HE	
HUMPHREY **Ozias** b. Honiton. 1742 - 1810 Portrait artist & miniaturist Exh: RA, London & Prov. AG's	Ⓗ	

HP	**PADER** Hilaire b. Toulouse. 1607 - 1677 Religious & landscape subjects Exh: France	HP
	PAULY Horatius b. Holland 1644 - 1686 ? Genre, portrait & still life subjects Exh: Florence, Vienna	HP
	PAYNE, RWS Henry A. b. Birmingham. 1868 - 1939 Portrait, mural & landscape artist Exh: London & Prov. AG's	HP H.P.
	PILLEAU. RI, ROI Henry b. England. 1815 - 1899 Landscape & genre artist Exh: RA, SS, BI, NWS, RI, London & Prov. AG's	HP
	POT Heindrick Gerritsz b. Haarlem. 1585 - 1657 Historical, portraits & genre subjects Exh: Holland, France, UK	HP
	POTHOVEN Hendrick b. Amsterdam. 1725 - 1795 Portrait artist Exh: Holland	H.P. f
	POTTER. RBA Frank Huddlestone b. London. 1845 - 1887 Genre & landscape artist Exh: RA, SS, GG, SA, London & Prov. AG's	HP
	PYLE Howard b. Wilmington. 1853 - 1911 Painter & illustrator Exh: Paris, US	H⁵:– HP H H.p HP
	LEMBKE Johann Philipp b. Nuremburg 1631 - 1711 Portraits & battle scenes Exh: Holland, Sweden, Prague, Vienna	HL HL 1649 HL
HR	**HEEMSKERK (The Elder)** Egbert van b. Haarlem. 1610 - 1680 Genre, rustic interiors etc Exh: France, Italy, UK	HR

660

HILLINGFORD Robert Alexander b. London. 1828 - 1907 Genre & historical subjects Exh: RA, BI, SS, UK AG's	
HOFFMANN Hans b. ? - 1591 ? Portraits, insects & floral subjects Exh: Austria, Hungary	
MANUEL Hans Rudolf b. Switzerland. 1525 ? - 1572 Religious & portrait subjects Exh: Switzerland	
MILEHAM. NSA Harry Robert b. London. 1878 - ? Portraits & historical figure subjects Exh: RA, NG, NSA, Prov. AG's, Italy, Canada, etc.	
OKE Henry Reginald b. London. 1871 - ? Oil & watercolourist Exh: London & Prov. AG's	
RAILTON Herbert b. Pleavington. 1858 - 1910 Landscape & architectural subjects Exh: UK AG's	
RAVESTEYN Hubert Van b. Holland. 1638 - 1692 ? Still life & genre subjects Exh: Holland, Germany, Austria etc.	
RIEDEL Anton Henrich b. Dresden. 1763 - 1809 ? Portrait artist	
RIVIERE Benjamin Jean Pierre Henri b. Paris. 1864 - 1951 Landscape artist Exh: France	
ROBERT Hubert b. Paris. 1733 - 1808 Genre, architectural & landscape artist Exh: France, Belgium, US, Germany	

HR		
RUITH Horace Van Fl. 1888 - 1914 Portrait, figure, genre & landscape artist Exh: RA, UK AG's, Germany		
RYLAND. RI Henry b. Biggleswade. 1856 - 1924 Classical figure subjects Exh: RA, GG, NG, NWS, London & Prov. AG's		
RAMBERG Johann Heinrich b. Hanover. 1763 - 1840 Historical & portrait artist Exh: Germany, UK		
VOLKMANN Hans Richard Von b. Germany. 1860 - 1927 Landscape artist Exh: Germany		

HS

SCHAUFFELIN (The Younger) Hans b. Germany. 1515 - 1582 ?		
SELOUS (or SLOUS) Henry Courtney b. London. 1811 - 1890 Portrait, historical, genre & landscape artist Exh: RA, SS, BI, London & Prov. AG's		
SOMM Francois Clement Sommier b. Rouen. 1844 - 1907 Genre subjects & caricaturist Exh: France		
SPEED Harold b. London. 1872 - 1957 Portraits, figures & historical subjects Exh: NG, UK AG's, Paris		
HISBENS (or HISBEL-PENN) FL. Nuremberg. 17th C. Portrait artist		
SCHRORER Hans Friedrich Fl. Germany. 17th C. Painter & engraver		

SCOREL Jan Van b. Holland. 1475 - 1562 Religious, historical & portrait artist Exh: Holland, Germany, Italy, Austria, UK	HSF	**HS**
SPRINGINKLEE Hans b. Germany. ? - 1540 Painter & engraver	HK HSK	
MARKS Henry Stacy b. London. 1829 - 1898 Animals, genre & historical subjects Exh: RA, BI, SS, GG, OWS, Prov. AG's, Germany	HSM	
SPECKARD Hans b. Brussels. ? - 1577 ? Portraits & genre subjects Exh: Germany, Italy, Austria	H. S. P.	
HIRSCH Alphonse b. Paris. 1843 - 1884 Genre & portrait artist Exh: France	HSR	
TUKE. RA, RWS Henry Scott b. York. 1858 - 1929 Genre, coastal scenes & portrait artist Exh: RA, NEAC, GG, NG, SS, NWS, Prov. AG's, Australia	H.ST H.S.J	
HUGHES, ROI Talbot b. London. 1869 - 1942 Genre subjects Exh: RA, ROI, WG, Prov. AG's	TH	**HT**
THORNYCROFT, SWA Helen Fl. 1864 - 1912 Genre, floral, landscape & religious subjects Exh: RA, SS, NWS, NG	TH	
HALLIDAY Michael Frederick b. 1822 - 1869 Genre, portrait & landscape artist Exh: RA, NPG	18 MF 66	
DAWSON Henry Thomas Fl. Chertsey. 1860 - 1878 Marine artist Exh: RA, BI, SS, US AK'S	HD	

SCHAFER. RBA **Henry Thomas** Fl. London. 19th – 20th C. Genre artist & sculptor Exh: RA, GG, NWS, SS, etc.	H.T.S

ULRICH **Heinrich** b. Nuremberg. 1572 ? - 1621 Portrait, religious & landscape artist	HV HV HV
VERNET **Emile Jean Horace** b. Paris. 1789 - 1863 Military, historical & portrait artist Exh: France, Holland, UK	H.V.
BORCHT (The Younger) **Hendrik van der** b. 1614 - 1654 Historical subjects	HdB
BORCHT (The Elder) **Hendrik van der** b. Brussels. 1583 - 1660 Still life, religious & historical subjects	HVd
NYPOORT **Justus Van Den** b. Utrecht. 1625 ? - 1692 ? Genre subjects Exh: Holland, Russia	JVD N.J.
FRANCK **Hans Ulrich** b. 1603 - 1680 Historical subjects	HF HF
HOVE **Hubertus van** b. Hague. 1814 - 1865 Architecture & landscape artist Exh: Holland, Germany	H.V.H.
RAVESTEYN **Hubert Van** b. Holland. 1638 - 1692 ? Still life & genre subjects Exh: Holland, Germany, Austria etc.	H.V.R.
STEENWYCK (The Elder) **Hendrik Van** b. Holland. 1550 ? - 1603 Architectural & church interiors Exh: Holland, Germany, Russia, France, Austria, etc.	1573 HVS

SWANEVELT **Herman Van** b. Holland. 1600 ? - 1655 Landscape artist Exh: France, Italy, UK, Austria, Germany	*HSt* *HS* *HSt*	HV
VERSCHURING **Henrik** b. Holland. 1627 - 1690 Battle scenes, genre & landscape artist Exh: Holland, Germany, France, Russia, UK	*HS* *H.Vg*	
WATERSCHOODT **Heinrich Van** b. Antwerp. ? - 1748 Battle scenes, genre & floral subjects Exh: Germany	*H.V.W*	
HENSEL **Wilhelm** b. 1794 - 1861 Portraits & historical subjects Exh: Germany	*HW* *HW*	HW
HOWITT **William Samuel** b. 1765 - 1822 Sporting & hunting scenes Exh: SA, RA	*HW*	
WALLIS, RI **Henry** b. London. 1830 - 1916 Landscape, portrait & historical subjects Exh: RA, RI, VA, NPG, UK AG's	*HW* *1856*	
WELLINGTON. Hon. ARCA **Hubert Lindsay** b. Gloucester. 1879 - Painter in oil media Exh: NEAC, RA, Italy	*HW*	
WOODS, RA **Henry** b. Warrington. 1846 - 1921 Rustic, venetian & genre subjects Exh: RA, London & Prov. AG's, S. Africa	*H.W.*	
ADAMS, RBA, R.Cam.A. **Harry William** b. Worcester. 1868— Winter scenes, landscapes, etc. Exh: RA, London & Prov. AG's, X	*HWA.*	
BLOEMAERT **Hendrick** b. Utrecht. 1601 ? - 1672 Portraits, historical, allegorical & genre subjects Exh: Holland, Germany, Hungary, Russia, etc.	*HB 1633*	

HW	**BREWER** **Henry William** b. Oxford ? - 1903 Churches & Church interiors Exh: RA, SS, BI	HwB
	DAVIS, RA **Henry William Banks** b. London. 1833 - 1914 Animals & landscape artist Exh: RA, SS, BI, NG, UK AG's, Paris, Vienna	H.W.B.D.
	WELLS, RA **Henry Tanworth** b. London. 1828 - 1903 Portraits, genre & miniaturist Exh: RA, NG, UK AG's	H.J.W. 〼 1901
	HAWKINS **Harold Frederick Weaver** b. London. 1893 - Portrait, figure & landscape artist Exh: RA, NEAC, London & Prov. AG's	Hwtt
	WILLIAMS **John Haynes** b. 1836 - 1908 Genre artist & illustrator Exh: RA, UK AG's	Jno H-W
	HUNT, ARSA, RSW, OM **William Holman** b. London. 1827 - 1910 Portrait, religious, genre & imaginative subjects Exh: RA, OWS, GG, NG, etc	₩
	HEINCE **Zacharie** b. Paris. 1611 - 1669 Portraits & genre subjects Exh: France	ℲH
I	**LOUND** **Thomas** b. 1802 - 1861 Landscape artist Exh: VA, UK AG's	I 1833
	VERMEYEN **Jan Cornelisz** b. Holland. 1500 ? - 1559 Portraits & historical subjects	15Ĭ45
IA	**DELSENBACH** **Johann Adam** b. Nuremburg. 1687 - 1765 Portrait & landscape artist	IAD

BEUCKLAER **Joachim** b. Antwerp. 1530 - 1570 Domestic, game & still life subjects	·B· 1566	IB
CALLOT **Jacques** b. Nancy. 1592 - 1635 Historical, biblical, genre & military subjects etc Exh: UK & European AG's	C̶ C̶ invent fec.	IC
CAMPAGNOLA **Giulio** b. Italy. 1481 - 1500 ? Miniaturist	C̶	
CASSIE, RSA, RSW **James** b. Scotland. 1819 - 1879 Landscape & marine artist Exh: RA, BI, SS, UK AG's	ȼ Ƒ 1871	
PHILLOTT **Constance** Fl. 1864 - 1904 Genre, historical & landscape artist Exh: RWS, UK AG's	Ȼ Ȼ Ȼ	
DORNER (The Elder) **Johann Jakob** b. Germany. 1741 - 1813 Religious, historical, genre & land- scape artist Exh: Germany, Switzerland	ICD.	
DASVELDT **Jan H.** b. Amsterdam. 1770 - 1850 Animal & landscape artist Exh: Holland, France	ID.	ID
DICK **Isabel Elizabeth** b. UK. 20th C. Still life subjects Exh: RA, SWA	ID	
DUCQ **Jan le** b. The Hague. 1630 ? - 1676 Genre, military, animals & landscape artist Exh: France, Austria, UK etc	ID·66ı	
LAIRESSE **Gerard de** b. Liege. 1641 - 1711 Historical & portrait artist Exh: France, Germany, Holland	ꓘD	

IE	**WILLIAMS** **Idris Elgina** b. 1918 - Painter in oil & pastel media, etcher Exh: London & Prov. AG's	
	HODGSON, RA, HFRPE **John Evan** b. London. 1831 - 1895 Genre, landscapes, eastern & Historical subjects Exh: RA, BI, SS etc	
	IRELAND **Thomas** Fl. 1880 - 1903 Landscape artist Exh: RA, SS, NWS, GG	
IH	**HUCHTENBURG** **Jan van** b. Haarlem. 1647 - 1733 Military subjects Exh: Holland, Belgium, France, London	
	HERLIN **Auguste Joseph** b. Lille. 1815 - 1900 Genre artist Exh: France	
II	**BIEDERMANN** **Johann Jakob** b. Switzerland. 1763 - 1830 Portraits, animals & landscape artist Exh: Switzerland, Germany etc	
IJ	**KNOWLES, RBA** **Davidson** Fl. 1879 - 1902 Animal & landscape artist Exh: RA, SS, Prov. AG's	
	LINNELL **James Thomas** b. 1826 - 1905 Genre, historical & landscape artist Exh: RA, UK AG's	
IL	**FIDLER** **Harry** b. Salisbury. ? - 1935 Genre & landscape artist Exh: London & Prov. AG's	
	LIMMER **Emil** b. Germany 1854 - ? Genre artist & illustrator Exh: Germany	

MAHONEY, NWS **James** b. Cork. 1816 - 1879 European architectural views Exh: RA, VA, UK AG's		IM
MECHAU **Jakob Wilhelm** b. Leipzig. 1745 - 1808 Historical & landscape artist Exh: Scandinavia		
SWAN **John Macallan** b. England. 1847 - 1910 Animal, genre & landscape subjects Exh: UK, Holland, Australia, Canada		
TURNER. RA **Joseph Mallord William** b. London. 1775 - 1851 Land & seascapes, venetian & historical subjects Exh: RA, NG, NPG, VA, Prov. AG's, France, US, Canada, etc.		
OLIVER **John** b. London. 1616 - 1701 Portraits & religious subjects		IO
D'ARPINO **Giuseppe Cesari** b. Nr. Naples. 1568 ? - 1640 Portraits, historical & battle scenes		
LUTGENDORFF (Baron De) **Ferdinand Karl Theodor** **Christoph Peter** b. Germany. 1785 - 1858 Genre. portraits & miniaturist		
PASSAVANT **Johann David** b. Frankfurt. 1787 - 1861 Genre & historical subjects Exh: Germany		IP
PALMER, RWS **Samuel** b. Sainte-Marie Newington. 1805 - 1881 Landscape artist & watercolourist Exh: RA, BI, BM, VA, UK AG's		IS
SCHNORR VON CAROLSFELD **Julius Veit Hans** b. Leipzig. 1794 - 1872 Religious & genre subjects Exh: Germany		

IS	**SOUKENS** **Jan** Fl. Holland. 1678 - 1725 Genre & landscape subjects	(I - S) 1678
	STEEN **Jan Havicksz** b. Leyden. 1626 - 1679 Genre, tavern scenes etc. Exh: International AG's	
	STELLA **Jacques De** b. Lyon. 1596 - 1657 Biblical & historical subjects Exh: France, Italy, Germany, Austria, etc.	
	STORCK **Jacobus** Fl. Amsterdam. 17th C. Marine & landscape artist Exh: Holland, US, UK, Germany, Russia	I S
	SMART. RE **Douglas Ion** b. UK. 1879 - Etcher & watercolourist Exh: London & Prov. AG's	
IV	**VUCHT** **Jan Van Der** b. Rotterdam. 1603 ? - 1637 Architectural subjects Exh: Germany, Russia	I. V.
	BONASONE **Giulio di Antonio** b. Bologne. 1498 ? - 1580 ? Biblical & mythological subjects	IVB
	RAFFAELLO **Santi** b. Urbino. 1483 - 1520 Portraits, religious & historical subjects Exh: International AG's	I.V.R.
IW	**BAUR** **John William** b. Strasburg 1600 - 1640 Landscape artist Exh: Germany, Switzerland	IWB

WAINWRIGHT, RWS **William John** b. Birmingham. 1855 - 1931 Portraits, genre & historical subjects Exh: OWS, UK AG's, Paris		IW
WINGHE **Jeremias Van** b. Brussels. 1578 — 1645 Historical & portrait artist Exh: Germany		
WATSON. RWS, RBA **John Dawson** b. Sedburgh. 1832 - 1892 Genre & landscape artist Exh: RA, SS, BI, OWS, GG, VA & Prov. AG's		
JONES **Langford** b. London. 1888 - Painter, engraver & sculptor Exh: RA & Prov. AG's etc		J
KOBULADZE **Sergei** b. Akhaltsikhe. 1909 - Oil, charcoal, gouache media		
MECKENEM **Israel** b. ? - 1503 ? Religious subjects Exh: France, Germany		
ALDRIDGE **John Arthur Malcolm** b. London. 1905 - Portrait, still life & landscape artist Exh: RA, London & Prov. AG's		JA
ASSELYN (or ASSELIN) **Jan** b. 1610 - 1652 ? Landscape artist Exh: Holland, Belgium, Germany, Hungary, France etc.		
SCOREL **Jan Van** b. Holland. 1475 - 1562 Religious, historical & portrait artist Exh: Holland, Germany, Italy, Austria, UK		
BOECKHORST **Johann** b. Munster. 1605 - 1668 Historical & portrait artist Exh: Belgium, Sweden, Austria etc		

JA	**HOUSTON, RSA** John Adam b. Wales. 1812 - 1884 Genre & historical subjects Exh: RA, SBA, BI, UK AG's	*JAH RSA*
	O'CONNOR James Arthur b. Dublin. 1792 - 1841 Landscape artist Exh: RA, SS, VA, London & Prov. AG's, France, Ireland	*JAO.C 1830*
	WINGHE Jeremias Van b. Brussels. 1578 — 1645 Historical & portrait artist Exh: Germany	*J.a.W*
JB	**BALLANTINE, RSA** John b. Kelso. 1815 - 1897 Historical, genre & portrait artist Exh: RA, UK AG's	*JB*
	BARNARD Frederick b. London 1846 - 1896 Domestic & genre subjects Exh: RA, SS.	*JB*
	BATEMAN, RA, ARWS James b. Kendal. 1893 - 1959 Landscape artist Exh: RA, UK AG's	*JB* *JB*
	BAYES, RMS Jessie b. London. Fl. 19th-20th C. Painter in oil media etc Exh: RA, Int. Ex. Paris, Rome, Canada, US, etc	*JB*
	BEDFORD John Bates b. Yorkshire. 1823 - ? Genre, historical & portrait artist Exh: RA, BI, UK AG's	*18 JB 60* *JB*
	BERGLER (THE YOUNGER) Joseph b. 1753 - 1829 Historical subjects	*JB.* *B.* *B* *JB.* *JB.*
	BERGMULLER John George b. Dirkheim, Bavaria. 1688 - 1762 Portraits & historical subjects	*Bf.* *JB* *B.* *B.* *JB* *JB.*

BILL, ARWA John Gordon b. London. 1915 - Landscape artist Exh: NEAC, RWA, Prov. AG's	
BUNDSEN Jes b. Assens. 1766 - 1829 Architectural & landscape artist Exh: Germany	
BUNNEY John Wharlton b. London. 1828 - 1882 Venetian scenes Exh: RA, Prov. AG's	
BURNE-JONES Sir Philip b. London. 1861 - 1926 Portraits & architectural scenes Exh: London & Prov. AG's	
BUSK E. M. Fl. 1873 - 1889 Portrait artist Exh: R.A.	
TETAR VAN ELVEN Jan Baptiste b. Amsterdam. 1805 - 1879 Genre subjects Exh: Holland, Germany, Belgium	
BEICH Joachim Franz b. Ravensbourg. 1665 - 1748 Landscape artist Exh: France, Germany, Austria	
FLAMEN (or FLAMAND) Albert Flourished France 17th Century Portrait, genre & landscape artist Exh: UK, France	
BRAY Jacob de b. Haarlem. 1625 - 1680 Historical subjects	
BOWERS Stephen Fl. London. 1874 - 1891 Landscapes & river views Exh: SS, NWS	

CADENHEAD, RSA, RSW, NEAC, **James FSA** b. Aberdeen. 1858 - 1927 Landscape artist Exh: AAS, RSA etc	*JC*
CASSIE, RSA, RSW **James** b. Scotland. 1819 - 1879 Landscape & marine artist Exh: RA, BI, SS, UK AG's	*J̵C J̵C J̵C J̵C 1871*
CAVE **James** Fl. 1801 - 1817 Landscapes & Architectural subjects Exh: RA, Prov. AG's	*.J̵C. .J̵C.*
CHARLES **James** b. 1851 - 1906 Portraits, landscapes & rustic scenes Exh: RA, NG, PS, NEAC etc	*J̵C*
CHARLTON, RBA **John** b. Northumberland. 1849 - 1917 Portraits, battle scenes & sporting subjects. Exh: RA, SS, NWS, GG, NG, Prov. AG's, Australia	*JC*
COGELS **Joseph Charles** b. Brussels. 1786 - 1831 Landscape artist Exh: France, Germany	*J̵C*
CORNEILLE **Jean Baptiste** b. Paris. 1649 - 1695 Portraits, historical & biblical subjects Exh: France	*JC sculp*
CRAMP, ATD **Jonathan David** b. Sussex. 1930 - Oil, Charcoal & Gouache media	*J.C.*
CRAIG **James Stephenson** Fl. London. 1854 - 1870 Genre subjects Exh: UK AG's	*J̵C 1868*
CRAWHALL, RWS **Joseph** b. Newcastle. 1860 - 1913 Bird & animal subjects Exh: RA, UK AG's, Paris	*.J.C.*

CREUTFELDER **Johann** b. Nuremberg. 1570 - 1636 Religious subjects Exh: Austria	*[monogram]*
GRIFFIER **John** b. ? - 1750 ? Landscape artist Exh: UK	*[monogram: j.C,]*
GUTHRIE, PRSA, RSW **Sir James** b. Greenock. 1859 - 1930 Genre, portrait, landscape & historical subjects Exh: France, Germany, Australia, UK AG'S	*[four boxed monograms]*
JONES, RCA **Charles** b. Cardiff. 1836 - 1892 Animal & landscape artist Exh: RA, BI, SS, NWS, Australia	*[monogram]*
O'CONNOR, RHA **John Scorrer** b. 1913 - Landscape artist Exh: UK AG's	*[monogram]*
JONES **Ethel Gertrude** b. Liverpool Portrait & landscape artist Exh: WAG & Prov. AG's	*[monogram]*
FRISCH **Johann Christoph** b. Berlin. 1738 - 1815 Historical subjects Exh: Germany. France	*[monogram: JCF fc.]*
BRAND **Johann Christian** b. Vienna. 1722 - 1795 Landscape artist Exh: Germany, Austria, Italy	*[monogram: J.ch.B]*
KNAPTON **George** b. London. 1698 - 1778 Portrait artist Exh: NPG, UK AG's	*[monogram: K]*
ROBINSON **Sir John Charles** b. Nottingham. 1824 - 1912 Floral & landscape artist Exh: RA, VA, RE	*[monograms: JCR, JCR]*

JC	**WANS** **Jan Baptiste** b. Antwerp. 1628 - 1684 Landscape artist Exh: Belgium	*J.C.W.*
	WARD **James Charles** Fl. 1830 - 1859 Still life & landscape artist Exh: London & Prov. AG's	*W.J.C*
	WINTOUR, ARSA **John Crawford** b. Edinburgh. 1825 - 1882 Genre & landscape artist Exh: RSA, UK AG's	*JCW* *WCV 163*
JD	**DUDLEY** **John** b. Eton. 1915 - Portrait & landscape artist & miniaturist Exh: PAS, SM, RWS	*Jʹₐ*
	DUPRE **Jules** b. Nantes. 1811 - 1889 Genre, marine & landscapes etc Exh: France, Holland, Germany, Sweden etc	*J.D.*
	HARVEY-JONES **Dorothy** b. London. 1898 - Pastel & watercolourist Exh: RA	*HDJ* *1925.*
	WIT **Jacob De** b. Amsterdam. 1695 - 1754 Mythological, genre, portraits & historical subjects Exh: Holland, germany, France, Russia, Belgium	*JD* *JD fecit.*
	BATTEN **John Dickson** b. Plymouth 1860 - 1932 Figures & mythological subjects Exh: RA, GG, NG, Australia	JDB
	FRANCIS **John Deffett** b. Swansea. 1815 - 1901 Genre & portrait artist Exh: RA, BI, SS	*J.D.F.* *J.D.F.*
	DENMAN **Gladys** b. Hampstead. 1900 - Portrait, landscape artist & miniaturist Exh: RP, RWA, SWA, RMS, SM, RI	*GDS*

HARDING **James Duffield** b. Deptford. 1798 - 1863 Landscape artist Exh: RA, BI, SS, SA etc	*JDH*
LINTON. PRI, HRSW. **Sir James Dromgole** b. London. 1840 - 1916 Portraits, figure subjects & historical artist Exh: RA, SS, NWS, GG, NG, London & Prov. AG's	JDL
LUBIENIECKI **Bogdan Theodor** b. Poland. 1653 - ? Historical & landscape subjects Exh: Germany, Budapest	*JDL*.
PENSTONE **John Jewel** Fl. 1835 - 1895 Genre, figure & portrait artist Exh: RA, London & Prov. AG's	*DP*
DICKSEE **John Robert** b. London. 1817 - 1905 Genre & portrait artist Exh: London & Prov. AG's	*JD*
WAAL **Justus De** b. Utrecht. 1747 - ? Landscape & village scenes	*J.D.W*
WATSON. RWS, RBA **John Dawson** b. Sedburgh. 1832 - 1892 Genre & landscape artist Exh: RA, SS, BI, OWS, GG, VA & Prov. AG's	*J.D.W*
WINGFIELD **James Digman** b. ? - 1872 Genre & landscape artist Exh: RA, BI, SS, London & Prov. AG's	JDW
EECKELE (or EECKE) **Jan van** Flourished Bruges 16th Century Portraits & historical subjects	*JE*
EPISCOPIUS **Johannes** b. Amsterdam. 1628 - 1671 Landscapes & historical subjects etc Exh: UK, Holland, Germany, Austria	*J* *E* *JE*

JE	**ESSELENS** **Jacob** b. Amsterdam. 1626 - 1687 Landscape artist Exh: Holland, UK, Germany, France etc	*ℐℰ* *ℱ.ℰ.*
	CHRISTIE **James Elder** b. Fifeshire. 1847 - 1915 Genre, children & portrait artist Exh: RA, SS, GG, NG, UK AG's, Paris	*J.E ⓈᏎ* *J.E.C*
	HODGSON, RA, HFRPE **John Evan** b. London. 1831 - 1895 Genre, landscapes, eastern & Historical subjects Exh: RA, BI, SS etc	*JEH*
JF	**FALBE** **Joachim Martin** b. Berlin. 1709 - 1782 Genre artist	*(monogram)*
	FARRER **Thomas Charles** b. London. 1839 - 1891 Landscape artist Exh: RA, SS, UK AG's, US	*(monogram) 60*
	FELON **Joseph** b. Bordeaux. 1818 - 1896 Historical & allegorical subjects etc Exh: France	*JF*
	FINNEMORE **Joseph** b. Birmingham. 1860 - 1939 Genre & Portrait artist Exh: RA	*JF.* *J.F.*
	FINNIE, ARE, SSSBA **John** b. Aberdeen. 1829 - 1907 Landscape artist Exh: RA, BI, SS, UK AG'S, Paris	*Jℱ 1870* *18 Jℱ 71*
	FRANKLIN **John** b. 1800(?) - 1869(?) Architectural & historical subjects Exh: RA, SS, BI, London & Prov. AG's	*JF* *JF*
	FULLEYLOVE, RI **John** b. Leicester. 1845 - 1908 Genre, architectural & landscape artist Exh: RA, RI, SS, London & Prov. AG's	*JF*

HERRING John Frederick (Senior) b. Surrey. 1795 - 1865 Animal & sporting subjects Exh: RA, SS, BI, UK & European AG's, US	*J.Fred H* *JFH 1848* *J.F.H.* *JFH* **JF**
GENTILLI, BA Jeremy b. London. 1926 - Oil & watercolourist Exh: ROI, RBA etc	*JG.* **JG**
GILBERT, RA, PRWS Sir John b. London. 1817 - 1897 Historical subjects Exh: RA, BI, SS, OWS, London & Prov. AG's etc	*JG* *G* *G* *G*
GRAFF Johann Andreas b. Nuremberg. 1637 - 1701 Portraits, floral & landscape artist	*JG*
GRAHAM, HRSA Thomas Alexander Ferguson b. Scotland. 1840 - 1906 Portraits, coastal, country & oriental subjects Exh: RA, RSA, London & Prov. AG's	*T. G*
GREEN Henry Towneley b. England. 1836 - 1899 Oil & watercolourist Exh: RA, RI, RBA, London & Prov. AG's etc	*J. G.*
GRIFFIER (The Elder) Jan b. Amsterdam. 1652 ? - 1718 Landscape artist Exh: Holland, France, Germany, Hungary, Austria, UK etc	*JG*
KEERINCK Alexandre b. Antwerp. 1600 - 1652 Landscape artist Exh: France, Belgium, Holland	*K*
VLIET Jan Georg Van Der b. Delft. 1610 ? - ? Genre & historical subjects Exh: Holland	*JG* *JG* *JG.f* *JG*

LEFEBVRE **Claude** b. France. 1632 - 1675 ? Portrait artist Exh: PS, France, NPG	
FELLINI **Giulio Cesare** b. 1600 ? - 1656 Animal & genre subjects	
MANSFELD **Joseph George** b. Vienna. 1764 - 1817 Portrait & animal subjects	
BRONCKHORST **Jan Gerritsz van** b. Utrecht. 1603 - 1677 Historical & genre subjects Exh: Holland, Germany, Austria etc	
TARRATT **John Garfield** Figure & landscape subjects etc. Exh: WAG, RSA, London & Prov. AG's	
HAMILTON **Johann Georg de** b. Brussels. 1672 - 1737 Still life, horses & hunting scenes Exh: Hungary, Germany, Italy, Austria	
GODWARD **John William** Fl. 1887 - 1909 Genre, figures & oriental subjects Exh: RA, UK AG'S	
WINTER **Joseph Georg** b. Munich. 1751 - 1789 Hunting scenes & landscapes	
WOLFGANG **Gustav Andreas** b. Germany. 1692 - 1775 Painter & engraver	
HANCOCK **Jennetta Flora** Miniaturist Exh: RA, WAG, RI	

JG

JH

HASTINGS (Earl of Huntingdon) **John** b. London. 1901 - Mural paintings Exh: US, London & Prov. AG's.	
HAYLLAR, RBA **James** b. Chichester. 1829 - 1920 Portrait, genre & landscape artist Exh: RA, BI, SS London & Prov. AG's	
HENDERSON, RSW **Joseph** b. Perthshire; 1832 - 1908 Genre, portrait & marine artist Exh: RA, SS, RSW, UK AG'S	
HILDEBRANDT **Ferdinand Theodor** b. Stettin. 1804 - 1874 Portraits, genre & historical subjects Exh: Holland, Germany	
HOLBEIN (The Younger) **Hans** b. Augsbourg 1497 ? - 1543 Portraits & historical subjects Exh: France, Switzerland, UK, Spain, Belgium etc	
HOLLAND **John** Fl. Nottingham 19th C. Landscape artist Exh: BI, UK AG's	
HUGHES, DA, SGA **Jim** b. Ayr. 1934 - Figure, landscape & abstract subjects Exh: SGH	
PYLE **Howard** b. Wilmington. 1853 - 1911 Painter & illustrator Exh: Paris, US	
TANZIO **Antonio D'enrico** b. Italy. 1575 ? - 1635 Religious & portrait artist Exh: Italy	
TISCHBEIN (The Younger) **Johann Heinrich** b. Germany. 1742 - 1808 Portrait & landscape subjects Exh: Germany	

ABBE Hendrik b. Anvers. 1639— Portrait artist	*HA.delin.* *HA*
HAGEN Joris van der b. 1620 - 1669 Landscape artist Exh: Holland, France, Germany, Denmark, UK etc	*H H*
HARMS Johann Oswald b. Hamburg. 1643 - 1708 Architectural & landscape subjects Exh: Germany	*H fe.*
HARTMANN Johann Joseph b. Mannheim. 1753 - 1830 Landscape subjects etc Exh: Germany	*Hf*
WOODWARD Thomas b. Pershore. 1801 - 1852 Portraits, genre, animals & sporting subjects Exh: RA, BI, London & Prov. AG's	*FW 1837*
DALEM Hans van FL. 17th C. Portrait artist Exh: Austria, Germany, France	*HD. df 1.48*
HEEM Jan Davidsz de b. Utrecht. 1606 - 1684 Floral & still life subjects Exh: Russia, Scandinavia, UK & European AG's	*JD.1665* *J.D.*
HOLLAND James b. Burslem. 1800 - 1870 Landscapes & architectural scenes Exh: RA, RI, BI, London & Prov. AG's, Canada, US	*JHD*
HUBER Jean Daniel b. Geneva. 1754 - 1845 Animal subjects Exh: Geneva	*JHD 1784* *JHD*
BACON John Henry Frederick b. London. 1868 - 1914 Genre & historical subjects Exh: London & Prov. AG's, France	*J.H.F.B*

JH

682

FRISTON David Henry Fl. London mid 19th C. Figure painter Exh: RA	
DUBBELS Hendrik Jacobsz b. Amsterdam. 1621 ? - 1676 ? Marine artist Exh: Holland, Italy, France, Denmark Germany	
LEEMANS Johannes b. Holland. 1633 - 1688 Genre & still life subjects Exh: Amsterdam, Copenhagen	
LE JEUNE Henry L. b. London. 1820 - 1904 Genre subjects Exh: RA, BI, SS, Prov. AG's	
LEONARD John Henry b. Holderness. 1834 - 1904 Architectural & landscape artist Exh: RA, SS, London & Prov. AG's etc.	
LEYS (Baron) Henri Jan Augustyn b. Antwerp. 1815 - 1869 Portrait, historical & genre subjects Exh: Belgium, Holland, Germany, London, France	
LORIMER, ARWS John Henry b. Edinburgh. 1857 - 1936 Portrait, floral, genre & landscape artist Exh: UK AG's, US, Australia, France	
LUCAS Horatio Joseph b. 1839 - 1873 Landscape watercolourist Exh: RA, Prov. AG's	
RAMBERG Johann Heinrich b. Hanover. 1763 - 1840 Historical & portrait artist Exh: Germany, UK	
ROOS Johann Heinrich b. Otterberg. 1631 - 1685 Portraits & animal subjects Exh: Russia, European AG's	

JH	**SCHOENFELDT** **John Henry** b. Swabia. 1619 - 1680 ? Landscape & biblical subjects	*J.H. S.P.*
	HERZ **Johann** b. Nuremberg. 1599 - 1635 Miniatures & religious subjects	*JH*
JJ	**INGRES** **Jean Auguste Dominique** b. France. 1780 - 1867 Historical, mythological & religious subjects Exh: France, NG, Italy, Sweden	(monogram in oval)
	ISABEY **Jean Baptiste** b. Nancy. 1767 - 1855 Portrait painter & miniaturist Exh: France, Spain, UK, Germany, Spain etc	(monogram in shield)
	JOYANT **Jules Romain** b. Paris. 1803 - 1854 Landscape painter Exh: France	*J. J*
	BOISSIEU **Jean Jacques de** b. Lyons. 1736 - 1810 Portrait & landscape artist Exh: France, Germany, Switzerland etc	*J.J. DB*
	EECKHOUT **Jakob Joseph** b. Anvers. 1793 - 1861 Portraits, genre & historical subjects Exh: Holland, Belgium, France	**JJE** **JJE.**
	SANDRART **Jan** b. Frankfurt. 1588 - 1679 ? Religious subjects Exh: Germany	*JJS*
	TISSOT **James Jacques Joseph** b. Nantes. 1836 - 1902 Religious, historical & genre subjects Exh: PS, RA, SS, GG, Prov. AG's, Belgium, France	*JJ.T.*
	WILSON **John James** b. London. 1818 - 1875 Landscape & marine artist Exh: UK AG's	*J.J.W* *JJW*

KEERINCK **Alexandre** b. Antwerp. 1600 - 1652 Landscape artist Exh: France, Belgium, Holland	*K 1631*
KILBURN, RMS **Joyce** b. London. 1884 - Watercolour portrait miniaturist Exh: RA, SWA, RMS, Prov. AG's. Canada, Australia tc	JK
KOBELL **Jan 1** b. Rotterdam. 1756 - 1833 Genre & landscape artist Exh: Holland	JK
RATCLIFF. OBE, FRIBA, AMTPI, FFPS. **John** b. Yorkshire. 1914 - Painter in oil media	JK
PELHAM **Thomas Kent** Fl. 1860 - 1891 Genre subjects Exh: RA, BI, SS, Prov. AG's	JKP JKP. TKP
LEECH **John** b. London. 1817 - 1864 . Hunting scenes, humourous subjects etc. Exh: London & Prov. AG's	JL JL
LIEVENS (The Elder) **Johanis** b. Holland. 1607 - 1674 Portrait, historical, religious & genre artist Exh: Holland, Germany, France, Copenhagen, UK.	I.L.
LINGELBACH **Johannes** b. Germany. ? - 1674 Marine, genre & landscape subjects Exh: Holland, France, NG, Britain, Germany	JL
LINNELL **John** b. London. 1792 - 1882 Portraits & genre, historical & landscape artist Exh: RA, BI, OWS, Prov. AG's etc.	JL
LINNIG **Jan Theodor Joseph** b. Antwerp. 1815 - 1891 Architectural & landscape artist	*L fe 1831*

JK

JL

LIS **Jan** b. Holland. 1570 - 1629 Genre & historical artist Exh: Holland, France, Italy, Russia, Hungary, UK, etc.	*J L feut* *J.L. fe.*
ZIMMERMANN **Franz** b. Austria. 1864 - ? Historical & genre subjects Exh: Germany	*18 Z 34* *Z 35*
MAHONEY, NWS **James** b. Cork. 1816 - 1879 European architectural views Exh: RA, VA, UK AG's	*M* *M* *M*
MAJOR **Isaac** b. Germany. 1576 ? - 1630 Historical & landscape artist	*JM* *JM* *M*
MARTIN **John** b. Near Hexham. 1789 - 1854 Biblical, historical, architectural & landscape artist Exh: RA, BI, SS, London & Prov. AG's	*J.M*
MEEL (MIEL or MIELE) **Jan** b. Vlaardingen. 1599 - 1663 Fairs, markets, historical & landscape artist Exh: European AG's, US, etc.	*M* *JM*
MIEREVELD **Jan Van** b. Delt. 1604 - 1633 Portrait artist	*M*
MILLAIS **John Guille** b. Horsham. 1865 - 1931 Birds & animal subjects Exh: London & Prov. AG's	*JGM*
MITCHELL **John Campbell** b. Campbeltown. 1862 - 1922 Landscape artist Exh: UK AG's, Germany	*J.M.*
MORDUE, RMS, SWA **Truda** b. Hursley, Hants. 1909 - Watercolour, pastel artist & miniaturist Exh: RA, RI, FBA, RWS etc. X	*M*

MORTIMER. ARA John Hamilton b. Eastbourne. 1741 - 1779 Historical & portrait artist Exh: VA, NPG, London & Prov. AG's	*JA*
MABUSE (known as GOSSART) Jan De b. Maubeuge. 1478 ? - 1533 Portraits, biblical subjects & miniaturist Exh: European AG's	*JMB*
CARRICK John Mulcaster Fl. London. 1854 - 1878 Landscape artist Exh: RA, BI, SS	*JM*
MAYRHOFER Johann Nepomuk b. Austria. 1764 - 1832 Floral & still life subjects	*JM* *JH*
DIONISY Jan Michiel b. Belgium. 1794 - ? Miniaturist & portrait artist	*J M D*
MATHAM Jacob b. Haarlem. 1571 - 1631 Portrait artist Exh: Holland	*JMc*
PRICE Julius Mendes b. ? - 1924 Genre subjects Exh: RA, SS, Prov. AG's, Paris	*J.M.P.* *J.M.P.*
MOBERLY. MRI, NSA, BWS Mariquita Jenny b. Deptford, Kent. 1855 - ? Portrait, figure, still life, animal & landscape artist Exh: RA, RWA, RHA, RI, ROI, London & Prov. AG's, S. Africa. S. America, US, etc.	*M*
ROOS Johann Melchior b. Frankfurt. 1659 - 1731 Historical, portrait & animal subjects Exh; Germany, Holland	*JMR*
STRUDWICK John Melhuish b. 1849 - 1937 Genre subjects Exh: RA, SS, London & Prov. AG's	*JMS* *1873* *JMS 1893*

JM	**SWAN** **John Macallan** b. England. 1847 - 1910 Animal, genre & landscape subjects Exh: UK, Holland, Australia, Canada	J.M.S.
JN	**NASH** **Joseph** b. Marlow. 1808 - 1878 Interiors & architectural subjects Exh: RA, BI, NWS, OWS, PS, RWS etc	JN JN
	BERCHEM (or BERGHEM) **Nicolas (or Claes)** b. Amsterdam. 1620 - 1683 Hunting & coastal scenes, landscapes etc Exh: S. Africa, UK & European AG's	NB NB. NB.
	DAVIDSON, DA **J. Nina** b. Hamilton. 1895 - B/White, tempera & watercolour artist Exh: RSA, GI, etc	
	NICOL. RSA, ARA **Erskine** b. Leith. 1825 - 1904 Genre artist Exh: RA, BI, RSA, London & Prov. AG's	NE
JO	**JOHNSTON** **Sir Harry Hamilton** b. London. 1858 - 1927 Portrait, figure, animal & landscape artist Exh: RA, Prov. AG's	
	OSSENBECK **Jan Van** b. Rotterdam. 1624 ? - 1674 Genre & landscape subjects Exh: Germany, UK, France, Italy	J.O.f
JP	**PARKER. RWS** **John** b. Birmingham. 1839 - 1915 Genre & landscape artist Exh: RA, OWS, SS, GG, NG, etc.	JP JP
	PASMORE **John F.** Fl. London 19th C. Rustic genre, still life & animal subjects, etc. Exh: RA, BI, SS, London & Prov. AG's	P
	PEDDER **John** b. Liverpool. 1850 - 1929 Landscape artist Exh: RA, SS, NWS, GG, London & Prov. AG's	JP JP

688

PHILLIP. RA John b. Aberdeen. 1817 - 1867 Scottish & Spanish genre subjects Exh: RA, RSA, BI, SS, London & Prov. AG's		JP
PIPER John b. Epsom. 1903 - War artist, architectural landscapes & abstract subjects Exh: Tate, UK AG's, Paris		
PRICE James Fl. London 19th C Landscape artist Exh: RA, SS, BI, London & Prov. AG's		
KNIGHT, RA John Prescott b. Stafford. 1803 - 1881 Genre & portrait artist Exh: RA, BI, UK AG's		
LEIGH-PEMBERTON John b. London. 1911 - Oil, tempera & gouache media Exh: RA, ROI, NS, London & Prov. AG's		
NAFTEL, RWS Paul Jacob b. Chanvel. 1817 - 1891 Landscape artist Exh: RWS, GG, VA, Prov. AG's		
ISAAKSZ Pieter Franz b. 1569 - 1625 Historical & portriat painter Exh: Amsterdam, Copenhagen		
ZOMER Jan Pietersz b. Amsterdam. 1641 - 1726 Painter & engraver		
JACQUES Raphael b. Nancy. 1882 - 1914 Portrait & landscape artist Exh: France		JQ

JQ	**QUELLIN** **Jean Erasmus** b. Antwerp. 1634 ? - 1715 Historical & portrait subjects Exh: France, Belgium		
JR	**HEYDEN** **Jacob van der** b. Strasbourg. 1573 - 1645 Portraits & landscapes & mythological subjects		
	JENNINGS **Reginald George** b. London. 1872 - 1930 Portraits, figures, landscapes & miniatures Exh: RA, RI, SM.		
	RECHBERGER **Franz** b. Vienna. 1771 - 1841 Landscape artist Exh: Austria		
	RIBERA **Josef** b. Spain. 1588 - 1656 Biblical & portrait artist Exh: Spain, Italy, NG, France, Germany		
	ROBERTSON. ARWS, RPE **Charles** b. 1844 - 1891 Genre & landscape artist Exh: RA, OWS, SS, NWS, London & Prov. AG's		
	ROBERTSON **Janet** b. London. 1880 - ? Portrait, miniature & landscape artist Exh: RA, NPS, RMS, etc.		
	RUISDAEL (or RUYSDAEL) **Jacob Isaakszoon** b. Haarlem. 1628 ? - 1682 Landscape subjects Exh: Holland, Belgium, France, UK, US, etc.		
	RUISDAEL (or RUYSDAEL) **Jakob Salomonsz** b. Haarlem. 1630 ? - 1681 Landscape artist Exh: Holland, France, Hungary, Scandinavia		

690

RUSKIN. HRWS John b. London. 1819 - 1900 Architectural, floral & landscape artist Exh: OWS, RWS, London & Prov. AG's	*JR JR JR JR JR*
DUFF, RI, RE, PAS, MA, LL.B. John Robert Keitley b. London. 1862 - ? Rustic genre Exh: RA, SS, RI, London & Prov. AG's etc	*JR.*
REID John Robertson b. Edinburgh. 1851 - 1926 Genre, marine & landscape artist Exh: RA, RI, VA, UK, Australia, Germany	*J.R.R.*
STANHOPE John Roddam Spencer b. Cannon Hall. 1829 - 1908 Pre Raphaelite School Exh: UK AG's	*J RSS*
WEGUELIN, RWS John Reinhard b. South Stokes. 1849 - 1927 Genre & historical subjects Exh: RA, London & Prov. AG's, S. Africa	*JRW J.R.W.*
WELLS Josiah Robert Fl. 19th C. Marine & coastal subjects Exh: RA, NWS, SS, London & Prov. AG's	*JRW*
BLUNT, RBA John Sylvester b. Northants. 1874 - Street scenes & landscape artist Exh: RA & Prov. AG's	*JB*
PARROCEL Joseph b. Provence. 1646 - 1704 Battle scenes & historical subjects Exh: UK, France, Italy, Spain, etc.	*J.*
SANDRART Jan b. Frankfurt. 1588 - 1679 ? Religious subjects Exh: Germany	*J*
SANT. RA James b. London. 1820 - 1916 Portrait, allegorical & genre subjects Exh: RA, London AG's, Australia, Germany	*JS*

JS

SCHOUMAN **Isaak** b. Holland. 1801 ? - ? Military & landscape subjects	
SMITH **John** b. UK. 1652 ? - 1742 Genre & portrait artist	
SONJE **Jan Gabriel** b. Delft. 1625 ? - 1707 Landscape artist Exh: Germany, Holland, France	
SOUTHALL, RWS **Joseph Edward** b. Birmingham. 1861 - 1944 Genre, figure & landscape artist Exh: UK AG's, Paris	
STAVEREN **Jan Adriensz Van** b. Leyden. 1625 ? - 1668 Portrait, genre & landscape subjects Exh: Holland, Paris, UK	
STEEN **Jan Havicksz** b. Leyden. 1626 - 1679 Genre, tavern scenes etc. Exh: International AG's	
STEEPLE **John** b. ? - 1887 Landscapes & coastal scenes Exh: RA, SS, VA, Prov. AG's	
STOLKER **Jan** b. Amsterdam. 1724 - 1785 Portraits, & allegorical subjects Exh: Holland	
HILL, RBA **James Stevens** b. Exeter. 1854 - 1921 Landscape & floral subjects Exh: RA, SS, RIBA, Prov. AG's	J.S.H.
SCHUMANN **Johann Gottlob** b. Dresden. 1761 - 1810 Portrait & landscape artist	

STIMMER **Tobias** b. Switzerland. 1539 - 1584 Portrait, genre & religious subjects Exh: Switzerland		JS
SCHNITZLER **Michael Johann** b. Germany. 1782 - 1861 Still life subjects Exh: Germany		
ATHERTON **John Smith** Oil & watercolourist Exh: RA, RSA, RI, RWA, GI, etc.		
TENNIEL **Sir John** b. London. 1820 - 1914 Portraits, genre subjects & illustrator Exh: RI, NWS, SSSBA, VA, Prov.AG's, etc.	1870	JT
TROST **Andreas** b. Austria. ? - 1708 Genre, mythological & architectural subjects		
TISSOT **James Jacques Joseph** b. Nantes. 1836 - 1902 Religious, historical & genre subjects Exh: PS, RA, SS, GG, Prov. AG's, Belgium, France		
THOMA **Hans** b. Germany. 1839 - 1924 Religious, portrait, genre & landscape subjects Exh: Germany, US, Sweden, Austria, etc.		
NETTLESHIP **John Trivett** b. Kettering. 1847 - 1902 Genre & animal subjects Exh; RA, SS, GG, NWS, NG etc.	J.T.N.	
VEYRASSAT **Jules Jacques** b. Paris. 1828 - 1893 Animal & landscape subjects Exh: France	J V	JV
VIEN **Joseph Marie** b. Montpellier. 1716 - 1809 Religious & historical subjects Exh: French AG's	J.V J.V	

WINGHE **Jeremias Van** b. Brussels. 1578 – 1645 Historical & portrait artist Exh: Germany	J·V. 1597
ASSEN **Jan van** b. Amsterdam 1635 ?- 1697 Portraits, landscapes & historical subjects Exh: Holland	J.v.A.
BENT **Johannes van der** b. Amsterdam. 1651 - 1690 Landscape artist Exh: Russia, Hungary, France, Holland etc	JB JB JB
BLOEMEN (or BLOMMEN) **Jan Frans van** b. 1662 ? - 1749 Landscape artist Exh: Russia, UK, & European AG's	J.v.B.Bn.
HERP (The Elder) **Willem van** b. Anvers. 1614 - 1677 Historical subjects Exh: France, Belgium, Sweden, Austria Ireland	JHl
NYMEGEN **Gerard Van** b. Rotterdam. 1735 - 1808 Landscape & portrait artist	gvn
ORLEY **Jan Van** b. Belgium. 1665 - 1735 Portraits & historical subjects Exh: Belgium	J.V.O.
PEE **Jan Van** b. Amsterdam. 1641 ?- 1710 Genre subjects Exh: Russia, Holland	N.f N.f
RAVENSWAY (The Younger) **Jan Van** b. Holland. 1815 - 1849 Landscape artist Exh: Holland	J.v.R Jr
ROBERT **Nicolas** b. France. 1614 - 1685 Genre artist & miniaturist	NR

ROBERT-FLEURY **Joseph Nicolas** b. Cologne. 1797 - 1890 Historical & biblical subjects Exh: France, Holland, US	*N.*	JV
VERKOLYE **Jan** b. Amsterdam. 1650 - 1693 Portrait, genre & historical subjects Exh: Holland, Germany, Russia, UK, etc.	*JVRf*	
SON **Joris Van** b. Belgium. 1623 - 1667 Still life subjects Exh: Belgium, Scandinavia	*J.V.S.*	
WALRAVEN **Isaac** b. Amsterdam. 1686 - 1765 Historical & genre subjects Exh: Holland	*JW*	JW
WANDELAAR **Jan** b. Amsterdam. 1690 - 1759 Portraits & religious subjects	*JW*	
WEBB **James** b. 1825? - 1895 Marine & landscape artist Exh: RA, BI, SS, VA, UK AG's, Australia	*J.W* *by.* *(JW)*	
WILKENS **Theodorus** b. Amsterdam. 1690 - 1748 Landscape artist Exh: Holland, Belgium, Germany, Austria	*JW. 1736*	
WORLIDGE **Thomas** b. Peterborough. 1700 - 1766 Portrait artist & miniaturist Exh: NPG, VA, London & Prov. AG's	*J.W*	
WYCK **Thomas** b. Holland. 1616 ? - 1677 Interiors, markets & marine subjects Exh: Russia, European AG's, UK, etc.	*JW*	
WYNANTS **Jan** b. Haarlem. 1630 ? - 1684 Landscape artist Exh: International AG's	*J.W* *JW*	

MEIL **Johann Wilhelm** b. Germany. 1733 - 1805 Historical & landscape artist Exh: Germany	*J.W.M.*
WOLF. RI **Joseph** b. Germany. 1820 - 1899 Bird & animal subjects Exh: RA, NWS, BI, SS, RI, VA & Prov. AG's	*JW* *JWR*
WARD. RA **James** b. London. 1769 - 1859 Landscape, genre & animal subjects Exh: RA, BI, SS, London & Prov. AG's	*JWR* *JWS*
SCHIRMER **Johann Wilhelm** b. Germany. 1807 - 1863 Biblical & landscape subjects Exh: Germany	*J.W.S.*
WATERHOUSE, RA **John William** b. Rome. 1849 - 1917 Mythological & historical subjects Exh: RA, UK AG's, Paris, Australia etc.	*JWW*
WILKIN **Frank. W.** b. London. 1800 ? - 1842 Portrait artist, miniaturist & historical subjects Exh: London & Prov. AG's	*JWW*
WINGHE **Jeremias Van** b. Brussels. 1578 — 1645 Historical & portrait artist Exh: Germany	*J W*
WRIGHT, RWS **John William** b. London. 1802 - 1848 Genre artist & watercolourist Exh: RA, BM, UK AG's	*JWW 1841* *JWW 1840*
YATES **Frederick** b. 1854 - 1919 Landscape & portrait artist Exh: London & Prov. AG's	*J.Y.* *J.Y.*
HUNTER **John Young** b. Glasgow. 1874 - 1953 Genre, historical & landscape artist Exh: UK AG's	J.Y.H.

KENNINGTON, RA Eric Henry b. London. 1888 - 1960 Portraits & military subjects Exh: UK AG's	K	K
ADDISON Byron Kent b. St Louis, US. 1937 - Painter & sculptor Exh: US AG's, X	KA	KA
CORBOULD Edward Henry b. London. 1815 - 1915 Genre & historical subjects Exh: RA, SS, GG, NWS	KHC	
KELSEY Frank Fl. 1887 - 1893 Marine artist Exh: RA, SS	FK	
KNELL William Adolphus b. 1805 - 1875 Marine artist Exh: RA, BI, SS, UK AG's	AK AK.	
KIRBY John Kynnersley Oil & watercolourist Exh: NEAC, London & Prov. AG's	KK	
BALLENBERGER Karl b. Germany 1801 - 1860 Portraits & mythological subjects Exh: Germany	KK	KB
BARDEN, ARIBA, ARCA, Kenneth AFAS(Eng) MSIA, AIBD b. Huddersfield 1924 - Landscapes, still life etc oil & watercolourist Exh: RA, RI, London & Prov. AG's Works in collections UK, Europe etc	K.B.	
BARRATT Krome b. London 1924 - Abstract subjects Exh: RA, ROI, RBA, NS, London & Prov. AG's	KB	
BODMER Karl b. Riesbach. 1809 - 1893 Animal & landscape artist Exh: European AG's	KB	

KC	**CARLSTEDT** **Kalle Frederik Oskar** b. Lieto. 1891 - Painter, graphic artist Exh: Russia, Sweden, Germany, Hungary, Switzerland etc	.KC. KC KC
	KARUTH **Ethel** Fl. 1900 - 1908 Portraits & Miniaturist Exh: RA	
	KING **Cecil George Charles** b. London. 1881 - 1942 Marine & landscape artist Exh: UK AG's, France	
	KNIGHT **Charles Parsons** b. Bristol. 1829 - 1897 Landscape & marine artist Exh: RA, BI, SS, UK, AG's, Hamburg	
	KRUMPIGEL **Karl** b. Prague. 1805 - 1832 Landscape artist	
KD	**KANDEL** **David** b. France. FL. 16th C. Floral subjects Exh: France	
KF	**KELLER** **Ferdinand** b. Germany. 1842 - 1922 Historical, portrait & landscape subjects Exh: France, Germany	
KG	**GRAY, ARCA, FSA etc** **George Edward Kruger** b. London. 1880 - Watercolourist Exh: RA, Paris, London & Prov. AG's	
	GREENAWAY **Kate** b. London. 1846 - 1901 Genre oil & watercolourist, engraver Exh: SS, VA, UK AG's, Australia etc.	KO KG. KG KG
KH	**HALSWELLE, ARSA** **Keeley** b. Richmond. 1832 - 1891 Genre & landscape artist Exh: RA, RSA, UK AG'S, Australia	K.H.

698

ATHAR Chiam b. Zlatapol, Russia 1902 - Painter in oil media Exh: Israel, PS, S. Africa etc.		KH
JOHNSON Katherine Architectural views, landscapes & flower subjects Exh: RA, RI, WAG & Prov. AG's		KI
KNOWLES, RBA Davidson Fl. 1879 - 1902 Animal & landscape artist Exh: RA, SS, Prov. AG's		
DUFF, RI, RE, PAS, MA, LL.B. John Robert Keitley b. London. 1862 - ? Rustic genre Exh: RA, SS, RI, London & Prov. AG's etc		KJ
DUJARDIN Karel b. Holland. 1622 - 1678 Portrait, genre & landscape artist Exh: France, Holland, Germany, Belgium, Hungary etc		
LEK. A.R. Cam.A, NDD, ATD. Karel b. Antwerp. 1929 - Etcher, engraver, oil, gouache, watercolourist etc. Exh: R.Cam.A, WAG, RBA, etc.		KL
LOCKWOOD. NDD Kenneth b. Huddersfield. 1920 - B/white, gouache, scraper-board, watercolour media Exh: London & Prov. AG's, etc.		
MEADOWS Joseph Kenny b. Cardiganshire. 1790 - 1874 Genre subjects Exh: RA, SS, VA		KM
ROWNTREE. ARWS Kenneth b. Scarborough. 1915 - Oil & watercolourist Exh: AIA, London & Prov. AG's		KR
RUSS Karl b. Vienna. 1779 - 1843 Historical subjects		

KAA **Jan van der** b. Holland. 1813 - 1877 Portraits & interior scenes Exh: Holland, Belgium, Germany	
MANDER (The Elder) **Karel Van** b. Belgium. 1548 - 1606 Religious & portrait artist Exh: Belgium, Holland, Austria	K.V.M *Kven pinxit* K̃ K̃
KEMP-WELCH, RI, RBC, RBA, RCA **Lucy Elizabeth** b. Bournemouth. FL. 19th - 20th C. Animal & landscape subjects etc Exh: RA, RI, London & Prov. AG's Australia, S. Africa	K.W
LABOUREUR **Jean Emile** b. Nantes. 1877 - 1943 Genre subjects & illustrator Exh: France	Ⱡ
LAWLESS **Matthew James** b. Dublin. 1837 - 1864 Genre subjects Exh: RA	L
LEIGHTON. PRA, RWS, HRCA, HRSW. **Lord Frederick** b. Scarborough. 1830 - 1896 Mythological & historical subjects Exh: RA, SS, OWS, GG, Germany, Australia	L
LEYDEN **Lucas Van** b. Holland 1494 - 1538 Religious & historical subjects Exh: France, Germany, Britain, Italy	L. L. L. L 1527 1525
LOTZE **Moritz Eduard** b. Germany. 1809 - 1890 Landscape subjects	L 1832
LOUND **Thomas** b. 1802 - 1861 Landscape artist Exh: VA, UK AG's	I 1833
STARR **Louisa (Mrs Canziani)** b. London. 1845 - 1909 Portraits, genre & historical subjects Exh: RA, SS, Prov. AG's	

KV

KW

L

ALENZA Y NIETO Leonardo b. Madrid. 1807 - 1845 Genre & Portrait artist Exh: Madrid	*L.A.*	LA
ANDREWS Lilian b. 1878 - Watercolourist of birds & animals Exh: RA, RSA, & Prov. AG's	*ÆA*	
APPELBEE, ARCA Leonard b. London 1914 - Portraits, still life & landscape artist Exh: RA, London & Prov. AG's	*LA*	
LANKESTER, BA, MB, B.CL, CANTAB, MRCS, LRCP Lionel W.A. b. Surrey. 1904 - B/white & watercolourist Exh: RWS & Prov. AG's	*A 1953*	
LEMAIRE Francois b. France. 1620 - 1688 Portrait artist Exh: France	*LA*	
LEPERE Auguste Louis b. Paris. 1849 - 1918 Landscape & genre subjects Exh: PS, France	*LA*	
SCHIAMINOSSI Raffaello b. Italy. 1529 - 1622 Religious & historical scenes	*L RF*	
BAKHUIZEN (or BAKHUYZEN) Ludolf b. Emden 1631 - 1708 Portrait & marine artist Exh: Holland, Germany, Belgium, France, Russia, UK etc	*LB LB*	LB
BASSINGTHWAITE Lewin b. Essex. 1928 - Painter Exh: US, London & Prov. AG's	*LB*	
BOULOGNE (The Younger) Louis de b. Paris. 1654 - 1733 Historical, religious & mythological subjects Exh: France, Russia	*LB*	

BRAMER **Leonard** b. Delft. 1596 - 1674 Portraits & historical subjects Exh: Holland, Germany, France, Austria, etc	L.B	
LEACH. FRSA **B.** b. Hong Kong. 1887 - Exh: London & Prov. AG's, Europe & Japan		
BLONDEEL **Lancelot** b. 1495? - 1581 ? Architectural ruins, conflagrations & religious subjects Exh: Holland, Belgium	1545	
COCLERS **Jean Baptiste Bernard** b. Liege. 1741 - 1817 Portrait, genre & religious subjects Exh: Holland	L.B.C.	
VALDES **Lucas De** b. Seville. 1661 - 1724 Portraits & religious subjects Exh: Spain		
CAMBIASI (or CAMBIASO) **Luca** b. 1527 - 1585 Portrait, historical, allegorical & biblical subjects Exh: France, Germany, Italy		
CARDI (or CIGOLI) **Lodovico** b. Italy. 1559 - 1613 Religious & historical subjects Exh: France, Italy, Germany, Russia etc.	LC	
CARRACCI **Lodovico** b. Italy. 1555 - 1619 Portrait, religious & historical subjects Exh: UK, European AG's	L.C.	
CHERON **Louis** b. Paris. 1660 - 1715 Historical subjects Exh: Italy, France, UK	L·C; inv.	
CRANACH **Lucas** b. Bavaria. 1472 - 1553 Religious, historical, landscape & portrait artist Exh: Scandinavia, Russia & European AG's	LC 1509	

LB

LC

702

CRAWSHAW, RSW, BA, LL.M. **Lionel Townsend** b. Nr. Doncaster. 20th C. Oil & watercolourist Exh: RA, RSA, PS, RSW	
CROKE **Lewis Edmund** b. London. 1875 - ? Etchings & pastel artist Exh: RA, France, Italy, Canada & Prov. AG's	
LAWRENSON **Charlotte Mary** b. Dublin. 1883 - Portrait artist Exh: RA, France, US	
LEBSCHEE **Carl August** b. Poland. 1800 - 1877 Scenic & landscape subjects Exh: Germany	
COLE **Philip William** b. Sussex. 1884 - Portrait & landscape artist Exh. RA, France	
LUDOVICE (The Elder) **Albert** b. 1820 - 1894 Genre subjects Exh: NG, UK AG's	
DAVID **Jacques Louis** b. Paris. 1748 - 1825 Portraits & historical subjects etc Exh: Russia & European AG's	
DAVIS, RI Lucien b. Liverpool. 1860 - 1951 Genre, portraits & landscape artist Exh: UK AG's	
DUNCAN Lawrence Fl. 1860 - 1891 Genre & landscape, oil & watercolourist Exh: London & Prov. AG's	
DICKINSON Lowes Cato b. London. 1819 - 1908 Portrait artist Exh: RA, NPG	

LD	**VINCI** **Leonardo Da** b. Italy. 1452 - 1519 Portraits, mythological, religious & historical subjects Exh: International AG's	*LDV* LDV. Ł
	CORONA **Leonardo** b. Italy. 1561 - 1605 Religious & historical subjects	Ł.I.C.
LE	**LAUDER, RSA** **James Eckford** b. Edinburgh. 1811 - 1869 Figures, historical & landscape painter Exh: UK AG's	Ł
	LEAR **Edward** b. London. 1812 - 1888 Birds, animals, topographical & landscape subjects Exh: SS, UK AG's etc.	Œ Ⅾ Ⓔ
LF	**FILDES, RA** **Sir Luke** b. Liverpool. 1844 - 1927 Genre & portrait artist Exh: RA, London & Prov. AG's, Germany	L.F.
	FLAMENG **Leopold** b. Brussels. 1831 - 1911 Religious & historical subjects etc Exh: France	ⱠF
	LIPPI **Lorenzo** b. Florence. 1606 - 1665 Religious, historical & portrait artist Exh: Italy, France, Vienna	Ł F.
	MUCKLEY **Louis Fairfax** b. Stourbridge. Fl. 1890 - 1902 Genre subjects Exh: London & Prov. AG's	L\|F
	DUBOURG **Louis Fabricius** b. Amsterdam. 1693 - 1775 Portraits, miniaturist etc Exh: Germany	LFDB LFDB LFD LFD LFD

GRIER **Louis** b. Melbourne. 1864 - 1922 Landscape & marine artist Exh: RA, SS, PS	LG	LG
LEGENDRE **Louis Felix** b. Paris. 1794 - ? Historical & landscape subjects	LG.	
LITTLE **George Leon** b. London. 1862 - 1941 Animal & landscape artist Exh: UK AG's	CL	
LUMSDEN, RSA **Ernest Steven** b. London. 1883 - Landscape artist & watercolourist Exh: UK AG's	GL 1931	
HASSALL, RI, RWA **John** b. 1868 - ? Painter in B/white & watercolour media Exh: London, Paris, etc	LH	LH
HEALEY **Leonard Douglas** b. Cheshire. 1894 - Pastel, oil & watercolourist Exh: London & Prov. AG's	LHD	
La HIRE **Laurent de** b. Paris. 1606 - 1656 Religious & historical subjects Exh: France, Italy, Prague, Budapest	LH L H	
LOVE, NDD, RWA **Hazel** b. Somerset. 1923 - Oil & watercolourist Exh: RWA, AIA, etc. X	HL	
LUCAS **Horatio Joseph** b. 1839 - 1873 Landscape watercolourist Exh: RA, Prov. AG's	HL 1865	
NONO **Luigi** b. Italy. 1850 – 1918 Historical & genre subjects Exh: Italy, S. America, Germany	L.IX:	

LG

LH

LI

705

LJ	**TENNIEL** **Sir John** b. London. 1820 - 1914 Portraits, genre subjects & illustrator Exh: RI, NWS, SSSBA, VA, Prov.AG's, etc.	
	FUCHS **Lodewijk Juliaan** b. Lille. 1814 - 1873 Landscape artist Exh: Holland	
LK	**KALF** **Willem** b. Amsterdam. 1622 - 1693 Still life, interiors & genre subjects Exh: France, Hungary, UK, Holland, Russia, Belgium etc	
	KNECHTELMAN **Lucas** F.L. Germany. 16th C. Historical subjects Exh: Germany	
	KNIGHT, RA, RWS **Dame Laura** b. 1877 - 1970 Circus, gipsy & theatrical subjects Exh: RA, UK AG's	
	KRUG **Ludwig** b. Nuremberg. 1489 - 1532 Historical & religious subjects	
LL	**LEGRAND** **Louis Auguste Mathieu** b. Dijon. 1863 - 1951 Genre artist & illustrator	
	LIMOSIN **Leonard** b. Limoges. 1505 ? - 1577 ? Religious subjects	
LM	**LANCHESTER** **Mary** b. 1864 - ? Flower subjects etc Exh: RA, RI, RBA & Prov. AG's	
	MATHIEU **Lambert Joseph** b. Belgium. 1804 - 1861 Historical, genre & portrait artist Exh: Belgium	

MIGNON Abraham b. 1640 - 1679 Floral & still life subjects Exh: Germany, Holland, Belgium, Italy, UK, France, etc.	*LAC* (monogram)	LM
MOYANO Louis A b. Liege. 1907 - Painter & engraver Exh: Belgium, France, etc.	*LM.* (monogram)	
MacDONALD. RMS Lucy Winifred b. London. 1872 - ? Miniaturist Exh: RA, RMS, Prov. AG's Canada etc.	*LM* (monogram)	
WARD Sir Leslie ('Spy') b. London. 1851 - 1922 Portrait artist & caricaturist Exh: UK AG's	*LMW* (in box)	
LYTTON. OBE, SSN Neville b. 1879 - ? Fresco, tempera & oil media Exh: RA, RBA, NEAC, RP, etc.	(monogram)	LN
LASTMAN Pieter Pietersz b. Amsterdam. 1583 - 1633 Religious & mythological subjects Exh: Holland, Germany	*L*	LP
PHILPOT Leonard b. 1877 - ? Still life subjects etc. Exh: RA, RI, London & Prov. AG's US, N. Zealand	*LP* (monogram)	
PASINELLI Lorenzo b. Bologna. 1629 - 1700 Religious & portrait artist Exh: Italy, Vienna, France	*L.P.F.*	
LEIGH-PEMBERTON John b. London. 1911 - Oil, tempera & gouache media Exh: RA, ROI, NS, London & Prov. AG's	(monogram)	
PENNI Luca b. Florence. 1500 - 1556 Historical subjects Exh: France, Italy	*L. P.R. L. L P R.*	

LP	**WITHOOS** Peter b. Holland. 1654 - 1693 Animals, insects & floral subjects Exh: Holland, Germany, Austria, UK	*P.W.* *P.W.*
LQ	**QUAGLIO** Lorenzo b. Munich. 1793 - 1869 Portrait & genre artist Exh: Germany	*LQ 1825* LQ
LR	**ROBERT** Leopold Louis b. France. 1794 - 1835 Genre & landscape artist Exh: France, Germany	*LR*
	SPADA Leonello b. Bologna. 1576 - 1622 Biblical subjects Exh: Italy, France, UK	*LR.*
	MANUEL Hans Rudolf b. Switzerland. 1525 ? - 1572 Religious & portrait subjects Exh: Switzerland	*LRMD*
LS	**FONTENAY** Louis Henri de b. Amsterdam. 1800 - ? Genre & historical subjects Exh: France	
	LUCAS. RA, RI John Seymour b. London. 1849 - 1923 Historical & genre subjects Exh: RA, SS, NWS, London & Prov. AG's, Australia	*SL*
	SAMBOURNE Linley b. UK. 1844 - 1910 Illustrator, cartoonist & painter Exh: RA, France	LS.
	SMYTHE. RA, RWS, RI Lionel Percy b. London. 1839 - 1918 Rustic genre & landscape artist Exh: RA, SS, BI, NWS, OWS, Australia	LS
	STANNARD Lilian (Mrs Silas) b. Woburn. 1884 - 1938 Landscapes & floral subjects Exh: London & Prov. AG's	L.St.

THACKERAY **Lance** b. ? - 1916 Genre & sporting scenes Exh: London & Prov. AG's	*LT* (monogram)	LT
THOMAS **Laura Estelle Owen** b. London. 1897 - Painter in oil & gouache media Exh: RA & Prov. AG's	*LEo* (monogram)	
VORTEL **Wilhelm** b. Dresden. 1793 - 1844 Landscape artist	*K* (monogram)	LV
VADDER **Lodewyk De** b. Brussels. 1605 - 1655 Landscape subjects Exh: Belgium, Germany, France	*ĐL* (monogram)	
LEYDEN **Lucas Van** b. Holland 1494 - 1538 Religious & historical subjects Exh: France, Germany, Britain, Italy	*LVL.* *LVL* (monograms)	
MITCHELL **Leonard Victor** b. New Zealand Portrait, figure, still life & landscape artist Exh: RA, PS, UK & European AG's N. Zealand, Australia etc.	*L.V.M* (monogram)	
NOORT **Lambert Van** b. Holland. 1520 ? — 1571 Religious subjects Exh: Belgium	*LVN* (monogram)	
LINT **Peter Van** b. Antwerp. 1609 ? - 1690 Portraits & religious subjects Exh: Belgium, France, Germany, Austria	*VL* (monogram)	
UDEN **Lucas Van** b. Antwerp. 1595 - 1672 ? Landscape & figure artist Exh: European AG's	*Lvv* (monogram)	
VALKENBORCH **Lucas Van** b. Belgium. 1530 ? - 1597 Genre & landscape artist Exh: Belgium, Germany, France, Holland	*LVV* (monogram)	

709

LW	**WAKEFIELD** **Larry Hilary Edward** b. Cheltenham. 1925 - Abstract expressionist & figurative subjects Exh: Paris, London & Prov. AG's	*L.W*
	WATERFORD **Lady Louisa** b. Paris. 1818 - 1891 Genre, biblical & mythological subjects Exh: GG, London AG's	*W*
	WATTEAU **Francois Louis Joseph** b. France. 1758 - 1823 Military, genre & historical subjects Exh: French AG's	*L.W.*
	WINDUS **William Lindsay** b. Liverpool. 1822 - 1907 Genre & historical subjects Exh: RA, BI, SS & Prov. AG's	*monogram*
LZ	**ZACCHIA** **Lorenzo** b. Italy. 1524 - 1587 ? Religious subjects Exh: Italy	*monogram*
M	**MARNY** **Paul** b. Paris. Ex. from 1857 Landscape artist Exh: France	*monogram*
	MASON **Eric** b. London. 1921 - Landscapes, towns & river scenes, architectural subjects etc. Exh: London & Prov. AG's, US	*≡M- ≡m-*
	MECHAU **Jakob Wilhelm** b. Leipzig. 1745 - 1808 Historical & landscape artist Exh: Scandinavia	*M*
	MOMPER **Jodocus** b. Antwerp. 1564 - 1635 Landscape artist Exh: Holland, France, Germany	*M:* *1615.*
	MURRAY. ARCA **William Grant** b. Portsoy. 1877 - 1950 Oil & watercolourist Exh: London & Prov. AG's	*monogram*

MYNOTT. RBA **Derek G.** b. London. 1926 - Oil & watercolourist Exh: RA, RBA, US, Prov. AG's		M
RUTLAND (Duchess of) **Violet.** b. Lancashire. 19th C. Sculptor & portrait artist Exh: RA, London & Prov. AG's, France, US		
HEEMSKERK **Marten Jacobsz van veen** b. Nr. Haarlem. 1498 - 1574 Historical artist Exh: Holland		MA
MAROT **Francois** b. Paris. 1666 - 1719 Religious & historical works Exh: France		
CARAVAGGIO **Michelangelo Merisi** b. Italy. 1562 - 1609 Portrait, religious, historical subjects etc. Exh: Scandinavian & European AG's etc		
MICHELANGELO (BUONARROTI) b. Italy. 1475 - 1564 Portraits, mythological & religious subjects etc. Exh: International AG's		
CLEEF **Henry van** b. Antwerp. 1510 - 1589 Landscape artist		
WAARD **Antonie** b. The Hague. 1689 - 1751 Historical, portrait, genre & animal subjects Exh: Holland		
ELLENRIEDER **Maria** b. Constance. 1791 - 1863 Portraits & historical subjects Exh: Switzerland, Germany		
FRANCESCHINI **Marco Antonio** b. 1648 - 1729 Historical, religious & mythological subjects Exh: Italy, Germany, France, Austria, Russia etc		

MA	**MEYER** **F.W.** Landscape, marine & coastal subjects Exh: RA, SS, London & Prov. AG's	
	SCHONGAUER **Martin** b. Germany. 1445 ? - 1491 Religious subjects Exh: Germany, Austria	*M a . s*
	MATON **Bartholomaeus** b. Stockholm. 1643 ? - ? Genre & portrait artist Exh: Holland, Belgium, Austria	MT on MT MT
MB	**BARLOW** **Mary** b. Manchester 1901 - Landscapes & animal subjects Exh: R. Cam.A. WAG	MB
	BAUER **Mari Alexander Jacques** b. The Hague 1867 - 1932 Figure & decorative painter Exh: European AG's	MB
	BOTTOMLEY John William b. Hamburg. 1816 - 1900 Sporting & animal subjects Exh: RA, SS, BI, UK AG's, Germany	MB
	BOWKETT **Jane Maria** Fl. 19th C. Domestic subjects Exh: RA, SS, BI	MB
	BRAY-BAKER, AMTC **May** b. London. 1887 - Landscapes, flowers & garden subjects Exh: SWA & Prov. AG's	MB
	BUTLER, RWS Mildred Anne b. Ireland. 1858 - 1941 Genre, animal & landscape artist Exh: RA, NWS, SS, GG, NG	MB
	MABUSE (known as GOSSART) **Jan De** b. Maubeuge. 1478 ? - 1533 Portraits, biblical subjects & miniaturist Exh: European AG's	MB JONN NALBODIUS INVENIT

MICHELANGELO (BUONARROTI) b. Italy. 1475 - 1564 Portraits, mythological & religious subjects etc. Exh: International AG's		MB
CARPENTER Margaret Sarah (nee Heddes) b. Salisbury. 1793 - 1872 Portrait artist Exh: BM, UK AG's		MC
CIRY **Michel** b. France. 1919 - Pastel, oil & watercolourist Exh: France, Belgium, Holland etc		
COATS **Mary** b. Paisley. Fl. 1920's Still life, marine & landscape artist Exh: UK AG's		
COUVE DE MURVILLE-DESENNE, FIL, FIAL **Lucie-Renee** b. Madagascar. 1920 - Portrait, floral & marine subjects Exh: RWA, London & prov. AG's		
COXIE **Michiel I** b. 1499 - 1592 Portraits, historical & religious subjects Exh: Russia, Germany, France, Belgium, Spain, Italy		
KLINGER **Max** b. Leipzig. 1857 - 1920 Historical, religious & genre subjects Exh: Germany, Australia		
MANNINI **Giacomo Antonio** b. Bologna. 1646 - 1732 Religious subjects Exh: Italy		
BOELLAARD **Margaretha Cornelia** b. Utrecht. 1795 - 1872 Genre & portrait artist		
McCANNELL. RWA, RBA, ARCA, **etc.** **Otway** b. Wallasey. 1883 - Pastel, Gouache, oil & watercolour media etc. Exh: RA, PS, London & Prov. AG's, Italy		

MC	**MILDE** Karl Julius b. Hamburg. 1803 - 1875 Marine, historical & landscape artist	
	SCHONGAUER Martin b. Germany. 1445 ? - 1491 Religious subjects Exh: Germany, Austria	
MD	**DAVISON** Minnie Dibdin Fl. London. 1893 - 1910 Genre & portrait miniaturist Exh: RA, UK AG's	
	DESBOUTIN Marcellin Gilbert b. France. 1823 - 1902 Portraits & genre subjects Exh: France	
	LINDTMAYER (The Younger) Daniel b. 1552 - 1607 Religious & landscape subjects Exh: France, UK, US, Germany	
	MADOU Jean Baptiste b. Brussels. 1796 - 1877 Genre subjects Exh: Holland, Belgium	
	MANUEL Niklaus Fl. Switzerland. 15th - 16th C. Portraits & historical subjects	
	MARTIN. ARCA, AMTC, ACT Dorothy Burt b. Wolverhampton. 1882 - Etcher, watercolourist etc. Exh: RA, SWA, Prov. AG's etc.	
	HONDECOETER Melchior de b. Utrecht. 1636 - 1695 Animals, birds, still life & landscape artist Exh: France, Holland, Belgium, Germany, Italy, UK etc	
	MARTSS Jan Fl. 17th C. Battle scenes	

MUTRIE **Martha Darlay** b. Manchester. 1824 - 1885 Fruit & floral subjects Exh: RA, VA, US, Australia	*M.D.M 1872*	MD
EARL **Maud** Fl. London/Paris. 1884 - 1908 Animal subjects Exh: RA, PS, US	*ME* *ME*	ME
MATHAM **Jacob** b. Haarlem. 1571 - 1631 Portrait artist Exh: Holland	*Me* **M**.*se*	
MEHEUT **Mathurin** b. France. 1882 - 1958 Genre & landscape subjects		
MEISSONIER **Jean Louis Ernest** b. Lyon. 1815 - 1891 Portraits, genre & historical subjects Exh: International AG's	*EM* *M*	
LIERNUR **Maria Elisabeth** b. Paris. 1802 - ? Portraits & miniaturist	*M. E M*	
FAULTE **Michel** Flourished 17th Century Portraits, religious & historical subjects	*MF*	MF
FESELEN **Melchior** b. ? - 1538 Historical subjects Exh: Germany	*NF* *MF*	
FLETCHER **Frank Morley** b. 1866 - 1949 Genre & portrait artist Exh: VA, London, Paris, Germany, US	*MF*	
FRANCKEN **Maximilien** b. ? - 1651 Genre & historical artist	*MF.*	

MF	**FREY** **Johann Michael** b. 1750 - 1813 Battle scenes, animals & landscape subjects	
	MATTHIOLI **Lodovico** b. Italy. 1662 - 1747 Religious, portraits & landscape artist Exh: Italy	
	MERIAN (The Elder) **Matthaus** b. Basle. 1593 - 1650 Portrait, landscape & historical subjects Exh: Switzerland	
	MOUCHERON **Frederic De** b. Holland 1633 - 1686 Landscape artist Exh: France, Belgium, Holland, Germany, UK	
MG	**GERTLER** **Mark** b. London. 1892 - 1939 Portraits, figures, still life, etc. Exh: UK AG's, Paris	
	GERUNG **Matthias** b. 1500 ? - 1570 ? Historical subjects Exh: Germany	
	GILLIES **Margaret** b. London. 1803 - 1887 Portraits, genre, interiors & miniaturist Exh: RA, SS, BI, VA, BM, etc.	
	GREIFFENHAGEN, RA **Maurice William** b. 1862 - 1931 Allegorical figures, portrait artist etc Exh: RA, SS, Germany, Italy, US etc	
	MANSON **George** b. Edinburgh. 1850 - 1876 Landscape artist Exh: UK AG's	
	WILSON **Mary G.W.** b. Falkirk. Landscape artist Exh: RSA, PAS, London & Prov. AG's	

HARDIE Martin b. London. 1875 - 1952 Landscape watercolourist Exh: RA, VA	*(monogram marks)*
HAUGHTON (The Younger) **Moses** b. England. 1772 - 1848 Portraits, genre & miniaturist Exh: RA, BI	*(MH monogram in oval)*
HERR **Michael** b. Germany. 1591 - 1661 Allegorical & historical subjects	*MH.*
HEYLBROUCK **Michael** b. Gand. 1635 - 1733 Painter and engraver	*(monogram mark)*
HOLLAND **Mabel Constance Burnes** b. Dawlish, Devon. 1885 - Landscape artist Exh: RWA, London & Prov. AG's	*(MH monogram)*
HUMPHREYS, ATD **Mark** b. Monaco. 1925 - Oil, gouache media etc Exh: London & Prov. AG's	*M.H.*
KRODEL (The Elder) **Matthias** b. Germany. ? - 1605 Portrait artist Exh: Germany	*(monogram mark)*
HORST **Nicolaus van der** b. Anvers. 1598 - 1646 Portraits & historical subjects etc	*(NH monogram)*
MANDYN **Jan** b. Haarlem. 1500 - 1560 ? Imaginative & historical subjects Exh: Holland, France, Germany, Austria	*(monogram mark)*
NISBET **M.H.** b. UK. Fl. 20th C. Genre & imaginative subjects Exh: London & Prov. AG's	*MHN*

MH

MH	**HANSEN** Hans Nicolai b. Copenhagen. 1853 - 1923 Genre & landscape artist Exh: RA, SS, Paris, Vienna, Copenhagen	
	MOORE, RA, RWS Henry b. York. 1831 - 1895 Marine & landscape artist Exh: RA, SS, BI, GG, VA, UK AG's	
	WILLIAMS John Haynes b. 1836 - 1908 Genre artist & illustrator Exh: RA, UK AG's	
MI	**HOME, Pres. SSA 1915 - 17** Robert b. Edinburgh. 1865 - ? Portrait & landscape artist Exh: RA, RSA, SSA, GI & Prov. AG's	
	INCLEDON Marjorie M. b. 1891 - Painter in oil media Exh: RA, ROI, RBA, RPS, etc	
	INGRES Jean Auguste Dominique b. France. 1780 - 1867 Historical, mythological & religious subjects Exh: France, NG, Italy, Sweden	
	PULLAN Margaret Ida Elizabeth b. India. 1907 - Painter in oil media Exh: PS, RP, RBA, USA, Prov. AG's	
MJ	**MAHONEY, NWS** James b. Cork. 1816 - 1879 European architectural views Exh: RA, VA, UK AG's	
	MIDDLETON John b. Norwich. 1828 - 1856 Landscape, oil & watercolourist Exh: RA, SS, London & Prov. AG's	
	HITCHCOCK Malcolm John b. Salisbury. 1929 - Railway subjects, figurative pointilist in various media Exh: RA, PS, RW of EA. R.Cam.A, etc	

MORTIMER. ARA John Hamilton b. Eastbourne. 1741 - 1779 Historical & portrait artist Exh: VA, NPG, London & Prov. AG's	*AM*	**MJ**
CARRICK John Mulcaster Fl. London. 1854 - 1878 Landscape artist Exh: RA, BI, SS	*JM*	
GIBSON Mary Josephine Fl. London late 19th C. Miniaturist Exh: RA	*M.J.G.*	
METTENLEITER Johann Michael b. Germany. 1765 - 1853 Religious, genre & historical subjects	*AMf.*	
KAGER Johan Mathias b. Munich. 1575 - 1634 Historical, religious & miniaturist painter Exh: Germany	*MK MK*	**MK**
KELLERHOVEN Moritz b. Germany. 1758 - 1830 Historical & portrait artist Exh: Munich, Vienna	*MK fe*	
KNECHTELMAN Marx b. Germany. FL. 15th C Historical & portrait artist Exh: Germany	*MK.*	
HARRISON Mary b. London. 1915 - Portraits, landscapes, still life subjects etc. Exh: RA, RSA, RBA, NEAC & London AG's etc	*M.K.H.*	
HEEMSKERK Marten Jacobsz van veen b. Nr. Haarlem. 1498 - 1574 Historical artist Exh: Holland	*MK.*	
LAROON (THE ELDER) Marcel b. Hague. 1653 - 1702 Portraits & interior scenes Exh: Amsterdam	*ML*	**ML**

ML	**LINDNER. RBA, RWS.** **Moffat Peter** b. Birmingham. 1852 - 1949 Landscape & marine artist Exh: RA, SS, NWS, GG, NG, NEAC, etc.	M.L.
	LORCH **Melchior** b. Denmark. 1527 - 1594 Portraits & historical subjects Exh: Germany, Denmark	
	MAINSSIEUX **Lucien** b. France. 1885 - Still life, landscape subjects & illustrator Exh: Paris	
	MARVY **Louis** b. France. 1815 - 1850 Landscape artist Exh: France	
	MENABUOI **Giusto Di Giovanni De** b. Florence. ? - 1393 Historical & religious subjects Exh: London	
	METTENLEITER **Johann Jakob** b. Germany. 1750 - 1825 Portraits, genre & landscape artist Exh: Russia, Germany	
	BROWN **Lucy Madox** b. 1843 - 1894 Watercolourist Exh: RA, etc	
MM	**McEVOY** **Mary** b. UK. Portraits, flower studies & interiors Exh: RA, PS, NEAC	
	MARIS **Matthijs** b. The Hague. 1839 - 1917 Genre & landscape subjects Exh: Holland, Canada	
	MAYER-MARTON. AM, OLE, ACM **HCM.** **George** b. Hungary. 1897 - Fresco, oil & watercolourist etc. Exh: Hungary, France, Germany, Belgium, UK, etc;	

MENPES. RBA, RPE **Mortimer** b. Australia. 1860 - 1938 Genre & street scenes etc. Exh: RA, NWS, GG, SS, etc.		MM
MACKIE, RSA, RSW **Charles H.** b. Aldershot. 1862 - 1920 Genre & landscape artist Exh: RA, UK & European AG's		MO
MAYS **Douglas Lionel** b. 1900 - B/white, oil & watercolourist Exh: RA, RBA, SGA, London & Prov. AG's, Canada		
ODDI **Mauro** b. Parma. 1639 - 1702 Historical subjects		
OSSINGER **Michel** Fl. Germany. 16th C. Religious subjects		
OSTENDORFER **Michael** b. Germany. 1490 ? - 1559 Historical & Portrait artist Exh: Germany, Hungary		
HENTALL, FRSA **Maurice Arthur** b. London. 1920 - Portraits, wildlife & landscape artist Exh: Canada, US, Australia, Spain, Norway & London AG's	MOL	
BRIL (The Younger) **Mattheus** b. 1550 ? - 1584 Landscape artist Exh: France, Italy		
MOLYN (The Elder) **Pieter** b. London 1595 - 1661 Genre & landscape subjects Exh: Holland, France, Germany		MP
PARKER. LIFA **Caroline Maude** b. London Still life & landscape artist Exh: London & Prov. AG's		

MP	
PEPYN **Marten** b. Antwerp. 1575 ? - 1642 Portraits & historical subjects Exh: Belgium, Austria, Sweden	MP. in. f. 1626
MOL **Pieter Van** b. Antwerp. 1599 - 1650 Portraits & religious subjects Exh: France, Germany, Holland	MPL 1615 MPL
McINTYRE **Raymond** Portrait, figure & landscape artist Exh: RA, NEAC & London AG's	
RICCI **Marco** b. Italy. 1676 - 1729 Historical & landscape subjects Exh: France, Italy, UK	MRf MR
ROBERTS **Marguerite Hazel** b. Llandudno. 1927 - Painter in pen & wash & oil media Exh: RA, R.Cam.A., London & Prov. AG's	MR.
RONALDSON. MA **Thomas Martine** b. Edinburgh. 1881 - ? Portrait artist Exh: RA, RSA, PS, WAG	MR
ROSE. RBA, ROI, FFPS **Muriel** b. London. 1923 - Landscape artist, print maker etc. Exh: RA, RSA, RGI, Paris, US, S. Africa, Prov. AG's, etc.	MR
ROSSELLI **Matteo** b. Florence. 1578 - 1650 Portraits & historical subjects Exh: France, Hungary, Italy	MR 608
BAINES, NDD, ATD, SGA, **FRSA, RDS, NS** **Richard John Mainwairing** b. Hastings. 1940 - Painter & etcher Exh: ROI, RBA, NS, SGA, Prov. AG's, X.	
CORBET **Matthew Ridley** b. Lincolnshire. 1850 - 1902 Portraits, Italian genre & landscapes Exh: RA, UK AG's, S. Africa, Australia	MRC 1881

MR

RICHARDSON, RSA, OWS **Thomas Miles (junior)** b. Newcastle. 1813 - 1890 Landscape oil & watercolourist Exh: VA, UK AG's	
SANDERS. ARMS **Margery Beverly** b. London. 1891 - Miniaturist & portrait artist Exh: PS, RA, RMS, WAG, Prov AG's, Canada	
SCHAFFNER **Martin** b. Germany. 1478 ? - 1546 ? Religious & portrait subjects Exh: Germany, France	
SCHEITS **Matthias** b. Hamburg. 1640 ? - 1700 ? Genre subjects Exh: Germany	
SENIOR **Mark** b. Hanging Heaton. 1864 - 1927 Genre, figure & landscape artist Exh: RA, UK AG's	
SMITH. CBE **Sir Matthew** b. Yorkshire. 1879 - Still life, figure & landscape artist Exh: London & Prov. AG's, Europe, Japan, US, etc.	
SPEER **Martin** b. Germany. 1700 - 1765 Historical subjects Exh: Germany	
STOKES **Marianne (née Preindlsberger)** b. Gratz. 1855 - 1927 Genre & portrait artist Exh: RA, SS, Prov. AG's	
SWEERTS **Michele** b. Brussels. 1624 - 1664 Genre subjects Exh: Holland, Germany, Russia, UK	
STONE **Marcus C** b. London. 1840 - 1921 Historical & genre subjects Exh: RA, London & Pro. AG's, Australia	

MR

MS

MS	**HAYTER** Sir George b. London. 1792 - 1871 Portraits, historical subjects & miniaturist Exh: RA, NPG, VA, UK AG'S, Italy	
MT	**MORDUE, RMS, SWA** **Truda** b. Hursley, Hants. 1909 - Watercolour, pastel artist & miniaturist Exh: RA, RI, FBA, RWS etc. X	
	THOMAS. WIAC, RBA, NEAC, **FRSA.** **Margaret** b. London. 1916 - Portrait, still life & landscape artist Exh: RA, RSA, RBA, NEAC, London & Scottish AG's	
	TODD, RA, RWS **Arthur Ralph Middleton** b. Cornwall. 1891 - 1966 Genre, portrait & landscape oil & watercolourist Exh: RA, RWS, UK AG's	
	MACTAGGART, RSA, RSW **William** b. Campbeltown. 1835 - 1910 Coastal scenes, genre & landscape artist Exh: RA, RSW, UK AG's	
MU	**MONTALBA. RWS** **Clara** b. Cheltenham 1842 - 1929 Interiors, landscape & marine artist Exh: RA, OWS, BI, SS, NG, GG, etc.	
	MUNNS. NSA, ASWA **Una Elaine** b. Warwickshire. 1900 - Portrait artist Exh: WAG, N. Zealand	
MV	**MAIR** **Alexander** b. Germany. 1559 ? - 1620 ? Genre & portrait artist	
	MALO **Vincent** b. Belgium. 1600 ? - 1650 ? Religious, battle scenes & landscape subjects Exh: Holland, London, Prague	
	MEER **Jan Van Der** b. Delft. 1632 ? - 1675 Historical, architectural, genre & landscape subjects Exh: Holland, Germany, NG, Paris, Vienna	

VANNI **Michelangelo** b. Sienna. 1583 - 1671		MV
AMEROM **Cornelius Hendrik** b. Arnheim 1804 - Portrait & landscape artist		
MANDER (The Elder) **Karel Van** b. Belgium. 1548 - 1606 Religious & portrait artist Exh: Belgium, Holland, Austria		
UYTTENBROECK **Moyses Van** b. The Hague. 1590 ? - 1648 Mythological & landscape subjects Exh: Holland, Germany, Belgium, Hungary		
MACKENZIE **Winifred Emily** b. London. 1888 - Portrait artist Exh: RA, SWA, etc.		MW
MACWHIRTER. RA, HRSA, RI **John** b. Edinburgh. 1839 - 1911 Landscape artist Exh: RA, NWS, GG & Prov. AG's etc.		
WAGENBAUR **Maximilian Joseph** b. Germany. 1774 - 1829 Animal & landscape subjects Exh: Germany		
NICHOLSON **Sir William** b. Newark. 1872 - Portraits, still life & genre subjects Exh: France, US, Italy, Argentine, UK		N
NOTHNAGEL **Johann Andreas Benjamin** b. Germany. 1729 - 1804 Genre & landscape artist Exh: Germany		
AMMAN **Justus** b. Zurich 1539 - 1591 Historical & mythological subjects		NA

NA	**COPE** **Sir Arthur Stockdale** b. London. 1857 - 1940 Portrait & landscape artist Exh: RA, UK AG's, Paris	
	NOWELL **Arthur Trevethin** b. Garndiffel. 1862 - 1940 Domestic genre Exh: PS, London & Prov. AG's	
NB	**BAIRSTOW** **Nancy** b. Wolstanton, Staffs. 19th - 20th C. Miniaturist Exh: PS, RA, RI.	
	BEGEYN **Abraham Jansz** b. 1637 - 1697 Landscape artist Exh: Holland, Germany, France etc	
	BENNETT **Newton** Fl. UK. ? - 1914 Landscape artist Exh: RA, SS, NWS	
	BERCHEM (or BERGHEM) **Nicolas (or Claes)** b. Amsterdam. 1620 - 1683 Hunting & coastal scenes, landscapes etc Exh: S. Africa, UK & European AG's	
	BERNAERTS **Nicasius** b. Anvers. 1620 - 1678 Still life, landscapes & animal subjects Exh: France	
	BROWN **Nellie Gertrude** b. Wolverhampton Landscape artist Exh: RA	
	BRUYN **Nicolaes de** b. Anvers. 1565 - 1652 Historical subjects Exh: Belgium, France	
NC	**NOLLI** **Carlo** b. Italy. ? - 1770 Painter & engraver Exh: Italy	

NOWLAN. RMS Carlotta b. London. ? - 1929 Flowers, animals & portrait miniaturist Exh: RA, RMS, X.		NC
CHAPRON Nicolas b. France. 1612 - 1656 Mythological subjects Exh: France, Russia etc	*NCHf.*	
DARLING Michael b. London. 1923 - Oil & gouache media Exh: RA, NEAC, RBA	*ND*	ND
DIAZ de la PENA Narcisse Virgile b. Bordeaux 1807 - 1876 Genre & landscape artist Exh: European, UK, Canadian AG's etc	*Il.·D* *N.D*	
DORIGNY Nicolas b. Paris. 1652 - 1746 Historical subjects Exh: UK, France	*ND.*	
NASH Paul b. Kent. 1889 - 1946 Landscape artist Exh: London & Prov. AG's, France		
NATHE Christoph b. Germany. 1753 - 1808 Portraits & landscape artist Exh: Germany	*RE*	NE
GONTCHAROVA Nathalie b. Moscow. 1881 - 1962 Painter & sculptor Exh: France	*N.g.*	NG
HANSEN Hans Nicolai b. Copenhagen. 1853 - 1923 Genre & landscape artist Exh: RA, SS, Paris, Vienna, Copenhagen	*HNH* *Hm3*	NH
HONE, RHA Nathanial (Junior) b. Dublin. 1831 - 1917 Landscape artist Exh: UK AG's	*NH*	

NJ	**JANES, RWS, RE, RSMA** **Norman** b. 1892 Painter, etcher & engraver Exh: RA, RE, RWS, NEAC, SMA, etc	*NJ*
	NEWTON. RI **John Edward** b. England. Fl. 19th C. Still life & landscape artist Exh: RA, SS, BI, NWS, London & Prov. AG's	*N*
NM	**MELDEMANN** **Nicolaus** Fl. Germany 16th C. Genre subjects & battle scenes	**NM**
	MINERS **Neil** b. Redruth. 1931 - Marine & landscape artist Exh: London & Prov. AG's, X UK	*NM*
	HAYNES **John** FL. 19th C. Genre painter Exh: RA, BI, SS, Prov. AG's	*Nma H - W*
	LUND **Niels Moller** b. 1863 - 1916 Portrait, figure, architectural & landscape subjects Exh: UK AG's, Paris	*N.ML.*
NP	**POUSSIN** **Nicolas** b. France. 1594 - 1665 Mythological, religious & landscape subjects Exh: Germany, France, UK, Scandinavia	*N.*
	PINSON **Nicolas** b. Valence. 1640 - ? Religious & portrait artist Exh: France	*NP Inf*
	NAFTEL, RWS **Paul Jacob** b. Chanvel. 1817 - 1891 Landscape artist Exh: RWS, GG, VA, Prov. AG's	*NP*
NS	**SOLIS (The Elder)** **Virgil** b. Nuremberg. 1514 - 1562 Mythological, portrait & genre subjects	*NS*

SWART **Jan** b. Holland. 1500 ? - 1553 ? Religious & historical subjects Exh: Belgium, Germany, Paris, London		**NS**
HOEY (The Elder) **Nikolaus van** b. Anvers. 1631 - 1679 Religious, mythological & battle scenes Exh: Austria	*N van H d.*	**NV**
HORST **Nicolaus van der** b. Anvers. 1598 - 1646 Portraits & historical subjects etc	*N.H*	
VERKOLYE **Nicolaas** b. Delft. 1673 - 1746 Historical & portrait artist Exh: Holland, Germany, France Russia	*N.v.K f* *N.vKf* *N.V.*	
NEATBY **William James** b. Barnsley. 1860 - 1910 Architectural & decorative artist Exh: WAG, London & Prov. AG's	*ωN*	**NW**
NERENZ **Wilhelm** b. Berlin. 1804 - 1871 Historical & genre subjects Exh: Germany	*W*	
NORTH. ARA, RWS **John William** b. London. 1842 - 1924 Genre & landscape artist Exh: RA, OWS, NG, GG, London AG's etc.	NW	
WESTLAKE **Nathaniel Hubert John** b. Romsey. 1833 - 1921 Biblical subjects Exh: UK AG's	*N-W*	
SOAMES **Corisande Wentworth** b. 1901 - Genre & portrait artist Exh: RA, RBA, RP, London & Prov. AG's	*—O—*	**O**
CADENHEAD, RSA, RSW, NEAC, **James FSA** b. Aberdeen. 1858 - 1927 Landscape artist Exh: AAS, RSA etc	*Ⓒ*	**OC**

OE	**BURRA** Edward b. London. 1905 - Surrealist Exh: UK AG's, France	
	BUSH, ARCA, RWA, RE Reginald Edgar James b. Cardiff. 1869 - ? Landscape artist Exh: RA, France, Italy, US	
	COLE Philip William b. Sussex. 1884 - Portrait & landscape artist Exh. RA, France	
OH	**HAIG (HAGG), RE** Axel Herman b. Gotland. 1835 - 1921 Architectural views Exh: London, Paris	
OI	**PITTMAN. ROI** Osmund b. London. 1874 - ? Landscape artist Exh: RA, ROI, London & Prov. AG's	
OJ	**JOHNSTON** Sir Harry Hamilton b. London. 1858 - 1927 Portrait, figure, animal & landscape artist Exh: RA, Prov. AG's	
	O'CONNOR, RHA John Scorrer b. 1913 - Landscape artist Exh: UK AG's	
OK	**KOKOSCHKA** Oskar b. Austria. 1886 - Landscapes & portrait artist Exh: UK, France, Germany	
OM	**DAVISON** Minnie Dibdin Fl. London. 1893 - 1910 Genre & portrait miniaturist Exh: RA, UK AG's	
	MACKIE, RSA, RSW Charles H. b. Aldershot. 1862 - 1920 Genre & landscape artist Exh: RA, UK & European AG's	

MAYS Douglas Lionel b. 1900 - B/white, oil & watercolourist Exh: RA, RBA, SGA, London & Prov. AG's, Canada		OM
OFFERMANS Anthony Jacob b. Holland. 1796 - 1839 ? Animal & landscape subjects Exh: Holland		
BEAVIS, RWS Richard b. Exmouth. 1824 - 1896 Rustic genre, animals, coastal & landscape subjects Exh: RA, SS, BI, OWS, NWS, GG, NG, & European AG's		OR
ROCHEBRUNE Octave Guillaume De b. France. 1824 - 1900 Genre subjects Exh: France		
OKE Henry Reginald b. London. 1871 - ? Oil & watercolourist Exh: London & Prov. AG's		
SENIOR. ARCA Oliver b. Nottingham. 1880 - Portrait, figure & landscape artist Exh: London & Prov. AG's		OS
STRANG, RA William b. Dumbarton. 1859 - 1921 Genre, figure & portrait artist Exh: RA, UK AG's, Paris		
DOBSON, RWS, RA William Charles Thomas b. Hamburg. 1817 - 1898 Genre, oil & watercolourist Exh' RA, RWS, London & Prov. AG's Australia	18 89	OT
VEEN Otto Van b. Leyden. 1556 - 1629 Bibical & portrait artist Exh: Belgium, Holland, France, UK, Germany		OV
OSBORNE, RHA William b. Dublin. 1823 - 1901 Portrait & animal subjects Exh: UK AG's		OW

OW	**WEST, VP RWS** **Joseph Walter** b. Hull. 1860 - 1933 Genre & landscape artist Exh: UK AG's, Paris	
	WHITING. ARBS **Onslow** Sculptor, portrait & animal subjects Exh: RA, London & Prov. AG's, PS	
	WILSON **Oscar** Genre artist Exh: RA, NWS, SS, Prov. AG's	
P	**DUCHEMIN** **Isaak** Flourished Belgium 17th Century Portraits & historical subjects	
	LAIRESSE **Gerard de** b. Liege. 1641 - 1711 Historical & portrait artist Exh: France, Germany, Holland	
	LEPOITTEVIN **Eugene Modeste Edmond** b. Paris. 1806 - 1870 Marine & figure landscapes Exh: France, Germany, Holland	
	PALMA (IL GIOVANE) **Jacopo** b. Venice. 1544 - 1628 Biblical, mythological & historical subjects Exh: UK & European AG's	
	PATON. ARE **Hugh** b. Glasgow. 1853 - 1927 Pastel, oil & watercolourist Exh: RA. RE. Prov. AG's, PS, US, Australia	
	PEPPERCORN **Arthur Douglas** b. London. 1847 - 1926 Marine & landscape artist Exh: RA, SS, London & Prov. AG's, Holland, Germany	
	PERUGINI **Charles Edward** b. Naples. 1839 - 1918 Genre & portrait artist Exh: RA, SS, NG, BI, etc.	

PFEIFFER **Francois Joseph** b. Liege. 1778 - 1835	
PHILLIP. RA **John** b. Aberdeen. 1817 - 1867 Scottish & Spanish genre subjects Exh: RA, RSA, BI, SS, London & Prov. AG's	
PHILLIPS **Walter Joseph** b. Barton-on-Humber. 1884 - Landscape artist Exh: VA, BM, London & Prov. AG's	
ANGEL **Philips** b. Middelbourg 1616 - 1684 Still life & genre subjects etc Exh: Germany	
PARSONS, RA, PRWS **Alfred** b. Somerset. 1847 - 1920 Landscape, oil & watercolourist Exh: RA, RI, NG, Paris, Berlin, Vienna	
PATTEN **Alfred Fowler** b. London. 1829 - 1888 Figure & portrait artist Exh: UK AG's	
PERIGAL **Arthur** b. London. 1816 - 1884 Landscape artist Exh: RSA, RA, Prov. AG's	
PIETERSZ **Aert** b. Amsterdam. 1550 ? - 1612 Portrait & genre artist Exh: Holland, Germany	
POTTER. RBA **Frank Huddlestone** b. London. 1845 - 1887 Genre & landscape artist Exh: RA, SS, GG, SA, London & Prov. AG's	
PETTITT **Edwin Alfred** b. Birmingham. 1840 - 1912 Landscape artist Exh: RA, Prov. AG's	

PA	**PRYNNE, RBA** **Edward A. Fellowes** b. 1854 - 1921 Portrait, figure & genre subjects Exh: RA, UK AG's	
	POCOCK. RMS **Alfred Lyndhurst** b. 1881 - Watercolourist Exh: RA, London & Prov. AG's, Canada	
PB	**BECKER** **Philipp Jacob** b. Germany. 1759 - 1829 Landscape & town scenes Exh: Germany	
	BOL **Pierre** b. Anvers. 1622 ? - 1674 ? Animals & still life artist Exh: UK, France, Hungary, Germany, Holland etc	
	BORDONE **Paris** b. Trevise. 1500 - 1571 Portrait, historical, biblical & mythological subjects Exh: Russia & European AG's	
	BRIL **Paul** b. Anvers. 1554 - 1626 Miniaturist & landscape artist Exh: UK, & European AG's	
	BRUEGHEL (The Elder) **Pieter** b. Brueghel. 1528? - 1569 Historical, genre, village scenes etc Exh: Russia, US, UK & European AG's	P.B.
	PASSAROTTI **Bartolomeo** b. Bologna. 1529 - 1592 Portraits & religious subjects Exh: Italy, Germany, France	
	BORCHT **Peter van der** b. 1600 ? - 1633 Figure & landscape artist	
PC	**BERRETTINI** **Pietro** b. 1596 - 1669 Religious & historical subjects Exh: Holland, France, Italy, Germany etc.	

734

CESPEDES **Pablo de** b. Spain. 1538 - 1608 Portraits & religious subjects Exh: Spain	
CLAESZ **Pieter** b. 1590 - 1661 Still life artist Exh: Holland, Germany, Hungary, Russia etc	
CONNARD **Philip** b. Southport 1865 (1875?) - 1958 Landscape, marine & portrait artist Exh: RA, UK AG's	
COOPER **Phyllis** b. London. 1895 - Miniaturist & heraldic artist Exh: RA, RMS, RI, SWA	
COOPSE **Pieter** b. Holland. 17th Cent. Marine artist Exh: Sweden	
PETTAFOR **Charles R.** Fl. 1870 - 1900 Landscape & architectural views Exh: London & Prov. AG's	
POELENBURG **Cornelis Van** b. Utrecht. 1586 - 1667 Portraits, genre, historical & landscape artist Exh: UK & European AG's	
CALDERON, RA **Philip Hermogenes** b. Poitiers. 1833 - 1898 Genre & historical subjects Exh: RA, UK AG's, Germany	
GALLAND **Pierre Victor** b. Geneva. 1822 - 1892 Landscape & portrait artist Exh: France	
WONDER **Pieter Christoffel** b. Utrecht. 1780 - 1852 Portrait, interior scenes & genre subjects Exh: Holland, NPG, RA, BI	

DONKER Pieter b. Holland. 1635 ? - 1668 Historical subjects	
PENSTONE John Jewel Fl. 1835 - 1895 Genre, figure & portrait artist Exh: RA, London & Prov. AG's	
GREBBER Pieter Fransz de b. Haarlem. 1600 ? - 1693 ? Portraits, religious & historical subjects Exh: Holland, France, Hungary, Germany etc	
HOOCH (or HOOGH) Pieter de b. Rotterdam. 1629 - 1681 Genre subjects, portraits, interiors etc. Exh: UK, France, Italy, Germany, Austria etc	

CHIPPERFIELD Phyllis Ethel b. Bloxham, Oxon. 1887 - Miniaturist & watercolourist Exh: RA, PS, WAG, RI, SM	
DIELMAN Pierre Emmanuel b. Belgium. 1800 - 1858 Landscape & animal subjects Exh: France, Italy, Switzerland	
PARRIS Edmund Thomas b. London. 1793 - 1873 Genre, portrait, panorama & historical subjects Exh: BI, SS, VA, NPG	

FRUYTIERS Philip b. Antwerp. 1610 - 1666 Portraits & historical subjects Exh: Holland	
FRANCKEN Pieter H. FL. 17th C. Religious & historical subjects Exh: Holland	
PACHECO Francisco b. Spain. 1564 - 1654 Biblical & portrait artist Exh: Spain, France, Budapest	

736

PROVIS **Alfred** Fl. 1843 - 1886 Interiors & genre subjects Exh: RA, BI, SS, VA		**PF**
NOTER **Pierre Francois** b. Belgium. 1779 - 1843 Landscape subjects etc. Exh: Holland, Belgium		
POOLE, RA **Paul Falconer** b. Bristol. 1807 - 1879 Genre, historical & portrait artist Exh: RA, BI, SS, NG, VA, UK AG's, Paris, Hamburg		
GAUGUIN **Paul** b. Paris. 1848 - 1903 Tahitian scenes & figures, still life subjects, portraits etc Exh: US, UK, European AG's etc		**PG**
PATTEN, ARA **George** b. 1801 - 1865 Portrait, historical & mythological subjects Exh: RA, VA, NPG, UK AG's, Italy		
POPE **Gustav** b. 1852 - 1895 Portrait, genre & historical subjects Exh: UK AG's		
GUERIN **Pierre Narcisse** b. Paris. 1774 - 1833 Portraits & historical subjects Exh: Germany, France, Spain etc		
PINWELL. RWS **George John** b. High Wycombe. 1842 - 1875 Genre & historical watercolourist Exh: OWS, London & Prov. AG's Australia		
WESTENBERG **Pieter George** b. Holland. 1791 - 1873 Architectural & landscape subjects Exh: Holland		
FEDDES (van Harlingen) **Pieter** b. Harlingen. 1586 - 1634 Portrait & historical subjects		**PH**

HESS **Peter Heinrich Lambert von** b. Dusseldorf. 1792 - 1871 Genre & battle scenes Exh: Germany	*PH*
HOOCH (or HOOGH) **Pieter de** b. Rotterdam. 1629 - 1681 Genre subjects, portraits, interiors etc Exh: UK, France, Italy, Germany, Austria etc	**PH**
JACOMB-HOOD, RPE, MVO, RBA **George Percy** b. Surrey. 1857 - 1929 Portrait, genre & historical subjects Exh: RA, SS, GG, NG, PS, NEAC etc	*PH*
JUVENEL (The Elder) **Paul** b. Nuremberg. 1579 - 1643 Religious & historical subjects Exh: Nuremberg	*PP* *1634* *PP*
PYLE **Howard** b. Wilmington. 1853 - 1911 Painter & illustrator Exh: Paris, US	*Hꝯ:-* *HP* *H* *H·P* *HP*
BRINCKMANN **Philipp Hieronymus** b. 1709 - 1761 Landscapes & biblical subjects Exh: Germany	*PB*
HAMERTON **Philip Gilbert** b. Laneside. 1834 - 1891 Landscape artist Exh: London & Prov. AG's etc	*P* *H* *G*
WOUWERMAN **Philips** b. Haarlem. 1619 - 1668 Hunting & battle scenes, fairs, landscapes etc. Exh: International AG's	*PW* *PW* *PW* *PW* *PW* *PW* *PW* *PW* *PW*

LEIGH-PEMBERTON **John** b. London. 1911 - Oil, tempera & gouache media Exh: RA, ROI, NS, London & Prov. AG's		**PH**
HALL **Thomas P.** b. 19th C. Genre & historical subjects Exh: RA, BI, SS		
ARCHER RSA **James** b. Edinburgh 1823 - 1904 Genre, portraits, landscapes & historical subjects Exh: RA, BI, SS, RSA		**PI**
PRIDE **John** b. Liverpool. 1877 - ? Etcher, artist in various media Exh: WAG, Prov. AG's, Spain		
PASMORE **John F.** Fl. London 19th C. Rustic genre, still life & animal subjects, etc. Exh: RA, BI, SS, London & Prov. AG's		**PJ**
PIPER **John** b. Epsom. 1903 - War artist, architectural 　　landscapes & abstract 　　subjects Exh: Tate, UK AG's, Paris		
PLATT. ARCA **John Edgar** b. Leek. 1886 - Colour woodcut artist & painter Exh: London & Prov. AG's, X	19 62	
TILLEMANS **Peter** b. Antwerp. 1684 - 1734 Figures, animals, battle scenes & landscape artist Exh: Belgium, Russia, UK	*P T*　　　*P T.*	
KNIGHT, RA **John Prescott** b. Stafford. 1803 - 1881 Genre & portrait artist Exh: RA, BI, UK AG's	*R*	**PK**
KRAFFT **Johann Peter** b. Germany. 1780 - 1856 Portrait, historical, genre & landscape artist Exh: France, Vienna	*K.*	

LANCASTER, RI, ARE, RBA, ARCA **Percy** b. Manchester. 1878 - 1951 Landscape artist Exh: RA, London & Prov. AG's	
LANDE **Willem van** b. Holland. 1610 - ? Historical subjects	
LASTMAN **Claes Pietersz** b. Haarlem. 1586? - 1625 Portraits & religious subjects Exh: Holland	
LASTMAN **Pieter Pietersz** b. Amsterdam. 1583 - 1633 Religious & mythological subjects Exh: Holland, Germany	
LELY. Bt. **Sir Peter (Van Der Faes)** b. Westphalia. 1618 - 1680 Portrait artist Exh: NG, NPG, VA, France, Germany, Italy.	
LEYSTER **Judith** b. Haarlem. 1600 ? - 1660 Genre & interior scenes Exh: Holland, Germany, Paris, Sweden	
LOMAZZO **Giovanni Paolo** b. Milan. 1538 - 1600 Genre subjects Exh: Milan, Vienna	
LYONET **Pieter** b. Holland. 1708 - 1789 Genre subjects	
PARKER. ARMS, SSWA **Elizabeth Rose** b. Renfrewshire Portrait miniaturist & landscape artist Exh: London & Prov. AG's, Canada	
CAREY, ATD **Peter Leonard** b. Manchester. 1931 - Exh: London & Prov. AG's	

LOON Peter Van b. Belgium. 1600 ? - 1652 ? Historical & landscape artist	*RL*	PM
MARILHAT Prosper Georges Antoine b. France. 1811 - 1847 Landscape artist Exh: France, Russia, UK	*P.M.*	
MOREELSE Paulus b. Utrecht. 1571 - 1638 Portrait, genre & historical subjects Exh: Holland, Germany, Belgium	*1638 M RM M RM*	
MORRIS. RA Philip Richard b. Davonport. 1836 - 1902 Portraits, biblical, genre & historical subjects Exh: RA, London & Provs AG's, Australia	*PM*	
NEGRI Pier Martire b. Italy. 1601 ? - 1661 Historical & portrait artist Exh: Italy	*P M.*	
PULLAN Margaret Ida Elizabeth b. India. 1907 - Painter in oil media Exh: PS, RP, RBA, USA, Prov. AG's	*MP*	
MOLYN Petrus Marius b. Rotterdam. 1819 - 1849 Genre subjects Exh: Holland	*P MM*	
NOLPE Pieter b. Amserdam. 1613 ? - 1652 Landscape artist Exh: Switzerland, Holland, Germany	*N N*	PN
NORTON Peter John b. Hampshire. 1913 - Landscapes, interiors & figurative subjects Exh: S. Africa, Egypt, France, London & Prov. AG's etc.	*P.N.*	
PATON. RSA Sir Joseph Noel b. Dunfermline. 1821 - 1901 Biblical, mythological, historical & imaginative subjects Exh: RA, RSA, Canada, Australia	*PN*	

PN	**PEREDA (the Elder)** **Antonio** Fl. 15th - 16th C. Biblical subjects	
	BRUYN **Nicolaes de** b. Anvers. 1565 - 1652 Historical subjects Exh: Belgium, France	
	NAFTEL, RWS **Paul Jacob** b. Chanvel. 1817 - 1891 Landscape artist Exh: RWS, GG, VA, Prov. AG's	
PO	**JENNINGS, ARE, ARCA** **Philip O.** b. London. 1921 - Etcher & watercolourist Exh: RA, London & Prov. AG's, US	POJ 1951
	POLLOCK **Courtenay Edward Maxwell** b. Birmingham. 1877 - 1943 Figure & portrait artist Exh: RBA, UK AG's	
PP	**PAGE. Mem.SM** **Patricia** b. London. 1909 - Portrait miniaturist Exh: RWS, SM & London AG's etc.	
	PERUGINO (PIETRO VANNUCCI) **II** b. Nr. Perugia. 1446 ? - 1523 Portraits, religious & historical subjects Exh: UK & European AG's	
	POTTER **Pieter Symonsz** b. Holland. 1597 ? - 1652 Biblical, military, portrait & still life subjects Exh: Holland, Germany, France, UK	
	POURBUS **Peeter Jansz** b. Gouda. 1510 ? - 1584 Historical & portrait artist Exh: Holland, Belgium, Sweden, UK	P. AN DNI 1573
	RUBENS **Peter Paul** b. Siegen. 1577 - 1640 Portraits, historical, genre & landscape artist Exh: International AG's	P.P.R

742

QUAST **Pieter Jansz** b. Amsterdam. 1606 - 1647 Portraits, domestic & humourous genre subjects Exh: France, Austria, Russia, Holland, UK		PQ
PICKERSGILL, RA **Frederick Richard** b. London. 1820 - 1900 Historical genre Exh: RA, BI, VA, UK AG's		PR
BERLIN Sven Paul b. 1911 - Painter & sculptor Exh: US AG's. X.		PS
PALMER, RWS **Samuel** b. Sainte-Marie Newington. 1805 - 1881 Landscape artist & watercolourist Exh: RA, BI, BM, VA, UK AG's		
PROUT **Samuel Gillespie** b. 1822 - 1911 Landscapes & architectural subjects Exh: VA, London AG's		
STEVENS **Peeter** b. Belgium. 1567 - 1624 ? Landscape artist Exh: Germany, France, Austria	P S	
STUBENRAUCH **Philipp Von** b. Vienna. 1784 - 1848 Genre subjects		
PARRY, ARMS, FRSA **Sheila Harwood** b. Salford. 1924 - Gouache & oil media Exh: RWS, RMS, London & Prov. AG's, Australia etc.		
SPENCE **Robert** b. Tynemouth. 1871 - 1964 Landscapes & historical subjects Exh: UK AG's		
TOWNSEND **Patty** Fl. UK. 19th - 20th C. Genre & landscape artist Exh: RA, NWS, SS, London & Prov. AG's		PT

BRUSSEL Paul Theodor van b. Holland. 1754 - 1795 Still life & floral subjects Exh: Germany, France	*P.T.B.* PTVB

NOLPE Pieter b. Amsterdam. 1613 ? - 1652 Landscape artist Exh: Switzerland, Holland, Germany	
ASCH Pieter Jansz van b. Delft 1603 - 1678 Landscape artist Exh: Holland, Hungary, Scandinavia, UK, etc	PA PA PA
BLEECK Pieter van b. Holland. 1700 - 1764 Portrait artist Exh: SOA	P.v.B ft 1754 P.V.B 1751 P.V.B 1747 PB
BLOEMEN (called STANDARD) Pieter van b. Antwerp. 1649 - 1719 Battle scenes, fairs, portraits, animals & landscapes Exh: Russia, US & European AG's	P.V.B. PB PB P.V.B 1702
MERCKELBACH Pieter b. Holland. 1633 ? - 1673	PB
PASSE (The Elder) Crispin De b. Holland. 1564 ? - 1637 Portraits & bibical subjects	
LELY. Bt. Sir Peter (Van Der Faes) b. Westphalia. 1618 - 1680 Portrait artist Exh: NG, NPG, VA, France, Germany, Italy.	P.V.D Lys 1650
HILLEGAERT (The Elder) Pauwels van b. Amsterdam. 1595 - 1640 Portraits, military & historical subjects	PVHf
HULST Pieter van der b. Dortrecht. 1651 - 1727 Genre & portrait artist Exh: Italy, Holland	P.VH f.

LINT **Peter Van** b. Antwerp. 1609 ? - 1690 Portraits & religious subjects Exh: Belgium, France, Germany, Austria	P.v.L	PV
PIAZZA **Martino** b. Italy ? - 1527 ? Religious subjects Exh; Italy, UK	RMP	
PRINSEP, RA **Valentine Cameron** b. Calcutta. 1836 - 1904 Portraits, genre & historical subjects Exh: NPG, RA, London & Prov. AG's, Germany, France		
RYCK **Pieter Cornelisz Van** b. Delft. 1568 - 1635 ? Genre subjects Exh: Holland	PR p.	
SCHENDEL **Petrus Van** b. Belgium. 1806 - 1870 Genre & historical subjects Exh: Belgium, Germany, Holland	PVS	
SLINGELAND **Pieter Cornelisz Van** b. Leyden. 1640 - 1691 Portraits, genre subjects & miniaturist Exh: Holland, Germany, Italy, UK, Russia, etc.		
SOMER **Paul Van** b. Antwerp. 1576 - 1621 Portraits & historical subjects Exh: NPG, Copenhagen		
VEIT **Philippe** b. Berlin. 1793 - 1877 Biblical & architectural subjects Exh: Germany		
VELDE **Peter Van De** b. Antwerp. 1634 - 1687 Marine artist Exh: Belgium, Russia, Scandinavia, Holland, France	P. V. V.	
WENDELSTADT **Carl Friedrich** b. Germany. 1786 - 1840 Portrait, genre & landscape artist Exh: Germany		PW

PW	**WITHOOS** Peter b. Holland. 1654 - 1693 Animals, insects & floral subjects Exh: Holland, Germany, Austria, UK	*P.W.*　　　　*P.W.*
	WOUWERMAN Philips b. Haarlem. 1619 - 1668 Hunting & battle scenes, fairs, landscapes etc. Exh: International AG's	*PW PW PW PW* *PW*
	WOUWERMAN Pieter b. Haarlem. 1623 - 1682 Battles, military subjects & landscapes Exh: Belgium, Austria, Russia, Holland, Germany, France, UK, etc.	*P.w.　　P.w*
	WYETH. ARCA Paul James Logan b. London. 1920 - Mural & portrait artist Exh: RA, London & Prov. AG's, US, Canada, Australia	*(PW)　　(PW)*
	PATON. RSA, RSW Walter Hugh b. Scotland. 1828 - 1895 Landscape artist Exh: RSA, RA, RSW, Australia	*P* monogram
PX	**PREISSLER** Johann Justin b. Nuremberg. 1698 - 1771 Religious & genre subjects Exh: Germany, Italy	*P* monogram
PZ	**OZANNE** Pierre b. Brest. 1737 - 1813 Marine artist Exh: France	*PZ*
QE	**QUELLIN** Jean Erasmus b. Antwerp. 1634 ? - 1715 Historical & portrait subjects Exh: France, Belgium	*Q　　Q*
QM	**QUENNEL. Hon.ARIBA** Marjorie b. Kent. 1883 - B/white, oil & watercolourist Exh: RA, London & Prov. AG's, US	*Q*
QV	**BREKELENKAM** Quiringh Gerritsz van b. Holland. 1621 ? - 1668 Genre artist Exh: France, Germany, Hungary etc	*QVB* *1654*　　　*QB·1661*

KRAUS **Philippe Joseph** b. Germany. 1789 - 1864 Miniature portraits & landscapes Exh: Germany	
MACBETH. RA, RI, RPE, RWS **Robert Walker** b. UK. 1848 - 1910 Landscape & rustic genre subjects Exh: RA, OWS, GG, NG, France, Germany	
QUAST **Pieter Jansz** b. Amsterdam. 1606 - 1647 Portraits, domestic & humourous genre subjects Exh: France, Austria, Russia, Holland, UK	
RAHL **Karl** b. Austria. 1770 - 1843 Portraits, historical & genre subjects Exh: Austria	
REID **Sir George** b. Aberdeen. 1841 - 1913 Portrait & landscape artist Exh: RSW, RSA, UK, NPG, Australia	
ROBERTS **Walter James** b. Doncaster. 1907 - B/white, oil & watercolourist Exh: London & Prov. AG's	
ROGHMAN **Roeland** b. Amsterdam. 1597 - 1686 Landscape subjects Exh: Germany, France, London	
ROMBOUTS **Theodor** b. Antwerp. 1597 - 1637 Portraits & historical subjects Exh: Holland, Germany, Russia, France, Austria	
ROSSER. Mem.USA **John** b. London. 1931 - Genre subjects, town & landscapes Exh: RI, ROI, NEAC, US, PS, R.Cam.A., London & Prov. AG's X. UK, US.	
RUISDAEL (or RUYSDAEL) **Jacob Isaakszoon** b. Haarlem. 1628 ? - 1682 Landscape subjects Exh: Holland, Belgium, France, UK, US, etc.	

R	**TOULMIN. FRGS, AMIMI, AM Inst.W.** **John** b. 1911 - Gouache & watercolourist Exh: London & Prov. AG's	℞
RA	**ANSDELL, RA** **Richard** b. Liverpool. 1815 - 1885 Spanish genre, animals & sporting subjects Exh: RA, BI, UK AG's, Germany	*RA* *RA* *RA*
	ATKINSON **Robert** b. Leeds. 1863 - 1896 Landscape artist Exh: RA, UK AG's, Australia	*R.a.* *Ra*
	RUSSON **Agatha** b. Wisconsin, US. 1903 - Crayon, oil & watercolourist Exh: ROI, RBA, London & Prov. AG's	*R*
	SCHIAMINOSSI **Raffaello** b. Italy. 1529 - 1622 Religious & historical scenes	*RAF*
RB	**BELL, RA** **Robert Anning** b. 1863 - 1933 Figure artist Exh: RA, NEAC, RWS etc	RAN B
	BARBER **Reginald** Fl. L. 19th - 20th C. Genre & portrait artist Exh: RA, London & Prov. AG's, Paris	18 *RB* 91
	BARTON, RWS **Rose** b. 1856 - 1929 Genre & landscape watercolourist Exh: OWS, RA, London & Prov. AG's, Ireland	*RB*
	BEAVIS, RWS **Richard** b. Exmouth. 1824 - 1896 Rustic genre, animals, coastal & landscape subjects Exh: RA, SS, BI, OWS, NWS, GG, NG, & European AG's	*(RB)* *RB*
	BONHEUR **Marie Rosalie (Rosa)** b. Bordeaux. 1822 - 1899 Genre, animal & landscape artist Exh: UK, France etc	*R.B*

BRANDARD **Robert** b. Birmingham. 1805 - 1862 Landscape artist Exh: RA, BI, SS, NWS		RB
BROWNING **Robert Barrett** b. 1846 - 1912 Painter & sculptor Exh: RA, GG, UK AG's, Paris		
BEAVIS, RWS **Richard** b. Exmouth. 1824 - 1896 Rustic genre, animals, coastal & landscape subjects Exh: RA, SS, BI, OWS, NWS, GG, NG, & European AG's		
BREBIETTE **Pierre** b. France. 1598 - 1650 ? Biblical & mythological subjects		
RICKETTS, RA **Charles** b. Geneva. 1866 - 1931 Genre & historical subjects Exh: RI, RA, UK AG's		RC
RIETSCHOOF **Jan Claes** b. Holland. 1652 - 1719 Marine artist Exh: Holland, Sweden, Leningrad		
EXLEY **James Robert Granville** b. Nr. Bradford. 1878 - ? Painter & engraver Exh: RA, RE		
WOODVILLE. RI **Richard Caton** b. 1856 - 1926 Military & battle scenes Exh: RA, NG, BI, NWS, Prov. AG's		
ELDRED **Charles D.** Fl. 1889 - 1909 Marine watercolourist Exh: US		RD
GREENHAM, RBA, RO **Robert Duckworth** b. London. 1906 - Portraits, marine, abstract, landscape subjects etc Exh: RA, RBA, ROI, London & Prov. AG's		

RF	**BIGIO** **Francesco** b. Florence. 1482 - 1525 Portraits & historical subjects Exh: Germany, Italy, UK, France	
	FINDLAY, ATD **Peter Gillanders** b. Madras. 1917 - Oil & watercolourist Exh: London & Prov. AG's	
	FOWLER, RWS **Robert** b. Liverpool. 1853 - 1926 Mythological & allegorical subjects Exh: RA, RI, SS etc	
RG	**GARDELLE** **Robert** b. Geneva. 1682 - 1766 Portrait artist Exh: Switzerland	
	GOFF **Robert Charles** b. London. 1837 - ? Landscape artist Exh: UK AG'S, Italy	
	GREENLEES **Robert** b. 1820 - 1904 Landscape artist Exh: UK AG'S	
	RHEAD **George Woolliscroft** b. 1855 - 1920 Genre subjects Exh: London & Prov. AG's	
	RICHMOND, RA **George** b. Brompton. 1809 - 1896 Portraits & historical subjects Exh: RA, VA, NPG, UK AG's	
	ROBERTSON **Walford Graham** b. 1867 - 1948 Portrait & landscape artist Exh: London & Prov. AG's	
	REYNOLDS **Frederick George** b. 1828 - 1921 Landscape artist Exh: London & Prov. AG's	

ROTENBECK George Daniel b Nuremberg. 1645 - 1705 Historical & portrait artist		**RG**
HUTCHISON, RSA, RSW Robert Gemmell b. 1855 - 1936 Genre & still life subjects Exh: RA, RSA, ROI, Prov. AG's		
HALS Reynier Fransz b. 1627 ? - 1671 Genre artist Exh: Holland		**RH**
HEDLEY Ralph b. Richmond. 1851 - 1913 Genre & landscape artist Exh: RA, SS, UK AG'S		
HEYWORTH, ROI Richard b. 1862 - ? Landscape artist Exh: RA, ROI, London & Prov. AG's		
HILLINGFORD Robert Alexander b. London. 1828 - 1907 Genre & historical subjects Exh: RA, BI, SS, UK AG's		
RUITH Horace Van Fl. 1888 - 1914 Portrait, figure, genre & landscape artist Exh: RA, UK AG's, Germany		
REMBRANT (or RIJN) Harmensz Van b. Holland. 1606 - 1669 Portraits & historical subjects Exh: International AG's		
PARKER. ARCA Richard Henry b. Dewsbury. 1881 1930 Etcher, oil & watercolourist Exh: London & Prov. AG's, X		

GORDON, RBA Robert James Fl. late 19th C. Genre subjects Exh: RA, SS, UK, AG's	*RJG*
JOBLING Robert b. Newcastle. 1841 - 1923 Genre, river & marine subjects Exh: RA, SS. Prov. AG's etc.	*RJ*
RAVESTEYN Jan Anthonisz Van b. The Hague. 1570 - 1657 Portrait artist Exh: Holland, France, Belgium, Germany, US, UK, etc.	*R R R R*
REMBRANT (or RIJN) Harmensz Van b. Holland. 1606 - 1669 Portraits & historical subjects Exh: International AG's	*Rj. Q*
ROSAPINA Francesco b. Italy. 1762 - 1841 Genre subjects Exh: Italy	*K*
ROWLEY Jean b Mersey Island. 1920 - Nature subjects, oil & ceramics media Exh: RBA & Southern UK AG's	*R*
BURN Rodney Joseph b. London. 1899 - Portraits, abstract & marine artist Exh: RA, NEAC, RWA & Prov. AG's	*R.J.B.*
LLOYD Reginal James b. Hereford. 1926 - Abstract & landscape artist Exh: RBA, RWA, London & Prov. AG's	*R.J.L.*
WICKENDEN Robert b. Rochester, UK. 1861 - ? Portrait, genre & landscape artist Exh: France, Germany, Belgium, US, UK.	*R.J.W'94*
LISTER. ARMS, KMS, FRSA, SM, etc. Raymond George b. Cambridge. 1919 - Silhouette & miniaturist Exh: R.Cam.A, RMS, RSA, USA Paris, etc.	*R.*

LITTLE Robert W. b. London. 1855 - 1944 Flowers, interiors, genre & landscape artist Exh: RA, OWS, GG, London & Prov. AG's	*R. L.*	**RL**
HARVEY, FICS Reginald Leonard b. London. 1897 - Equine watercolourist Exh: London & Prov. AG's	*R/LH.*	
MACKERTICH. Mem.RBA, NEAC Robin b. Lucknow, India. 1921 - Portraits, figures, still life & landscape artist. Exh: RA, RWA, NEAC, RBA	*R·M.*	**RM**
MEYER Rudolph Theodor b. Zurich. 1605 - 1638 Historical & portrait artist Exh: Switzerland	*RM* *RM* *RM*	
MORGAN Robert b. Wales. 1921 - Graphic design & industrial landscapes Exh: London & Prov. AG's	*RM.*	
MORLEY. RBA Robert b. 1857 - 1941 Animal, genre, landscape & historical subjects Exh: RA, SS, London & Prov. AG's	*RM*	
ROOKE. RWS Thomas Matthew b. London. 1842 - 1942 Portrait, religious, architectural & landscape artist Exh: RA, NWS, NG, GG, OWS, etc.	*TMR*	
BAINES, NDD, ATD, SGA, **FRSA, RDS, NS** Richard John Mainwairing b. Hastings. 1940 - Painter & etcher Exh: ROI, RBA, NS, SGA, Prov. AG's, X.	*RB.*	
CORBET Matthew Ridley b. Lincolnshire. 1850 - 1902 Portraits, Italian genre & landscapes Exh: RA, UK AG's, S. Africa, Australia	*MRC* *1881*	
MANUEL Hans Rudolf b. Switzerland. 1525 ? - 1572 Religious & portrait subjects Exh: Switzerland	*RMD* *RMD*	

RM	**COVENTRY** Robert McGown b. Glasgow. 1855 - 1914 Marine & landscape artist Exh: UK & European AG's	RMGG
	MILES **Thomas Rose** Fl. 1869 - 1902 Marine & landscape artist Exh: RA, Prov. AG's, Australia	J.R.m
	McGREGOR, RSA **Robert** b. Yorkshire, 1848 - 1922 Genre & landscape artist Exh: RA, PS, UK AG's	RMy
RO	**REDON** **Odilon** b. Bordeaux. 1840 - 1916 Genre, portraits & still life subjects Exh: France, US, Holland	
	ROCHEBRUNE **Octave Guillaume De** b. France. 1824 - 1900 Genre subjects Exh: France	OR
RP	**PEACOCK** **Ralph** b. London. 1868 - 1946 Portrait & landscape artist Exh: RA, GG, SS, Prov. AG's, France	R.P. RP
	PICOU **Robert** b. Tours. 1593 ? - 1671 Genre & religious subjects Exh: France	R P Jer
RR	**REDGRAVE, RA** **Richard** b. London. 1804 - 1888 Genre & landscape artist Exh: RA, VA, NPG, France, Germany	RR
	ROBERTSON. RPE **Henry Robert** b. Windsor. 1839 - 1921 Portrait, genre, landscape artist & miniaturist Exh: RA, BI, NWS, SS, GG, etc.	
RS	**RAVEN** **John Samuel** b. Suffolk. 1829 - 1877 Landscape artist Exh: BI, London & Prov. AG's	1865

REMBRANT (or RIJN) Harmensz Van b. Holland. 1606 - 1669 Portraits & historical subjects Exh: International AG's	*R.S.*	RS
SAUTER Rudolf Helmut b. Bavaria. 1895 - Portraits, still life, semi-abstract & landscape artist Exh: RA, RSA, IS, RP, WAG, US, etc.	*.R.S.* *R.S.*	
SAVERY Roeland b. Courtrai. 1576 - 1639 Animals, floral & landscape subjects Exh: Russia, European AG's	*RS*	
SEDDON. PL.D., FMA, ARCA Richard Harding b. Sheffield. 1915 - Oil & watercolourist Exh: RA, RBA, RIBA, NEAC, RBA, Prov. AG's	*RS.*	
CHATTOCK, RE Richard Samual b. Solihull. 1825 - 1906 Landscape artist Exh: RA, NWS, SS etc	*R.S.(*	
SPENCE Robert b. Tynemouth. 1871 - 1964 Landscapes & historical subjects Exh: UK AG's	*S S*	
THORBURN, ARA Robert b. Dumfries. 1818 - 1885 Painter & miniaturist Exh: RA, UK AG's	*R.T.*	RT
RAFFAELLO Santi b. Urbino. 1483 - 1520 Portraits, religious & historical subjects Exh: International AG's	*R. R. RV. RA*	RV
RAVEN Thomas Fl. England 19th C. Landscape artist Exh: VA	*R*	
SCHIAMINOSSI Raffaello b. Italy. 1529 - 1622 Religious & historical scenes	*RF*	

ORLEY **Richard Van** b. Brussels. 1663 - 1732 Historical & genre subjects Exh: Belgium, Prague	*R.V.O.*
WAY **Thomas Robert** b. 1861 ? - 1913 Painter & lithographer	*RW*
WESTALL **Richard** b. England. 1765 - 1836 Mythological, genre & landscape subjects Exh: RA, NPG, NG, VA, London & Prov. AG's	**RW**
WIMMER **Rudolf** b. Germany. 1849 - 1915 Genre & portrait artist Exh: Germany	*RW*
BENGOUGH **R. W.** Fl. 1830 - 1836 Marine artist Exh: BI, SS, Prov. AG's	*RWB*
RADCLYFFE **Charles Walter** b. Birmingham 1817 - 1903 Landscape artist Exh: RA, BI, SS, VA	*ₒWᵣ.*
COLQUHOUN, DFA, **Ithel** b. Assam. 1906 - Exh: RA, CAS & London AG's	*(monogram)*
LUCAS. RMS, (HS)FRHS, SWA, **UA.** **Suzanne** b. Calcutta. 1915 - Miniatures & watercolours of folowers, animals etc. Exh: RA, PS, RWS,FBS,SWLA,SWA, UA,US, Australia, London AG's	*(monogram)*
SAUBER **Robert** b. London. 1868 - 1936 Genre & portrait artist Exh: RA, SS, London & Prov. AG's, France	*S*
SHORT, RA **Sir Frank** b. London. 1857 - 1945 Landscape oil & watercolourist Exh: RA, VA, UK AG's, France	*(three monograms)*

RV

RW

S

SPECKTER **Erwin** b. Hamburg. 1806 - 1835 Portrait & religious subjects Exh: Germany		S
SPITZWEG **Carl** b. Munich. 1808 - 1885 Genre & landscape artist Exh: Germany		
STAPLES. BT **Sir Robert Ponsonby** b. 1853 - 1943 Portrait, genre & landscape artist Exh: RA, GG, SS, London & Prov. AG's		
ADAMSON **Sydney** b. Dundee. Fl. 1908 - 1920 Portraits & landscape artist Exh: RA, UK, AG's		SA
ANDERSON **Stanley** b. Bristol. 1884 - Genre & architectural subjects Exh: RA, WG, Prov. AG's		
SADLER. RBA **Walter Dendy** b. Dorking. 1854 - 1923 Interior & genre artist Exh: RA, GG, SS, London & Prov. AG's		
SAINT AUBIN **Gabriel Jacques De** b. Paris. 1724 - 1780 Genre & portrait artist Exh: France		
SOLOMAN **Abraham** b. London. 1824 - 1862 Genre & historical subjects Exh: RA, BI, UK AG's		
ALMA-TADEMA, OM, RA **Sir Lawrence** b. Westfriesland 1836 - 1912 Greek & Roman subjects Exh: RA, OWS, GG, NG, Germany France, Spain, Russia etc		
JUAN **De Sevilla Romero y Escalante** b. Grenada. 1643 - 1695 Religious subjects Exh: Spain, Budapest		

BACH **Alois** b. 1809 - 1893 Genre, historical, animal & landscape artist Exh: Germany	*monogram*
BERLIN Sven Paul b. 1911 - Painter & sculptor Exh: US AG's. X.	*monogram*
BOTTICELLI **Sandro** b. Florence. 1444 - 1510 Portraits, religious, mythological, historical subjects etc Exh: UK, Russia, & European AG's	*SB.*
BOUCHER **Francois** b. Paris. 1703 - 1770 Mythological, genre, historical, portrait & landscape artist Exh: UK, France, Germany, Switzerland etc	*monogram*
BOURDON **Sebastien** b. Montpelier. 1616 - 1671 Portrait, historical, biblical & landscape artist Exh: Russia, UK, & European AG's	*SB*
BOWERS Stephen Fl. London. 1874 - 1891 Landscapes & river views Exh: SS, NWS	*monograms*
SLEIGH. RBSA **Bernard** b. Birmingham. 1872 - ? Oil & watercolourist Exh: RA, Prov. AG's, Canada, US	*·SB·*
SOLVYNS **Balthazar** b. Antwerp. 1760 - 1824 Marine artist	*monogram*
ADAMSON Sarah Gough b. Manchester. Fl. 1905-1950 Still life & floral subjects Exh: France, UK	*SBA*
BERKELEY Stanley Fl. London. ? - 1909 Animals, sporting & historical subjects Exh: RA, SS, NWS, GG	*St·B*

CARTER **Samuel John** b. Norfolk. 1835 - 1892 Animals & sporting scenes Exh: RA, BI, SS, GG & Prov. AG's	*(monogram JC)*
SCHORN **Carl** b. Dusseldorf. 1803 - 1850 Historical & genre subjects Exh: Germany	*(monogram)*
SCHUT **Cornelis** b. Antwerp. 1597 - 1655 Religious subjects Exh: Holland, Belgium, Germany	*(monogram)*
SELLIER **Charles Francois** b. Nancy. 1830 - 1882 Portrait & genre subjects Exh: France	*(monogram)*
SHANNON. RA, ARPE **Charles Haslewood** b. Lincolnshire. 1865 - 1937 Portrait & figure subjects Exh: RA, NEAC, SS, NG, London & Prov. AG's	*(two monograms)*
SPACKMAN. RBA, RMS, FRSA, **AR.Cam.A., etc.** **Cyril Saunders** b. Cleveland, Ohio. 1887 - Sculptor, etcher & painter Exh: RA, PS, WAG, R.Cam.A., RBSA, RWEA, US, etc.	*(monogram)*
SPRINGER **Cornelis** b. Amsterdam. 1817 - 1891 Landscape & architectural subjects Exh: Holland, Germany	*(monogram)*
CORBOULD **Edward Henry** b. London. 1815 - 1915 Genre & historical subjects Exh: RA, SS, GG, NWS	*(monogram)*
PALAMEDES **Anthonie** b. Delft. 1601 - 1673 Portrait artist Exh: Holland, UK, US, France, Germany	*(monogram)*
SUTCLIFFE **Irene** b. Nr. Whitby. 1883 - ? Miniaturist Exh: RA, RSA	*(monogram)*

SC

SD

SD	**DURINGER** **Daniel** b. 1720 - 1786 Animal, landscape & portrait artist Exh: Switzerland	*monogram*
	VOS **Simon De** b. Antwerp. 1603 - 1676 Historical, genre & portrait subjects Exh: Belgium, Germany, France, Holland, Etc.	*SD*
SE	**SCHOEN** **Erhard** Fl. Germany. 16th C. Religious subjects Exh: Germany, France	*monograms*
	SOUTHALL, RWS **Joseph Edward** b. Birmingham. 1861 - 1944 Genre, figure & landscape artist Exh: UK AG's, Paris	*monograms 1941*
	HOGLEY **Stephen E.** Fl. 1874 - 1881 Landscape artist Exh: SS, Prov. AG's	*S.E.H.*
	KEMP-WELCH, RI, RBC, RBA, RCA **Lucy Elizabeth** b. Bournemouth. FL. 19th - 20th C. Animal & landscape subjects etc Exh: RA, RI, London & Prov. AG's Australia, S. Africa	*SE.K-W*
SF	**SCHNORR VON CAROLSFELD** **Julius Veit Hans** b. Leipzig. 1794 - 1872 Religious & genre subjects Exh: Germany	*monogram 1819.*
	SEVERIN. RA, RSA (Belgium) **Mark** b. 1906 - Painter & engraver Exh: RA, London & Prov. AG's	*monogram*
	SHIELDS **Frederick James** b. Hartlepool. 1833 - 1911 Genre, oil & watercolourist Exh: London & Prov. AG's	*monogram*
	STEIN **August Ludwig** b. Germany. 1732 - 1814 Religious portrait & genre subjects Exh: Germany	*S.f.*

GORE **Frederick Spencer** b. Surrey. 1878 - 1914 Landscape artist Exh: London & Prov. AG's	*SFG*	**SF**
MEDWORTH. RBA **Frank Charles** Etcher, painter & engraver Exh: RA, RSA, RI, NEAC, London AG's, Italy, France		
STEVENS. BA **George Alexander** b. London. 1901 - Portrait & landscape artist Exh: NEAC, London & Prov. AG's		**SG**
HALE **Edward Matthew** b. Hastings. 1852 - ? Military & marine subjects etc Exh: RA, SS, GG, NG etc		**SH**
HANSEN **Sigvard Marius** b. Copenhagen. 1859 - ? Landscape oil & watercolourist Exh: RA, Germany, Sweden		
SOMM **Francois Clement Sommier** b. Rouen. 1844 - 1907 Genre subjects & caricaturist Exh: France		
SPEED **Harold** b. London. 1872 - 1957 Portraits, figures & historical subjects Exh: NG, UK AG's, Paris		
STEWART. RMS **Hilda Joyce** b. London. 1891 - Portrait miniaturist Exh: RA, RMS, London & Prov. AG's Canada		
HOLBEIN **Sigmund** b. Augsbourg. 1465 ? - 1540 Portraits & religious subjects etc Exh: UK, Germany, Austria		
WOHLGEMUTH **Michel** b. Nuremberg. 1434 - 1519 Portraits & religious subjects Exh: France, Germany		

SH	**SCHAEFELS** **Hendrik Frans** b. Antwerp. 1827 - 1904 Marine & historical subjects Exh: Belgium	
	STURMER **Johann Heinrich** b. Germany. 1774 - 1855 Genre, portrait & landscape subjects Exh: Germany	
	PARRY, ARMS, FRSA **Sheila Harwood** b. Salford. 1924 - Gouache & oil media Exh: RWS, RMS, London & Prov. AG's, Australia etc.	
	RIBERA **Josef** b. Spain. 1588 - 1656 Biblical & portrait artist Exh: Spain, Italy, NG, France, Germany	
	STEER. RI **Henry Reynolds** b. London. 1858 - 1928 Genre & landscape artist Exh: RA, NWS, SS, RI, WAG & Prov. AG's	
	SAEMREDAM **Jan Pietersz** b. Holland. 1565 - 1607	
	SANDRART **Joachim** b. Frankfurt-on-Maine. 1606 - 1688 Portraits, landscapes & historical subjects Exh: Germany, Holland, Italy etc.	
	HOOGSTRATEN **Samuel van** b. Dortrecht. 1627 - 1678 Portraits, genre & historical artist Exh: Holland, Austria	
SI	**SAEMREDAM** **Jan Pietersz** b. Holland. 1565 - 1607	
	SMITS **Gaspar** b. Holland. 1635 ? - 1707 ? Historical & portrait artist	

SMART. RE Douglas Ion b. UK. 1879 - Etcher & watercolourist Exh: London & Prov. AG's				**SI**
REYNOLDS. PRA Sir Joshua b. Devon. 1723 - 1792 Portraits & historical subjects Exh: International AG's				
SCHNORR VON CAROLSFELD Hans Veit Friedrich b. Germany. 1764 - 1841 Portrait, genre & historical subjects Exh: Germany				**SJ**
SKEAPING. FSAM John b. Liverpool. Figure & landscape artist Exh: WAG, London & Prov. AG's				
SLEATOR. ARHA, RHA James Sinton b. Ireland Portrait, still life & landscape artist Exh: London, Scottish & Irish AG's				
SOLOMAN. RA, PRBA Joseph Solomon b. London. 1860 - 1927 Portraits, mythological & historical subjects Exh: RA, NG, SS, London & Prov. AG's				
STEEPLE John b. ? - 1887 Landscapes & coastal scenes Exh: RA, SS, VA, Prov. AG's				
PEPLOE, RSA Samuel John b. Edinburgh. 1871 - 1935 Genre, still life & landscape artist Exh: UK AG's				
SLABBAERT Karel b. Holland. 1619 ? - 1654 Genre & portrait artist Exh: Holland, Germany				**SK**
LASSAM Susie b. Dulwich. 1875 - ? Miniaturist Exh: RA, PS, WAG				**SL**

763

SL	**LEYSTER** Judith b. Haarlem. 1600 ? - 1660 Genre & interior scenes Exh: Holland, Germany, Paris, Sweden	
	LUCAS. RA, RI John Seymour b. London. 1849 - 1923 Historical & genre subjects Exh: RA, SS, NWS, London & Prov. AG's, Australia	
	SCOTT Gerald b. Surrey. 1916 - Drawings & sculpture Exh: RA, RWA & Prov. AG's	
	STRAUCH Lorenz b. Nuremberg. 1554 - 1630 Portrait & architectural subjects Exh: Germany, Italy	
	FILDES, RA Sir Luke b. Liverpool. 1844 - 1927 Genre & portrait artist Exh: RA, London & Prov. AG's, Germany	
	LE SUEUR Louis b. Paris. 1746 - ? Animals & landscape artist	
SM	**METEYARD. RBSA** Sidney b. UK. 1868 - 1947 Painter in oil, watercolour & tempera media Exh: RA, PS, London & Prov. AG's	
	SLEE. AMTC Mary b. Carlisle. Miniaturist Exh: RA, RMS, RSA, RBSA, WAG, etc.	
	SMYTHE. ARSW Minnie b. London Watercolourist Exh: London & Prov. AG's	
	STILLMAN (NEE SPARTALI) Marie b. London. 1844 - 1927 Pre-raphaelite painter Exh: RA, SS, GG, NG, NWS	

VILLAMENA **Francisco** b. Assisi. 1566 - 1624 Portraits & religious subjects Exh: Italy, Austria		SM
SCHNITZLER **Michael Johann** b. Germany. 1782 - 1861 Still life subjects Exh: Germany		
GHISI **Adamo** b. Mantoue. 1530 ? - 1574 Genre, biblical & historical subjects		SN
SOMERSET **Nina Evelyn Mary** Decorative & ecclesiastical artist Exh: PS, SWA, Prov. AG's		
DRING, ARCA, NSPC **James** b. London. 1905 - Oil & watercolourist Exh: RA, RBA, NSPS, NEAC, Prov. AG's, Europe & US		SO
STRANG, RA **William** b. Dumbarton. 1859 - 1921 Genre, figure & portrait artist Exh: RA, UK AG's, Paris		
PAGET **Sidney E.** b. 1861 - 1908 Portrait, genre & landscape artist Exh: RA, SS, UK AG's		SP
PALMER, RWS **Samuel** b. Sainte-Marie Newington. 1805 - 1881 Landscape artist & watercolourist Exh: RA, BI, BM, VA, UK AG's		
PROUT **Samuel Gillespie** b. 1822 - 1911 Landscapes & architectural subjects Exh: VA, London AG's		
SCHOUBROECK **Pieter** b. Belgium. 1570 - 1607 Historical & landscape subjects Exh: Germany, Vienna, Copenhagen		

SP	**SPRUYT** **Philippe Lambert Joseph** b. Belgium. 1727 - 1801 Oil & watercolourist	*P* *SP* *S. P*
	HALL **Sydney Prior** b. Newmarket. 1842 - 1922 Historical & genre subjects Exh: UK AG's	*S.P.H.*
	RIBERA **Josef** b. Spain. 1588 - 1656 Biblical & portrait artist Exh: Spain, Italy, NG, France, Germany	*SP*
SR	**RAVEN** **John Samuel** b. Suffolk. 1829 - 1877 Landscape artist Exh: BI, London & Prov. AG's	*SR* *1865*
	RAYNER, ARWS **Samuel** b. ? - 1874 Architectural subjects Exh: UK AG's	*SR. 1870*
	READ. RWS **Samuel** b. Ipswich. 1816 - 1883 Architectural subjects Exh: RA, OWS, SS, London & Prov. AG's etc.	*SR* *R* *SR*
	ROSA **Salvator** b. Italy. 1615 - 1673 Genre, battle scenes, marine, landscape & historical subjects Exh: European AG's, US, UK, etc.	*SR R R SR R* *SR SR SR SR SR*
	RUISDAEL (or RUYSDAEL) **Salomon Van** b. Holland. 1600 ? - 1670 Landscape artist Exh: UK & European AG's etc.	*SR* *SR*
	SAVERY **Roeland** b. Courtrai. 1576 - 1639 Animals, floral & landscape subjects Exh: Russia, European AG's	*SR.*

SPENCE **Robert** b. Tynemouth. 1871 - 1964 Landscapes & historical subjects Exh: UK AG's		**SR**
SOLOMON **Simeon** b. London. 1840 - 1905 Religious & mythological subjects etc. Exh: RA, SS, NG, GG, London & Prov. AG's		**SS**
SPENCER, RA **Sir Stanley** b. Cookham. 1892 - 1959 Figures & religious subjects Exh: RA, London & Prov. AG's	S.S.	
SPURRIER **Steven** b. London. 1878 - 1961 Figure & landscape artist Exh: UK AG's	S.S. S.S.	
SWART **Jan** b. Holland. 1500 ? - 1553 ? Religious & historical subjects Exh: Belgium, Germany, Paris, London		
COLE **Philip Tennyson** Fl. 1878 - 1889 Portraits & Domestic genre Exh: RA, UK AG's, Australia		**ST**
STIMMER **Tobias** b. Switzerland. 1539 - 1584 Portrait, genre & religious subjects Exh: Switzerland		
TUSHINGHAM **Sidney** b. Burslem. 1884 - 1968 Landscape artist Exh: RA, UK AG's		
SAINT ANDRE **Simon Bernard De** b. Paris. 1614 - 1677 Portrait & still life subjects Exh: France	St A.	
SALISBURY. RPS, CVO, LL.D. **Frank O.** b. Harpenden. 1874 - 1962 Portraits & historical subjects etc Exh: RA, RI, RP, Prov. AG's, Canada, US, etc.		

STEINLEN
Theophile Alexandre
b. Switzerland. 1859 - 1923
Genre subjects
Exh: France, Germany, Switzerland

RUTLAND (Duchess of)
Violet.
b. Lancashire. 19th C.
Sculptor & portrait artist
Exh: RA, London & Prov. AG's,
France, US

SIEGER
Victor
b. Vienna. 1843 ? - 1905
Genre subjects
Exh: Vienna, Munich

VACCARO
Andrea
b. Naples. 1598 ? - 1670
Biblical & historical subjects
Exh: Italy, France, Madrid, Germany

VOUET
Simon
b. Paris. 1590 - 1649
Historical & portrait artist
Exh: US, Russia, European AG's etc.

VRANCX
Sebastien
b. Antwerp. 1573 ? - 1647
Historical, battle & hunting scenes
Exh: Holland, Germany, Spain,
Austria, France, etc.

SOMER
Jan Van
b. Amsterdam. 1645 - 1699 ?
Genre & portrait artist

RUISDAEL (or **RUYSDAEL**)
Salomon Van
b. Holland. 1600 ? - 1670
Landscape artist
Exh: UK & European AG's etc.

VAN VEEN
Stuyvesant
b. New York. 1910 -
Painter in oil, watercolour etc.
Exh: US AG's, X

SHIRLAW
Walter
b. Paisley. 1838 - 1909
Portrait, genre & landscape artist
Exh: UK AG's, US, Germany,
France

STRUTT **William** b. 1826 - 1915 Genre, animals & portrait artist Exh: RA, SS, NG, Prov. AG's	
SWEBACH **Bernard Edouard** b. Paris. 1800 - 1870 Genre & military subjects Exh: France, Belgium	
WALTERS **Samuel** b. London. 1811 - 1882 Marine artist Exh: RA, BI, SS, Prov. AG's	
WARBURTON **Samuel** b. Douglas. I.O.M. 1874 - ? Miniaturist, portrait & landscape artist Exh: RA, RMS, WAG & Prov. AG's	
WARNBERGER **Simon** b. Germany. 1769 - 1847 Landscape artist Exh: Germany	
WATSON **Sydney Robert** b. Middlesex. 1892 - Painter in oil & tempera. Exh: NEAC, RA, London & Prov. AG's	
WATTEAU **Francois Louis Joseph** b. France. 1758 - 1823 Military, genre & historical subjects Exh: French AG's	
SCOTT **William Bell** b. Edinburgh. 1811 - 1890 Genre & historical subjects Exh: RSA, RA, SS, BI, VA, Prov. AG's	
WINGHE **Jeremias Van** b. Brussels. 1578 — 1645 Historical & portrait artist Exh: Germany	

T	**STANLEY** **Lady Dorothy (née Tennant)** b. 1855 - 1926 Genre & portrait artist Exh: RA, NG, London & Prov. AG's	
	TENNANT **Dorothy** b. UK. ? - 1926 Genre artist Exh: RA, NG, GG, etc.	
	TOPHAM. RI **Frank William Warwick** b. London. 1838 - 1929 Genre & historical subjects Exh: RA, NG, SS, NWS, GG, BI, Prov. AG's, Australia	
	TURNER. RA **Joseph Mallord William** b. London. 1775 - 1851 Land & seascapes, venetian & historical subjects Exh: RA, NG, NPG, VA, Prov. AG's, France, US, Canada, etc.	
TA	**FROHLICH** **Anton** b. 1776 - 1841 Religious subjects	
	TANZIO **Antonio D'enrico** b. Italy. 1575 ? - 1635 Religious & portrait artist Exh: Italy	
	NOWELL **Arthur Trevethin** b. Garndiffel. 1862 - 1940 Domestic genre Exh: PS, London & Prov. AG's	
TB	**BAKER** **Thomas** b. 1809 - 1869 Landscape artist Exh: RA, BM, VA, Prov. AG's	
	BURKE, RBA **Harold Arthur** b. London. 1852 - ? Landscape, figure & portrait artist Exh: RA, SS, France etc	
	TILBORG (The Elder) **Egidius** b. Antwerp. 1578 - 1632 Genre & landscape subjects Exh: France	

BALE **C.T.** Fl 19th C. Still life subjects Exh: RA, SS & UK AG's		**TB**
HARDY **Thomas Bush** b. Sheffield. 1842 - 1897 Marine oil & watercolourist Exh: RA, SS, VA, UK AG's	T.B.H. T.B.N	
BILL, ARWA John Gordon b. London. 1915 - Landscape artist Exh: NEAC, RWA, Prov. AG's	JB	
WIRGMAN **Theodor Blake** b. 1848 - 1925 Portrait, genre & historical subjects Exh: RA, SS, GG, NG, NWS, NPG, Prov. AG's, US	T.B.W	
COUTURE **Thomas** b. France. 1815 - 1879 Genre & historical subjects Exh: France, Holland, Germany, Italy, UK etc	T. C.	**TC**
CRESWICK, RA Thomas b. Sheffield. 1811 - 1869 Landscape artist Exh: RA, BI, SS, UK & European AG's	Ƒ 1841 TC 1840 TC Ƒ 1841	
THELOT **Antoine Charles** b. France. 1853 - ? Historical, portrait & landscape subjects Exh: France	TC	
THOMPSON. RCA **Constance Dutton** Pastel, oil & watercolourist Exh: RA, RBA, WAG, R.Cam.A. Prov. AG's	TDC	
DIBDIN **Thomas Colman** b. London. 1810 - 1893 Architectural & landscape artist Exh: BI, SS, RA	TCD	
TUNNICLIFFE. RA, RE **Charles, Frederick** b. Langley. 1901 - Engraver, oil & watercolourist Exh: RA, London & Prov. AG's	TC TC	

TC	**GOTCH** Thomas Cooper b. Kettering. 1854 - 1931 Genre & landscape artist Exh: RA, SS, UK AG'S, Australia	*T.C.G.* *T.C.G.*
TD	**DAVIDSON** Thomas Fl. 1863 - 1909 Genre & historical subjects Exh: RA, SS, BI	D D
	DAVIES Thomas b. Denbighshire. 1899 - Oil & watercolourist Exh: London & Prov. AG's	T
	TYRRELL-LEWIS Dione b. London. 1903 - Landscape artist Exh: SWA, NEAG, London & Prov. AG's	IL
	LUBIENIECKI Bogdan Theodor b. Poland. 1653 - ? Historical & landscape subjects Exh: Germany, Budapest	*TDL Inv*
TE	**ELLIS** Tristram J b. England. 1844 - 1922 Landscape artist Exh: RA, NWS, GG	T.E.
	TAYLER Edward b. Orbe. 1828 - 1906 Portrait artist & miniaturist Exh: RA, SS, RI, London & Prov. AG's	E.T. ET
	TSCHAGGENY Edmond Jean Baptiste b. Brussels. 1818 - 1873 Animal subjects Exh: Belgium, France, Germany	$ET.\frac{3}{56}$
	TEMPESTA Antonio b. Florence. 1555 - 1630 Processions, battle & hunting scenes, landscapes & historical subjects Exh: Italy, Germany, France	E F
	HAYNES Edward Trevanyon Fl. 1867 - 1885 Genre & historical subjects Exh: RA	ETH 80

LOWINSKY. NEAC **Thomas Esmond** b.1892 - Painter & illustrator Exh: London & Prov. AG's		TE
FAITHORNE **William** b. London. 1616 - 1691 Portrait artist Exh: UK, AG's		TF
VECELLIO **Tiziano** b. Venice. 1570 ? - 1650 ? Portraits & historical subjects		
FARRER **Thomas Charles** b. London. 1839 - 1891 Landscape artist Exh: RA, SS, UK AG's, US		
MARSHALL **Thomas Falcon** b. Liverpool. 1818 - 1878 Portrait, genre, historical & landscape artist Exh: RA, BI, SS, VA		
GRIFFITHS **Tom** Fl. late 19th C. Landscape artist Exh: RA, SS, UK AG'S		TG
GRANT **William James** b. London. 1829 - 1866 Genre & historical subjects Exh: RA		
THOMSON. RMS **Emily Gertrude** b. Glasgow. Portrait, figure artist; miniaturist Exh: London & Prov. AG's, Belgium, Canada		
TARRATT **John Garfield** Figure & landscape subjects etc. Exh: WAG, RSA, London & Prov. AG's		
HELMBRECKER **Dirk Theodor** b. Haarlem. 1633 - 1696 Genre, & historical subjects Exh: Italy, France		TH

HEYDEN **Jacob van der** b. Strasbourg. 1573 - 1645 Portraits & landscapes & mythological subjects	*[monogram]*
HILDEBRANDT **Ferdinand Theodor** b. Stettin. 1804 - 1874 Portraits, genre & historical subjects Exh: Holland, Germany	*[monogram]* *[monogram]* 1826
HIMPEL **Anthonis or Abraham** b. Amsterdam. 1634 - ? Genre, landscapes & historical subjects	*[monogram]*
HUGHES, ROI **Talbot** b. London. 1869 - 1942 Genre subjects Exh: RA, ROI, WG, Prov. AG's	*[monogram]*
THORNYCROFT, SWA **Helen** Fl. 1864 - 1912 Genre, floral, landscape & religious subjects Exh: RA, SS, NWS, NG	*[monogram]*
DAWSON **Henry Thomas** Fl. Chertsey. 1860 - 1878 Marine artist Exh: RA, BI, SS, US AK'S	*[monogram]*
JELGERSMA **Tako** b. Harlingen. 1702 - 1795 Marine & portrait artist Exh: Belgium, Holland, London, Vienna	*[monogram]*
ROUSSEAU **Theodore** b. Paris. 1812 - 1867 Landscape subjects Exh: France, Holland, US, London, Belgium	T H R ·
SCHAEPKENS **Theodor** b. Germany. 1810 - 1883 Genre subjects Exh: Germany	*Th. S.* *Th. S*
WELLS, RA **Henry Tanworth** b. London. 1828 - 1903 Portraits, genre & miniaturist Exh: RA, NG, UK AG's	H.T.W. *[monogram]* 1901

COATES **Thomas John** b. Birmingham. 1941 - Portraits, industrial subjects, land- scapes, drawings & watercolourist Exh: ROI, RP, PAS, RBA, GS, CPS, RBSA, RA London & Prov. AG's	*JC*	TJ
TISSOT **James Jacques Joseph** b. Nantes. 1836 - 1902 Religious, historical & genre subjects Exh: PS, RA, SS, GG, Prov. AG's, Belgium, France		
TALBOT-KELLY. RI **Capt. Richard Barrett** b. Birkenhead. 1896 - Birds & historical figure subjects Exh: RA, RI, PS, Prov. AG's		TK
KEYSER **Thomas** b. Amsterdam. 1596 - 1667 Portrait painter Exh: Belgium, Germany, UK, France, Sweden	AN. 1627.	
FAIRLESS **Thomas Ker** b. Hexham 1825(?) - 1853 Marine & landscape artist Exh: RA, Prov. AG's	TKF	
PELHAM **Thomas Kent** Fl. 1860 - 1891 Genre subjects Exh: RA, BI, SS, Prov. AG's	TKP	
TOULOUSE-LAUTREC-MONFA **Henri Marie Raymonde De** b. France. 1864 - 1901 Portraits, figure & genre subjects Exh: International AG's		TL
TESTA **Pietro** b. Italy. 1611 - 1650 Allegorical & portrait & historical subjects Exh: Italy, France, Russia, Austria		
SHOOSMITH **Thurston Laidlaw** b. Northampton. 1865 - 1933 Landscape watercolourist Exh: London & Prov. AG's	*TLS*	
THULDEN **Theodor Van** b. Holland. 1606 - 1676 Religious & genre subjects Exh: Belgium, Germany, France, Spain	TM	TM

TM	**DOW, RSW** **Thomas Millie** b. Fifeshire. 1848 - 1919 Genre & landscape artist Exh: London & Prov. AG's	TMD T.M.D
	MARTSS **Jan** Fl. 17th C. Battle scenes	MD.I.s
	JOY **Thomas Musgrove** b. Kent. 1812 - 1866 Portraits, genre, sporting & historical subjects Exh: RA, SS, NWS, NI	(TMJ)
	RICHARDSON, RSA, OWS **Thomas Miles (junior)** b. Newcastle. 1813 - 1890 Landscape oil & watercolourist Exh: VA, UK AG's	TMR TMR TMR
	MACTAGGART, RSA, RSW **William** b. Campbeltown. 1835 - 1910 Coastal scenes, genre & landscape artist Exh: RA, RSW, UK AG's	XXX58 XXX6
TN	**TAYLOR. RMS** **Norah Helen** b. London. 1885 - Painter & miniaturist Exh: RA, PS, US., Canada, Australia etc.	NTH.
TO	**THOMSON** **Margaret Stanley** b. Ormskirk. 1891 - Etcher, watercolourist etc. Exh: WAG, London & Prov. AG's, Canada	♀
TP	**THOMAS. RPE** **Percy** b. London. 1846 - 1922 Portraits, genre, landscape & architectural subjects Exh: RA, SS, London & Prov. AG's	Þ
	TURTON **Dorothy Babara Jessie** b. Cape Colony, S.A. 20th Cent. Portraits, landscapes, interiors etc., oil, watercolour & miniaturist Exh: RMS, USA, London & Prov. AG's, US	Þ
	PRITCHETT **Robert Taylor** b. 1823 - 1907 Genre & landscape artist Exh: RA, VA, London & Prov. AG's	RP

776

RYSSELBERGHE Theodore b. Belgium. 1862 - 1926 Genre & portrait artist Exh: Holland, Belgium, France		
TOLMAN Ruel Pardee b. Vermont, US. 1878 - Illustrator & portrait artist		
MILES Thomas Rose Fl. 1869 - 1902 Marine & landscape artist Exh: RA, Prov. AG's, Australia		
REDGRAVE, RA Richard b. London. 1804 - 1888 Genre & landscape artist Exh: RA, VA, NPG, France, Germany		
SPENCE Thomas Ralph b. Nr. Richmond. 1855? - ? Landscape artist & decorator Exh: UK AG's		
WAY Thomas Robert b. 1861 ? - 1913 Painter & lithographer		
BRANDARD Robert b. Birmingham. 1805 - 1862 Landscape artist Exh: RA, BI, SS, NWS		
COLE Philip Tennyson Fl. 1878 - 1889 Portraits & Domestic genre Exh: RA, UK AG's, Australia		
SCHNORR VON CAROLSFELD Julius Veit Hans b. Leipzig. 1794 - 1872 Religious & genre subjects Exh: Germany		
STEPHAN Joseph b. Germany. ? - 1786 Animal & landscape subjects Exh: Germany		

TS	**STIMMER** **Tobias** b. Switzerland. 1539 - 1584 Portrait, genre & religious subjects Exh: Switzerland	*T S.*
	TUSHINGHAM **Sidney** b. Burslem. 1884 - 1968 Landscape artist Exh: RA, UK AG's	
	SANDYS **Frederick** b. England. 1832 - 1904 Portrait & figure artist Exh: RA, UK, Melbourne	
	SALISBURY. RPS, CVO, LL.D. **Frank O.** b. Harpenden. 1874 - 1962 Portraits & historical subjects etc Exh: RA, RI, RP, Prov. AG's, Canada, US, etc.	
	SELB **Josef** b. Germany. 1784 - 1832 Painter & lithographer	
	SOLOMAN. RA, PRBA **Joseph Solomon** b. London. 1860 - 1927 Portraits, mythological & historical subjects Exh: RA, NG, SS, London & Prov. AG's	
	SMITH **James Burrell** Fl. 19th C. Landscape artist Exh: SS, VA	
TT	**IRELAND** **Thomas** Fl. 1880 - 1903 Landscape artist Exh: RA, SS, NWS, GG	
TV	**ECKENBRECHER** **Karl Themistocles von** b. Athens. 1842 - ? Oriental subjects, landscapes etc Exh: German AG's	*T.v.E*
	LOON **Theodor Van** b. Belgium. 1629 - 1678 Religious & landscape subjects	*T v. L.*

THULDEN **Theodor Van** b. Holland. 1606 - 1676 Religious & genre subjects Exh: Belgium, Germany, France, Spain	TvT. M.	TV
TAYLOR **Charles William** b. Wolverhampton. 1878 - 1960 Genre, landscape artist & engraver Exh: UK AG's	WT WT	TW
THOMAS. FRSA **Winifred M.** b. Pengam. 1910 - Gouache, oil & watercolourist Exh: RBSA, London & Prov. AG's	WT	
TURNER. RGI, UA **William** b. Andover. 1877 - ? Portrait artist Exh: RA, RBA, USA, RSA, RGI, PS, etc.	WT	
WAGHORN. RWA **Tom** b. London. 1900 - Watercolourist Exh: RA, RI, RBA, NEAC, RWA, Prov. AG's	WT	
WEBSTER. RA **Thomas** b. London. 1886 - Portraits, genre & historical subjects Exh: RA, SS, BI, VA, Prov. AG's, US	TW	
WELLER **J.** b. 1698 - ? Portrait artist Exh: London	TW TW 1821. TW	
WHITEHEAD **Tom** b. Yorkshire. 1886 - Portrait, genre & landscape artist Exh: London & Prov. AG's	WT.	
WILKENS **Theodorus** b. Amsterdam. 1690 - 1748 Landscape artist Exh: Holland, Belgium, Germany, Austria	TW. 1736	
WORLIDGE **Thomas** b. Peterborough. 1700 - 1766 Portrait artist & miniaturist Exh: NPG, VA, London & Prov. AG's	T.W	

TW	**WYCK** **Thomas** b. Holland. 1616 ? - 1677 Interiors, markets & marine subjects Exh: Russia, European AG's, UK, etc.	
	DOBSON, RWS, RA **William Charles Thomas** b. Hamburg. 1817 - 1898 Genre, oil & watercolourist Exh' RA, RWS, London & Prov. AG's Australia	
	THOMAS **William Cave** b. London. 1820 - ? Historical, genre, Pre-Raphaelite School Exh: VA, NG, London & Prov. AG's	
	TIFFIN **Walter Francis** b. 1817 - 1900 Landscape artist & miniaturist Exh: RA, BI, SS	
	TOPHAM, RWS **Francis William** b. Leeds. 1808 - 1877 Genre subjects Exh: RA, BI, SS, VA, London & Prov. AG's	
	WILSON. RI **Thomas Walter** b. London. 1851 - ? Genre, architectural & landscape artist Exh: RA, SS, NWS, Prov. AG's, Australia	
TZ	**LEIGHTON. PRA, RWS, HRCA, HRSW.** **Lord Frederick** b. Scarborough. 1830 - 1896 Mythological & historical subjects Exh: RA, SS, OWS, GG, Germany, Australia	
	PETZL **Joseph** b. Munich. 1803 - 1871 Genre subjects Exh: Germany	
U	**UTTER** **Andre** b. Paris. 1886 - 1948 Still life, genre & landscape subjects	
UB	**SCOTT** **William Bell** b. Edinburgh. 1811 - 1890 Genre & historical subjects Exh: RSA, RA, SS, BI, VA, Prov. AG's	

RAINBIRD **Victor Noble** b. Northsheilds. 1888 - Pastel, oil & watercolour media Exh: RA, WAG, London & Prov. AG's	*[monogram]*	UR
WEYDEN **Roger** b. Belgium. 1400 ? - 1464 Portraits & religious subjects Exh: Belgium, Germany, US, France, UK	*[two monograms]*	V
AKEN **Jan van** b. Holland. 1614 - ? Landscape artist	*[three monograms]*	VA
VACCARO **Andrea** b. Naples. 1598 ? - 1670 Biblical & historical subjects Exh: Italy, France, Madrid, Germany	*[monogram]*	
FERG **Franz de Paula** b. Vienna. 1689 - 1740 Genre & landscape artist Exh: Germany, Hungary, Italy, Austria etc	*[monogram]*	
GOES **Hugo van der** b. Gand. 1420 ? - 1482 Religious subjects & miniatures Exh: Holland, Germany, Italy, UK, Russia, France, Austria	*[monogram]*	
VALESIO **Francesco** b. Bologne. 1560 ? - ? Portraits & landscape artist	*[monogram]*	
VALESIO **Giovanni Luigi** b. Italy. 1583 ? - 1650 ? Religious subjects & miniaturist Exh: Italy	*[monogram]*	
AUDENAERDE **Robert van** b. Ghent 1663 - 1743 Portraits & biblical subjects	*[three monograms]*	
BENNETT **Violet** b. London. 1902 - Tempera & oil media Exh: RA, & Prov. AG's	*[monogram]*	VB

VB	**BONASONE** **Giulio di Antonio** b. Bologne. 1498 ? - 1580 ? Biblical & mythological subjects	
	BRUNTON, RMS **Violet** b. Yorkshire. 1878 - ? Miniaturist Exh: RA, Royal Min. Soc.	
	BRUSSEL **Hermanus van** b. Haarlem. 1763 - 1815 Landscape artist Exh: Holland	
	VERBEECK **Pieter Cornelis** b. Haarlem. 1610 - 1654 Hunting scenes Exh: Holland, Germany, Italy, UK	
VC	**CRAWHALL, RWS** **Joseph** b. Newcastle. 1860 - 1913 Bird & animal subjects Exh: RA, UK AG's, Paris	
	CLEEF **Henry van** b. Antwerp. 1510 - 1589 Landscape artist	
	CLEVE **Hendrick 111 van** b. Anvers. 1525 - 1589 Landscape artist	
VD	**DEONON** **Vivant Dominique** b. France. 1747 - 1825 Portrait, genre & landscape artist Exh: France	
	BENT **Johannes van der** b. Amsterdam. 1651 - 1690 Landscape artist Exh: Russia, Hungary, France, Holland etc	
	DERUET (or DERVET) **Claude** b. Nancy. 1588 - 1662 Portrait & historical subjects Exh: France	

VIGNE Felix De b. Belgium. 1806 - 1862 Historical, genre & portrait artist Exh: Belgium		VD
HEYDEN (or HEYDE) Jan van der b. 1637 - 1712 Still life, genre & landscape artist Exh: UK, Russia & European AG's		
KELLEN (The Younger) David van der b. Utrecht. 1827 - 1895 Historical, archaeological & genre subjects Exh: Holland, France		
LADENSPELDER Johann b. Holland. 1511 - ? Religious subjects		VE
GINGELEN Jacques van b. Anvers. 1801 - ? Landscape artist		VG
GOYEN (or GOIEN) Jan Josefoz van b. Leyden. 1596 - 1665 Landscapes, portraits, sea & river scenes Exh: Holland, France, Belgium, Germany, Russia etc		
VIGNON Claude v. Tours. 1593 - 1670 Religious & historical subjects Exh: France, Italy		
VIGNON Claude Francois b. Paris. 1633 - 1703 Historical subjects Exh: Paris		
DORNER (The Elder) Johann Jakob b. Germany. 1741 - 1813 Religious, historical, genre & landscape artist Exh: Germany, Switzerland		VI
LUTGENDORFF (Baron De) Ferdinand Karl Theodor Christoph Peter b. Germany. 1785 - 1858 Genre, portraits & miniaturist		

VK	**VERKOLYE** **Jan** b. Amsterdam. 1650 - 1693 Portrait, genre & historical subjects Exh: Holland, Germany, Russia, UK, etc.	
	KAA **Jan van der** b. Holland. 1813 - 1877 Portraits & interior scenes Exh: Holland, Belgium, Germany	
VL	**VALESIO** **Giovanni Luigi** b. Italy. 1583 ? - 1650 ? Religious subjects & miniaturist Exh: Italy	
	LINT **Peter Van** b. Antwerp. 1609 ? - 1690 Portraits & religious subjects Exh: Belgium, France, Germany, Austria	
VM	**MIGNOT** **Victor** b. Brussels. 1872 - ? Painter & engraver	
	MITCHELL **Leonard Victor** b. New Zealand Portrait, figure, still life & landscape artist Exh: RA, PS, UK & European AG's N. Zealand, Australia etc.	
	VALCKENBORG **(or VALKENBORCH)** **Martin Van** b. Belgium. 1535 - 1612 Portraits, genre & landscape artist Exh: Germany, Italy	
VP	**PASMORE. CBE, MA** **Victor** b. Surrey. 1908 - Portraits, still life & landscape artist Exh: London & Prov. AG's, France	
VR	**REGEMORTER** **Ignatius Josephus Van** b. Antwerp. 1785 - 1873 Genre, landscape subjects Exh: Holland, Belgium, Germany	
	ROSS. MSIA **Victor** b. Nowawes. 1899 - Pen & wash, oil media, etc. Exh: London AG's, Germany	

RUSKIN. HRWS **John** b. London. 1819 - 1900 Architectural, floral & landscape artist Exh: OWS, RWS, London & Prov. AG's	*VR*		**VR**
RUTLAND (Duchess of) **Violet** b. Lancashire. 19th C. Sculptor & portrait artist Exh: RA, London & Prov. AG's, France, US	*YR*		
WILKIE. RA **Sir David** b. Fife. 1785 - 1841 Historical, genre & portrait artist Exh: RA, BI, NPG, NG, VA, Prov. AG's, US, Germany, etc.	*VW*	*VW 1820*	
SCHLICHTEN **Johann Franz Von Der** b. Germany. 1725 - 1795 Genre subjects Exh: Germany	*V.S*		**VS**
SOLIS (The Elder) **Virgil** b. Nuremberg. 1514 - 1562 Mythological, portrait & genre subjects	*VS*	*V*	
STALBURCH **Jan Van** Fl. Belgium. 16th C. Painter & engraver	*VS*		
DOUGLAS, PRSA **Sir William Fettes** b. Edinburgh. 1822 - 1891 Interiors, landscapes & historical genre Exh: RA, RSA, London & Prov. AG's	*monogram*		**W**
FRICK, RE, FZS **Winifred Marie Louise** b. Ramsgate Bird & animal subjects Exh: RA, RE, PS, SWA	*monogram*		
INCHBOLD **John William** b. Leeds. 1830 - 1888 Landscape artist Exh: SS, RA, VA, NG, UK AG's	*monogram*	*W*	
VICKERS **Vincent Cartwright** b. London. 1879 - Pen & ink media, watercolourist etc. Exh: RA, London & Prov. AG's	*V.W.*		

W	**WATSON** **John Bernard** b. Yorkshire. 1924 - Pen, oil, crayon & watercolourist Exh: London & Prov. AG's	
	WAXSCHLUNGER **Johann Paul** b. Germany. 1660 ? - 1724 Floral, animal & landscape subjects Exh: Germany	
	WEBSTER **Roland Harding** b. Chester. 1873 - ? Pastel, oil & watercolourist Exh: London & Prov. AG's	
	WHITFIELD **George** Figure artist Exh: London & Prov. AG's	
	WINGATE. PRSA **Sir James Lawton** b. Glasgow. 1846 - 1924 Landscapes & moonlight scenes Exh: RA, RSA, Prov. AG's	
	WOLMARK **Alfred Aaron** b. Varsovie. 1877 - 1961 Still life, portraits & landscape artist Exh: RA, London & Prov. AG's	
	WOOG **Raymond** b. Paris. 1875 - ? Portraits, still life & landscape artist Exh: France	
WA	**ANDERSON** **William** Fl. London. 1856 - 1893 Landscape artist Exh: RA, SS, UK AG's	
	HENSEL **Wilhelm** b. 1794 - 1861 Portraits & historical subjects Exh: Germany	
	WATERHOUSE, RA **Alfred** b. Liverpool. 1830 - 1905 Landscape & architectural subjects Exh: London & Prov. AG's	

WATTEAU **Jean Antoine** b. France. 1684 - 1721 Fetes, genre subjects etc. Exh: Russia, UK & European AG's		**WA**
WERGE-HARTLEY. NDD, ATD **Alan** b. Leeds. 1931 - Marine landscapes Exh: Prov. AG's, X, UK		
BALL **Wilfred Williams** b. London 1853 - 1917 Landscape & Marine artist Exh: RA, SS, NWS, GG		**WB**
BAYES **Walter** b. London Fl. 19th-20th C. Landscape artist Exh: RA & UK AG's		
BEMMEL **Wilhelm von** b. Utrecht. 1630 - 1708 Landscape artist Exh: Holland, Germany, Austria		
BROMLEY **William** Fl. 1835 - 1888 Genre & landscape artist Exh: RA, BI, SS		
BROOKER **William** b. London. 1918 - Painter in oid media Exh: RA, RWA & Prov. AG's		
BURTON **William Shakespeare** b. 1824 - 1916 Historical subjects Exh: RA, BI		
BUYTEWECH **Willem Pieter** b. Rotterdam. 1585 ? - 1628 ? Biblical, genre, landscapes etc Exh: Germany		
SCHMID **Matthias** b. Austria. 1835 - 1923 Historical & genre subjects Exh: Germany, Austria		

WB	

SCOTT **William Bell** b. Edinburgh. 1811 - 1890 Genre & historical subjects Exh: RSA, RA, SS, BI, VA, Prov. AG's	
GARDNER **William Biscombe** b. London. 1848(?) - 1919 Landscape artist Exh: RA, London & Prov. AG's	
RICHMOND, RA **William Blake** b. London. 1842 - 1874 Historical & landscape artist Exh: RA, NPG, VA, UK AG's	
CARPENTER Margaret Sarah (nee Heddes) b. Salisbury. 1793 - 1872 Portrait artist Exh: BM, UK AG's	
COLLINGWOOD RWS William b. Greenwich. 1819 - 1903 Landscape artist Exh: RA, UK AG's	
CONGDON **William** b. Providence, USA. 1912 - Oil & watercolourist Exh: US, AG's, Rome, Venice etc	
CRANE, RWS **Walter** b. Liverpool. 1845 - 1915 Portrait, figure & landscape artist Exh: RA, OWS, NWS, GG, London & Prov. AG's	
WAEL **Cornelis De** b. Antwerp. 1592 - 1667 Historical & military subjects Exh: Belgium, France, Austria	
WALTON **Cecile** b. Glasgow. 1891 - Genre subjects, illustration & sculptress Exh: UK AG's	

WC

WATKINS **John** Fl. London. 19th C. Mythological & genre subjects Exh: RA, SS, NWS, GG, VA, etc.	*ℓW*	**WC**
WINZER **Charles Freegrove** b. Varsovie. 1886 - Spanish & Oriental subjects Exh: London AG's, Paris, Moscow, Venice, US, India	*CW*	
SYMONS **William Christian** b. London. 1845 - 1911 Portrait, genre, historical, still life & landscape artist Exh: RA, NWS, GG, SS, ROI, Prov. AG's	W.C.S.	
WINTOUR, ARSA **John Crawford** b. Edinburgh. 1825 - 1882 Genre & landscape artist Exh: RSA, UK AG's	*WC /63*	
CATON-WOODVILLE **William Passenham** b. London. 1884 - Still life & 18th century subjects Exh: RA, WAG	*w.ℰ.w*	
DALGLISH **William** b. 1860(?) - 1909 Landscape artist Exh: RA, UK AG's	*WD*	**WD**
DAVIS **William** b. Dublin. 1812 - 1873 Landscape artist Exh: RA, UK AG'S etc.	*WD* *1861*	
DEWHURST **Wynford** b. Manchester. 1864 - ? Landscape artist Exh: UK AG's	*W.D W.D. W.D.*	
DEXTER, RBA **Walter** b. Wellingborough. 1876 - 1958 Portraits, landscapes, domestic & still life subjects Exh: RA, RBA	*WD*	
DYCE, RA, HRSA **William** b. Aberdeen. 1806 - 1864 Portraits, religious & historical subjects Exh: RA, RSA, BI, London & Prov. AG's, Germany	*WD* *WD* *1845*	

WD	**ADAMS** **William Dacre** b. Oxford. 1864 - 1951 Portraits, genre & architectural subjects Exh: RA, NG, UKAG's, Paris	*WDA 1901*
	MACKAY, RSA **William Darling** b. Gifford. 1844 - 1924 Genre & landscape artist Exh: UK AG's	*WDM.*
	POORTER **Willem De** b. Holland. 1608 - 1648 ? Allegorical & historical subjects Exh: Holland, UK, Germany, Austria	*W.D.P.*
	SADLER. RBA **Walter Dendy** b. Dorking. 1854 - 1923 Interior & genre artist Exh: RA, GG, SS, London & Prov. AG's	*WDS*
WE	**WILLIAMS** **Edward** b. London. 1782 - 1855 Landscape artist & miniaturist Exh: RA, BI, SS, VA, London & Prov. AG's	*EW*
	WORRALL. RA **Ella** b. Liverpool. 1863 - ? Landscape artist & miniaturist Exh: RA & Prov. AG's	*EW*
	WALKER, RWS **William Eyre.** b. Manchester. 1847 - 1930 Landscape artist & watercolourist Exh: RWS, UK AG's	*W.E.W. RWS*
WF	**VAILLANT** **Wallerant** b. France. 1623 - 1677 Portrait artist Exh: Holland, France, NG, VIA	*Wf WF.*
	WEISSENBRUCH **Johannes** b. The Hague. 1824 - 1880 Landscape artist Exh: Holland, UK	*Wf*
	WEST, VP RWS **Joseph Walter** b. Hull. 1860 - 1933 Genre & landscape artist Exh: UK AG's, Paris	*JW*

		WF
WESTON **Florence** Figure, floral & landscape artist Exh: RBSA, London & Prov. AG's		
WIRGMAN. LAA, SAM **Frances** b. Birkenhead. 1888 - Portraits, landscape artist & miniaturist Exh: WAG, RCA & Prov. AG's		
GILES William b. Reading. 1872 - Genre & landscape artist Exh: RA, BM, Prov. AG's		WG
GOODMAN Walter b. London. 1838 - ? Genre & portrait artist Exh: RA, UK AG's		
GROSSMITH W. Weedon Fl. 1875 - 1890 Genre & portrait artist Exh: RA, SS, London & Prov. AG's		
WESTBY. RMS **Grace Mary Stanley** b. Sydney. 1896 - Miniaturist Exh: RA, RMS, London & Prov. AG's		
WILLIAMS **George Augustus** b. 1814 - 1901 Coastal, landscape & moonlight scenes Exh: RA, BI, London & Prov. AG's etc.		
GILLIES, RA, RSA, RSW **Sir William George** b. 1894 - 1973 Portrait, still life & landscape artist Exh: RA, RSW, UK AG'S, etc.	W.G.G.	
HERDMAN **William Gawin** b. Liverpool. 1805 - 1882 Landscape artist Exh: UK AG's	W.G.H. W.G.H	
WOODS. MA **John Goodrich Wemyss** Watercolourist Exh: RA, London & Prov. AG's		

791

WG	**GODWARD** **John William** Fl. 1887 - 1909 Genre, figures & oriental subjects Exh: RA, UK AG'S			
WH	**HARTLEY** **William** b. Liverpool Watercolourist Exh: WAG, RI			
	HAUSSOULLIER **Guillaume** b. Paris. 1818 - 1891 Historical subjects Exh: France			
	HENNESSY, ROI **William John** b. Ireland. 1839 - 1920 Genre & landscape artist Exh: RA, SS, GG, UK AG's, US			
	HOEVENAAR **Willem Pieter** b. Utrecht. 1808 - 1863 Genre subjects Exh Holland			
	HOGARTH **William** b. London. 1697 - 1764 Portraits, Genre & Historical subjects Exh: Switzerland, UK, France etc			
	HOLE, RSA, RWS, RE **William** b. Salisbury. 1846 - 1917 Genre & landscape artist Exh: RA, UK AG's			
	HUBER **Wolfgang** b, 1490 - 1553 Genre, religious & landscape artist Exh: Dublin, Germany			
	HUNT **Walter** b. London. 1861 - ? Animals, still life, genre subjects etc Exh: RA, London & Prov. AG's			
	NIVINSKI **Iganti Ignatievitch** b. Moscow. 1881 - Oil & watercolourist			

BARTLETT William H. b. 1858 - ? Genre landscapes & sporting subjects Exh: UK, AG's, France	WHB
BIRCH William Henry b. Epsom. 1895 - 1968 Portrait & landscape artist Exh: RA, UK AG's	WHB
BORROW William Henry Fl. 1863 - 1890 Marine & landscape artist Exh: RA, BI, SS	W.H.B.
CROME William Henry b. Norwich. 1806 - 1873 Landscape artist Exh: UK AG's	WHC
KNIGHT William Henry b. Newbury. 1823 - 1863 Genre subjects Exh: SS, RA, BI, Prov. AG's	WHK. 57
MARGETSON William Henry b. 1861 - 1940 Genre, figure & portrait artist Exh: RA, UK AG's	W.h.m.
HAIG (HAGG), RE Axel Herman b. Gotland. 1835 - 1921 Architectural views Exh: London, Paris	18 (AH) 50 19 (AH) 03
WELLS, RA Henry Tanworth b. London. 1828 - 1903 Portraits, genre & miniaturist Exh: RA, NG, UK AG's	HTW 1901
WILLIAMSON W.H. Fl. 1853 - 1875 Marine artist Exh: RA, BI, SS, Prov. AG's	W.H.W. 1861
WAEL Lucas Janszen De b. Antwerp. 1591 - 1661 Historical & landscape subjects Exh: Belgium, Norway	Xv ÔH

TURNER. RA **Joseph Mallord William** b. London. 1775 - 1851 Land & seascapes, venetian & historical subjects Exh: RA, NG, NPG, VA, Prov. AG's, France, US, Canada, etc.		
WEBB **James** b. 1825? - 1895 Marine & landscape artist Exh: RA, BI, SS, VA, UK AG's, Australia		
WHITE. RI **John** b. Edinburgh. 1851 - 1933 Portrait, genre, marine & landscape artist Exh' RA, NWS, SS, GG, London & Prov. AG's		
WILLIAMS. ARDS, RDS **Juliet Nora** Floral & landscape artist Exh: RA, ROI, London & Prov. AG's		
TROOSTWYK **Wouter Joannes Van** b. Amsterdam. 1782 - 1810 Landscape artist Exh: Holland		
WEBBE **William J.** Fl. 19th C. Genre, animal & landscape artist Exh: RA, SS, BI, & Prov. AG's		
WRIGHT, RWS **John William** b. London. 1802 - 1848 Genre artist & watercolourist Exh: RA, BM, UK AG's		
KNYFF **Wouter** b. Holland. 1607 - 1693 Landscape artist Exh: Holland, France, Dublin, Russia, Sweden		
LANGLEY, RI **Walter** b. Birmingham 1852 - 1922 Genre & landscape artist Exh: RA, SS, NWS, London & Prov. AG's, Italy		
LAWSON **William** b. Yorkshire. 1893 - Watercolourist . Portraits & miniatures Exh: RA		

WJ

WK

WL

LEITCH. RI. **William Leighton** b. Glasgow. 1804 - 1883 Landscape artist Exh: RA, BI, SS, NWS. London & Prov. AG's		**WL**
LITTLEJOHN. DA, ARSA **William Hunter** b. Scotland. 1929 - Painter in oil media Exh: London & Prov. AG's		
LODGE **William** b. Leeds. 1649 - 1689 Portraits, landscapes & architectural subjects		
LUKER **William, (Junior)** b. London. 1867 - ? Portraits, genre & landscape artist Exh: RA, SS, NWS & Prov. AG's		
WYLLIE. RA, RI **William Lionel** b. London. 1851 - 1931 Marine & coastal subjects Exh: RA, NWS, SS, GG, Prov. AG's, Australia		
MILLNER **William Edward** b. 1849 - 1895 Genre & animal subjects Exh: RA, SS, BI, London AG's etc.		**WM**
MORGAN **Evelyn De** b. 1855 - 1919 Pre-raphaelite artist Exh: GG, NG, London & Prov. AG's		
MULLER **William James** b. Bristol. 1812 - 1845 Venetian & mid-Eastern scenes Exh: VA, UK & European AG's, Canada		
FRAZER, RSA **William Miller** b. Perthshire. 1865 - ? Landscape artist Exh: UK AG's		
NEATBY **William James** b. Barnsley. 1860 - 1910 Architectural & decorative artist Exh: WAG, London & Prov. AG's		**WN**

WO	**OSBORNE, RHA** **William** b. Dublin. 1823 - 1901 Portrait & animal subjects Exh: UK AG's	
	WAGNER **Otto** b. Germany. 1803 - 1861 Landscape & architectural subjects Exh: Germany, Norway	Dresd 18 W 39
	OAKES, ARA, RSA **John Wright** b. Cheshire. 1820 - 1887 Landscape artist Exh: RA, BI, VA, UK AG's	1850
WP	**PAGET** **Walter** Fl. London 19th C. Painter & illustrator	WP WP
	PADGETT **William** b. England. 1851 - 1904 Landscape artist Exh: RA, GG, SS, NG, London & Prov. AG's	WP
	PROFANT **Wenzel** b. Luxembourg. 1913 - Painter & sculptor Exh: Belgium, France, Germany, Switzerland, etc.	WP.
	WILKIE. RA **Sir David** b. Fife. 1785 - 1841 Historical, genre & portrait artist Exh: RA, BI, NPG, NG, VA, Prov. AG's, US, Germany, etc.	W W 1819
WQ	**ORCHARDSON. RA** **Sir William Quiller** b. Edinburgh. 1832 - 1910 Portraits & genre subjects Exh: RA, GG, NG, BI, London & Prov. AG's, Germany, Italy, Australia	WQO W
WR	**RIKKERS** **Willem** b. Amsterdam. 1812 - ? Portraits & interior subjects	WR WR
	ROTHENSTEIN **Sir William** b. Bradford. 1872 - 1945 Portraits, landscapes & interior scenes Exh: UK AG's, Canada, Germany, US, Australia	WR WR WHR

RADCLYFFE **Charles Walter** b. Birmingham 1817 - 1903 Landscape artist Exh: RA, BI, SS, VA		WR
SAY **William** b. England. 1768 - 1834 Genre, Portrait & landscape artist		WS
SCHADOW **Wilhelm** b. Berlin. 1788 - 1862 Religious & portrait artist Exh: Germany		
SCHELLINKS **Willem** b. Amsterdam. 1627 - 1678 Figure, marine & landscape artist Exh: Holland, Italy, US, UK, Germany		
SHIRLAW **Walter** b. Paisley. 1838 - 1909 Portrait, genre & landscape artist Exh: UK AG's, US, Germany, France		
SMALL. RI **William** b. Edinburgh. 1843 - ? Genre, land & coastal subjects etc. Exh: RA, NWS, GG, & Prov. AG's		
SPARKS (Mrs. Spooner) **Wendy R.S.** b. Kingston-on-Thames. 1930 - Religiously inspired meta- psychological subjects Exh: London & Prov. AG's, France, Germany, US, Australia, Greece, etc.		
STEWART **William** b. Greenwich. 1886 - Painter & Illustrator Exh: RA, RBA		
STRUTT **William** b. 1826 - 1915 Genre, animals & portrait artist Exh: RA, SS, NG, Prov. AG's		
SWANENBURGH **Willem Isaaksz** b. Holland. 1581 - 1612 Historical & portrait artist		

WS	**WULFRAET** **Margaretha** b. Holland. 1678 - 1741 Genre, historical & portrait artist Exh: Helsinki	
	WORTLEY **Archibald Stuart James** b. 1849 - 1905 Portraits & sporting subjects Exh: RA, GG, NG, London & Prov. AG's, etc.	
	STACEY. BWS, ROI, RBA **Walter S** b. London. 1846 - 1929 Genre, figure & landscape artist Exh: RA, RI, ROI, RBA, NWS, SS, Prov. AG's	
WT	**TAYLOR** **Charles William** b. Wolverhampton. 1878 - 1960 Genre, landscape artist & engraver Exh: UK AG's	
	WEBSTER, RA **Thomas** b. London. 1800 - 1886 Portraits, genre & historical subjects Exh: RA, VA, UK AG's	
	GAMBARO **Lattanzio** b. Brescia. 1530 ? - 1574 ? Portraits & historical subjects Exh: Italy	
	WAY **Charles Jones** b. Darmouth. 1834 - 1900 Landscape oil & watercolourist Exh: Canada, Switzerland, UK AG's	
	WILSON. RI **Thomas Walter** b. London. 1851 - ? Genre, architectural & landscape artist Exh: RA, SS, NWS, Prov. AG's, Australia	
	TOPHAM, RWS **Francis William** b. Leeds. 1808 - 1877 Genre subjects Exh: RA, BI, SS, VA, London & Prov. AG's	
	MACTAGGART, RSA, RSW **William** b. Campbeltown. 1835 - 1910 Coastal scenes, genre & landscape artist Exh: RA, RSW, UK AG's	

DOBSON, RWS, RA William Charles Thomas b. Hamburg. 1817 - 1898 Genre, oil & watercolourist Exh' RA, RWS, London & Prov. AG's Australia	18 88 18 89	WT
WARRENER **William Thomas** Fl. 1887 - 1892 Domestic genre Exh: UK AG's, Paris	W.T.W	
VAILLANT **Wallerant** b. France. 1623 - 1677 Portrait artist Exh: Holland, France, NG, VIA	W W W V / W V	WV
WALTON **Violet** b. Bootle. 1901 - Oil & watercolourist Exh: WAG, London & Prov. AG's	W	
WENDELSTADT **Carl Friedrich** b. Germany. 1786 - 1840 Portrait, genre & landscape artist Exh: Germany	Ψ	
VELDE (The Younger) **Willem Van De** b. Leyden. 1633 - 1707 Marine artist Exh: Holland, Belgium, France, UK' Germany, etc.	W V V V W V.V. W V V / W V V	
VALCKERT **Werner** b. Holland. 1585 ? - 1627 ? Portraits, historical subjects Exh: Holland, Germany	W V VA	
WEEKES **William** Fl. 1865 - 1904 Genre & animal subjects Exh: London AG's	W	WW
WAINWRIGHT, RWS **William John** b. Birmingham. 1855 - 1931 Portraits, genre & historical subjects Exh: OWS, UK AG's, Paris	WJW WJW	
OULESS. RA **Walter William** b. Jersey, C.I. 1848 - 1933 Portrait artist Exh: RA, London & Prov. AG's, Italy	W. W. O.	

WY	**OTTLEY** **William Young** b. England. 1771 - 1836 Portrait artist Exh: RA, London & Prov. AG's	*WYO* W.Y.O *WYO*
X	**WILLOUGHBY** **Vera** Watercolourist & illustrator	
XA	**AMMAN** **Justus** b. Zurich 1539 - 1591 Historical & mythological subjects	
	ATKINSON **W.A.** Fl. London. 1849 - 1867 Genre & historical subjects Exh: RA, BI, SS	
XG	**GLINK** **Franz Xavier** b. Germany. 1795 - 1873 Historical subjects Exh: German AG's	
Y	**ENRAGHT-MOONY** **Robert James** b. Athlone Landscape artist Exh: RA, PS, NEAC, Prov. & US AG's	
YA	**KILIAN** **Lukas** b. Germany. 1579 - 1637 Religious subjects Exh: Italy	
	FOORT **Karel** b. Ypres. 1510 - 1562 Historical subjects etc	
YR	**VRIES** **Roelof** b. Haarlem. 1631 ? - 1681 ? Landscape artist Exh: Germany, Holland, Russia, Scandinavia, France, etc.	
Z	**HUBER** **Wolfgang** b, 1490 - 1553 Genre, religious & landscape artist Exh: Dublin, Germany	

800

PATON. ARE Hugh b. Glasgow. 1853 - ? Pastel, oil & watercolourist Exh: RA. RE. Prov. AG's, PS, US, Australia		
ZEITBLOM Bartholome b. Germany. 1455 ? - 1518 ? Biblical subjects Exh: Germany, France, UK		ZB
ZIAR Elizabeth Rosemary b. St. Ives. 1919 - Watercolourist Exh: RI, RBSA, SWA, UA, France, etc.		ZE
HILDEBRANDT Ferdinand Theodor b. Stettin. 1804 - 1874 Portraits, genre & historical subjects Exh: Holland, Germany		ZH
ZIEGLER Henry Bryan b. London. 1793 - 1874 Portraits & landscape artist Exh: London & Prov. AG's		ZI
ZUBERLEIN Jakob b. Germany. 1556 - 1607 Portrait artist Exh: Germany		
ZAUFFELY Johann Joseph b. Germany. 1733 - 1810 Genre, portrait & historical subjects Exh: Germany, Austria, US, UK, France		ZJ
ZIMMERMANN Franz b. Austria. 1864 - ? Historical & genre subjects Exh: Germany		
WEHME Zacharias b. Dresden. 1550 ? - 1606 Portrait artist Exh: Germany		ZW

UNCLASSIFIED

BRANDARD Robert b. Birmingham. 1805 - 1862 Landscape artist Exh: RA, BI, SS, NWS	
CALLCOTT Charles Fl. London. 1873 - 1877 Genre subjects Exh: RA, SS	
COPE Sir Arthur Stockdale b. London. 1857 - 1940 Portrait & landscape artist Exh: RA, UK AG's, Paris	
COPE, RA Charles West b. 1811 - 1890 Religious & historical subjects Exh: RA, BI, London & Prov. AG's, Australia	
CORBOULD Edward Henry b. London. 1815 - 1915 Genre & historical subjects Exh: RA, SS, GG, NWS	
DREVET Jean Baptiste b. Lyon. 1854 - ? Marine & landscape artist Exh: France	
DUNCAN Lawrence Fl. 1860 - 1891 Genre & landscape, oil & watercolourist Exh: London & Prov. AG's	
ELMORE Richard Fl. 1852 - 1885 Landscape artist Exh: RA, SS, UK AG's	
FALBE Joachim Martin b. Berlin. 1709 - 1782 Genre artist	

FRY, RA E. Maxwell b. Cheshire. 1899 - Portraits & landscape artist Exh: RA & London AG's	
GOES **Hugo van der** b. Gand. 1420 ? - 1482 Religious subjects & miniatures Exh: Holland, Germany, Italy, UK, Russia, France, Austria	
GOODWIN **Harry** b. ? - 1925 Genre, oil & watercolourist Exh: London & Prov. AG's	
HANSEN **Hans Nicolai** b. Copenhagen. 1853 - 1923 Genre & landscape artist Exh: RA, SS, Paris, Vienna, Copenhagen	
HASSAM **Childe** b. Boston (U.S.) 1859 - ? Genre, town & landscape subjects etc Exh: France, Germany, US, UK	
HAYTER **Sir George** b. London. 1792 - 1871 Portraits, historical subjects & miniaturist Exh: RA, NPG, VA, UK AG'S, Italy	
HEDOUIN **Pierre Edmond Alexandre** b. France. 1820 - 1889 Portraits, genre, landscapes & eastern subjects Exh: French AG's	
HUNTER, ARA, RI, RSW **Colin** b. Glasgow. 1841 - 1904 Coastal, sea & landscape artist Exh: RA, London & Prov. AG's	
ISENDYCK (or YSENDYCK) **Anton van** b. Anvers. 1801 - 1875 Historical & portrait painter Exh: Belgium, France	
JACQUEMART **Jules Ferdinand** b. Paris. 1837 - 1880 Watercolourist & engraver Exh: France	

KENNEDY **William Denholm** b. Dumfries. 1813 - 1865 Portrait, historical, genre & landscape artist Exh: RA, SS, UK AG's	
KOBULADZE **Sergei** b. Akhaltsikhe. 1909 - Oil, charcoal, gouache media	
KOEKKOEK **Hermanus** b. Holland. 1815 - 1882 Marine artist Exh: England, Holland, Melbourne	
LANDERER **Ferdinand** b. Austria. 1746 - 1795 Genre, landscapes & mythological subjects	
LAUDER, RSA **James Eckford** b. Edinburgh. 1811 - 1869 Figures, historical & landscape painter Exh: UK AG's	
MENZIES-JONES. BA **Llewelyn Frederick** b. Surrey. 1889 - Etcher & landscape artist Exh: RI, PAS, etc.	
MURRAY. RA, HRSA, RSW **Sir David** b. Glasgow. 1849 - 1933 Landscape & marine artist Exh: RA, NWS, OWS, RSA, GG, Prov. AG's, Australia	
NICOTERA **Marco Antonio** Fl. Naples. 1590 - 1600 Religious subjects Exh: Naples	
NORTON. ARCA **Wilfred** b. Salop. 1880 - ? Exh: RA, London & Prov. AG's, France, Germany, US.	
OFFERMANS **Anthony Jacob** b. Holland. 1796 - 1839 ? Animal & landscape subjects Exh: Holland	

PARKER. ARMS, SSWA **Elizabeth Rose** b. Renfrewshire Portrait miniaturist & landscape artist Exh: London & Prov. AG's, Canada	
PARMIGIANO **Fabrizio Andrea** b. Italy. 1555 - 1600 ? Landscape artist Exh: Italy	
PATRY. RBA **Edward** b. London. 1856 - 1940 Genre & portrait artist Exh: RA, SS, PS, Belgium	
PERKINS **Charles C.** b. Boston. 1823 - 1886 Painter & engraver	
PRINS **Pierre Ernest** b. Paris. 1838 - 1913 Landscape artist Exh: France, Germany	
PULSFORD. ARSA **Charles** b. Leek. 1912 - Exh: RSA, SSA, London & Prov. AG's, France, etc.	
QUESNEL (The Elder) **Francois** b. Edinburgh. 1543 - 1619 Historical & Portrait artist Exh: France, Italy	
REILLY **Freda E.** Painter in pastel media Exh: PAS, London & Prov. AG's	
REMBRANT (or RIJN) **Harmensz Van** b. Holland. 1606 - 1669 Portraits & historical subjects Exh: International AG's	
ROSSETTI **Gabriel Charles Dante** b. London. 1828 - 1882 Portraits, figure & historical subjects Exh: NG, NPG, VA, Prov. AG's, US.	

SAAGMOLEN **Martinus** b. Holland. 1620 - 1669 Historical subjects	
SAFTLEVEN **Herman** b. Rotterdam. 1609 ? - 1685 Landscape artist Exh: France, Holland, Germany, Hungary, UK, etc.	
SCHAUFFELIN **Hans Leonard** b. Nuremberg. 1480 ? - 1538 ? Religious & portrait artist Exh: Germany, Austria	
SCHMID **Matthias** b. Austria. 1835 - 1923 Historical & genre subjects Exh: Germany, Austria	
STELLA **Jacques De** b. Lyon. 1596 - 1657 Biblical & historical subjects Exh: France, Italy, Germany, Austria, etc.	.I.✶ FECIT. 1625.
THIELE **Johann Friedrich Alexandre** b. Dresden. 1747 - 1803 Landscape subjects Exh: Germany, Norway	
VICKERS **Vincent Cartwright** b. London. 1879 - Pen & ink media, watercolourist etc. Exh: RA, London & Prov. AG's	
WAINWRIGHT, RWS **William John** b. Birmingham. 1855 - 1931 Portraits, genre & historical subjects Exh: OWS, UK AG's, Paris	
WERNER **Fritz** b. Berlin. 1827 - 1908 Historical & genre subjects Exh: Germany	
WILSON **Hugh Cameron** b. Glasgow Portrait, figure & landscape artist Exh: London & Scottish AG's	

WORSFOLD **Maud Beatrice** Portrait artist Exh: RA & Prov. AG's	
YATES **Mary** b. Chislehurst. 1891 - Landscape artist & sculptor Exh: RA, RSA, PAS, Prov. AG's	

SYMBOLS

For ease of reference symbols have been grouped, as far as possible, according to their basic form. The following marginal definitions have been given to denote the form in each group under which symbols have been classified:—

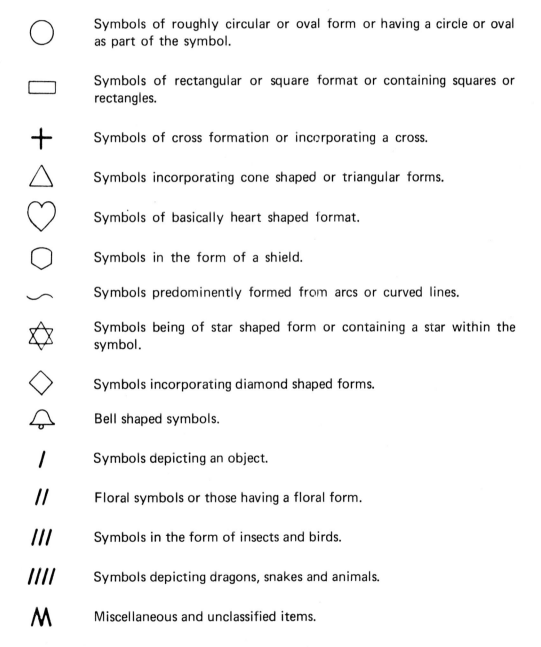

○ Symbols of roughly circular or oval form or having a circle or oval as part of the symbol.

▭ Symbols of rectangular or square format or containing squares or rectangles.

+ Symbols of cross formation or incorporating a cross.

△ Symbols incorporating cone shaped or triangular forms.

♡ Symbols of basically heart shaped format.

⬠ Symbols in the form of a shield.

⌣ Symbols predominently formed from arcs or curved lines.

✡ Symbols being of star shaped form or containing a star within the symbol.

◇ Symbols incorporating diamond shaped forms.

🔔 Bell shaped symbols.

/ Symbols depicting an object.

// Floral symbols or those having a floral form.

/// Symbols in the form of insects and birds.

//// Symbols depicting dragons, snakes and animals.

M Miscellaneous and unclassified items.

It will be found in some instances that the letters forming a monogram may appear as a symbol. These have been included in this section.

ALBERTINELLI **Mariotto** b. Florence. 1474 - 1515 Religious subjects Exh: France, Italy, UK, US, Austria	
BAKER **Ethelwyn** b. Belfast Sculptor, watercolourist etc Exh: RA, RBS, AIA, WAG, etc	
BARNES **E.C.** b. London Fl. 19th C. Genre, Domestic & interior subjects Exh: RA, SS, BI, & Prov. AG's	
BRIL (The Younger) **Mattheus** b. 1550 ? - 1584 Landscape artist Exh: France, Italy	
BROOK **Eleanor Christina** Artist in oil media Exh: London & Prov. AG's	
BURRA **Edward** b. London. 1905 - Surrealist Exh: UK AG's, France	
CADENHEAD, RSA, RSW,NEAC, **James FSA** b. Aberdeen. 1858 - ? Landscape artist Exh: AAS, RSA etc	
DAVIDSON, DA **J. Nina** b. Hamilton. 1895 - B/White, tempera & watercolour artist Exh: RSA, GI, etc	
DREVET **Jean Baptiste** b. Lyon. 1854 - ? Marine & landscape artist Exh: France	
DRING, ARCA, NSPC **James** b. London. 1905 - Oil & watercolourist Exh: RA, RBA, NSPS, NEAC, Prov. AG's, Europe & US	

DUNCAN, RSA, RSW John McKirdy b. Dundee. 1866 - 1945 Genre, historical & landscape artist Exh: RA, VA, UK AG's	
DURER Albrecht b. Nuremberg. 1471 - 1528 Portraits, landscapes & historical subjects. Exh: International AG's & collections	
FALCON, RBA, MA Thomas Adolphus b. Yorkshire. 1872 - ? Landscape artist Exh: London & Prov. AG's	
HAGGIS John b. London. 1897 - Portrait, figure & landscape artist Exh: RA, RPS, PS, WAG, ROI, RSA, NEAC, RWEA etc. Prov. AG's	
LANKESTER, BA, MB, B.CL, **CANTAB, MRCS, LRCP** Lionel W.A. b. Surrey. 1904 - B/white & watercolourist Exh: RWS & Prov. AG's	
LEECH John b. London. 1817 - 1864 . Hunting scenes, humourous subjects etc. Exh: London & Prov. AG's	
McINTYRE Raymond Portrait, figure & landscape artist Exh: RA, NEAC & London AG's	
MENPES. RBA, RPE Mortimer b. Australia. 1860 - 1938 Genre & street scenes etc. Exh: RA, NWS, GG, SS, etc.	
MUCKLEY Louis Fairfax b. Stourbridge. Fl. 1890 - 1902 Genre subjects Exh: London & Prov. AG's	
PICART LE DOUX Charles Alexandre b. Paris. 1881 - 1959 Genre, still life & landscape subjects etc. Exh: France, Russia	

PITTMAN. ROI **Osmund** b. London. 1874 - ? Landscape artist Exh: RA, ROI, London & Prov. AG's	φ
POCOCK. ROI, RE, RI, PAS **Anna** b. London. 1882 - Portraits, figure & floral subjects Exh: RA, PS, Italy, Canada, US, N.Z., UK, Prov. AG's	
POND **Arthur** b. London. 1705 ? - 1758 Portrait artist Exh: NPG, BM	
PULSFORD. ARSA **Charles** b. Leek. 1912 - Exh: RSA, SSA, London & Prov. AG's, France, etc.	φ
QUENNEL. Hon.ARIBA **Marjorie** b. Kent. 1883 - B/white, oil & watercolourist Exh: RA, London & Prov. AG's, US	
RIVIERE **Benjamin Jean Pierre Henri** b. Paris. 1864 - 1951 Landscape artist Exh: France	
ROSSETTI **Gabriel Charles Dante** b. London. 1828 - 1882 Portraits, figure & historical subjects Exh: NG, NPG, VA, Prov. AG's, US.	
SENIOR. ARCA **Oliver** b. Nottingham. 1880 - Portrait, figure & landscape artist Exh: London & Prov. AG's	
SIMON **Franz** b. Czechoslovakia. 1877 - Landscape artist Exh: Prague, Paris	
SOMM **Francois Clement Sommier** b. Rouen. 1844 - 1907 Genre subjects & caricaturist Exh: France	

TOULOUSE-LAUTREC-MONFA **Henri Marie Raymonde De** b. France. 1864 - 1901 Portraits, figure & genre subjects Exh: International AG's	
WAKEFIELD **Larry Hilary Edward** b. Cheltenham. 1925 - Abstract expressionist & figurative subjects Exh: Paris, London & Prov. AG's	
WEBSTER **Roland Harding** b. Chester. 1873 - ? Pastel, oil & watercolourist Exh: London & Prov. AG's	
WHISTLER. PRBA **James Abbott MacNeill** b. Lowell, US. 1834 - 1903 Genre & portrait artist Exh: RA, SS, London & Prov. AG's, European AG's	
YATES **Mary** b. Chislehurst. 1891 - Landscape artist & sculptor Exh: RA, RSA, PAS, Prov. AG's	
COLQUHOUN, DFA, **Ithel** b. Assam. 1906 - Exh: RA, CAS & London AG's	
PISSARRO. NEAC **Lucien** b. Paris. 1863 - ? Engraver & landscape artist Exh: London & Prov. AG's	
SOAMES **Corisande Wentworth** b. 1901 - Genre & portrait artist Exh: RA, RBA, RP, London & Prov. AG's	
BIRD **Mary Holden** Landscape watercolourist Exh: RA, RI, RSW, RBA, PS	

BRIL Paul b. Anvers. 1554 - 1626 Miniaturist & landscape artist Exh: UK, & European AG's	
ARCHER RSA James b. Edinburgh 1823 - 1904 Genre, portraits, landscapes & historical subjects Exh: RA, BI, SS, RSA	
BUTTER, BA Edward James b. London. 1873 - ? Landscapes & interior subjects Exh: RA, IS, GI	
CLIFFORD Edward C. b. Bristol. 1844 - 1907 Portraits & biblical subjects Exh: RA, SS, NWS, GG, NG etc	
DADDI Bernado b. Italy. 1512 ? - 1570 Genre & historical subjects	
DEONON Vivant Dominique b. France. 1747 - 1825 Portrait, genre & landscape artist Exh: France	
DOBLE Frank Sellar b. Liverpool. 1898 - Oil & watercolourist Exh: WAG & Prov. AG's	
DURER Albrecht b. Nuremberg. 1471 - 1528 Portraits, landscapes & historical subjects. Exh: International AG's & collections	
FAIRHURST, FRIBA Harry Smith b. Blackburn Oil & watercolourist Exh: RA, London & Prov. AG's	
FREEMAN, ARCS, B.Sc, Frank b. Barbados. 1901 - Landscape, figure & portrait artist	

GLEDSTANES, RBA, FRSA etc **Elsie** Oil, pastel & watercolourist Exh: RA, RBA, RP, SWA, PAS, & Prov. AG's	
HARRISON, Mem. SSA **Edward Stroud** b. Edinburgh. 1879 - ? Exh: Paris & Prov. AG's	
HITCHCOCK **Harold** b. London. 1914 - Imaginary & visionary landscapes with figures. oil, acrylic & water- colourist. Exh: RA, US, London & Prov. AG's	
HOEFNAGEL (or HUFNAGEL) **George** b. 1542 - 1600 Miniaturist & portrait artist	
HUGHES **Arthur** b. London. 1832 - 1915 Genre & romantic subjects Exh: RA, GG, NG etc	
MENPES. RBA, RPE **Mortimer** b. Australia. 1860 - 1938 Genre & street scenes etc. Exh: RA, NWS, GG, SS, etc.	
MICHELANGELO (BUONARROTI) b. Italy. 1475 - 1564 Portraits, mythological & religious subjects etc. Exh: International AG's	
RENI **Guido** b. Italy. 1575 - 1642 Religious & historical subjects Exh: France, Italy, Germany, UK, US, Scandinavia	
SOUTHALL. ARWS, NEAC **Joseph Edward** b. Nottingham. 1861 - ? Genre subjects Exh: London & Prov. AG's, Paris	
WEBB **Clifford Cyril** b. London. 1895 - Landscapes, views & architectural subjects Exh: RA, NEAC & Prov. AG's	

WERNER **Fritz** b. Berlin. 1827 - 1908 Historical & genre subjects Exh: Germany	
WHISTLER. PRBA **James Abbott MacNeill** b. Lowell, US. 1834 - 1903 Genre & portrait artist Exh: RA, SS, London & Prov. AG's, European AG's	
ZUBERLEIN **Jakob** b. Germany. 1556 - 1607 Portrait artist Exh: Germany	
BARNES **E.C.** b. London Fl. 19th C. Genre, Domestic & interior subjects Exh: RA, SS, BI, & Prov. AG's	
FRASER (the Elder), ARSA **Alexander George** b. Edinburgh. 1786 - 1865 Genre, historical & landscape artist Exh: RA, ARSA, UK AG'S, US	
GRAHAM, RA **Peter** b. Edinburgh. 1836 - 1921 Coastal scenes & landscape artist Exh: RA, London & Prov. AG's, Australia	
HUGHES **Arthur** b. London. 1832 - 1915 Genre & romantic subjects Exh: RA, GG, NG etc	
IRELAND **Thomas** Fl. 1880 - 1903 Landscape artist Exh: RA, SS, NWS, GG	
PIETERSZ **Aert** b. Amsterdam. 1550 ? - 1612 Portrait & genre artist Exh: Holland, Germany	
PRITCHETT **Robert Taylor** b. 1823 - 1907 Genre & landscape artist Exh: RA, VA, London & Prov. AG's	

THOMSON **Margaret Stanley** b. Ormskirk. 1891 - Etcher, watercolourist etc. Exh: WAG, London & Prov. AG's, Canada	
WATSON. RWS, RBA **John Dawson** b. Sedburgh. 1832 - 1892 Genre & landscape artist Exh: RA, SS, BI, OWS, GG, VA & Prov. AG's	
WILLOUGHBY **Vera** Watercolourist & illustrator	
BINCK **Jakob** b. Cologne. 1500? - 1569 Portrait artist	
COURTOIS **Jacques** b. St. Hippolyte. 1621 - 1676 Battle scenes, portraits, landscapes & historical subjects Exh: France, Hungary, Germany, Italy, Spain	
ENGELBERTSZ **Cornelis** b. Leyde. 1468? - 1533 Biblical & historical subjects Exh: Holland, France, Germany, Hungary, UK etc	
ERTZ, RBA, FRSA **Edward Frederick** b. Illinois. 1862 - 1954 Etcher, oil & watercolourist Exh: RA, RBA, London, Paris, Munich & US	
HOEFNAGEL (or HUFNAGEL) **George** b. 1542 - 1600 Miniaturist & portrait artist	
HOVE **Hubertus van** b. Hague. 1814 - 1865 Architecture & landscape artist Exh: Holland, Germany	
JOPLING, RI **Joseph Middleton** b. London. 1831 - 1884 Portraits, genre, still life, landscapes etc Exh: RA, SS, NWS, GG, RI & Prov. AG's	

816

SPACKMAN. RBA, RMS, FRSA, AR.Cam.A., etc. **Cyril Saunders** b. Cleveland, Ohio. 1887 - Sculptor, etcher & painter Exh: RA, PS, WAG, R.Cam.A., RBSA, RWEA, US, etc.	
TENNANT **Dorothy** b. UK. ? - 1926 Genre artist Exh: RA, NG, GG, etc.	
WHISTLER. PRBA **James Abbott MacNeill** b. Lowell, US. 1834 - 1903 Genre & portrait artist Exh: RA, SS, London & Prov. AG's, European AG's	
CORREGIO **Antonio (Allegri) da** b. Correggio. 1494 - 1534 Landscapes, religious & mythological subjects Exh: International AG's	
ROBERTSON. RPE **Henry Robert** b. Windsor. 1839 - 1921 Portrait, genre, landscape artist & miniaturist Exh: RA, BI, NWS, SS, GG, etc.	
VACCARO **Andrea** b. Naples. 1598 ? - 1670 Biblical & historical subjects Exh: Italy, France, Madrid, Germany	
MILLAIS. BT, PRA, HRI, HRCA. **Sir John Everett** b. Southampton. 1829 - 1896 Portrait, figure & historical subjects etc. Exh: RA, BI, GG, NG, NWS, London & Prov. AG's, Italy Australia	
FELLNER **Ferdinand August Michael** b. Germany. 1799 - 1859 Historical subjects	
ISABEY **Jean Baptiste** b. Nancy. 1767 - 1855 Portrait painter & miniaturist Exh: France, Spain, UK, Germany, Spain etc	
JOBSON **Patrick** b. UK. 20th C. Oil, pastel, tempera & watercolour media Exh: London & Prov. AG's X	

METEYARD. RBSA **Sidney** b. UK. 1868 - 1947 Painter in oil, watercolour & tempera media Exh: RA, PS, London & Prov. AG's	
SCOREL **Jan Van** b. Holland. 1475 - 1562 Religious, historical & portrait artist Exh: Holland, Germany, Italy, Austria, UK	
SWART **Jan** b. Holland. 1500 ? - 1553 ? Religious & historical subjects Exh: Belgium, Germany, Paris, London	
WHISTLER. PRBA **James Abbott MacNeill** b. Lowell, US. 1834 - 1903 Genre & portrait artist Exh: RA, SS, London & Prov. AG's, European AG's	
ABDO **Alexander** b. Buckhurst Hill, Eng. 1865— Phantasies, landscapes & symbolical subjects Exh: RA, R.Cam.A., RWA, WAG	
ARMFIELD **Maxwell** b. Ringwood 1882 - Tempera & watercolourist Exh: RA, PS, & Prov. AG's etc	
BROUGHTON, SWA **Aya** b. Kyoto, Japan Oil & watercolourist Exh: RA, WIAC, NS, RBA, RI, ROI, PS etc	
BURGESS **Gelett** b. Boston, Mass. 1876 - ? Topographical & impressionist subjects Exh: US	
CHAUVEAU **Francois** b. Paris. 1613 - 1676 Miniaturist	
DUCHEMIN **Isaak** Flourished Belgium 17th Century Portraits & historical subjects	

MOONY. RBA, Mem.NSA. etc. **Robert James Enraght** b. Ireland. 1879 - ? Tempera, oil & watercolourist Exh: RA, RI, RBA, NEAC, RWA, RBSA, U S. etc.	
FALCON, RBA, MA **Thomas Adolphus** b. Yorkshire. 1872 - ? Landscape artist Exh: London & Prov. AG's	
JONES **Langford** b. London. 1888 - Painter, engraver & sculptor Exh: RA & Prov. AG's etc	
LANCASTER, RI, ARE, RBA, ARCA **Percy** b. Manchester. 1878 - 1951 Landscape artist Exh: RA, London & Prov. AG's	
LEITCH. RI. **William Leighton** b. Glasgow. 1804 - 1883 Landscape artist Exh: RA, BI, SS, NWS. London & Prov. AG's	
LUCAS. RMS, (HS)FRHS, SWA, **UA.** **Suzanne** b. Calcutta. 1915 - Miniatures & watercolours of folowers, animals etc. Exh: RA, PS, RWS,FBS,SWLA,SWA, UA,US, Australia. London AG's	
MOORE. ARWS **Albert Joseph** b. York. 1841 - 1893 Classical figure subjects Exh: RA, OWS, SS, NG, GG. London & Prov. AG's	
PLATT. ARCA **John Edgar** b. Leek. 1886 - Colour woodcut artist & painter Exh: London & Prov. AG's, X	
SIEURAC **Francois Joseph Juste** b. France. 1781 - 1832 Miniaturist Exh: France	
VILLAMENA **Francisco** b. Assisi. 1566 - 1624 Portraits & religious subjects Exh: Italy, Austria	

WORSFOLD **Maud Beatrice** Portrait artist Exh: RA & Prov. AG's		
BORCHT (The Elder) **Hendrik van der** b. Brussels. 1583 - 1660 Still life, religious & historical subjects		
BOYER d'AGUILLES **Jean Baptiste** b. France. 1645 - 1709 Historical subjects		
CANZIANI, RBA, FRGS **Estella L.M.** b. 1887 - Black & white, oil & watercolourist Exh: RA, RSA, RBA, RI & Prov. AG's		
STELLA **Jacques De** b. Lyon. 1596 - 1657 Biblical & historical subjects Exh: France, Italy, Germany, Austria, etc.	★F. ROMÆ	◻FROMÆ
AKEN **Jan van** b. Holland. 1614 - ? Landscape artist		
JONES **Langford** b. London. 1888 - Painter, engraver & sculptor Exh: RA & Prov. AG's etc		
EMSLIE **Alfred Edward** Fl. London late 19th C. Genre oil & watercolourist Exh: RA, SS, OWS, NWS, GG, Paris		
SPITZWEG **Carl** b. Munich. 1808 - 1885 Genre & landscape artist Exh: Germany		
JACQUEMART **Jules Ferdinand** b. Paris. 1837 - 1880 Watercolourist & engraver Exh: France		

820

LEHMANN Wilhelm Auguste Rudolf b. Ottensen. 1819 - 1905 Genre & portrait artist Exh: France, Italy	*1874 ... 18 97*
MENPES. RBA, RPE **Mortimer** b. Australia. 1860 - 1938 Genre & street scenes etc. Exh: RA, NWS, GG, SS, etc.	
MILES **Arthur** Fl. 1851 - 1880 Portraits & genre subjects Exh: NG, UK AG's	*18 57*
MONTMORENCY **Miles Fletcher De** b. Wallington. 1893 - Oil, Pastel & watercolourist Exh: RA, IS, PS, Italy, etc.	*1928*
MORGAN **Alfred** Fl. 1862 - 1902 Floral, genre, animal & landscape subjects Exh: RA, BI, SS, VA	
MURRAY. ARCA **William Grant** b. Portsoy. 1877 - 1950 Oil & watercolourist Exh: London & Prov. AG's	
ALTDORFER **Albrecht** b. Altdorff - Bavaria 1488 - 1538 Mythological, biblical & historical subjects Exh: Germany, France, Austria	
BLONDEEL **Lancelot** b. 1495? - 1581 ? Architectural ruins, conflagrations & religious subjects Exh: Holland, Belgium	
DOSSI **Battista** b. Italy. 1474 ? - 1548 Humourous genre & landscape artist Exh: Italy	
KADISH **Norman Maurice** b. London. 1916 - Portraits, genre, locomotives, still life and marine & religious subjects Exh: RA, ROI, RBA, SEA, London & Prov. AG's etc	

MERRITT **Anna Lee** b. Philadelphia. 1844 - ? Genre & portrait artist Exh: RA, NG, GG, etc.	
MORIN **Edmond** b. France. 1824 - 1882 Portrait & landscape artist Exh: France	
POMEDELLO **Giovanni Maria** b. Italy. 1478 - 1537 ? Historical & genre artist Exh: Italy	
RICHARDSON (The Elder) **Jonathan** b. London. 1665 - 1745 Portrait artist Exh: NPG, VA	
WEST. RWS **Joseph Walter** b. Hull. ? - 1933 Oil & watercolourist Exh: London & Prov. AG's, Paris	
BUSH, ROI **Harry** b. Brighton. 1883 - 1957 Painter in oil media Exh: RA, ROI, RWA, PS, Canada etc	
CHAPMAN **Robert** b. Birmingham. 1933 - Portraits, still life, genre, nudes, landscapes & subjectivism Exh: Belgium, ROI, London & Prov. AG's etc	
HARRISON, RSMA **Ian** b. Staines. 1935 - Portraits & marine subjects. Miniaturist Exh: RMS, London & Prov. AG's	
La FARGUE **Paulus Constantin** b. Hague. 1732 - 1782 Landscape subjects Exh: NG, The Hague, Frankfurt	
PHILLIPS **Walter Joseph** b. Barton-on-Humber. 1884 - Landscape artist Exh: VA, BM, London & Prov. AG's	

RUTLAND (Duchess of) **Violet.** b. Lancashire. 19th C. Sculptor & portrait artist Exh: RA, London & Prov. AG's, France, US		//
SALKELD. ARHA **Cecil Ffrench** b. Assam. 1908 - Tempera, pencil, oil media etc. Exh: London & Prov. AG's, Germany, US, Canada		
UTTER **Andre** b. Paris. 1886 - 1948 Still life, genre & landscape subjects		
WHISTLER. PRBA **James Abbott MacNeill** b. Lowell, US. 1834 - 1903 Genre & portrait artist Exh: RA, SS, London & Prov. AG's, European AG's		
AUSTEN, RI, RE **Winifred Marie Louise** b. Ramsgate. Fl. 19th-20th C. Bird & animal subjects Exh: RA, RI, RE, etc		///
DOUGLAS, PRSA **Sir William Fettes** b. Edinburgh. 1822 - 1891 Interiors, landscapes & historical genre Exh: RA, RSA, London & Prov. AG's		
FRICK, RE, FZS **Winifred Marie Louise** b. Ramsgate Bird & animal subjects Exh: RA, RE, PS, SWA		
SOMM **Francois Clement Sommier** b. Rouen. 1844 - 1907 Genre subjects & caricaturist Exh: France		
BLES **Hendrik de** b. Bovines. 1480 ? - 1550 ? Biblical, historical & landscape artist Exh: Russia & European AG's		
BOTTINI **Georges** b. Paris. 1873 - 1906 Figures, nudes, genre & portrait artist Exh: France		

BUHOT **Felix Hilaire** b. Valognes. 1847 - 1898 Landscape artist Exh: France		
VINCKEBONS **David** b. Belgium. 1576 - 1629 Genre & landscape artist Exh: Holland, Belgium, Germany, France		
CRANACH **Lucas** b. Bavaria. 1472 - 1553 Religious, historical, landscape & portrait artist Exh: Scandinavia, Russia & European AG's		
SCOTT **Gerald** b. Surrey. 1916 - Drawings & sculpture Exh: RA, RWA & Prov. AG's		
FOSSARD **G.F.M. de** FL. 20th C. Oil & watercolourist Exh: UK AG's		
HONDIUS (The Younger) **Hendrik** b. Amsterdam. 1597 ? 1644 ? Portraits, genre & landscape artist		
BRUEGHEL **Jan** b. Brussels. 1568 - 1625 Biblical, landscape & still life subjects Exh: UK & European AG's		
CURMAN **William Alan** b. Milwaukee, US. 1949 - Conceptual subjects Exh: New York, Milwaukee & other US AG's		
FAIRHURST, FRIBA **Harry Smith** b. Blackburn Oil & watercolourist Exh: RA, London & Prov. AG's		

LIMMER **Emil** b. Germany 1854 - ? Genre artist & illustrator Exh: Germany	
McEVOY **Mary** b. UK. Portraits, flower studies & interiors Exh: RA, PS, NEAC	
PEPPERCORN **Arthur Douglas** b. London. 1847 - 1926 Marine & landscape artist Exh: RA, SS, London & Prov. AG's, Holland, Germany	
ROCHEBRUNE **Octave Guillaume De** b. France. 1824 - 1900 Genre subjects Exh: France	
WENDELSTADT **Carl Friedrich** b. Germany. 1786 - 1840 Portrait, genre & landscape artist Exh: Germany	

ILLEGIBLE
& MISLEADING
SIGNATURES

Signatures which are illegible are classified in this section. These have been listed alphabetically under the first positively identifiable letter in the signature. Signatures in which the first three or four letters are legible have not been included as these can easily be found by reference to the first section of the Directory.

Signatures which are misleading in that they do not indicate the true surname of the artist are also listed here and have been indexed alphabetically under the foremost letter of the signature.

Signatures given under the "Unclassified" heading at the end of this section are those which are either portrayed in foreign characters or do not contain an easily recognisable letter for classification. These have been listed alphabetically according to the name of the artist.

ACKROYD **Norman** b. Leeds. 1938– Exh: Switzerland, Holland, S.Africa, US, Austria, London & Prov. AG's	*(signature)*
CANALETTO (or CANAL) **Antonio** b. Venice. 1697 - 1768 Landscapes, architectural & venetian subjects Exh: US, UK & European AG's etc	*A Canal f*
LILLFORD. ARCA, RBA. **Ralph** b. Doncaster. 1932 - Oil & B/white media Exh: London & Prov. AG's	*(signature)*
HEINONEN **Aarre** b. Lahti. 1906 - Oil & watercolourist Exh: Holland, France, Germany etc	*(signature)*
DALI **Salvador** b. Figueras. 1904 - Surrealist Exh: International AG's	*(signature)*
VAN ABBE. ARE, RBA, SGA **Salomon** b. Amsterdam. 1883 - Etcher oil & watercolourist Exh: RA, PS, RHA, RWEA, WAG, S. Africa, etc.	*Abbe*
VALLMITJANA **Abel** b. Barcelona. 1910 - Painter & sculptor Exh: X, UK, Europe, Israel, US	*A de Vallmitjana Abel Vollmitjana*
BLOEMAERT **Abraham** b. Dortrecht. 1564 ? - 1651 Portraits, mythological, genre & historical subjects Exh: UK & European AG's	*Ablo Inven Ablo*
PUJOL **Alexandre Denis Abel De** b. France. 1787 - 1861 Bibical & historical subjects Exh: France	*Abel de Pujol*
BLOEMAËRT **Adriën** b. Utrecht. 1609 - 1666 Landscape artist Exh: Holland, Russia etc	*A Bloemaert*

CARRACCI **Annibale** b. Italy. 1560 - 1609 Portrait, religious, mythological, genre & landscape artist Exh: UK & European AG's	A CAR BON 1587
MENZEL **Adolf Friedrich Erdmann** b. Germany. 1815 - 1905 Genre subjects Exh: Germany, Russia	*A. Menzl*
AACHEN (or Ach) **Johann von** b. Cologne. 1552–1616 Religious & mythological subjects Exh: London & European galleries	*ACH.*
GIESS **Jules Alfred** b. France. 1901 - Exh: Italy, France	*A GIESS*
ALKEN **Henry** b. London. 1784 - 1851 Hunting & sporting subjects Exh: RA & Prov. AG's	*H. acker*
LEEUW **Alexis De** Fl. 19th C. Landscape artist	*A. de Leeuw.*
NEUVILLE **Alphonse Marie De** b. France. 1835 - 1885 Battle scenes & genre subjects Exh: France, New York	*A De Neuville*
REDON **Odilon** b. Bordeaux. 1840 - 1916 Genre, portraits & still life subjects Exh: France, US, Holland	*odilon redon*
OFFICER. BA, MA, FRSA, ATD **David Adrian** b. Belfast Exh: RA, RI, France, S. Africa, Canada, Australia, US, etc.	*adrian*
FURSE **Roger Kemble** b. Kent. 1903 - Oil, gouache & watercolourist Exh: Paris, London & Prov. AG's X	*r. furse*

CARRACCI **Agostino** b. Italy. 1557 - 1602 Portrait, religious & landscape artist Exh: UK, Germany, France, Italy, Austria etc	*Agostino*
LA PATELLIERE **Amedee Marie Dominique Dubois De** b. Nantes. 1890 - 1932 Portrait & rurul subjects Exh: France	*A de la Patelliere*
STANILAND. FRSA, LRCP, MRCS **Bernard Gareth** b. Canterbury. 1900 - Sculptor, oil & watercolourist Exh: London & Prov. AG's	*B Staniland*
LAITILA **Atte** b. Finland. 1893 - Oil, pastel & watercolourist Exh: Russia, Scandinavia & European AG's	*Laitila*
GRAFF (or GRAF) **Antoine** b. 1736 - 1813 Portrait artist & miniaturist Exh: France, Germany	*A graff pinx*
KUMLEIN **Akke** b. Stockholm. 1884 - 1949 Oil & tempera media Exh: London & Stockholm	*akke Kumlien*
LAURŒUS **Alexander** b. Denmark. 1783 - 1823 Interior & family scenes Exh: Sweden, Helsinki	*A Laureus*
CANO **Alonso** b. Grenada. 1601 - 1667 Portraits, biblical & historical subjects Exh: Germany, Hungary, Russia, Spain etc	*ALCA*
WILES. LSIA **E. Alec** b. Southampton. 1924 - Portrait, marine & landscape artist Exh: RA, RP, RBA, SGA, Prov. AG's	*alec*
LE BOURG **Albert Charles** b. France. 1849 - 1928 Landscape artist Exh: France, Bucharest	*A. Lebourg*

VAROTARI **Alessandro** b. Padua. 1588 - 1648 Portraits & historical subjects Exh: Italy, Germany, Hungary, Spain, Austria, etc.	*Alex° Varot°*
LASTMAN **Pieter Pietersz** b. Amsterdam. 1583 - 1633 Religious & mythological subjects Exh: Holland, Germany	*Pasiman fecit.* *1614*
GWYNNE-JONES, DSO, ARA **Allan** b. London. 1894 - Exh: London & Prov. AG's, France	*Allan Gwynne Jones*
HALLIDAY **Michael Frederick** b. 1822 - 1869 Genre, portrait & landscape artist Exh: RA, NPG	*Halliday*
ALLORI **Angiolo (called il Bronzino)** b. Montecelli 1502 - 1572 Portraits & historical subjects	*All Br*
MICHELANGELO (BUONARROTI) b. Italy. 1475 - 1564 Portraits, mythological & religious subjects etc. Exh: International AG's	AMaBOaRO.
KENNEDY **Alexander Grieve** b. Liverpool. 1889 - Exh: London & Prov. AG's	"A MACULRIC"
BORGOGNONE (known as Ambrogio **Ambrogio da Fossano)** b. Milan. 1455 - 1523 Biblical & historical subjects Exh: Germany, Italy, France, UK etc	*Ambrosio* *Bgogon*
CAMPI **Antonio** b. Cremona. 1536 ? - 1591 ? Historical & mythological subjects etc.	AN CAM. 1583. ATCA
MANTEGNA **Andrea** b. Italy. 1431 - 1506 Religious, historical & mythological subjects Exh: Italy, France, UK, Spain, Germany, etc.	*Andreas Mantinia C·P·F*

BIELER, LLD, RCA, OSA, CGP, FCA **Andre** b. Lausanne. 1896 - Painter & sculptor Exh: Canada, US & European AG's	*André Bieler*
d'AGNOLO **Andrea (called Andrea del Sarto)** b. Florence. 1487 - 1531 Portraits, biblical & historical subjects	AND. SAR . FLO FAC
YEOMAN. FSIA **Antonia** b. Australia. 1913 - Pen/ink & watercolourist Exh: RSA, SGA, London & Prov. AG's	*Anton*
TOUCHAGUES **Louis** b. France. 1893 - Portraits, genre subjects & illustrator Exh: France, UK	*Touchagues*
BESNARD **Paul Albert** b. Paris. 1849 - 1934 Portrait & figure artist Exh: US & European AG's	*Besnard*
AVED **Jacques Andre Joseph** b. Douai 1702 - 1766 Portrait artist Exh: Holland, France	AED
RUTHERSTON. Hon.MA., RWS **Albert Daniel** b. Bradford. 1881 - 1953 Figure & landscape artist Exh: NEAC, RI, France, Italy, S. America, etc.	*A Rutherston R*
HACKNEY, RWS, RE, ARCA **Arthur** b. Yorkshire. 1925 - Oil & watercolourist Exh: RA, RE, RWS	*Arthur Hackney*
DAVIES, RBA, RCA **Arthur Edward** b. Cardiganshire. 1893 - B/White, oil & watercolourist Exh: RA, RSA, RWA, France & Prov. AG's	*Arthur Edward*
WYNEN **Dominicus Van** b. Amsterdam. 1661 - 1690 ? Imaginative & genre subjects	*ASCANIUS*

OSTERLIND Anders b. France. 1887 - 1960 Landscape artist Exh: France, Belgium, Holland	
BROUILLET Pierre Andre b. Austria. 1857 - 1920 Genre artist Exh: France	
HAUGHTON, PRUA, FRSA, **Wilfred James** **FIAL, RUA** b. Hillmount. 1921 - Oil & watercolourist Exh: RHA, RUA, RI etc	
RAVIER Auguste Francois b. Lyon. 1814 - 1895 Landscape artist Exh: France	
WILLAERTS Abraham b. Utrecht. 1603 ? - 1669 Marine, portrait & genre subjects Exh: Holland, Germany, France, UK	
BROUGHTON, SWA Aya b. Kyoto, Japan Oil & watercolourist Exh: RA, WIAC, NS, RBA, RI, ROI, PS etc	
BAJ Enrico b. Milan 1924 - Painter in collage Exh: USA, London, Holland, France etc	
BISCAINO Bartolommeo b. 1632 - 1657 Biblical & historical subjects Exh: Italy, Germany	
BACKER Jacob Adriaensz b. Holland 1608 - 1651 Historical & Portrait artist Exh: Holland, Germany	
BEAMAN Richard Bancroft b. US. 1909 - Painter & sculptor Exh: US, X.	

MURILLO **Bartolome Esteban** b. Spain. 1617 ? - 1682 Religious, genre & portrait artist Exh: International AG's	*BAR͞Ṭ꞊M͞VRI LLO* *en sevilla año do 1670꞊* *B͞n M͞C Hisp.*
TISIO **Benvenuto Da Garofalo** b. Garofalo. 1481 - 1559 Historical, mythological subjects Exh: European AG's, Russia, etc.	*B. Garofolo*
GILLIGAN **Barbara** b. London. 1913 - Painter in oil media Exh: London & Prov. AG's	*Barbara Gilligan*
GALLI (called BIBIENA) **Ferdinando** b. Bologna. 1657 - 1743 Decorations & architechtural subjects	*Bibiena*
CARPEAUX **Jean Baptiste** b. France. 1827 - 1875 Portrait & genre artist Exh: France, Germany etc	*B͞ᵗ Carpeaux*
BELIN **Jean** b. Caen. 1653 - 1715 Still life subjects. Exh: France	*Bef*
MESHAM **Isabel Beatrice** b. Eire. 1896 - Etcher, oil & aquatint media Exh: RA, PS, London AG's	*J B. Mesham*
BOBA **George** b. Riems. 1550 ? - ? Portrait artist Exh: France	*BOB BOB. BOB*
BOUHOT **Etienne** b. France. 1780 - 1862 Town views & architectural subjects Exh: France	*Bouhot.* *1840*
BOS (or BOSCHE) **Jerome** b. Bois-le-Duc. 1450 ? - 1516 Biblical & bizarre subjects Exh: Russia, US & European AG's	*Boɫche boschs k*

BRIGGS, FIBP, FRPS **William George** b. London. 1888 - Painter in oil media Exh: ROI, London & Prov. AG's	
BRENET **Nicolas Guy** b. Paris. 1728 - 1792 Biblical, mythological & historical subjects Exh: France	
BOLDINI **Jean** b. Italy. 1845 - 1931 Genre & portrait artist Exh: UK & European AG's	
CIGNANI **Carlo** b. Italy. 1628 - 1719 Biblical & historical subjects etc Exh: UK & European AG's	
DILLIS **Cantius von** b. Germany. 1779 - 1856 Landscape artist Exh: Germany	
CALIARI **Carlo** b. Venice. 1570 - 1596 Portrait, biblical & historical subjects. Exh: France, Belgium, Italy etc	
CARRENO de MIRANDA **Don Juan** b. Spain. 1614 - 1685 Portraits & historical subjects Exh: Spain	
CRIVELLI **Carlo** b. Venice. 1435 ? - 1494 ? Religious subjects Exh: Germany, US, UK, Belgium, Hungary etc	
CALLCOTT, RA **Sir Augustus Wall** b. London. 1779 - 1844 Portraits, historical, marine & land- scape artist Exh: RA, UK AG's, Germany etc	
CAVEDONE **Giacomo** b. Sassuolo. 1577 - 1660 Portraits, religious & historical subjects. Exh: France, Italy, Russia, Germany	

COUVE DE MURVILLE-DESENNE, FIL, FIAL **Lucie-Renee** b. Madagascar. 1920 - Portrait, floral & marine subjects Exh: RWA, London & prov. AG's	
OHL **Gabrielle** b. Madagascar. 1928 Black & white & oil media Exh: French AG's, UK, Belgium, Italy etc.	
BENNER **Emmanuel** b. France. 1836 - 1896 Portraits, still life, genre & landscape artist Exh: France, Holland, Switzerland	
BLEKER (BLECKER or BLICKER) **Gerrit Claesz** b. Haarlem. ? - 1656. Religious & landscape artist Exh: Holland, Austria, Hungary etc	
DESENNE, FIAL **Lucie Renee** b. Madagascar. 1920 - Portrait & marine subjects Exh: RWA, London & Prov. AG's	
DOV (or DOU) **Gerrit** b. Leyden. 1613 - 1675 Genre & portrait artist Exh: Russia & European AG's	
AIGUIER **Louis Auguste Laurent** b. Toulon. 1819 - 1865 Landscape artist Exh: European AG's	
KEATING, RHA **John** b. Limerick. 1889 - Oil & watercolourist Exh: London & Prov. AG's, X	
HECHT, MFPS, NS **Godfrey** b. London. 1902 - Gouache, ink & oil media etc Exh: ROI, NS, SGA, & Prov. AG's	
SACCHI **Carlo** b. Pavia. 1616 - 1706 Historical subjects	

GUERCINO Giovanni Francesco Barbieri b. Italy. 1591 - 1666 Portraits, religious, historical & landscape artist Exh: Russia, European AG's etc	*Gⁿᵒ da Cento. Fⁿᵒ Du Cento.* *CFᵗCentˢ CFcntⁱˢ.*
CHANNING-RENTON Capt. Ernest Matthew b. Plymouth. 1895 - Painter of landscapes, battle scenes etc Exh: RSBA & Int. AG's	*Channing.*
BROWNE, Hon. Mem. SAF Charles Egerton b. London. 1910 - Animals, figurative subjects & sculpture Exh: PS, LAS, SWLA, RBA, USA, NEAC, London & Prov. AG's	*Chas E. Browne.*
EYLES Charles b. London. 1851 - ? Landscape artist Exh: RA, RBA, RI	*Chas. Eyles*
COLLANTES Francisco b. Madrid. 1599 - 1656 Landscapes, Historical & floral subjects Exh: France	*Col- Col*
GELLEE (or LORRAINE) Claude b. France. 1600 - 1682 Marine & landscape artist Exh: UK & European AG's, Russia	*CLAVDIO. G.I.V. ROMÆ 1644* *CLAVDIO IN ROMÆ 1639 claudio f*
LEIGHTON Clare b. London. 1901 - Painter & wood engraver Exh: RA, NEAC, Venice etc.	*Clare Leighton*
LIEVENS (The Younger) Jan Andrees b. Antwerp. 1644 - ? Genre & historical works Exh: Amsterdam	*CA Lievens*
MARSHALL. ARMS Clemency Christian Sinclair b. Fife. 1900 - Miniaturist. B/white, oil & watercolourist Exh: RA, PS, etc.	*Clemency Marshall.*

NANTEUL-LEBŒUF **Celestin Francois** b. Rome. 1813 - 1873 Genre subjects - illustrator Exh: France	
HAERLEM (called CORNELISZ) **Cornelis van** b. Haarlem. 1562 - 1638 Biblical & historical subjects	
SOULAGES **Pierre Jean Louis** b. Rodez, France. 1919 - Oil & watercolourist Exh: Germany, Holland, Hungary, Scandinavia, US, S. America, etc.	
CUNINGHAM **Oswald Hamilton** b. Newry, Ireland. 1883 - Oil & watercolourist Exh: RA, RHA, PS	
VAROTARI **Dario** b. Verona. 1539 - 1596 Religious subjects Exh: Italy	
MILLS **David** b. Colchester. 1947 - Subtle kinetics, abstract subjects etc. Exh: London & Prov. AG's	
PRATT. Mem.SWLA, FOBA **David Ellis** b. Kobe, Japan. 1911 - Portrait, marine, abstract, animal, nature & landscape artist Exh: London & Prov. AG's	
FOGGIE, ARSA, RSW **David** b. Dundee. 1878 - 1948 Portrait & figure artist Exh: RA, London & Prov. AG's, Germany	
VINCKEBONS **David** b. Belgium. 1576 - 1629 Genre & landscape artist Exh: Holland, Belgium, Germany, France	
DESCOURS **Michel Hubert** b. Bernay. 1717 - 1775 Portraits & religious subjects Exh: France etc	

BEJOT **Eugene** b. Paris. 1867 - 1931 Landscape subjects etc. Exh: London, Paris	
NITTIS **Giuseppe de** b. Italy. 1846 - 1884 Genre subjects Exh: France	
MATHEWS **Denis** b. London. 1913 - Oil & watercolourist Exh: London & Prov. AG's	
DURRANT, NDD, FRSA **Roy Turner** b. 1925 - Oil, gouache & watercolourist Exh: RA, London & Prov. AG's	
DIGNIMONT **Andre** b Paris. 1891 - 1965 Portrait, figure & genre subjects Exh: France	
SOUTHALL **Derek** b. Coventry. 1930 - Exh: London & Prov. AG's, Austria, Germany, etc.	
CAMPAGNOLA **Domenico** b. Padua. 1484 - 1550 Mythological, historical & landscape artist	
CATON-WOODVILLE **Dorothy Priestley** b. Chislehurst. 19th - 20th C. Watercolourist of portraits & miniatures Exh: RA, PS, RMS, US	
DUFRENOY **Georges Leon** b. France. 1870 - 1942 Figure & landscape artist Exh: Belgium, France	
TOL **Dominicus Van** b. 1635 ? - 1676 Genre, interiors & portrait artist Exh: Holland, Germany, France, Russia, US, etc.	

DAGNAN-BOUVERET **Pascal Adolphe Jean** b. Paris. 1852 - 1929 Mythological, genre & portrait artist Exh: France, Italy, Germany, Russia etc	
LEBASQUE **Henri** b. France. 1865 - 1937 Genre & scenic subjects Exh: France, PS	
DUEZ **Ernest Ange** b. Paris. 1843 - 1896 Portrait, genre & landscape artist Exh: France, Germany, US	
LEECH. RHA. **William John** b. Dublin. 1881 - Genre, portrait & landscape artist Exh: PS, Ireland, etc.	
ZELLER **Georg Eugen** b. Zurich. 1889 - Pencil & oil media Exh: Switzerland	
WAUTERS **Jef** b. Belgium. 1927 - Painter in oils	
WILLIAMS **Idris Elgina** b. 1918 - Painter in oil & pastel media, etcher Exh: London & Prov. AG's	
EISEN **Charles Dominique Joseph** b. Valenciennes. 1720 - 1778 Genre subjects etc Exh: European AG's	
DONNE, NDD, ATD, FRSA, SG **Peter Ivan** b. India. 1927 - Landscapes, oil, acrylic & watercolour, drawings, etc. Exh: London & Prov. AG's	
DEMEL **Richard** b. Poland. 1921 - Engraver, oil & b/white media Exh: RBA, London & Prov & Italian AG's	

TINDALL. RBA **William Edwin** b. Scarborough. 1863 - ? Landscape artist Exh: RA, London & Prov. AG's	*!!! Edwin Tindall*
MARSAL **Edovard Antoine** b. Montpellier. 1845 - ? Historical & genre subjects Exh: France	*E Marsal*
ELWES **Simon** b. Rugby. 1902 - Portrait artist Exh: RA, London & Prov. AG's France	*Simon Elwes*
HEIM **Francois Joseph** b. France. 1787 - 1865 Portraits & historical paintings Exh: France	*Heim*
DINKEL, ARWS, ARCA **Ernest Michael** b. Huddersfield. 1894 - Oil, tempera & watercolourist Exh: RA, NEAC, R. Scot. A, RWS	*Ern Dinkel*
BURWELL **William Ernst** b. Kingston-on-Hull. 1911 - Oil & watercolourist Exh: RA, RI, NEAC, RHA, PS & Prov. AG's	*Ernst Burwell*
PERGAUT (or PERGAULT) **Dominique** b. France. 1729 - 1808 Historical, still life & landscape subjects Exh: France	*Pergaut*
GEORGHIOU **George Pol** b. Cyprus. 1901 - Painter in oil media Exh: London, Paris, Milan, Basle, Nicosia etc	*Geo Pol 51*
PETITJEAN **Edmond Marie** b. France. 1844 - 1925 Landscape artist Exh: France	*E. Petitjean*
GLEIZES **Albert** b. Paris. 1881 - 1953 Cubist & abstract subjects Exh: France	*Alb Gleizes*

PERMEKE **Constant** b. Antwerp. 1886 - 1951 Interiors, figures, marine & landscape artist	*Permeke* *28*
STUVEN **Ernst** b. Hamburg. 1660 - 1712 Still life & floral subjects Exh: Germany	*Ernst Stuwen L*
HARPER, RBSA, Hon.Sec.RSA **Edward S.** b. 1854 - ? Portrait & figure artist Exh: RA & Prov. AG's	*ESPER*
FELS **Elias** b. 1614 - 1655 Portraits & historical subjects	*E Te ls*
SPIRO **Eugen** b. Germany. 1874 - ? Still life, portrait, genre & landscape subjects Exh: Germany	*Eugen Spuo*
WILLIAMS **Edward Charles** b. 1807 - 1881 Landscape & coastal subjects Exh: RA, SS, BI, & Prov. AG's	*EW ms*
JAENISCH **Hans** b. Eilenstedt. 1907 - Exh: France, Germany, US, etc	*jae*
MARINUS **Ferdinand Joseph Bernard** b. Antwerp. 1808 - 1890 Marine, genre & landscape artist Exh: Belgium, Germany	*F. Marinus*
RILEY. FRSA **Frank W.** b. London. 1922 - Portraits, still life & landscape artist Exh: RA, London AG's	*Frank*
FANTIN-LATOUR **Ignace Henri Jean Theodore** b. Grenoble. 1836 - 1904 Still life, historical, genre & figure artist Exh: France, Germany, Belgium, Italy, UK etc	*Fantin 58*

BRANGWYN, ARA, RA, RE, Hon. Mem. RSA, RMS, PSCA, VP, IAL, RWA & Int. Soc.s **Sir Frank William** b. Bruges. 1867 - 1956 Architectural, bridge & river scenes marine subjects etc. Exh: RA.RSA,WAG,GI,RWS, GG, etc	
BYLERT **Jan van** b. Utrecht. 1603 - 1671 Portraits, historical & genre subjects Exh: Holland, Germany, Hungary, France, UK etc	
FORTUNY Y CARBO **Mariano** b. Reus. 1838 - 1874 Genre & historical subjects Exh: Spain, Denmark, Germany, Italy, US, S. America etc	
BAROCCI (also called FIORI) **Frederigo** b. Urbino 1526 - 1612 Portraits, religious & historical subjects Exh: Belgium, Russia, Hungary, Germany, France etc	
FLORIS **Frans 1** b. Anvers. 1516 - 1570 Portraits & historical subjects etc Exh: Germany, Italy, France, UK, Sweden etc	
AHLERS-HESTERMANN **Frederich** b. Hamburg. 1883 - Pastel & oil media Exh: Berlin, Munich, Paris etc.	
CRABBELS **Florent Nicolas** b. Anvers. 1829 - 1896 Landscape artist Exh: Canada, Belgium	
MARCHAND **Jean Hippolyte** b. Paris. 1883 - 1940 Genre, landscapes & illustrator Exh: France, London, US, Tokyo, Geneva, Berlin	
MOLENAER **Jan Miense** b. Haarlem. 1610 ? - 1668 Rustic genre & landscape artist Exh: European AG's	
SOUKENS **Jan** Fl. Holland. 1678 - 1725 Genre & landscape subjects	

FRAGONARD **Jean Honore** b. Grasse. 1732 - 1806 Portrait, figure, genre & landscape subjects etc Exh: UK & European AG's	*Frago.*
FOSSARD **G.F.M. de** FL. 20th C. Oil & watercolourist Exh: UK AG's	*de Fossard*
SEGHERS **Francois** b. Brussels. 1849 - ? Floral artist Exh: Belgium	*Franchoissighers fecit*
DEHN FULLER, FFPS, WIAC, NS **Cynthia** b. Portsmouth Artist in oils & gouache media Exh: London, Europe & Australia	*Francyn.*
FRANQUE **Jean Pierre** b. France. 1774 - 1860 Biblical & historical subjects Exh: France	*P franque.*
FREMINET **Martin** b. Paris. 1567 - 1619 Portraits & historical subjects etc Exh: France	*MFre*
STEELE **Jeffrey** b. Cardiff. 1931 - Systematic constructivist Exh: UK, US, France, Holland, Switzerland, etc.	*Jeffrey Steele*
RHEIN **Fritz** b. Germany. 1873 - ? Portrait, still life & landscape subjects Exh: Germany	*Fritz Rhein*
FRONTIER **Jean Charles** b. Paris. 1701 - 1763 Biblical & mythological subjects Exh: France	*Froutier.*
THAULOW **Fritz** b. Norway. 1847 - 1906 Genre & landscape artist Exh: France, Germany, US, Sweden	*Frits Thaulow*

RICCHINO Francesco b. Italy. 1518 ? - 1568 ?	*F. Rizi*
OUWERKERK Timotheus Wilhelmus b. Holland. 1845 - 1910 Landscape artist Exh: Holland	*F W Ouwerkerk*
GRIMM, ROI, RP, PNS, etc Stanley A. b. London. 1891 - Portrait, figure & landscape artist Exh: RA, RP, ROI, NS, Prov. AG's, Europe, Russia, US	*[signatures]*
DAKEYNE Gabriel b. Yorkshire. 1916 - Portrait, marine, still life, landscapes etc. Exh: RA, RWS, SWA, RWEA, PS, London & Prov. AG's etc	*Gabriel Dakeyne*
CIPRIANI Giovanni Battista b. Florence. 1727 - 1785 Portraits, religious & historical subjects Exh: UK, Italy, France	*GBª cipr.*
CAMPHUYSEN Govert Dircksz b. Holland. 1624 ? - 1672 Portrait, figure, animal & genre artist Exh: Holland, Germany, France, UK etc	*Cj Camphuijsen tot Amsterdam*
GAVARNI Sulpice Guillaume Chevalier b. Paris. 1804 - 1866 Watercolourist, gouache media etc Exh: European AG's	*Gavarni*
DEAKINS George Richard b. Gosport, 1911 - Varied subjects. Oil, gouache etc Exh: PS, RSA, London & Prov. AG's. Europe, US etc	*GEORGES*
BERCK-HEYDE Gerard b. Haarlem. 1638 - 1698 Landscapes & architectural subjects Exh: France, Italy, Germany, Holland, Austria etc	*Gerrit Berck. 1676*
CRETI Donato b. Italy. 1671 - 1749 Historical subjects Exh: Italy	*Creti - D -*

VASARI **Giorgio** b. Italy. 1511 - 1574 Religious subjects Exh: Italy, France, Germany, Austria	GEORG.ARRET.
GUEST **George** b. Rotherham. 1939 - Portrait, interior, landscape figurative oil & watercolourist Exh: RWS, London & Prov. AG's, US, Australia, Dublin etc	*G Guest*
DAVIS **George Horace** b. London. 1881 - Military subjects Exh: RA, & European AG's	G.H.DAVIS.
GIRODET de ROUCY TRIOSON **Anne Louis** b. France. 1767 - 1824 Historical subjects, portraits etc Exh: France, Belgium, Switzerland	*Girodet a Rome 1791*
OS **Pieter Gerardus Van** b. The Hague. 1776 - 1839 Animals, landscapes & miniaturist Exh: Holland	*G.H.Os*
LAIRESSE **Gerard de** b. Liege. 1641 - 1711 Historical & portrait artist Exh: France, Germany, Holland	*G. Laire*
MAINWARING **Geoffrey Richard** b. Australia. 1912 - Pastel, gouache, pen & wash, oil & watercolour media etc. Exh: Australian AG's	*G Mainwaring 1953*
GOLTZIUS **Hendrik** b. Mulbrecht. 1558 - 1616 Historical & mythological subjects etc Exh: Holland, Germany, Russia, France, Austria etc	M GoL-s M.GoL:s
GROS **Antoine Jean (Baron)** b. Paris. 1771 - 1835 Historical & mythological subjects Exh: France, Switzerland, UK etc	*Gros.*
FLAD **Georg** b. Heidelberg. 1853 - 1913 Landscape artist Exh: Germany	*G Flad.*

MAYER-MARTON. AM, OLB, ACM HCM. **George** b. Hungary. 1897 - Fresco, oil & watercolourist etc. Exh: Hungary, France, Germany, Belgium, UK, etc;	
THOMA **Hans** b. Germany. 1839 - 1924 Religious, portrait, genre & landscape subjects Exh: Germany, US, Sweden, Austria, etc.	
VERBRUGGE **Jean Charles** b. Bruges 1756 - 1831 Interior scenes & landscapes Exh: Holland	
HACCURIA **Maurice** b. Goyer. 1919 - Exh: Holland, Belgium, France, Italy, Germany	
HAMILTON **Eleanor G** Watercolourist Exh: RA, SWA, WIAC, RHA, PS, US etc	
SARGENT **John Singer** b. Florence. 1856 - 1925 Portrait & genre artist Exh: RA, RI, RSA, UK, US, Paris	
CARRACCI **Annibale** b. Italy. 1560 - 1609 Portrait, religious, mythological, genre & landscape artist Exh: UK & European AG's	
HOLBEIN (The Younger) **Hans** b. Augsbourg 1497 ? - 1543 Portraits & historical subjects Exh: France, Switzerland, UK, Spain, Belgium etc	
DENIS **Maurice** b. France. 1870 - 1943 Religious, figure, genre & landscapes etc Exh: France, Belgium, Italy	
STUBENRAUCH **Hans** b. Germany. 1875 - ? Painter & illustrator	

WEBSTER **Herman Armour** b. New York. 1878 - Landscape artist Exh: US, Germany, Italy, France, UK	
HUGTENBURG **(or HUCHTENBURGH)** **Jacob van** b. Haarlem. 1639 - 1675 Landscape artist	
BLES **Hendrik de** b. Bovines. 1480 ? - 1550 ? Biblical, historical & landscape artist Exh: Russia & European AG's	
CORTE **Juan de la** b. Madrid. 1597 - 1660 Portraits, battle scenes & historical subjects	
YATES. RI **Hal** b. Manchester. 1907 - Landscapes etc., watercolourist Exh: RA, RI, RWS, USA, NOAS, RBA, RSA, MAFA	
MOCETTO **Girolamo** b. Verona. 1458 ? - 1531 ? Portraits, religious & historical scenes Exh: UK, France, Italy	
PEACOCK. Mem. USA **Herbert L.** b. Norfolk. 1910 - Architectural & landscape subjects & miniaturist Exh: USA, NS, NEAC, RI, RMS, PAS, RWEA, PS, etc.	
HEGEDUS **Laszlo** b; Budapest. 1920 - Graphic art, oil & watercolourist Exh: London, Budapest, X Hungary, Australia etc	
PILGRIM **Herbert Francis** b. London. 1915 - Animal studies etc. Exh: London & Prov. AG's	
GRAVELOT **Hubert Francois Bourguignon** b. Paris. 1699 - 1773 Portrait, genre & historical subjects etc. Exh: UK, France	

SHIELS **Anthony Nicol** b. Salford. 1938 - Painter in oil & gouache media Exh: London & Prov. AG's	
LANOUE **Felix Hippolyte** b. Versailles. 1812 - 1872 Landscape artist Exh: France	
STUART-BROWN **Henry James** b. Bathgate. 1871 - ? Etcher, oil & watercolourist Exh: RA, RSA, London & Prov. AG's, Australia etc.	
SAMACHINI **Orazio** b. Bologna. 1532 - 1577 Religious subjects Exh: Italy	
RIGAUD **Hyacinthe Francois Honore** b. France. 1659 - 1743 Portraits & historical subjects Exh: France, UK, Germany, etc.	
RIPSZAM **Henrik** b. Hungary. 1889 - Pastel, oil & watercolour media etc. Exh: France, Hungary, UK, Tokyo, S. America, etc.	
SPILMAN **Hendrik** b. Amsterdam. 1721 - 1784 Portraits & landscape artist Exh: Holland	
HUNDERTWASSER **Friedrich** b. Vienna. 1928 - Oil, tempera & watercolourist Exh: Italy, France, Japan, Germany, Switzerland, Holland, London etc	
CRUIKSHANK **George** b. London. 1792 - 1878 Humourous & historical subjects Exh: London & Prov. AG's	
HURSMANS **Cornelis** b. Antwerp. 1648 - 1727 Landscape painter Exh: Belgium, Germany, France, London.	

ANTHONISSEN **Hendrick van** b. Anvers 1606 - 1660 Marine and landscape subjects Exh: Holland, Germany, UK etc	*H.V.ANT.*
STEENWYCK (The Younger) **Hendrik Van** b. Amsterdam. 1580 ? - 1649 Historical, architectural & interior scenes Exh: UK, Russia & European AG's	H.V.STEIN.1642
SIMA **Miron** b. Russia. 1902 - Oil & gouache media etc. Exh: Germany, Israel, France, S. Africa, US	*Miyl Oily*
MUSPRATT **Alicia Frances** b. Lancashire Exh: RA, PS, ROI, RBA, SWA, RP etc.	*Alicia F. Muspratt.*
FIDLER, ARCA **Constance Louise** b. England. 1904 - Portrait artist Exh: RBA, NEAC, & Prov. AG's	*Fidler*
DUCQ **Jan le** b. The Hague. 1630 ? - 1676 Genre, military, animals & landscape artist Exh: France, Austria, UK etc	J Duc
BARNES **Alfred Richard Innott** B. London 1899 - Painter in oil media Exh: RA, ROI, USA, RI, etc	INNOTT
NOLLEKENS **Joseph Frans** b. Antwerp. 1702 - 1748 Portrait, genre & landscape artist Exh: Switzerland	J:NolS.F Inols
FRASER **Donald Hamilton** b. London. 1929 - Painter in oils Exh: European & US.AG's	Fraser
TROKES **Heinz** b. Duisberg. 1913 - Exh: Italy, Japan, Germany, US, France, Spain, etc.	Trökes 64

CESARI **Giuseppe** b. Rome. 1560 ? - 1640 Religious & historical subjects Exh: France, Hungary, Germany, Italy, UK etc	Φ PIN.
PORCELLIS **Julius** b. Holland. 1609 ? - 1645 Marine artist Exh: Holland, Germany, France	I. PON
MOSSCHER **Jacob De** Fl. Holland. 16th - 17th C. Landscape artist Exh: Germany, Copenhagen	Jvan moscher
SIMON **Johanan** b. Berlin. 1905 - Painter in oil media Exh: France, Israel Italy, S. Africa, US, etc.	יוחנן סימון
TAILLASSON **Jean Joseph** b. Bordeaux. 1745 - 1809 Historical & genre subjects Exh: France	Taillasson JJ.
COOK **Aynsley James** b. London. 1934 - Wild life artist Exh: SWLA, London & Prov. AG's Norway	James Aynsley. ?
HEYDEN (or HEYDE) **Jan van der** b. 1637 - 1712 Still life, genre & landscape artist Exh: UK, Russia & European AG's	Jan van der Heyden JvdHeyde.
VAERTEN **Joannes Cornelius Maria** b. Belgium. 1909 - Tempera, oil & watercolour media Exh: European AG's	Janvaerten
MONNOYER **Jean Baptiste** b. Lille. 1636 - 1699 Floral subjects Exh: European AG's	J:Baptiste J.Baptiste

COOSEMANS **Joseph Theodore** b. Brussels. 1828 - 1904 Landscape artist Exh: Belgium, France	
JONES, Ass. Mem. SAF **Thomas Dempster** b. N. Wales. 1914 - Portrait, equestrian & landscape artist Exh: RA, PS, RBA, RI, USA, R.CamA US, London & Prov. AG's etc	
DOES (The Younger) **Jacob van der** b. Amsterdam. 1654 - 1699 Figures, animals, landscapes & historical subjects	
GIGOUX **Jean Francois** b. Besancon. 1806 - 1894 Portraits, genre & historical subjects Exh: France	
DEDINA **Jean** b. Czeckoslavakia. 1870 - ? Genre & portrait artist Exh: Paris, Prague	
HEEM **Jan Davidsz de** b. Utrecht. 1606 - 1684 Floral & still life subjects Exh: Russia, Scandinavia, UK & European AG's	
MAPP. ARCA **John Ernest** b. Northampton. 1926 - Oil & watercolourist Exh: RA, London & Prov. AG's	
PILS **Isidore Alexandre Augustin** b. Paris. 1813 - 1875 Historical & genre subjects Exh: France, UK, Belgium	
ROBERTSON **Janet Elspeth** b. 1896 - Watercolourist Exh: London & Prov. AG's, France, Canada, US, etc.	
OS **Pieter Gerardus Van** b. The Hague. 1776 - 1839 Animals, landscapes & miniaturist Exh: Holland	

SUCHET **Joseph Francois** b. Marseille. 1824 - 1896 Marine artist Exh: France	
JORDAENS **Jacob** b. Antwerp. 1593 - 1678 Portraits, historical & mythological subjects Exh: France, Holland, Germany, Italy etc	
HELST **Bartholomeus van der** b. Haarlem. 1613 - 1670 Portrait artist Exh: Russia, UK & European AG's	
PLATT. ARCA **John Edgar** b. Leek. 1886 - Colour woodcut artist & painter Exh: London & Prov. AG's, X	
CARTER **John** b. London. 1910 - Landscape artist Exh: RIBA, RI & UK AG's	
CESARI **Giuseppe** b. Rome. 1560 ? - 1640 Religious & historical subjects Exh: France, Hungary, Germany, Italy, UK etc	
PARROCEL **Joseph** b. Provence. 1646 - 1704 Battle scenes & historical subjects Exh: UK, France, Italy, Spain, etc.	
WIT **Jacob De** b. Amsterdam. 1695 - 1754 Mythological, genre, portraits & historical subjects Exh: Holland, germany, France, Russia, Belgium	
ATHERTON **John Smith** Oil & watercolourist Exh: RA, RSA, RI, RWA, GI, etc.	
RIDDEL. ARSA, RSW **James** b. Glasgow. ? - 1928 Portrait, genre & landscape artist Exh: RA, RSA, & Prov. AG's	

KRUSEMAN **Jan Adam Janszoon** b. Haarlem. 1804 - 1862 Portrait artist Exh: Holland, Germany	
SONJE **Jan Gabriel** b. Delft. 1625 ? - 1707 Landscape artist Exh: Germany, Holland, France	
TISSOT **James Jacques Joseph** b. Nantes. 1836 - 1902 Religious, historical & genre subjects Exh: PS, RA, SS, GG, Prov. AG's, Belgium, France	
STEEN **Jan Havicksz** b. Leyden. 1626 - 1679 Genre, tavern scenes etc. Exh: International AG's	
INGRES **Jean Auguste Dominique** b. France. 1780 - 1867 Historical, mythological & religious subjects Exh: France, NG, Italy, Sweden	
BOILLY **Julien Leopold** b. Paris. 1796 - 1874 Portrait artist Exh: France	
GIRARDET **Jules** b. Versailles. 1856 - ? Portrait, genre & historical subjects Exh: France, Switzerland	
STREEK **Jurian Van** b. Amsterdam. 1632 ? - 1687 Portrait & still life subjects Exh: France, Holland, Austria	
ATHAR **Chiam** b. Zlatapol, Russia 1902 - Painter in oil media Exh: Israel, PS, S. Africa etc.	
BROWNE, ATD, ASWA **Kathleen** b. Christchurch, N.Z. 1905 - Pen & wash, oil media etc Exh: PS, RA, R.Scot.A, RBA, SWA, WIAC, Prov. AG's & abroad	

MANE-KATZ b. Russia. 1894 - 1962 Genre & figure compositions Exh: France, Israel, UK, US, Belgium, S. Africa, etc.	
SHACKLETON. RSMA, SWLA **Keith Hope** b. Weybridge. 1923 - B/white & oil media Exh: London & Prov. AG's	
KEERINCK **Alexandre** b. Antwerp. 1600 - 1652 Landscape artist Exh: France, Belgium, Holland	
KONINCK **Jacob 1** b. Amsterdam. 1616 - 1708 Portrait & landscape subjects Exh: NG, Brussels, Rotterdam, Leningrad	
BARRATT **Krome** b. London 1924 - Abstract subjects Exh: RA, ROI, RBA, NS, London & Prov. AG's	
SEEGER **Karl Ludwig** b. Germany. 1808 - 1866 Landscape artist Exh: Germany	
KUMLEIN **Akke** b. Stockholm. 1884 - 1949 Oil & tempera media Exh: London & Stockholm	
ROUSSEL **Ker Xavier** b. France. 1867 - 1944 Genre & mythological subjects Exh: France, Russia, Scandinavia	
CHOFFARD **Pierre Philippe** b. Paris. 1730 - 1809 Portrait, genre, & landscape artist Exh: France	
NUR. MA **A.S. Ali** b. Egypt. 1906 - Painter, etcher, cartoonist Exh: Egypt, Italy, Stockholm, London	

VLAMINCK **Maurice De** b. Paris. 1876 - 1958 Portraits, still life & landscape subjects etc. Exh: UK & European AG's	
FONTANA **Lavinia** b. Bologna. 1552 - 1602 Portraits & historical subjects Exh: France, Italy, Russia, UK	
BOUSSINGAULT **Jean Louis** b. Paris. 1883 - 1943 Still life, portrait & genre subjects Exh: France	
JONGH **Ludolf** b. 1616 - 1679 Portrait, genre, battle scenes & landscape artist Exh: Holland, Dublin, Geneva, Germany, Russia	
LA RUE **Philibert Benoit De** b. Paris. 1718 - 1780 Battle scenes, portraits & landscapes	
UNDERWOOD **Leon** b. 1890 - Portraits, genre & Mexican scenes Exh: UK AG's	
BILL, DWB, IPC, UAH, Hon. FAIR **MOEV** **Max** b. Switzerland. 1908 Painter & sculptor Exh: X, Europe	
WALSHAW. BWS **Charles Moats** b. Coventry. 1884 - Landscape artist Exh: BWS, RBSA, London & Prov. AG's	
LEVY – DHURMER **Lucien** b. Alger. 1865 - 1953 Genre artist Exh: France	
CARRACCI **Ludovico** b. Italy. 1555 - 1619 Portrait, religious & historical subjects Exh: UK, European AG's	

PIKE **Leonard** b. London. 1887 - Oil, watercolourist etc. Exh: RA, PS, RI, RSA, RBA, RGI, PAS, RWA, Prov. AG's	
LEGRAND **Louis Auguste Mathieu** b. Dijon. 1863 - 1951 Genre artist & illustrator	
BOURGEOIS **Charles Guillaume Alexandre** b. Amiens. 1759 - 1832 Miniaturist	
BUISSERET **Louis** b. Belgium. 1888 - ? Painter & engraver Exh: European AG's & US	
SERGENT **Lucien Pierre** b. France. 1849 - 1904 Battle scenes Exh: France	
LURCAT **Jean** b. France. 1891 - 1966 Genre subjects Exh: US, France, Moscow, Vienna	
TABAR **Francois Germain Leopold** b. Paris. 1818 - 1869 Historical & landscape subjects Exh: France	
MUSZYNSKI. RBA, DA **Leszek Tadeusz** b. Poland. 1923 - Painter in oil media Exh: London & Prov. AG's	
LUIGI (Called L'Ingegnio) **Andrea Di** b. Assisi. 1470 - 1512 ? Portraits & historical subjects	
Mac GONIGAL. PRHA, Hon.RA, **Hon.RSA. LL.D, (NC)** **Maurice Joseph** b. Dublin. 1900 - Portraits, genre, still life, landscape, oil & watercolourist etc. Exh: RA, RHA, Dublin US & European AG's	

CZIMBALMOS **Magdolna Paal** b. Hungary Portraits etc Exh: France, Germany, Canada, US, X	*Magdolna Paal Czimbalmos*
IRALA **Yuso** b. Madrid. 1680 - 1753 Historical & religious subjects Exh: Spain	*M·Ira Poyuso*
MAES **Jan Baptist Lodewyck** b. Belgium. 1794 - 1856 Portrait, historical & genre subjects Exh: Holland, Germany	*Mans. pinx*
BIRKHEAD (nee RALSTON) **Margaret** b. Farnborough. 1934 - Panel design & landscape artist Exh: London & Prov. AG's, US	*Mara*
ZULAWSKI. SMP, AIA **Marek** b. Rome. 1908 - Painter Exh: RA, London & Prov. AG's, Italy, US, Australia, Finland, etc.	*Marek*
COSWAY **Maria Cecilia Louisa Catherine** b. Florence. 1759 - 1838 Miniaturist Exh: RA. Italy	*Maria C del.*
LEWISON **Marjorie** b. Bristol. 1901 - Orientally influenced landscape & figure studies Exh: London & Prov. AG's, Japan	*MARJORIE*
KUYTENBROUWER (The Younger) **Martinus Antonius** b. Holland. 1821 - 1897 Hunting scenes & landscapes Exh: Brussels, Rotterdam	*Martinus*
VERBURGH **Medard** b. Belgium. 1886 - Still life, marine, figure & landscape subjects Exh: Belgium, US	*M. Verburgh.*
STERNE **Maurice** b. Libau. 1877 - ? Portraits, figures, still life & landscape artist Exh: US	*Maurice Sterne*

BEERBOHM **Max** b. London. 1872 - 1956 Painter & caricaturist Exh: London & Prov. AG's	*Max*
BAUER **Mari Alexander Jacques** b. The Hague 1867 - 1932 Figure & decorative painter Exh: European AG's	*MBauer*
EDWARDES **May de Montravel** b. London. 1887 - Miniaturist Exh: PS, SA, RA, RI, SM etc	*M. de M.-*
MEGAN **Renier** b. Brussels. 1637 - 1690 Landscape artist Exh: Belgium, Vienna	*MEG*
MEISSONIER **Justin Aurele** b. Turin. 1675 - 1750 Landscape & figure subjects etc. Exh: Italy, France	*Mé rin*
METHUEN. MA(Oxon), RA, RWS, **NEAC, PRWA, FSA, Hon.ARIBA** **Lord** b. 1886 - Figure & landscape artist Exh: RA, PS, London & Prov. AG's etc.	*Methuen.*
WOLVERSON. NDD, ATD **Margaret Elizabeth** b. Weston-Super-Mare. 1937 - Portraits, animals landscapes & miniaturist Exh: RMS, X UK, US	*MEWolverson*
SWAN **John Macallan** b. England. 1847 - 1910 Animal, genre & landscape subjects Exh: UK, Holland, Australia, Canada	*MSWAN.*
STOOP **Maerton** b. Holland. 1620 ? - 1647 Genre & military subjects Exh: Holland, Germany, Hungary	*M Stoop*
KMIT **Michael** b. Stryj. 1910 Exh: European AG's	*Michael Kmit*

CERQUOZZI **Michelangelo** b. Rome. 1602 ? - 1660 Still life, historical, battle scenes etc Exh: France, Germany, Italy, Spain etc	*Mic.*
MICHELANGELO (BUONARROTI) b. Italy. 1475 - 1564 Portraits, mythological & religious subjects etc. Exh: International AG's	*Michel Ange*
AYRTON, FRSA **Michael** b. London 1921 - Painter & sculptor Exh: London & Prov AG's. Italy, Germany, France & USA	*michael ayrton*
OURVANTZOFF **Miguel** b. St. Petersburg. 1897 - Tempera, oil & watercolour media Exh: Spain, US, S. America etc.	*Miguelourvantzoff*
LESZCZYNSKI **Michal Antoni** b. Poland. 1906 - B/white, oil & watercolourist Exh: RA, RI, NS, London AG's, U.S. etc.	*M. Leszczynski*
NEVEU (or NAIVEU) **Mathys** b. Leyden. 1647 - 1721 Portraits, interiors, genre & still life subjects Exh: Holland, Germany, Hungary, Switzerland, France etc.	*M. Neveu 1703*
BRACQUEMOND **Felix** b. Paris. 1833 - 1914 Portrait & landscape artist Exh: France	*Braquemond*
MONKMAN **Percy** b. Bradford. 1892 - Gouache, oil & watercolour media Exh: RBA, RI, London & Prov. AG's	*P.monkman j.*
MONTANE **Roger** b. Bordeaux. 1916 - Painter in oil media Exh: France, US	*Montané*
MOREELSE **Paulus** b. Utrecht. 1571 - 1638 Portrait, genre & historical subjects Exh: Holland, Germany, Belgium	*More: fe: A°. 1615*

KREMER **Petrus** b. Antwerp. 1801 - 1888 Genre & historical artist Exh: Holland, Montreal	
HOBBEMA **Meyndert** b. Amsterdam. 1638 - 1709 Landscape artist Exh: UK & European AG's etc	
GUTMAN **Nachum** b. Telenesht, Russia. 1893 - Oil, gouache & watercolourist Exh: Europe, S. Africa, US, London & S. America	
MINERS **Neil** b. Redruth. 1931 - Marine & landscape artist Exh: London & Prov. AG's, X UK	
HITCHENS, CBE **Sydney Ivon** b. London. 1893 - Still life & landscape artist Exh: London & Prov. AG's, Italy, France, Holland	
ANQUETIN **Louis** b. Etrepagny 1861 - 1932 Still life, genre & portrait artist Exh: France, UK AG's	
GELDER **Aart de** b. Dortrecht. 1645 - 1727 Historical & portrait artist Exh: France, Holland, Germany, Belgium, Russia, etc	
SKOLD **Ottel** b. China. 1894 - Portraits, figures, still life & landscape artist Exh: Scandinavia, France, Germany, etc.	
OCKENDON. ATD **Kathleen Ursula** b. London. 1913 - Watercolourist Exh: RA, London & Prov. AG's	
PENNE **Charles Olivier De** b. Paris. 1831 - 1897 Animal & landscape artist Exh: France	

HARRIS, OBE **Tomas** b. London. 1908 - Painter in oil media Exh: France, Spain, US etc	
O'NEIL **Bernard** b. 1919 - Painter & sculptor Exh: RSA, SSA, Canada, London & Prov. AG's	
HOOFT **Nicolas** b. The Hague. 1664 - 1748 Historical, genre & landscape artist Exh: Sweden, Germany	
GARDNER **Phyllis** b. Cambridge. 1890 - Watercolour & tempera media Exh: NEAC, RMS, London AG's etc	
ORPEN, RA, RWS, RHA **Sir William Newenham Montague** b. Stillorgan. 1878 - 1931 Genre & portrait artist Exh: NEAC, RA, UK AG's, Paris, US	
OAKES, ARA, RSA **John Wright** b. Cheshire. 1820 - 1887 Landscape artist Exh: RA, BI, VA, UK AG's	
LASZLO DE LOMBOS **Philip Alexius De** b. Budapest. 1869 - ? Portrait artist Exh: SOA, NPG, Britain, Italy, France	
MIGNARD **Paul** b. Avignon. 1639 ? - 1691 Portrait artist Exh: France, Germany, Turin	
BOL **Pierre** b. Anvers. 1622 ? - 1674 ? Animals & still life artist Exh: UK, France, Hungary, Germany, Holland etc	
STEVENS **Peeter** b. Belgium. 1567 - 1624 ? Landscape artist Exh: Germany, France, Austria	

TOSELAND **Peter Harold** b. Broughton, Northants. 1917 - Portraits, landscapes & topographical subjects Exh: RA, RI, Prov. AG's	*Peter Toseland*
KLEINHANS **Robert Burton** b. Reynoldsville, US. 1907 - Land & seascapes Exh: US AG's	*PETITJEAN*
PERUGINO (PIETRO VANNUCCI) **II** b. Nr. Perugia. 1446 ? - 1523 Portraits, religious & historical subjects Exh: UK & European AG's	PETRVS PERVSINVS PINXIT
PICART LE DOUX **Charles Alexandre** b. Paris. 1881 - 1959 Genre, still life & landscape subjects etc. Exh: France, Russia	*Picart Le Doux -*
QUAST **Pieter Jansz** b. Amsterdam. 1606 - 1647 Portraits, domestic & humourous genre subjects Exh: France, Austria, Russia, Holland, UK	*Pictorquast Jnr 1633*
ROY **Pierre** b. Nantes. 1880 - 1950 Genre subjects & illustrator Exh: France, US, UK	*Pierre Roy*
DIERCKX **Pierre Jacques** b. Anvers. 1855 - ? Genre subjects Exh: Belgium, Germany	*Dierckx*
PIERRE **Jean Baptiste Marie** b. Paris. 1713 - 1789 Religious & historical subjects Exh: France, Russia	*Pierre*
KASTEELS **Peter 11** b. Belgium. FL. 17th C. Painter of battle scenes Exh: Germany, Belgium	*P KASTEELS*
KONINCK **Philips de** b. Amsterdam. 1619 - 1688 Portrait, historical & landscape subjects	*P-ko* *P-koning*

PLANASDURA. IIAL **E.** b. Barcelona. 1921 - Abstract art Exh: Spain, France, Switzerland, Italy, S. America. etc.	
LE MATTAIS **Pierre Joseph** b. France. 1726 - 1759 Marine & mythological subjects	
MONTEZIN **Pierre Eugene** b. Paris. 1874 - 1946 Landscape artist Exh: France, Germany	
PRASSINOS **Mario** b. Istambul. 1916 - Etcher & Painter Exh: France	
PRUD'HON **Pierre** b. France. 1758 - 1823 Historical & portrait artist Exh: France, London	
ASCH **Pieter Jansz van** b. Delft 1603 - 1678 Landscape artist Exh: Holland, Hungary, Scandinavia, UK, etc	
LOON **Pieter Van** b. Haarlem. 1731 - 1784 Still life & floral subjects Exh: Belgium, Holland, Vienna, Lisbon	
HAILE **Richard Neville** b. London. 1895 Miniaturist Exh: RA, London & Prov. AG's	
VANNI **Rafaello** b. Sienna. 1587 - 1678 Religious subjects Exh: Italy	
BIRKHEAD (nee RALSTON) **Margaret** b. Farnborough. 1934 - Panel design & landscape artist Exh: London & Prov. AG's, US	

RAVESTEYN **Hubert Van** b. Holland. 1638 - 1692 ? Still life & genre subjects Exh: Holland, Germany, Austria etc.	
RAVESTEYN **Jan Anthonisz Van** b. The Hague. 1570 - 1657 Portrait artist Exh: Holland, France, Belgium, Germany, US, UK, etc.	
BRAKENBURG **Richard** b. 1650 - 1702 Genre & portrait artist Exh: Holland, France, Germany, Hungary etc	
DROLLING **Martin** b. 1752 - 1817 Interiors, genre & portrait artist Exh: France, Germany	
RYCKKALS **Frans** b. Holland. 1600 - 1647 Genre, still life & landscape subjects Exh: Holland, Germany, Belgium	
LLOYD **Reginal James** b. Hereford. 1926 - Abstract & landscape artist Exh: RBA, RWA, London & Prov. AG's	
BOSSHARD **Rodolph Theophile** b. 1889 - Still life, landscapes & nudes Exh: European AG's	
REMBRANT (or RIJN) **Harmensz Van** b. Holland. 1606 - 1669 Portraits & historical subjects Exh: International AG's	
DUNLOP, RBA **Ronald Ossory** b. Dublin. 1894 - Painter in oil media Exh: London RBA, NS etc	
ROOS **Jacob** b. Rome. 1682 - ? Landscape subjects Exh: France, Germany	

DICKENS **Rosemary** b. Salisbury 1943 - Floral, birds, & landscape subjects etc. Exh: London & Prov. AG's	*Rosemary*
THORNE-WAITE **Robert** b. England. 1842 - ? Genre & landscape subjects Exh: RA, RI, UK, Sydney	*R. Thorn Waite*
OEFELE **Franciszek Ignacy** b. Poland. 1721 - 1797 Portrait artist Exh: Germany, Poland	*Foe*
RUISDAEL (or RUYSDAEL) **Jacob Isaakszoon** b. Haarlem. 1628 ? - 1682 Landscape subjects Exh: Holland, Belgium, France, UK, US, etc.	*Ruysdael in. 1649 Ruisdael*
MANETTI **Rutilio Di Lorenzo** b. Sienna. 1571 - 1639 Religious & historical subjects Exh: Italy, France, Madrid	*RuMan*
SPEAR.RA, ARCA **Ruskin** b. 1911 - Exh: RA, London & Prov. AG's, US, Australia, Russia, Belgium, etc.	*Ruskin Spear*
SCHEFFER **Ary** b. Germany. 1795 - 1858 Historical & portrait artist Exh: France, Germany, UK, US	*Ary Scheffer*
COELLO **Alonso Sanchez** b. Valencia. 1515 - 1590 Historical & portrait artist Exh: Germany, UK, Spain	*Sanchez.F*
SCHNEIDER **Otto J** b. Atlanta. 1875 - ? Painter & engraver	*Schneider*
COMPAGNO **Scipione** b. Naples. 1624 ? - 1680 Biblical & historical subjects	*Scip:f*

ESPAGNAT Georges d' b. Paris. 1870 - 1950 Portrait, still life, genre & landscape artist Exh: France	
SEPO Severo b. Italy. 1895 - Painter & sculptor Exh: Italy	
SASSOFERRATO (called Giovanni Battista Salvi) b. Sassoferrato. 1609 - 1685 Religious subjects Exh: European AG's, Russia, US, UK	
HALL Gertrude b. 1874 - ? Watercolourist Exh: PS, IS, RI etc	
PILS Isidore Alexandre Augustin b. Paris. 1813 - 1875 Historical & genre subjects Exh: France, UK, Belgium	
HURRY Leslie b. London. 1909 - Oil, ink & watercolour media Exh: London & Prov. exhibitions. Canada, S. Africa etc	
SOROLLA Y BASTIDA Joaquin b. Spain. 1863 - 1923 Marine, portraits & genre subjects Exh: Spain, Italy, US	
STRAUCH Georg b. Nuremberg. 1613 - 1675 Historical subjects Exh: Austria	
TISSOT James Jacques Joseph b. Nantes. 1836 - 1902 Religious, historical & genre subjects Exh: PS, RA, SS, GG, Prov. AG's, Belgium, France	
WILSON Stanley R. b. London. 1890 - Oil & watercolourist Exh: RA, London & Prov. AG's	

STOCKER **Hans** b. Basle. 1896 - Exh: Switzerland, Germany	*Stocker*
LUCAS. RMS, (HS)FRHS, SWA, UA. **Suzanne** b. Calcutta. 1915 - Miniatures & watercolours of folowers, animals etc. Exh: RA, PS, RWS,FBS,SWLA,SWA, UA.US, Australia, London AG's	*(signature) LUCAS*
LUCE **Maximilien** b. Paris. 1858 - 1941 Landscape & genre subjects, neo-impressionist Exh: France	*Luce*
GUILLAUMIN **Jean Baptiste Armand** b. Paris. 1841 - 1927 Landscape artist Exh: France	*Guillaumin*
SIPILA **Sulho Wilhelmi** b. Aland. 1895 - Sculptor, oil & watercolourist Exh: Holland, Russia, Scandinavia, Germany, etc.	*Sulho*
BERLIN Sven Paul b. 1911 - Painter & sculptor Exh: US AG's. X.	*Sven.*
TRAFFELET **Frederic Edward** b. Berne. 1897 - Fresco, oil & watercolourist Exh: Switzerland, X.	*Traffelet*
FIDLER Harry b. Salisbury. ? - 1935 Genre & landscape artist Exh: London & Prov. AG's	*Hd.*
WADE **Thomas** b. Wharton. 1828 - 1891 Genre & landscape artist Exh: RA, BI, London & Prov. AG's	*WADE 1868*
HATWELL Anthony b. London. 1931 - Painter & sculptor Exh: X	*Hatwell*

RYSSELBERGHE **Theodore** b. Belgium. 1862 - 1926 Genre & portrait artist Exh: Holland, Belgium, France	*Théov Ro 1888*
TITIAN **(Tiziano Vecelli)** b. Capo Del Cadore. 1477 ? – 1576 Religious, historical, mythological & portrait artist Exh: International AG's	*Tizianus* *. F.*
TURNEY. ABWS **Arthur Allin** b. Shercock. 1896 - Marine watercolourist Exh: BWS & Prov. AG's	*ATurney.*
ECKENBRECHER **Karl Themistocles von** b. Athens. 1842 - ? Oriental subjects, landscapes etc Exh: German AG's	*TvEckenbrecher*
QUELLIN **Jean Erasmus** b. Antwerp. 1634 ? - 1715 Historical & portrait subjects Exh: France, Belgium	*Quellinus*
TURNER **Charles** b. England. 1773 - 1857 Portrait & genre subjects Exh: ARA, NPG, Prov. AG's	*Turner*
RAVENSWAY (The Elder) **Jan Van** b. Holland. 1789 - 1869 Landscape & animal subjects Exh: Holland	*J.V.R.*
VALESIO **Giovanni Luigi** b. Italy. 1583 ? - 1650 ? Religious subjects & miniaturist Exh: Italy	*Vⁱ VAL*
BLARENBERGHE **Louis Nicolas van** b. Lille. 1716 - 1794 Battle scenes, landscapes & miniatures Exh: Holland, UK, France	*Van B*
LELY. Bt. **Sir Peter (Van Der Faes)** b. Westphalia. 1618 - 1680 Portrait artist Exh: NG, NPG, VA, France, Germany, Italy.	*P.D. Faes f*

FANTIN-LATOUR Victoria b. Paris. 1840 - ? Still life artist Exh: France	*V Dubourg*
HAGEN Joris van der b. 1620 - 1669 Landscape artist Exh: Holland, France, Germany, Denmark, UK etc	*verhaege fe 1652*
VERON Alexandre Paul Joseph b. Paris. 1773 - ? Historical & floral subjects Exh: France	*Veron Bellecourt*
URRABIETA ORTIZ Y VIERGE Daniel b. Madrid. 1851 - 1904 Genre subjects & illustrator Exh: Australia, France, Spain	*VIERGE*
GOGH Vincent Willem van b. Zundert. 1853 - 1890 Genre, still life & landscape impressionist Exh: World-wide AG's & collections	*Vincent Vincent*
GOLDSMITH William b. Sleaford. 1931 - Abstract subjects Exh: London & Prov. AG's	*W Goldsmith*
WATTEAU Jean Antoine b. France. 1684 - 1721 Fetes, genre subjects etc. Exh: Russia, UK & European AG's	*Watt Wa Wat. f. Wa f.* *Watt f. Watt..*
BEMMEL Wilhelm von b. Utrecht. 1630 - 1708 Landscape artist Exh: Holland, Germany, Austria	*WBem f*
BUYTEWECH Willem Pieter b. Rotterdam. 1585 ? - 1628 ? Biblical, genre, landscapes etc Exh: Germany	*WBugt. Inv.*
WEST. RWS Joseph Walter b. Hull. ? - 1933 Oil & watercolourist Exh: London & Prov. AG's, Paris	*wJFe*

LEE-HANKEY. ARWS, RE, ROI. **William Lee** b. 1869 - 1952 Engraver, oil & watercolourist etc. Exh: RA, RWS, RE, ROI, PS etc.	
WEIR **Harrisson William** b. Lewes. 1824 - 1906 Animal & landscape subjects Exh: RA, SSBA, VA, BI, NWS	
GLEHN **Wilfred Gabriel de** b. London. 1870 - ? Figure & genre artist Exh: UK, Australia	
VIDAL **Vincent** b. France. 1811 - 1887 Portrait artist Exh: France	
IWILL **Marie Joseph Leon Clavel** b. Paris. 1850 - 1923 Marine & landscape painter Exh: France	
DRING **Dennis William** b. London. 1904 - Portrait & landscape artist Exh: RA, RWS, RP	
FERNANDO **Winitha** b. Colombo. 1935 - Figurative artist Exh: PS, France, Switzerland, London AG's, Ceylon etc	
PILAWSKI. NDD, ROI **Wieslaw** b. Russia. 1916 - Painter in oil media Exh: RA, ROI, RBA, NS, London & Prov. AG's	
FRYER, SMA **Wilfred Moody** b. London. 1891 - B/White, oil & watercolourist Exh: RA, RI, RBA & Prov. AG's	
HUTCHISON, HRA, PRSA, Hon.RA, **RSA, ARSA, RP.** **Sir William Oliphant** b. Kirkcaldy. 1889 - Portrait & landscape artist Exh: RA, RSA, NEAC, GI, IS	

BAGDATOPOLOUS **William Spencer** b. Greece 1888 - Drawing & watercolourist Exh: RI, Holland, US, UK AG's etc	*W. S. Bylstejilis*
TYRWHITT. RBA, MA **Walter Spencer Stanhope** b. Oxford. 1859 - 1932 Architectural & landscape artist Exh: RA, RI, RBA, London & Prov. AG's	*WS Tyrwhitt*
UNGER **Edouard** b. Germany. 1853 - 1894 Historical & genre subjects Exh: Germany	*W. Ung*
WYCK **Thomas** b. Holland. 1616 ? - 1677 Interiors, markets & marine subjects Exh: Russia, European AG's, UK, etc.	*Bwyck*
YEEND-KING **Lilian** b. Paris. 1882 - Landscape artist Exh: RA, RI, ROI, Prov. AG's	*Y. KING.*
ZWENGAUER **Anton** b. Munich. 1810 - 1884 Landscape artist Exh: Germany, Switzerland	*Zwgr. 1831*
SCHLEGER. FSIA **Hans** b. Germany Exh: UK AG's, France, US, etc.	*ZERo*
ROMER **Zofja** b. Dorpat. 1885 - Portraits & landscape artist Exh: UK, Poland, Russia, France, US, Italy, etc.	*Z Romer*

UNCLASSIFIED

CHANG, BA, Mem. RI, RWA **Chien-Ying** b. 1915 - Watercolourist Exh: RA, RI, RBA etc	張蒨英

DALI **Salvador** b. Figueras. 1904 - Surrealist Exh: International AG's	
FEI **Cheng-Wu** b. China. 1914 - Exh: RA, RI, RWA, RWS, NEAC, & Prov. AG's	
FOUJITA **Tsugouharu** b. Tokyo. 1886 - Figure, animal, still life, genre & land- scape subjects etc Exh: Japan, France, Belgium, Germany US. etc	
KWOK **David** b. Peiping, China. 1919 - Watercolourist Exh: China, London & US. AG's	
MERVYN. ARCM **Sonia** Pastel, oil & watercolour media Exh: RA, London & Prov. AG's	
MOULES. RSW **George Frederick** b. 1918 - Watercolourist Exh: RA, RSA, WAG, GI, RBA, RSW etc.	
NALECZ **Halima** b. Poland Painter in oil media Exh: French & UK AG's	
PUTZ **Leo** b. Germany, 1869 - ? Genre subjects Exh: Germany, Hungary	
RACIM **Mohammed** b. Algiers. 1896 - Watercolourist Exh: European & Mid. Eastern AG's	
RAMAUGE **Roberto** b. Argentina. 1890 - Landscape artist Exh: France	

RANKEN. VP. ROI, RI **William Bruce Ellis** b. Edinburgh. 1881 - Portrait, interior, flower & landscape artist Exh: NEAC, RS, RA, RI, NPS, RP, RSA, US, etc.	*[signature]* 1926.
SAHAI. ARIBA **Virendra** b. India. 1933 - Ink, oil & watercolourist Exh: London & Prov. AG's, France	*[signature]*
SEGALL **Lasar** b. Russia. 1890 - 1957 Abstract studies Exh: Brazil, US, European AG's	*[signature]*
SELIM **Jewed** b. Ankara. 1920 - Painter & sculptor Exh: London, Egypt, India, etc.	*[signature]*
TONKS **Myles Denison Boswell** b. Nr. Chatham. 1890 - Landscape, oil & watercolourist Exh: RA, NEAC, London & Prov. AG's	*[signature]*
CHANG, BA, Mem. RI, RWA **Chien-Ying** b. 1915 - Watercolourist Exh: RA, RI, RBA etc	張倩英 *[seal]*
BENGTZ **E. A. Ture** b. US. 1907 - Exh: X, US	*[signature]*
FRITH, RA **William Powell** b. Yorkshire. 1819 - 1909 Genre, portrait & historical subjects Exh: RA, BI, SS, France, Belgium, 　　　Austria	W.P.Frith

16th EDITION 1983/84
TWO VOLUMES
£ 59.50 *plus postage and package*

INTERNATIONAL DIRECTORY OF ARTS

For over 30 years the International Directory of Arts has provided the most comprehensive and up-to-date documentation on the world of art. More than 100,000 checked addresses from all over the world are classified and listed in alphabetical order according to countries and towns.

It includes a great deal of useful information on all spheres of art, on collections, exhibitions, preservation of ancient art and the art dealing business. Additional special data completes this massive collection of addresses. Numerous illustrations and display advertisements give supplementary and worthwhile information.

This uniquely comprehensive work will save you time-consuming reference to several different handbooks.

The 16th edition 1983/84 appears in October 1982; two volumes in encyclopedia-like format 170 × 200 mm with approx. 2,000 pages; completely revised and up-dated. Every effort has been made to incorporate the many changes that have occurred in the art world during the last two years – about 40% of the editorial listings are new or revised.

Volume I

MUSEUMS AND PUBLIC GALLERIES
A complete list of places from all over the world where collections and exhibitions may be seen, with names of directors and important curators. This category is compiled in close co-operation with the International Council of Museums (ICOM), Paris.

ACADEMIES, UNIVERSITIES, ART SCHOOLS
Public and private art schools and research institutions from all over the world.

ART ASSOCIATIONS
Fine Art associations, trade associations for art and antique dealers, clubs that sponsor artists, etc.

RESTORERS
Experts who restore and preserve art pieces, their special field of activity is indicated.

EXPERT-NAMES
A list in alphabetical order of museum directors and their staff, other experts from all art fields.

Volume II

ART AND ANTIQUE DEALERS
Names and exact addresses of specialists and firms in the art dealing business coded to show their specialities.

NUMISMATICS
Numismatic dealers and antique dealers with numismatic departments.

GALLERIES
Art dealers and private galleries dealing in old and modern paintings, sculptures and graphic art.

AUCTIONEERS

ART PUBLISHERS
With information on the publishing programmes.

ART PUBLICATIONS
as well as trade publications on archaeology, ancient art and folklore.

ANTIQUARIAN AND ART BOOKSELLERS
Antiquarians dealing in old, rare books, old prints and autographs.

ARTISTS
Active contemporary artists, sculptors and engravers whose work has been recognized by galleries, dealers and collectors. Numerous illustrations of the artists' works are published in this section.

COLLECTORS
Names and addresses of sponsors and persons collecting art, indicating their special field of interest.

ART ADDRESS VERLAG MÜLLER GMBH & CO. KG

D-6000 Frankfurt/Main 1, Grosse Eschenheimer Strasse 16
or GEORGE PRIOR ASSOCIATED PUBLISHERS, High Holborn House, 52–54 High Holborn, London WC1V 6RL